NEW SPIRIT,
NEW MONEY.
ART IN THE 1980s

NEW SPIRIT, NEW SCULPTURE, NEW MONEY:
ART IN THE 1980s

Richard Cork

Yale University Press
New Haven and London

To Polly,
with all my love

Designed by Ruth Applin and Beatrix McIntyre
Set in Bembo
Printed in China through World Print

Library of Congress Cataloging-in-publication data:
Cork, Richard.
 New spirit, new sculpture, new money : art in the 1980s / Richard Cork.
 p. cm.
Includes index.
 ISBN 0-300-09509-0 (pbk. : alk. paper)
 1. Art, British – 20th century – Themes, motives. 2. Avant-garde (Aesthetics) – Great Britain – History – 20th century. 3. Art – Exhibitions. I. Title: Art in the 1980s. II. Title.
 N6768 .C675 2002
 709'.41'09048–dc21

 2002153137

Frontispiece: Photograph of Richard Cork, 1980

CONTENTS

STAYING POWER

All these articles were written for the *Evening Standard* (until the end of 1983) or *The Listener* (from 1984 until 1989), apart from 'Sport and Art', published by the *International Herald Tribune*; 'Trees in Extremis', published by *The Independent on Sunday*; 'Common Ground in Dorset', published by Common Ground; 'Keith Haring' and 'Jean-Michel Basquiat', both published by *The Times*; and 'State of the Art', which first appeared in *The Times Literary Supplement*.

AUTHOR'S BIOGRAPHY

Richard Cork is an art critic, historian, broadcaster and exhibition organiser. He read art history at Cambridge, where he was awarded a Doctorate in 1978. He has been Art Critic of the London *Evening Standard*, Editor of *Studio International*, Art Critic of *The Listener* and Chief Art Critic of *The Times*. In 1989–90 he was the Slade Professor of Fine Art at Cambridge, and from 1992–5 the Henry Moore Senior Fellow at the Courtauld Institute. He then served as Chair of the Visual Arts Panel at the Arts Council of England until 1998. He was recently appointed a Syndic of the Fitzwilliam Museum, Cambridge, and a member of the Advisory Council for the Paul Mellon Centre.

A frequent broadcaster on radio and television, he has organised major contemporary and historical exhibitions at the Tate Gallery, the Royal Academy, the Hayward Gallery and elsewhere in Europe. His international exhibition on Art and the First World War, held in Berlin and London, won a National Art Collections Fund Award in 1995. His books include a two-volume study of Vorticism, awarded the John Llewelyn Rhys Prize in 1976; *Art Beyond the Gallery*, winner of the Banister Fletcher Award for the best art book in 1985; *David Bomberg*, 1987; *A Bitter Truth: Avant-garde Art and the Great War*, 1994; and *Jacob Epstein*, 1999. The present book is part of a four-volume collection of his critical writings on modern art, all published in 2003.

ACKNOWLEDGEMENTS

I must again thank Charles Wintour, who in 1980 brought me back to the *Evening Standard* soon after he returned there for his second and final bout as its Editor. I am also grateful to Russell Twisk, who gave me a new platform at *The Listener* in 1984, and to all the artists, galleries and museums who so generously supplied illustrations for this book.

Thanks are due to Veronica Wadley, Editor of the *Evening Standard*, Greg Dyke, Director-General of the BBC, Common Ground, and the Editors of *The Times*, the *International Herald Tribune*, *The Independent on Sunday* and *The Times Literary Supplement* for granting me permission to publish material that originally appeared in their publications.

At Yale, Ruth Applin and Beatrix McIntyre deserve an accolade for handling with such skill and patience all the complexities of publishing four books at once. My thanks also go, as ever, to my publisher John Nicoll. His enthusiasm for this project was invaluable, and I am fortunate indeed to benefit once again from his wisdom.

Each of these books is dedicated to one of my four children. Adam, Polly, Katy and Joe can never know how much they have sustained and delighted me, while my wife Vena has always given me a limitless amount of encouragement, friendship and love.

INTRODUCTION

From the outset, the 1980s were marked by an aggressive attempt to reassert the old dominance of painting. Plenty of artists and critics were eager to decry the range of valuable new liberties claimed during the previous decade and argue that painting, after a fallow period, was now ready to flourish at the expense of all the heretical alternatives. Having supported the right to work in a far wider variety of ways, I insisted in 1980 that equal status should be given to every valid option within a rich multiplicity of methods and materials. Both painting and sculpture would have a very honourable place here, of course. But any bid to bring back their *exclusive* sovereignty, at the expense of everything that the 1970s had achieved, ought in my view to be opposed. Without such resistance, hard-won freedoms would once again find themselves curtailed, merely to satisfy the prejudices of those who maintained that 'greatness' in art was only attainable with pigment, canvas, steel or bronze.

In London, this bigotry was disturbingly apparent in the 1980 *Hayward Annual*, an otherwise enjoyable celebration of contemporary British painting. John Hoyland, the exhibition's selector and one of Britain's finest abstractionists, declared in the catalogue that all the participants 'have addressed themselves to painting or sculpture and the pursuit of High Art.' The critic Tim Hilton, who helped Hoyland with the show, went even further in his essay. He categorically insisted that the alternative media developed during the 1970s were 'a minor art', and they 'had no relationship whatsoever to the major art of the time.' According to Hilton, the 1980 *Hayward Annual* 'exhibits that kind of art in which high art can legitimately be sought.' And since the show consisted almost entirely of large paintings on canvas – apart from a trio of abstract sculptors, included to reveal their influence on the painters – the bias was all too clear. It assumed that artists could aspire to 'high merit' solely through the two orthodox media, and that painting was by far the more important of them.

Such reasoning was as arrogant as it was ill-founded. Painters and sculptors of the 1980s took justifiable pride in the knowledge that they belonged to a magnificent, continuing tradition. But why should other artists not achieve equal distinction by exploring new ways of making

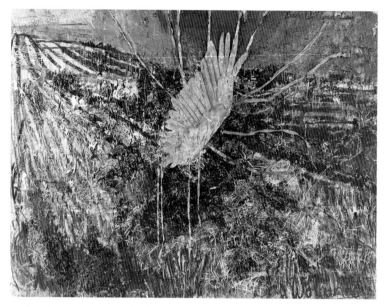

1. Anselm Kiefer, *Das Wölund-Lied*, 1982

visual imagery as well? The activity we choose to call 'art' has continu-
ally altered in response to the needs of different societies. So there was
no reason why artists should be scorned and regarded as automatically
inferior for deciding to explore resources made available in the late
twentieth century. By pretending that painting and sculpture contained
the sole key to 'high fine art', supporters of the early 1980s' backlash
betrayed gross sentimentality and intolerance. The logical outcome of
such claims would have been to close down new avenues, at a time when
artists benefited from a greater breadth of working possibilities than ever
before. Writing once more for the *Evening Standard*, where Charles
Wintour had returned as Editor, I was determined to resist all attempts
to implement such a repressive move.

When the Royal Academy announced that it would mount a
polemical show called *A New Spirit in Painting*, I feared a reprise of the
arguments buttressing the 1980 *Hayward Annual*. But when this major
international survey opened in 1981, it did not seek to present a
supremacist view of painting. Several of the selected artists, Per Kirkeby
and A. R. Penck among them, regarded paint on canvas as only one way
of working among the many they explored. Others, like the elderly

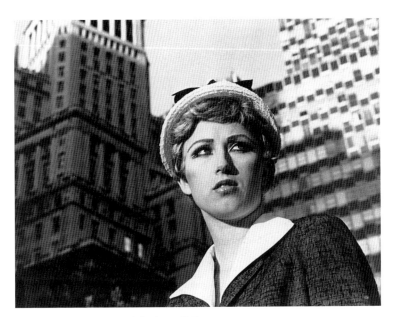

2. Cindy Sherman, *Untitled Film Still #21*, 1978

Picasso, had spent their careers restlessly proving that they could make art from whatever materials they chose. So although *A New Spirit in Painting* quickly came to be regarded in some quarters as a rallying-cry for opponents of the previous decade's innovations, it was far less repressive than the *Hayward Annual*. Although largely European, the selection found room for the prodigious late work of Philip Guston, whose poignantly posthumous solo show at the Whitechapel Art Gallery proved such a revelation the following year. And the Royal Academy survey did succeed in giving prominence to a new generation of figurative painters in Germany and Italy, so that artists as substantial as Georg Baselitz and the outstanding, impassioned Anselm Kiefer finally began to receive the wide attention they had merited for some time.

In one respect, however, *A New Spirit in Painting* seemed alarmingly limited. Although thirty-eight artists were included, they were all male. Women played no part at all, and their exclusion gave the exhibition a retrograde air. It was depressing for everyone who had been heartened, during the 1970s, by the surging interest in women artists from past and present alike. It also failed to reflect my awareness, when the 1980s arrived, of an increasing number of memorable exhibitions by women. Right at the

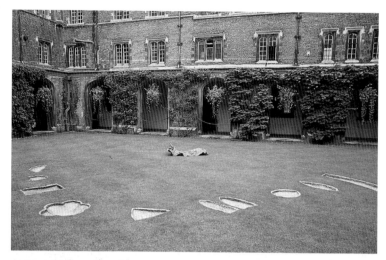

3. Veronica Ryan, Installation at Jesus College, Cambridge, 1988

beginning of the decade, the ICA mounted a major international season of shows devoted to women's art. The most impressive of them, a show called *Issues* curated by Lucy Lippard in 1980, brought together a number of powerful and provocative contributions from, among others, Maria Karras, Nancy Spero, May Stevens and Mierle Laderman Ukeles.

The whole notion of collective surveys, dealing exclusively and polemically with feminist concerns, dwindled as the decade proceeded. But in their place an impressive number of solo shows by women was staged. Indeed, I would argue that their sustained flowering was one of the most positive aspects of art during this period. Young artists as substantial as Helen Chadwick, Shirazeh Houshiary, Magdalena Jetelová, Cindy Sherman and Alison Wilding all played a distinguished part in the vitality of new art, while from a more senior generation Paula Rego was at last recognised with a powerful retrospective at the Serpentine Gallery. By the end of the decade, when Meret Oppenheim's long and subversive career was brought to an end with her death, women often seemed more outstanding than men in mixed shows like the Whitechapel Art Gallery's *From Two Worlds*, where Lubaina Himid, Houria Niati and Veronica Ryan made memorable contributions to an exhibition of artists whose roots lay far outside Euro-American boundaries.

Despite the familiar geographical limits circumscribing *A New Spirit in Painting*, interest grew throughout the decade in art from other, less

4. Rasheed Araeen, *Look Mamma, Macho!*, 1983–6

5. Aubrey Williams, *Shostakovich Quartet No. 7, Opus 108*, 1980

familiar parts of the world. New work from Africa, Bangladesh, the Caribbean, India and Japan particularly impressed me, and at the end of the 1980s Rasheed Araeen organised a valuable exhibition called *The Other Story*. Born in Karachi but now settled in London, Araeen offered a refreshing corrective to the orthodox view of post-war British art. He emphasised the historical significance of *emigrés* like Avinash Chandra and F. N. Souza, part of what V. S. Naipaul has termed the 'great movement of peoples that was to take place in the second half of the twentieth century.' It brought other, younger artists to the west as well, including Balraj Khanna and Aubrey Williams who each arrived at an individual fusion of modernism and the art of his native country. The same bal-

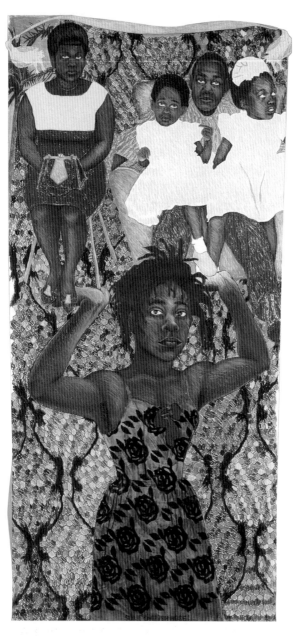

6. Sonia Boyce, *She Ain't Holding them Up, She's Holding on (Some English Rose)*

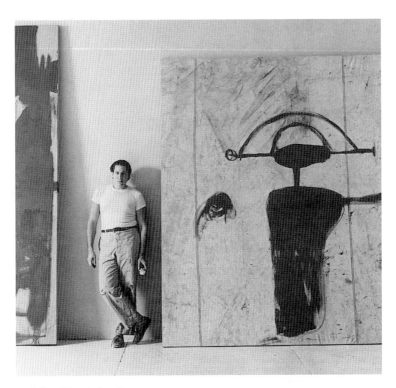

7. Julian Schnabel, 1982

ancing act can be found in the work of succeeding generations, from Gavin Jantjes to Sonia Boyce, whose resilience in dealing with the often intolerant attitudes souring British society helped to create the conditions where young black artists of the 1990s have been able to thrive.

This ever-broadening awareness of contemporary art produced across the world proved salutary, especially in Britain where New York had been the cynosure ever since the emergence of Abstract Expressionism after the Second World War. The Manhattan of the early 1980s did, admittedly, produce Julian Schnabel, who arrived in international exhibitions of new painting with extraordinary swiftness. Before long, he was relentlessly promoted as the greatest young American artist of his generation. The prices of Schnabel's work rose to confirm these inflated claims. He became a focus of attempts to prove that New York painting had not, after all, foundered in comparison with the renewed strength of

German and Italian art. But the praise and money lavished on Schnabel by his admirers provoked, in turn, vociferous resentment. His detractors argued that he was nothing more than a creation of art-market hype. Although the climate of controversy surrounding him made a level-headed assessment of the work itself very difficult, he soon came to typify in my mind the wildly excessive reputation-making that ended up devaluing so much of the vaunted new painting.

Sculpture, on the other hand, certainly underwent a momentous and, in the end, more persuasive renewal. During the 1970s, when the whole notion of a three-dimensional object was widely questioned, the term 'sculpture' found itself reformulated, challenged and widened in meaning almost beyond recognition. By the time I organised an exhibition at the Royal College of Art in 1974, called *Sculpture Now: Dissolution or Redefinition?*, the answer to that question hung in the balance. Some of the work on display, by Carl Andre, Dan Flavin, Don Judd and Ulrich Rückriem, reduced the language of sculptural expression to a state of unprecedented austerity. But other exhibits, including pieces by Mel Bochner, Gilbert & George, Dan Graham, Joseph Kosuth, Richard Long and Dennis Oppenheim, departed so radically from the Minimalist tradition that 'sculpture', in the accepted sense of the word, no longer appeared to be the end-product.

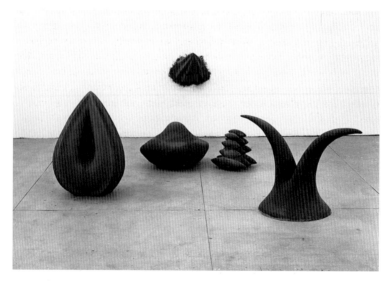

8. Anish Kapoor, *Red in the Centre*, 1982

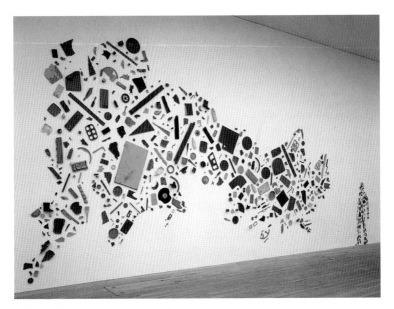

9. Tony Cragg, *Britain Seen from the North*, 1981

The onset of the 1980s, though, witnessed a dramatic resurgence of interest in the possibilities of sculptural activity. A new generation of artists discovered that it provided them with the freedom to deploy a wealth of images and references that so many sculptors had excluded from their work a decade before. The old purist concentration on reductive form, often of an extremely abstract kind, gave way to an eruption of far more flamboyant alternatives. Revelling in showmanship, exotic flourishes and outrageous humour, it was boisterous enough to inaugurate an expansive new mood among young practitioners of the so-called 'New Sculpture.' Many of them were unafraid to explore the possibilities of representation once again, and the results took an often intoxicating variety of forms. Some, born far outside the boundaries of the West, were intent on reconciling their British identity with foreign traditions. Anish Kapoor's elemental forms coated in glowing pigments referred as much to his Indian heritage as to modern European sculpture, while Shirazeh Houshiary's sensuous work in wood, plaster, clay and straw fused western influences with her Iranian origins.

The majority of young sculptors were more overtly involved with the contemporary world. Like the recession-torn country they inhabited,

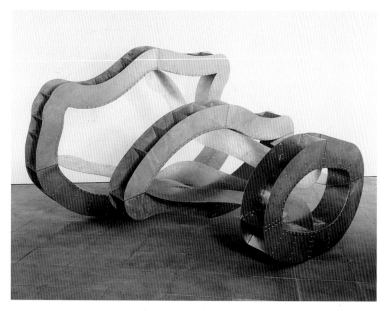

10. Richard Deacon, *Feast for the Eye*, 1986–7

their work was conscious of waste, violence and redundancy. But they adopted an oblique approach to such issues rather than commenting on the condition of the 1980s in an obvious way. Nor was there anything weary or defeatist about their sculpture. It was notable for wit, freshness of vision and a vigorous refusal to be satisfied with stale formulae. Even though it employed three-dimensional objects once again, and to that extent seemed in sympathy with traditional notions about sculpture, its makers obeyed no rules except their own. Several of them recycled cast-off materials, persuading the most wretched of scavenged objects to take on powerful and unpredictable new identities. Tony Cragg made no attempt to disguise the unloved tables, desks and cupboards he assembled in such imposing groups, but they took on a surprisingly formal grandeur which linked them with Richard Deacon's more imposing, monumental work. Bill Woodrow, fond of bizarre transformations, cut up clapped-out twin-tubs and car bonnets in order to twist the metal strips into cacti and guitars. These artists, scouring beaches, gutters and waste-tips for an extraordinary variety of thrown-away fragments, conveyed satirical and even angry views on the state of the nation. But they never mounted

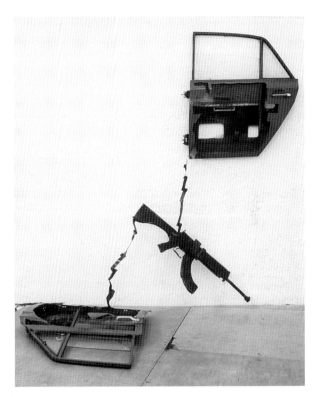

11. Bill Woodrow, *Two Blue Car Doors*, 1981

polemical onslaughts on the society whose products preoccupied them. Although their work was filled with matter apparently culled from an industrial wasteland, where everything was worn out and littered the environment, they marshalled the detritus with great zest and clarity.

Not that the first half of the decade gave much cause for optimism about the well-being of modern art under Margaret Thatcher's philistine reign as Prime Minister. She did nothing to foster its development, and in the summer of 1983 the biggest show of contemporary sculpture ever mounted in Britain was marred by a tragic act of vandalism. The exhibition, held both at the Hayward and Serpentine Galleries, was a well-timed celebration of the new vitality energising young sculptors. Their work proved boisterous enough to spill out of the buildings into the open air as well, where it mocked the drabness of the South Bank and

lolled insolently in the grass at Kensington Gardens. Even the older contributors, whose earlier work was still severely abstract, were affected by the expansive new mood. But abstraction, despite its new-found exuberance, became the exception. Most of the younger sculptors were unafraid to explore the possibilities of representation once again, and they took an often bewildering variety of forms. None more provocatively than David Mach's *Polaris*, assembled from many thousands of old car tyres and looking as if it had strayed up the Thames like a lost whale before becoming stranded on the South Bank concourse. Mach exploited an irreverent sense of absurdity: his beached behemoth reminded us that the real Polaris would eventually become as obsolescent as the clapped-out rubber he had used to make this colossal replica. But it tempted a vandal to set about torching the sculpture, and in the rashness of his attempt he burned himself to death.

The publicity surrounding this terrible accident gave the press a renewed opportunity to assail contemporary art once again. And towards the end of 1983 I became aware of a refusal, on the part of the *Evening Standard*'s new Editor Louis Kirby, to publish my reviews of exhibitions by young artists. Sometimes, without warning or explanation, they failed to appear, and in November I received a letter from Kirby informing me that he could no longer publish art reviews on a regular basis. Instead, he wanted me to contribute occasional articles on what he described as 'major exhibitions.' In my reply, I explained how strongly I felt that the *Standard*'s art critic, as well as reviewing 'major exhibitions', should also attend to the 'wealth of smaller galleries, many of which support exciting new developments and artists who never appear in big institutional shows. They often merit attention, and so do artists who make work outside the gallery altogether.' I concluded by hoping that he would be prepared to reconsider his decision, and maintain the art column on a weekly basis. But when we met to discuss the problem Kirby was adamant, and over the next couple of months all my attempts to propose reviews of exhibitions were turned down on the grounds that they were not 'important' enough. I began to realise that the *Standard* was no longer interested in the vitality of London as a centre for contemporary art. In my letter of resignation, I wrote that 'I cannot be associated with such a drastic diminution of the part I have always attempted to play on this newspaper. It is a deplorable development.' For the rest of the decade I wrote a weekly art review in *The Listener*, while my successor on the *Standard*, Brian Sewell, was given every encouragement to indulge his unremitting contempt for the spirit of adventure in contemporary art.

By the time the Orwellian year of 1984 arrived, the prospects

looked alarmingly embattled. Sturdy campaigns of protest were mounted against the threatened closure of art schools and fine art departments in a number of places, but the government seemed set on cutting them back with a ruthlessness evident in so much of the Thatcher administration's strategy. The educational system in Britain has never given art the importance it deserves, and the cuts threatened to leave it with an even more subordinate role in our culture. Students encountered greater difficulties in obtaining the places they needed; artists found that the part-time teaching which supported their own work had become desperately scarce; and the whole idea of surviving as an artist looked less viable year by year.

Then, in the spring of 1984, another disturbing event menaced gallery-going throughout the country. As if to bear out Eliot's description of April as 'the cruellest month', the National Maritime Museum imposed an entry charge on its unsuspecting visitors. Precisely a decade had passed since the last disastrous turnstile scheme was implemented in our national museums, decimating visitor figures at the National Gallery and elsewhere. A short while after the introduction of those earlier entry charges, they were mercifully repealed by the incoming Labour government. The anger and consternation aroused by the scheme had been so widespread that everyone imagined it would never be reintroduced. But the National Maritime Museum's alarming new initiative heralded the onset of a fresh attempt to install turnstiles across the country. I was passionately opposed to such a prospect. As a schoolboy with severely limited funds, I had been able to frequent many great national collections with the help of the free museum principle. Confronted by a charge, I would not have been able to visit them so regularly. Entry charges militate against such sustained explorations, and they also foster the reprehensible belief that art is only intended for those who can afford it. In a decade when many museums were attempting through education programmes to widen their audience, and reach people who had never visited a gallery in their lives, the spectre of the turnstiles was anathema.

Besides, the prodigious growth of sponsorship placed museums in a better financial position and should have helped them ward off the need for entry charges. During 1984 a whole clutch of powerful corporations – including American Express, Pearson's and Carlsberg – supported mammoth surveys at prominent London venues. Catalogues, which had grown increasingly magnificent, reached a hitherto unparalleled splendour with the appearance of the immense George Stubbs publication at the Tate Gallery, munificently subsidised by United Technologies Corporation. A vehement demonstration outside the Tate

12. The Pirelli Garden at the Victoria & Albert Museum, London

on the press day expressed understandable concern about the gallery's involvement with a company responsible, among other things, for manufacturing nuclear missiles. But the sponsorship juggernaut was now unstoppable, and in October the Royal Academy's selection of paintings from the Thyssen-Bornemisza collection was brought to us courtesy of Mobil. The reason why a multi-millionaire like Baron Thyssen should have needed to be oiled by Mobil remained mysterious.

But this much was clear: at a time when increasingly feverish prices were being paid for work by the most celebrated painters, commercial sponsorship delighted in favouring exhibitions of well-established art held at the most prestige-laden galleries. The Victoria & Albert Museum, where a so-called voluntary entry charge was soon introduced, found itself basking in the beneficence of the mighty corporations who sponsored its new Toshiba Gallery and Pirelli Garden. Their advent prompted me to fantasise about future V&A visitors moving from the Renault Room to the Volvo Vestibule, taking in the Hitachi Hall, the Sony Staircase and the Porsche Patio on their way. But the future of less mightily-endowed enterprises grew more worrying. Although small gal-

leries dedicated to young and little-known artists still managed to survive, and new ones succeeded in opening, innovative work found its existence increasingly threatened as the 1980s proceeded. Hence my desire to see some, at least, of the new lavish sponsorship put to more adventurous uses. Companies, I wrote, should acknowledge their responsibilities to living artists as well as the Pre-Raphaelites, and be prepared to back experimentation.

Plenty of the wealthiest collectors preferred to concentrate their spiralling resources on long-established artists, and before recession put an end to the moguls' rivalrous bidding the major auction houses witnessed a prodigious surge of price rises. The most astonishing amount of money to be lavished in the late 1989 salerooms centred on a painting by a living artist. When de Kooning's typically boisterous *Interchange* came under the hammer in early November, it was expected to fetch between $4 million and $6 million. But the feverish mood then galvanising auction houses confounded even the most heady estimate. Suddenly, when bidding paused at $1.7 million, a voice shouted out: 'Six million dollars!' And that leap was only the start of a heated battle between two men – the bearded Swedish art investor Bo Alveryd and Japanese dealer Shineki Kameyama, a familiar auction-room figure given to wearing a down-at-heel raincoat and carrying a plastic bag. At the climax of this adrenalin-inducing tussle, the (then) Mighty Yen carried the day. *Interchange* was knocked down to Kameyama for $20.7 million – a phenomenal new world record for a living artist.

The voracious Japanese appetite for art had previously focused on work from the Impressionist period. A version of Van Gogh's *Sunflowers*, which started the bout of saleroom mania by reaching a record price in 1987, was acquired by the president of a Tokyo insurance company. Artists of Van Gogh's generation had learned a great deal from Japanese colour prints, and wealthy Tokyo collectors instinctively responded to this manifestation of a shared sensibility between East and West. Now, however, their enthusiasm for European art widened so spectacularly that it boosted the prices of modern works to even more insane levels. In a written Parliamentary answer, the Conservative arts minister Richard Luce revealed in 1989 that auction prices for Impressionist paintings had risen by a staggering 974 per cent over the last decade.

It prompted me to wonder how the future of contemporary art would be affected by similar increases, and I feared that the cash value of a work by a living artist might easily come to override any understanding of its aesthetic significance. Old-fashioned love of art could increasingly be replaced by hunger for investment. And this emphasis on monetary value

13. Malcolm Morley, *Cradle of Civilization with American Women*, 1982

alone meant that museum visitors, confronted by a great painting, would be tempted to regard it simply as a multi-million-dollar banknote framed on the wall. Auction reports played a more and more prominent part in newspaper coverage of the arts, while the tabloid press only deigned to discuss painting or sculpture when the latest saleroom sensation was given yet another exclamatory headline. 'If art is perceived just as a means of making a fast and fatuously easy profit', I warned, 'then the whole activity is degraded beyond recall.'

Although contemporary art did not seem to yield as much glamour or publicity as the auction-house hunger manifested by bidders with mega-bucks to spare, several new developments proved that contemporary art could arouse an unusual amount of public interest. One of them was the Turner Prize, which managed to acquire even in its first uncertain year of existence a notoriety that its literary equivalent, the Booker Prize, has only consistently achieved in the latter part of its life. I dislike treating artists as race-horses, and the choice of US-based Malcolm

14. Robert Gober, *Double Sink*, 1984

Morley as the first winner seemed frankly eccentric in view of his utter detachment from Britain over the past quarter of a century. But the extraordinary media interest generated by the Turner Prize did succeed in enlarging general awareness of contemporary art. If it stirred some people out of their customary apathy and prompted them to look closely at the shortlisted exhibits, then the dubious aspects of the event were countered by more positive results. By the time I was invited to join the Turner jury in 1988, when we dispensed with the shortlist and awarded the prize to Tony Cragg, the whole event had begun to play a focused role in supporting the most impressive young artists of the decade.

Contemporary art also gained more attention when it was enhanced by the arrival of major new exhibition spaces. Halfway through the decade the Saatchi Gallery opened in a former North London paint factory, superbly converted by Max Gordon. Although its inaugural show concentrated on established senior artists like Judd and Warhol, Charles and Doris Saatchi soon introduced London to a new generation of young artists from New York, including Robert Gober, Jeff Koons, Tim Rollins with his 'kids', and Haim Steinbach. These artists had a significant effect on an emergent generation of British art students, especially those who studied at Goldsmiths College. At the Whitechapel, a distinguished gallery interior was sensitively renewed and extended in a scheme that provided its Director, Nicholas Serota, with invaluable expe-

rience for his future development of Tate. And outside London, where contemporary art was much harder to find on public display, the opening of Tate Liverpool in Jesse Hartley's Victorian dockland warehouse was a seminal event. Even if James Stirling's conversion was flawed, the 'Tate of the North' proved immensely popular with visitors. So did Richard Calvocoressi's enlightened approach to display in the handsome new premises acquired for the Scottish National Gallery of Modern Art in Edinburgh, where each exhibit was honoured with a far greater amount of space to breathe. And the opening of new premises for the National Gallery of Canada transformed Ottawa's ability to display its extensive collection with the space it deserved.

Another encouraging sign centred on the amount of energy channelled into art for places beyond the confines of the gallery. In the previous decade, the majority of 'fine artists' tended to sneer at the notion of making work for public spaces. Since it smacked too much of populist dilution, such ventures were usually left in the hands of 'community artists'. The development of more widespread and convincing art in public settings was further hampered by the dearth of sustained critical writing on the subject. However valuable the occasional report, catalogue essay and magazine article may have been, they were no substitute for a more general recognition among reviewers that extra-gallery work

15. Scottish National Gallery of Modern Art, with William Turnbull's *Large Horse*

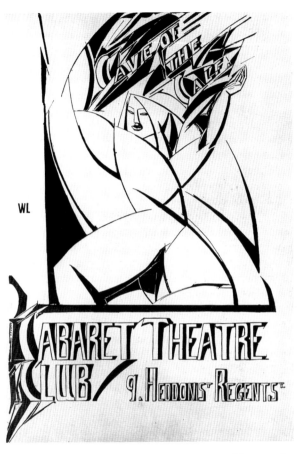

16. Wyndham Lewis, poster for *Cabaret Theatre Club: Cave of the Calf*, 1912

deserved regular appraisal. During my final years at the *Evening Standard* I became increasingly aware of this problem. Studying precedents in the early twentieth century, I wrote a book called *Art Beyond the Gallery* focusing on memorable modernist initiatives in locations as diverse as an avant-garde cabaret club, an artists' restaurant, a Belgravia drawing-room, the headquarters of the Underground Railway and a Cadena Café. Examining the past helped me to become more aware of opportunities in the present. Rather than confining my newspaper column to exhibitions alone, I also

attempted to discuss new art made specifically for a broad range of alternative contexts like schools, hospitals, theatres, tube stations, gardens, railway tracks and billboards on street corners.

Since the immense quantity of gallery and museum shows always made great demands on the space available, I realised that newspapers could do far more to examine work executed away from the well-trodden exhibition route. Too often, the advent of extra-gallery art was treated solely as a 'news' item, with a photograph of bystanders partially obscuring the work itself and a brief, sarcastic caption emphasizing how much money taxpayers had contributed to its cost through the Arts Council. During that period the weekly art review in *The Times* was still headlined 'Galleries', and by excluding most other art from regular critical appraisal, newspaper editors implied that extra-gallery activities did not share the elevated status enjoyed by work displayed in museums and dealers' showrooms.

For a while, at least, the growth of genuinely impressive artists' interventions in the world outside was bedevilled by their mistaken belief that they somehow had to make a stark choice between The Gallery and The Community. This either/or mentality discouraged many from considering the possibilities of work in public locations, and it also cut off so-called 'community art' from any sustaining, informed awareness of the best gallery work. It was an unnecessarily polarised division. I wanted to see individuals on both sides of this arbitrary barrier developing a more supple approach. Artists who had never tried making public work before should in my view be warmly encouraged to do so, in the hope that they might be stimulated by the unaccustomed challenge. Conversely, artists entirely devoted to 'community' projects could have benefited from setting time aside from their own work now and again, so that they returned to the collaborative task with their imaginations recharged.

In other words, I favoured a far greater freedom of manoeuvre, a more extended interplay between public and private realms. Many substantial artists who had spent their whole careers showing in galleries might, in my view, produce exhilarating work when invited to work on a large scale for a specific site. If extra-gallery projects were to flourish properly, they had to attract the energies of those most likely to contribute an inventive vitality that spurned hackneyed solutions and glib formulae. When Richard Serra's *Fulcrum* was installed in the City of London's new Broadgate development in 1987, it set a new standard for public sculpture at its most taut, purged, rigorous and arresting. The advent of *Fulcrum* convinced me that I did not want the public arena to be invaded by opportunists, executing commissions without thinking hard enough about the precise requirements of the place their work inhabited. Far too

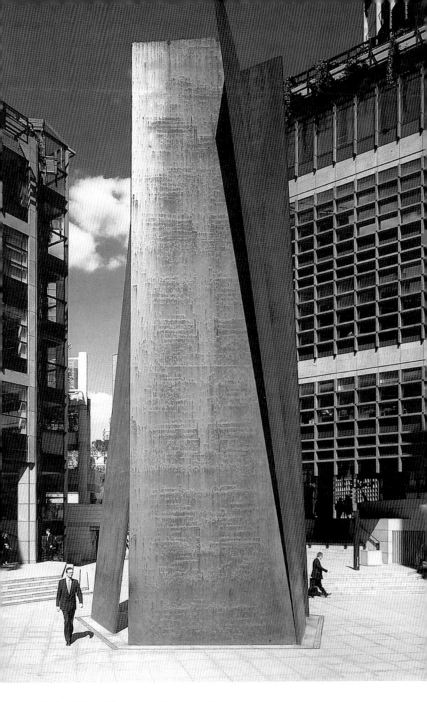

17. Richard Serra, *Fulcrum*, at Broadgate, London, 1987

18. Richard Wilson, *One Piece at a Time*, 1987, South Tower, Tyne Bridge, Gateshead (commissioned by TSWA 3D)

many excruciating blunders have been perpetrated by artists refusing to take the distinct character of the location fully into account. The immortal phrase 'turd in the plaza', first coined by the architectural group SITE, summed up the failure of all that banal sculpture dumped in civic precincts by arrogant practitioners who prepared maquettes in their studios and then had them enlarged to boorish, grandiose proportions.

Considerable disagreement arose in the 1980s over the notion of spending one per cent of the cost of every public building on art. My own view was that one per cent legislation seemed a high-risk undertaking. Unless it was accompanied by a profound change in attitudes, especially among architects and developers, the outcome could well be calamitous. One per cent was such a limited amount that it could easily have fostered a rash of tokenist work, and I had no desire to be surrounded by tepid art reluctantly tacked onto buildings by people who resented being legally obliged to commission artists. The whole perplexing debate hinged on whether such legislation would unleash a flood of half-hearted images that devalued the extra-gallery enterprise, or whether it would enable artists and architects to learn once again how genuine acts of collaboration can take place.

To a significant extent, however, old prejudices did begin to break down during the 1980s. Spurred by grants and artist-in-residence schemes, as well as more enlightened and open-minded ideas about how best to approach the challenge of working outside the gallery, a growing number of projects were undertaken by artists who would never have considered them before. Many of them are discussed in this book, and they range from enormously ambitious, urban projects like TSWA 3D to the quiet sensitivity underlying Common Ground's sustained exploration of rural possibilities in Dorset. I welcomed the invitations to write the catalogue essays for both these highly contrasted endeavours, learning a great deal alike from TSWA 3D's nation-wide involvement with major city sites and Common Ground's belief in the importance of even the most modest, bucolic locale. Serving as a Trustee of the newly formed Public Art Development Trust also sharpened my awareness of the complex challenges facing anyone brave enough to venture into volatile contexts far removed from the hushed, white-walled sanctuary of the gallery. I lectured extensively on the problems involved, and summarised my ideas in the PADT publication *A Place for Art* after a series of seminars sponsored by the Trust were held in London.

No setting presented more acute problems than the hospital. Impersonal, sterile and often downright depressing, most medical interiors in the National Health Service seemed bent on making patients feel a great deal worse. Anonymous corridors stretched ahead, their bleak walls unalleviated by anything except the occasional, confusing blizzard of signs and health warnings. So I was delighted when the King's Fund, a medical charity that dispenses millions of pounds each year to National Health buildings, asked me in the late 1980s to make a personal choice of six prints by contemporary artists. Over 200 copies of each

19. King's Fund Print by Anish Kapoor, 1989

image would be produced, and then offered to hospitals as a framed set at just over cost price. The vulnerability of patients might have prompted me to select over-polite work. But I saw no reason to play safe. Rather than opting for artists so bland that no one would ever notice them, I commissioned a deliberately diverse group with powerful, singular visions of the world. All of them, including Helen Chadwick, Richard Long and Anish Kapoor, responded with gratifying intensity. After a special exhibition at the AIR Gallery, the prints gradually found homes in medical buildings throughout the country. Since more people walk every day through a large hospital than enter the Tate Gallery, the artists were assured of an immense audience. The success of the scheme in humanising those clinical, Kafkaesque interiors stimulated my hope that contemporary art would become effective in a far wider sphere. It coincided with a changing attitude among architects, who ceased to regard ornament as a crime and began once again to entertain the possibility of making artists' work an integral part of their buildings. As a result, the Orwellian nightmare of 1984 subsequently gave way to a more affirmative vision after all.

NEW BLOOD

THE FLOWERING OF WOMEN'S ART

27 November 1980

In a society more equal than our own, women artists would not need to organise exhibitions which completely ruled out the participation of men. After all, such events dramatise the division between the sexes rather than treating male and female artists on the same level, regardless of gender. But until women are granted the rights they have been struggling to establish, they can hardly be blamed for standing together and insisting that their art deserves proper attention. What other course of action is open to them, when evidence of discrimination continues to surface? Not long ago, women artists of all persuasions felt understandably affronted when the winners of the Arts Council's annual awards were announced. Although women made up nearly a quarter of the 670 applicants, none of them received an award, and they were absent from the lengthy shortlist as well. Their anger was increased by the realization that the selection panel was all-male, and that one of its members had the gall to justify his decision on the grounds that 'women don't have the depth to be artists'.

Such insults are still – unbelievably – all too common, and the attitudes behind them must have affected the choice of Arts Council award-winners. Even if the rest of the committee drew up the shortlist without consciously airing male prejudice, I find it impossible to accept their judgement that *all* the women applicants were inferior. There are in this country an ever-increasing number of independent and imaginative female artists who have no need to fear comparison with their male counterparts. To protest at their complete exclusion from the awards is not, therefore, to indulge in special pleading and support them simply on the basis of sex. That would be as patronizing as it is divisive, paying no attention to the quality of their art, which deserves recognition on its own merits alone.

The flowering of the women's movement has undoubtedly helped them to develop, but until now they have experienced considerable difficulty in showing their work. During the 1970s, when many surveys devoted exclusively to women's art, past and present, were held elsewhere in the world, Britain resisted. Even when a big show of women artists was eventually staged at the Hayward Gallery in 1978, a last-minute failure of nerve led to the inexplicable inclusion of seven men as well. It implied that women were somehow unable to sustain large-scale exposure on their own, and only now are amends beginning to be made.

Gathering a momentum too great for even the sturdiest flood-barriers to withstand, women's art has suddenly burst triumphantly into view all over London. Not only is there an impressive variety of one-woman exhibitions, ranging from Edwina Leapman's quiet, minimal abstractions at Annely Juda to Margaret Harrison's forceful feminist commitment at the welcome new Pentonville Gallery. Maggi Hambling has also been appointed, in preference to several male contenders, as the first Artist in Residence at the National Gallery, where she paints, talks to visitors and holds exhibitions of her work in progress.

But ambitious group surveys have been mounted as well, all marked by a spirit of assurance which indicates that women today are more determined than ever to fight against classification as second-class citizens. Claire Smith, who has organised an intelligent two-part exhibition at the Acme Gallery, defiantly announces that the 'tendencies criticised for being weaknesses' in women's art should be regarded instead as a positive source of strength. The overall standard achieved by the work on view proved her point, suggesting that the particular insights women bring to their work both modify and enrich our existing, male-orientated views of what art should be.

This likelihood has received further confirmation at the ICA, where an entire season of mixed theme shows started with a provocative selection of *Women's Images of Men*. Neatly turning the tables on male art's traditional obsession with women as an object of desire, it demonstrated that men can, from now on, expect to be scrutinised in images which reveal them as aggressive and vulnerable, ridiculous and desirable, posturing and dependent. Because our society is still so patriarchal, a dominant note of resentment and satirical debunking ran through the exhibition: time and again, man became a target for artists who were obviously rejoicing in the chance to vent their stored-up spleen.

But the second ICA show, *About Time*, used video and performance less stridently to explore how women see their changing selves in domestic roles, television advertising, cosmetic surgery and a wealth of other contexts. I found myself very moved by the realization that so many young women are defining their experience of the world in ways which art has never encompassed before. By the end of this century, the alternative values they are incorporating in their work will surely have changed the nature of art to a radical extent. Feminist perceptions, so often thwarted before they could be properly expressed, now seem set fair to have as beneficial an impact on art as on society in general.

Just how wide-ranging that impact might be is indicated by the ICA's current show, *Issues*, for me the climax of all the current women's art

20. Roberta Graham, *Short Cuts to Sharp Looks*, from *About Time*, at ICA, London, 1980

events. Organised by Lucy Lippard, it brings together an international selection of work with a keen awareness of the social and political realities confronting the women who produced it. Nothing is allowed to obscure their central concern with those issues, and they use a wide variety of media to drive their meanings home. While Nancy Spero ensures that the brutal torturing of women in Chile is clearly denounced through her giant hand-printed lettering and agonised painted figures, Suzanne Lacy and Leslie Labowitz chart the effects of rape with photographs and scrawled testaments from victims or eyewitnesses. Mary Kelly uses the essay-form and a series of inscriptions on slate to disclose how her own child learns to read, write and adapt to the bureaucratic school system which gradually erodes her maternal influence over the boy. And May Stevens juxtaposes her mother, an 'ordinary' housewife who became mute in middle age, with the 'extraordinary' eloquence of Rosa Luxemburg, the German revolutionary leader.

The personal and the political, private lives and public events, are interwoven throughout this challenging exhibition. Margaret Harrison

displays items once owned by her mother-in-law to show how industrialization has forced working-class women to lose their old skills in handmade patchwork, and turn instead to the mass-production of doilies in factories. Maria Karras likewise drew on her experience as a Greek child growing up in America when she conducted a series of photographic interviews with women of different cultural backgrounds now living in California. The posters she produced are shown at the ICA, but Karras rightly stresses that they were originally made to be installed for six months on 1,000 Los Angeles city buses.

Her determination to work beyond the boundaries of the gallery, in areas of life where artists have never penetrated before, is shared by other exhibitors, too. Loraine Leeson's militant posters on women's health are really intended for use in hospitals, community centres and other welfare locations where they are not regarded as 'Art' at all. And Mierle Laderman Ukeles, who documents an arduous project in which she met every single one of New York's 8,500 sanitation men, has been carrying out a similar venture with the dustmen of Westminster this week. It is impossible for anyone not directly involved with her scheme, which aims at raising the low esteem in which garbage collectors are held by the public, to gauge its effectiveness or otherwise. Looking at it from a distance, I have my doubts. But Ukeles's readiness to enter a 'man's world' without any qualms at all shows how confident women artists have become about claiming the equality of status they deserve.

TOWARDS A PAINTING RENAISSANCE
15 January 1981

'A New Spirit in Painting': the title resounds from the Royal Academy's winter exhibition like a clarion-call heralding the advent of spring. It immediately suggests that a fresh generation of artists has emerged, along with the 1980s, to revitalise a tradition which a decade ago seemed in decline. High hopes are therefore aroused. If painting is indeed poised to renew itself, the fruits of such a renaissance would delight anyone who admires great paintings from previous eras and wants to find work of equal stature in art today.

Does the Academy's courageous optimism over their show turn out to be justified? On balance, my answer is an enthusiastic 'yes'. But it only

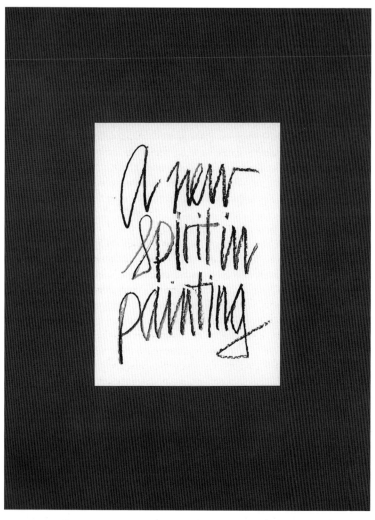

21. Cover of *A New Spirit in Painting* catalogue, Royal Academy, London, 1981

succeeds in an unexpected sense, which fails to fulfil the promise apparently given by its stirring title. The younger artists presented here offer no overwhelming proof of their ability to rejuvenate the painting tradition. Instead, it is the senior and middle-aged painters who really do convey outspoken imaginative intensity. Four of Picasso's last pictures

occupy a symbolic position at the survey's entrance, and their headlong willingness to disclose a ninety-year-old man's violent, improvised, shockingly uninhibited feelings about the world sets the emotional temperature for the rest of the exhibition. Despite his obvious unevenness – the *Reclining Nude* of 1971 is a slack and inept image – late Picasso transmits at best a wild, exhilarating response to his subjects. His audacious use of the brush veers between extremes of affection and brutality. Alternately caressing and savaging a figure or a landscape, he allows his impulsive marks an extraordinary amount of licence. We are aware of them equally as passages of agitated, gestural paint and as attempts to represent visible reality. Picasso's determination to give both these aspects their full due means that his last works – which may yet prove very influential – remain open-ended and supple in their approach.

It is an attitude that benefits many of the strongest pictures in the show. With a few exceptions, they could be described as figurative. But not the small-minded kind of representational painting that rigidly opposes abstraction. The oldest living artists on view have all, in their very diverse ways, learned a great deal from the abstract experiments conducted throughout the modern period. Francis Bacon often places his writhing, vigorously handled figures against calm areas of flat colour which recall the severe, striped canvases of extreme American abstraction. Matta's enormous panoramas of humanity embroiled in a mechanised society are filled with lunging linear rhythms that possess a life of their own, quite apart from the awesome universe they depict. Philip Guston, who confounded admirers of his abstract work by reverting in his sixties to a more figurative style, allows the man and objects in a late painting called *Desert* to hover within a freely brushed space reminiscent of his abstract pictures. And Willem de Kooning, the great surviving master of Abstract Expressionism, shows in his recent paintings that a myriad possible references to bodies, hillsides, skies and much else besides can be found in his ambiguous untitled paintings, which refuse to restrict their range of possible meanings for the sake of an easily identifiable subject.

These senior artists, along with Balthus and the rather disappointing Jean Hélion, dominate the show and dictate the breadth of its sympathies. I warm to the generous, undogmatic view of painting it presents, and welcome the organisers' refusal to insist on the supremacy of one narrow style. The richest future for painting surely lies in a very wide exploration of the possibilities opened up by so many enterprising painters during the earlier years of the twentieth century. As if to stress the manifold directions painting can now pursue, much of the show is

hung on the principle of provocative contrast. The austere grey, blue and black panels which make up Brice Marden's puritanical contributions are shown opposite Frank Stella's gaudy celebrations of 'exotic birds', where glass, lacquer, glitter and other brash materials are flaunted on metal reliefs that swoop, curl and lean into outrageous forms as they play with our perceptions of space.

Both these artists happen to be abstract and American. But just as the exhibition rightly demolishes the myth that progressive painters can only advance by ridding themselves of representation, so it scotches the illusion that New York painting still rules the Western art world. If the American colossus has not exactly been toppled, it is at least reduced to a more appropriate scale by a selection which proves that Europe now has a lot to offer. Judging by New Yorker Julian Schnabel, a young participant who throws wax, putty, velvet and even broken crockery into his feverish paintings, some US artists are now prepared to flaunt a deliberately hectic temperament more commonly associated with Mediterranean countries. And many of the Europeans compare well with Warhol, whose contributions show how far he has degenerated into a vapid salon portraitist, viewing life merely as an endless parade of glazed celebrities waiting to be recognised at a chic Manhattan party.

But if Warhol's inclusion is hard to understand, excellent painters in mid-career abound throughout the survey, and nowhere more than Britain. Frank Auerbach, whose years of consistent dedication have flowered into an eloquent maturity, shows his turbulent cityscapes and heads in the same room as Lucian Freud. The latter's clinical yet impassioned investigations of his own mother, an anonymous nude woman or an elderly homosexual entwined in his naked lover's limbs, have never looked stronger. Howard Hodgkin and R. B. Kitaj, both of whom I have admired for many years, are still extending themselves in deeply satisfying ways. While David Hockney, showing a vast Californian painting of Mulholland Drive, has discovered a looser and more expressive means of reviving his old love-affair with the swimming-pools and lush vegetation around his Los Angeles home.

Hockney's intoxication with a West Coast paradise, strewn with frank homages to the inspiration of Matisse, could hardly be more at odds with the lugubrious harshness of the large West German contingent. Anselm Kiefer's best painting here uses a loosely splashed technique derived from Abstract Expressionism to ram home his far from abstract vision of postwar Germany as a raw and devastated land, where the wounds in the earth are still painfully exposed to view. Markus Lüpertz's series called *Black-Red-Gold*, with its melancholy references to gun-wheels and an

abandoned soldier's helmet, shows a similar preoccupation with the aftermath of his country's terrible conflicts. Taken as a whole, the brooding German presence in this survey forces us to acknowledge the continuing potency of the Expressionist tradition, too often ignored by historians and critics of modern art. Never afraid to uncover the most disturbing and private of an individual's obsessions, it provides the exhibition with an emphasis on emotion at its most direct, whether erotic, lyrical, aggressive or ecstatic.

But the German contribution only forms part of a wide-ranging survey, where adventurous painters of many kinds can be seen grappling energetically with accessible and fundamental human experiences. Such a commitment should enable them, in time, to win the respect and admiration of a broad public. Even so, it would not do to be over-optimistic, faced with the number of emergent artists like Julian Schnabel or Sandro Chia who attract attention simply through a raucous display of pictorial bad manners. Sloppiness and hectoring ostentation are unfortunately rampant in some highly-publicised 'new painting' circles, and elevating clumsy exaggeration into a virtue will never be a substitute for the sustained, meditative exploration which can alone produce great art. It is a pity that none of the young painters at the Academy possesses a talent anywhere near as momentous as Picasso, who at their age was immersed in the Cubist revolution.

The number of exhibitors who use film, performance and other alternatives alongside their painting – Merz, Penck, McLean, Fetting, Hacker and Kirkeby among them – indicates that paint on canvas need no longer be regarded as an exclusive preoccupation. So I am glad that this absorbing exhibition, unlike the 1980 *Hayward Annual*, does not maintain that painting is the only true 'high art'. But I also recognise that the Academy survey convincingly shows how older painters of different persuasions are working with a vitality and power which may, with luck, help a future generation to bring about a rebirth comparable with the finest painting of the past.

ART FROM MODERN AFRICA
29 January 1981

In the early years of this century, artists and collectors all over Europe became profoundly excited by the hypnotic, even bewitching power of African masks and figure carvings. But at the very same period Europe's colonial invaders brutally disrupted the civilizations which had produced those awesome objects. Could any irony conceivably be more cruel? While African art helped Picasso and other innovators to rebel against European tradition, the colonizing powers reversed this process by imposing their own civilization throughout the so-called 'dark continent'. African artists found themselves being trained in schools where provincial forms of Western art were taught, and where missionaries regarded ancient tribal carvings as pagan barbarities. The loss of cultural self-esteem was incalculable.

Now that independence has been granted to so many parts of Africa, a new spirit of national confidence has mercifully begun to reappear. No longer willing to ape European styles at several removes, African artists are attempting to reconcile their own traditions with the demands of a rapidly changing society. Many of the tensions which result are exposed in a long-overdue survey of contemporary art from Africa at the Commonwealth Institute, where more than three hundred works of wildly uneven quality have been brought together from about a dozen countries.

The very first exhibit, painted with lacquer on cardboard by a Nigerian who boasts the resplendent name Y. K. Special, is a revealing image. A placid, palm-fringed huddle of village huts is shown, treated with an appealing simplicity that suggests how much the Douanier Rousseau may have owed to comparable native paintings from the past. But the foreground is dominated by the surprising black silhouette of a car, bouncing along a sun-scorched track where animal transport would look more at home. So far as Y. K. Special is concerned, the car probably symbolises the immense machine-age revolution which imported Western civilization has brought about. To our eyes, though, this old-fashioned vehicle bumping through the bush is a quaint reminder that Africa still remains distanced from the ruthless technological pace set by Europe and America. The picture therefore holds a lot of 'charm' for collectors from the industrial West, and it is significant that the owner turns out to be a wealthy resident of Hamburg. Moreover, the painting's cryptic title, *Not For Friend*, implies that the artist himself realises the difficulty of selling such work within his local community. Until recently, the Nigerian élite preferred to spend its money

in more ostentatious ways, and the majority of people there are too poor to afford anything but the cheapest of images. So a great deal of work is exported, and collectors or dealers from Brussels, Paris and an extraordinary number of West German cities have lent pictures to the present exhibition.

Such a heavy reliance on foreign patronage carries dangers. Too many artists turn, very deliberately, to the production of kitsch tourist fodder, and the Commonwealth Institute show has its share of cloying wildlife scenes, where even a lion is not ashamed to bat a sentimental eyelid at possible buyers. These African equivalents of our flying ducks at sunset should never be allowed to stray beyond the airport foyers which sell and fully deserve them. I was relieved to turn away from winsome zebras and discover the far more authentic urgency of a poster painter called Middle Art, whose bitter recollection of his country's civil strife is emblazoned with the message 'WAR IS NOT GOOD' painted in red-tinged capitals across the sky. But it is disturbing to realise that his impassioned warning, which could speak very directly to people who share Middle Art's personal experience of internecine conflict, hangs in the Parisian home of Baroness Sybill von Tiesenhausen. This removal from grass-roots audience contact cannot be healthy: it encourages African artists to ignore the response of their own public and cater instead for a sophisticated but distanced clientele, some of whom may well smile at what they so patronizingly describe as 'primitive' expression.

The vigorous street art flourishing throughout the continent should, in theory at least, be immune to these pressures. Painted by self-taught artists who have only been trained in signwriters' studios to master freehand lettering and other skills, it mainly consists of vivid, direct and unselfconscious shop-signs advertising the delights of a haircut or a new dress. One marvellous barber's sign from the Upper Volta sports a dizzying choice of styles, from the nostalgic early sixties innocence of 'Beatles' and 'Kennedy' (both classic examples of Euro-American cultural invasion in the Third World) to the altogether more sinister 'Police' or the seductive 'Pick-Up'. All these options are arranged in strip-cartoon frames, like a demented Polyphoto where the sitter has quickly changed his haircut in between each shot. And another sign, this time for mechanical repairs, is equally disarming: under the announcement 'ICI BON SPECIALISTE DE MECANIQUE' a man in a yellow polka-dot shirt dances towards a motorbike, grinning roguishly while waving an enormous screwdriver in one hand and an outsize spanner in the other.

When positioned in the shops, such images clearly do form a prominent and unforced part of daily African life. But even these pre-eminently public, functional signs are marketable abroad, and one Berlin dealer owns

22. African Hairdresser's shop sign

most of the examples on display here. Stripped of their locations, exported and now arranged on a white wall like objects in a museum, the signs have been robbed of their original purpose. By rights, the exhibition organisers should have informed visitors of the shop-signs' initial settings, perhaps with photographs showing similar images *in situ* now. But apart from three irrelevant plants sprouting out of tubs, and a token map indicating the participant countries, nothing is supplied to remind us that African art springs from contexts very different from our own gallery-centred culture.

Although this distortion is regrettable, the best of the pictures on view still managed to override my irritation. Refusing to borrow third-hand idioms from modern Western art, pander to the jet-lagged souvenir-hunter, or copy traditional styles with no understanding of the religious beliefs which gave African art of the past its intensity, they offered genuine imaginative insights into the dramatic extremes of experience found everywhere in the continent today. The constant threat of famine is movingly expressed by Joel Oswaggo from Kenya, whose drawing of two starving natives is entitled, with appropriate terseness, *Hunger*. A skeletal village elder, his costume dangling from shrunken hips, stares piteously down at a dying woman with shrivelled breasts slumped on the ground. The artist only accentuates their misery by contrasting it with the beauty of the lake and mountains around them.

But Mabota, a Mozambique painter, makes the art of protest more explicit by identifying the precise cause of suffering – in his case, Executioner Chico of the Portuguese secret police. A notorious torturer, Chico is shown flailing and kicking his chained prisoners from the freedom movement, who can only weep with pain or vomit bright scarlet blood. Elsewhere in the show, Kasongo bears witness to an airborne raid on Stanleyville, where a plane belches parachutes falling like black bombs from the clouds. The soldiers who have reached the ground show no mercy on their victims, regardless of age or sex. War in Africa has little time for codes of honour. It is a struggle to the death.

To set against these scenes of terror and despair, other artists convey the more joyful side of African life. A Nigerian painter who calls himself Enugu Rainbow Arts shows a spirited canvas of an emaciated man on a Sunbeam bicycle gleefully carrying a yam in his saddle-basket, first fruit of the markets re-emerging after the war. And Art P. Moke's picture of President Mobutu visiting a town astride an elephant, with a phalanx of snarling leopards in attendance as his bodyguard, proves that ceremonies of almost surrealist improbability still take place in a newly independent country like Zaire.

Nothing in this exhibition has the compelling stature of the greatest art Africa has produced: a superlative Benin bronze from the British Museum would outclass everything on display here. But less than a century has passed since the most appalling days of imperialist suppression, when a British force slaughtered the Benin people and looted most of their art wholesale. It takes time to recover from such a history, and the infectious vitality and diversity of contemporary African work bodes well for a brilliant future resurgence. I only hope that the West, with its incessant appetite for bankable trophies, does not once again manipulate and distort the art produced in this magnificent, much-abused continent.

ANSELM KIEFER

10 June 1983

Armed with enough courageous and unsettling eloquence to place him among the outstanding young painters of today, Anselm Kiefer confronts traumatic themes which many of his fellow-Germans would prefer to avoid. Rather than pretending that the horror of Nazism never existed, or attempting to minimise its terrible and lasting significance, he insists on facing up to the full, disturbing reality of his nation's history. Although he never experienced the rise of Fascism and the protracted misery of the Second World War, Kiefer cannot help being acutely aware of their consequences. He refuses to draw facile comfort from the economic recovery of post-war Germany, or its determination never again to pursue the perverted course charted by Hitler and his cronies. Kiefer's profoundly disquieting art reveals that diabolic ghosts from the past still haunt the memories of Germans now, and he believes that the artist's imagination can bring this troubled legacy up to the surface of the national consciousness. Only thus, he implies, will the festering accumulation of guilt, fear and sorrow ever be exorcised.

But his work is sufficiently honest and passionate to ensure that the exposure proves raw and violent. Instead of producing images which deal with the past alone, Kiefer shows us a Germany where the destruction inflicted by history is still painfully apparent. His landscapes thrust us into the deep furrows of fields so badly ravaged that nothing could grow in their blackened, scarred earth. Kiefer's paint is handled with such impulsive freedom that it drips and oozes, as if the terrain were still bleeding

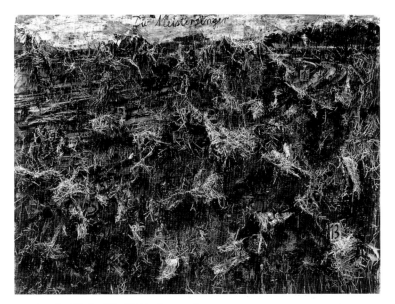

23. Anselm Kiefer, *Die Meistersinger*, 1982

in the aftermath of a devastating onslaught. He lets our eyes travel over this battered wasteland towards an equally bleak distance, where the desolation is alleviated only by sudden flares of angry flame and the deceptively languorous pall of smoke. On the far horizon a line of words advances towards some singed trees, spelling out a bitter and melancholy old German song which urges the cockchafer to fly from the war, for 'Pomerania is burnt up'. So is the scorched and deserted world in Kiefer's landscapes, and the reference to Pomerania indicates his awareness of Germany's divided and dismembered condition today.

All the same, these tragic and brooding pictures are not just apocalyptic visions hatched inside the artist's feverish mind. They gain much of their baleful conviction from Kiefer's close and incessant scrutiny of the countryside around his home in an isolated village south of Frankfurt. Here he is able to witness the annual burning of stubble after the straw has been cut, and all his landscapes gain immensely from Kiefer's first-hand observation of nature. This familiarity with the precise formation of a ploughed furrow or a harvested crop enables him to root even the most harrowing and turbulent paintings in a credible, down-to-earth reality.

He moves with such ease from agricultural fact to epic invention that

they become fused into a new unity, most notably perhaps in the work inspired by Paul Celan's poem about the Aryan blonde Margarete and the dark-haired Jewish Sulamith. Using these two symbolic women to lament the destruction of Germany's Jewish culture, Kiefer conveys his sense of loss through the forms of the Odenwald landscape. Margarete's hair is metamorphosed into clusters of golden straw, which lie inert and helpless on the fissured soil after they have been cut down. But Sulamith's 'ashen' hair meets a far more horrible fate, consumed by the flames as they flicker across the charred, gouged earth. Looking at these wildly handled, enormous canvases is often an overwhelming experience, and they do not equivocate about Kiefer's melancholy awareness of waste and death. Ultimately, however, they are not depressing. Kiefer's work is charged with impetuous vigour, and the pulse of his pictorial energy gives the paintings a life-affirming exuberance which counters their gruelling preoccupation with the folly and megalomaniac ambitions marring German history.

Nowhere is this more powerfully expressed than in the series of vast paintings based on deserted yet eerily preserved monumental architecture. Their resemblance to the grandiose buildings erected or planned for the greater glory of the Third Reich is unmistakable. But the panoramic scale employed by Kiefer does not mean his looming pictures rejoice in the tub-thumping martial optimism and invincible strength which Hitler wanted his tyrannical temples to convey. Forlorn and futile, the massive rows of columns and dimly lit chambers dominating these sombre paintings all testify to a sense of echoing emptiness. They are not ruins, and no signs of picturesque decay are allowed to temper their awful immensity. That is why they are so unnerving. The authority celebrated by these buildings has long since been destroyed, but the architectural shells linger on.

Anyone who has seen such monuments in German cities knows just how disconcerting they can appear: silent and boorishly bulky witnesses to an era which most passers-by would like to forget. Kiefer, by contrast, believes that we should all remember. His work ruminates over the real meaning of these buildings today, and he uses his ever-growing skill as a painter to turn them into a vehicle for mediations on the uneasy relationship between the present and the past. Although dismal puddles of rainwater have settled on the vast glass roof in one picture, and a desultory air of neglect pervades all these monuments, they remain intact. But Kiefer undermines their apparent stability in other, more subtle ways. The thick, creamy impasto he heaps on walls and ceilings is often riddled with tiny cracks. Thunderous skies, which look as if they are about

to boil over and expend their pent-up fury on the buildings beneath, seem more solid than the stonework they threaten to engulf. The supposedly secure columns turn out to be resting their weight on questionable foundations, too. The floors of these courtyards and halls are painted in a disconcerting manner, offering treacherously soft surfaces for the unwary to walk on. Sometimes the floor appears to fade away altogether, and the ponderous mass of Third Reich architecture is seen to rely for support on a terrifying void. The walls provide no reassurance, either. On close inspection, the dark planes between the columns reveal themselves as strips of paper printed with black woodcuts, and they act as barriers sealing off all possible escape routes.

With tempestuous, lightning-riven skies above and the abyss below, we feel trapped somewhere inside these nightmarish buildings. In one painting, ironically entitled *To The Supreme Being*, daylight penetrates tall windows and irradiates the ceiling with a weird purple hue. Elsewhere, flames burning in metal holders cast their ruddy orange glow on the rest of a cavernous interior. But Kiefer does not use his rich and sonorous sense of colour to ennoble these doomed edifices. The extraordinary combination of oil, emulsion, shellac and latex he employs as his materials ends up, in a particularly ominous painting, producing thin brown trickles of liquid which seep through the building's crevices like rusty water. The walls seem to be weeping, just as Sulamith's hair cascades in ashen torrents from her bowed head.

Much of Kiefer's work sounds an elegiac note, implying that the tears shed during the period of Fascism's bloody reign are still falling today. He counts himself among the mourners, but there is nothing self-indulgent or morbid about this determination to place tragedy at the forefront of his art. Far from wallowing in despair, he wants to uncover Germany's psychic wounds in order to give them a chance of healing. Nor does he think it will be a quick, easy process, the outcome of which can be confidently predicted. Kiefer calls many of these architectural paintings *The Artist's Studio*, to indicate that their vast, chilling spaces are ultimately located inside his own imagination. He remains obsessed by them, and shows no sign of shaking their imagery off. They even appear to make him feel he is inhabiting an embattled yet defiant bunker, liable at any moment to be assailed by further traumas.

But he refuses to evade them. His stance as an artist is poignantly defined by the strange, lonely objects which occupy the centre of each building he depicts. At first they resemble lamp-posts, and then we realise that they consist of painters' palettes balanced on top of thin, elongated poles. Like the tomb of the unknown warrior, this isolated sentinel acts

as a mute yet memorable testimony. The palette seems precarious, and might at any moment fall from its perch. But Kiefer, through his art, is committed to keeping it in position for as long as his conscience endures.

NEW ART AT THE TATE
15 September 1983

With his hammer held up ready to strike, an enormous man towers far above visitors entering the Tate Gallery's boisterous survey of *New Art*. This aluminium and steel giant appears to be shaping the object held in his other massive hand, and the act of hammering prepares us for the clangorous impact of the exhibition beyond. For the artists gathered there are not, on the whole, motivated by a sense of modesty or restraint. They hit out at the onlooker with the forcefulness of Jon Borofsky's metal colossus, and they proudly brandish their exuberance in images swollen with outsize emotions.

Walking round the show is therefore a frankly discordant experience. Time and again, the works seem so exclamatory that they fight against each other, and woe betide the quieter exhibits caught in the middle of the mêlée. The overwhelming majority of the images selected by Michael Compton seek to assail our nerve-ends. They bombard us with extravagant visions, and their undisguised display of feeling marks them out dramatically from the art of the 1970s. Ten years ago, the prevailing mood was austere and analytical, an affair of the brain rather than the heart. But the early 1980s is witnessing a widespread reassertion of anxiety, vehemence, wit, theatricality and decorative excess. Rigorous intellectualism has given way to unashamed flamboyance, often explosive in character. The investigation of new materials, which marked so much adventurous art in the 1970s, has been replaced by a return to the orthodoxy of paint, brush and canvas. Abstraction is difficult to find, as artists embrace figurative styles and feel free to quote from painters of the past.

Alongside this new enthusiasm for art history, sometimes stretching back to the most primitive civilizations, the focus of interest has shifted away from New York. No single city is now the dominant centre of contemporary art, and Europe has recovered much of its former importance as young artists find inspiration in the rich painting traditions of Italy and

24. Jon Borofsky, *Hammering Man* at Tate Gallery, London, 1983

Germany. National identities, submerged for so many years while artists enjoyed travelling widely and participating in an international dialogue, have once more become pronounced. Many German painters are now acutely aware not only of their Expressionist forebears but also of their country's cultural legacy in general. Anselm Kiefer is the most haunting of the artists who are resurrecting, often in a painful and disturbing way, aspects of German traditions which have lain dormant for many years. As for the new Italians, they no longer feel the need to follow the Futurists' example and denounce the past. Sandro Chia's rumbustious paintings are littered with quotations from the Renaissance, while other Italians attempt to bring about unlikely marriages between their own heritage and cultures as distant as India.

But one of the merits of Compton's selection is its refusal to draw a neat, artificial line between the 1980s and the immediately preceding period. Senior artists like Joseph Beuys and Mario Merz, who established their reputations well over a decade ago, are included here in order to define their continuing influence on the new generation. Both these older men have grown in stature as recent developments enable us to see their achievements in a fresh light. But the 1980s have also brought into prominence other middle-generation artists whose work was unjustly neglected before. Although Georg Baselitz has been painting with considerable power for over twenty years, his pictures have only recently been given the attention they merit. His work should make us cautious about claiming too much 'newness' for the emergent generation of painters. Other older artists like A. R. Penck, Jannis Kounellis and Sigmar Polke also deserve the places Compton has granted them here, for they helped in their very different ways to develop many of the attitudes that have now become so widely adopted.

The truth is, of course, that any 'new art' is always dependent on the work preceding it. Some of the youngest exhibitors, especially among the British contingent, recall Pop Art in their involvement with mass-media images and popular culture. But the emphasis is now radically different. The household appliances in Pop pictures were usually gleaming, efficient and up-to-date, whereas Bill Woodrow's washing-machines are junk objects fit only for recycling into images as unpredictable as an Indian head-dress. Tony Cragg's vast wall-sculpture, *Britain seen from the North*, transforms the entire island into a brilliantly coloured waste land of plastic and metal detritus. A similar spirit of irony and disenchantment feeds the work of young American artists like Robert Longo, who uses the posturing of an over-muscled nude male pin-up to attack the aggression of a society where rocket silos have become part of the national

landscape. Cindy Sherman uses herself as a sly and resourceful model in colour photographs that comment on how women's images are fashioned by the manipulative camera's lens.

Sherman is accompanied by disappointingly few women in a show dominated to an unbalanced extent by male artists. The inclusion of Annette Messager, Rose Garrard and Shirazeh Houshiary cannot compensate for the absence of other women artists, at a time when they are at last establishing themselves on more equal terms with their male counterparts. But in most other respects Compton has succeeded in mounting a lively and stimulating survey that celebrates a lot of contemporary art's positive elements. As long as we resist the efforts of those who would like painting to oust all the alternative media artists can now employ, the years ahead could well create a favourable climate for work more truly representative of the diversity and richness of humanity as a whole. Dogma and rigidity are mercifully absent from this enjoyable exhibition, which also marks a welcome determination by the Tate to devote a major show to the latest developments in art. It is far too long since Millbank last organised a survey of new work on an international scale, and I hope this positive commitment will become a permanent feature of the Tate's exhibition policy from now on.

GEORG BASELITZ AND FRANCESCO CLEMENTE
6 October 1983 and 27 January 1983

I: Baselitz

When the Whitechapel Art Gallery closes its doors at the end of October, London will lose one of its finest exhibition spaces until the reopening occurs in spring 1985. The renovation and improvements carried out over the next eighteen months will vastly improve the gallery's facilities, and its staff should be congratulated for raising well over £1 million in these straitened times. But its temporary closure is bound to sadden anyone who values the Whitechapel for the contemporary and historical exhibitions held there. The Director, Nicholas Serota, has mounted a consistently memorable programme that includes some of the best shows staged in Britain over the past few years: the great Beckmann triptychs, the Cornell retrospective, Kahlo and Modotti, the

monumental survey of twentieth-century British sculpture, and Guston's late paintings.

The current exhibition, selected from Georg Baselitz's work since 1960, is typical of the Whitechapel's ability to provide a substantial examination of living artists who have only been seen here before in fragmented ways. Baselitz was first displayed in London two years ago, when a selection of his recent canvases was included in the notorious Royal Academy exhibition, *A New Spirit in Painting*. Although confused in parts, it was a timely and stimulating show which forced London to become aware of a widespread resurgence of outspoken, large-scale and often expressionist painting in Europe and America. But many critics were incensed, and their scorn was invariably focused on Baselitz's contributions. Because several of his pictures contained inverted images, he was accused of gimmickry. His detractors failed to realise that Baselitz, far from being a jumped-up young artist who owed his fame to a cheap trick, was a seasoned forty-two-year-old with two decades of varied and inventive work already behind him. The Whitechapel is therefore performing a much-needed service by revealing the extent of his previous work.

This is not a full-scale retrospective: the important graphics are missing and so are the powerful painted carvings he has executed in recent years. But enough is assembled here to show how Baselitz, born in Saxony just after the Second World War, began by reacting against the abstractionist climate of art in the late 1950s. His birthplace became part of East Germany, and right from the outset Baselitz's work conveys the anger, disgust and alienation that so many other young Germans experienced in the post-Nazi era. 'I am warped, bloated and sodden with memories,' he announced in a growling 1961 manifesto aptly entitled *Pandemonium I*. A gruesome series of foot paintings, each one apparently severed and festering, confronts visitors as they enter the exhibition. A sense of suffering and loss pervades these battered chunks of flesh, even though Baselitz's free handling refuses to illustrate their ailments. He always gives his pigment an unusual amount of licence, at the same time dealing with subjects as readily identifiable as animals, landscapes, humans and birds. For Baselitz wants to make us acutely aware of how as well as what he paints, often allowing colour and outspoken brushwork to enjoy a life of their own.

The isolated figures who trudge through his mid-1960s pictures, rugged yet burdened by heavy knapsacks and the darkness around them, are never modelled with great solidity. Baselitz's pictorial devices keep invading them, cutting through their bodies and even dividing the canvases into segments which refuse to fit together. The exhibition makes

25. Georg Baselitz, *Orange-Eater I*, 1981

clear that his decision around 1970 to start painting upside-down subjects was the logical outcome of these earlier tactics, but Baselitz does not indulge in disruption for its own sake. Although he wants to escape from an excessive reliance on the subject, his inverted figures also transmit powerful feelings of vertigo, loneliness and desperation. In the past few

years, Baselitz's handling has become even more raw and agitated, often employing high-keyed and rasping colours. The dangling, puppet-like figures are beginning to resume more conventional positions, indicating perhaps that the upside-down phase is coming to an end.

Throughout his career, Baselitz has been an uneven painter, and sometimes his work looks disappointingly hasty – especially in comparison with Anselm Kiefer, whom I regard as the best of the new German painters. But one of Baselitz's most impressive recent pictures, *Woman on the Beach*, has a bruised fragility that suggests he is now developing an enlarged sense of tenderness and compassion.

II: Clemente

If animals appear in Francesco Clemente's work, they are likely to be cut in half and gushing blood. When couples embrace, they cling together desperately as if hiding from the huge eyes staring at them from the borders of the canvas. Clemente's show is called *The Fourteen Stations*, which immediately suggests that Christ's passion is the subject. But a self-portrait, superimposed on an image of the crucifixion, announces that the artist's own experiences and fantasies are being explored here. Born in Naples and familiar with life in Rome on the one hand and Madras on the other, Clemente is certainly alive to religions and artistic traditions in both East and West. *The Fourteen Stations*, however, were painted during a winter stay in New York, where the challenge of American art prompted him to attempt oil painting on a large scale for the first time.

The results are uneven, tumultuous and intermittently impressive. If Clemente's bold, impulsive handling often slithers into outright clumsiness, it sometimes succeeds in conveying the reckless and complex emotions of a thirty-year-old artist preoccupied with sex, death, revulsion, love and fear. In *The Fourteen Stations*, and another cycle called *The Midnight Sun* at the Anthony d'Offay Gallery, the moods range from exultation to horror. At one moment we are confronted by a gigantic face, half smiling and half snarling, which widens its mouth to reveal rows of skulls where the teeth should be. Elsewhere we find ourselves observed from above by an airborne trio of naked women, who link hands and stare down as if in haughty triumph. But then the mood darkens again, and a howling figure tears off his white shirt to reveal the terrible castration inflicted on his body. In the distance an erupting volcano echoes his distress, for Clemente often uses the surrounding landscape to reinforce the pain or pleasure of his human subjects.

One painting seems to include a specific reference to the grimmest streets of New York: rats, rubbish and excrement are scattered across the lower half of a composition where a naked man lies helpless on the ground, covered with discarded women's shoes. But on the whole the figures inhabit a more generalised region, and glimpses of Italian hillsides on one canvas are replaced in another by images of an ocean where submarines and destroyers battle for survival. Clemente seems obsessed with the precariousness of life in these troubled, outspoken and frantically inventive paintings. A sense of threat pervades his pictures, and in the final painting of *The Fourteen Stations* series a permanent state of siege has set in. Snowflakes tumble out of a merciless, ice-blue sky, while the lovers huddle together in their efforts to escape from the cold. But they have found shelter underneath the head of a sinister giant who stares impassively out at us, refusing to offer any hope that a thaw might one day set in and melt all the suffering away.

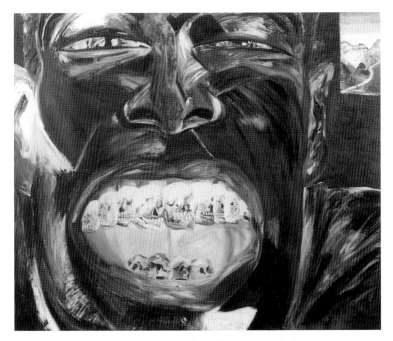

26. Francesco Clemente, *Painting III* from *The Fourteen Stations*, 1981–2

RICHARD DEACON

8 April 1985

The exhilarating upsurge of vitality enjoyed by British sculpture in the 1980s has been marred, here and there, by febrile gimmicks and puerility. High spirits can easily deteriorate into silliness, and some young sculptors are quite unable to distinguish between novelty-seeking and authentic invention. That is why Richard Deacon looks set to endure well after some of his contemporaries have become irretrievably tiresome. Avoiding whimsicality and sensationalism, he stays close to a set of steady concerns that have already yielded results as memorable as they are eloquent.

Unlike Tony Cragg and Bill Woodrow, the other outstanding practitioners of the 'new sculpture', Deacon does not employ the detritus of urban society. Although he has used corrugated iron, linoleum and concrete, which belong clearly enough to the modern world, they seem more neutral than the battered utensils and plastic refuse scavenged by Woodrow and Cragg. Deacon refers to his materials as 'stuff', and he is equally happy working with traditional substances like wood and brass. For his imagination is fired by the oblique yet haunting relationship between mythology and contemporary life. During a visit to America, a year after leaving the Royal College of Art in 1978, he became preoccupied with Rilke's *Sonnets to Orpheus*. Lacking the facilities to make sculpture there, he embarked instead on a series of drawings which became instrumental in defining his singularity as an artist. His earlier involvement with rectilinear forms gave way to a more organic language, and the image of Orpheus as a singing or listening head assumed a special potency.

It certainly inspired the most impressive sculpture in his new Tate exhibition, where a large work called *For Those Who Have Ears, No. 2* marks one of the high points in Deacon's career so far. This deceptively fluent and easeful object contains no direct, representational reference to either Orpheus or his seductive music. It looks, at first glance, like a wholly abstract sculpture – an exuberant looping of lines in space. But anyone at all susceptible to the expansive flourish of the sculpture soon begins savouring the complex range of connotations it arouses. Deacon was particularly impressed by 'the quality of actuality' in Rilke's poetry, and *For Those Who Have Ears, No. 2* retains its own vividly independent existence. But Rilke's ability to make objects 'stand for other things' was equally apparent to Deacon, who invests his work with a multiplicity of associations.

The strips of laminated wood swoop down from the apex of the sculpture and burgeon into billowing curves. They flow with a gracefulness as beguiling as Orpheus's music, and the lines evoke the movement of the sounds he transmitted through the air. Deacon may also have been thinking of the flocks of birds who found themselves charmed by Orpheus's recital. For the lines of wood could alternatively be viewed as the tracks left after a soaring and plunging flight across the sky. Nor does the possible array of references end there. The shape of Orpheus's lyre, and the strings he plucked, are both implicit in this richly suggestive sculpture. As for the work's overall motion, it has a generosity, a sense of gathering together and embracing, which aptly signifies the way Orpheus appealed to the wild animals congregating to hear him play. The only qualification required of his listeners was that they should 'have ears', and the swollen contours of Deacon's sculpture are inviting enough to encompass a wide audience.

Although this work is one of his most assured performances, serenely obeying Pater's claim that 'all art constantly aspires towards the condition of music', it does not suffer from excessive relaxation. There is tension as well as buoyancy in these rippling coils of wood, especially when they meet the floor and bend to the side in response. They are all held firmly in place by the uppermost line, which exerts a sinewy control over the entire ensemble. But it is still a very open and lyrical sculpture compared with *Falling on Deaf Ears, No. 1*, where Deacon moves away from frank declaration to explore a more ambiguous, hidden and troubled area of feeling.

Taking his cue this time from the myth of Odysseus, who strapped himself to the ship's mast in order to resist the siren's beckoning song, Deacon fabricates the form of a vessel from galvanised steel. Even though it is riveted like the armour-plated hull of a destroyer, the vessel's prow looks as far removed from modern shipping as the mysterious cabin veiled by green curtains behind. The whole curious object bears a tantalizing resemblance to an ancient barge, or perhaps a fragment of a quinquereme salvaged from some remote Homeric location. But it resists final classification, and the sobriety of Deacon's workaday materials thwarts any attempt to imagine the sculpture gleaming with a sumptuous antique patina. It even confounds the initial expectations aroused by the curtained chamber. The canvas folds look as if they might be cloaking some clandestine encounter which would provide a key to Deacon's meaning. Inspection reveals, however, that the chamber is empty, and the softness of the canvas becomes even stranger when it flaps against the rigid steel container.

Compared with the complete lack of subterfuge displayed by *For Those Who Have Ears, No. 2*, this sculpture is a perverse and baffling creature.

The so-called prow could just as easily be a tail, and it rises up in the air with the stealth of a sea-serpent. Much of Deacon's work combines the mechanical and the organic in a very unpredictable way, and *Falling on Deaf Ears, No. 1* is half boat and half animal. It also conveys powerful erotic overtones, for the cavity-like chamber has been brought into provocative contact with the phallic prow or tail. An extraordinary ambiguity results: the male and female forms appear to be parts of a single entity rather than separate beings. In *The Eye Has It*, another work executed in 1984, a spermatozoal shape wriggles towards a gaping circular entrance in a far more straightforward manner, and neither form relinquishes its independent identity. But the Odysseus sculpture interweaves masculine and feminine attributes with deliberately enigmatic intent.

Deacon enjoys engineering such encounters: a smaller work called *On The Face Of It* contrasts the veiled secrecy of a draped and bulging canvas with the sinuous steel curling nakedly from its dark aperture. Openness and enclosure, lyricism and plain statement, the mechanical and the sexual, functionalism and poetic licence – these are the oppositions which his sculpture manages to conjoin in surprising and resonant new amalgams. I find them as difficult to resist as Orpheus's music must once have been, reverberating in the mind long after the last of his lyre's strings was stilled.

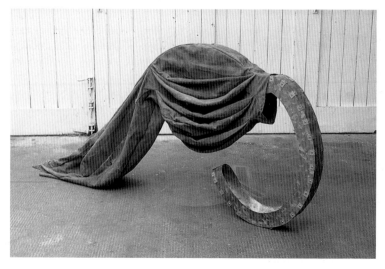

27. Richard Deacon, *On the Face of It*, 1984

ALISON WILDING
25 April 1985

Unlike so many other young British sculptors, who delight in seizing our attention with unabashed spectacle and exotic materials, Alison Wilding opts for austerity and quietness. Modest in scale, subdued in colour and spare in form, her work refuses to reach out and assail the viewer. Sometimes, as if warning us against trespassing too far onto the sculpture's territory, she surrounds it with a perimeter line which defines the boundary limits of object and spectator alike. Her work might well be easy to overlook in an exhibition full of clamorous imagery, but its reticence is a source of strength rather than a defect. After a while, Wilding's restraint takes on an eloquence of its own. Her refusal to indulge in exclamatory devices is paralleled by a reluctance to reveal her sculpture's possible range of meanings too quickly. She gains from prolonged exploration, whereas some of her zanier contemporaries soon exhaust their initial attractiveness and become stale.

Wilding's sensitively organised exhibition at the Serpentine Gallery, her first one-person show in London for almost a decade, encourages a sustained investigation. Each sculpture is given enough room to establish its own identity without fear of domination by an extrovert neighbour, and Wilding selects the places they occupy with characteristic precision. Even though she shows great flexibility in her choice of sites, the works are never permitted to straggle in an unruly way from one area of the gallery over to another. They all inhabit very distinct locations, either on the floor or the wall. And just as Wilding never encourages us to invade the space inhabited by her floor-based sculpture, so she positions her wall-works sufficiently high to prevent us from wandering too near them. In the case of *Scree*, a small funnel-shaped piece projecting into the air above our heads, a warning is hinted at as well. For the funnel's open mouth reveals a steep bank of powdered blue sand piled within, ready to descend with the speed of an avalanche on anyone rash enough to reach up and touch its soft granules.

The precarious sense of poise conveyed with such gentle humour in *Scree* runs through all Wilding's work. Occasionally her preoccupation with balance is presented very directly: in *Hard for Hard* an elongated brass form, inescapably reminiscent of a dolphin, perches on a ball-shaped fossil as if performing a trick. But on the whole Wilding takes care to avoid any reference to an identifiable presence, human or animal. Metaphor is her forte, and she is at her best when the sculpture stops well

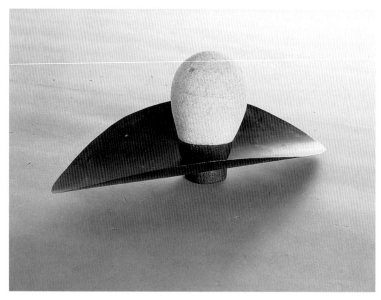

28. Alison Wilding, *Brim*, 1984

short of conjuring recognizable images and retains its mystery intact. Her forms are often organic, to be sure: a lump of oak lies comfortably in the middle of *Indelible Field*, and its biomorphic roundness recalls Barbara Hepworth's obsession with fertile swellings. But Wilding does not share Hepworth's willingness to evoke a wave's motion or the curving arm of a Cornish bay. The oak, half egg and half drum, refuses to be pinned down, and Hepworth's purist respect for the innate character of her materials has not been inherited by Wilding. She applied a mixture of oil paint and graphite to the oak's surface, thereby producing a darkly gleaming skin more redolent of fruit than wood. Moreover, she juxtaposes this organic form with thin strips of brass and copper, which introduce a more mechanistic mood and curve round the oak in an encircling movement. The territorial confinement is not quite completed: two openings still offer the enclosed wood possible escape-routes, and Wilding's desire to balance her elements is once again fulfilled. But the tension between two very different orders of feeling is palpable enough, and a fascination with duality can be found in her art wherever we look.

The opposition between metal and wood, machine and organism, volume and flatness takes many forms, and they are profoundly ambiguous

in their implications. Is the sheet of leaded steel in *Curvaturae* protecting the nearby chestnut form, or threatening it? Wilding leaves the question open, so that we can explore every inflexion in the relationship between these two elements. The enfolding movement of the steel seems prepared to ward off any assault the chestnut might experience. At the same time, though, the chestnut's independence could well be endangered by the steel's open arms, ready perhaps to engulf its companion entirely. Wilding has a partiality for subtly menacing implications: in a small yet potent wall-work called *Well*, a predatory snout protrudes from the centre of a circular steel shield. But she is too unassertive an artist ever to accentuate this strain of aggression at the expense of other, more pacific priorities. In *Ahead Beside*, a bulbous painted wood form appears to be overshadowed by an angular fragment of galvanised steel, extending into space like a shark's fin. The prospect of violence remains latent, however; and when Wilding cuts a similar fin shape from the base of a sculpture called *Deep*, the threatening overtones virtually disappear. For a small ovoid lump of ash is permitted to lie in the space Wilding has cut here, and it seems to be nestling quietly at the foot of the steel expanse stretching far above. Far taller than most of Wilding's work, *Deep* proves that she can handle large dimensions with assurance. The steel has been rubbed with oil paint into a richly textured surface, alive with activity and yet steadfastly refusing to indulge in anything too excitable or demonstrative.

Wilding always prefers to proceed with discretion and stealth, and in *Nature: Blue and Gold* she summarises her preoccupations with outstanding economy and flair. A nodule of ash, rubbed this time into a pigmented blue dark enough to suggest a cocoa bean, is contrasted with a glittering sheet of brass. Although these two elements are joined together, no complacent union has been achieved. On the contrary: the ash appears to have thrust into the brass and pierced it, as dramatically as the fish lodged in the gullet of Gaudier-Brzeska's Vorticist masterpiece *Bird Swallowing Fish*. Wilding eschews Gaudier's harsh, combative dynamism in favour of a more gentle encounter. But her two protagonists seem to hold the balance of power as evenly as in Gaudier's sculpture, where the bird is either consuming the fish or choking on it. Wilding's brass is likewise caught half-way between splitting apart and closing on the ash with pincer-like arms. Sensual tenderness and jarring incompatibility coexist in this sculpture with memorable aplomb. It proves that a wealth of complex relationships can be uncovered in Wilding's deceptively muted work by anyone patient enough to look.

JULIAN OPIE

2 May 1985

Far and away the most exuberant of the new British sculptors, Julian Opie is also a decade younger than Cragg, Woodrow and Deacon. He takes a youthful delight in even the most tawdry aspects of the contemporary world, and conveys his relish with infectious zest. His work gives the vivid impression of a man in a hurry, dealing with experiences as quickly as customers receive their meals at fast-food counters. Sharp, snappy and easily digestible, Opie's art is knowing enough to cock a snook at the spectacle of a feverish, souped-up society hell-bent on doing everything with minimum fuss and maximum speed. Many of his works dramatise the whole process of zippy, breathless activity. One piece on show at the ICA includes a hand arrested in the act of painting a half-finished kitchen still life. Another, slyly entitled *Making It*, consists of a mundane shelf bristling with household tools – saw, screwdriver and hammer – which exude hyper-efficient DIY enthusiasm.

This frank emphasis on work in progress suggests an awareness of Robert Morris's early sculpture *Box with the sound of its own making*. A small walnut cube containing a tape-recorder which played a three-hour record of the box's construction, Morris's work asserts minimal form and at the same time implies that it will never be completed. The link with Opie's concerns is evident enough, and he displays a preference throughout his art for the clear-cut, four-square language which Minimalism likewise favoured. But in many other respects Opie is far removed from the minimalist aesthetic, rejecting in particular its insistence on the extreme refinement of abstract form. Very specific and easily identified meanings emblazon Opie's art, and his ebullient humour is also very different from Minimalism's purist austerity. One of his works, which arranges cigarettes in severe horizontal rows, is cheekily entitled *Barnett Newman*. In this respect, he has something in common with the even more anarchic and rumbustious Tingueley, whose kinetic *Debricollage* of 1970 includes a banging hammer strikingly reminiscent of Opie's implements.

But Tingueley deals with real tools and machine-parts, whereas Opie's working strategies are wholly deceptive. A large floor-area is littered with a piece called *Old Debts* – an assortment of chequebooks, office files, telephone directories, airmail letters and a passport, all scattered across the carpet supposedly after a grand clear-out. A more careful look discloses that they are made of painted steel, like the rest of Opie's work, and their apparent illusionism is revealed close-to as a dashing but very schematic

shorthand – swift flicks of the brush rather than elaborate depiction. Neither a painter nor a sculptor in the orthodox sense, Opie uses oils and an oxy-acetylene torch almost as a draughtsman wields a pencil. He thinks of his works as drawings, and has developed a dashing linear idiom which stamps all his art with an instantly recognizable handwriting.

It is a jaunty style, even when Opie deals with melancholy feelings. Lovelorn loneliness is a constant preoccupation. But *Blue (Nights)*, which sends the capital letters of the word 'BLUE' cascading to the floor from a solitary lampshade, has a chunky vigour which suggests Opie is ruefully smiling at his own emotions. Everything in his work is set free to float in a gravity-defying space that promotes a sense of euphoria. If Opie has a satirical streak, he is far too good-natured to excoriate the often tacky world he depicts. As its title indicates, *15 Monets* mocks the mass-reproduction of Impressionist paintings by bunching together a clutch of simulated water-lilies, haystacks, poplars and Houses of Parliaments. Despite the differences in theme and period, each image is reduced to the same clichéd idiom by Opie's slick brushwork. He implies that Monet's vision has been bastardised by a plethora of routine prints, and they are made even more reprehensible by the stretched-canvas supports on which they lie. Opie is fully aware of their vulgarity, but he falls far short of con-

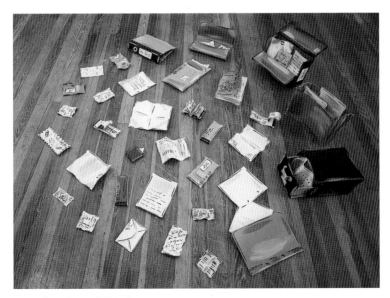

29. Julian Opie, *Old Debts*, 1985

demning it. Indeed, there is something irrepressible about the way these 'facsimile originals' are made to dance crazily around the big numerals '15'. Opie cannot help savouring their shameless banality, and the whole structure of the work apes the breeziness of window displays in high-street print shops.

Even as he laughs at brazen commercialism, Opie relishes it, nowhere more than in *Chinese Takeaway* which sends an upside-down mêlée of Oriental words, tree, sun and rocks tumbling down a wall to terminate, saucily enough, in an empty food carton and a bill. His fascination with the kitsch décor of cheap cafés is as keen as his fondness for Visa cards, Oxo packets, cardboard boxes and the curling covers of *Yellow Pages*. They are all part of Opie's everyday life, and he possesses Oldenburg's voracious appetite for even the most garish products of late-twentieth-century urban society. Like Oldenburg, he enjoys playing tricks with scale – at one moment faithfully adhering to the actual size of eight little matchboxes clustered in a corner, and then blowing up cigarette packets to outsize dimensions which entirely transform them. I expect Opie would thrive on commissions for public sculpture, for he handles monumental scale with a sunny assurance and an instinctive ability to entertain rare in contemporary art. His capacity to handle large-scale works is given fuller rein in the spacious ICA rooms than in the more confined surroundings of his other show at the Lisson Gallery. But he looks flamboyant in both exhibitions, and Opie's precocious interna-tional success has intensified his innate high spirits rather than burdened them with excessive demands.

Nevertheless, a doubt remains. Although it may sound churlish to carp at any young artist lucky enough to achieve a sizeable reputation so soon, I do find Opie's prolific insouciance rather worrying. Slickness is a dangerous weapon to employ, however ironic the purpose may be, and sometimes his work looks altogether too pat. Easily absorbed and almost as easily exhausted, this effervescent art lacks the richness and complex-ity which makes a sculptor like Deacon so rewarding. While I was visit-ing the ICA show a number of people looked round it, and they were clearly diverted by Opie's wit and vivacity. But they all left quite rapidly, sensing no doubt that the art he produces is incapable of sustaining attention for very long. Although Opie may not mind engaging us for only a brief timespan, the best art has always been able to invite and repay the most sustained examination imaginable.

CHRIS KILLIP AND GRAHAM SMITH
12 September 1985

The hardship, bitterness and despair of unemployment usually seem far removed from the Serpentine Gallery's green placidity. Looking out of its windows towards Kensington Gardens in high summer, visitors could be forgiven for imagining that economic blight and urban dereliction play no part in contemporary Britain. So it is quite a shock to turn away from dappled parkland views and encounter, on the gallery walls, an uncompromising survey of life in north-east England. Chris Killip and Graham Smith, who display their photographs side by side in this powerful exhibition, call it *Another Country*. I can see why. The world they explore is a narrowly circumscribed one, hit by the severest effects of recession and monetarist harshness. Killip is best known for an earlier study, in the Paul Strand tradition, of the Isle of Man. His affection for the land and its people never blinded him to the toughness of ordinary existence. But now he has exchanged his native island for an altogether more desolate locale. The open skies and dignified isolation so evident in his Isle of Man photographs give way here to a sense of paralysis and futility.

A picture of a Tyneside supermarket is filled to choking-point with solid ranks of baked-beans cans, massed around a notice which promotes a 'Heinz Beans Free Offer – "World of Survival" Wildlife Kit'. It is a grimly appropriate announcement. Life for the people in Killip's photographs is primarily a matter of getting through the day without succumbing to terminal lassitude. The sea forms a backdrop to his studies of Lynemouth and the fishing village of Skillingrove, but no one seems able to take any pleasure in it. Rocker and Rosie, buttoned and hooded against the wind, are too tired to take much notice of the waves in the distance. Hands smeared black, they pause for breath on the journey home with a consignment of seacoal. Rosie seems resigned to a gruelling and meagre existence, and the residual strength in her weatherbeaten face suggests that she will continue to struggle for a livelihood. On Whitehaven Beach, by contrast, local youths gather in an aimless group and kill time by sniffing glue. The ritual is carried out in a desultory way, as if the sniffers themselves acknowledge its pointlessness.

But what options are open to them? Judging by Killip's close-up study called *North East Coast*, the beach offers little except pollution and detritus. Broken bottles, bones and a discarded contraceptive outnumber the shells, and the mood does not shift very significantly when Killip turns

30. Chris Killip, *Untitled*, n.d., (formerly entitled *Concert, Sunderland*)

his attention inland. A man carrying a child on his shoulders in Scottswood Road, Newcastle, seems at first to be smiling as he stares into the distance. But closer inspection discloses that he is contorting his face against the glare of a day which probably promises him nothing. Time and again, similar moments of apparent optimism turn out to be countered by darker considerations. Although a girl called Helen seems to be enjoying her hoola-hoop, she is obliged to play with it on a dispiriting stretch of waste ground heaped with rubbish. Elsewhere, in a photograph called *New Year's Day*, a father celebrates by cuddling his daughter in a caravan. But even here another girl, half cut off by the edge of the picture, looks on pensively as if oppressed by the knowledge that their happiness only has a momentary significance.

The unease is so pervasive in Killip's work that his one scene of full-blooded enjoyment also turns out to be the most sinister in its implications. *Concert, Sunderland* is the terse title for an extraordinary image, where the flashlight illuminates a tangle of semi-naked figures presumably swaying to the music. One shaven-headed dancer, his ear pierced

with a variety of rings and pins, lurches to the left and bunches his hand into a fist. Another figure, stripped to the waist and baring the word 'Angelic' under his nipple, dives towards his neighbours like a rugby player barging into a scrum. But the photograph is dominated by a youth who leans forward and yells, braces dangling round his waist and zipper brazenly open. Two hands appear to be restraining him or preventing him from falling, and all over the picture a strange choreography of arms and fingers can be seen. Clutching, pointing, pushing and clenching, they signify a peculiar blend of intimacy and aggression. So far as I can tell, the sweat-stained boisterousness displayed here is quite harmless. But Killip's observant and understanding eye is sharp enough to reveal the pent-up violence in these wild, flailing bodies – a violence which could easily erupt at a football match or a street-gang confrontation.

His co-exhibitor, Graham Smith, sometimes takes a more humorous view. Sticking to the pubs and clubs of Giro Corner, the down-at-heel area of Middlesbrough where he grew up, Smith relishes the comedy of Eddie sitting alone with a pint perched comfortably on his ample paunch. He enjoys catching his father's aghast expression at the precise moment when Smith Senior loses a bet on the Grand National, and he encourages pub regulars to adopt theatrical poses. Realizing his camera is there, a few of them play up to it. But I preferred the photographs which do not rely on people's awareness of the watching lens to give them interest. One of Smith's pictures bears the memorable title *I thought I saw Liz Taylor and Bob Mitchum in the back room of the 'Comical'*. On this occasion, though, the drinkers in question seem unconscious of their look-alike potential. Nor does their claim need to be pressed. It is enough that Smith was on hand to record their bizarre resemblance, and his long familiarity with the neighbourhood means that they are pre-pared to accept his inquisitive presence. He even felt able to stop a cou-ple in the street, ask the wife to hold up her giant picture of Elvis while her husband minds a pram weighed down with assorted household belongings, and then title the photograph *What she wanted and who she got*.

There is a robust, music-hall cheekiness about such strategies which marks Smith out from the more austere Killip, and yet both men hang together uncannily well at the Serpentine. They share a determination to examine, with straightforward and unpretentious honesty, the everyday life of a society in sad decline. Their determination to focus only on the aspects they really care about leads them into repetitiveness, and the show could have benefited from more rigorous editing. I came across too many photographs of boozers at shabby corner tables, and abject figures

slumped on benches. The photographers would probably claim that the monotony induced by these recurrent images makes its own point. But I would have preferred a pared-down selection, so that the disconcerting impact of *Another Country* could be registered with even greater force among the trees and flowerbeds of a more privileged England.

MAGDALENA JETELOVÁ
26 September 1985

The initial impact of Magdalena Jetelová's sculpture centres on its spectacular scale, solidity and weight. Massive chunks of oak, which seem to have been sheered from the tree by a giant's axe, are built up into outsize tables, stairs and houses. The wood is left in a deliberately raw state, so that grain and texture can be savoured in all their sensuousness. They exude the atmosphere of a forest rather than a sculptor's studio, and the rough-hewn structures evoke a primeval way of life. Stumbling across Jetelová's work in a remote wood, we might easily imagine that it was the remnant of an ancient settlement. Each sculpture seems big enough to shelter under, tough enough to offer safety against marauders; and the iron construction underpinning it looks firm enough to ensure durability.

After a while, though, these sturdy objects give rise to other, less reassuring thoughts. If they refer back to a more primitive era, what happened to the civilization which produced them? More disturbing still are the signs that some of the structures have suffered grievous attacks. One group of houses in Jetelová's impressive Riverside Studios exhibition has been blackened by smoke, and the robustness of their lower walls gives way, further up, to a more skeletal framework. They look as if a furious fire has left them damaged and irreparably weakened. Although one of the houses is supported by the struts of this scorched super-structure, it tilts at a dangerous angle.

Jetelová's imagination is preoccupied with images of destruction, and these houses are in fact the remaining fragments of an elaborate event she recorded on video. The buildings there were clustered together in a more tightly organised and defensive way. But coloured smoke gushes from their gaping roofs, and an ominous sound-track accentuates the sense of doom. Although the video only lasts a couple of minutes, it establishes an apocalyptic mood clearly enough. The deserted houses

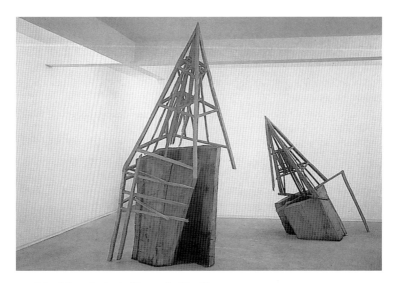

31. Magdalena Jetelová, *Place*, 1985 (detail)

have been left to burn by an invader who is determined to achieve total subjugation, and may even glory in the full-blooded swirl of red smoke filling the landscape with its announcement of death.

Despite the video's dramatization of disaster, I found it less disturbing than the sculptures themselves. Jetelová's central strength lies in her ability to physically shape the materials she understands so well. The video distanced me from the tactile immediacy of her work, and diminished its crucial sense of scale. The flaring houses seemed more like models than full-size buildings, entirely lacking the bulk and awesome height which her sculpture forcibly impresses on the spectator. I also realised, turning away from the video to renew my first-hand encounter with objects in the round, that Jetelová is at her most potent when she holds the destructive forces on a tight rein. The fascination of a work like *Place* rests in its ambiguity. Rising up into a triangular form, like a hut improvised from hacked logs, it invites the viewer to enter the shadowy interior and linger beneath its enormous wood roof. But no permanent haven is vouchsafed there. *Place* remains open on both sides, vulnerable to invasion at any time. And the crazily leaning, lurching rhythm created by its oak segments carries unmistakable intimations of collapse. At once formidable and frail, beefy and unstable, it offers protection and insecurity

in equal measure. Jetelová knows just how fundamental the attraction of a shelter really is, and she also appreciates how threatened we can feel when its promise of safety is undermined. *Place* appears to have been shaken by a profound tremor. It buckles under the strain, and only succeeds in retaining an upright position by pushing the strength of its components to their limits. Jetelová's manipulation of her materials is consummate enough to let *Place* perform a precarious balancing-act, poised half-way between stability and disintegration.

The most arresting expression of this acrobatic feat can be found in *Stairs*. Seen from the side, its steps zigzag towards a point high on the gallery wall. For all their battered, uneven structure, they appear broad enough to support our weight. The iron underpinning promotes confidence, too, and for a moment at least the steps hold out the prospect of escape from the uncertainties of the floor-bound work. But *Stairs* does not terminate when it touches the wall. Instead, the steps double back on themselves and veer crazily upwards again. This teetering stretch of roughly-scored slabs seems designed to frustrate and indeed repel our advance. It ends very suddenly, in a stubby wedge which looks precarious enough to fall on our heads.

Such an arbitrary reversal, confounding all our expectations about what a flight of stairs should do, has a dreamlike quality. Steps might well behave in this topsy-turvy way during a nightmare, causing the sleeper to break out in a sweat and shout in alarm. But as long as we continue to examine her sculpture, Jetelová does not let us wake up and restore objects to their normal proportions. The dream persists wherever we look, and the vastness of *The March* is so overwhelming that it takes on a fairy-tale character. We stare up at this enormous chair like children discovering a throne in the castle of a mountain king. It seems to belong to a remote era once again, and the broadness of its oak slabs is undermined by the tipsy inclination of the seat and legs. One of the back supports is encrusted with extra layers of brusquely cut wood, as if the chair had begun to sprout a growth. It has a mouldering air, and a pathos that counteracts the suggestion of domineering menace it might otherwise have conveyed.

Perhaps Jetelová provided a clue to her underlying intentions when she exhibited an earlier and more stable version of this chair in a Prague exhibition. It was installed on a hillside near Hradcany Castle, where the rulers of Bohemia held sway from the ninth century onwards. The medieval context makes absolute sense, and so does the reference to her country's distant history. For although Jetelová has now left Czechoslovakia and settled in Germany, she has not abandoned it in her work. On the contrary: everything she makes somehow ends up bearing,

however obliquely, on the dilemma of her native land. In Jetelová's sculpture the desire to reach back from the troubles of the present, and regain contact with an older tradition, is surely motivated by an urge to recover a sense of cultural identity. But the paradoxical fragility of the huge objects she carves and assembles also reveals her awareness of the difficulties involved. The threat of dismemberment and conflagration permeating her work indicates how haunted she has become by the possibility of her country's extinction. Rather than clinging to a nostalgic vision of the past, in the hope that it will vanquish present-day anxieties, she confronts her fears and incorporates them in her work.

The outcome, inevitably, is a tragic art. But it is not depressing or fatalistic. Jetelová's sculpture is resilient as well as besieged, and its vigorous certitude stubbornly insists that the power of an individual imagination is capable of triumphing over the forces that attempt to suppress it. Everyone, Czechoslovak or not, can take heart from such an achievement.

NEW IMAGE GLASGOW
7 November 1985

Battered by the barbarities of industrial recession, monetarist austerity and grievous architectural destruction, Glasgow had every excuse for giving up the struggle to retain its vitality. But in recent years this beleaguered city has displayed extraordinary resilience. Even though many areas still look horribly devastated, and life can often be gruelling on the tower-block estates, there has been a marked resurgence of cultural energy. The opening of handsome new musems – most notably the Burrell building, which is an object lesson in how to house a very disparate collection with coherence and panache – has not simply turned Glasgow into a tourist attraction. It has also coincided with the emergence of a rumbustious new generation of figurative painters.

The temptation to regard the artists assembled in the Air Gallery's *New Image Glasgow* exhibition as a tightly knit group should be resisted. Behind their shared energy and exuberance, sharp differences in viewpoint are soon detectable. But they all studied at Glasgow School of Art in the early 1980s, and are united by a belief in outspoken, large-scale figuration riddled with references to the art of the past. Their work is characterised by a sense of high-spirited eruption, as if they were intox-

32. Steven Campbell, *The Re-illustrated Highland Diaries of Queen Victoria*, 1985

icated by the possibilities of developing a form of painting which rejected modernist abstraction as vigorously as it spurned timid academicism.

Steven Campbell, the oldest and most impressive of these artists, only studied at Glasgow School of Art after seven years as a steel-works maintenance engineer. Although his paintings contain references to Spencer, Baselitz, Chia and much else besides, he fuses this awareness of European tradition with a sturdily independent outlook. There is nothing at all ingratiating about his use of thickly loaded pigment. The figures who stumble through his crowded compositions are solid, heavily built young men quite capable of manual labour in a steel yard. But in Campbell's work there is no hint of industrial Glasgow. His protagonists are trans-

formed into bumbling hikers, and they wander across a rural terrain teeming with treacherous trees, predatory animals and traps for the unwary traveller.

Campbell has already created an imaginative world definably his own, a world of frustration, deception and absurdity. His wanderers are confounded by signposts that lead nowhere, woods where danger lies in wait, and landscapes which sometimes turn out to be elaborate exercises in decoy and camouflage. There is always a deliberate feeling of artifice in Campbell's work, and nowhere more than in the settings he devises for his convoluted tableaux. Despite their outdoor locales, the paintings really appear to be filled with stage scenery, in front of which actors perform their preposterous, thwarted yet oddly defiant antics. Seasoned with Wodehousian wit, and constructed on an epic scale which lends a perverse grandeur to the futility of the events it depicts, Campbell's art dramatises the bewilderment and folly of existence with infectious relish.

Adrian Wiszniewski, who is five years younger than Campbell, has a more ardent and romantic temperament. His gouache study of a *Poet* presents the artist as a lovelorn adolescent, reclining on the ground with a self-conscious elegance reminiscent of Elizabethan miniatures. The pose he adopts could well have been modelled on Isaac Oliver's portrait of Edward Herbert lying in a glade, and Herbert's decorative shield conveys sentiments remarkably close to Wiszniewski's. The motto 'Magica Sympathia' is inscribed on the shield's border, and frames a design of a heart rising from flames or wings. Smoke and golden sparks shower around the heart with a scintillating excitement which Wiszniewski would understand, for his paintings are alive with similar incidents. In *Young Bachelor*, the hero stands at the door of a barn-like interior and brandishes a lantern in the darkness. Its flame possesses an energy formidable enough to make the lantern quiver, and give off whirling lines of brilliant light. Their rhythms, echoed by the bark texture of the barn's walls and the restless folds coursing across the youth's jacket, recall Van Gogh's writhing contours. But the tilt of the young bachelor's head, and the ease with which he places one hand in a pocket, have a dreaminess Van Gogh never displayed.

For all the vivacity of Wiszniewski's linear extravagance, and his glowing stained-glass colours, he belongs to the pining, chivalrous world of the Elizabethan courtier. His lovers are gallant figures, lost in idealised fantasies and forever sending heartfelt messages to the object of their affections. There is a melancholy strain in his paintings, but it should not be confused with gloominess or pessimism. Rather is it the emotion of an artist enamoured even with the pain of unrequited love. Although I

find Wiszniewski's drawings more satisfactory than his paintings, which can appear garish to a fault, the intensity of his headlong ebullience often succeeds in compensating for the awkwardness afflicting his handling of pigment. He also compares well with Mario Rossi, who explores a similarly feverish autobiographical world but clutters it with an embarrassment of props and special effects. In *How Many Angels Can Stand on the End of a Pin?*, the avalanche of debris culled from both antiquity and everyday life buries the young man with considerable aplomb. But elsewhere Rossi can become too hectic for his own good, and he would do well to learn from Wiszniewski's ability to convey meaning with greater economy and directness.

All these painters, along with Stephen Barclay who seems haunted by an almost Germanic vision of ravaged post-war Europe, deal with myth and symbol rather than the life observable around them. In this respect they can be clearly differentiated from Ken Currie and Peter Howson, both of whom root their work more straightforwardly in the urban locale they know best. Howson views the Glaswegian scene with a sour and satirical eye. His boxer, pummelling a punch-bag in an eerily lit gymnasium, is well past his prime. The attempt he makes to keep his collapsing body trim seems as doomed as the faces of the figures in *El Dorado*, bracing themselves to withstand the bitterness of unemployment in a Scottish winter. Howson becomes openly savage when he paints *Priesthill Salomé*, suggesting that prostitutes and racketeers thrive in overheated interiors while good men huddle jobless outside.

His indignation is shared by Currie, who charts the slow decline of workers' expectations in Glasgow since the euphoria of 1945. Monumental conté drawings, which indicate that Currie would like to carry out murals in direct line of descent from the Mexican revolutionary painters, set dock labourers and their wives in a harsh industrial context. His command of design is confident enough, his ambition praiseworthy and his sincerity self-evident. But he must guard against the habit of reducing his figures to stereotypes. Stanley Spencer, whose great *Shipbuilding on the Clyde* sequence surely provided Currie with some of his inspiration, would never have turned the people of Glasgow into such characterless embodiments of proletarian rectitude. The curse of so much committed socialist art is its tendency to rely on political clichés, and Currie must shed them if his work is to develop the authenticity it deserves.

HELEN CHADWICK

12 June 1986

The initial emotion generated by Helen Chadwick's extraordinary new work, *Of Mutability*, is an unequivocal delight. Floating on the surface of a raised ovoid 'pool' in the ICA's Upper Gallery, twelve near-naked women relish sensual pleasure with languorous abandon. Divested of all the constraints they might feel beyond the water's edge, they arch, twist and curl in attitudes of bliss. And the onlooker, gazing down at this deliciously self-contained spectacle, may well feel envious of the gratification they savour.

With the ecstatic freedom of figures in a rococo ceiling decoration, they seem able to enlist the entire natural world in their pursuit of untrammelled satisfaction. One woman propels her serpentine limbs towards a lamb, and greets the animal with a kiss. Nearby, another bare-breasted nymph gives herself up to the appreciative attentions of assorted sea-creatures. Elsewhere a woman whose pose deliberately echoes the provocative stance of Boucher's *Miss O'Murphy* loses herself in a flirtatious game with a cloud of tumbling feathers. All round the pool, the female nude seems deliriously at one with the attributes accompanying her, and the five golden spheres resting among them accentuate the harmony she embodies. Their ideal forms are reminiscent

33. Helen Chadwick, *Of Mutability*, 1986 (detail)

of the solids Chadwick employed in an earlier work, *Ego Geometria Sum*, where images of her own childhood and adolescence were enclosed in a pyramid, a cube and other geometrical structures. Their clear-cut contours were far more restrictive than the pool with its freely flowing swimmers, moving through the blue fluid unhampered by their proximity to the spheres. Nothing seems capable of disrupting the '*luxe, calme et volupté*' of this marine paradise, presided over by the twining Salomonic columns on the walls that surround the cossetted women. Swelling into extravagant curves and garlanded with flower-strewn foliage, the columns offer protection to the pool's inhabitants even as they reinforce the theme of ripeness and fulfilment.

Above the columns, however, an alternative mood is asserted. For they are all crowned by the weeping features of Chadwick herself. Although the heads vary in their expression, representing the different stages of crying recorded in successive photomat portraits, they are united by the tears they shed. Contemplating the erotic nirvana below, they lament its inevitable transience. And the realization that the pool is awash with bitter salt liquid from these sad eyes lends a radically different layer of meaning to the entire room. Seen from this melancholy perspective, the floating figures no longer appear as triumphant as before. Their very plenitude anticipates engorgement, and one of the women personifies the blend of pleasure and pain this condition entails. With a noose strung between her neck and ankle, she contorts her body and gags a cornucopia of fruit and vegetables which swirl through the water in front of her. Chadwick intended her primarily to embody the principle of orgiastic excess, and there is nothing vomit-like about the harvest of succulent food streaming from her mouth. But the noose does introduce a disturbingly masochistic dimension to her pleasure, and the sheer lavishness of this discharge signifies that the outermost limits of delight have now been reached.

The feeling of evanescence is intensified by the presence of the golden spheres. Solid, gleaming and incontrovertible, they make the images of women suddenly seem fragile. These swimmers are, after all, made up of paper sheets xeroxed with the bodies and objects they represent. Laid out on the surface of the raised pool, they look thin, flat and susceptible to fading. Far less durable than the spheres, and assuming in outline a jagged form, the images appear almost too frail to sustain the exuberance they depict. Their physical vulnerability confirms the sense of impermanence. Ultimate extinction is foreshadowed even in the rapturous blue pool, and Chadwick prefaces the publication accompanying her show with a sombre warning from Spenser's *The Faerie Queene*:

How-ever fayre it flourish for a time,
Yet see we soone decay; and, being dead,
To turne again unto their earthly slime.

The realization that Chadwick must have used dead animals, fish and birds for her xeroxing adds to the preoccupation with mortality. It gives a particularly macabre dimension to the encounter between the woman and the goose, whose head is inclined towards her breast while its webbed foot touches her stomach. There is a dark northern strain in Chadwick's imagination which runs counter to all the rococo effervescence. The confrontation could have produced a jarring dislocation, but she manages to fuse sensuality and transience in a work which yields a remarkable richness of interpretation.

It is impossible to decide whether *Of Mutability* stresses life-enhancing joy at the expense of tragic dissolution, or vice versa. Both are held in equal balance. The vivacity with which Chadwick organises her complex interweaving of all the disparate xeroxed elements gives the work an acrobatic panache. But it certainly does not prevail over the intimations of decay. In a second room, separated from the ovoid pool and yet still connected with it, a companion piece called *Carcass* occupies the space in uncompromising isolation. Its four straight sides of glass, amounting to a presence as stark as a minimalist sculpture, offer a severe contrast to the undulating playfulness of the swimmers beyond. And this harsh rigidity is accentuated by the contents of the tower. Chadwick has filled it with compost, partly derived from the remains of animals and fruit she employed in the xeroxing process. Here is the detritus left over from the fecund display of earthly delights next door. All that now remains of the brimming cornucopia and the amorous lamb is exposed with inescapable clarity by the container. Compressed beyond recognition into a multicoloured pulp, it bubbles and shifts like restless geological strata preparing themselves for an upheaval.

Carcass may sound as gruesome as its title, and it undoubtedly succeeds in confirming the presentiment of decomposition established by the other room. Surprisingly, though, it continues the balancing act Chadwick initiated in the pool. For the compost is heatedly engaged in the generation of new life, just as Spenser pointed out after lamenting the 'earthly slime' of the world's decline:

Yet, out of their decay and mortall crime,
 We daily see new creatures to arize;
And of their Winter spring another Prime.

So the essential dynamic of Chadwick's new work is an awareness, not only of exaltation and destruction, but also of change. Just as her earlier art was always securely rooted in autobiographical experience, so now she places images of her thirty-three-year-old body at the very centre of the flux. In previous works, all as carefully considered as *Of Mutability*, she explored the conflicts between individuals and the impersonal structures which threaten to control their lives. One work, *Model Institution*, imprisoned a range of recorded voices inside clinical booths resembling Social Security Offices. The crushing authority of the structure explained why the voices expressed so much pain and bewilderment, but their protesting resilience still held out hope in a wilderness of unemployment. While never underestimating the forces of alienation and despair, Chadwick's art seeks to expose and contest them. Even here, in a work which has the temerity to confront the ultimate threat posed by mortality itself, she manages to offer some consolation. For the women in the pool insist on giving their bodies up to delectable experience, even though they are surrounded by reminders that time will claim them as a sacrifice in the end.

ART FROM THE CARIBBEAN
3 July 1986

Why has it taken London so long to mount its first exhibition of contemporary Caribbean art? The question reflects no credit on a nation which numbers among its population so many former inhabitants of Jamaica, Trinidad and other islands in the area. Far from displaying an active interest in Caribbean work, Britain has ignored it in favour of Euro-American art. Our narrow preoccupation with the culture of NATO countries has led us to behave as if artists living outside this cosy circle scarcely exist. We imagine, in our complacency, that Caribbean art is bound to be parochial. But the truth is that our own reluctance to look beyond accustomed horizons smacks of parochialism at its most myopic.

The paintings and sculpture assembled for the Commonwealth Institute's exhibition of *Caribbean Art Now* are not, on the whole, insular in outlook. They include, admittedly, the work of seventy-year-old Canute Caliste, who lives on a tiny dependency of Grenada called Carriacou and executes unsophisticated scenes of local life. Caliste paints a mermaid resting on the beach path with as much conviction as he depicts quadrille

dancers stepping out to the accompaniment of a tambourine, violin, triangle and drum. He is the Alfred Wallis of the Caribbean, and his vision of island existence is as innocent of art history as Wallis's bird's-eye views of St Ives. But in this survey at least, Caliste is the exception who proves the rule that Caribbean artists draw on an omnivorous range of sources for their inspiration. At one extreme, the work embraces meticulous photo-realism in the paintings of Arthur Atkinson, who has allowed his job as an advertising art director to give his still-life compositions an uncomfortable amount of polished slickness. And at the other end of the stylistic spectrum, Winston Patrick's mahogany carving is as spare as an austere sculpture by a thorough-going Manhattan Minimalist. But the closer Caribbean artists approach to the 'isms' of the North American gallery circuit, the less convincing they become. An awareness of international idioms seems to take precedence over an authentic vision of the world they know best. That is why I preferred the work which, even as it declares an indebtedness to artists from other cultures, succeeds in harnessing those influences to convey a more personal response.

Kenwyn Crichlow exemplifies such an approach. His shimmering canvases, handled with a fluency which reflects the exuberance of an intoxicated imagination, turn his native Trinidad into images of Arcadia. Having studied in London and become thoroughly acquainted with the European abstract tradition, he thrives on an enduring admiration for late Monet in particular. Crichlow's ecstatic celebrations of vegetal richness, and the incandescent light which bursts through the rainforest's canopy to irradiate the foliage with colours of peacock intensity, are as exalted in feeling as Monet's summations of his water-borne paradise at Giverny. For all their homage to the Frenchman's great lily-strewn panoramas, and their desire to avoid references to specific scenes, Crichlow's blazing canvases remain rooted in an infatuation with the island where they were painted.

Trinidad kindles this kind of heightened lyricism in other artists, too. Isaiah Boodhoo, who often takes the poems of fellow islanders as a starting-point, discovers in his surroundings an Eden reminiscent of Gauguin's Tahiti. But when he paints a burnished sea capped by a dark metallic sky, or the tropical plants brandishing their outsize leaves beyond his studio window, Boodhoo laces his exhilaration with an awareness of Trinidad's more ominous aspects. A seemingly carefree study of his young niece swinging on a tyre turns out, on closer inspection, to contain intimations of a more sombre mood as well. The feeling is confirmed by *A Flowing Black River of Women* where, in an impassioned response to both the figures and the landscape they occupy, Boodhoo blends the erotic and the thunderous in equal measure.

The dark side of his art should not be exaggerated, though. He is, fundamentally, as captivated by Trinidad as Crichlow; and the warmth of their love for the island becomes clearer still when compared with the more volatile and fiery temper of Jamaican art. A proud culture, convinced of its superiority in the Caribbean and equipped with galleries, an art magazine and a School of Art, Jamaica looks after its painters and sculptors far better than any of the other islands. But that does not mean it produces smug or placid art. On the contrary: the socio-economic turbulence of the post-independence period, exacerbated by the resurgence of Rastafarianism, has ensured that painters in particular express this unrest in their work. Its most aggressive form is reached with the aptly named David Boxer, whose *Dread Song* offers a maelstrom of outspoken Rasta defiance. His *Memories of Colonisation* series provides one of the few moments in the show when Caribbean art displays overt fury about the oppressions of the past. Carved African masks, vast and implacable, are seen forcing their way into imposing colonial interiors, brusquely displacing the full-length aristocratic and governmental portraits which used to line the walls.

Christopher Gonzalez is scarcely less exclamatory. But his mannerist images of Christ and Bob Marley (almost interchangeable) are infused with a strain of neurotic exaltation. The Marley drawing is frankly heroic, a study for an unexecuted monument to the king of reggae. It seems alive with the stubborn pulse of the music it extols. Closer to El Greco than the modern movement, Gonzalez's religious symbolism is defiantly dedicated to helping him fulfil his self-appointed role of the artist as seer. In stylistic terms, he remains far removed from the older Milton George, whose affiliations with Picasso and German Expressionism bring him very close to the concerns of many younger painters in Europe. *In the Park*, which the catalogue describes as 'a humorous commentary on the mores of men and women who frequent Kingston public parks', seemed to my eye more of a holocaust than a satire. Figures, trees and grass are all consumed in a canvas scorched by flamelike colours worthy of Nolde at his most incendiary. George's grotesquely distorted Christ, skewered on a cross and lit by searing white stripes in the sky behind, is equally harsh. But his *Judgement* triptych, coal-black and devoid of incident apart from scattered numbers and the occasional visionary gleam, proves that he is also capable of more sombre meditations.

Not all Jamaican art is clamorous or brooding: the island has sustained the altogether more factual and tender work of Judy MacMillan, who sets solitary figures in landscapes with the conscientious dullness of a predictable exhibitor at the Royal Academy Summer Exhibition. But on

34. Francisco Cabral, *Mother's Milk*, 1989

the whole, tempestuous outbreaks seem to be the Jamaican painter's forte, and it is surprising that their combined onslaught does not in the end carry the power of Francisco Cabral's remarkable chair sculptures.

Displayed in a row like thrones arranged for a solemn ceremony, they are the most commanding objects on view. Their origins lie in the chair Cabral made for a house he built overlooking Port of Spain Savannah. He soon discovered, however, that the result was more eloquent than any of his more orthodox paintings and sculptures. So the chairs became his principal art form, and he has turned them into surprisingly flexible vehicles for his ideas.

Some are quietly affirmative, like the tribute to hard maternal labour which transforms the seat into a washing-tub full of children's clothes. Others are more ambiguous, especially the *Historical Site* chair with its echoes of sturdy, white-shuttered colonial architecture and a painted cannon pointing confidently out to sea. This is a verandah sculpture, built for rumination in an attempt to understand Trinidad's past. But Cabral is also capable of conveying anger about the present and alarm over the future. *Rib Cage* discloses a soldier's helmet under its seat, while the machine-gun arms lead up to a chair-back emblazoned with a swastika and crowned by a Ku-Klux-Klan hood. Still more chilling is *Nuclear Dogs*, where the seat has been transformed into a dartboard filled with different national flags. The brutish animals prowling around its perimeter are fixed to chains held by a spectral figure, who dominates the chair with a death's head and wings. There is no escape from the pervasive threat he poses, not even in an island where the prospect of global obliteration might easily be forgotten. Cabral's outward-looking art remains vigilant enough to warn that the Caribbean is haunted by the shadow of Paradise Lost.

STEPHEN COX

21 August 1986

On the first occasion I wrote about Stephen Cox's work, he was exhibiting a colossal expanse of plasterboard covered in a shimmering combination of silver sand and lime. It stretched twenty-one feet across the width of the gallery, and intrigued me with an ambitious determination to take minimalist painting into a three-dimensional area where architecture and sculpture were both brought into play. But I was at the same time worried about the 'perilously aloof' character of an enterprise 'removed to a region of purist aesthetic experience which few will ever want to explore'.

Almost a decade has passed since those doubts were voiced, and I soon realised that Cox saw this extreme purism only as the starting-point for a gradual enrichment of his initial sculptural statement. Colour, which had played such a bleached and reticent part in the freestanding plaster walls, was allowed an increasingly varied and resplendent role. Figurative imagery, excluded from the smooth and inviolate blankness of the early work, began to make an appearance in sculpture that no longer adhered to thoroughgoing abstraction. Manual mark-making, in the form of delicately carved incisions, lent an element of individual 'handwriting' to the work of an artist who had originally allowed nothing to disrupt the impersonal sweep of his serene surfaces. Fragmentation, enabling Cox to arrange several 'broken' pieces in an ensemble which never quite added up to a 'complete' sculpture, permitted him to escape from uninterrupted geometrical severity. And references to the past, focusing at first on the Italian Renaissance period, let Cox meditate on sculptural tradition rather than concentrating so exclusively on the legacy of post-war American abstraction in general and Barnett Newman in particular.

All these developments enhanced Cox's work immeasurably. The *tabula rasa* of his early wall sculptures gained in meaning, formal elaboration and restrained decorative splendour. Such gratifying changes also coincided with a widespread resurgence of interest in figuration, the heritage of antiquity and a catholic variety of new materials for sculpture. Unlike so many of his contemporaries, though, he displayed no interest in salvaging scraps of junk from the street. Rather did he cast his mind back to the first half of this century, when so many adventurous sculptors had been fired by the idea of 'carving direct' and respecting the identity of the block to the point where it helped to dictate the form assumed by the finished work. While other young sculptors set out to prove that virtually anything could be regarded as legitimate material, so long as it was transformed by the artist's imagination, Cox preferred to concentrate on stone and marble. Reading Adrian Stokes's passionate and densely informed writings on quattrocento carvers, and the geological evolution of the stones they employed, convinced him that 'the Mediterranean is the womb of my civilisation, a limestone basin whose crustacea have accumulated and been thrust up to form mountains'.

Cox is not the first British sculptor to have been inspired by Stokes to seek direct inspiration in the early Renaissance. The now-forgotten Gilbert Ledward was so enthralled by *Stones of Rimini* that he went out to see Agostino di Duccio's carvings for himself and ended up making a *Monolith* in Roman stone as a form of homage. But the differences between Ledward and Cox are instructive. *Monolith*, for all its undoub-

35. Stephen Cox, *Tondo: We Must Always Turn South*, 1981

ted skill and sincerity, comes perilously near to pastiche. Cox, by contrast, in the work closest in spirit to Stokes's writings, produces an independent equivalent rather than a nostalgic echo of Agostino. Although *Tondo: We Must Always Turn South* pays tribute to the format favoured by early Renaissance sculptors, the oval carved on its surface does not try to ape quattrocento precedent. Like many of Cox's works, the colour emblazoned on this lump of Verona of St Ambrosia marble is, within self-imposed limits, surprisingly sumptuous. It evokes the glowing copper of a sun, an image reinforced by the flame-like fingers leaping from its upper edge. But it carries more sexual associations as well, for Cox has become increasingly willing to let his sculpture incorporate references to swollen organic fruitfulness.

This eroticism reached its most extravagant expression in the *Ecstasy of St Agatha*, a three-part sculpture which twists Rosso di Verona marble into flowing, undulating baroque fragments savouring the unbridled sensuality of shoulders, buttocks and breasts. Nothing quite so erogenous has been seen in British sculpture since Eric Gill's most heated carvings of the 1920s, and Cox also shares Gill's enthusiasm for the civilization which produced the most ecstatic celebration of sexuality in its carvings. India, the focus of his current exhibition at the Tate Gallery, achieved in its temples a union of sculpture and architecture which he was bound to find intensely rewarding. For Cox's work has harboured strong architectural aspirations ever since the days of the earliest wall works, and it is no accident that many of his 'classical' works contain references to ruined buildings. Their state of decay chimes with the broken segments Cox himself favoured, and their obstinate refusal to form a whole implies an elegiac awareness of our fractured relationship with classical civilization.

Fragmentation is also employed in a vast granite sculpture at the Tate called *Thousand Pillared Hall*, which consists of ten upright slabs delicately coloured and incised with the columnar interior of an Indian temple. The immense receding perspective set up by pillars, ceiling and floor recalls the equally awesome structure of Anselm Kiefer's empty Third Reich monuments, but Cox's lyrical work lacks the brooding mortification of the German's paintings. Using rubbed ochre, faded maroon and rust colour as a means of conjuring up an ancient patina, Cox's panoramic work brings together the resources of painting and sculpture to pay homage to the inspiration he finds in architecture. No people can be discerned in this immense building apart from a figure on the extreme left, whose presence is counterbalanced at the other end by the 'absence' of a blank slab of granite. But in *Rock Cut: Holy Family* the whole central area is given over to a frankly Indian devotional group, and the feeling that Cox's carving could well have been excavated is strengthened by the rough-hewn boulders surrounding this group on every side. It is a reverential image, exuding the sense of awe experienced by a Western traveller fortunate enough to encounter the great monuments of Indian sculpture *in situ*.

There is, however, a more disturbed side to Cox's recent work. In *Origin*, the reverence for the past is replaced by a sense of disruption: a huge breast-like form has been split into quarters, revealing insides as blackened as the partially charred nipple above. Sanctity has been besmirched, and the feeling of violation is openly dramatised by a work called *Brides of Manamai*. Although its five upright granite blocks recall the structure of the *Thousand Pillared Hall*, the sense of tragedy is this time inescapable. For they have been defiled by black paint, and the

lengths of silk trailing towards an even more blackened lump of granite are smeared with paint. This outspoken reaction to the unacceptable aspects of Indian marital convention is the most expressionist work Cox has ever made, but he ensures that calm is restored in the set of five carvings hanging on the opposite wall. *Tanmatras* is a tribute to the five organs of understanding in the Samkhya philosophy. Each one is equated with an element like Earth, Water or Fire, and their polished ovals reiterate Cox's abiding interest in the source of art and life alike, the fundamental and wholly affirmative egg of creation itself.

FROM TWO WORLDS
28 August 1986

There is a lot of truth in the accusation that the British art establishment, preoccupied with Euro-American developments, tends to ignore artists whose roots lie elsewhere in the world. Ignorance thrives, and misunderstandings about the precise nature of their work mount to an intolerable level. Accusations of racism and cultural colonialism add to the tension, creating a polarised state of affairs which implies that the two crudely opposed camps have nothing in common. But the truth is that connections can be discovered at every turn. Many of today's most fêted European artists are acutely conscious of cultures far beyond their geographical boundaries, finding there an inspiration as potent as the excitement Picasso discovered in African carvings at the beginning of this century. The art produced in Third World countries often displays a similar awareness of the European tradition, and work made by British artists whose families originate in Africa, India and the Caribbean reveals an even greater degree of cross-fertilization.

The Whitechapel Art Gallery, situated in an area with a high immigrant population, is a particularly appropriate place to explore such issues. Seeking to replace prejudice with a more informed alternative, the gallery has mounted a welcome survey of sixteen artists whose work can be encompassed by the umbrella title *From Two Worlds*. Although diverse in both character and intention, they are united by a desire to attain a fusion of the heterogeneous influences which shape their art. None of them, I am sure, would minimise the problems involved. Some were born in Britain, others came here during their childhood, and a few have lived

here only for a short while. The challenge of arriving at a synthesis varies in every case, but it remains for all of them the one way forward.

Even when the artists have a minimal experience of the country their parents left behind, the pull it exerts on their imagination cannot be denied. Veronica Ryan, who grew up in Hertfordshire, spent a single year in Montserrat when she was seven. The experience of that visit, combined with a deep-seated urge to define her identity through art, ensured that the sculpture she makes today possesses a strong relationship with the Caribbean. Swollen, ripe forms redolent of fruit and pods lie on the floor, their ample dimensions hollowed out to contain smaller shapes which recall flowers, beakers and other simple implements. This ensemble of eight components is called *Attempts to Fill Vacant Spaces*, a wry title that uses humour to hint at the crucial importance of sculpture in Ryan's life. For by arriving at an art capable of encompassing her links with non-European sculpture, she produces work which acknowledges the full complexity of her origins. Ryan recently researched the influence of European art in contemporary African work at the School of Oriental and African Studies, and her own work attempts to reverse that tendency. As the title of another sculpture indicates, she wants to give her Caribbean inheritance *A Place in the Scheme of Things*. It is no accident that her work centres on images of enclosure and voyaging: Ryan regards sculpture as a process of discovery, and the outcome suggests that she derives great satisfaction from an ability to make her work embrace the widest possible range of multi-cultural references.

Although it focuses on non-European sources with such intensity, Ryan's art would not look at all out of place in a survey of modern British sculpture. Her work seems at home in either world, and all through the exhibition a similar duality can be found. Shafique Uddin's restless, nervous paintings often take as their subjects the London street scenes he grew up in after moving from Bangladesh at the age of nine. But the elongated figures moving through these open-air markets cannot be disentangled from his memories of life in the village of Borobari, and the fusillade of agitated brushstrokes he employs often recall the fabric of textiles. In a painting called *Countryside*, two people reminiscent of the main couple in Seurat's *Grande Jatte* parade across the flat, patterned surface. The rest of the painting escapes from European associations altogether, though, proving that Uddin is quickened by the stimulus of enlivening British art with the exuberant rhythms, wit and tonal sensibility of the country where he was born.

A rich vein of joyful energy runs through this show, animating Zadok Ben-David's uninhibited story-telling with a theatricality which

36. Saleem Arif, installation in *From Two Worlds*, Whitechapel Art Gallery, London, 1986

prompts him to envelop a brilliant yellow cat in a circle of wildly dancing monkeys. Surreal accidents and combinations of the outsize and the diminutive abound in his zestful work, so that a tiny lizard hunter balanced precariously on a huge fruit-like base finds himself 'followed by his wrong shadow'. Ben-David's Israeli origins may be far removed from Saleem Arif's Hyderabad home, but the latter shares a similar fascination with the potency of folk tales. Mixing acrylic and sand which he then applies to paper and muslin, Arif composes 'enchantments' filled with

references to gardens, birds, fish and the elemental forces of nature. He feeds off stories remembered from his childhood, and Islamic design is as important to him as the influence of Indian miniatures. But the boldness of these cut-out forms suggests that he has also been looking at late Matisse, and the results are charged with a sense of exhilarating freedom.

By no means all the contributors share Arif's *joie de vivre*. Dislocation haunts the work of Zanzibar-born Lubaina Himid, most notably in *My Parents / Their Children* which explores the divide between the two sides of her family. Her grandfather, a Lancashire publican, never met her grandmother 'who loved to dance in Zanzibar'. Their portraits are separated by a flurry of white pigment signifying 'the sea, the sand and the time' which 'kept them apart'. Himid's poignant sense of loss gives way to outright anger in Houria Niati's sequence of canvases, which takes as their starting-point Delacroix's *Women of Algiers*. Born in Algeria, she suffered brutal first-hand experience of the war of independence. Quite understandably, it has coloured her attitude towards the languorous image of passive, cosseted womanhood painted by Delacroix. In place of his seductive romanticism, she paints female nudes whose faces have been erased by fierce, slashing actions of the brush. The mood here is closer to Picasso's harshly distorted *Demoiselles d'Avignon* than to Delacroix, and Niati's women bear the unmistakable marks of oppression and torture. But they also possess a resilience which implies a defiant determination to overcome the horrors of the past.

In this respect they share a common resolve with the black figures dominating Keith Piper's extensive installation. Its cue is taken from a diary displayed on a stand, open at the pages recording the artist's first meeting with his grandfather. Piper, who was brought up in Birmingham, found the old man initially disapproving, but he mellowed later and impressed on the young artist an African saying now written in bold capitals above the black figures' heads: 'The spirit will not descend without song.' Each of the figures carries a story of oppression on his body, ranging from slave history to Soweto today. They all end by stressing the importance of song in their struggle, and the figures themselves appear to be possessed by the spirit of the music. A chanting song likewise accompanies a selection of radical liberation speeches relayed from the mouths of bronze heads nearby, confirming the overtly political thrust of Piper's work. Other artists avoid such a polemical approach, and yet a related spirit – forthright, courageous and independent – can be found throughout this heartening exhibition. I hope the Whitechapel will follow up the initiative established here, and that other galleries soon open their doors to further explorations of Britain's multi-cultural identity.

JULIAN SCHNABEL

2 October 1986

Excessive notoriety, as well as being dangerous in itself, always distorts our understanding of art. It prompts some to overestimate, others to denigrate. Extreme positions are adopted, and no one is encouraged to look carefully at the work in question. Instead of concentrating on what really can be seen and assessed, viewers approach it with eyes clouded by rumours of outrageous hype, unimaginable prices and precocious arrogance.

Nobody succeeds more effectively in arousing either hero-worship or execration than Julian Schnabel. His very name is calculated to trigger off polarised reactions, even from people who have never seen more than a handful of his paintings. For Schnabel has become, in an astonishingly short period, the epitome of the Unstoppable Young Artist. When the 1980s began, he had hardly been heard of, outside a small number of galleries where his early work was shown. Now, by contrast, he is the most celebrated American artist of his generation, eagerly sought after by curators, dealers and collectors able to pay the exorbitant sums his work commands. In a decade overshadowed by the vast commercial success of neo-expressionism, and a general resurgence of enthusiasm for figurative painting on the grandest conceivable scale, he is promoted as New York's answer to all the outspoken German and Italian painters who have once more made European art the centre of attention. He is a key factor in the Americans' bid to prevent interest from swinging too sharply away from their home-grown art, and efforts are made to cast him in the same heroic mould as Jackson Pollock. But the attempt to expand Schnabel into a colossus excites the understandable envy of all those artists who have not been favoured by big-spending patronage. Inflated expectations can easily rebound on the painters they are supposed to glorify, and Schnabel often seems to be a victim of the immoderate claims made on his behalf.

So where does the truth lie? The Whitechapel Art Gallery offers an opportunity to find out by displaying an ample selection of his work since 1975, and it reveals a far less 'sensational' artist than the one created by his admirers and detractors alike. Even though it contains only a fraction of his output and focuses on major works alone, Schnabel is clearly an uneven painter. The man promoted as a giant proceeding from one triumph to the next is shown here in all his fallibility. When he relies primarily on paint, the work often looks either crude or anaemic. If the pigment is heaped on with the aid of modelling paste or wax, it can qui-

ckly become turgid. But if he decides to apply it very thinly, the outcome seems wan and oddly tentative. Schnabel lacks the ability to draw with paint in a wholly convincing manner, and so he resorts to wilful ugliness or a handling which appears lacking in essential energy. *Portrait of God* is little more than an angry scrawl, deposited on tarpaulin by an artist determined to push cursoriness beyond the limits of acceptability. It shows Schnabel at his most bloody-minded and perfunctory, whereas *Griddle* discloses the uncertain side of his temperament. The contours of the figure are hesitantly drawn, and they end up looking listless.

These are serious deficiencies, cutting away at the image of Schnabel as a Titan who never fails to provoke awe. But they do not mean that he is devoid of substantial achievement. Unlike his most vitriolic critics, who recoil so violently from the publicity surrounding Schnabel that they dismiss him as a mere charlatan, I do not believe he should be rejected so hastily. For this exhibition confirms my previous impression that he comes convincingly to life as an artist when paint is only one of the resources at his disposal.

The earliest work on view here, *Jack the Bellboy*, 'A Season in Hell', contains three cavities brutally hacked out of the canvas surface. They have a disruptive, boorish impact, energizing what might otherwise have been a rather slack picture, and in subsequent works Schnabel began to explore the expressive possibilities of materials that projected from the picture-surface. He was right to do so. The broken crockery, antlers, charred wood and animal hide variously employed in his works over the past decade perform the same animating role as the cavities once did. Schnabel's use of smashed plates is particularly successful, setting up an open conflict between paint and crockery which unleashes a powerful sense of discordancy.

An encounter with Gaudí's mosaics at the Park Güell in Barcelona was instrumental in the development of this unconventional material. 'I had a funny idea that I could make a painting the size of the closet from my room in Barcelona', he wrote later, 'and that I could cover it with broken plates.' However fragmented the Park Güell mosaics are, though, they still add up to a homogeneous pattern. Schnabel's crockery does not. Embedded in his pictures at a whole range of different angles, the plates' smashed edges fracture the unity of the surface and rise up to assail the spectator. Schnabel's way with paint no longer seems wanting here. On the contrary: his very awkwardness and refusal to ingratiate through pigment acts as an ideal accompaniment to the crockery.

Battered, smeared and discarded, these broken pieces of china stick out harshly from the pictures they aggravate. Sometimes they seem wholly

37. Julian Schnabel, *Circumnavigating the Sea of Shit*, 1979

urban in derivation, evoking the New York ambience where Schnabel spent most of his childhood and where he returned to work as a cook in restaurants equipped with similar crockery during the 1970s. The plates he uses here look like the remnants of a thousand cataclysmic arguments engendered by the pressures of living in crowded and aggressive surroundings. They convey both anger and despair, implying that the act of smashing is in itself a demonstration of resilience even as it signals frustration and hopelessness. At other times, however, the crockery carries a very different set of meanings. *The Mud in Mudanza*, one of the

most impressive works on view, signifies a landscape rather than a big-city environment. But it is no less jarring and disturbed. The fractured plates now appear to have been deposited in a dried-up riverbed, and the colours dragged across them are sickly enough to be redolent of destructive effluents. This is an image of nature polluted and defiled.

The damage seems so grievous that it could well be irreversible, and even when Schnabel makes a picture called *The Sea* he discovers layer after layer of detritus impeding its flow. Fragments redolent of classical civilization can be discovered among the plates this time. They demonstrate an involvement with antiquity which Schnabel shares with many of his European contemporaries, and he ultimately has more in common with German and Italian painters than with Pollock or most American artists of his own generation. During the course of an interview published in the Whitechapel catalogue, he talks about his links with Kiefer and Clemente, explaining that 'our work is very different in many ways but in all of it there's a feeling that these things were in the world already and that they were deformed'. Elsewhere, Schnabel mentions his interest in 'the metaphoric power of materials', and he certainly manages to charge his broken crockery works with a tragic apprehension. In his best pictures, he does succeed in conveying a wild and troubled vision of a world despoiled, bent on its own extinction. Schnabel's inadequacies as an artist, no less than his sadly bloated reputation, should not blind us to the authentic and chilling eloquence of his most heartfelt forebodings.

ANTONY GORMLEY
19 March 1987

Unlike many of his contemporaries who have made the new British sculpture so rewarding in the 1980s, Antony Gormley places the figure at the very heart of his work. He follows Renaissance artists in viewing humanity as the centre of creation, and his most typical working method encourages the idea that he aims at a direct, faithful representation of his own physical experience. He poses for a great many of these images, submitting himself to the unpleasant process of creating a plaster mould around his naked body. So the final sculpture, whether calmly erect or sitting in a characteristically hunched stance, is closely allied with Gormley's consciousness of the position he occupies in the world.

This supposedly literal approach to the challenge of contemporary figurative art is, however, deceptive. For the completed work differs in several respects from the figure used as Gormley's starting-point. The more his sculpture is scrutinised, the less it appears to resemble a real human body at all. The overall greyness and dull gleam of the lead encasing his images is far removed from the interplay of skin, bone, muscle and flesh. It drains the forms of the animation and warmth they might be expected to possess, leaving behind a marmoreal repose which seems closer to death than life. There is a mummy-like quality about Gormley's figures, as if they had recently been exhumed from a prolonged period of incarceration in a tomb.

Their uncanny stillness is reinforced by his insistence on generalizing the bodies he presents for our inspection. Facial features are reduced to the most minimal statement of essentials, so that eyes, ears and mouths are virtually eliminated. A blank expression results, and the rest of the figure is just as anonymous. The structure of the torso has been smoothed away, shorn of anatomical detail in the same summary manner as the hands and feet, where no individual fingers or toes are visible. Gormley's body therefore becomes a kind of Everyman, personifying the race to which he belongs rather than a particular person. This archetype is distanced still further from a live model by the network of soldered lines travelling across his sculpture's surface. They stamp a rectilinear geometry on the rounded, organic forms, openly declaring the existence of a uniform framework underlying every figure he produces. It has a levelling effect, making images very different in both scale and pose conform to the same linear grid. It also gives the statues a defensive air, suggesting that they have been joined together with sufficient firmness to resist any possible onslaught.

Ultimately, however, all these strategies end up stressing the vulnerability of Gormley's people. The lines keeping his figures intact reveal, at the same time, the method of their construction, reminding us that they have been put together as a series of components which could be dismantled at will. The sense of expectancy in his work adds to this foreboding. Gormley's humans seem affected by their awareness of a fate that might at any moment confront them. Resigned to the point of outright stoicism, they stiffen themselves in readiness for possible danger.

The feeling of a world at risk is confirmed by the work Gormley makes without the aid of his own body. *Room*, a dour monolith composed of five raw concrete slabs, is so fortress-like that it does not even possess a doorway. The few windows inserted in its otherwise unyielding bulk are minuscule, seemingly intended as a means of observing and fir-

38. Antony Gormley, *Fathers and Sons, Monuments and Toys, Gods and Artists*, 1984–6

ing at antagonists without. This squat, boorish presence resembles a pill-box left over from the Second World War, or alternatively the kind of structure that might house the survivors of a nuclear holocaust. But when I peered through one window of the turret-like block on top of *Room*'s main structure, all my eyes could see inside the gloom was an identical window in the opposite wall. In between, a disconcerting void prevailed, suggesting that no one is manning this eerie bunker. In some notes written for his Serpentine Gallery exhibition, Gormley declares that 'a house is the form of vulnerability, darkness is revealed by light.' The empty interior of *Room* appears even more desolate than its unpre-possessing façade, and the imagination of the artist who made it seems haunted by visions of a world alarmingly close to extinction.

Gormley is not a sculptor to hammer apocalyptic meanings home. The most successful of his Serpentine rooms, an installation containing the two figures who comprise a work called *Fathers and Sons, Monuments and Toys, Gods and Artists*, are as muted as most of his other human images. Disdaining rhetoric of any kind, a colossal man dominates the

end of the gallery with arms held firmly against his sides and legs closed together. As immobile and remote as the Egyptian statuary which Gormley surely admires, he gazes towards the other end of the room where a child's form stands erect. This time, the little legs are slightly parted, and the arms half-raised to acknowledge the prospect of future growth. But there is something tentative about this gesture, as if the son were conscious of the possibility that full stature may never be achieved. The child's frailty is accentuated by the contrast in size between his body and the eight-and-a-half-feet father towering beyond him. The deliberate removal of this colossus from the boy, and the withdrawn stance of a man who makes no attempt to demonstrate his kinship with the child, hold out no promise of paternal protection. The isolation of these marooned figures could hardly be more complete, as they stand divided by a space seemingly too great to be bridged.

The extreme quietism of Gormley's work invites us to project into its subdued and 'vacant' forms our own preoccupations. While he clearly welcomes this process, though, Gormley is never content to allow the spectator free associative play. Our responses are always directed, albeit in the most discreet manner, by the sculpture itself. Even the smallest pieces channel our interpretative impulses along distinct lines. A modest little object called *Heart* could almost be overlooked by the hasty viewer walking past it on the floor. But once noticed, its implications are forceful enough. For this polygonal lump of lead appears as sharp-edged as a prehistoric flint, and looks more like a weapon than the organic pump which sustains human life.

Gormley perceives a cold and apprehensive hardening at the centre of existence. It affects his reaction to the impeccably tended lawn outside the Serpentine, where the full-scale shape of a glider has been laid to rest. In the exhibition catalogue a lyrical photograph of just such a glider is reproduced, celebrating its airborne grace as the pilot floats through a sky incandescent with bright summer sunshine. Here, by contrast, the icy grass of Kensington Gardens in winter proves a bleak resting-place for an object entitled *Vehicle*. The wing that once rose a few inches from the turf was broken soon after Gormley placed the plane on its site, but he decided not to mend it. So the glider remains drooping and forlorn, grounded by a predicament which seems to rule out any prospect of future flight. Robbed of its former function and weighed down by the ubiquitous lead casing, this grey phantom disrupts the parkland calm with intimations of paralysis. Gormley has written that 'sculpture, in stillness, can transmit what may not be seen', and the uncompromising insights he reveals here contain little for our comfort.

TONY CRAGG
26 March 1987

In 1986 Tony Cragg made a cast-iron sculpture called *Eye Bath*, a title which could well stand as the key to his overall intentions as an artist. For Cragg would like his work to refresh our way of looking at the world, ousting the tired vision that so often takes the apparent familiarity of reality for granted. He aims to replace this jaded lack of responsiveness with a stimulating alternative, which sets up encounters direct and questioning enough to generate a new relationship with the materials that surround us. Instead of remaining detached from the welter of disparate forms, textures and colours assailing our existence, he invites us to see them as if for the very first time.

When Cragg first established himself as a pioneer of the new British sculpture in the late 1970s, attention focused on his preference for plastic detritus. The novelty of this material as a sculptural ingredient, combined with its references to proliferating obsolescence, dominated most of the debate about his work. Cragg encouraged this view to a certain extent, making a wall-piece as colossal as *Britain seen from the North* which could be interpreted as a polemical diagnosis of his country's malaise. Standing perilously near a map of the entire island tipping towards him, a figure gazes askance at the collapsing UK and at the cornucopia of plastic fragments it contains. Since the man's body is also filled with the same jumble of waste-material, Cragg appeared to be brooding over the chronic pollution and redundancy riddling life in a nation he had decided to leave in 1977.

But to see his preoccupation with junk simply as a state-of-the-nation indictment would be a mistake. For one thing, Cragg assembled the plastic shards with such zest and resourcefulness that the entire image possessed an unexpectedly festive tang. The sharp, inventive and witty deployment of these 'debased' elements implied a complex attitude on his part. Even as he appeared to be proposing that our culture had become irrevocably defiled, Cragg jolted the viewer into an awareness of the true character of materials too often dismissed as mere rubbish. His formal finesse and eye for seductive colour persuaded us to reconsider objects from which we usually feel estranged.

Cragg shared this sense of alienation, and behind the work he has produced during the 1980s lies a fierce commitment to understanding far more about the identity of everything that industrial manufacturing has done to transform the face of the contemporary environment. He

equates his exploration with survival. Confronted by the prospect of living in a permanent state of disaffection, removed from the escalating artifice around him, he attempts to establish encounters with the man-made world just as enriching and profound as those provided by the organic, natural order.

Cragg's Hayward Gallery exhibition, which confirms his outstanding stature among the young sculptors of the 1980s, is animated throughout by a deft and inquisitive reaction to the remarkably diverse array of materials he now deploys. Far from simply condemning the 'irresponsible and manipulative' way in which so many objects are now produced, and seeking to escape into a world where nature still prevails in her most inviolate state, Cragg is not afraid to deal with late-twentieth-century urban civilization in the frankest and least prejudiced manner imaginable. Plastic is still in evidence, most dramatically in a huge frieze called *Riot* which spreads the gesticulating figures of street-fighters and visored policemen across the surface of a wide, white wall. The clangorous and exclamatory colours Cragg selects, combined with the dehumanizing effect of the fragments, adds up to a shrill and staccato experience. Men, horses and weapons alike seem on the point of disintegration, just as the unrest depicted by *Riot* threatens to destabilise the societies where such violence is most prevalent.

Elsewhere, though, he turns away from this overt involvement with socio-political turmoil and meditates on the meaning of components scavenged from the waste-lots, skips and factory dumps of a culture bent on an incessant process of discarding. Plastic plays a part in *Minster*, but its role is subordinated this time to the identity of metal, wood and rubber. Cragg builds them into a cluster of spires, allowing these rusted and well-worn elements to take on a soaring quality. As elegant as minarets, they allow us to savour the distinct shape and subtly variegated hue of each constituent part while asserting wholeness as well. The ecclesiastical overtones of *Minster* become fused, at the same time, with a more sinister mood. For these 'spires' evoke the form of missiles, too, extending their pointed shafts towards the chilly metropolitan sky.

Cragg's coolly analytical temperament would never allow him to force such a meaning on the spectator. The intimation of apocalyptic armaments in *Minster* remains subservient, in the end, to the elegance and lucidity of the spires' architectural strength. But an awareness of darker and more destructive forces does run through his work, reaching especially disquieting proportions in a panoramic sculpture called *Echo*. What are these forms, composed with an angular severity which recalls Cubism on one level and Minimalism on another? Massed in an epic semicircle

39. Tony Cragg, *Riot*, 1987 (detail)

like the boulders of a mountainous terrain, they also suggest the forms of gaunt buildings. Cragg's blocks have no distinguishing features, however. Limited to a subdued range of umber, ochre, sepia and the occasional plane of pale green, they refuse to be pinned down to either an urban or a rural context. The freely scrawled marks drawn on their flat surfaces with wax crayon similarly rebuff confident identification, emphasizing homogeneity and yet retaining the ambiguity Cragg desires.

He wants to question the whole notion of landscape in industrialised society, suggesting that an apparently 'natural' stretch of countryside could be as much of an artificial construction as a group of offices or houses in a modern city. The length of gleaming terracotta pipe inserted so blatantly into *Echo* refers to rural water-channelling as much as it signifies urban drainage, while the concrete ring and gashed metal canister might likewise inhabit a landscape besmirched by human exploitation. The most eerie aspect of *Echo*, though, resides in its emptiness. The seeming solidity of its main masses is a sham. Made of wood they may be, but the thin panels have a tackiness about them and they conceal an

inner void. These deceptive forms sum up the ersatz character of so much contemporary Euro-American life. Stacked together like once-functional objects consigned to a lumber-room, they exude the melancholy air of things which have outlived their usefulness and linger on as mere shells.

All the same, the elegiac strain in *Echo* is countered by a perverse grandeur. While Cragg probes the hollowness of the world he inhabits, his work constantly invites us to give time and attention to materials we might normally consider beneath our regard. By prompting a close and thoughtful engagement with a row of vases, beakers and jars made of eroded glass, he reveals a surprising beauty in their fragile, ghostly whiteness. In all his art there is an inherent respect for the elements he finds and incorporates. Rather than transforming them out of all recognition, Cragg usually prefers to let them assert their own identity in the sculptural context he has devised. Sometimes, as in *Crackerboxes*, he adopts too passive an attitude towards his materials and they fail to sustain our interest. But this inertness is rare in Cragg's work, which has become replete with moments of quiet revelation and genuine imaginative insight. There are signs, in the recent sculpture, that invented forms are playing a more significant role, and that he is discovering the fascination of investing utensils as banal as a laboratory test-tube with the 'primitive' dignity of an imposing vessel in cast steel. Even here, however, the metamorphosis ultimately makes us return to Cragg's starting-point and reconsider the test-tube as an object in its own right. The eye-bath principle is implemented to the full, helping us move away from the dangers of detachment and enter into a more sensuous involvement with the apparently irredeemable aspects of our adulterated world.

ART AND MAPPING
2 April 1987

Having lived in the same house for almost fifteen years, I sometimes wonder if we ought to be moving on. But my children dismiss these ruminations out of hand. Since they have all been brought up here, and two of them were actually born in the attic, their desire to stay put is only to be expected. All the same, I was surprised by the fierceness of their resistance to the mere suggestion of leaving. They are profoundly

attached not only to our creaking terraced house, but also to the surrounding area. And so, in the end, am I.

The whole notion of a special place, a locality which helps us to define our sense of selfhood, is surely gaining in importance. As society becomes ever more impersonal and standardised, especially in the largest cities, the need to identify with a particular vicinity grows more pressing. Its familiar character reinforces the sense of individuality which seems so threatened by the dehumanization of modern life. Hence, I suppose, the enthusiastic response given by artists last year to an invitation from Common Ground to make a 'parish map'. As a member of the selection panel, I realised soon enough that a diverse range of painters, sculptors and artists working in alternative media were all united by the strength of their feelings about spaces they had reason to savour. The only doubt in my mind, as we finalised the exhibition now at the London Ecology Centre, centred on how their work would lend itself to the idea of a map.

I need not have worried. The history of map images in twentieth-century art is, after all, quite extensive. From de Chirico's incorporation of atlas fragments in his paintings around 1916, to Richard Long's frank employment of Ordnance Survey sections in his walking pieces, the map has proved of enduring fascination. It is, admittedly, easiest to use if the artist already deploys collage elements or works in a relatively diagrammatic fashion. Simon Lewty, who has for many years preferred a meandering linear style with plentiful recourse to boundaries, signs and other inscriptions, was able to produce a 'map' without altering his usual idiom at all. The result is one of the most successful exhibits, charting his response to a long-familiar stretch of Warwickshire with delightful discursiveness. Lewty's line takes us on a ramble through Old Milverton, discovering on the way an assortment of fossil-like forms, quirky bumps in the landscape and recollections of previous visits. As any wanderer might, he pauses to contemplate compelling features of the terrain: hillsides that take on the shape of animals, and a pond which prompts him to remember the 'smell of paraffin oil and burning plastic as he threw the two remaining pieces into the stream'. Lewty's handwriting grows into guilty capitals as he asks himself 'WOULD HE DO THIS AGAIN? WOULD HE DO THIS NOW?'. On the whole, though, he celebrates the continuing existence of a place loaded with Proustian memory-triggers. By giving this cherished locale visual form, Lewty clearly wants to help preserve Old Milverton at a time when it has 'come to be more or less surrounded – yet not swallowed up – by the town'.

Not all the spaces pictured here are under threat. Adrian Berg, who paints the view from his window over Regent's Park with devoted per-

sistence, has no reason to suspect that it will ever be spoiled. Infatuated with every aspect of the seasonal changes it undergoes, and the park's felicitous relationship with the Nash terraces on the border, he paints it so obsessively that an enormous emotional dependence is implied. Berg needs Regent's Park for his daily nourishment. And even he is obliged to admit that the phalanx of buildings included in the lower section of his picture, representing the view from his back window and roof, 'gives me pause'. Urban London seems to be pressing in from below, doubtless making Berg love his oasis-like patch of trees, flowers and lawns still more fervently than before.

Artists born in another country can root themselves in Britain with equal intensity. Balraj Khanna, who grew up in India before moving to London, now regards his home territory of Maida Vale as *The Real Centre of the Universe*. That is the title of his delicately painted and astonishingly detailed contribution, a rapturous tribute to the landmarks, waterways and people he has come to know so well. The ardour in Khanna's title reflects above all his passion for Lord's cricket ground, represented here by a black oval which seems to act as a magnetic field. But a cornucopia of other incidents abound in this *tour de force*, where the canal is transformed into a glittering fantasy and dreamlike vessels drift towards graceful bridges. Khanna's Maida Vale is an unashamedly magical space, charged with erotic memories and bizarre encounters. He even manages to find wry humour in the so-called Dwelling Units clustered around the perimeter of this enchanted district. And the fusion of Indian and European cultures to be found in Khanna's pictorial language matches the multiracial diversity of the buildings and people he sets down in his remarkable canvas.

Khanna's image derives from adult experience, whereas Helen Chadwick feeds off childhood recollections of Croydon. Concentrating on her relationship with Littleheath Woods, she assembles with the aid of photocopied images an exquisitely composed recreation of a young girl's nearness to nature. The presence of pylons reminds us that Croydon woodland is far removed from the countryside at its wildest. But the accumulation of materials around the ecstatic figure of the girl demonstrates, eloquently enough, how close a rapport she achieved with the conker tree, the badgers' setts and the squirrel-haunted environs of the pond. The womb-like enclosure Chadwick once enjoyed inevitably contrasts with subsequent perceptions. She refers to her memory of Littleheath Woods as 'my own lost shelter', and elsewhere in the show bleak analyses of present-day alienation can be found. Stephen Willats maps the debris left at the foot of a council tower-block in Hayes, where

40, 41. David Nash, *A Personal Parish* and detail, 1987

a 'sense of place' is desperately hard to find. But this disconsolate series of cast-off images does represent an attempt to form a rough-and-ready landscape, thereby testifying to the survival of this fundamental human need even in areas where everything seems to militate against its continuation.

Survival is also the issue dominating Conrad Atkinson's uncompromising sequence of images devoted to his home town of Cleator Moor. A relentless awareness of the dangers posed by nearby Sellafield permeates his mapping. The town and its immediate surroundings are spattered with small splashes of pale colour, pleasing to the eye until a close examination discloses the ominous words written in the washes. 'Strontium', 'disappearance', 'permissable', 'leukemia' and 'causal relationship' are among them, adding up to a litany so gruesome that each colour takes on the sinister appearance of polluted rain.

The post-Chernobyl landscape is even more vulnerable than before, and the most 'unspoiled' areas are often at greatest risk. David Nash, who lives in Blaenau Ffestiniog, has every reason to be conscious of the damage radiation inflicted last year on the hill farms of Wales. He persists, however, in seeing his homeland in affirmative terms. With ink and graphite, he has drawn an image of *A Personal Parish* entirely from words, spelling out the presence of the grass, rock, cliff, path, field, oak, bog, thorn and crag which directly inspire his sculpture. Occasionally we find sections filled with words like 'factory', 'yard' and 'car dump', but on the whole he is able to cite undefiled nature throughout this terrain. It adds up to a curiously moving testament, naming and at the same time praising the extent of his prolonged involvement with a locality he values as source and sustenance alike.

BOYD WEBB

28 May 1987

Of all the artists who were bold enough to start using photography as their principal vehicle during the 1970s, Boyd Webb now stands among the most remarkable. Far from finding the camera a cul-de-sac, he has allowed it to help him develop a personal and eloquent art which seems in no way constrained by his adopted medium. Photography has proved, for Webb, an excellent means of defining the dreamlike images that dominate his imagination. Having employed it initially as the most satisfac-

tory means of documenting the life-size fibreglass figures he used to make, Webb now concentrates exclusively on the large-scale and unique colour photographs which fill the walls of his exhibitions.

But his origins as a sculptor remain significant. He finds no great fascination either in the workings of the camera or in the majority of photographs its practitioners produce. The central interest focuses, in his view, on the tableaux he arranges with such dextrous yet sparing delicacy within the boundaries of his own studio. While building up these highly theatrical scenes he is, of course, very aware of how they will appear when scrutinised through his lens. But he professes scant interest in the technical or aesthetic aspects of photography. The camera is, essentially, a means to an end, and the seductive prints he displays represent the most direct available means of presenting the vision Webb distils from his diagnosis of the human condition. If his work is encountered singly, with no foreknowledge, it can appear mystifying and capricious to a fault. A devotee of Sufi parables, and unafraid of deploying a dry humour which some artists might consider perilously close to flippancy, he insists on immersing us, without any reservations, in the perplexing strangeness of his world. But when a large body of work is assembled, in exhibitions as comprehensive as the retrospective now at the Whitechapel Art Gallery, the cumulative effect proves that Webb's contradictory universe has an underlying logic and consistency that makes memorable poetic sense.

It is, for the most part, a perverse and frustrating locale. Elements which at first appear to resemble the sea turn out, on prolonged inspection, to be enormous swathes of linoleum or wallpaper. Life-size elephants are frankly simulated, whether painted and stuffed or held together with wood and string. Panoramic expanses of mountain and sky, however persuasive they may seem for a few seconds, make little attempt to disguise the fact that Webb has 'faked' them with the most unlikely materials imaginable. In common with several British sculptors of his generation, he enjoys an involvement with low-grade discarded plastic and other synthetic cast-offs. Webb handles them with a relish and sensitivity which reveals how sculptural his thinking remains. Rather than trying to hide their former identity, he allows them to retain their original character even as they take on a new meaning in the images he devises.

Looking at a Webb photograph therefore entails becoming aware of the folds and creases in the material he slings across the studio. But a consciousness of this artifice enhances our response to the work. While recognizing the fact that everything is simulated, and that the figures he includes are carefully posed for the purpose, we take pleasure in the transformations he engineers with such deceptive ease. Flimsy sheets of paper

are metamorphosed, almost effortlessly, into the palpable hulk of an ocean-going liner or the star-bespattered immensity of outer space. We find ourselves becoming the willing accomplices in Webb's sleight of hand, admiring the deft simplicity with which he achieves his pictorial conjuring tricks. Although the row of tiny animals making their way across a distant mountain-top clearly consists of nothing more than toys, they also beguile us into seeing them as the inhabitants of an epic landscape.

Webb's New Zealand childhood has left an enduring mark on his vision of the natural world. The sea which heaves and undulates through so many of his photographs tends to be pellucid in quality, glinting and dancing in the light. Mountain ranges have a feathery delicacy redolent of heat-haze or a sun-glare brighter by far than anything he could perceive in his adopted England. Objects and people alike often float in a submarine region that derives, at least in part, from his own experience of underwater swimming.

There is, however, no possibility of mistaking this almost mythological realm for nirvana. In Webb's art, paradise may not be wholly lost, but it certainly appears under incessant siege. Sometimes the besmirching process is relatively harmless, confined to nothing more apocalyptic than a smeared deposit of guano on a clump of grey rock. Elsewhere the mood darkens, though, as fruit and vegetables in a terminal state of decay languish on poles beneath a suffocating layer of ice-floes. After a while, everything takes on a distinctly beleaguered air, as if the entire planet were struggling to recover from an unidentified yet grievous calamity. Gold-embossed volumes lie scattered on the ocean-bed, abandoned after a disaster which has also left two telephone receivers suspended absurdly in the water above. Although voices could perhaps be attempting to communicate through them, there is no prospect of their babble alleviating the predicament that plunged the instruments into the sea. Nor can there be much hope for the survival of the man in a work called *Lung*, who stretches up from the ocean floor to clutch at an accordion proffered by a figure in a small lurching boat. Every enterprise appears doomed, and hope confined to the bottles which tilt and bob in the waves. They may contain messages, but Webb is far too wry and undeceived to imply that anyone will ever find them.

Most of the figures who inhabit his images are isolated and *in extremis*. One naked bather strives ridiculously to untangle strips of film which have wrapped themselves round his ankles, while a clothed man lies spreadeagled as he tries to gain nourishment from a breast lodged unaccountably in the barnacled hull of a ship. Everywhere you look, humanity is struggling to survive what can only be described as post-nuclear circumstances. These perplexed victims invariably seem in danger of com-

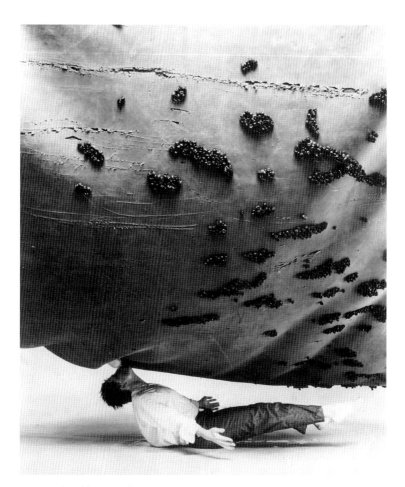

42. Boyd Webb, *Nourish*, 1984

pounding the global malaise by implementing misconceived ways of relieving their plight. In an especially ominous print called *Nemesis*, a subterranean figure keeps himself alive by breathing through a tube that rises up to the surface of the ground. But the tube leads straight into a weird ball, so swollen with the air generated by the man that it bursts through the walls of a farm-building.

Webb, in fact, is obsessed by the frailty of our late twentieth-century existence. A haunting sequence of prints escapes into outer space, and yet

they provide no sense of release from the dangers afflicting either the globe or its occupants. However loudly the woman in *Supplicant* bellows through her megaphone, and raises her arm beseechingly, there seems little likelihood of a response from the vast emptiness of the cosmos surrounding her rock-like planet. The paradoxical serenity and lyricism in Webb's work should never blind us to the laconic warnings he persists in issuing. Even while we smile at the knitting and electric toaster dangling so fatuously from the belly of a spaceship, he ensures that their melancholy futility sours the void through which they swing.

BILL WOODROW

11 June 1987

With wit, dexterity, mordant indignation and an acute eye for the unexpected, Bill Woodrow transforms the battered remnants of our throwaway society into very remarkable sculptures. Normally, the discarded washing-machines and clapped-out furniture he uses in his work would not be worth a second glance. But Woodrow, combing the area of London near his home, scavenges this ugly, unloved detritus and brings about a marvellously unpredictable metamorphosis.

His fundamental method, in this Lazarus-like enterprise, is deceptively straightforward. The rubbish he salvages from inner-city skips, dumps and waste-lots is sliced up so that a new image emerges from the material he has cut free. The directness with which Woodrow tears into the junk objects is nakedly exposed: they remain there, jagged and gaping, as testaments to the surgical efficiency of the sculptor who conducted the operations on their frayed bodies. But just as a surgeon makes incisions in order to generate fresh life, so Woodrow's cutting energies are dedicated to an almost ecological belief in the importance of recycling the unwanted and supposedly 'useless' cast-offs he selects. Although he makes no attempt to stitch up the wounded objects, umbilical cords often attach them to the images created from their shattered frames. The worn-through and the new, the familiar and the bizarre, are displayed together so that we can witness the passage from one to another and wonder at the extraordinary change Woodrow has engendered.

However unlikely the outcome may be, his best works always possess the inevitability of an achieved imaginative act. He works with equal

potency on the most modest and the grandest of scales, too. In 1981 he dismembered a black umbrella, leaving its crushed remains sprawled on the floor with 'fingers' of material seeping like bloodstains from handle and hood. Next to this shattered carcass, a crow constructed on an armature of spokes tugged at a loose strip of umbrella fabric like a predator feeding off carrion. The original identity of the umbrella was openly declared, and yet Woodrow managed at the same time to persuade us into seeing it as a mangled creature who would soon be devoured completely.

This central tension, between victim and aggressor, recurs in a multitude of guises – some more covert than others. In one of his largest early works, a rusted car door, a cheap ironing-board and a well-used twin-tub were all cut up so ingeniously that strands leading from each of them joined to form a North American Indian head-dress. It hung on a stand in the middle of the wrecked implements like an inexplicable apparition rising from a junk-heap. At first sight nothing more than an outrageous conceit, it soon provoked an awareness of the contrast between Indian culture and our own. The magnificence and apparent wholeness of the feathered head-dress made the degradation of its companions even more apparent, prompting dark reflections on the instant obsolescence of machine-orientated society. But nobody inhabited the head-dress: it remained impaled and inert, like a relic on display in a museum. And there was a desolate air about its entanglement with the innards of the carved-up objects, implying that we have infected the Indian way of life with our distorted, waste-obsessed values.

The Lisson Gallery show where Woodrow first displayed both those works seemed impressive enough for me to conclude, in a review, that he was 'one of the best British sculptors of the new generation'. Now, five years later, his latest exhibition at the same gallery fully confirms the promise he held out then. His handling of materials has remained continually ingenious: in a piece aptly called *Do it yourself*, fragments of an old wooden chair are turned into a shovel and a sharp-pointed scythe, while elsewhere a table has been chopped up and reassembled as a macabre tree with metal lockers dangling from its branches. But the infectious high spirits which allow Woodrow to carry off these feats never leads him into fancifulness or mere whimsy. For all the beguiling sleight of hand, his skills as a sculptural conjuror are always dedicated to immensely serious purposes.

At his most concise, he is able to cut a copper funnel into a series of painted flames, all leaping up towards a steel frying-pan where a chop lies pinioned on a fork. Shaped into the unmistakable contours of Africa, the hapless continent of meat is condemned to a burning summed up by

Woodrow's ironically hearty title: *Well done!* Equally at home on a grand scale, he also gives his preoccupation with the Third World monumental form in *Madagascar*. Here, a dingy yet ample turkey carpet hangs from the wall, its centre covered with white acrylic besmirched in one area by blood-red paint dribbling down its virginal expanse. Attached to the carpet is a metal tree broken by a cleaver, where a reptile perches as it stretches out an enormous tongue towards a framed painting of an idyllic coastline. The picture is frankly touristic, a kitsch souvenir of an island seen from the vantage of package-holiday commercialism alone. So images of exploitation and violation go hand in hand, proving that Woodrow's vision is darker and more bitter than before.

Everywhere he looks, civilization and human existence appear either threatened or utterly defiled. A big work waspishly called *English Heritage, Humpty Fucking Dumpty* confronts us with a crazy, teetering pile of vaulting boxes, all held precariously in position by an old book, a clock-in machine and a wooden case. Sitting on top of this inebriated ensemble is the egg-man himself, made out of a rusty water-cylinder which sprouts tiny arms, legs and a scarlet bow-tie. Not only Humpty Dumpty but the whole apparatus on which he sits seems about to fall, and Woodrow views the imminence of national collapse with a characteristic blend of knockabout humour and caustic pessimism. Like Boyd Webb, whose wittily apocalyptic vision he shares to a certain extent, Woodrow regards late-twentieth-century existence with consistent foreboding. Whether he looks inwards or outwards, ominous conclusions are reached about the body personal and the body politic alike. *Self Portrait, you are what you eat* presents the sculptor's head as a supermarket basket, its plastic handles twisted into facial features that dance wildly in front of a cello head. The body below is nothing more than a stove pipe, and a walk round it discloses that within its torn side dangle a horseshoe, a flower and a wire brush.

When he turns away from this disconsolate diagnosis of internal pollution, Woodrow slices a brown metal locker into the shape of a giant drum. With a harshness worthy of Günter Grass's novel, scissors have been stuck into both its sides, ripping in one instance through the 'skin' bearing an outline map of Europe. Although the locker itself is too static and decimated to spring into life as a marching drummer, bearing his grim message of destruction across the continent, the threat is there. Woodrow sees humanity as a gaggle of passengers in a ship of fools – an image he has employed repeatedly in recent years – and the terminal danger posed by overweening violence dominates his current work.

War-head, a relatively modest sculpture which turns a wooden card-filing cabinet into a dehumanised agent of conflict, summarises his fears.

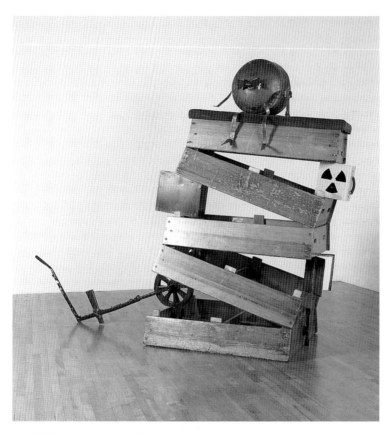

43. Bill Woodrow, *English Heritage, Humpty Fucking Dumpty*, 1987

Striding bossily yet blindly forward, this absurd bureaucratic figure carries a metal box in one of his hands. The familiar umbilical ribbon streams up from the box and changes into a camouflaged nuclear bomber, occupying the space where the robot's head should be. The toy-sized plane therefore becomes *War-head*'s guiding intelligence, silently guaranteeing that this busy little offspring of Yeats's 'rough beast' will bustle towards Armageddon with unstoppable clockwork conviction. By turns wry, fantastic, satirical and macabre, it mocks the suicidal idiocy of the military impulse in order to ram home the gravest warning Woodrow could possibly issue.

DOCUMENTA 1987

25 June 1987

Nothing in this year's Documenta matches the capricious extravagance displayed a decade ago by the American artist Walter de Maria, who spent £¼ million of a Texas oil company's money drilling a hole in the Friedrichsplatz to a depth of a kilometre. The hole was then covered over, so that nothing remained but the concept – and a memory, in my mind at least, of unpalatable self-indulgence. It is a relief to realise that such outrageous expenditure forms no part of the relatively sober 1987 Documenta. As befits a period when art is no longer dominated by an overweening new movement, a fashionable style that stamps its identity on the historical moment when it appeared, the Kassel exhibition is content to recapitulate rather than announce an innovative revelation. But it is still valuable to stage an event as mammoth as this celebrated five-year round-up of contemporary developments. 'In the late '80s', announces Manfred Schneckenburger, the Artistic Director of *Documenta 8*, 'there are no new strategies, but rather new combinations', and he has attempted to concentrate on artists who move in their work 'from the individual to the social'.

At first, walking through the vast Museum Fridericianum which houses the largest single part of the survey, it seemed difficult to make sense of such a generalised declaration. So many artists are gathered here, spilling out from the main rooms on to landings and round lift-shafts, that I found myself wrenched continually from one disparate experience to the next. After a while, though, certain social concerns do stand out. At their most political, they receive hard-hitting expression in the work of Hans Haacke, who dominates the entrance hall with a piece ironically called *Continuity*. It turns out to be an uncompromising condemnation of Deutsche Bank's involvement, via Daimler-Benz AG, in the South African economy. The disturbing details are spelled out in gilded frames, and they flank a central installation containing, among other elements, a vast colour photograph of sixteen-year-old Zola Jantjies's funeral in 1985, where the coffin-bearers all raised their fists in silent yet eloquent protest.

Nothing else in the Fridericianum aims at a specific target with Haacke's cold-eyed clarity, but plenty of other artists share his sense of dissatisfaction and anger. The most polemical is Klaus Staeck, an admirer of John Heartfield. His photomontage posters are pasted all over a landing wall next to a counter where he sells his own postcards and illustrated

publications. Inside the galleries, Robert Longo gives vent to his disgust with military aggression in *Samurai Overdrive*, an obscenely violent green monster festooned with bullets, weapons, a smashed guitar and a breast that resembles a bomb. Science fiction, or a realistic assessment of the destructive urge? Longo does not say, but a partial answer is provided by Leon Golub. His stark trio of paintings includes an *Interrogation* scene where a black man is hanging from a beam, surrounded by figures who regard his suffering with wry and callous detachment. As for Anselm Kiefer, his immense canvas employs furrowed pigment to dramatise a ravaged German landscape not yet recovered from the traumatic aftermath of the Second World War.

Suburban anguish can be just as devastating for its victims as alarm over more global afflictions, and Eric Fischl investigates it with voyeuristic precision. In the affluent yet spiritually desolate American homes he explores, a woman in a wedding dress is discovered smoking, her hand clutching the leash of a dog who provides no comfort for the solitude she endures. Even the boy who, in another canvas, assumes a grinning cat's mask as a disguise, can be seen staring through the animal's mouth with a foreboding that borders on outright anxiety. Elsewhere, in a small yet potent room entitled *Archives, Leçons de Ténèbres*, Christian Boltanski continues the theme of childhood frustrations by ranging row upon row of family snapshots on racks, like a claustrophobic museum store-room where the past seems to have become tantalizingly out of reach.

By no means all the exhibits deal solely with anger and despair. Antony Gormley, one of the few British artists in this year's Documenta, shows a crouching man in lead lying helpless on the floor. But he is accompanied by a double figure, joined back-to-back and looking both ways, while the two people in another sculpture appear to affirm ecstatic physical union. The possibility of growth, allied this time to a harmonious relationship with nature, can be found in Giuseppe Penone's installation. Although many of the large earthenware pots assembled in his room contain nothing except soil, some of them sprout figures who merge with clusters of foliage as if impelled by a desire to transform themselves into the plant-life that supports them.

Natural materials are much in evidence at Kassel, nowhere more spectacularly than in Magdalena Jetelová's space. She fills a large part of it with an enormous sculpture made from tree-trunks, and the work's power derives to a significant extent from her willingness openly to declare the rough-cut, forest-heavy identity of the wood she employs. Jetelová's foursquare structure also resembles a primitive arch, through which visitors have to move in order to reach the next gallery. It exemplifies, in this

respect, another important aspect of the exhibition. For much of the sculpture, especially the outdoor work positioned in what the earnest Documenta press release so disarmingly describes as 'neuralgic points within the city', aspires towards the condition of architecture.

In the central Königsplatz, a busy radial point where tramlines intersect and the young linger, George Trakas has constructed a multi-part work replete with steps, ramps and bridges. To comprehend the installation, viewers must walk up, along and through it, noticing as they do so that Trakas (like Jetelová) favours a mighty length of wood rising from the concrete square like an errant tree. Ulrich Rückriem handles the architectural metaphor in a more paradoxical way. Even though his contribution is placed in a shabby parking-lot, far removed from the pristine whiteness of the museum context, he has built his own walls as an integral part of the sculpture. A huge lump of quarried stone guards the entrance to this strange arena, and an ordinary door leads to the 'courtyard' within. Here an even larger stone megalith sits, sliced in two places thinly enough to be glimpsed only as sudden flashes of light as we move past the boulder. Rückriem, not usually noted for his humour, seems to be wryly implying that sculpture needs a room of its own even when it strays outside the gallery's confines.

The architectural theme is carried over into the magnificent baroque Auepark, where a number of sculptors have made works specifically for its tree-lined avenues, lakes and open grassland. Thomas Schütte has taken the idea to an absurd conclusion, building an igloo-like shop of white stone where ice-cream will be sold below a Mario Merz quotation picked out in neon. Then, in the middle of an expansive lawn, Scott Burton turns sculpture into furniture by installing a circular stone 'ottoman' where fatigued Documenta visitors quickly filled up a lot of the available seats. But the most memorable of all the parkland works adopted a tougher stance. At the entrance to a formal tree-lined walkway, Ian Hamilton Finlay has placed *A View to the Temple* – four wooden guillotines standing in a row with the sinister correctitude of sentinels on the alert. The blades grow thinner and sharper as the sequence proceeds, and the inscriptions they bear are equally chilling. 'Terror is the piety of the revolution' declare the words incised so elegantly on the final blade, spelling out their maker's commitment to an art impelled 'by some grand moral idea'. Finlay may be one of the oldest contributors to Documenta 8, but the uncompromising precision and rigour of his work ensured that it can be counted among the most powerful images in this encyclopaedic event.

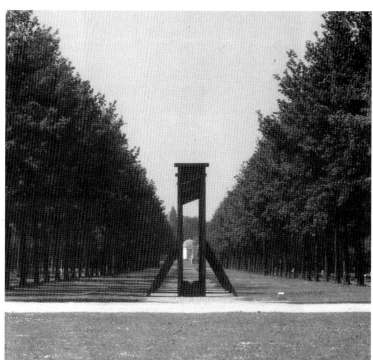

44. Ian Hamilton Finlay, *A View to the Temple* at Documenta, 1987

ART AS VESSEL

17 September 1987

Bravely defying what he calls the 'spurious distinctions between the fine arts and the crafts', Anthony Stokes brings these separate worlds together in a stimulating show at the Serpentine Gallery. The theme that unites them is 'Vessel' – a natural enough choice when considering ceramicists like Lucy Rie or Alison Britton, but less obvious when the work of a disparate array of sculptors is shown alongside them. Is a preoccupation

with vessels really to be found in sculpture today? The answer, rather surprisingly, is yes, but only if the word is interpreted in its widest possible sense. For Stokes has trawled an exceptionally large net through the ocean of contemporary art, and the catch assembled here embraces everything from the mundane to the exalted.

At the most functional level, four buckets half-filled with water are displayed on a wooden platform by Michael Craig-Martin. Suspended in the air by ropes tied to the ceiling, these workaday objects are presented without camouflage in all their shining banality. Other artists, however, cannot resist interfering with the ordinary containers they employ. Richard Wentworth joins three tin baths together in a single undulating form, and places a hard metal surface where the water-level might normally be expected to rest. As for Bill Woodrow, he attacks a trio of old soup containers with his customary trenchancy, fashioning from their twisted sides some large spoons smeared with brown stains. The violation of his ready-made material is matched by a sense of degrading privation, and in Tony Cragg's hands this disquiet takes the form of outright spillage. He places a tipped-over vessel on the floor, as a provocative obstacle impeding visitors' movements from one gallery to the next. A sinister ooze of solidified silver liquid spreads from the neck of Cragg's sculpture, defiling its surroundings with a polluting substance that looks ominously difficult to disperse.

A macabre strain is detectable in several other sculptures as well, suggesting a shared feeling that vessel symbolism in the late twentieth century is bound to be accompanied by intimations of vulnerability and defilement. Bob Law, displaying one of the smallest works in the show, places a green heart in a coffin. And Stephen Cox besmirches all four of his huge carvings of a mouth, ears, eyes and nose with a deposit of black oil. There is no escape from this unease, even when artists deal explicitly with the past rather than the present. Edward Allington places two mass-reproduced busts of Apollo on a plinth, and their gaze is directed towards a little urn hung on the wall behind like a discreet yet obstinate *memento mori*. Ian Hamilton Finlay uses gruesome humour in his quirky contribution, a row of three harmless teapots crowned by miniature models of guillotines. On the sides of these bizarre objects, a deceptively elegant inscription explains that 'there are two aspects to the French Revolution, the epic and the domestic – the guillotine and the teapot'. What kind of lethal nectar would be served in such militant receptacles, I wonder?

Not all the sculptural exhibits are marked by the shadows of violence and frailty. The small wooden vessel which Alison Wilding hangs high on a wall is stuffed with nothing more aggressive than a length of cloth.

45. Richard Wentworth with exhibit in *The Vessel*, Serpentine Gallery, London, 1987

Barry Flanagan is even more blithe, presenting a mythological creature with a head-dress of horns and cactus forms leaning over a tall vase with contemplative serenity. The title incised on this bronze, *Mid Summer Song*, reinforces the mood of sensuous reverie, even if the emptiness of the vessel suggests that a seasonal drought might be preventing the animal from slaking his thirst.

Flanagan's other exhibits, a collection of wriggly objects freely modelled in clay, are laid out on glass tops supported by geometric wooden bases. The table-like ensembles appear to propose that sculpture aspires to the condition of furniture, and in another room Bruce McLean takes this idea to a flamboyant conclusion. Beside a huge metal fireplace

festooned with the outlines of an exclamatory face and hand, the irrepressible Glaswegian has placed a towering yellow jug. It bears the contours of a female nude, and on the other side of the fireplace a colossal head with Modigliani features rears up slyly from the hearth. As in so much of his work, McLean satirises the fashion-conscious life-style that might be enacted in front of such a set-piece. But he relishes making it at the same time, so we cannot tell where impish social comment ends and exuberant inventiveness begins.

Anish Kapoor, whose mighty stone monolith with a deep blue interior resembles an ancient throne, also shows leanings towards furniture. And the most explicit manifestation of the tendency belongs to André Dubreuil, whose extravagantly looping chairs dare the visitor to test them out. It would be inaccurate, though, to imply that the entire exhibition is filled with uninhibited gesturing. The virtues of reticence are embodied in many of the ceramicists' contributions – most notably the quietist Lucy Rie, whose six bottles and bowls are restricted to off-white and pale pink as they assert their delicate, subtly beguiling authority. Janice Tchalenko understands the strength of understatement, too. Her five dark pots streaked with reds, yellows and blues cluster tightly together on a reflective black base, sumptuous and yet wisely restrained. Even Alison Britton knows how to bridle her Pollockesque exhilaration, splattering freely gestured strokes and spots of colour on compact vessels with their hints of anthropomorphism kept firmly under control. I much preferred her disciplined vivacity to the brashness of Simon Moore, whose garish glass candlesticks sprout jagged teeth in a seemingly deliberate attempt to affront.

Even so, the most self-effacing work on view in this category-breaking show is made, not by a ceramicist or a sculptor, but a painter. Peter Kinley, straying outside the confines of his easel, has made a small bronze turtle and placed it in a pool set into the gallery floor. Ideal as a garden sculpture, it looks supremely content hiding away from the gallery world beneath a protective layer of water.

NY ART NOW
24 September 1987

After a lengthy period when New York seemed to have lost its ability to spawn young artists of major significance, cries of an exciting new generation are once again reverberating across the Atlantic. This time, the focus is on the city's East Village, and the group of artists who have emerged from its galleries already find themselves labelled like an instant movement. Neo-Geo is perhaps the most catchy of the titles bestowed on them, and Neo-Conceptualism by a long way the dullest. But I prefer the term Smart Art, for the diverse work they produce is characterised by slickness, a knowing attitude towards the marketing of art and a love of quoting from earlier twentieth-century images in a sly, self-consciously clever manner. Since so much of the work goes all out for instantaneous impact, and is packaged with a glossy professionalism worthy of the smoothest advertising agency, it seems appropriate that the Saatchi Collection has purchased Smart Art in bulk. Their blindingly white gallery in Boundary Road provides a streamlined venue for an exhibition called *NY Art Now*, where nine representatives of this brash development are given ample space to show off their stylishness.

Duchamp is one of the presiding spirits here, and his most jaunty disciple is Jeff Koons. Like Tony Cragg and Bill Woodrow, he relies very heavily on ready-made objects; but unlike his British counterparts, Koons does not interfere with the Hoovers and basketballs he incorporates in his sculpture. With blithe insouciance, he simply installs these state-of-the-art household cleaners in immaculate plexiglass containers. There they stand or hang, often resting on tubes of fluorescent light which recall Dan Flavin's minimalist sculpture from the 1960s. The purism of Flavin has been besmirched by these implements, with names like *Celebrity IV*, *New Shelton 5 Gallon Wet/Dry* and *Quickbroom*. But they fail to sustain anything more than a passing interest, and the only Koons to hold my attention were the basketballs suspended in see-through tanks of water. The distortions to which they are subjected proved unsettling and mysterious as my eyes travelled round these swollen, flattened or elongated icons of American sporting life.

Robert Gober is another unashamed Duchampian, for his enlarged white sinks are directly reminiscent of the seminal *Urinal/Fountain* of 1917. Cumbersome and deliberately crude in scale, design and texture, they take on a wry anthropomorphic humour after a while. What at first seems nothing more than heavy-handed Duchampian idolatry becomes,

46. Jeff Koons, *Vest with Aqualung*, 1985

in the end, a reflection of Gober's changing moods and perception of himself. In *Partially Buried Sink* the great slab of white cast iron has half-descended into a bed of grass, like a tombstone doomed to be swallowed up by a marshy cemetery. And in *Two Bent Sinks*, these massive forms are merged to produce a vagina-like aperture, heavy with sexual ambiguity.

The inspiration of Duchamp's large glass looms in several of the huge linen works carried out by Tim Rollins and the 'kids' he teaches. Using

gold water-colour and charcoal on a ground of pages from Kafka's *Amerika*, this collaborative group makes clangorous images which do at least manage to escape from ingrown concerns and address themselves to the world beyond. *Red Alice (South Bronx)* is suffused with a matt and almost rust-coloured acrylic, suggestive of dried blood and intended, according to Rollins, to recall 'every book, every newspaper article about girls being murdered, abused, tortured or raped'.

References to the countryside are hard to find in this urban art, so the fragment of driftwood included in Haim Steinbach's *Country Weave* comes as a surprise. But only for a moment. Steinbach places it next to some straw baskets on a formica ledge which, like Koons's white tubes, casts a glance back to minimalist sculpture. In other words, the driftwood is treated only as an isolated souvenir, removed from its original context and preciously displayed like a collector's item in a chic New York apartment. Elsewhere in his section Steinbach delights in juxtaposing objects as disparate as some Nike sneakers and a row of brass candlesticks. The couplings seemed arbitrary and whimsical rather than in any way profound, and throughout the exhibition I felt disappointed by the amount of art-about-art playfulness.

Ashley Bickerton appeared, at times, to be dealing with serious and even tragic themes. His *Abstract Painting for People 4 (Bad)* contains references to cancer, swastikas, skulls, syphilis and nuclear warheads. But they are handled in a flip designer-graphics idiom which divorces them from all sign of engagement or emotion. The ills of the world seem, in his work, no more important than the logos for Alcoa, Liquitex and other firms festooning a plywood structure like the ultimate example of a commercially sponsored art object. Although some kind of comment on market values is presumably intended, it seems too childish to achieve a trenchant aim. A similar weakness vitiates the projecting canvases by Meyer Vaisman, who places rubber nipples, building blocks and backwards-running clocks on the surface of inked slabs saluting Mondrian, Newman and even Klee.

Judging by the amount of work displayed by Philip Taaffe, he is the artist regarded most highly by the Saatchis. He is also, however, the most irritating in his insistence on playing tricks with quotations from artists of the past. Everything he touches here contains overt references to other painters. Often using linoprint collage with acrylic, Taaffe produces eye-bending exercises in an optical style derived from Bridget Riley's mono-chrome period. The handmade appearance of his images is perhaps meant to counter the impersonal finish of Riley's originals, just as he interrupts a painting appropriated from Ellsworth Kelly with a heretical stripe. But

the *frisson* created by such invasions is both paltry and fleeting, just as Ross Bleckner causes only a momentary jolt by placing a cute gift-wrap bow in a painting otherwise filled with vertical coloured stripes.

After a while, I longed for an artist who did not need to rely so heavily on reacting to Vasarely, Judd, Ryman or whoever else is subverted, negated and saluted in this tiresome survey. The strategies deployed here may have succeeded in establishing their makers as the hottest property in town, but most of them will quickly look as dated as last year's department-store fashions. On my way out, Peter Halley's garish day-glo abstractions, with their diagrammatic suggestions of prisons, summed up all my misgivings about a show where so many exhibitors are trapped inside their endless obsession with stylistic games. Someone ought to open the gaol door, and encourage them to explore life outside the claustrophobic art-world cell.

SHIRAZEH HOUSHIARY
15 October 1987

Sturdily made of resonant brass, mottled copper or gleaming zinc, Shirazeh Houshiary's latest work is not afraid of large volumes and expansive flourishes. The curving of majestic wings dominates her imagery, and it invests the sculpture with a rounded, organic palpability. There is something very graspable about the plump, gourd-like forms swelling out of *The Earth is an Angel*, a flamboyant object which seems almost to grow as we contemplate its heaving bulbous masses.

After a while, though, this sense of fructifying abundance relinquishes its hold. It is replaced by the realization that Houshiary employs sculptural substance in order, paradoxically, to point towards an incorporeal dimension of meaning. Her works may rest on the floor, and often take up a considerable amount of space, but they do not treat the ground as a resting-place. They touch it only in part, like divers using springboards to project them into a less earthbound existence. Houshiary's forms are constantly coiling away from the floor in search of an unconstrained region. The wing shapes in *The Earth is an Angel* rise up until they are free to wave their tips at each other, clearly rejoicing in their ability to move through the air. Even the biggest work in her impressive Lisson Gallery exhibition, *Beating of her Wings*, ascends through a sequence of

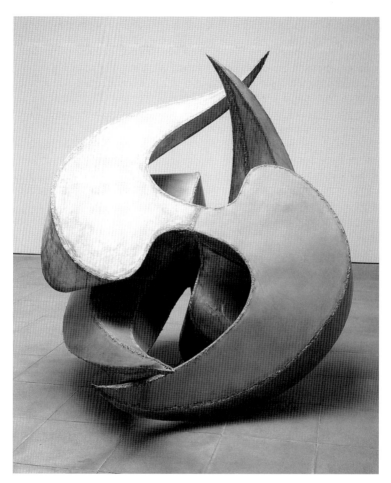

47. Shirazeh Houshiary, *The Earth is an Angel*, 1987

grand waves and loops towards a climax where two crescent-like forms touch at the highest point of the sculpture in an ecstatic union.

This desire to move away from an assertion of materiality alone, and intimate the importance of a spiritual realm, links Houshiary's work with the concerns of Anish Kapoor. While he has defined his identity as a sculptor by drawing on the heritage of his native India, she finds plentiful stimulus in the art and thought of Persia. Although Houshiary came

to London at the age of eight, she is still inspired by the culture she left behind in Shiraz. Many of her current preoccupations stem from the book of Zoroaster, where the angel of earth brings about a miraculous regeneration after the death of Gayomart, the primordial man. Gathering the gold from his body and burying it in the soil, the angel manages to nurture the growth of a man/woman. Hence the emphasis in Houshiary's sculpture on transcending mortal limitations. While she has no desire to illustrate Zoroaster's text in a literal manner, it feeds her imagination just as richly as the Persian legend which provided the starting-point for the clay and straw images shown in 1982 under the collective title *Listen to the Tale of the Reed*.

Then as now, the source-material was handled so broadly that her work did not become closed to anyone unversed in Persian literature's symbolic meanings. The comparison reveals, however, the extent to which she has in recent years developed a language less reliant on overt reference to creatures, totems, altars, sentinels and other representatives of a prehistoric world. Nothing displayed in the current show can be pinned down to such a clear representational role. Just as Houshiary has left the primeval materials of straw and clay far behind, so she relies no longer on the figurative allusions which still pervaded her erotic sequence of *L'Invitation au Voyage* sculptures in 1983. With the decision to employ metals, often contrasted in a single work so that the relationship between light and dark is explored, she has committed herself to a more ambiguous use of imagery. Even the wing shapes escape definitive classification, and they are the only references that can now be identified with any confidence.

Most of the time Houshiary inclines towards a more ethereal realm, especially in a trio of independent yet interrelated small sculptures called *Fire*, *The Angel of Thought* and *Shadow*. As their titles indicate, she wants to make tactile form manifest the power of invisible forces. One of these works curves up from the floor and then folds inwards, like a plant hiding from the light. But the principal focus of the piece is provided by the two arms which ascend high in the air. Reminiscent of antennae, they seem eager to make themselves receptive to potent signals from elements we cannot see.

The idea of turning sculpture into a vehicle for such elusive ends is, of course, audacious. How can an activity so dependent on the assertion of three-dimensional matter guide the viewer towards immateriality? One answer is provided by *Breath*, a low-lying work which twists both brass and copper into a flowing ellipse. Although its arms are solid enough, they seem to run past our gaze and evade any robust affirma-

tion of their own graspable substance. Rather than confronting us with incontrovertible physicality, they slip and glide in their determination to confound stasis and move towards a more fluid alternative. As we walk round *Breath*, discovering that it never comes to rest and thereby denies any possibility of a fixed viewing-point, the prevalence of rhythm is established above everything else. The entire work expands and contracts like breathing itself, and this constant interplay between outwards and inwards leads us to the very centre of Houshiary's concerns.

Sculpture, for her, answers 'a need for an intermediate world which connects one with the other', the 'heavenly and the earthly'. It is a complex aim, especially for an artist who rejoices so much in the sensuous appeal of the natural world and remains intent on retaining its beguiling presence in the objects she produces. Sometimes the largest works seem too bulky to let her admit as much of the 'heavenly' as she would wish. But elaboration and the grand scale impede her only occasionally. One of the biggest pieces, *Between Earth and Sky*, fills most of a room with its lazily spreading forms, and yet the result is the very opposite of cumbersome or oppressive. Supported by snakelike forms that undulate half-hidden beneath them, two enormous 'leaves' of flecked green copper extend towards each other from the far corners of the gallery. The expectancy they create is compelling. Suspended between the two levels of reality Houshiary wants to bridge, they hang in space and engender an overall mood of gentle, open serenity. They appear to be offering themselves, relishing their life and yet ready for the moment when their solidity gives way to the dissolution which ultimately confronts us all.

THE SHORTCOMINGS OF THE TURNER PRIZE
3 December 1987

Now that the 1987 Turner Prize cheque for £10,000 has been collected by the richly deserving Richard Deacon, it is possible to discuss the whole event without feverish speculation about the winner's identity. The exhibition devoted to the six-person shortlist continues at the Tate until 13 December, and it raises plenty of questions about the purpose of such an award. There is nothing wrong, in principle, with giving a prize for 'an outstanding contribution to art in Britain' – a much better formulation than the previous Turner Prizes, which were for 'the greatest

contribution to art in Britain'. If it benefits an artist of merit, and gains a wider audience for contemporary work, the idea should be applauded. After all, Turner thought well enough of prizes to instigate one himself, even if his good intentions (as in so many other matters) were never implemented. But does the award named after him, and instituted three years ago with considerable media attention, really arouse worthwhile interest in the art of our own time?

The problem with the Turner Prize is bound up with its identity as a race. Announcing a shortlist is tantamount to setting up five unlucky candidates as fall-guys for the eventual winner. The problem is exacerbated by the difficulty of arriving at a choice which does not seem arbitrary. With the Booker Prize, attention is focused on a specific novel by each contender, newly published and clearly assessable. The yardstick for the Turner Prize is altogether more generalized: without a particular work to focus on, many people wonder how the six names on the shortlist have been arrived at in any given year. Brief reasons are given in the catalogue, but in some cases they only compound the confusion. Patrick Caulfield, who has been painting distinguished pictures for well over twenty years and held a much-admired Tate retrospective in 1981, is included for selecting a show of Old Masters at the National Gallery. Why should he have been chosen for that event, rather than for an exhibition of his own work? We do not know, and a similar mystery surrounds two of the other candidates. Thérèse Oulton, justly praised by the Turner jury for her 'fresh contribution to the tradition of oil painting', first excited widespread attention with her *Fools' Gold* exhibition three years ago. It would have been more timely to single her out then, and the reason for Declan McGonagle's presence on the 1987 shortlist is equally unclear. He has been running the Orchard Gallery in Derry with great flair since 1978. The best moment to single him out would have been in 1984, when he left (temporarily, as it turned out) to become Exhibitions Director at the ICA. Why is 1987 his special year?

The other three contestants have, by contrast, enjoyed special attention within the last twelve months. Helen Chadwick's *Of Mutability*, a sensual yet poignant meditation on transience, was a highlight of the ICA's 1986 season. Richard Long's retrospective at the Guggenheim Museum in New York crowned a career which began, with precocious confidence, over twenty years ago. Since the show was a high point in the work of a poetic and single-minded artist, who has done so much to transform our ideas about sculpture's relationship with the land, it makes absolute sense to find him on the shortlist. As for Richard Deacon, his touring show *For Those Who Have Eyes* confirmed his status as an out-

standing young sculptor, flamboyant and yet incisively disciplined. His increasingly assured and multi-layered images are among the finest examples of the much-admired new British sculpture of the 1980s, and the jury made an excellent choice in giving him the prize.

The Tate argues that 'we aim to draw public attention to all those whom we shortlist: this matters as much as winning the prize itself'. I welcome the aim, but the exhibition mounted at the gallery appears a disappointingly half-hearted affair. Artists need a generous amount of space in order to establish themselves with the identity they deserve. Here, only Long has been given room which lets his work breathe a little, most notably in an expansive circular floor-piece which dominates the show. Caulfield, Oulton and Deacon have been allowed two works each, while Chadwick is confined to a single exhibit. McGonagle's activities are documented in a rather indigestible way, too: surely it would have been better to mount an audio-visual display which brought the Orchard Gallery to life, and permitted him to explain how he has established it as an international centre for modern art? Such an installation

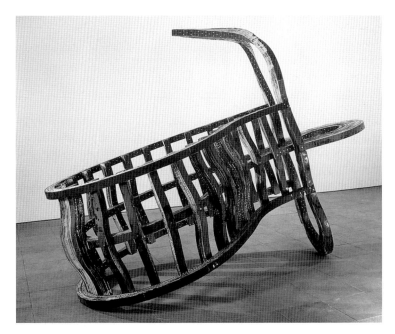

48. Richard Deacon, *Fish Out of Water*, 1986–7

would cost more, of course, but the Tate ought to be prepared to make the Turner Prize exhibition a more meaningful and substantial occasion.

If it wants convincingly to fulfil its desire 'to increase public interest in contemporary art', the gallery should have allotted a great deal more space to all the artists involved. Only then would the visitor be able to encounter their work at full stretch, and treat the exhibition as a major occasion rather than a side-show. Perhaps acknowledging that more could be done, the catalogue of the present offering reveals that 'we hope in future to be able to offer the winner a small exhibition at the Tate Gallery in the summer after the award has been made'. The word 'small' still sounds rather half-hearted, however. If the public is to be given the chance to understand why the prizewinner's work is so significant, he should be granted a substantial show – and as soon after the presentation as possible, before memories of the 1987 award grow cold. The Tate could make the Turner Prize a valuable means of enhancing visitors' appreciation and enjoyment of modern art. But the whole exercise needs to be carried out on a grander scale, so that the Tate's own belief in the prize is manifested with overwhelming conviction in the rooms of the gallery itself.

JOHN VIRTUE

28 January 1988

Working in self-imposed isolation, and with single-minded commitment, John Virtue has dedicated himself to the landscape around Green Haworth for the past decade. The village itself is little more than a scatter of houses on the edge of the Pennine moorland. But the country around it is epic in scale, and on his persistent walks Virtue was able to scrutinise a constantly changing locale. On the hill where he lived until last December, clusters of trees across the road from his house are protected by the hollow they inhabit. Up on the top, by contrast, the flatness of terrain situated 800 feet above sea level exposes everything in sight to the bleak Lancashire climate.

The harshness of this lonely setting receives direct expression in the art Virtue produced there. During his incessant explorations of Green Haworth, he would stop at innumerable points and carry out rapid, terse studies of the spartan world around him. These staccato marks in pencil

or charcoal were then worked on back in the studio, where he wielded a whole range of pen-nibs and scored the paper with resolute yet supple ink cross-hatching. The dense network of intercutting lines builds up a textural richness closer in its overall effect to painting than drawing. Thickened with shellac, and more recently animated by splashes of white gouache, Virtue's chosen medium clearly provides him with the expressive resources he needs. But it is restricted in comparison with the materials many other artists employ, and it parallels his determination to concentrate exclusively on the land he knows best.

A Lancastrian by birth, Virtue has been familiar since childhood with the gaunt structure of the country in the Green Haworth vicinity. It is an environment to which he was anxious to return after studying at the Slade, and its remoteness suited an artist who feels divorced from the concerns of his contemporaries. During a decade dominated by the revival of figurative painting with an expressionist bias, he has pursued a path far removed from fashionably agitated ways of working. Shunning rhetoric and illustration alike, he prefers an austere art undiluted by anything which threatens to impede his search for the essence of experience. To that end, he discards all references to the people who live in Green Haworth, and along with them the objects associated with their lives. No figures can be detected in Virtue's work. The village is deserted, and vehicles do not punctuate its empty roads. Only the houses signify a human presence; but they look so marooned in the moorland bareness that it is easy to imagine their occupants as defensive beings, unwilling to stray beyond the protective limits of home. Virtue is fascinated by solitude, and some years ago he produced a work entitled *126 Studies of the Fever Hospital at night*. It centred on one of the most lonely buildings in the area, erected during the Victorian period as an isolation unit for infectious diseases. Stranded some distance from the village, the hospital's image exemplifies Virtue's instinctive feeling for well-worn structures long since rooted in the primordial land which supports them.

All the same, there is nothing predictable or reassuring about the vision presented in his one-man show at the Lisson Gallery. Even as he strives for a rigorous summary of the Green Haworth locality, Virtue is almost painfully alive to the complexity of perception. A single view, which implied that every alternative had for the moment been ruled out, is anathema to him. He only discovered his singularity as an artist after taking the decision, startling at the time, to assemble a number of different drawings within a single frame. The same procedure has been adhered to ever since, but not in a dogmatic manner. Each group of images requires, in his view, a distinct approach, and he takes a long time

49. John Virtue, *Landscape No. 80*, 1988

to feel his way towards the combination which eventually feels inevitable and right.

Sometimes an awesome quantity of units is massed together, amounting to a vast assertion of his belief that the experience of a landscape cannot be reduced to one corner of it. Less frequently, he reduces the components and increases their individual sizes, so that as few as four images are grouped together in the grid formation Virtue always favours.

Whatever the permutations involved in a particular work, though, he ensures that the assembled elements frustrate any narrative reading we might seek to impose. No obvious connection binds one image to the next. Our eyes are wrenched as they move across the surface of Virtue's demanding pictures. He insists that we confront the overwhelming wealth of perceptual possibilities presented by an area as we travel through it. Refusing to conform to the traditional role of the landscapist as a static observer, he stresses instead the imperatives of an artist forever on the move.

However baffled we may at first feel, Virtue's work soon begins to impose its peculiar logic on the spectator. After all, our own memories of a place are invariably as multi-faceted as his pictures. We do not, on the whole, content ourselves with one steady stare: our curiosity leads us to dart over a scene, and Virtue's art amounts to a tacit admission of this restlessness. It is a risky strategy to adopt, for indigestible confusion could easily be the outcome. And there are times when his images offer a daunting excess of forms, which bombard us with their burgeoning variety of vantages. On the whole, though, he avoids the dangers of daunting prolixity. Each view is so sharply etched, and built up with such an unerring grasp of fundamental structure, that Virtue achieves monumental repose even in the midst of all these proliferating units. The subtlety with which he marshals the different sheets into their final order is also a crucial factor. Their aggregate seems to have been determined according to a natural process rather than a calculating system. His work possesses real organic conviction, and after a while takes on an inevitability of its own.

Although it is at heart a Nordic vision, insisting on the chiselled austerity of an exposed and elemental region, considerable sensuousness can be found here as well. Without forcing a sublime mood in any way, Virtue's finest work attains a resonant grandeur that reveals the strength of emotion beneath the taut formal discipline. Imposing, penumbral and utterly devoted to an obsessive way of seeing, his work enlarges our awareness of the inexhaustible mystery underlying a world we think we know but do not really see.

THÉRÈSE OULTON
4 February 1988

At first glance, Thérèse Oulton's new paintings appear to present hard, rock-like surfaces which assert the textural density of pigment at every turn. Our eyes find themselves confronted by the solidity and ruggedness of a cliff-face, tauter by far than the work that established her reputation in the *Fool's Gold* exhibition four years ago. The sense of space there was often boundless, and much of the drama arose from the spectacle created by skeins of paint flung into a void. Now, by contrast, everything initially seems to have rigidified – as if Oulton wanted to impose a stern discipline and curb the romantic excess of her younger self.

In doing so, she runs the risk of losing the exalted and often sublime mood which used to permeate her pictures. A passage from Robert Musil's *The Man Without Qualities* prefaces the catalogue of her latest show at Marlborough Fine Art, and it ends with the words: 'By then it has lost its wings and taken on an unmysterious solidity.' A similar danger hangs over her own paintings, and at times she does not avoid it. *Pearl One*, for instance, looks burdened by the tight layering of pigment built up on the canvas. Oulton appears so set on countering illusionism by stressing the physical substance of her materials that she manages, on occasion, to curtail her imagination too severely.

Even so, the most impressive pictures escape from this dour constriction. The more we examine them, the more their seeming tightness leads on to reveal rich layers of meaning. Just when we have decided that the new Oultons emphasise flatness at the expense of the dreamlike vistas she used to explore, the mass of crinkled paint in *Counterfoil* gives way at the top to a more atmospheric passage. Redolent of a misty sky, it encourages us to see the entire image more clearly, in terms of a mountainous landscape. But it resembles a region of the mind more than a terrain Oulton might have visited. At the base of the composition a pair of shallow steps emerges from the paint-deposits, suggesting the artifice of stage scenery. The entire picture begins to look like an arena where momentous events might occur, and in *Descant* the wall of pigment taking up most of the design begins to shift. Partially pulled aside like a gigantic curtain, it discloses a smokier and far more shadowy area behind. The looseness with which this almost nebulous region is handled contrasts absolutely with the craggy folds of the 'curtain'. Oulton has set up a deliberate opposition here, disturbing the majestic steadiness of canvases like *Counterfoil*. A sense of unease is introduced, and *In Fidelity*

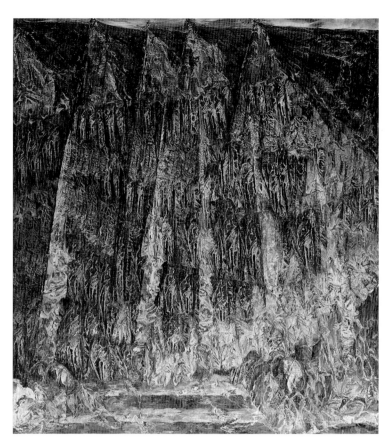

50. Thérèse Oulton, *Counterfoil*, 1987

increases this rupture by letting a buckled pair of 'curtains' dominate the composition. They run through the picture like a seismic fault, pointing to a sense of insecurity far removed from the apparent impregnability reigning elsewhere.

All the same, even the most wrenched of these canvases is firmer than the earliest exhibit on view here. Called *Countenance*, it revels in a tempest of mark-making which proves how concerned Oulton has since become to stiffen her current work with structural rigour. She seems to be searching for a way of placing turbulent emotion within a more controlled framework, and in *Second Subject* it takes a surprisingly sumptuous

form. Burnished by colours which evoke the flaring splendour of autumn, the blocks of furrowed paint ascend from a reflective passage resembling water at the base of the picture. They fan outwards, with a sonorous expansiveness that calls to mind a sequence of grand symphonic chords. 'I am switching to the realm of music,' wrote Klee in another quotation Oulton has included in her catalogue. He discusses the idea of 'a structural net, on which musical ideas are quantitatively and qualitatively played out', and goes on to declare that 'the function of a pictorial work is the manner in which it betrays to the eye its structure-in-time'. Oulton, who studied music with eager dedication as a child, is clearly excited by the relationship between painting and her former passion. Just as Pater would have wished, these pictures aspire towards the condition of music, and she often seems to regard her work as a series of variations on a theme. *Counterfoil* is like an inverted restatement of *Second Subject*, albeit replacing water with stone and exploring a different chromatic range throughout.

Above all, though, Oulton appears to be concerned with landscape references as metaphors for her own states of mind. Despite the manifold links binding her images, indicating that one grows out of its predecessor with organic consistency, a broad range of emotions is explored in her work. *Double Back* is hard and aggressive, filled with suggestions of a bunched fist, whereas *Descant* dramatises the transition between defensiveness and disclosure as the sturdy 'curtain' is replaced by a troubling emptiness.

Among the most memorable paintings is a large canvas occupied, for the most part, by a cliff-like expanse of sombre pigment. Encrusted and almost petrified, the picture's predominantly grey-brown surface is alleviated, here and there, by slivers of yellow and pale green. They imply that something might be growing among the bareness, and these hints of vegetation follow the same path as two streams of white dropping from one ridge to the next. Inescapably reminiscent of rivulets splashing their way down a mountainside, they irrigate a painting otherwise notable for its parched austerity. They also introduce a melancholy mood, and Oulton confirms the note of sadness by calling the picture *Lachrimae*. She adopted the name as the title for the entire exhibition, thereby emphasizing the elegiac strain in her temperament. But the painting itself is restrained in its exploration of pathos. The 'water' is little more than a trickle, controlled by an artist who remains set on preventing herself from indulging in the emotional outpourings that used to flourish in her work.

THE VENICE BIENNALE 1988

7 July 1988

Half-encased in a coffin-like block, Marisol's sculpture of Picasso gazes mournfully out at the national pavilions displaying their assorted offerings at the 43rd Venice Biennale. What, I wonder, would the old painter make of this encyclopaedic event if he were released from the block and allowed to roam around here?

He might well have felt dismayed by the vacuity of so many contributions to the 1988 instalment of this venerable art jamboree. They appear to have been affected by the boneheadedness of the official theme, 'Quality and Actuality', which is supposed to unite all the participants. Walking through the Giardini di Castello, where each country shows off its chosen contenders, I was dispirited to realise how widespread the feebleness really was. At the French pavilion, which could once have been relied on to set a formidable standard, Claude Viallat presents a series of garish, stultifying patterns. They amounted to little more than décor, while at the West German pavilion across the way Felix Droese provides an equally numbing experience. He calls it the *House of Weaponlessness*, and seems dedicated to disarmament in many of his headlong pronouncements. The work itself, however, consists of crude paper cut-outs and sprawling wooden installations which convey little of such beliefs. Nor does the catalogue provide a way in to Droese's art. Dierk Stemmler has written an unintentionally hilarious essay which begins: 'For Felix Droese there is no figurative material that he is incapable of adopting, into which he is incapable of spiritually penetrating and which he is incapable of using for the artistic quests of great breadth which he undertakes: "Where are we, we men, today, in this anthropological moment?"'

The answer, according to the East German pavilion, is a hell of unrelieved *angst*. Although a number of painters are exhibiting here, and their styles vary from Neue Sachlichkeit revivalism to expressionist wildness, they all seem to be haunted by a remorseless depression. But at least the East Germans are coherent in their harshness. Over in the Greek pavilion, Nikos is given free rein, buttressed by the critical claim that 'his work takes form as the extreme appropriation of the object to the point of its dematerialisation, and as the total investment of autonomous, physical expressivity of gesture'. Not surprisingly, in view of this gobbledegook, total mayhem appeared to dominate Nikos's section. One exhibit looked as if the artist had gathered together all his stray works from the past few

years and dumped them, pell-mell, in the corner as a 'major installation'. I only hope Nikos has not been given as many public commissions as Poul Gernes, whose work at the Danish pavilion overcame formidable opposition to win my prize for the most excruciating contribution to the '88 Biennale. After reeling through his strident images, many of which are made from alcyd enamel on masonite, I was even more disheartened to learn from a prominent placard that 'among Poul Gernes' most significant contributions . . . are his monumental decorations – more than 50 works, spread all over Denmark'.

Not all the pavilions provide such distressing experiences. The Australians, Biennale newcomers who only finished building their smart white structure at the last moment, present a confident display of outspoken epic-scale mythological paintings by one of their most robust artists, Arthur Boyd. As for the Russians, they are celebrating *Glasnost* with a retrospective of the little-known Aristarch Lentulov. Until recently, he would have been frowned on in the USSR, as a painter who succumbed to the decadent influence of the Western avant-garde. But now that Delaunay and Kandinsky are no longer dismissed in Moscow, Lentulov's achievement is at last officially acknowledged. An eclectic yet pleasing artist, who died in 1943 at the age of sixty-one, he was profoundly indebted to the Cubists and Futurists – some of whom he met during well-timed visits to Paris and Italy. A large, exuberant painting of 1914, called *A Victorious Battle*, sums up the almost nursery-rhyme blitheness with which the Russian cavalry charged off to the First World War. It was, for them, a huge adventure; and Lentulov clearly shared their naïve belief in the Russian army's proud invincibility.

Although the large main pavilion this year is devoted to Italian art, its most memorable sections are occupied by artists from other countries who have links with Italy. Leaving aside Niki de Saint-Phalle's gaudy hydra-headed monster sculpture, the rooms by Sol LeWitt, Markus Lüpertz and especially Cy Twombly testify to the stimulus which an Italian life can afford. Twombly's watery, green-and-white installation owes more to Monet than anyone else, but the fact remains that he has spent much of his long and fruitful career in Rome. His handling of paint is consummate, too, offering a welcome corrective to the clumsiness of so many younger neo-expressionist artists who gained such inflated reputations in the early 1980s. Leading members of that generation are given generous spaces in the Italian section, and they seem to have arrived at an awkward stage in their formerly meteoric progress. Sandro Chia is particularly lacking in his former verve, while Enzo Cucchi's dark, varnished iron and resin pieces are enigmatically in search

of a fresh direction. The irrepressible Francesco Clemente, whose sexually ambiguous figures are shown enclosed in urns, seems more certain of his own identity as an artist. But Mimmo Paladino has struck out on a quite different path with his double row of carved figures, blanched and hieratic like statues unearthed from a prehistoric tomb.

Susana Solano, whose work impressed me at the Spanish pavilion, looks far more sure of the path she wants to pursue. Made of iron, to which gravel or marble slabs are sometimes added, her stern sculptures are obsessed by a sense of paralysis and imprisonment. Grim and often cage-like, offering little hope of escape from this oppressive condition, her work has defined its singular territory with forbidding assurance.

Jasper Johns is such a celebrated artist that his American pavilion show might seem, on the face of it, a rather predictable event. But the truth is that Johns has exhibited little in Europe over the past decade, and his work is undergoing a remarkable change. Although the progression appears to be away from the abstract and towards the figurative, it is by no means so simple. For one thing, the earlier work from the 1970s is inspired by dance themes, or Munch's painting *Between the Clock and the Bed*. And for another, the death-haunted series of recent 'season' pictures are still informed by a rigorous formal discipline – despite the inclusion of more recognizable human references.

The principal excitement of the Biennale, though, is provided by a British artist. At the risk of sounding chauvinistic, I believe that Tony Cragg's sculpture adds up to the most memorable pavilion this year. He has handled each room with great judgement and aplomb – playing monumental works off against lighter companions, juxtaposing massive simplicity with deft complexity, and employing a continually refreshing range of materials. One wall-work, *Policeman*, is made from the plastic found-objects which first established Cragg's reputation a decade ago. But in recent years he has made himself more responsible for the shaping of the work. Bottles assume outsize dimensions, cast in steel with strange limpet-like forms attached to their surfaces. The most familiar and 'degraded' of objects take on a surprising new identity at every turn, transformed by an intelligent and poetic sculptor alive to every aspect of the complex interplay between the natural and man-made worlds. Cragg's pavilion contains a mature, resourceful and yet provocative achievement. I only wish the rest of this disappointing Biennale had attained the standard he sets.

51. Tony Cragg, *Policeman*, 1988, in the British Pavilion, Venice Biennale, 1988

DEACON AND CRAGG

15 December 1988

If I had to pinpoint the single most positive development in British art during the 1980s, it would have to be the exceptional fertility of the new sculpture. The generation which emerged at the beginning of the decade revitalised the sculptural tradition, and its most impressive members show no sign of premature exhaustion. They are gaining in strength all the time, and the awarding of the last two Turner Prizes to Richard Deacon and Tony Cragg recognised their achievement. Both sculptors are, at thirty-nine, continuing to develop rather than complacently reiterating past work. Plentiful proof is offered at their current exhibitions. Deacon's show at the Whitechapel Art Gallery is, effectively, his first big London display since winning the Turner Prize last year. Cragg's exhibition at the Lisson Gallery opened only days after he collected the 1988 Prize on which, to declare an interest, I served as a jury member. His new show testifies to the range and inventiveness which impressed so many visitors to his pavilion at the Venice Biennale this summer.

Of the two exhibitions, Deacon's is by far the larger and more comprehensive. It begins in exhilarating style with a colossal sculpture called *Like A Snail (B)*, which confronts us immediately after passing through the entrance. Despite its size, this great ribbed structure invites the viewer to step inside through a welcoming gap. There, in the middle of the work, its full flamboyance becomes clear. The laminated wood ribs curve upwards from their circular base and then, at around eye-level, they bend in before surging out once more to culminate in a crown-like circle at the summit. Although the entire operatic work is filled with sprung tension, it might have become inert at the apex. But Deacon avoids that danger with winning bravado. He slings a gleaming aluminium ring from the top of the sculpture, where it dangles down like a heavy bracelet. At first surprising, this insouciant gesture ultimately seems just right. It counters and lightens the inevitability of the ribs' concerted movement, while at the same time reinforcing the overall theme of circular wholeness. A convivial and protective work, for all its towering dimensions, *Like A Snail (B)* shows Deacon at his most balanced and humane even as it asserts a playful readiness to push ideas through to a spectacular extreme.

This high-spirited flourish serves as an ideal introduction to a hugely enjoyable show. I found myself responding with instinctive relish to the alert dialogue he conducts between burgeoning exuberance and severe containment, organic richness and geometrical discipline. References to

52. Richard Deacon, *The Back of my Hand No. 6*, 1987

the human body abound, but they are never easy to pin down. Always preferring poetic resonance to anything more literal, Deacon rejoices in his work's ability to conjure a stimulating wealth of associations. He also employs a consistently supple breadth of materials, incorporating a box of sponge in *The Back of My Hand No. 6*, placing four bars of pink formica inside the mild steel structure of *Art For Other People No. 23*, and juxtaposing carpet with hardboard and phosphor bronze in *These Are The Facts*.

I never felt that such versatility became merely arbitrary or capricious. Alongside Deacon's penchant for unusual, almost heretical materials lies his abiding love of laminated wood or hardboard. Its lean, sinuous presence can be found in many of the exhibits, and *Bounds of Sense* sends it looping upwards in a crazy racetrack of linear energy. All this airborne dynamism is countered by the triangular steel base which partially rests on the floor, and leads in turn to a sinister tongue-like form curving up at an angle. It has a restraining influence on the work's leanings towards rhetoric, for Deacon always ends up reaffirming his fundamental commitment to spare, concise expression.

This priority is at one with his willingness to expose how the sculpture is made at every turn. Throughout the show, the role of rivets and screws is openly declared, just as he never attempts to hide the glue spilling from the sides of the laminated wood. Sometimes the ubiquitous screws assume a decorative elegance, while elsewhere they take on a defensive appearance – as if the sculpture were preparing itself like a fortress against the prospect of assault. But in *These Are The Facts*, a remarkably brutal work, they brandish a sharp-pointed aggression that warns us away from treating it with easy familiarity. For all the enlivening panache and openness of Deacon's art, it does harbour a dark side as well. *Body of Thought No. 2* has a convoluted, knotty menace which threatens to crush the pods inserted within its coils. As for *Struck Dumb*, which brings the upper section of the show to an implacable conclusion, it fills the space with a display of sullen, enclosed bulk. A deep red steel 'bow' seals off the front of this swollen, brooding presence like a gag over a mouth. It appears to be warning the critic that silence, at times, is the most appropriate response.

Deacon's work grows in formal and expressive authority all the time, and he now deserves to be counted among the very finest sculptors at work anywhere in the world. So does Cragg, although his one-man show at the Lisson Gallery contains only half-a-dozen pieces and cannot be equated with his major exhibition at the Venice pavilion. The best of his new Lisson works reveal his capabilities to the full, all the same. Cragg's earlier preference for 'found' plastic is nowhere to be seen, and

he places instead a more traditional reliance on wood, granite, bronze and plaster. But that does not mean he has relinquished his old questioning intelligence, which forces us to re-examine our own attitude towards these materials and their social usage. Fascinated by the relationship in the late twentieth-century world between the urban and the rural, the man-made and the natural, ephemerality and permanence, Cragg deploys a variety of resourceful strategies.

In the main arena at the Lisson, he displays at first a work which seems to have been culled from a beach. It is entitled *Pebbles*, and spreads across the floor in a loose, apparently haphazard arrangement. Detritus is mixed in with the shingle, and an outsize white bottle lies on top of the heap. While containing an unavoidable reference to pollution, the bottle possesses a strangely pleasing purity of form. And the 'pebbles' themselves turn out to be far removed from nature. They are made of polystyrene, like everything else in this profoundly deceptive and troubling sculpture.

The exhibit beyond it could hardly be more contrasted. After the scattering of *Pebbles*, Cragg now presents a monumental bronze apparently inspired by the form of a retort. His work has been preoccupied with images of vessels for several years, and sometimes the containers are pushed over to spill their liquid across the ground. No such alarming accident has occurred here. Part of the sculpture shows an upright retort, composed and harmonious. But it glides into another form which swoops very dramatically towards the floor, revealing a mysterious shadowy recess. Around the other side, this complex and ambiguous work swells into a ripeness redolent of buttocks or breasts. It is, I think, the most resoundingly sensual sculpture Cragg has so far made, and discloses a fascinating link with a sculptor he has never resembled before – Henry Moore.

As befits a sculptor entering his prime, Cragg is on the move. A splendidly unpredictable artist, he will soon be granted the opportunity to show his work at full stretch to a British public in the Tate Gallery's Turner Prize exhibition. On the evidence of this continually intelligent and refreshing show, it should be an outstanding event.

PHOTOGRAPHY NOW
2 March 1989

The elderly man with the bushy eyebrows seems, at first glance, instantly familiar. His face stirs memories of a thousand news photographs and television head-shots, signifying the authority of superpower statesmanship. After a while, though, the features become tantalizing rather than identifiable. Do they belong to Brezhnev, Reagan or a disturbing hybrid whose national and political loyalties have become merged in an ambiguous new synthesis? The answer is that Nancy Burson, the artist responsible for this infinitely teasing portrait, produced it with help from two computer scientists. Using a video camera, a computer and a software programme, they converted images of both Reagan and Brezhnev into digital form. The American president has ten per cent more of his face in the final image than the Soviet leader, for Burson has mixed the proportions according to the amount of nuclear warheads in their

53. Nancy Burson, (with David Kramlich and Richard Carling) *Warhead I (Reagan 55%, Brezhnev 45%)*, 1982

respective stockpiles. So the result is as much a portrait of mega-death as of two ageing politicians. It implies, with chilling precision, that the men responsible for the world's future survival have become merged in an eerie Big Brother composite.

The fact that such a picture has been included in *Photography Now*, at the Victoria and Albert Museum, is a measure of the exhibition's scope. The show marks the 150th anniversary of the first official announcement of photography's invention, and reveals just how far the medium has travelled since those early daguerreotype days. Burson's techniques were inconceivable to François Arago, the man who made that historic announcement in January 1839. But Arago, an astronomer, physicist and politician, would surely have been fascinated by the range of possibilities available to the photographer today. Mark Haworth-Booth, the survey's organiser, likens its contents to 'a set of arrows, or avenues, pointing outwards in some of the many directions an artist interested in photography might explore'.

Despite his very deliberate reference to 'artist', the remarkably open-minded Haworth-Booth has included advertising among the many alternatives he examines. One early section in the show is dominated by two huge 48-sheet posters from the celebrated Benson & Hedges campaign, conducted by the CDP agency with increasing sophistication and cheek since 1962. Its surrealist wit reached a climax of impudence last year, when the ubiquitous gold pack disappeared from billboards altogether. Instead, elaborate still-life arrangements of fans and spinners were deemed sufficient – simply because their *style* announced the product on its own. Only the government health warning along the bottom of these supremely assured, not to say arrogant images discloses the fact that cigarettes lie behind all the pictorial confection. A similar canny single-mindedness is detectable in the field of fashion photography, where Bruce Weber blurs the boundaries between his commercial and personal pictures. The sensual, languorous and homoerotic studies of blond Californian youths on show here represent his non-advertising work. But they could easily be deployed in fashion magazines to promote the kind of smouldering hedonism which designers of male underwear are now so eager to market.

Not that the exhibition neglects the documentary photography which has flourished ever since Daguerre's period. As part of an ambitious attempt to photograph 'manual labour at the dawn of the 21st century', Sebastião Salgado visited the Serra Pelada Goldmine in Brazil. The scenes he found there had more in common with ancient civilizations than our own time. Hundreds of settlers rushed to the mountain where

gold was discovered in 1980, and Salgado photographed the frantic press of muddy bodies carrying heavy bags of soil up rudimentary ladders to the crater's edge. It is an awesome and unnerving spectacle. Desperation combined with greed prompt these workers to endure intolerable conditions, and Salgado's camera stresses their teeming insignificance as they strive for the elusive treasure.

Since photography is well equipped to convey epic immensity, Frank Gohlke's sequence on the Mount St Helens eruption is equally memorable. Working from helicopters as well as the ground for four summers after the event, he concentrates on the surrounding landscape rather than the smoking peak itself. The explosion laid waste to 230 square miles around St Helens, killing around two million animals. Gohlke does full justice to the desolation, as well as finding an unexpected beauty in the amalgam of ash and snow on the east face of the Mount. The emptiness of this vast, forlorn region is ominously presented, like an intimation of the nuclear winter which threatens us all.

Humour plays its part throughout the show too, most disarmingly in the work of William Wegman. Formerly known as one of the wittiest Conceptual artists, Wegman made his Weimaraner dog 'Man Ray' into the star of his work. Undaunted by the animal's death, he has now found a pliable successor in 'Fay Ray'. Sporting a pair of blatant false eyelashes, she poses next to Wegman's young assistant Andrea Beeman. They seem on equal terms, and in a diptych the artist Ed Ruscha directs a deadpan smile towards the dog's echoing leer. The funniest picture, though, is *Dressed For Ball*, where 'Fay Ray' dons a lavishly ornamental gown in order to open her mouth and catch a red ball spinning in the studio's darkness.

Because Wegman now relies so heavily on the camera, he enjoys attention in photography and fine-art circles alike. The barriers which once segregated them are being dismantled with increasing frequency, so that Helen Chadwick moves easily from one camp over to the other. Her elaborate installation *The Oval Court* was first created for the ICA in 1986, but now it reappears in the second half of the V & A survey near photographic series by Lee Friedlander and Masahisa Fukase. The 'pool' taking up much of Chadwick's floor-space swims with images of ripeness and decomposition, all recorded on an ordinary photocopying machine. They contrast with the gleaming gold-leaf balls ranged around them, and Chadwick's sorrowing face (taken from instant passport photos) looks down from Salomonic columns drawn by computer. All these late twentieth-century devices are used, however, to elaborate on a theme as old as humanity: the transience of mortal pleasure and the inevitability of decay.

MARIE-JO LAFONTAINE AND EUAN UGLOW
27 July 1989

A cluster of dark monoliths confronts visitors to the ground-floor space at the Whitechapel Art Gallery. Grouped in a conspiratorial circle, they reveal nothing about the events relayed within. Only the sound of ritualistic dance-steps and equally primal singing give any hint of the drama. But once the entrance is located and we move inside the circle, video monitors surround us on each of the monolithic structures. Apart from a slight time-lapse between one screen and the next, the same images appear on them all. They chart the progress of a tense, unexplained struggle enacted by two anonymous young men. After a few seconds it exerts a mounting fascination, and never lets up until the conflict terminates in sudden, mysterious defeat.

Marie-Jo Lafontaine, the Belgian artist responsible for this compelling installation, has long been fascinated by formalised displays of male aggression. Boxing and bullfighting have been explored in previous works, but the Whitechapel piece dramatises a less familiar encounter. The title, *Victoria*, refers to a tango-like victory dance, and the two men spend much of their time encircling each other in movements that echo the arrangement of the monitors. Even when they close in, physical violence is hard to discern. Their hands and arms seem curiously unwilling to inflict corporeal damage. Instead, a distinct erotic charge is generated by lunges reminiscent of a caress or embrace. I thought at one stage of Epstein's colossal *Jacob and the Angel*, where the two figures are embroiled in a combat as much sexual as spiritual. Here, however, signs of any real bodily struggle are hard to pin down. The men in *Victoria* stare at one another, close-to, like stags about to lock horns.

As the ritual proceeds, it takes on an increasingly psychological emphasis. Although the figures begin to sweat, and signs of fatigue start to disrupt their former proud composure, these are the outward manifestations of fierce mental antagonism. The victor must break his opponent's belief in himself, and when that moment comes the defeated man stands motionless while tears travel down his stunned face. Eventually, he falls forward like a severed tree-trunk. But the other figure shows no reaction, either of triumph or sadistic satisfaction. He merely stares at the camera with complete impassivity, a machine-like embodiment of the need to subjugate.

It is a relief to escape from this claustrophobic arena, where virile aggression is seen as a dehumanizing and deeply destructive force. The

54. Marie-Jo Lafontaine, *Victoria*, 1988

other half of Lafontaine's show invites us to enter white, spacious rooms hung with large-scale monochrome photographs. Each one presents a young woman's face, strongly lit from the left and staring out at the viewer. The pose recalls the final image of the *Victoria* video, and yet the difference is enormous. For these women, selected from nearly 200, gaze out with evident humanity. Far from seeking to impress by projecting a single-minded arrogance, they are unafraid to reveal tenderness and even vulnerability.

The identical format adopted in each photograph, where the head rises dignified and erect from a maroon panel, might have fostered a feeling of remoteness. But these faces are not cold. Their undoubted strength is tempered by a sympathy which has nothing to do with impersonal pride. Moreover, the women span an enormous range of racial variations. Taken as a whole, they imply an assertion on the artist's part of a shared, underlying grace irrespective of national characteristics. The series is therefore celebratory as *Victoria* is perturbing. While making us keenly conscious of the individual differences between Asian, African and Greek features, these monumental photographs end up affirming unity, reconciliation and a steady sense of poise.

Upstairs at the Whitechapel, Euan Uglow is given a small yet revealing retrospective. At first, there seems to be no connection between his patient, methodical paintings of the posed female nude and Lafontaine's work. But Catherine Lampert, who inaugurates her directorship of the gallery with this double bill, must have sensed that the juxtaposition would prove rewarding. So indeed it does. Uglow is in a direct line of descent from his teacher at the Slade, William Coldstream. Both men share a passion for clarity of observation, defining the figure with an exactitude bordering on the fanatical. Uglow's work is the product of intense, painstaking refinement, and like his mentor he leaves the evidence of perpetual measuring exposed on the final canvas. Sometimes these marks enclose the figure like stitching. A network of thin lines and star-points runs all the way round the contours of the nude in *The Diagonal*, giving the image an almost surgical air. Elsewhere this obsessive geometry is less evident, and Uglow allows a Mediterranean sense of colour to alleviate the perpetual calculation. *Summer Picture* is outstanding in this respect, rejoicing in a pellucid light blue behind the woman seated on the hard desk.

Even here, though, Uglow never lets us forget his image's origin in a studio pose. He would not dream of pretending that the women in his pictures were anything other than models, patiently enduring the artist's scrutiny. One of the paintings bears the title *The Quarry*, *Pignano*, and there is a feeling throughout the show of a hunter pursuing the perceptual truth about the bodies he examines with such zeal. The strength of his commitment, and the precision with which he carries it out, command respect. Canvases from the early 1960s – smaller and more subdued than his recent work – are hung freely among paintings from the 1980s, proving the consistency of Uglow's preoccupations over the last thirty years. At their finest, they achieve a hieratic stillness and calm which possess surprising connections with the serenity of the women's heads in Lafontaine's show below.

What I miss in Uglow's work, though, is a readiness to regard his nudes as people rather than forms waiting to be pinned down. Most of his models turn their faces away from him, stare down at the floor or hide their features in arms and hands. They remain distant and apart. On the rare occasions when they do look up and confront the artist – as in *Miss Venne* or *Nude with Green Background* – they appear glum. The boredom of posing for interminable periods is not disguised. Nor is Uglow's refusal to break down this icy objectivity. He stays detached, regarding the models more as blanched statues than creatures of flesh and blood. In one picture, disconcertingly called *Narcissus*, a man appears in the same room as the posed nude. But he stares at an overmantel mirror rather than directly at her, and his features remain blank.

ANISH KAPOOR
14 December 1989

The main arena in Anish Kapoor's powerful new exhibition is inhabited by sixteen immense blocks of red sandstone, all rough-hewn from a quarry in Cumbria. Their bulk almost fills the available space, obliging the viewer to negotiate a narrow pathway around the boulder-like forms. From the middle of this monumental assembly, we become intensely aware of weight and material substance as our gaze travels across the entire earth-coloured mass. There the lumps of matter rest, as primordial and unexplained as a congregation of stones marking some ancient religious site.

Their solidity seems incontrovertible, and yet each stone is pierced at the centre of its uppermost surface by a small aperture which ends up undermining all this material palpability. At first glance, these circular holes look like black discs which could, perhaps, have been painted on the blocks. But closer inspection reveals the strange and disquieting truth. As we peer into the apertures, our eyes become conscious of the unfathomable emptiness within. It subverts everything we thought so redoubtable about the stones. Their very substance is called into question, by a tantalizing area of inky darkness which could indicate that the interior of every block is nothing more than a void.

In this calm and yet profoundly unsettling sculpture, Kapoor therefore brings the opposite extremes of volume and vacuum, the quantifiable and the unknown, into dramatic confrontation. The reassuring certainty of heavy stone, which gives the ensemble so much of its initial appeal, is only evoked in order to point towards a fundamental mystery at the heart of things. Kapoor uses the awesome four-square presences, in the largest work he has so far produced, as a means of approaching a state of immateriality.

The language he employs has links with minimalist sculptors like Ulrich Rückriem, and yet Kapoor's concern with metaphysical opposi-tions is central to an Indian view of the world. This synthesis of the Asian and European reflects the cultural complexity of an artist who grew up in Bombay before studying in London and settling here. A return visit to India in 1979, just before he embarked on his mature work, marked an important moment of self-definition. For Kapoor, deeply involved by this time with Rothko, Klein and Beuys, the trip reawakened his awareness of the duality permeating Indian religious thought. In the shrines to Shiva, he found a nourishing tension between spiritual remoteness and highly

55. Anish Kapoor, *Void Field*, 1989 (detail)

charged sexuality. Outside the temples, where powder colour is sold for use in sacred rituals, he discovered another abiding source of inspiration – the realization that sculpture could be made directly out of colour itself.

After returning to London, Kapoor knew that he could now begin to produce an art which moved away from the concerns of so much con-

temporary abstract sculpture. The powdered pigment enabled him to deploy colour with a beguiling and sensuous immediacy. His use of brilliant, unadulterated red, yellow and blue marked Kapoor's sculpture out from the prevailing austerity of sculptors who would never have contemplated coating their work with such outspoken hues. His work exerted an instantaneous attraction, and in one sense enhanced the ripe, organic and graspable character of the fruitlike and often openly erotic forms he favoured. In another respect, though, the sheer luminosity of these shimmering colours moved his work into a sphere far beyond physical gratification. At once desirable and ethereal, tactile and dreamlike, Kapoor's sculpture floated between the realms of earth and heaven. It achieved this remarkable feat with apparent ease, too. Shapes redolent of a phallus, a gourd, a mountain or a breast relate very directly to our experience of the world, and seem inherently understandable. Only after a while does their purity – of form as well as the glowing, compacted colour – make them separate as well.

That is why Kapoor's work is so paradoxical. How can sculpture which appeals so strongly to our sensual knowledge also make us conscious of its hieratic otherness? The question would probably sound strange to the sculptor himself, born as he was in a country where art is imbued with spiritual feeling of the most instinctive kind. He decided, early in his career, to place almost all his work under the generic title of '1,000 Names'. It emphasised the sequential nature of the objects he placed on the wall or floor, and at the same time implied that they were fragmentary contributions to his quest for a larger whole. Whether grouped in clusters or ranged in lines, they resembled forms set out with meditative deliberation for use in a ritualistic event. Although the event itself never took place, Kapoor was undoubtedly stimulated by the idea that the artist could take on a shaman-like role. This notion of a priestly calling once again unites the oriental and occidental cultures, for Beuys believed in the importance of the shaman as deeply as an Indian. Kapoor himself remembers watching a snake charmer playing music and dancing all day in his parents' garden, trying to tempt a pair of Cobras out of their lair in the undergrowth. This trance-like performance eventually proved successful, and the potency of ritual has stayed alive in Kapoor's imagination ever since.

The stones now assembled with such megalithic force at the Lisson Gallery could likewise be seen as components prepared for an unspecified ceremony. Like the great blocks left so unaccountably at Stonehenge, they have an air of momentousness about them. But there is nothing grandiose or self-consciously exotic about these silent, expectant presences. Their origins in a quarry are entirely undisguised, for Kapoor has

realised that their primal impact would be impaired by any attempt to tamper with the brusquely sliced form they possess. Their rawness makes the apertures they contain even stranger and more intriguing. Each neatly circular hole is in absolute contrast with the crude irregularity of the stone, and the darkness inside is unalleviated by any stray chinks of light. We are invited to stare down into this penumbral region and acknowledge that the massive certitude of the block encloses a midnight void, without any rational explanation or perceptible limit.

This haunting revelation is reversed in the only other work on display. Unlike the stone installation, which spreads right across the lower gallery, *Angel* consists of a solitary piece of slate. Lying on the floor, at a far lower level than the block beyond, it is coated in a luminous blue pigment reminiscent of Kapoor's earlier use of powdered colour. The slate has not, however, been shaped into one of the swollen forms which he used to favour. It is even more roughly cut than the lumps of red sandstone, and holds none of the organic connotations that pervade his previous sculpture. The slate has been left in its natural state, but only to be robbed of physicality by the deep, melting envelope of blue. The colour has a dis-embodying effect, making the work appear to hover gently above the floor like a cloud. Being and non-being are united with the apparently effortless inevitability which characterises all Kapoor's finest work. This graceful and poetic sculptor fully deserves to have been chosen as Britain's representative at next year's Venice Biennale, and I look forward to discovering how he transforms the pavilion there with a fusion of the sensual and the sublime.

JEAN-MICHEL BASQUIAT

12 March 1996

Dying of a heroin overdose at the age of twenty-seven, Jean-Michel Basquiat has subsequently achieved cult status. Even during his short life he quickly became celebrated: first as an adroit spray painter of New York buildings under the provocative pseudonym SAMO (code for 'same old shit'), and then as a darling of the Manhattan gallery scene. Extraordinarily prolific, he completed more than 500 paintings, often of a herculean size. Their success proved that a young black artist could be lionised by white America, and his subsequent collaboration with Andy

56. Jean-Michel Basquiat, *Untitled (Skull)*, 1981

Warhol marked Basquiat's apotheosis as a fashionable prodigy who insisted on working in paint-smeared Armani suits.

But was he any good? Now, for the first time since his death in 1988, he has been given a solo exhibition in a British public gallery. It offers an opportunity to discover if Basquiat's work was anything more than the by-product of his legendary charisma. The space at the Serpentine Gallery does not allow more than a fraction of his torrential output to be displayed. But this limitation may well be an advantage. The speed

with which he worked inevitably led to slipshod moments throughout his career. Basquiat's œuvre is wildly uneven, so the Serpentine has been well-advised to concentrate on the most memorable images and leave the dross alone.

The first room is enough to confound scepticism. Far from looking like the work of an untutored barbarian, high on his notoriety as a graffiti artist from the streets of Brooklyn, the paintings assembled here testify to the power of his draughtsmanship. Even when only twenty, he produced a large canvas called *Untitled (Skull)* which shows how gifted Basquiat really was. It also reveals the turbulence of his imagination, dominated by mortality at an age when most of us relegate death to some reassuringly vague future. Like so many of his head images, *Untitled (Skull)* may be a self-portrait. The teeth have long since decayed, and short, spiky hair sticks up like stubble on a convict's shaven crown. This is a beleaguered face, but its determination remains formidable. The eyes blaze with energy, and the welter of images inside the skull evokes the dangerous urban world that shaped Basquiat's vision. The city seems to be lodged in his brain, feeding him with the incessant nourishment he needed.

The dynamism pulsing so paradoxically through this *memento mori* is a measure, too, of Basquiat's ambition. He wanted to succeed, and by 1982 was prepared to proclaim his individuality on the most monumental of canvases. *Boy and Dog in a Johnnypump* is a colossal painting, but it does not seem marred by a sense of strain. Using acrylic and oil paintstick as well as spray paint, Basquiat ensures that the entire surface is quickened by his deft, supple and above all fluent mark-making. Cooling themselves in the water gushing from a city fire hydrant, both boy and animal revel in the cascade. The space around them is brushed, stained and dribbled with a spattered freedom reminiscent of de Kooning at his most unbridled. But the grin on the black boy's mask-like face is threatening as well as joyful. Basquiat appears to be playing with the racist stereotype of the 'frightening' black youth. The figure raises his arms in a gesture that might seem aggressive. It also stirs memories of a crucifixion, however. And the lines of thin white pigment running through his body look like the X-ray of a skeleton.

Even at his most exuberant, then, Basquiat could not oust thoughts of suffering. *Boy and Dog in a Johnnypump* turns out to be a surprisingly complex and ambiguous picture, far removed from the splashy high spirits which give the painting its initial impact. The darker side of Basquiat's imagination was undoubtedly scarred by his awareness of racial intolerance, but it also owes something to the traumatic moment when he was

hit by a car at the age of eight. Serious enough to demand a prolonged convalescence, the injury made Basquiat keenly conscious of his own body. The interest was reinforced when his mother gave him a book on human anatomy, and in 1982 he produced a large painting inspired by Leonardo's pioneering studies of the body. Rather than ending up as a straightforward homage to the Renaissance master, it is as quirky as any of Basquiat's pictures. Leonardo's exquisite draughtsmanship is nowhere to be seen. Instead, on a canvas that looks like four rough panels badly joined together, a misshapen head and a scrawny male nude dominate the painting. A half-naked railway worker toils beside a track meandering across all the panels, and everywhere you look Basquiat has scribbled comments like 'bad foot' which give the picture an offhand, diary-like mood.

From then on, words played an increasingly eloquent part in his paintings. *Jawbone of an Ass* contains at its heart an outpouring of writing, as Basquiat's awkward capital letters spell out a host of names, places and events ranging from the pharoahs and Christ to Lincoln's Emancipation Proclamation, which granted freedom to the black slaves of the Deep South. Images of crowns and cartoon characters are pushed to the sides, where their lightheartedness sits oddly with references to Cleopatra and Sophocles in the centre. Basquiat delighted in leaping from one world over to another. Many of his paintings resemble enormous urban walls, covered in an apparently random blizzard of drawings, paint-smears and scrawled messages. But as you move through the exhibition, so the seeming arbitrariness takes on a crazy coherence of its own. Basquiat is above all a poet of the big city, fired by the acute visual dislocations bombarding anyone who inhabits a metropolis as jarring and adrenalin-pumping as New York.

This accelerating fame, fuelled by the widespread hunger for neo-expressionist painting in the 1980s, did not bring Basquiat any peace of mind. Madonna, with whom he had an affair, recalls that 'he didn't know how good he was and he was plagued with insecurities'. All the evidence suggests that he felt guilty about wealth, and gave most of his money away. But the dollars enabled Basquiat to indulge in the drug habit which killed him. As the show proceeds, there is a sense of the early energy draining away. The collaboration with Warhol diluted Basquiat's art rather than enriching it, and at times his work seems disconcertingly slapdash. Alongside these signs of deterioration, though, I noticed an increasing awareness of vulnerability. Basquiat's inner plight must have deepened his insights into the human predicament, and the green head looming out of *In Italian* seems far more frail than his previous figures. Written references to the heart and blood punctuate the surrounding

space, as if Basquiat was becoming obsessed with the body's capacity to survive. And in *Victor 25448* a bandaged man is seen tumbling through space. The cause of his affliction remains mysterious, but the rest of the canvas contains words as ominous as 'Fatal Injury' and 'A Beating Awaits You Here'. Painted only a year before he died, this lacerating image can be seen with hindsight as painfully prophetic.

Not all the late paintings are haunted by presentiments of the end. *Lester Yellow* is an exuberant work, alive with raucous visual and verbal exclamations about the mad pleasures of horse-racing. On the whole, however, these final works testify to a gathering awareness of extinction. *Riding with Death*, painted shortly before his fatal overdose, has the character of a final testament. A brown figure rides a skeletal mount, and extends both arms in a gesture reminiscent of his forerunner in *Boy and Dog in a Johnnypump*. Compared with the overwhelming vitality of that early painting, though, *Riding with Death* is shorn of substance. No flowing water hydrant animates the dun-coloured mist surrounding the rider. It seems impenetrable, ruling out any possibility that words might once again crowd the picture with their garrulous presence. A terminal silence prevails here, and even Death is a fragmented animal barely able to move its blanched bones forward. They hover in space, ready at any instant to break up and disappear in the void.

STAYING POWER

RICHARD LONG

18 June 1981

Richard Long was virtually the first artist of my own generation whose work moved me very deeply. I still remember the enormous excitement it gave me to discover him over a decade ago, and the sustained imaginative quality of his art since then has certainly not lessened my initial admiration. Indeed, his latest exhibition at Anthony d'Offay proves that Long continues to refine and extend his intensely personal vision of the countryside as an inexhaustible source of wonder, a place which can only be fully savoured by the committed traveller.

Most artists who concentrate on landscape subscribe to the notion that their subjects should be viewed from a fixed position. Although they may have wandered miles in order to reach their chosen site, no hint of journeying can be found in the image they finally produce. Behaving more like spectators than explorers, they admire the prospect from a suitable distance and would not dream of regarding it as a terrain to be traversed. But Long has never been content with such a static role. To him, a landscape is above all something worth walking across. Only thus can he make the discoveries that fire him, and so the act of travelling is placed at the very centre of his work. Armed with a physical stamina which far outstretches the enfeebled foot-power of many modern city-dwellers, he tirelessly sets out on expeditions I would consider impossible endurance tests. He is also willing to accept a degree of isolation few of us could bear, wandering through remote regions of the world where human company is hard to find.

On these trips, Long cuts himself off from all avoidable contact with other people – and from the urban centres where they congregate – so that he can regain at least a semblance of the relationship man used to have with the earth. Undistracted by anything except the fundamental elements of the land itself, he becomes alert to the possibilities inherent in the simplest materials he encounters. Instead of sitting down like a conventional landscapist and making an image with the implements he has brought with him, Long always uses the natural contents of the scene.

The most mundane stones can be up-ended, kicked into a loose formation, or scattered wide across a plain. They can even be stacked into groups as monumental as Stonehenge, but there is never any sense of an artist imposing an alien object on a setting which was more beautiful before the interference took place. As a contrast to sculptors who make their work in a studio, and then transport it out-of-doors to be placed in

a rural context, Long responds to each location on its own particular terms. In one of the photographic pieces at his current show, he cleared a straight path through a stony Bolivian plain, but this white line takes its place among a whole intersecting network of similar tracks made by animals who previously passed over the ground. The form taken by Long's marks was therefore suggested by the marks he found there, and this fusion avoided the danger he might otherwise have run of violating the land with intrusive gestures.

Just as Long tries to honour the character of a site, so he never tampers with the existing shapes of the materials he discovers. He will group them together in new patterns, extract them to disclose formations which could not previously be seen, and sometimes hurl them considerable distances if he wants to employ chance or work over a very large area of ground. All the time, though, he heeds a fundamental instinct about the sanctity of nature, and his refusal to disrupt it with inappropriate activities shows how much respect Long retains for the countryside he explores. Even when the stones and other materials are transferred to a gallery, they are not cut up or combined with each other in ways which obscure their original identity. Each separate chunk is allowed to keep its singular character at the same time as Long places it in gatherings of similar elements. He invites us to absorb the peculiar colours, textures and shapes of the fragments arranged in primal forms on the gallery floor. Nothing, not even knobbly lumps with undignified names like Breaky Bottom Flint, is too common or humble for Long to respect and celebrate.

The value of such an attitude, when the abuse of our natural resources still continues apace, hardly needs to be stressed. It is all of a piece with Long's insistence on travelling through the land and enduring its inevitable hazards, in the hope that a more profound knowledge of his surroundings will result. Now that Western societies have become so divorced from the natural world, we need his restorative art more urgently than ever.

But how can the experience of a journey best be conveyed to gallery visitors who have not shared it? Long's solutions to this challenge take many different forms. Sometimes, in multi-part photo-works, he selects reverberative moments from the trip and lets them 'stand in' for the expedition as a whole. Appreciating the strength of understatement, he knows as well as the writer of a Japanese *haiku* that the most sparing words can often carry the most powerful emotions. The lines which trace the course of his walks on Ordnance Survey sheets, or the pencilled notes explaining what, where and how far, make no inordinate demands on the spectator's intelligence and do not require any specialised knowledge of art.

Nor does the new book of Long's written pieces, which follow walks he has recently undertaken and define the experiences they gave him in limpid sequences of place-names, climate details, distances covered and terse but telling observations like 'into a low sun' or 'floating ground'. They indicate, as clearly as the directional lines Long habitually creates within the countryside, the momentum of the artist as he wanders over awesome hillsides, empty valleys and dried-up riverbeds.

One of the floor sculptures in the d'Offay exhibition transmits the emphasis on incessant motion just as strongly as the photographs, maps and texts. It is a gigantic spiral of grey slate pieces which unfold from a tightly coiled centre in a steady, majestic rhythm of ever-broadening curves. Viewed from the innermost gallery, it can be seen in conjunction with a large terracotta circle painted on the wall behind. This warm disc, filled with the straggling marks left by Long's fingers as he pressed them against the wall, hangs over the slate spiral like a sun about to set on a vast, uninhabited landscape. Taken together, the two exhibits hauntingly evoke the kind of gaunt, epic surroundings Long often favours. Looking at this impressive ensemble, with its ability to suggest spaces far greater than the one it actually occupies, I almost found it possible to imagine myself standing on the mountain-top shown in the best of the photographic pieces at the exhibition.

57. Richard Long, *A Line in Scotland Cul Mór*, 1981

It shows Cul Mór in Scotland, where Long pushed up well over twenty stones from their recumbent positions on the rocky ground. Photographed from behind, they form a quirky silhouetted procession which seems to be swaying and jerking towards the very edge of the plateau. Beyond them, a sublime range of further mountain ridges, paper-thin in the haze, stretches away into the luminous distance. Although I know that stones cannot walk, it is easy to see this oddly animated parade as a symbol of Long's own determination to stride over wild and deserted country for as many years as his legs will carry him. I hope his wish is granted, and look forward to enjoying the poetic resonance of the images he brings back.

THE VENICE BIENNALE 1980
6 June 1980

To anyone concerned about art's thwarted relationship with society today, Venice is at once an inspiration and a reproach. Wherever you look, artists have made an indispensable contribution to this most beautiful of cities. Not simply by carving statues or painting altarpieces for the churches and civic buildings, plentiful though they are at every turn. The role of an art work extends far beyond the places where it might be expected to flourish, and becomes instead part of the everyday Venetian fabric. Walk down the humblest alley-way, where light only penetrates with fitful intensity, and the shadows will often reveal a sculpture set in to the wall above your head. Nowhere, it seems, is there a location too lowly to be ignored by one of the many image-makers who have transformed Venice into a continuous visual delight. It is as if the art concentrated in religious and secular centres was so superabundant that it spilled out across the whole city as well, where Venetians have come to regard it as a natural adjunct of their working lives.

But even while we admire this remarkably complete interaction, our pleasure is darkened by the realization that such achievements belong to the past. Neither Venice nor any other Western city has managed to make present-day art an integral part of its surroundings. And, as a tacit confirmation of the modern artist's removal to a more marginal position in society, Venice now acts as host to a huge biennial exhibition tucked away on the edge of town. Here, in a woodland setting quiet enough to

let visitors forget the existence of the city and its inhabitants, thirty-two countries have this year housed samples of their art inside national pavilions. And the artists are reduced to performing as ambassadorial representatives, dutifully on display in spaces reserved for Culture. The isolation of the event from any direct involvement with Venice itself, where artists once succeeded in moulding a complete cityscape, shows how confined so much art has become by its modern role as a gallery activity. These restrictions are especially apparent in the 1980 Biennale, for the overall theme of 'Art in the 70s' claims to examine the changes initiated by the revolutionary demonstrations of 1968. The political disruption was accompanied by a widespread desire among young artists to stop making unique objects for gallery consumption, and bring their work into more immediate contact with the world beyond. Art appeared on the streets as part of the larger movement towards social change, and it seemed for a moment that artists might play a more central part in the life of their time.

But the moment soon passed. It is not even acknowledged in the survey of seventies art at the main Biennale pavilion, an exhibition devoted entirely to celebrating individual stars whose reputations have been established within the gallery system. The only sign that work was made outside this system is provided by some perfunctory slides of Land Art projects by Robert Smithson or Christo, carried out in settings so remote that they are known largely through reproductions alone. And Walter de Maria's glossy photographs of the rods he erected in distant countryside serve as a reminder that outdoor ventures quickly end up back on the dealers' walls in the form of framed documentation. Walking through the rest of the main pavilion, divided into spaces where the participants have been invited to do whatever they wish, I found that the sense of confinement grew stronger. Although the range of material now available to Western artists is wider than it has ever been, they are unable to harness this formidable new potential to the creation of work beyond the boundaries defined by the exhibition cubicle. Neon, video, photography, film, felt, fat, fire and electric light were among the proliferation of media on offer, employed in exhibits which departed from the old idea of the art work as a framed picture or a single three-dimensional object. The traditional practices of painting and sculpture were to the fore as well, ranging from figuration as literal as Nancy Graves's weirdly simulated skeletons to abstraction as austere as Gerhard Richter's all-grey canvases. But all too often the limitless freedom of means resulted in disappointingly self-indulgent and trivial ends. Like prisoners supplied with the equipment to do anything they wish, and yet condemned to the four walls of a cell, many of the artists seemed to have turned in on themselves

and smothered every available surface with obscure, arbitrary and eccentric imagery.

If societies in the West can be blamed for failing to provide art with a wider purpose than bizarre behaviour in a gallery, the Communist countries at the Biennale offered no solution to the problem. China showed a horrific collection of hand-embroidered pictures which looked like coloured photographs and promoted the most wearisome bromides – heroic smiling workers, thrusting tractors, over-optimistic harvests. They were nothing more than kitsch propaganda aimed at the tourist trade. No good will ever come from forcing artists to tread a rigid ideological line, and even in the Yugoslavian pavilion a series of grandiose war memorials reflected little credit on the sculptors who won the commissions to make them.

These monuments represent state patronage at its most chilling and impersonal, whereas the most memorable images in the 1980 Biennale came from artists who were not labouring under such fearsome obligations. At the Polish pavilion, Magdalena Abakanowicz showed row upon row of identical, headless, hollowed-out figures, mute victims of some unnameable act of destruction. Canada screened a varied programme of

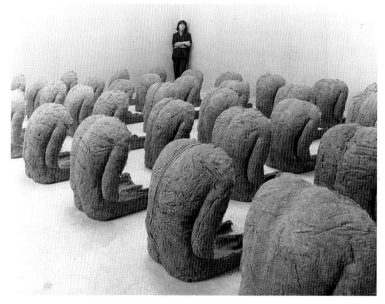

58. Magdalena Abakanowicz, *Backs*, 1976–80

video work, some of it (notably the hard-hitting tape on police training by Pierre Falardeau and Julien Poulin) determined to use a mass medium for powerful social comment. West Germany showed, in the dismembered but resilient wood figure by Georg Baselitz and Anselm Kiefer's panoramic, baleful paintings about history and war, that some artists are still prepared to confront the tragedies of the twentieth century with unsentimental grandeur. And Nicholas Pope, in the British pavilion, was so stimulated by the large room allotted to him that he produced a long line of freestanding larch timbers which constituted his most rewarding sculpture so far. Part forest, part stockade and part figure-group, it suggested that Pope is a sculptor who might well thrive on the kind of public commissions that release artists rather than repress them.

Will such opportunities arise more frequently in the 1980s, helping art grow out of the self-absorption and enclosed arenas which have hampered its renewal during the past decade? I am tempted to give a sceptical reply, because so much depends on whether society learns how to nurture artists with understanding and imagination. But Venice, by great good fortune, survives to prove against all the odds that it can be done.

CONRAD ATKINSON
10 December 1981

At first glance the white walls of the ICA's main gallery look as if they have been sprayed with Valentine's Day graffiti. Huge red hearts, sixteen of them in all, dominate the space, and it would be natural to assume that they enclose messages of love. But the contents of the first heart very quickly shatter such an illusion. Row upon row of small white cards, on which a watercolour map of the world has been painted, carry disconcerting statements about the balance of global economic power. 'In 1979,' a card reveals, 'nearly one third of all world trade was from sales and transfers within Multinational corporations.' Other cards explore the same subject in more detail, especially South America where one Multinational company controls half the exports of six countries. By the time you have finished reading, the notion of a planet dominated to an alarming extent by impersonal big-business interests has been quietly established.

But Conrad Atkinson, the artist who has selected these facts and assembled them like pieces of evidence at a tribunal, does not deal solely with

words. The second heart contains a painted yellow butterfly filled with tins and packets of bird repellent spray, vegetable pest duster and garden insect killer. Their garishly cheerful designs and friendly instructions – 'now in ready measured sachets' – are at odds with the deadly cargo they contain. Succeeding hearts on the rest of the wall use postcard views of the English landscape, newspaper cuttings, shampoo packets, slimmers' aids and much else besides to build up images of a world riven with hideously misplaced priorities. Whether the danger comes from radiation leakage or harmful chemical sprays, Atkinson makes clear that the body of society is suffering from a terrible – and quite possibly terminal – affliction. Instead of pumping good red blood from one part of the organism to another, his hearts are congested with the monstrous injustices they contain.

One of the most effective blockages can be found in the seventh heart, where packs of pet food are arranged in the form of a dog. Legs outstretched in frisky flight, and tail sticking up jauntily in the air, this canine caricature is enjoying the best of health. The 'Good Boy Choc Drops' and cat delicacies which make up his body bear witness to the quality of the nutrients lavished on domestic animals in the West: one of the packets gushingly describes its contents as 'complete moist meals in individual airtight packs – seafood flavour.' But below this absurdly cosseted hound, two scraps of paper are being kicked by his hind paw. They explain that underdeveloped countries, where many children die from chronic malnutrition, export about 3½ million tons of high-class protein to the West each year. Although 'much of the protein goes to feeding livestock or pets', Atkinson makes clear that we prefer to let our favourite four-legged friends trample this devastating information underfoot.

On the gallery's other wall the diseased hearts widen his exposé still further. One after another the Irish problem, nuclear war, aid to El Salvador, the aftermath of Vietnam, arms manufacturing and South African racism are all indicted by a blizzard of damning facts. The printed statements are usually enlivened by visual devices, like the watercolour camouflage designs which smother the cartoon outlines of American soldiers. And some of the evidence Atkinson has marshalled here is shocking enough: 'A recent American Alert signalled world-wide preparing all aircraft for takeoff was a mistake, due to the running of a war-game programme on a military computer without switching out the connection to the Alert system'.

But although the steady accumulation of evidence on the second wall carries its own relentless power, there is in the end too much data on too many subjects. Most visitors can only be expected to read a limited

amount of texts while standing up, and Atkinson runs the danger of exhausting them before they have managed to scrutinise everything he presents. It is a pity, because the hour-glass arrangement on the gallery floor shows how succinctly Atkinson is able to organise his material when he summarises the show's themes and issues a stark warning. One half of the hour-glass is stuffed to the point of overkill with weapons, media information and a surfeit of food. The other half is strewn with melancholy dead leaves and famine-stricken bowls. Atkinson does not say when time will finally run out on this grotesque imbalance between us and the Third World, but he hardly needs to.

The writing is on the wall, not only at the ICA but also at the Pentonville Two Gallery, where Atkinson uses his intimate knowledge of West Cumbria to puncture the Lake District idyll. Related concerns run through a sixteen-foot work, *For Wordsworth; For West Cumbria*, which has been purchased by the Tate Gallery and goes on view there at the end of next week. These three shows, combined with the publication of a comprehensive book on Atkinson's work called *Picturing the System*, mean that we no longer have any excuse for ignoring his diagnosis of a malaise which affects us all.

59. Conrad Atkinson, *For Wordsworth; For West Cumbria*, 1980

DAN GRAHAM

7 January 1982

With quiet but weirdly unsettling ingenuity, Dan Graham dismantles many of the barriers which divide our understanding of the world into rigid, separate compartments. Although he has chosen to exhibit his latest work in a London gallery, everything displayed there flouts our expectations of what an artist's show usually contains. Most exhibitions encourage us to follow the conventional way of looking at art, and remain at a safe remove from the objects on view. But the large-scale structure occupying the Lisson's first room invites us to walk inside, exploring its puzzling surfaces from every conceivable angle.

As soon as we start the investigation, Graham lets us discover that we are an integral part of the work he has made. By confronting our reflections in the full-length stretches of mirror installed in the exterior walls, or finding that a huge glass sheet plays the part of a diagonal wall within, we activate the full meaning of the model. If other visitors have entered it from the opposite side, we stare at them through the transparent wall while they, in turn, direct equally awkward glances at us. Our presence completes the work Graham has initiated, and he ensures that we are acutely conscious of our own reactions wherever we look. The comfortable distance between art and its audience has been undermined. We feel uneasy and exposed.

But the mirrored walls also supply views of the street outside, thereby directing our attention away from the gallery towards the larger world Graham would like to work in. This glass construction is a model of a *Pavilion/Sculpture* now being erected in the grounds of Argonne National Laboratory, an energy research centre near Chicago. As its double title indicates, Graham's structure will play an ambiguous role in the woodland area where the laboratory is sited. Half architecture and half art, it helps dissolve the boundaries which normally seal off these disciplines from each other. On one level it will be used as a summerhouse, related in form and materials to the main building. Just as great country mansions were often accompanied by little rustic resting-places designed in a similar vein, so Graham's pavilion echoes the glass-sheathed semicircle of a laboratory which makes use of solar energy. But it is at the same time a 'minimal' sculpture made by an artist, and strollers who approach it in search of peaceful meditation are likely to be disconcerted by its unexplained oddities. Instead of losing themselves in contemplation of the landscape, they might well be dazzled by the two interior

60. Dan Graham, *Pavilion/Sculpture for Argonne National Laboratory, Illinois,*
1978–81

mirrors angled to catch a prismatic reflection of the morning sun. They
may even end up feeling that the normal function of such a pavilion has
been subverted by the glass walls, turning its occupants from hidden
observers into people nervously aware of being observed.

This stealthy yet complete reversal of our comfortable preconceptions
runs through all Graham's work. His favourite stalking-ground is
American suburbia, where the silent majority quietly goes about its busi-
ness without expecting any undue disturbance. Here, in this most pre-
dictable and reassuring of regions, Graham's cool but effective strategies
would cause people to re-examine their most unremarkable everyday
surroundings. If he had his way, the entire façade of a house on a
respectable estate would be replaced by a sheet of glass, stripping the
building of its cosy identity. Passers-by and occupants alike might be for-
given for feeling disorientated by the sight of an ordinary home trans-
formed into a shop-window filled with domestic furniture and bric-à-
brac, none of which was ever intended to be exposed to public scrutiny.
But Graham does not stop there. He wants to add to the disquiet by
installing a mirrored wall in the middle of the house as well. Although it
lets the home's back half remain private, the mirror's reflection of the
street turns everything inside out. The house is invaded by images of

other homes across the road, and people stopping to stare at this extraordinary building will find their own reflections included in the bewildering tableau.

Graham's tactics draw a considerable amount of their strength from his refusal to adopt an openly aggressive stance. Rather than hurling angry brick-bats at housing estates, or recommending that such places should be bulldozed without delay, he calmly holds them up for inspection. The glass wall he employs would not seem threatening in an office block, or a modern house isolated in countryside where the owners have no fear of being overlooked. But by using it to disclose the contents of a suburban interior, he shows how simply a scene we take for granted can be revealed in all its disconcerting alienation.

The most unnerving of Graham's projects pushes his ideas to an almost dream-like extreme. It centres on the cinema, a place which usually derives much of its magic from the dark, consoling secrecy inside the auditorium. Nothing of this enclosed haven is visible from the outside, apart from a few tantalizing images which normally provide a hint of the film currently being shown there. But in Graham's proposed cinema, situated on the ground floor of an office in a busy corner of the city, the division between inside and out melts mysteriously away. The façade is made of two-way mirrored glass, permitting viewers on the street to see into the cinema when darkness has fallen and the house lights are up. Members of the audience are therefore on display, not reassuringly obscured from view. But all they can see inside is their own reflection on the mirrored walls.

When the lights go down and the film begins, a reversal occurs, allowing the audience to look out into the street. This eerie awareness of the world beyond the cinema sanctuary prevents movie-goers from becoming lost in the illusionistic world presented by the film. But because the screen itself is a mirror, it projects a reverse image of the film right through the cinema's façade. As a result, pedestrians are confronted by an uncanny spectacle: the film seen the wrong way round, and behind it the faces of the audience in the front row of the stalls. If such a mesmerizing building were ever erected, it would turn passers-by into voyeurs and make audiences shift apprehensively in their seats. At the Lisson, a special model with a miniature film playing on the screen has been placed in a darkened room, and it gives some idea of the hallucinatory effect a full-size version would have. Graham is well aware of the nearest precedent for his scheme: Johannes Duiker's 1934 Handelsblad Cineac in Amsterdam, where glass cutaways at the corner and entrance expose both the projection-room and balcony audience to street view. But Graham's

plan, which defies the categorial divisions between artist and architect, would make people inside and out far more awkwardly conscious of themselves as voyeurs whose gazes are returned in equal measure.

Like most of his projects, this deeply subversive model has yet to be realised on the architectural scale which would enable it to exert the maximum amount of potency. Lodged in our environment, and unrecognizable as 'art' in any orthodox sense of the word, Graham's cunning displacements could only be financed by patrons bold and imaginative enough to accept the consequences. But somehow, against all the odds, these fascinating plans ought to be built. Then their strange and unclassifiable sorcery could take us by surprise when we least expect it, in a sunlit park, a placid housing estate or a shadowy corner of the street.

MALCOLM MORLEY
7 July 1983

The first time I saw Malcolm Morley's work, it gave me a shock comparable with a sudden blow in the stomach. At an exhibition of photorealist paintings, where every other artist seemed to view modern life through the lens of a camera at its most bland, glassy and hygienic, he displayed an angry picture called *Race Track*. The canvas was based on a poster advertising the pleasures of Greyville Race Course in South Africa. Morley had spent many meticulous months painting the well-watered turf, the smart spectators thronging the stands in their thousands, and the affluent Durban cityscape shimmering in the sunlight beyond. The outcome was a formidable technical achievement, the culmination of all the paintings he had based on equally alluring postcards and illustrated brochures in the late 1960s. But after Morley completed this *tour de force*, he decided to vandalise it. A gigantic scarlet cross was smeared over his painstaking pigment, announcing with brutal clarity the artist's repudiation of the image he had so carefully copied.

First and foremost, it was of course a dramatic declaration of Morley's antagonism towards apartheid. His rejection of the perverted values which turn a South-African racecourse into an all-white enclave was unmistakable, and the mark he chose to make gained extra force by looking like the initial that Malcolm X had adopted as a leader of the black protest movement. But the painting derived much of its extraordinary

power to disturb from Morley's calculated defacement of his own patiently crafted work. The cross was not slashed onto the canvas in a moment of rashness. It was a coolly premeditated act, and he gauged the exact position of the two scarlet bars with as much nicety as he had devoted to the rest of the picture. Morley painted the cross on a plastic sheet, which was only pressed down on the race-course scene after it had been moved around to find the precise place he required. The marks therefore seem perfectly judged in compositional terms even as they push their aggressive impasto through the bright blue Durban sky, the dense crowds and the otherwise spotless track. They meet right in the centre of the galloping horses, ensuring that we cannot tell who is in the lead. By obscuring so many of the riders and their mounts, Morley negates the entire purpose of the event and implicitly denies its right to exist.

But this many-layered painting also declares war on the kind of art Morley had spent the past few years developing. In 1964 he began depicting with obsessive frequency a series of patiently detailed images of ocean liners. One of them slips smoothly past the skyline of New York, where he has lived ever since graduating from the Royal College of Art. None of the liner pictures is, however, based on direct observation. After an abortive attempt to paint a ship down at the Manhattan dockside, Morley decided to operate at several removes from reality. He based the paintings on postcards and travel leaflets, detaching himself even further by dividing these photographs into grids and transferring them, section by section, to the canvas. Each part was therefore viewed in isolation from the whole, and Morley often painted the pictures upside-down to ensure that he retained his distance from the source material. This sense of remoteness is the dominant emotion in all his early liner pictures. Serene, gleaming and secure, the *Empire Monarch* and the *Cristoforo Colombo* ride the waves with an imperious ease which Morley seems to have found immensely reassuring. As a child in Blitz-torn London, he was captivated by the sea and ships, regarding them no doubt as a means of escaping from his immediate environment into a sublime dream-world. The first liner paintings confirm this feeling. They seem completely imperturbable, and symbolise perhaps his anxious desire for a womb-like shelter from the turbulence of adult life.

But after a while the sheer calmness of these supposedly soothing images begins to turn sour. People appear in the ships, either sunning themselves with self-conscious languor on deck or grinning remorselessly at each other over a champagne-laden supper-table. A woman's black-gloved arm thrusts itself into the foreground of *Ship's Dinner Party* with surprising forcefulness, and it looks oddly mechanical. The laugh-

ing guests nearby seem manic and artificial, enclosed in a vulgar dining-room which suddenly appears hellish rather than enticing.

Liners can become claustrophobic, and so too can a method of painting if it prevents the artist from expressing his full personality. By the end of the 1960s the photo-realist style had been turned into a highly commercial proposition by dealers who promoted Morley and several other artists as a new movement. He felt unbearably restricted by this pigeon-holing, and the scarlet cross slashed across *Race Track* could well be interpreted as an explosive refusal to remain identified with the photo-realists' bandwagon. They produced a smooth and sanitised version of the world, whereas Morley felt a mounting need to unleash the wilder side of his temperament. The liners had sheltered him for long enough, and during the 1970s he conducted a series of furious pictorial assaults on his former vision.

His reliance on postcards and other photographic material remained, but now the sunny equilibrium was disrupted with astonishing violence. Impeccable politeness gave way in Morley's work to outrageously bad manners. His painted copy of the cover of the Los Angeles Yellow Pages, far more roughly handled than before, is split down the centre by a jagged black line. It scythes through the painting like a fissure caused by the earthquake Los Angeles has always feared, and the entire city seems to shudder as Morley assails its skyscrapers with a storm of stabbing pink brushmarks. Two years later, Piccadilly Circus is subjected to a still more cataclysmic attack, the climax of which involved Morley's friends shooting arrows into a bag of grey paint which spattered all over the picture's hectic surface. Soon afterwards, he launched a full-scale onslaught on the complacency of his ocean liners by showing a plane crashing with horrific force on to the SS *Amsterdam*. He had painted the same ship with total composure a decade earlier, but now it has been transformed into the tragic site of a disaster. The painting is called *The Age of Catastrophe*, and it demonstrates with jarring vigour how Morley's imagination moved in ten short years from Nirvana to Apocalypse.

His handling of paint discarded all its former methodical rigidity and became agitated beyond measure, openly registering terror, venom and an almost childish urge to destroy. Viewed in psychoanalytical terms, his work had swung from the glazed repression of the photo-realist paintings to the opposite extreme – a feverish readiness to unburden himself and disclose even his most destructive fantasies. Occasionally the paintings suggest that he was beside himself with fury, giving vent to emotions which had grown monstrously distorted during the period when he refused to express them at all. But the work itself never deteriorated

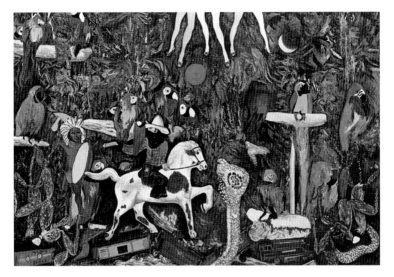

61. Malcolm Morley, *Christmas Tree – The Lonely Ranger Lost in the Jungle of Erotic Desires*, 1979

into careless incoherence. Although his copy of Raphael's *School of Athens* looks anarchic when examined close-to, and displaces a whole section of the fresco so that the sages' heads are detached from their bodies, the brushwork becomes amazingly exact viewed from a suitable distance.

As the 1980s approached, so Morley's frenzy finally abated. *The Grand Bayonet Charge of the Legionnaires in the Sahara* seems at first to be revelling in slaughter, but the soldiers are blundering cartoon figures capable only of knifing each other in the back by mistake. Morley's handling becomes less agitated and more expansive, gaining a new fluency from his discovery of watercolour's resources. Savouring the comic absurdity of his released desires as well as their desperation, he seems to have exorcised the most demoniac side of the personality which emerged during the previous decade. Although the recent paintings are sometimes marred by an indulgence in exaggerated clumsiness, they indicate a new ability to become reconciled with the stress and turmoil of his imaginative life.

In one of the most spirited canvases, he sees himself, with endearing wit, as *The Lonely Ranger Lost in the Jungle of Erotic Desires*. The derailed train which had previously been seen smashing its way through gondolas on a Guardí-like Venetian lagoon is now a harmless toy, trampled

underfoot by the Ranger's steed. A cobra rears up in front of him and a Red Indian behind, tomahawk in hand. But they are no more threatening than the gaudy parrots who festoon the exotic undergrowth through which the Ranger rides. He holds a pink dildo, waving it at his aggressors like a six-gun. The women's legs dangling like mannequins from the top of the canvas seem impervious to his farcical display of potency, and everything in this immensely decorative Rousseauesque frieze appears as harmless as baubles. No wonder the artist added the words 'Christmas Tree' to the painting's title. Having learned how to expose the deepest recesses of his psyche, in the hope of coming to terms with even its most distressing impulses, Morley can now afford to smile at the phantoms of an inner world he was once too fearful to investigate.

JOHN WALKER
7 February 1985

The widespread renewal of interest in figurative painting has presented many middle-generation artists with a dilemma which either invigorates or defeats them. Some, in their eagerness to discard an older commitment to abstraction, simply leap on a figurative bandwagon and betray the character of their earlier work. The studios of the 1980s are littered with strident, crudely handled canvases by painters whose sudden apostasy seems little more than a fashionable manœuvre. But other artists have made a sincere and courageous attempt to incorporate figuration in images which still retain a fully coherent connection with their previous concerns. They have managed to extend and enrich their art without bastardizing their former achievements. Indeed, the strength of their latest work derives in large part from a willingness honestly to explore a fruitful tension between old preoccupations and new, letting them confront each other with dramatic openness.

No one has succeeded more magnificently in constructing a hard-won, authentic synthesis from this conflict than John Walker. During the 1980s, his prolific painting and print-making prove how impressively he has risen to the challenge of tackling figuration while remaining faithful to his long-term involvement with an abstract language. One of the main reasons for Walker's success lies in his refusal to proceed in a schematic way, as if conducting a theoretical debate about the viability of alternative

styles. He admitted the figurative presence to his work in an instinctive rather than a programmatic manner. A mysterious shape, inspired fundamentally by Goya's *Duchess of Alba* without aping it in any literal sense, began to invade his paintings at the end of the 1970s. It seemed to arrive unbidden, like an inexplicable apparition from a dream, and inserted itself in surroundings which at first stayed stubbornly close to the austerity of his earlier images. Although this enigmatic intruder could be related to a full-length figure, it resisted clear identification and also remained compatible with the severe geometrical forms which Walker placed nearby.

As his imagination became obsessed by its possibilities, however, the shape began to shed the cool discretion of *Alba in Grey* and flaunt a more expansive persona. The slab-like forms accompanying it move diagonally into space, revealing a greater sense of recession than Walker had ever allowed himself before. They begin to resemble segments of painted scenery, and the Alba shape takes on a frankly theatrical guise. Gathered in more tightly at the centre and then flaring towards the ground with the fullness of an elaborate costume, its contours become more outspoken. Walker's interest in the stylised gestures of Kabuki theatre is reflected in the clear-cut boldness with which the shape now holds the stage, and in some paintings its surface flowers into exotic patterns reminiscent of a kimono.

But the immensity of the penumbral spaces behind this orchidaceous performer persists in giving Walker's work an ominous mood. A painting called *Daintree I* brings the shape up against a colossal dun-coloured structure which seems poised to subdue everything in its path. For all the extrovert plumage Alba displays, she suddenly looks vulnerable and diminished. In this respect, the paintings reflect the disturbing impact of Walker's first visit to Australia, where he visited Quinkan to see the Aboriginal paintings on its rock escarpments and explored the eerie, primeval atmosphere of the Daintree rainforest. No wonder the Alba shape begins to waver in the face of such awesome experiences. *Bronze Alba* is an autumnal image, where dying golden leaves replace the brilliant Japanese decoration and the surrounding vastness threatens to extinguish the entire painting with a midnight gloom.

The shape survives in subsequent pictures, but by now it has assumed a waif-like air. Ghostly white against a portentous backdrop where darkness is alleviated only by a flicker of lurid light, the Alba becomes transformed into a lonely child. These paintings, which all bear the name *Infanta*, are the most touching and heartfelt of his images. They clearly signify the emotions of an English artist who came to Australia, decided to live there and quickly became overtaken by the size and strangeness of a continent wholly unlike anything he had encountered before.

In the largest and most panoramic canvases executed after his arrival, the shape which he had brought with him as a talisman of the Western tradition in painting is pushed to one side, by jostling and assertive forms redolent of the country he now inhabited. *Melbourne Labyrinth* shows the struggle enacted in an overcast arena, whereas *For T. Summerfield* transposes it to a dazzlingly lit locale vibrating with tropical heat and glare. In the latter canvas, the Alba/Infanta shape seems on the point of melting into a blazing yellow-ochre cliff positioned behind, while other, more organic forms sprout, rear and bulge elsewhere. To my eye these huge, hectic compositions are not as satisfactorily resolved as the paintings where Walker concentrates on a few elements. Grandiloquent rather than genuinely overwhelming, *For T. Summerfield* exposes a strain of blustering rhetoric which fails to impress.

But it is greatly outnumbered by the canvases which reassert discipline and focus with far greater coherence on a direct encounter between Western art and Oceanic culture, where modernity is ranged against primitive myth. It is an arresting spectacle. The Alba/Infanta sags in the middle, as if bowing to the pressure of forces Walker feels compelled to unleash. Riddled with arrows like a St Sebastian struggling to retain his balance, this beleaguered presence no longer inhabits the stage with any sureness. The brushwork both within and without its unsteady contours becomes wilder and more ragged, giving way at times to a quotation from Matthew scribbled on the picture-surface with an urgency which matches its crusading message: 'In truth, in very truth, I tell you I am the door.'

In another context these words would serve as a comfort for the martyred saint, bleeding to death from his arrow-wounds. But here, written in an agitated hand and frequently disrupted by smearing and erasure, they appear as detached from their biblical origins as the victim reeling below them. Walker might well be inviting us to equate 'the door' with the picture plane, for his work seems increasingly ready to open up the flat surface and investigate the eerie distances beyond. He also wants to imply that the missionary eloquence of Matthew's text takes on a very different meaning when it is imposed on cultures radically removed from Christianity. Like any thoughtful visitor to Australia, Walker is conscious of the destruction which Western missionary zeal wrought in Oceania. That, surely, is why the biblical words are scrawled so peremptorily across the canvas, and why the Alba/Infanta/Sebastian shape is finally confronted by a tribal mask impaled on a pole. The primordial magic which Christianity sought to suppress has not been ousted altogether. Although cruelly displaced, it refuses to be vanquished either from Australia or Walker's own troubled imagination.

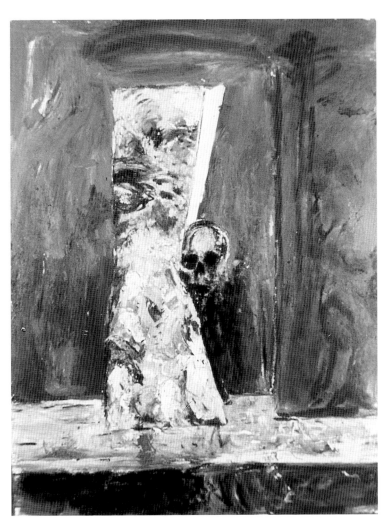

62. John Walker, *Oceania IX*, 1982

The whole complex problem involved in recognizing the validity of two utterly distinct cultures is given its most overt expression in a large 1984 triptych called *Oceania my dilemma III*. It is an apocalyptic vision, leading inexorably towards the baleful revelation at the centre. In one of the side panels a wrought-iron chair, evocative of European elegance and

lazy summer afternoons in the garden, carries a skull on its seat. Western equanimity is further shattered by another skull, floating in an indeterminate space above or behind, which seems about to burrow into the resplendent golden Alba shape and undermine its stability. It looks as isolated as the sombre mask dangling from a nearby pole, and in the other side panel it sags under the impact of the arrows piercing its bulk. The space above is once again dominated by the quotation from Matthew, but this time the words are rubbed to an almost illegible extent.

The Christian message is literally fading in the face of some powerful alternative, and the central panel discloses its startling identity. Here the Sebastian shape, drained of its colours and reduced to a blood-flecked pallor, finally keels over and gives off the defenceless pathos of a wounded animal. It appears to be slinking away from the phantasmic figure, half man and half skeleton, who rears up to fill the rest of the canvas with jutting, stick-like limbs, wildly staring eyes and a mouth parted to reveal jagged teeth. This hallucinatory invader seems at first to be triumphing over the broken shape below. But after a while it begins to look no more victorious than its martyred companion. Its staring eyes are aghast, not exultant, and it is just as divorced from its original context as the wrought-iron chair. The knowledge that it derives from the thunder-and-lightning man depicted on Aboriginal bark paintings of the Gun-winggu tribe only adds to the sense of alienation. For this mythical spirit of dreaming is in the grip of a nightmare which Walker knows will never come to an end. Even if the last vestiges of Oceanic culture were destroyed by the West, its potency would still linger on to haunt the conscience of anyone who really cares about the value of indigenous civilizations.

Walker cares, and his paintings signal the distress he feels. But they prove as well that he is galvanised by the challenge of making eloquent art out of the dilemma. In a painting called *The Maprik Head* executed in 1984, the battered yet resilient Alba shape reasserts itself on stage and appears to stare up at the tribal mask hanging from its pole. The two cultures contemplate each other without flinching, and Walker's marvellously sensuous, supple and resourceful handling shows how ardently he is fired by the task of welding these disparate extremes into a single entity. It is a daunting aim, with melodrama and incoherence as ever-present dangers. But Walker has never been afraid to pitch his ambitions as high as possible, and all the signs are that he will not overreach himself.

JUDY CHICAGO AND *THE DINNER PARTY*
21 March 1985

The extraordinary spirit of optimism which created *The Dinner Party* is announced before we arrive at the enormous, darkened arena where this feminist monument is displayed. A sequence of tapestries hanging like banners in the entrance passage make the visionary character of the work abundantly clear. Swirling images, and phrases as biblical as 'And Lo' or 'A Sign To See', look forward to a time when the feminine principle will be accorded its rightful place in the world. It is an unashamedly Utopian prospect, rooted in the hope that the goddess 'She' might one day restore the proper balance of human life. 'And then', declares the final banner, 'Everywhere Was Eden Once Again.'

Lofty statements of faith in the future are easy enough to issue, and if the tapestries were exhibited in isolation their message would seem unpersuasive. But *The Dinner Party* itself demonstrates that even the most high-flown belief can be translated into sustained action. For five arduous years Judy Chicago laboured on this massive celebration of women in history, and she needed help from almost 400 people to complete it. The amount of hard work, complex co-ordination and sheer good will involved in its execution is genuinely awesome. Needlework and china painting, two activities traditionally associated with women and deployed here on a lavish scale, require inordinate amounts of time and patience. The thirty-nine place-settings in *The Dinner Party* would never have been finished without a prodigious application of collective will-power, and on that level alone it offers a moving testament to the dedication and stamina of the makers who gathered in Chicago's California studio. Susan Hill, a prime mover in the embroidery of the runners, felt that they were all engaged 'in an effort to regain our history, to honour our tradition, and to build for ourselves an indisputable monument of proof that we can work together, sustain ourselves, be feminine and tough or masculine and soft, all at the same time'.

Related statements pepper the documentary section of the show, giving the lie to suspicions that Judy Chicago dominated the enterprise too heavily and expected everyone to execute her designs with unquestioning humility. There *is* a worrying clash between the prominence of her name and the work's supposedly collective character: a huge photograph of Chicago herself is brandished on the pavement outside, inviting visitors to go round the installation with an audio guide recorded by the artist. But her obtrusiveness in the exhibition's promotion should not be

63. Judy Chicago, *The Dinner Party*, 1979

censured too harshly. After all, she remains responsible for the conception and supervision of the entire project, and in the shadowy chamber containing *The Dinner Party* her single-minded control over the work pays immediate dividends.

It has a strong theatrical presence. Illuminated by a battery of overhead lights which make it blaze against the surrounding darkness, the gigantic table relies for its initial impact on the assertion of geometrical form. The inverted triangle is declared with as much frankness as in an abstract sculpture, and at first glance it seems to owe allegiance to the minimal-

ist aesthetic. But the primacy of its three white bars is only intended as a framework, an austere foil for the rich elaboration of the place settings contained within the triangle. Once the identity of the plates, chalices, cutlery, napkins and runners becomes clear, all thoughts of purist geometry give way to an awareness of the table's meaning.

The triangular shape is itself an ancient symbol of female power, and Chicago has explained that the thirteen place-settings arranged on each wing refer to the number of disciples at the Last Supper and the number of members in a witches' coven. Sacramental overtones are thereby fused with feminist polemic. The visitors who file so quietly around this immense object soon realise that they are attending a feast in honour of women whose contribution to history deserved commemorating on the grandest possible scale. It amounts to an act of reparation, paying homage not only to outstanding individuals but also to goddesses like Ishtar and Kali who have either been unfairly forgotten or misrepresented as destructive forces.

Chicago's own form-language is very heraldic, and clearly emblazoned on the plates. Its rigorous consistency stands in dramatic contrast to the eclectic designs on the runners, where a profusion of needlework styles and techniques is given full rein. Sometimes the runners are so outspoken that they threaten to overwhelm the plate designs, and elsewhere the relationship between them is either more evenly matched or reversed. This fluctuation reflects Chicago's awareness of the varying degrees of success these women experienced in rising above the social constraints they encountered.

A similar complexity can be found on the shimmering floor, assembled from over 2,000 hand-cast porcelain tiles, which supports the table. The tiles are covered with the names of 999 notable women, clustered in groups round the place-setting which most closely represents their activities. But inside the triangular table they seem oddly vulnerable and difficult to read, looking more like flotsam cast on to the sea than a heroic roll-call destined to be remembered for ever. For all her mighty resolve and visionary enthusiasm, Chicago acknowledges in *The Dinner Party* that the women it celebrates do not yet enjoy the place they deserve. The backs of the runners, visible across the table's expanse, are impossible to see in all their details. And although the final series of plates rises up into sculptural form, they are still confined within their place-settings and unable to free themselves completely from the plates' enclosing contours.

My main reservation about this *tour de force* of feminist collaboration centres on the 'butterfly-vagina' image which runs through all the plates. Attempts have been made to vary it in accordance with the character of

each woman and the culture of her period: Isabella d'Este's design focuses on a Renaissance colonnade, and Artemisia Gentileschi's plate displays a convoluted swirl of baroque drapery. But so many of the designs reiterate the vaginal motif that it becomes, in the end, restrictive. A celebration of distinguished men would seem narrow indeed if it concentrated too exclusively on phallic imagery, and *The Dinner Party* seems over-preoccupied with a single organic form. It is a pity. Women should be represented in all their prodigious diversity, not reduced to an image far more monotonous and limiting than Chicago can ever have intended.

PETER KENNARD
8 August 1985

Nothing, at first sight, appears to be wrong. The chimney at Willy Lott's house is still smoking gently, the dog wags his tail at the mill stream's edge, and the well-watered fields of Dedham are swept by an archetypal blend of sunlight and cloud-shadow. But then the unease begins to stir. Why has Constable's most famous painting been reproduced on poster-scale in subdued monochrome, depriving *The Hay Wain* of the high-summer richness which has helped to lodge it so securely in English affections? The answer is at once unexpected and shocking. For the harvest-wagon is no longer empty. Three nuclear missiles point up from its rickety wooden bars, and the wagon-riders have lost the placid rusticity Constable gave them. One wears an American soldier's helmet, while his companion's face is obscured by a sinister goggled mask. His gesticulating hand, which looked so harmless in *The Hay Wain* itself, now takes on an ominous note. He might well be signalling the onset of an enemy attack. At any instant this rural scene might be obliterated, and Constable's idyll transformed into a scorched wasteland devoid of natural life.

By assailing the very heart of the English people's feeling for their country, Peter Kennard's photomontage brings home the full horror of the nuclear threat. To see *The Hay Wain*'s peacefulness desecrated by gleaming war-heads makes us all realise, suddenly and unforgettably, the full implications of the danger we face. No amount of statistical information about the likely casualties, the duration of the nuclear winter and the injuries caused by the blast, can convey the obscenity of total destruction as sharply or succinctly as this image.

64. Peter Kennard photomontage from *No Nuclear Weapons*, 1981

Nor does Kennard let us off the hook in his other *Target London* posters, commissioned by the GLC to promote its policy of making the city a Nuclear Free Zone. A selection of them forms the climax of his *Images Against War* exhibition at the Barbican Centre, and they add up to a relentless experience. The missiles reappear wherever we look. At one moment they stick out of the entire globe like bristles on a porcupine's back, and then they are vomited out of the mouth-funnel worn by a masked planetary face whose eyes have been exchanged for the American and Soviet flags. Kennard sees the earth as a vessel so bloated

with armaments that it might well burst under the intolerable strain. He is haunted by the vulnerability of the land-masses where strike-forces are sited, and in one chilling image a magnifying-glass is placed over a map of Britain to reveal the fragile skeleton of a human body.

Death seems inescapable, despite the advice offered by the notorious Home Office booklet *Protect and Survive*. Kennard uses extracts from this absurd publication with sardonic precision. Selecting the phrase 'remove net curtains' from the booklet's section on how to limit fire hazards, he prints it in orange below a picture of a grievously burned face behind a window. In another photomontage, a skull is shown mournfully reading *Protect and Survive* beneath an even more risible quotation: 'Don't forget to take this booklet with you.' But the most hard-hitting attack on governmental imbecility occurs in a poster called *Inferno*, where Kennard produces a distressing aerial view of Britain consumed by a country-wide fire storm. The whole island is choking in radioactive smoke, and the terror of it is envenomed by black comedy when we read the immortal words from the Home Office booklet above the conflagration: 'If you have a home fire extinguisher – keep it handy'.

Kennard refuses to accept such ludicrous Civil Defence fantasies, which muffle the real meaning of the nuclear threat and attempt to allay our misgivings. His posters act as a much-needed corrective to the placebos provided by the HMSO, for he knows that outright nuclear war is no respecter of net-curtain removal or any other trifling manœuvres recommended to us when the final warning comes. Most of us prefer not to contemplate the prospect of annihilation, but Kennard confronts its true awfulness. In the justified belief that complacency is the most dangerous reaction of all, he shows us a land devastated by the onslaught.

A cluster of signs which would normally guide visitors through hospital are shown embedded in a pyramid of rubble, their arrows all pointing downwards. An even more disconcerting image shows the British Isles as a bleached-out radiation victim, helpless in the grasp of mechanical hands manipulated by a face peering through a sealed window. Kennard is under no illusions about what modern war means, and he uses his trenchant skills as a polemical artist to drive its reality home. Just as John Heartfield sliced and retouched photographs of the Nazi era to expose the corruption and bestiality propagated by Hitler and his cronies, so Kennard dedicates his command of photomontage to discrediting the whole notion of nuclear conflict. Heartfield understood the Fascist menace long before most people in Europe were willing to acknowledge its evil, and Kennard plays a similarly prophetic role today. He sees, with unnerving lucidity, the inevitable consequences of the arms

race. The more sophisticated our weaponry becomes, the less likely we are to survive its deployment.

Understandably enough, the prospect of total extinction is anathema to Kennard. His Barbican exhibition discloses that he has been conducting a stern pictorial campaign against war ever since 1965, when he filled the pages of a notebook with little drawings called *Vietnam Cross*. He was only sixteen at the time, and these sketches seem equally indebted to Sutherland's crucifixion paintings and George Grosz's *Christ with a Gas Mask*. Some Bacon-like studies from the same year, of *The Animals of War*, prove that Kennard was already learning how to make images of death really repellent, while a Goyaesque heap of corpses in a blackened landscape suggests that he viewed the destruction of human life with despair. But compared with his subsequent work, these early pictures are oddly discreet and restrained to a fault. Only after Kennard discovered the resources of photomontage did he learn how to discard delicacy and make bold, commanding statements. He managed, finally, to give his private preoccupations an uncompromising public voice.

If these early experiments with a new medium compare poorly with the concerted power of his recent work, they still have the capacity to offend. One day after the Barbican show opened, censorship was imposed by a major British company which had hired the foyer for a morning conference with a Chilean official. The company insisted that Kennard's *Santiago Stadium 1973 I*, which juxtaposed Chilean soldiers with carcasses in an abattoir and a strangled corpse, be removed from the wall. Another related work was covered in a blanket, but Kennard decided against removing the entire exhibition as a protest. He wanted it 'to reach as wide a public as possible'. He was surely right to do so, and the GLC poster commission has given him a marvellous opportunity to reach a larger audience than ever before. Since it coincided with and helped to precipitate the full maturity of his work, the commission produced a harrowing testament to the finest photomontage artist in Britain today. It also indicates, in the final images of the *Target London* sequence, that Kennard is now prepared to admit a strain of hard-won optimism into his imagery. After the terrible pictures of a mushroom cloud hanging over parched earth littered with shrouded bodies, of Tower Bridge in ruins and Britain as a gigantic aircraft carrier laden with deadly weaponry, an image of hope appears. Kennard shows a missile thrusting into the sky and then, stage by miraculous stage, shedding its deadly cargo until an ear of wheat is revealed. It stands as a salutary metamorphosis.

HOWARD HODGKIN
10 October 1985

Ever since its doors opened, the Whitechapel Art Gallery has effortlessly established itself as the most beautiful exhibition space in London. But now, after a two-year closure period when it has been greatly missed, the remodelled and extended building seems even more beguiling than ever. The airiness and exhilarating sense of space in the ground-floor gallery has been intensified, so that it heightens the perceptions of anyone looking at the art on display.

The same improvement can be found in the upper gallery, and in a new exhibition space on the same floor where Jacqueline Poncelet's textured clay works extend their pincers, spikes and horns across walls and floor alike. Pushing her work towards sculpture and away from an earlier involvement with craft ceramics, Poncelet has mounted a lively and inventive show. It promises well for the programme pursued by the New Gallery, where younger artists will be able to show their work independently of the exhibitions in the main galleries. It is as welcome an addition to the Whitechapel's facilities as the lecture theatre, education room and audio-visual room, which will enable the staff to develop their educational role and strengthen their already close links with the local community.

But the Whitechapel devotes the major part of its exhibition space to artists of international stature, and the main event at the moment is a distinguished selection of fifty paintings by Howard Hodgkin. We have seen far too little of his work since the Arts Council's memorable retrospective in 1976. That survey convinced me that he was one of the most rewarding painters in Britain, and I have been keenly looking forward to his Whitechapel exhibition. I was not disappointed. Rather than simply confirming my previous admiration, the new show proves that Hodgkin has developed and enriched his art very considerably since 1976. He is now at the height of his powers, and the inclusion of a few paintings from the mid-seventies reveals just how much he has changed over the past decade.

When I last saw *Grantchester Road*, it seemed to announce a grander, more confident and freely expressive phase in Hodgkin's work. But compared with the paintings he has subsequently executed, it now looks restrained and almost severe. The rectilinear strength of architectural forms dominates the picture, preventing him from allowing his innate exuberance free rein. Since then, however, he has learned how to loosen up and explore a more uninhibited and sensuous vision. The preoccupa-

tion with memory is still there, and he continues to favour the device of a containing frame through which people and places from the past can be summoned and given new meaning. The attachment to a particular moment in the artist's life, like the experience celebrated in *Grantchester Road*, is still as paramount as ever. But the recent paintings are less dependent on a literal reconstruction of the personalities and surroundings Hodgkin remembers. The emphasis now is placed, not so much on portraits of particular individuals in their habitual settings, but on the artist's own emotional autobiography. Titles like *Day Dreams*, *Reading the Letter* and *Counting the Days* now predominate. Many of them are less specifically attached to locations than before, and more bound up with the drama of a mood.

The range of feeling has widened, too. Sometimes, as in *Sad Flowers*, the entire painting seems on the point of dissolving into melancholy. A couple of Hodgkin's brushmarks cascade down the panel like rivers in full flood, and the composition is spattered with drops of intense blue as if a rainstorm were about to develop. It conveys the sensation of weeping with extraordinary directness, and Hodgkin is equally effective when he deals with sharper and more poisonous feelings. Always capable of working powerfully on a small scale, he shows in a little painting called *Jealousy* how to transmit a stabbing emotion as well. The outer areas of the picture are overcast, as though Hodgkin were viewing the incident through a dark cloud of anguish. In the middle of this fuzzy umber and sombre sepia, a tiny rectangle lights up the image. It seems to contain an orange figure, hunched uncomfortably against an acid combination of lemon and lime. Although a sense of mystery pervades the painting, the sourness of its central section is painfully apparent.

On the whole, though, Hodgkin is far too buoyant and expansive an artist to linger over negative emotions for too long. The other most remarkable development in his new work is its frank declaration of the erotic. Several paintings take bedroom pleasures as their theme. *Clean Sheets* employs long, straggling strokes of mint green to celebrate the delights of fresh linen and, at the same time, the excitement of bringing disorder to a newly made bed. The sensuality becomes even more heated in a painting called *In the Honeymoon Suite*, where layer upon layer of warm red pigment enclose a visceral image. Its looming forms and smouldering colours seem preoccupied with swellings, cavities and orifices. A highly private painting, it shows that Hodgkin is prepared to disclose moments of sexual intimacy which would never have appeared in his earlier work. Now he is willing to share even his most secret pleasures. *Waking Up in Naples* places us next to a sun-tanned body

65. Howard Hodgkin, *View from Venice*, 1984–5

reclining on a bed. Hodgkin's brushwork takes on a new tenderness and spontaneity as he summarises the impact of early morning sun on naked flesh. His paint here has an almost oriental delicacy, and beyond the glowing body he washes in a broad expanse of turquoise light which irradiates the entire upper half of the picture.

The vocabulary of marks employed by Hodgkin has grown more supple and eloquent in recent years. He moves, at will, from tight, urgent thrusts of the brush to the most liquid sweeps of pigment. They carry much of the work's potent emotional charge, and always conjure up the physical actions which brought them into being. His latest paintings are the most outspoken of all in this respect. *Souvenirs*, by far the largest picture Hodgkin has ever made, covers an elaborately composed scene with a huge screen of bold green circles. They threaten to obliterate the painting beneath, allowing it to show through only in tantalizing fragments. Hodgkin thereby thwarts our natural desire to see with clarity, and all the evidence suggests that he is becoming increasingly concerned with dissolution and flux.

A decade ago, in a painting like *Small Durand Gardens*, the curving elongated figure, chunky window and compact furniture were all realised with great lucidity and firmness. The components of the design all looked as solid as the thick wooden base Hodgkin always likes to paint on. But today, this palpability has been replaced by a more evanescent vision. In *None but the Brave Deserves the Fair* both figure and surroundings appear to be melting. Physical substance is giving way to a more ethereal alternative, and Hodgkin's pigment assumes a wispy character which washes the painting in a film of milkiness. Sexual ecstasy of the most rapt kind is the theme of this panel, where the brushwork seems to have been applied by a man whose desires are thoroughly sated. But the process of loosening and blurring also characterises other recent paintings dealing with very different themes, indicating that Hodgkin is now probing deeper than ever before into the recesses of his innermost memories.

FAY GODWIN
31 October 1985

To a casual eye, Fay Godwin might appear simply to be celebrating some of her country's most familiar landmarks. Glencoe, Avebury, Stourhead, Montacute House and the White Horse of Uffington all appear in her photographs, just as they do in countless calendar surveys of Beautiful Britain. But anyone who takes the trouble to look at Godwin's work more closely will realise that she offers a refreshing corrective to the picturesque tourist view. There is nothing glamorous or predictable about her approach, and even the most well-worn location seems to have been observed as if for the very first time. Far from wearying us with yet another prospect of a prehistoric chalk drawing, she trains her lens on the White Horse's eye and reveals how closely its form is integrated with the plunge, swell and curve of Dragon Hill. Rather than looking like a drawing imposed on the landscape, the White Horse seems in Godwin's photographs to be almost indistinguishable from the ground on which it is inscribed. And this sense of an unforced union, often between the most surprising and apparently irreconcileable elements, can be found time and again in her Serpentine Gallery exhibition.

Look at her study of a *Pillbox near Appledore, Kent*. Unassuming at first, the squat and boorish hulk of this deserted structure soon takes on an

enigmatic mystery. Surrounded by the trees and plant-life of the Kentish landscape at its most sylvan, the pillbox and its two defensive windows demonstrate that the most lyrical stretch of countryside can harbour ugly instruments of war. But the overall mood of this photograph is elegiac rather than aggressive. The pillbox is mouldering, and the lichen already spreading over its crude blocks of concrete suggest that nature is gradually beginning to soften and smother its harsh cubic volumes.

The whole process is already far advanced in a study of *Lumb Valley, Yorkshire*. Her title this time gives nothing away, and at first the dark column rising out of the sloping woods could be mistaken for a massive tree-trunk. Then the fall of light, which often plays a gentle yet dramatic role in Godwin's work, discloses that the form is made of bricks. This mouldering chimney, which must once have asserted itself in Lumb Valley with all the thrusting confidence of the early Industrial Revolution, is now enfolded by spreading ferns and sun-flecked foliage. I suspect that Godwin takes enormous pleasure in witnessing such acts of quiet but thoroughgoing reclamation. Although a photograph like *Stranded Materials, Pett Level* proves that she admires the clean-cut, angular geometry of modern building components dumped on a beach, her fundamental affections lie in the countryside at its most unsullied. She does not even allow people to inhabit her landscapes. Channel ferries are

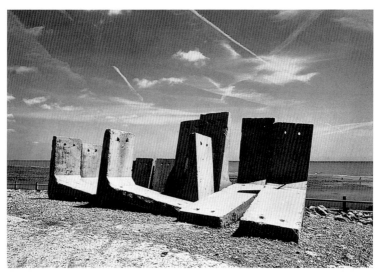

66. Fay Godwin, *Stranded Materials, Pett Level*, 1984

glimpsed, in a particularly compelling picture, moving mistily to and from the Eastern Docks at Dover. But their human cargo seems irrelevant, and the boats themselves look oddly insubstantial compared with the snow-covered cliffs dominating the foreground.

Wherever she goes on her long, attentive wanderings through the country, Godwin is always acutely conscious of the land as a primordial presence. Contemporary intrusions on the locales she scrutinises are seen as temporary phenomena, and relegated to a suitably subordinate position. Cooling towers are only seen as pale apparitions hovering in the hazy distance, looking flimsier still in contrast with the broken yet redoubtable masonry of Richborough Castle. The thin columns of Kemsley Paper Mills seem on the point of sinking into a tangle of grass, stones and wild flowers at the Swale; and when Godwin does allow a car to occupy the most prominent part of her composition, it is already a rotting wreck half-submerged in the detritus-filled waters of Cliffe Lagoon.

A quirky sense of humour is detectable in some of her photographs: a picture briskly called *Royal Military Canal* reveals rank upon rank of sheep lined up on the opposite bank, staring across at the intruder with uniform expectancy. They look like a comic army determined to resist any unwelcome advance on their territory, and Godwin's role as an observer is brought to the forefront of our attention. But the rest of the photographs contain few reminders of her presence in the scenes she surveys. The least demonstrative of photographers, Godwin cultivates reticence almost as a mark of respect for the landscape. Like Richard Long, whose admiration for standing stones and prehistoric mazes she fully shares, her work is rooted in a profound belief in the sanctity of nature. Rather than disrupting the countryside, they both seek to honour its inviolate character. Hence their preference for remote locations where mechanization has not yet been able to tarnish ancient harmonies. Godwin cherishes the isolation and purity of Barbary Castle Clump in springtime with a fervency which recalls Paul Nash. She may stop short of his visionary response to similar clumps marooned on swollen hillsides. But her rapt veneration of the Barbary Castle trees, bowing to the wind as it rustles and cleanses their sprouting branches, shows how much in thrall she is to the allure of a special place.

Sometimes Godwin finds this heightened significance in the most unexceptional setting. At Cratcliffe Tor in the Peak District she turned away from epic panoramas in order to focus her lens on a scattering of the most slender wild grasses sheltering near a massive rock. They look frail up against its deeply shadowed immensity, and could easily be crushed if the rock ever shifted in its bed. But when she took her

photograph, they exemplified the balance between strength and delicacy which she values in nature. Godwin is constantly impressed by vulnerability, whether she finds it in a group of tiny silhouetted cows dwarfed by a looming Cumbria mountainside, or in the lonely sapling on the horizon of an otherwise bleak and levelled moorland near Tomintoul. On the rare occasions when she includes a house, hotel or caravan, they are invariably seen from a considerable distance which stresses their diminutive status in the surrounding vastness. Perhaps that is why the standing stones of Orkney and Lewis appear so often in her work. They embody, even in rings and clusters, the uncompromising solitude experienced by anyone prepared to explore the wildest stretches of the country. Looking at Godwin's study of a single stone from the Ring of Brogar, I was struck by its highly anthropomorphic identity. It seemed to take on a weathered human character, standing with battered yet resilient poise in a landscape which offered no discernible shelter from the elements.

Always aware of decay and evanescence, but eager to affirm the notion of continuity and survival as well, Godwin's best work extends well beyond the polished blandness of most landscape photographers. Her underlying concerns are movingly summarised in a picture taken *From St Andrews Cathedral Tower*. Half the composition is filled with the gravestones far below. But any incipient melancholia is offset by the action of the light, which makes each stone cast a long shadow towards the edge of the land beyond. A huge shadow, flung out from the tower itself, actually succeeds in traversing the churchyard and reaching the water. Here its thrust is taken up, in a different direction, by an old harbour wall. So the straining diagonal interplay between crosses, shadows and churchyard perimeters gives way, finally, to the consoling placidity of an immense, enduring sea.

R. B. KITAJ
5 December 1985

Rembrandt's *Polish Rider* bestrides his mount with imperturbable poise. The dusky countryside he moves through may contain hidden threats, and his animal's hind legs are eerily reminiscent of a drawing Rembrandt once made of a skeleton horse in the anatomical theatre at Leyden. But the possibility of danger is confronted with calmness by the rider's deter-

67. R. B. Kitaj, *The Jewish Rider*, 1984–5

mined gaze. His youthful features look serene in the evening light as he surveys the landscape, and the weapons slung round him imply that his vigilance will never falter.

Kitaj's *Jewish Rider*, by contrast, is ageing and defenceless. Slumped on the seat of a train, he stares down into his own troubled thoughts rather than scrutinizing his surroundings. Perhaps he has just turned away in consternation from the view through his window, where a line of black smoke drifts out of a tall chimney towards a cross on the hilltop nearby. The terrain all around looks parched, as if the heat generated by this sinister incinerator had spread throughout the area. It certainly seems to have penetrated the train, scalding the passenger's trousers with vehement slashes of scarlet and orange. The entire compartment appears air-

less and claustrophobic, suggesting that the man is trapped in a cell from which he cannot escape.

Outside the door Kitaj has included a thin, vertiginous strip of red carpet, shooting up towards a uniformed conductor who appears to be brandishing a stick. The jerking figure struts and scowls, apparently bent on keeping the traveller in his place. So the rider has no alternative but to endure his confinement, in a stifling chamber where even the head-rests jut out from the wall with aggressive force. Kitaj's brushmarks are at their most hectic in this area of the painting. Their jarring rhythms reinforce the cacophonous colours, and the voyager looks haggard. All the same, he thrusts his right arm out in exactly the same stubborn pose as the *Polish Rider*. The elbow projects boldly into the room, a resolute gesture defying the cramped space he inhabits. Despite everything, this balding and burdened man is fortified by a sense of resolution. Discernible on the seat beside him is the vestigial form of a horse's head, closely based on the animal in Rembrandt's painting. It implies that the Polish rider's vigilance is inherited in the train's compartment by a wanderer who keeps the dilemma of the Jewish race at the forefront of his mind.

So, too, does Kitaj himself. In the preface to the catalogue of his impressive and absorbing Marlborough Gallery exhibition he declares that 'the subject which interests me much of the time' can be called 'Jews in trouble, or – Jews in danger.' In recent years, as a result of what he describes as his attempt 'to give myself (back) to myself', Kitaj has become overtly concerned with his Jewish identity. Apart from the *Jewish Rider*, this preoccupation is most memorably expressed at the Marlborough show by *The Jewish School*. Marco Livingstone points out, in a handsome and informative new book on Kitaj, that the canvas is based on a nineteenth-century German anti-semitic engraving. By depicting a group of Jewish children misbehaving themselves in the classroom, the engraver hoped to discredit them and expose their supposedly deep-seated anarchy. But Kitaj transforms this disreputable propaganda into a profoundly sympathetic vision of the Jewish condition. The boy writing on the blackboard no longer looks like an unruly scribbler. With conspicuous care, he defines the facial contours of a golem – the legendary Jewish figure who is brought to life by supernatural means. Sure enough, the white outlines grow into the limbs of a flesh-coloured human, who seems about to step out from the blackboard and establish an independent and miraculous identity.

But the handling of thighs, calves and feet is still unfinished. The figure is therefore incapable of saving the children, and this crucial failure gives a wholly new meaning to the boy butting his head against a brick

column elsewhere in the composition. Although he might have appeared merely bad-tempered, in this context his drastic gesture can be seen as a fierce protest against the fate which will overcome so many of his race. Kitaj's brushwork, far more freely expressive now than it was a decade ago, matches the turbulence of such a theme. The schoolroom's wall and floor are covered in broken patches of lime, mustard and lemon which have an appropriately bitter impact. It is an outspoken painting in every respect, and even its humour is boisterous: an upturned well on the teacher's lofty desk is caught at the moment when dark ink is spilling towards the pupils below. The pervasive presence of the chimney elsewhere in Kitaj's new work also prompts us to see the brick column in this tragic light. The boy could, quite literally, be throwing his head against the kind of structure where victims of the Nazi holocaust met their deaths.

Kitaj is haunted by the persecution of the Jews, and a series of oil studies for *Passion (1940–45)* deal head-on with the concentration camps themselves. They are, as befits their harrowing theme, elegiac images which meditate on all the senseless waste with grief rather than anger predominating. But not all his recent paintings are suffused with gloom. In *Cecil Court, London WC2 (The Refugees)*, a summoning-up of his early years in the metropolis, he deals with some of the survivors of anti-semitic victimization. As if to celebrate their good fortune, the figures enliven the alley-way of second-hand bookshops with outlandish and even gravity-defying poses. Their semi-airborne elongation is reminiscent of early Chagall, another artist who wanted to bring about a fusion of Jewish culture and European modernism. Their declamatory attitudes and almost acrobatic showmanship derive from Kitaj's involvement with the 'beautiful craziness' of Yiddish Theatre, and in *Cecil Court* a feeling of affectionate exhilaration triumphs over the dislocation these characters also experience.

Kitaj, in fact, knows just how to amalgamate pathos and exuberance in a complex union. At first sight, his *Amerika (Baseball)* looks like a rip-roaring tribute to boyhood memories of the pick-up ball games he played as a teenager in the small upstate New York town of Troy. Many of the figures swing their bats and hurl their balls with festive animation. But the more this painting is examined, the stranger it becomes. Compared with the heroic close-up studies of baseball players Kitaj made in the 1960s, these flailing figures seem oddly diminutive. However hard they strain, swerve and stretch, their bodies are dwarfed by the immensity of the blue arena. After a while, I grew more conscious of the empty spaces in this picture. They outweigh the frenetic activity and

make each player seem almost vulnerable. The feeling of isolation was confirmed when I realised that Kitaj had adapted his tree-fringed setting from the huge field where Velázquez painted Philip IV hunting wild boar. Transplanted from America to Spain, and yet informed by lingering memories of Ohio and Troy, the figures performing on this immense plain all appear oblivious of their surroundings. But to our eyes they look displaced, and in front of their enclosure Kitaj has painted himself staring back at their exertions with tiredness on his blanched face. He could well be brooding on his own position, as an American Jew who has chosen to settle in Europe and yet feels impelled to recover an identity he had earlier been in danger of ignoring. His decision to adopt the spelling of Kafka's *Amerika* signifies his awareness of exile clearly enough, and the baseball players do indeed seem poignantly beyond reach. But in terms of his art, Kitaj now shows every sign of finally arriving home and producing grand, impassioned images which augur well for the paintings yet to come.

JIM DINE'S GRAPHIC WORK
27 February 1986

Some artists regard prints as little more than a by-product of their main work. Images already brought to a refined state as paintings reappear, scarcely altered, in the form of glossy screenprints. The results are depressing. They look like reproductions rather than works conceived during the print-making process, and prompt the suspicion that commercial motives alone brought them into being. For what other impulse could possibly lie behind such spurious enterprises? Failing to extend the artists' vision in any discernible way, they appear to be merely an easy means of making money without bothering to invent something new. The print, in these all too familiar circumstances, deteriorates into a spin-off. It devalues an activity which can produce a body of work as supreme as Picasso's *Vollard Suite*, where the resources of etching and aquatint are deployed with exquisite mastery.

I do not want to suggest that Jim Dine has attained anything as formidable as Picasso's level of achievement. But the exhibition of his recent graphic work at Waddington Galleries offers heartening proof of an artist who still regards print-making as an essential – and indeed central – part

of his work. Most of the pictures displayed here are as imposing in dimension and substantial in form as grand paintings. The prices they command are also very sizeable, amounting in one case to a hefty £7,250 for a fourteen-colour woodcut in an edition of seventy-five. Dine and his dealer stand to gain over half a million pounds if the entire edition were sold, so print-making today can be an enormously profitable undertaking. But at least these prints are handsome in the extreme, demonstrating that Dine takes just as many pains over their production as he would over an oil.

He does, in fact, undermine any rigid divisions between different techniques and materials by fusing them in sometimes very elaborate procedures. As if to acknowledge their importance, the gallery captions give precise and detailed information about the making of each exhibit. And they are fascinating to read. The multicoloured *Nine Views of Winter* consists of a 'woodcut from one sawn mahogany plywood block and one stainless steel plate, printed in two colours with hand painting in several colours of oil and white oil stick after second printing, with scraping after editioning'. In other words, Dine sees no reason why the act of cutting and the act of painting should not go hand in hand, contributing so deftly to a multi-layered whole that we often cannot tell where one strategy ends and another begins.

The range of expression Dine commands is unusually wide. On one wall, in *Two Hearts for the Moment*, he uses a combination of hand-painting and lithography to produce an image almost as rich and opulent as an oil on canvas. Then, in a very different mood, he employs etching and drypoint to make a notably austere study of a skull called *The Side View*. In both cases, the technique is used to reinforce the meaning Dine wishes to convey. The hearts are exuberant and almost seem to pulsate in front of our eyes; the skull is bleached and brittle, long since drained of everything the heart exists to sustain. These two polarities dominate the entire show, giving it a life-or-death momentousness.

Dine was fifty last year, and a growing preoccupation with mortality is evident in his recent work. Since he has always been an autobiographical artist, the skull could well be intended as his own. Unlike John Walker, who has also made extensive use of very Cézannesque skulls in the last few years, Dine's *memento mori* seems quite personal. It certainly haunts the exhibition, appearing at one point in a diptych next to the heart. But perhaps its most startling appearance occurs in a print where the skull is clustered with a blood-red heart and a looming crucifix. The outspoken emotionalism here links Dine with younger American artists like Julian Schnabel, who in his time has tackled the Golgotha theme

68. Jim Dine, *The Side View*, 1986

with unabashed, even reckless ardency. Dine's treatment of the skull motif looks reticent compared with such neo-expressionist rhetoric. But there can be no mistaking the sombreness which overtakes his work whenever the death's head comes into view.

Its presence in the show gives a macabre edge to the group of darkly bearded and bald self-portraits, all of which show the artist as a grim presence frowning at his reflection in the mirror. Far more impressive than Dine's other, strangely uncertain and disquieting portraits of his wife Nancy, they confirm the feeling of bleakness which now gives his work a more tragic dimension. Even the heart becomes black in one brooding print, and an ominous image of a fir tree bedecked with blossom is

remarkable for its monochromatic sobriety. It could be a Christmas tree, but the unrelieved emphasis on grey and white suggests that Dine is in no mood to produce a straightforwardly festive picture here. His idea of Christmas is far more likely to be conveyed by a chilling image – the kind of print exhibited under the title *Winter Window on Chapel Street*, where the ubiquitous heart has turned white as if encrusted with ice.

Dine is fascinated by the metamorphoses a single image can undergo. Near the frost-laden picture, an identical heart exudes the warmth of high summer against a sensuous green-and-yellow ground redolent of dappled foliage. He also enjoys playing with styles in a more detached vein, executing versions of the Venus de Milo which vary from planar cubist severity to a flowing idiom which lets the artist's 'handwriting' display itself with great suppleness. Ultimately, though, Dine refuses to hide himself behind style in the way some artists prefer. He likes to declare himself and his obsessions with as much vigour and directness as he can muster, brandishing a full-blooded involvement which reminds us of his early association with Happenings, Oldenburg and the heady days of Pop Art.

This show charts the middle age of a man who has left the brashness of Pop far behind, and yet still reserves the right to make a frank, frontal assault on our emotions. Occasionally the sheer weight of feeling threatens to overwhelm these prints, as if Dine had failed to discover an adequate means of articulating his inner turbulence. A book of poems he illustrated recently, called *The Temple of Flora*, is pertinent in this respect, opening as it does at a page where Robert Hass's *Passiflora* explores the theme of mating whales. Hass speculates about one of the whales, declaring that 'the thought he can't quite form is like the passionflower, hopeful, obscure, a little too involved'. The same simile could well be applied to some of Dine's more outspoken and optimistic prints, especially when his hearts start throbbing with so much colour-saturated feeling that they verge on the melodramatic. The most exclamatory of the bath-robe pictures – those strange headless effigies, swathed in garments which seem more important than the figure they enclose – likewise look excitable to a fault. But this tendency to indulge in overheated demonstrations of emotion does not mar Dine's finest prints, where his commitment to the medium is wedded to an obsessive concern with both the joy and the vulnerability of human experience.

ADRIAN BERG AND VICTOR WILLING

10 July 1986

As artists, Adrian Berg and Victor Willing could hardly be more differ-ent. Both are British, in their late fifties, with a long commitment to painting behind them. And both have now been given major London exhibitions which confirm their reputations: Berg at the Serpentine and Willing at the Whitechapel. But there the connections end. Berg has concentrated, for the past quarter of a century, on looking outwards: he has subjected the flowers and foliage visible from his Regent's Park flat to a tireless, devoted scrutiny. Willing, by contrast, has only defined his true identity over the last decade, and he has done so by looking inwards. While Berg experienced little hesitation about recognizing his principal source of inspiration, ever since he began painting the view at Gloucester Gate, Willing struggled hard to arrive at his own pictorial territory. He succeeded, after returning to London in 1974 from a protracted period in Portugal, by leaving direct observation behind and painting his intense hallucinations instead. This reliance on a visionary world released Willing from the constraints of working from life, an activity which had inhibited his development before then. Berg, on the other hand, began to thrive after abandoning his early preoccupation with grids, maps and game-boards in favour of studying the landscape at first hand.

The prevailing moods of their work are sharply at variance, too. Berg's art, as befits a man who has spent so much of his career gazing at one of London's most beautiful parks, is predisposed to celebrate. He rejoices in the burgeoning trees and blooms which often billow out to all four edges of the canvas, enfolding the viewer in an efflorescence of leaves, petals and blossoms. Although he is fascinated by the changes a landscape undergoes, throughout the year, there is no apparent undertow of melan-choly attached to the cycle of growth and destruction. He first discov-ered how to paint Regent's Park when the snow fell and clarified every-thing within sight. So Berg's work does not treat winter in an elegiac spirit. Several recent paintings take months as uncompromising as November and February as their subjects, but the outcome is far from severe. The wild and intricate patterns described by frost-laden branches give the park an irresistible vitality, and Berg warms each panorama with a defiant abundance of crimson, purple and mauve. The presence of such resplendent colours, at times of year which most painters find sombre and bare, is a measure of his determination to irradiate even the chilliest prospect. In Berg's work, all the endemic frustrations inflicted on the rest

69. Victor Willing, *Place with a Red Thing*, 1980

of us by the English climate fall away. We are left with a shimmering, luxuriant and sometimes overpowering vision of Arcadia, and the artist seems bent on persuading both himself and his audience that his permanently enchanted land really does exist.

The world presented by Willing's work is, however, wholly induced by daytime dreams. Even if he had not explained that many of his largest paintings spring from hallucinations, their origins would still be clear. Their eeriness is equally inescapable. Unlike Berg's buoyant and endlessly fructifying gardens, the arena defined by Willing's art is austere, ominous and enclosed. The space in most of his pictures is bounded by unadorned walls, and the suggestion of a cell is confirmed by the props they contain. In a huge triptych called *Place* a rudimentary structure is installed within the room, like a hut built by someone marooned on an alien island. A tropical plant sprouts in one of the side panels, but there is no hint of the exotic surroundings which should accompany it. Embedded in a yellow tub, and pitched against a plain grey wall behind, the plant appears just as constrained as the boat in another of Willing's canvases. For this hapless vessel, its sail cut loose and deck devoid of human life, is

beached in an acid green interior. A spotlight is trained on the boat, and a distant doorway seems to offer a glimpse of sun beyond. But there is no indication that escape is imminent for the stricken craft. It is condemned to endure these claustrophobic confines; and other pictures imply that change, if it does eventually occur, will be for the worse.

One bleak triptych shows the ubiquitous room awash with mud. Although an outsize daffodil manages to rise above this threatening liquid, the entire space is presumably at risk. So is the enormous plant which spreads itself across the expanse of *Cythère*. The colours it flaunts are almost as flaring as the banks of flowers in a Berg park, and yet Willing's plant derives no sustenance from its environment. Bare blocks stand behind, offering an arid rebuff to the whole notion of untrammelled growth. All Willing's imagery is riddled with intimations of loss, suffering and extinction. Empty clothes dangle from a swing supported by pale blue columns too thin to stay upright for long. A snake-form curls round a stunted tree as if to crush its last vestiges of life. And in one of the last big canvases, executed just before multiple sclerosis forced Willing to concentrate on smaller works, a Charon-like *Boatman* brandishes his pole as if inviting passengers to board his ferry for the next life.

Does Berg's work therefore have anything in common with Willing's? Beyond their shared belief in the continuing potency of the painting tradition, very little. But the gap between Berg's hedonistic desire to embrace the richness of the outside world, and Willing's withdrawal to a stark inner chamber where hope is hard to find, can still be exaggerated. After all, there is a satisfying tension in all Willing's best pictures between the declaration of despair and an equally powerful urge to counter it with analytical restraint. The earliest canvas on view reminds us that his relentless use of an interior originates in the life room at the Slade, where William Coldstream taught him much about the virtues of reserve. Willing afterwards fought against Coldstream's influence, and only matured as an artist when he escaped from that kind of tenacious observation. But the notable coolness and understatement of his finest canvases prove that he has always preferred to filter anxiety through a discipline as strict, in its way, as the careful scrutiny informing his early life-room nude. Much of his work, paradoxically, is marked by a stillness which gratifies even as it refuses to console.

Nor can Berg be described simply as an incurable sensualist who wants to do nothing more than immerse himself in the opulence of nature. For one thing, his drawings are surprisingly spare and undemonstrative, accompanied more often than not by detailed notes about the sunlight, the colours and the types of trees he depicts. Moreover, his completed

canvases testify to a restless desire to go far beyond retinal sensation. Berg is forever dividing up his canvas into thin strips, so that several different stages in the year can be compressed in a single image. He also likes to fuse four views of a landscape in a picture which offers a coherent reading from every side. The man who once plotted map-like paintings is still detectable here, marshalling and multiplying until he threatens, in an immense new canvas of Sheffield Park, to assault us with a surfeit of reiterated vistas. There is something uncomfortably driven and overworked about these daunting summations. They suggest that Berg's intoxicated vision of Eden may at heart be a hard-fought affair, beleaguered by the constant effort involved in keeping less idyllic insights at bay.

FOSTER, ROGERS AND STIRLING
16 October 1986

A few years ago, the whole notion of staging a celebratory exhibition of new architecture at the Royal Academy would have seemed risible. After all, what on earth was there to celebrate? The public perception of architecture was disastrously jaundiced. Far too many stained concrete megaliths had been constructed and found wanting, often in place of historic buildings whose loss was deplored. Architects did not seem to care about either the surroundings they violated or the people doomed to inhabit the brutal edifices they erected. The only priority seemed to be functionalism of the most depressing kind, closely allied with the desire to reap obscene profits at the expense of everyone's environment.

I have few illusions about the extent to which architectural attitudes have changed since then. Only the other week, this column deplored the lost opportunities in the design of the new Terminal 4 building at Heathrow, where yet another inhospitable interior now alienates the visitors it is supposed to welcome. But there is, at the very least, widespread acknowledgement among young architects that the old soulless solutions are no longer excusable. And in Britain the three representatives of the older generation whose work seems to offer most hope for the future are Norman Foster, Richard Rogers and James Stirling. This much-publicised triumvirate are the heroes of the RA survey, and the works they display there put forward a variety of solutions to the problem of regenerating architecture in the late twentieth century.

The exhibitor most clearly allied to the functionalist legacy is, paradoxically, the youngest of the three. Foster's colossal £500 million Hong Kong Bank, probably the most expensive building in the world, fits quite happily into its skyscraper-strewn location. From the outside, in fact, its gaunt forms constitute an extreme statement of the machine aesthetic rather than proposing an alternative. But inside, Foster's desire to arrive at a more inventive and warm-hearted architecture is evident immediately. Instead of the conventional stack of standardised storeys, linked by lifts which afford no idea of the structure they pass through, the Hong Kong Bank offers an opened-out space pierced by vast escalators. Without visiting the building, I cannot tell whether the experience they provide is exhilarating or merely vertiginous. But Foster seems to have employed the most sophisticated and innovative of technological resources to produce a more stimulating, spatially varied interior than mega-office-blocks have ever provided before. The boldly exposed cruciform structure of the mighty shafts shows, too, that Foster can create architectural forms as muscular and dramatic as the 'strainer arches' in Wells Cathedral — a precedent which suggests he admires architecture of the past as well as the great modernist achievements.

Since he designed the Sainsbury Centre for Visual Arts in Norwich some eight years ago, Foster has learned how to make his buildings more congenial for the people who work in them. At the Sainsbury Centre I was shocked to discover how small and oppressive the university teachers' offices were, especially in comparison with the lightness and amplitude of the gallery area. But his abandoned designs for the BBC's new Broadcasting Centre, which occupy an entire gallery at the RA, turn the entrance into an airy atrium where visitors could enjoy shops, exhibitions, a café and even a Museum of Broadcasting. I fear that the BBC's alternative building at White City will not prove as inviting as Foster's proposal, which honours its context by offering from its interior a view through the glass frontage of Nash's All Soul's *tempietto* across the street.

Foster, who also acknowledges the Nash church through the very positioning of his frontage, is conscious no doubt of Nash's single-minded ability to carve a great thoroughfare from Regent's Park down through the heart of the West End. And Rogers, a former partner of Foster's in the early days of 'high-tech' enthusiasm, would like London to regain the spirit of grand enterprise that once enabled Nash to transform the metropolis. The most spectacular item in the RA show is neither a scale model nor a photograph of a building — it is an expanse of water traversing most of the longest gallery in Burlington House. Signifying the Thames, it leads up to a model of the bridge which Rogers would like to fling across the river in

70. Richard Rogers, model of the proposed new bridge for London, in the exhibition at the Royal Academy, London, 1986

place of the unlovable Hungerford Bridge. Taking his cue from the elegant Brunel suspension bridge which used to occupy this site, he proposes a biro-thin walk-way supported by a science-fiction steel tower. Equipped with circular viewing platforms and a cluster of other unspecified public amenities, this shining structure rises into the air like a space station built for Dan Dare on the banks of the Thames. Rogers' instantly recognizable form-language often reminds me of the environment inhabited by *Eagle*'s pioneering cosmonaut in the 1950s. The bridge would be an audacious addition to the riverscape, but no more of an affront than the much-mourned Skylon which reared up from its launching-pad in the Festival of Britain period.

I find the full implications of Rogers' ambitious plans for the South Bank site and the Embankment opposite rather difficult to grasp. Will commuters *really* be prepared to accept the wholesale sweeping-away of

Charing Cross Station, which means that they would have to take a monorail shuttle across Rogers' bridge from Waterloo? It would clearly be less convenient for them, and yet I am in great sympathy with Rogers' desire to animate the Thames. For the most part, the river is an asset London ignores, and any imaginative attempt to facilitate its enjoyment should be supported. So ought Rogers' bid to provide a better-planned link between Trafalgar Square and the South Bank area, which at the moment seems far too remote from the other side of the Thames. The political and organizational clout to implement Rogers' plans may be lacking, but the members of the new South Bank Board would do well to look closely at his vision of the site they now control.

The completion of Rogers' new building for Lloyd's ensures that London at last possesses a full-blown sample of the gregarious and spectacular style which makes the Pompidou Centre such a popular landmark in Paris. With its openly declared debt to the Crystal Palace, and an equally wholehearted commitment to maximum flexibility in the technological age, the Lloyd's structure has already stamped the City with its ebullient identity. But James Stirling has not, as yet, been so fortunate. None of his Tate Gallery buildings is complete, and his shortlisted entry for the National Gallery extension was passed over in favour of Robert Venturi. The extensive series of plans for the building demonstrate its exceptional quality, chiming with a sensitive location while asserting glass-walled modernity as well.

This felicitous fusion of elements from the present and the past lies at the centre of Stirling's mature work. Having started his career as an unrepentant modernist, most notably with the stern and lucid Leicester University Engineering Building, he later recoiled from an aesthetic which led him to design two stark housing developments at Runcorn New Town. The passion for severity and precise structure still informs his buildings, but at Stuttgart his extension to the Staatsgalerie also introduces a wealth of historical references. The outcome, which combines elements of the machine aesthetic with neo-classicism and courteous tributes to Stuttgart's architectural past, might easily have deteriorated into an eclectic jumble. But Stirling's bracing rigour, and his ability to quote from history without indulging in pastiche, ensures that the Staatsgalerie building is a coherent and distinctive achievement. Moreover, it is savoured by the visitors who walk round and relax among its ramps, footpaths and monumental drum, thereby proving that today's architecture can find public favour without completely rejecting modernism in a headlong flight towards the seductive consolations of tradition.

SOL LEWITT

20 November 1986

At a time when figurative painting of the most heated and expressionist kind is still so fashionable, Sol LeWitt's art might well find little support. Cool, ordered and meticulously systematic, it stands at the opposite extreme to work that stakes everything on the outpouring of naked emotion. The term Conceptual Art, to which LeWitt announced his loyalty in some influential writings published towards the end of the 1960s, immediately suggests something cerebral in character. It became, as his work developed, a matter of eliminating all the subjectivity which the artist considered irrelevant.

LeWitt came to maturity during a period of widespread reaction against the Abstract Expressionism practised by the previous generation. Like Judd, Andre, Morris and other American artists who shared a preference for the minimal, he aimed at freeing himself from the primacy of the personal gesture. Indeed, LeWitt went further than most in his desire to escape from the notion of unique 'handwriting' in art and the belief that one set of improvised marks suggests another in a free and organic manner. He insisted that the idea was paramount, and that any perceptual delight given by the image itself was subservient to the governing conceptual framework. He even surrendered the right to execute the work himself. In most cases, LeWitt's art is carried out by assistants following his written instructions, thereby proving the sincerity of his claim that the idea predominates from first to last.

Such a plan might easily lead, in the hands of a lesser artist, to an unbearably chilling and desiccated outcome. But two exhibitions now enable us to discover a surprising richness in the work LeWitt produces. At the Tate Gallery, a retrospective survey of his print-making activities over the past fifteen years reveals just how various and resourceful his work has been. Etchings, woodcuts, lithographs, silkscreens and books all testify to his irrepressible inventiveness, and they scotch the suspicion that he might be nothing more than a cheerless deviser of numbing diagrams. There is, unquestionably, something very stern and puritanical about LeWitt's sets of instructions, which range from the terse (*Lines, Not Long, Not Straight & Not Touching*) to the dizzyingly complex (*All One-, Two-, Three- And Four-Part Combinations Of Lines In Four Directions And Four Colours, Each Within A Square*). But their visual outcome often has a surprising exuberance. The fascination of LeWitt's work, for me, lies in the tension between what he says it is about, and what the images themselves convey.

Take an etching sequence called *Scribbles Printed In Four Directions Using Four Colours*. The title could hardly be more curt, but the prints themselves have a scrambled energy which is almost lyrical in its wildness. The lines leap, curl and twist into ever more dense and fantastic elaboration. They end up recalling the dithyrambic ecstasy of Jackson Pollock, against whom LeWitt's work is supposed to be so sternly set.

Not all the prints possess that kind of freewheeling dynamism, of course. Some instructions give the draughtsman more leeway than others, and Jeremy Lewison points out in his catalogue introduction that the 'Location' series is constructed according to elaborate rules which must be obeyed with absolute precision: 'deviation would result in failure'. But the most interesting prints are the ones where LeWitt sets off an intense linear activity that ends up confounding, or at the very least enriching, the spare economy of the initial instructions. I was intrigued to discover how many representational associations were generated by even the most austere works on view. The title of a set of seven black-and-white etchings made in 1973 is, for example, resolutely sober: *Straight, Not Straight and Broken Lines In All Horizontal Combinations* (*Three Kinds of Lines & All Their Combinations*). It sounds like a fairly severe starting-point for a work of art, and yet the results evoke all kinds of references to the visible world – sunlight shimmering on the surface of a still sea, patterns running across a television screen, and other phenomena which depart very radically from the apparent abstraction of LeWitt's original scheme.

On one level, admittedly, his work offers the pleasures of a rigorous organization, building like a Bach fugue into a bracing structure with its own internal logic. Looking at LeWitt's art is tantamount to coming across a grammar of line and colour, and he helps us to realise the infinitude of possibilities when the various components are combined and recombined with such lucidity. But on another level, this obsessive devotion to primal forms bears witness to experiences beyond the purism of geometry for its own sake. At an early stage in his career, LeWitt worked for I. M. Pei as a graphic artist, designing 'brochures and letterheads and building models of towers and parking lots'. Leaving aside the clear connections between the limpidity of Pei's buildings and LeWitt's partiality for equally spare and ordered structures, I feel that all his art is permeated by an architectural vision.

It appears most dramatically in his large-scale works, often executed with a sensitive awareness of the buildings they occupy. LeWitt is at his most impressive in these grand wall drawings. He thrives on monumental dimensions, which release in him a breadth and majestic weight not often evident in the more modest format of his printed work. Executed

71. Sol LeWitt, *Stars – Light Centre (set of 7)*, 1983

directly on to the surface of the walls, and therefore lasting no longer than the duration of the exhibition, they show just how commanding and outspoken LeWitt's art can become. Some of his wall drawings are at the ICA this month, and they offer an ideal complement to the Tate survey. For although he is at home in both contexts, the prints survey can be seen as a pictorial laboratory where he quietly puts his conceptual programme through its paces before arriving at a climax with the architectural work. Here, in an arena where he is able to show how magisterial his art really is, LeWitt sheds his reputation as a master of dry calculation and becomes instead the creator of a severe and awesome beauty which transforms the spaces it inhabits. I hope architects visit these exhibitions, and realise the potential rewards of collaborating with an artist who can enliven a building with such resounding conviction.

BOYLE FAMILY
11 December 1986

I cannot imagine many artists joining forces with their children and exhibiting at the Hayward Gallery under the umbrella name of 'Boyle Family'. Nor can there be many sons and daughters who are prepared, like Georgia and Sebastian Boyle, to work alongside their parents as a united team. The whole notion of such close-knit collaboration could easily end in calamity and bitter resentment on both sides. But Mark Boyle and Joan Hills have been working together, 'on the same pictures' as he puts it, for over twenty years. So they are clearly stimulated by sharing and discussing their art with each other, and involving their children was a natural extension of this activity. 'The idea that art can only be produced by obsessed individuals is a neurotic aberration of our time', Mark Boyle has declared, thereby identifying himself with a willingness to let others help him in a spirit of non-competitive exploration.

Neither he nor Joan Hills allowed their own preferences to get in the way when they embarked on the *Journey to the Surface of the Earth* in 1968. At a time when so many idealistic hopes were raised for the future throughout Europe, they decided to undertake a wildly ambitious voyage around the planet. As many as 1,000 sites are included in the *World Series* they initiated during that headily optimistic period, and each location generates a substantial number of large-scale works. Their entire lives will be devoted to a venture they can never fully complete, and yet the crucial choice of sites was made by a random procedure deliberately removed from the artists' control. Darts were thrown at maps by blindfolded people invited to carry out the selection for them. Boyle and Hills accepted the outcome of that random ritual; and when they finally arrive at one of the settings thus ordained, a right angle is thrown into the air to land on the ground and determine the particular plot of earth according to chance once again.

Few painters would be willing to relinquish the right to choose the slice of ground that will form the subject of their work. To them, it would seem dangerously akin to a negation of the creative will. But Boyle and Hills regarded the adoption of random methods as a positive step, an integral part of their desire to escape from all the preconceptions and predictable strategies they might otherwise have been tempted to pursue. 'Our entire upbringing and education are directed towards planting the proper snobberies, the right preferences', Boyle wrote in 1965, explaining that 'ultimately these studies are concerned with everything

as it is'. He and Hills had already begun to concentrate the viewers' attention on aspects of reality which were usually deemed too raw or banal to merit sustained attention. A year before, they staged a perform-ance in a dilapidated West London house that led the audience through to a dark, curtained room. When everyone was seated, the curtains swept aside to reveal nothing but a shop window looking on to the street. A similar invitation, to examine the familiar face of the world with such unexpected intensity that its fundamental strangeness is revealed, has been extended by their work ever since. Although the performances and light shows of the 1960s have given way to painstaking reconstructions of the sites scrutinised on their Jules Verne-like *Journey*, the impulse to discover significance and mystery in even the most mundane aspects of our surroundings has remained fiercely consistent.

Both Boyle and Hills were largely self-taught, so they had few scru-ples about discarding traditional materials and devising their own means of making world-pictures with astonishing fidelity and exactitude. Boyle's experience of an art school was confined to one day, which taught him only that no one there was interested in the 'large knot of twisted and battered lead piping' he had brought in from the street. The Head of Sculpture asked him to make a clay copy of a Roman plaster cast, but Boyle was more interested in his found object. He still is, and over the intervening years Boyle and Hills learned how to translate their boundless appetite for the actuality of things into carefully crafted fac-similes of the world they scrutinise with such acuity.

Although the precise details of the technique used in their work has been kept secret, 'painted fibreglass' is the medium they admit to employ-ing. Those two words cannot convey the prodigious sense of realism commanded by the Boyle Family's art. It is as if huge samples of the world had been lifted wholesale from their original positions and mounted, in all their material palpability, on the walls of a gallery. The majority of these massive slabs have been turned on their sides, but the dramatic transfer from horizontality has not entailed the loss of any twigs, stones, straw and other stray matter embedded in their surfaces. It is all still there, even the green hosepipe sprawled next to the draincover and the delicate worm cast lying like a tiny relief on the rippled sand of a Hebrides beach.

A passionate ecological conscience surely underlies the Boyles' respect for 'things exactly as they are', to borrow a potent phrase from Wallace Stevens's teasing meditation on reality and illusion in *The Man with the Blue Guitar*. They do not, however, reserve this respect only for nature at her most undefiled. An expanse of gouged mud in a lorry park, preserved down to the soiled fragment of orange carpet half-buried in the ooze, is

accorded as much reverence as a sample of arid rock and baked green shale from Mount Ziel in the Central Australian Desert.

From the very outset of their explorations, before the *Journey* was fully mapped out and officially launched, Boyle and Hills turned their attention with equal care to urban and rural subjects. The lyrical ribbed undulations of Camber Sands at their most laundered and inviolate was reproduced with uncanny verisimilitude; but so was a patch of land at Shepherds Bush, epitomizing the scrubbiness of an inner-city site bruised by incessant misuse and strewn with the waste of a rubbish-ridden society. The accumulated detritus of metropolitan life was studied here with a fascinated understanding which would only reappear in British art when the 'new sculpture' emerged during the 1980s, replete with its alert awareness of unlikely eloquence in even the most abject of cast-off materials. So far as Boyle and Hills were concerned, though, the urban context remained only one possibility among the multitude marked out by the darts on a map they committed themselves to exploring as objectively as possible.

The Boyle Family's exhibition is in this respect a progress report, showing how they tackled the distinctive challenges presented by a stretch of mud and stones near Toyama in Japan, the corrugated patterns of car tracks left behind on the greyness of *The Swiss Site*, and the diagonal ridges coursing across a ploughed field bristling with scraps of straw and scattered stones. The Boyles are adept at dealing with the delicate network of cracks

72. Boyle Family, *Broken Path Study with Black and White Tiles (West London)*, 1984/5

spreading over a parched Japanese quarry at Oya, where a crushed tin and a glove are almost the only forceful notes in a work otherwise dominated by bleached restraint. But they are equally prepared to produce a robust, forthright structure of worn cobbles, broken concrete and draincovers studded with glinting metal nuggets. The hard, battered surface of a pavement lined by a metal edge in Mark Boyle's native Glasgow impresses itself as powerfully on our senses as a Red Sandstone cliff from North East Scotland, and what unites them all is the artists' determination to find permanence in the face of imminent dissolution. The battered black-and-white tiles on the floor of a demolished London house are on the point of total disintegration, just as the outdoor works often focus on natural configurations which will soon be eroded or swept away by the inevitable action of wind and water. In the Boyles' work, however, the vulnerable takes on a consoling impregnability, and the remorselessness of decay is arrested so that we can contemplate the unexpected magnificence inherent in what would otherwise be relegated to oblivion.

STUART BRISLEY
5 February 1987

Situated in a royal park, the elegance of the Serpentine Gallery is still potent enough to remind visitors of its former role as a tearoom. In such hallowed surroundings, Stuart Brisley's exhibition could hardly seem more abrasive. For here, in one of the most beautiful and well-manicured parts of London, Brisley has filled his space with a disconcerting meditation on blight, dispossession, detritus and despair. The clash between location and art works enhances the disquieting impact of Brisley's vision. In the limpid calm of Kensington Gardens, it is easy to forget that other areas of the metropolis bear painful witness to deprivation and decay. But Brisley brings the reality of urban hardship to the forefront of our attention the moment we enter the gallery. Behind harsh ranks of dark wood, propped against the wall like a lean-to devised as a makeshift shelter, an assortment of discarded clothes lies in bedraggled piles. They testify to the wretchedness of the people who once wore them, and elsewhere in the room a freestanding structure intensifies the sense of relentless enclosure. We enter this strange, unexplained complex of barriers only to discover that it offers nothing apart from a confirmation of the malaise defined in

the rest of Brisley's exhibition. Everywhere we look, he confronts us with images that stress the stark dilemma of alienated lives.

This bitter analysis, as extreme in its way as the ills it seeks to expose, is based on Brisley's observation of the district in north London where he used to live. Georgiana Street, in Camden, contained a hostel for the homeless, but its inhabitants used to gather on a nearby patch of waste ground and sprawl in a stupor on the litter-strewn pavements. Brisley became fascinated not only by their aimless existence and the rubbish they accumulated in this forlorn terrain, but also by their refusal to become absorbed in the patterns of social behaviour governing the rest of the area's residents. As an artist who has always explored themes of iso-lation and suffering in his work, he may even have felt closer to their activities than he did to the more conventional lives led by the other inhabitants of the street.

At any rate, these rootless figures took hold of his imagination to such an extent that he began collecting refuse from the site. Other artists in the 1980s have shared this interest in scavenging, most notably sculptors like Tony Cragg and Bill Woodrow who have transformed their found objects with wit, inventiveness and sometimes disturbing savagery. Brisley, howev-er, prefers his detritus raw. He wants to remain faithful to the messiness and degradation it possessed in its original location. No one encountering the material he has assembled at the Serpentine could overlook its pathos, or mistake it for anything other than the miserable remnants of wasted lives.

All the same, Brisley makes no attempt to reconstruct the Georgiana Street site with the kind of fidelity achieved by the Boyle Family, who often explore neglected inner-city sites with meticulous care. He may have entitled the work inspired by his neighbourhood *The Georgiana Collection*, but the exhibition itself is by no means limited in reference to the particular condition of a single London neighbourhood. Far from it: Brisley's art proceeds from the local to the universal with such gaunt determination that the images he offers seem applicable to a whole range of human predicaments.

His use of steel mesh in several works reveals how effectively he is able to charge an unvarying material with different meanings. In one room, enormous expanses stand like impenetrable fencing between the specta-tor and the wall behind. Through the gaps in the mesh, however, a series of grainy monochrome photographs are visible, each one showing the same haggard woman standing next to an iron bedstead. The forms of the mesh structure chime with the equally severe framework of the bed, encouraging us to see the blanched figure as a prisoner helplessly enclosed in the architecture of a cell block. The photograph was, in fact,

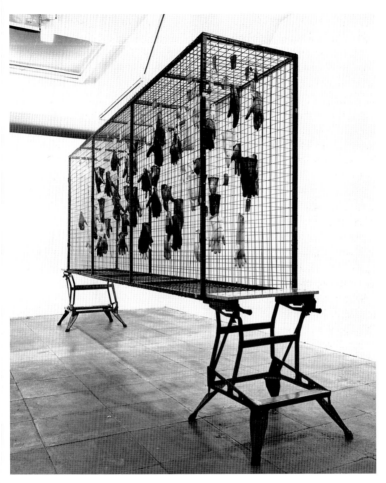

73. Stuart Brisley, *The Georgiana Collection "1=66,666 (March '83)"*, 1983

taken in an Ulster women's prison, but the plight it records could refer equally well to the inmates of similar institutions anywhere in the world.

The mesh recurs in the next room, which houses the two most powerful pieces in the exhibition. In the first of them, Brisley has assembled a cage resting at either end on do-it-yourself 'workmates'. Their supporting presence is ironic, for the rest of the sculpture testifies above all to a terrible paralysis afflicting everything within sight. Dangling mournfully

from the top of the cage, several dozen gloves punctuate its space like items waiting to be collected from a lost-property office. But their desolating listlessness implies that they will never be returned to a life beyond the cage's cruel boundaries. A label hangs from each glove, as if to assist in a possible process of identification by a searching owner. The words and numbers written on these yellowing cards only manage, however, to accentuate the prevailing air of futility. Some bear the terse phrase 'without reason', while others gravely claim: 'This is a record of failure without parallel.' A number of them are supplied with a bureacratic tag, ZL6563950, which does its best to rob the gloves of their human associations altogether. And all of them, whether they are delicate women's gloves, streamlined drivers' gloves or heavy working gloves, have been filled to the brim with solidified plaster. Nobody could conceivably want to claim such grotesque apparitions. Deprived at once of beauty and function, they appear to be swollen with disuse. Overweight and undervalued, the gloves hover in their confines like a macabre metaphor for the futility and dejection to which so many people have been condemned during a decade of unemployment and social duress without precedent in post-war Britain.

At the other end of the room, the ubiquitous mesh makes another and still more haunting appearance. This time we come upon it with surprise, at the furthermost side of a forbidding grey triangle of painted wood which appears, for Brisley, unusually reticent. But the contrast between the enigmatic façade and the spectacle it presents within is absolute. We find ourselves staring through the mesh into a narrow chamber whose walls converge on a searchlight at the far end. Directed straight at our eyes, the blazing lamp is strong enough to dazzle and confound. It forces us to wince and peer as we struggle to find out what else this claustrophobic interior contains. Rows of cast-off clothing can with difficulty be made out in the glare, arranged in crumpled ranks like garments left behind by people who were ordered to strip before meeting their death. The chamber might, alternatively, be interpreted as a place where vagrants have sought rough-and-ready refuge. Such an image would certainly accord with the world Brisley came to know at Georgiana Street, but the aggressive and authoritarian searchlight asserts a more sinister order of feeling. So do the angry shadows cast on us as the beam passes through the mesh. It throws crazy patterns across our faces and bodies, as well as tattooing the wall behind us with its brutal geometry.

Nul Comma Nul, the work in question, was first displayed in an exhibition devoted to Orwell's *1984* at the Camden Arts Centre. It was by far the most impressive work in an otherwise uneven show, and crystallised the

appropriate mood of foreboding and depersonalised dread. Now, three years later, Brisley invites us to confront it again without such a specific Orwellian context. But the work loses none of its ability to appal. To come across *Nul Comma Nul* is to receive harrowing confirmation of all our most pessimistic suspicions about the heartless temper of the present time. Although Brisley's grim masterpiece is utterly without comfort, we recognise its essential honesty and respect its uncompromising desire to warn.

BALRAJ KHANNA
4 June 1987

Even though Balraj Khanna grew up a long way from the Indian coast, images of the sea haunt his imagination. His first experience of an ocean, during the flight to England that marked a decisive turning-point in his life, proved a revelation. It stirred memories of childhood dreams, and confirmed his fascination with the marine world as an inexhaustible metaphor for the fundamental mystery of life. References to the sea abound in Khanna's one-man show at the Horizon Gallery. Everything within sight appears to be floating in an ambiguous region, poised either on the surface of the water or beneath the waves. For many years now, he has employed an instrument normally used for spraying fixative on to drawings. By blowing the paint through a tube, he gives the deposits spreading across the canvas something of the rhythmic movement associated with his own breathing. The tiny particles of pigment have an undulating motion which evokes the heave and swell of the ocean. Some of the recent canvases possess a granular texture as well, produced by adding a fairly rough-grained sand to the paint. Blown at an angle to intensify luminosity, they give a layered richness and provoke intriguing questions about the role played by the forms that wriggle and dart their way across Khanna's compositions.

Are these creatures free-floating, or embedded in the encrusted paint-texture? The paintings leave the question open, just as they refuse, finally, to be identified with the sea alone. One of the most beautiful pictures on view here, *Patang Bazi*, refers in its title to the kite matches Khanna remembers playing with relish during his childhood in the Punjab. The forms hovering on the surface of this canvas are indeed reminiscent of the coloured paper structures Indian children still make for this fiercely

competitive yet exhilarating sport, and the lines that curve and dangle from them could well be attached to invisible hands beyond the boundaries of the picture. Other exhibits contain references to the kind of burgeoning plant-life which enthralled Khanna when he painted a prolonged series of *Forest* pictures almost twenty years ago. But the difference is that, unlike the work of the 1960s, each form is now given an ample amount of space in which to assert its quirky vitality. The early paintings were filled to bursting-point with organic growth. A *horror vacui* was evident then, and Khanna may have come to feel that his canvases were in danger of being choked by the images they contained.

The sea offered him a way out of this pictorial thicket. At first it beguiled him so seductively that he was content to let each picture contain nothing except the primal movement of the waves. None of these paintings has been included in the Horizon Gallery show, which concentrates on work carried out over the past couple of years. But the lessons Khanna learned from them are clear enough in his current art. The forms he once again delights in unleashing are allowed to proliferate, and they move through the canvases with untrammelled ease. There is no suggestion, however, that they might crowd the picture-surface with the cornucopia of growth Khanna favoured in his early work. Wherever we look, a sense of spaciousness is apparent. Nowhere more dramatically than in an enormous painting called *Coming from Edinburgh*, ostensibly concerned with celebrating a visit to the Scottish capital. Here the composition takes on an infectiously festive air, tumbling and spiralling with a spirited energy redolent above all of the circus. There is an acrobatic effervescence about Khanna's most optimistic pictures which shows how much pleasure he takes in life. At a time when expressionist anxiety is so fashionable in contemporary art, he has no reservations about affirming his loyalty to the '*luxe, calme et volupté*' which Matisse made his ideal.

Ever since Khanna settled in London over two decades ago, critics have been quick to point out his connections with twentieth-century European painting. Klee and Miró are the two artists mentioned most frequently in this context, and his debt to both of them is real enough. But it would be a great mistake to stop there, implying that he owes nothing to his Indian heritage. A lover of his country's exquisite miniatures, Khanna is proud of the tradition to which they belong. Although their influence is not directly discernible, they have surely helped him escape from orthodox perspective, regard each picture as a field where linear configurations can flourish, and indulge in an abundance of incidental detail. The same characteristics can be found in Indian miniatures, even if Khanna's willingness to work on a large scale leaves their modest dimensions far behind. So the

74. Balraj Khanna, *Coming from Edinburgh*, 1986

truth is that he has arrived at an independent synthesis of eastern and western traditions in his paintings. Far from labouring awkwardly to reconcile these very disparate impulses, he shows every sign of savouring the delicate balancing act performed in his work.

Sometimes, though, the mood of buoyancy gives way to a darker alternative. A palpable tension arises between the apparent freedom and vivacity of the forms on the surface of the picture, and the misty regions swirling like currents in a treacherous estuary beneath. A feeling of transience pervades the image, as if to suggest that the gaiety of the carnival cannot last long. The blithe forms suddenly look frail, incapable of sustaining their energy and liable at any moment to sink back into the obscurity of the half-submerged layer. The sense of evanescence is accentuated by Khanna's handling of paint, for even the most 'solid' of the objects he depicts always dissolves into a cloud of tiny particles when viewed at close quarters. A consciousness of the inevitability of flux is detectable in all his canvases, however welcoming and boisterous they may appear. Khanna, who worked as a Foreign Correspondent during the India–Pakistan War and afterwards painted a vast elegy which deplored the lacerating conflict he had witnessed, is no stranger to the reality of destruction. Having written a spirited comic novel called *Nation of Fools*, based on his wryly affectionate experience of growing up in post-Independence India, he is now writing a second work of fiction on the theme of partition.

Ultimately, however, he refuses to let tragedy predominate in his paintings. Khanna's stance is generous and perpetually expectant, for he

prefers to relish the exuberance and wholeness of existence whenever possible. Having discovered how to invade his work with the tidal motion of the sea where life originated, he lets the resilient creatures who inhabit his paintings continue their dance to the music of time.

GILBERT & GEORGE
23 July 1987

It seems a long time now since Gilbert & George, the inseparable duo from St Martin's School of Art, established themselves as 'Living Sculptures'. Attired in formal suits that contrasted absolutely with the way most of their long-haired contemporaries dressed at the end of the 1960s, they claimed the right to work in a bewildering variety of ways. Stretching the term 'sculpture' to its outermost limits, the deceptively well-groomed and respectable pair used singing, lecturing, eating, drawing, meeting, writing and even painting as part of their tireless sculptural activities.

This diversity could hardly be further removed from their exhibitions of recent work at the Hayward Gallery and Anthony d'Offay, where photography is the sole means employed. Gilbert & George are no longer performing their bronze-face mime to Flanagan and Allan's music-hall song *Underneath the Arches*. Everything now focuses on the vast and fiercely coloured 'pictures' which, although dependent on the camera's resources, transform the unlovely Hayward into a secular cathedral emblazoned with heraldic images reminiscent of stained-glass windows. In early middle age, the once-unclassifiable double act has settled for a single-minded means of expression, and they know how to wield it with formidable authority. But despite all the changes their work has undergone over the past couple of decades, the underlying commitment remains the same. For Gilbert & George stay just as devoted to the heightened exploration of their own experiences as they were in 1971, when their credo-like booklet proclaimed that 'being living sculptures is our life blood, our destiny, our romance, our disaster, our light and life. As day breaks over us, we rise into our vacuum and the cold morning light filters dustily through the window. We step into the responsibility-suits of our art.' However elevated their work has become since the seeming innocence of those early days, they still persist in focusing on the significance of their everyday existence.

Although George was born in Devon and Gilbert hails from the Dolomites, they now lead a thoroughly urban life in an area of the East End where Prince Charles recently discovered inner-city privation as if for the very first time. The Spitalfields district is, in reality, a place of extremes, harbouring immigrant poverty and escalating property values in equal measure. It is an extraordinary region of the metropolis, filled with buildings redolent of the past and yet poised for spectacular redevelopment inspired by the ever-expanding financial prowess of the City. Gilbert & George's art does not deal directly with such themes. But a feeling of momentousness, of a world where dramatic events may at any instant erupt, does pervade the images they produce. Compared with their early photo-pieces, which concentrated almost exclusively on the pair themselves drinking, contemplating or wandering through the pan-elled rooms of their Fournier Street home, the outside world penetrates their current work to a forceful extent. Occasionally it ousts their oth-erwise ubiquitous presence altogether: in *Deatho Knocko* all we can see are the silhouettes of two heavily armoured knights engaging in unin-hibited combat with sword, ball and chain, while a couple of predatory insects above echo this aggression as they advance on each other. On the whole, though, the pictures contain likenesses of their makers clearly enough, and they take many different forms.

Sometimes they preside over the scene like colossi, observing the antics of the figures in these panoramic cityscapes while stressing their detachment from the world they survey. *Light* exemplifies this approach, for Gilbert & George rear up here behind one of the towers of Parliament and stand like impassive statues, entirely dominating the two youths who stare up at them with awe and unease. In other pictures, the two artists adopt a more active role. Although they retain their outsize dimensions in *Gateway*, keeping guard on either side of a frieze contain-ing fifteen young men ranged before a flowering hedge, Gilbert & George now seem part of the gang. Clutching staves fluorescent enough to resemble the glowing 'light sabres' in *Star Wars*, they appear ready to lead their army of street-wise recruits into a battle as uncompromising as the office-blocks punctuating the horizon.

Then there are immense set-pieces like *Life Without End*, an epic tableau stretching almost forty feet along the wall and filled with youths both naked and clothed, burgeoning plant-life and glimpses of aspiring gothic architecture. The artists kneel on the left of this vast symbolic image, their hands clasped in prayer. They resemble the donors in a Renaissance altarpiece, but there is nothing straightforwardly sacred about the picture in which they worship. A huge profile of a young man,

his mouth open in an angry shout, threatens to devour them. And instead of saints or angels, ranks of teenagers are assembled in a composition replete with ardent homoerotic feeling. They are the profane objects of Gilbert & George's delight, and yet the aura surrounding these Whitechapel youths gives off a beatific intensity.

This religious strain has grown enormously over the past few years, to the point where it now permeates everything the two artists produce. Some of their 1985 pictures are collectively entitled 'New Moral Works', and Gilbert & George often present themselves as latter-day crusaders involved in a quest to bring about universal enlightenment. 'The true function of Art', they announced in 1986, 'is to bring about new under-standing, progress and advancement', but no conventionalised piety can be found in their attempt to foster awareness among their audience. On the contrary: they have learned how to declare their sexual preoccupations with a frankness which some viewers are bound to find shocking. British art has never before dared to deal with subjects like *Tongue Fuck Cocks*, and neither have nude male bodies been presented with such unabashed ado-ration. Considerable courage is needed, even today, to brandish these con-cerns in public, and Gilbert & George should be congratulated for their honesty in exposing their inclinations on the grandest scale imaginable.

Conscious of their position as outsiders, removed from ordinary social life and mocked for their 'oddness', these resolute picture-makers have turned estrangement into a central strength. Confronting the issue of alienation head-on, they take every opportunity to stress their apartness even as their images deal with the contemporary world in all its raucous and disturbing complexity. They understand the restlessness which ani-mates life on the pavements of the metropolis, where walls are often besmirched with enraged graffiti and the prevailing impersonality easily leads to the despair of drop-outs, sprawled in their own alcoholic stupor on the steps of a Hawksmoor church.

In order to counter this destructiveness, and the nullity of unemploy-ment, the youths in Gilbert & George's work find consolation in the sol-idarity of a group. Here they all are, black faces as well as white, lauded for their vigour and defiance in tableaux vast enough to give them ample space for roaming. The pent-up violence which exploded in ugly street riots a few years ago is never very far away. But these images seek to make amends for the frustrations of life on the dole by giving the figures dignity and even nobility. However labyrinthine the pictures may be, they are given lucidity by the grid structure which Gilbert & George habitually employ. Stamped over the teeming elaboration of designs where leaves grow into wings, faces change colour with hallucinatory

75. Gilbert & George, *Tongue Fuck Cocks*, 1983

frequency and everything takes on the quality of a feverish dream, the stern black grid insists on a call to order. It signifies the discipline behind the exclamatory revelations, and hints at the hard-working resolve which has enabled Gilbert & George to generate such an inventive body of work from their fears, fantasies, frustrations and hopes.

MAPPLETHORPE'S PORTRAITS
7 April 1988

Robert Mapplethorpe's name has become synonymous with a candid, and sometimes disquieting, exploration of the male nude. Unafraid to disguise his interest in the sculpturally muscled bodies of the men who posed with such openness in his studio, Mapplethorpe celebrated their statuesque poise. But he also aroused controversy by appearing to imply that his models, mainly black and athletic, should be admired for their physiques alone. The debate about his work intensified when he exhibited close-up studies of genitals and frank tableaux involving leather or chains. Mapplethorpe was in danger of marginalizing himself, as a specialist in gay erotica so uninhibited that it overshadowed all his other work.

His new exhibition at the National Portrait Gallery seems motivated by a desire to redress the balance. Naked men are now hard to find, and when a well-hung nude does appear he turns out to be cradling a cat called Amos with considerable affection. The most provocative side of Mapplethorpe's work has been edited out, to be replaced by a consuming obsession with portraiture. At times, it still arises directly out of his earlier passion for the black male. Donald Cann, shoulders bare, stares at the lens with the same cool directness displayed by so many of his predecessors. Now, however, Cann's hands are placed at either side of his head, as if to segregate it from the rest of his body and focus attention on the face. Cann presents his features with the utmost deliberation, and Mapplethorpe obliges by allowing both head and hands to fill up most of the picture-space.

The calculating precision of this composition can be found in all his photographs. He is especially alive to overall purity of form in a superb study of Ken Moody and Robert Sherman. The two young men, both prematurely shaven of skull, display their profiles for the camera. Moody's dark skin glows in the light as he lowers his eyelids and withdraws into a dreamlike state. Sherman, his whiteness almost bleached against Moody's skin, gazes wide-eyed as he thrusts forward over his companion's shoulder. Sherman's thin lips could hardly be further removed from Moody's full mouth, and the black man's dignified composure is contrasted with the white man's fierce alertness. But they are united by the pictorial and sculptural priorities that govern Mapplethorpe's photograph – a way of seeing that becomes increasingly glacial and flawless as the once-precocious rule-flouter approaches a more settled middle age.

In 1975 he was prepared to portray the grinning Freya Stark lying jauntily in her sun-chair, with the incidental distractions of a house and well-stocked garden visible all around. In comparison with his later work, this early study now seems almost unruly. Hardly anyone smiles in Mapplethorpe's more recent photographs, and they are all contained within a severely geometric context. The tiled bath where James Ford reclines, his Adam's apple protuberant as he gazes resolutely upwards, is reduced to a Mondrian-like sequence of upright and horizontal forms. Benno Premsela's head is pitched against a lancing diagonal line that stretches all the way from one corner of the design to another. The structural rigour is alleviated, on occasions, by subversive humour: Louise Bourgeois looks naughty and conspiratorial as she clasps her own outrageous phallic sculpture underneath the arm of a monstrously hairy coat. But the theatricality in many of Mapplethorpe's portraits tends to be solemnly played out. Patti Smith holds up her neck-brace with the sobriety of a saint displaying the instrument that brought about her martyrdom. Warhol, his platinum wig even more bedraggled and lopsided than usual, stares out with a haggard expression which the halo of light behind does nothing to soften.

The prevailing mood of austerity encourages some of Mapplethorpe's sitters to cast their eyes down. Doris Saatchi, her blanched face hovering in a void of darkness, averts her gaze with an enigmatic aura worthy of Edith Sitwell at her most hooded. Peter Gabriel, clerical in a white collarless shirt and black jacket, seems determined to evade the camera's inspection altogether as he directs his attention towards the floor. Even the most ebullient and gregarious personalities take on a subdued air. Norman Mailer looks as correct and dutiful as a judge while he squares up to the lens, and Philip Johnson seems world-weary to the point of exhaustion as he deigns to acknowledge the photographer's presence.

Where Mapplethorpe is at his weakest, he serves up portraits of high-society beauties as haughty and unrevealing as fashion-plate effigies. One of his most recent works, a picture of Alexandra Kaust taken in 1988, is a stylish yet curiously empty exercise. Even his studies of Patti Smith, whom he once portrayed as gamine and approachable in the days when they lived together, have lately become rather high-flown and over-deliberated. In 1987 she holds up her dress with one elegant hand and a butterfly with the other, bestowing on the winged creature a winsome expression reminiscent of the Pre-Raphaelites in their coyest vein. Another portrait of the same sitter takes this aspiration to an even more questionable level, for the platinum photograph has been printed on to canvas. It is a spurious tactic, borrowing the status of painting in the hope, presumably, of elevating the

76. Robert Mapplethorpe, *Self-Portrait*, 1981

camera's dignity. Mapplethorpe began his exhibition career as a painter and sculptor in the early 1970s, and sometimes he appears to yearn for the apparatus of Fine Art at its most exalted.

He should know better. Mapplethorpe is sufficiently assured, both as a single-minded composer of images and a consummate technician, to dispense with such aspirations. In the self-portraits he shows an

admirable sense of irony, mocking his own diabolic reputation by presenting himself, lit by a sulphurous glow, with horns sprouting from his tousled hair. Even at forty Mapplethorpe retains a boyish sense of mischief, but he is equally capable of responding to the frailty of old age. The portrait of Alice Neel, taken shortly before her death, offers a moving presentiment of the dissolution to come. Framed by white wisps that look as if they might blow away in the wind, Neel's crinkled face has a brittle, papery quality. She closes her eyes like a woman preparing herself for the end, and uneasily parts her lips as if the act of breathing had become a struggle. This is a portrait of someone on the edge of extinction, and yet there is a quiet acceptance in Neel's features which prevents the picture from deteriorating into morbidity.

Death will arrive in time, even to the youthful Larry and Bobby whose leather-jacketed kiss has become an icon of gay emancipation since Mapplethorpe photographed it with such reverence in 1979. As their mouths close in an embrace that appears oblivious of the camera's presence, they had no inkling of the plague which would decimate their contemporaries so soon afterwards. Nor did Mapplethorpe, whose grave and lucid honouring of male beauty has already taken on an unexpected poignancy in our AIDS-haunted climate today.

WOVEN AIR
21 April 1988

Upstairs at the Whitechapel Art Gallery, two Bangladeshi weavers sit at their loom demonstrating Jamdani techniques. The dexterity they display, working with speed and suppleness on designs of considerable intricacy, demands great concentration. But they are able to chat with friends and strangers alike as their fingers twist and dart across the loom. Visitors' questions are answered while the work proceeds, and the weavers' sociability testifies to their assurance in continuing a textile tradition that has earned widespread respect for centuries.

This quiet demonstration of ancient skills lies at the heart of *Woven Air*, an exhibition devoted to the fabrics and garments made in Bangladesh over the last 250 years. The pertinence of such a survey in this gallery is clear enough. As many as 60,000 Bangladeshis live nearby – the latest arrivals to settle in an area long since peopled by successive waves of

immigrants. Many of them earn their living in the clothing trade, either as subcontractors for major manufacturers or 'machinists' for the proliferation of factories in the Brick Lane neighbourhood. The garment industry around there is often a harsh affair, with low pay for long hours spent in cramped and hazardous surroundings. Sweatshops have not, unfortunately, been banished from a district which used to be notorious for the hardship they engendered. But at least the community furnishes its members with a sense of identity, in a city where immigrants can easily find themselves isolated and cut off from their origins altogether. Although it has not saved them from racist aggression, a feeling of solidarity prevents the East End Bangladeshis from losing sight of the country they left behind.

Within the Whitechapel Art Gallery's vigorously international programme, *Woven Air* therefore makes special sense. It affirms that the achievements of Bangladeshi culture, far from being forgotten, deserve the accolade of a major exhibition. Mounted in the hope that the immigrant community will enjoy the insights it provides, it also aims at familiarizing the children of the emergent generation with a tradition they may never have seen in their parents' homeland. But non-Bangladeshi visitors have just as much to gain. The show enables them to learn about an aspect of weaving and embroidery from the Indian subcontinent which has been rarely exhibited in this country. Displaying these fine examples of muslin work in such a congenial setting may even help to promote a greater sense of tolerance among those most prepared to belittle or dismiss immigrant culture of any kind.

Beth Stockley, one of the show's organisers, certainly wants it to appeal to a non-specialist public. 'We have decided to give the exhibition a narrow focus in order to make it, paradoxically, relevant to a wider audience,' she explains in the catalogue preface. The concentration on muslins and *kanthas* will, she believes, align the survey even more closely with the Whitechapel's other shows. And the sense of focus does give it a coherence which a more broadly based selection might lack. The quality of muslin itself is everywhere apparent, in an exhibition that celebrates the fine, tight texture of a material spun from the toughest cotton crop available. Light enough to combat the heat and humidity of the Bangladesh summer, the muslin is spun in the coolest part of the day. While monsoon rains fall, swelling the country's three great rivers so much that they flood half the land for several months each year, women busy themselves embroidering the *kanthas*.

These coverings and spreads are usually made as presents, to mark significant occasions like a child's marriage, a birth, or a thank-offering to a *guru*. As folk arts invariably do, the images dominating *kantha* decora-

77. *Kantha* (detail showing central motif), early twentieth
century

tion mirror the lives of the women who produce them. Many depict a
centre or universe with a multi-leaf lotus floating on water, its undula-
tions conveyed by uneven rows of fine running stitches. Over fifty kinds
of stitch are employed, every one of which produces a distinct type of
image. Many reflect a desire for fertility, so that families may be blessed

with a burgeoning profusion of offspring. Creepers are used to symbolise such a wish, but other horticultural forms are more bound up with religious beliefs.

If the tree of life spreads its irrepressible branches across *kanthas* made by Muslims and Hindus alike, there is no mistaking the appearance of deities belonging to the Hindus alone. One particularly resplendent *ashon* – a spread for sitting on – contains Shiva and Parvati as well as Krishna and Radha. They adopt courtly poses identical to the stances assumed by the *zamindar* (landlord) and his wife, for whom the *ashon* was probably made on commission. As well as reinforcing their social status, the presence of the deities was intended to help the *zamindar* rebuff attempts by Muslim missionaries to achieve conversions. Embroidery is deployed here as a means of keeping the faith, whereas the *kantha* elsewhere becomes a vehicle for rather more zoological obsessions.

One spectacular *ashon* is festooned with symbols of peacocks, horses, tigers and other animals, amounting to a Noah's Ark of species all gathered within the firmly delineated borders. Even here, though, religion tends to lie beneath the most worldly-seeming designs. An especially sumptuous exhibit, the huge cotton covering loaned by the National Museums of Scotland, brandishes on its topmost level a row of elephants walking through a terrain heavy with flowers and plants. They take their place in a harvest-festival procession, which marches round the sides of the muslin in a stately parade of horses, cattle and less easily identifiable creatures. But the elephant symbolises the vehicle of the god Indra as well, and no *kantha* design should be taken at face value to embody a single level of meaning. Technical elaboration is accompanied by a corresponding richness of possible interpretations, even today when the *kantha* has largely lost its original function as a private object. Now that village life has altered and cheap household goods become widely available, it has taken on a very different role as a piece of public display. But the grand commissioned hanging produced by the Kumudini Trust for the Whitechapel brings the show to a stirring conclusion. The *kantha* tradition is still a living force, and the advent of new technologies will never replace the attractions of craft-based images directly expressing the lives of the people who made them with such heartfelt finesse.

PAULA REGO
3 November 1988

Without the support of the sturdy girl who presses firmly against him, the man leaning against the bed might well slide on to the floor. His splayed legs seem incapable of standing upright, even though his open right eye shows that he is, at least, awake. The other eye is obscured by the arm of a smiling woman, who clutches his upturned wrist and tugs urgently at his sleeve. Both she and the girl appear to be struggling to revive him, and he frowns at his helpless dependence on their efforts.

The striving is presided over by another girl, who stands beside the window and gazes towards them. She clasps her hands in an ambiguous gesture – either praying or cracking her knuckles in readiness to join in the mysterious antics on the eiderdown. Her shadow, cast across the chalky carpet by a pale yellow radiance in the sky, stops short of the bed and implies her inability to affect the event she witnesses with such silent intensity. But her statuesque stance is echoed by the female figure in the puppet theatre nearby, who stands over a struggle between Saint Michael and the dragon. Although they are nothing more than miniature toys, framed by the painted curtains, the battle enacted on their stage has a strange, unsettling connection with the attempt to revive the paralysed man.

Paula Rego calls this mesmeric painting *The Family*, and it seems permeated by a child's fear of the unknown. The sense of enigma generated here is akin to the memory of an incident remembered, but never quite understood, from many years ago. The setting itself may be based on the playroom in Portugal where Rego spent a great deal of her own girlhood. She recalls sitting on the floor and drawing for hours at a time, making involuntary noises while she worked. The miniature Spanish theatre she played with as a child could likewise have inspired the puppet stage in *The Family*. Indeed, the whole atmosphere pervading this potent image is redolent of a fairy-tale world, half magical and half threatening.

To the extent that Rego still works on the floor half a century later, in a studio she clearly equates with the early playroom, her recent paintings appear bent on re-enacting girlhood states of mind. But it would be a mistake to suppose that *The Family*, along with the other recent canvases which bring her Serpentine retrospective to such an impressive conclusion, is the work of a woman who has simply regressed to a child's state. While drawing on her formative memories with unusual fervency, Rego gives them pictorial order in an unmistakably complex, adult manner. The fascination relies on a subtle Blakean blend of innocence and experience.

78. Paula Rego, *The Family*, 1988

At first, the large new pictures seem notable for their clarity, order and nursery-rhyme devotion to story-telling. A neatly tailored young man sits on a roof terrace, holding his face up to the Mediterranean sun and smiling while an aproned girl combs his hair. The painting is entitled *Departure*, and a packed trunk lies waiting near his chair. Gradually, however, the entire scene takes on a Chirico-like air of uncanny expectancy. The villas on top of the dark cliff behind appear to be observing the two figures, waiting for something to happen. Attention begins to focus on the comb held so firmly above the youth's self-satisfied face. Its teeth hang down, carefully picked out in the light and ready to carve their way through his hair with unusual resolve. The comb's latent menace is confirmed by the expression of the girl, who addresses herself to the task in

the steeliest manner imaginable. Ostensibly subservient, she is in fact the dominant force.

All the same, Rego does not allow us to find out anything else about the ensemble she depicts here. Because her pictorial organization is so beguilingly lucid and magisterial, we expect to discover an explanation for these mysterious rituals. None is forthcoming, even in the enormous image which takes its title from Genet's *The Maids*. Once again, the servants of the household play the most commanding part in the drama: one reaches out to touch her mistress's bowed and despondent head, while the other seems to be restraining a girl whose arms are raised in protest or misery. The whole theatrical tableau is left open to interpretation, however. The care with which Rego recreates the affluent upholstered interior, its heavy drapes and ornaments, is in disquieting contrast with her refusal to elucidate an unequivocal meaning.

The artist has herself explained, in an interview, that the uniformed youth in *The Cadet and his Sister* is impotent. But that disclosure does not lessen the mystery of the picture as a whole, where the immaculately attired sister kneels to tie up his bootlaces. Like the maids and all the other female performers in Rego's work, she possesses an innate power. Her composure and deliberation highlight the awkwardness of the cadet, who spreads out his gloved fingers on the stone chair as if fearful of losing his balance. His jutting head leans sideways, and stares through a gap in the wall at an avenue of bunched trees. Although they frankly resemble painted stage scenery, this declaration of artifice does not diminish their claustrophobic aura. The trees look like an extension of the cadet's hemmed-in mind, and the porcelain cockerel standing in the foreground only accentuates his helplessness.

The hints of frustration and loss detectable in many of these pictures doubtless reflect the recent tragic death, from multiple sclerosis, of Rego's husband Victor Willing. None of them, though, refers to her bereavement in a direct way. She is not concerned with autobiographical disclosure so much as the creation of a complete imaginative world, with its own peculiar logic, settings and cast of characters. Any trace of sadness here is offset by the serenity which prevails in these remarkable images. *The Cadet and his Sister* is marked, ultimately, by a sense of acceptance.

Even Rego's most confined characters display an underlying strength of purpose that counteracts the curtailment imposed on them by circumstances. In *The Policeman's Daughter*, the protagonist appears doomed to sit in a bare room and polish her father's gleaming black boot. She is, however, a robust and eminently confident figure who rests on her chair with formidable authority. Energy courses through the convoluted folds

and shadows of her white dress like a seismic current. It culminates in the toughness of her right arm, which pushes out into an uncompromising elbow and then presses down hard on the pad cleaning the leather. Her other arm is mostly enclosed by the boot, but her shoulder is clearly visible and asserts a similar muscularity. With eyes downturned so much that she resembles a dreamer, this doughty daughter seems to be preparing herself for a different, less constrained life when she reaches adulthood. Her proud head takes on a hieratic dignity as she anticipates a future unhampered by menial responsibilities. Poised and resolute, she could almost personify the sureness with which Rego herself has arrived at an artistic maturity in the last few years. Putting the uncertainties of earlier decades behind her, she has discovered how to discipline her former turbulence without sacrificing any inner fire. The commitment to the complexity of the human condition remains the same, but it is conveyed now with the focused assurance of a single-minded vision.

BULATOV AND KABAKOV
23 March 1989

Back in the depressing pre-*Glasnost* doldrums, information about contemporary Russian art was desperately hard to obtain. The drought has been transformed into a flood over the past year or so, with Soviet artists exhibiting their latest work all over town. But while welcoming them here, I have become increasingly aware of their frequent mediocrity. Shaking off old attitudes cannot automatically guarantee better art. Too many of the painters so far displayed in London compare poorly with their western counterparts. Anxious to claim freedom of expression, Russian artists often produce inferior versions of the styles they are now allowed to emulate.

So the advent of two robust individualists at the ICA, Erik Bulatov and llya Kabakov, is especially heartening. Both men were born in 1933, and have been based in Moscow for many years. While utterly distinct in their approaches, they share a questioning attitude which must have made life very difficult before *perestroika* set in. Even now, as he benefits from acceptance in the USSR and a growing reputation in the west, Bulatov remains guarded about the changed climate. 'I do not share in the hopes expressed by many others that the recent liberalisation will

cause the "underground" to disappear and to break up into new, joyous and unrestrained production,' he declared in a 1987 interview, adding: 'nor do I think that this will come to pass in the near future'.

Such an opinion is all of a piece with the paintings Bulatov has been quietly yet steadfastly producing over the past couple of decades. Far from developing a sceptical voice only when Gorbachev came to power, he has been consistent in his standpoint since the earliest picture on display here. It is called *Red Horizon*, and at first glance seems to reinforce the roseate view of a glorious future put forward by approved art of the period. Five figures advance towards a panoramic beach, painted in a soft photographic idiom redolent of tourist brochures and propaganda posters. The aura of a youthful generation striding in the direction of infinite fulfilment, under an idyllic blue sky, is seductively presented. Right in the middle of this reassuring vision, however, Bulatov has inserted a thick red stripe bordered with gold. It runs across the painting where the horizon should be, and disrupts the bland pictorial unity created so carefully in the rest of the canvas.

The result is disquieting, both stylistically and thematically. Why has this blatant device been employed here, destroying spatial illusion and making the sea terminate in a fiery band which suggests conflagration more than optimism? The impact of this intrusion, reminiscent of the American hard-edge abstract painting then so reviled in Russia, reminded me of a similar tactic used by Malcolm Morley around the same period. He daubed a large scarlet cross over his own skilfully painted image of a South African racetrack. In his case, the red paint defaced the picture beneath, thereby implying a vehement condemnation of the society it depicted. Bulatov, by contrast, is more stealthy and difficult to pin down. Red, after all, is the most politically acceptable of colours in the Soviet Union. Couldn't *Red Horizon* be seen as an affirmation of the way Russia's ruling ideology triumphantly dominates everything in sight?

The element of ambiguity in such a painting doubtless helped to preserve Bulatov from the persecution meted out to other dissidents at that time. But the true meaning of his work now seems evident enough. In canvas after canvas, the visual rhetoric employed to bolster the approved view of Soviet life is used only in order to undermine its apparent authority. Colossal capital letters block out much of the summer sky in *Glory to the CPSU*, creating a sense of oppression even as they appear to laud the official party line. Figures walking up a hill past a dreary stretch of civic grass are overshadowed by a billboard image of Lenin striding in the opposite direction. Slogans are continually imposed on scenes of urban and rural existence, ordering, controlling and obstruct-

ing the pursuit of everyday pleasures like the picnic framed by words spelling out the presence of DANGER. At his most cunning, a 1977 painting called *Brezhnev* (*Soviet Cosmos*) implies overweening power by presenting the leader in a complacent pose beneath an image of complete global domination. At his most overt, ten years later, a picture of obedient conference delegates raising their hands in an assenting vote is partially obliterated by letters emphasizing the UNANIMOUS mood of the meeting.

Permitting such an artist to stage a mini-retrospective in the West represents a signal step forward in Soviet cultural policy. But the advance should not be allowed to wipe out memories of past repression. Kabakov, the other exhibitor at the ICA, was for many years only granted official recognition for his children's book illustrations. His other, more ambitious and complex work was carried out in virtual seclusion. Remaining for so long at odds with party policy seems, quite understandably, to have driven Kabakov in on himself. He was forced to cultivate an independent vision in defiance of 'acceptable' doctrines, and a stubborn, defensive mood pervades his art. 'When I submerge into my childhood world,' he explains, 'I see it inhabited by a number of the most strange and comic individuals, neighbours of our large, communal apartment.'

His labyrinthine installation leads the visitor through a sequence of rooms, each one supposedly cluttered with the accumulated paraphernalia of a secret life. They all testify to quirky preoccupations, like 'The Collector' whose space is festooned with old postcards and posters evoking a sentimentalised past otherwise beyond recall. Although Kabakov invites us to enter these rooms and examine their contents for as long as we like, a feeling of furtiveness prevails. We seem to be invading a series of intensely private worlds, sifting through the bric-à-brac assembled by people who could not prevent themselves from creating obsessive environments. Just as Schwitters filled part of his Hanover home with a proliferation of found objects and invented images which amounted to an engulfing *Merzbau*, so Kabakov turns the interiors of a crumbling Moscow block into a series of imaginary realms. As his name suggests, 'The Man Who Never Threw Anything Away' ended up making an almost uninhabitable room. Overloaded with painstakingly preserved debris, this manic chamber resembles the work of someone who kept reality at bay by constructing an alternative of his own. The same might well be said of Kabakov himself, obstinately developing an art which for many years remained invisible so far as the Russian public was concerned.

A siege mentality is conveyed in one area, belonging to 'The Man Who Flew Into Space From His Apartment'. The entrance is boarded off with a rudimentary wooden plank, nailed there either by its former

occupant or officials who have decided that its contents should be concealed. But alongside this strain of pathos, even more acute in the 'Abandoned Room' where a rope lies discarded with notes forlornly attached, Kabakov's humour saves his work from outright morbidity. The space belonging to 'The Untalented Artist' is stuffed with paintings of the most ludicrous banality and incompetence. Kabakov shares Kafka's ability to discover comedy even in the most intolerable circumstances, and the persistence with which he has pursued his embattled vision offers resilient proof of the human spirit's will to survive.

79. Ilya Kabakov, *The Man Who Flew Into Space From His Apartment*, 1981–8

SEAN SCULLY

25 May 1989

For much of the 1980s, abstraction was regarded as a questionable enterprise. Figurative art became dominant once again, often allied with blustering brushmarks and outright emotionalism. It implied a reaction against the austerity of painters who dealt solely with a language of squares, circles and oblongs. That kind of severity was equated with sterile remoteness, and many young artists felt the need to escape from an ingrown debate preoccupied with formal manœuvring on the canvas's surface. Abstraction came to be viewed as a hermetic pursuit, cut off from broader human concerns. Neo-expressionism prevailed – until the orgy of flailing pigment finally provoked, in its turn, a reassessment of rigour and classical control.

The finest of the figurative painters who have emerged in the past decade will, like Anselm Kiefer, sustain their reputations in this altered climate. But it also favours the work of artists who kept faith with their abstract convictions in a supple and questioning way. Sean Scully, whose magisterial exhibition is displayed to great advantage at the Whitechapel Art Gallery, is just such a painter. While remaining committed to the steady exploration of a non-figurative vocabulary, he has no patience with abstractionists who lose themselves in a thin-blooded obsession with geometric purity. 'To my mind,' he says, 'work which distances itself in that way becomes academic. It cannot be related to lived experience.' A great deal of current abstraction earns his disapproval on this score, and he wants to restore the nourishing relationship between art and life that he admires in Rothko or Suprematism during the Russian Revolution.

To his credit, though, Scully realises that there is no point in turning abstract art back to an earlier stage in its history. An instinctive mistrust of post-modernist quotation leaves him in favour of development rather than recapitulation, and to achieve that end he has overhauled his own work in a thoroughgoing manner. During the early 1970s, when the Dublin-born Scully first gained a reputation for himself, he used masking tape to make images of complex, overlapping grids. Airbrushing was sometimes deployed to enhance their clean, systematic impact. Although planned and executed with utter professionalism, they were over-frenetic and too anxious to load the canvas with eye-wearying meshes of interwoven structures. Brittle to a fault, they assailed the viewer with stridency instead of stimulating a more subtle engagement.

Judging by the work of the 1980s, which fills both the Whitechapel's

main galleries, Scully came to realise the limitations of these youthful exercises. A move to the USA in 1975 coincided with a growing urge to jettison the labyrinthine grids for ever. A far more measured reliance on stripes gradually took over, along with a desire to move away from taping and airbrush techniques. The paint which had once been so thin now became richer and more sensuous. It was as if Scully wanted to focus on the steady, essential strength of his vision, and that meant ceasing to rely on all the busy stratagems of the past. They had threatened to obscure this central concern, which was freed at last to assert its imperatives on canvases of imposing dimensions.

Scully has never been afraid of working on a monumental scale, and some of his early paintings were just as large as his more recent pictures. But the difference is that he has learned how to arrive at a monumentality of image to match the size of the canvas. The stripes he favours are, for the most part, sturdy forms capable of playing a dependable role in the construction of a building. They look securely lodged, and Scully bolsters this aura of incontrovertible power by making his canvases jut out forcefully from the walls where they hang. The paintings have a carpentered air, thick and almost sculptural in the way they take possession of space. They loom out at you like the facades of bulky buildings, and it would be tempting to speculate about the beneficial effect which the New York cityscape exerted on Scully's search for a stripped-down grandeur.

But to find vestigial skyscrapers in his work would be wide of the mark. The bands or bars that constitute the components of his art are more redolent of fences than architecture. Their roughness is far removed from the streamlined, self-conscious sheen of Manhattan office-blocks, and Scully has explained that 'I prefer the coarser parts. That's where I get my inspiration, from the docks and from railway arches.'

The thickness of his pigment reinforces this feeling of elementary bonding. Its layers appear to bind the different parts of a picture together, promoting cohesion in compositions which might otherwise fail to attain unity. For Scully takes considerable risks with the structure of his work. Each painting is assembled from three or four canvas panels, and he often stresses their separateness by creating frank contrasts between the stripes and colours they contain. There is little danger, in his art, of monumentality lapsing into a complacent routine. Scully's four-square finality is only achieved by resolving internal contradictions within the pictures. A grand succession of bars is often interrupted, at its heart, by a smaller inserted panel where another pictorial order asserts itself. Scully savours the challenge involved in marshalling these units, so that they finally arrive at an unpredictable compatibility. In *By Night and By Day* three distinct sets of

80. Sean Scully, *A Happy Land*, 1987

images abut one another: the thick horizontal bands of black and cream on the left are suddenly succeeded by thin, wavering vertical lines on a mustard ground, which in turn are wedged against a sequence of mighty stripes in black and red. The trio's conjunction could easily seem arbitrary and unresolved. But Scully manages to make them cohere, and in this act of hard-won unification can be found the key to his affirmative vision.

The toughness and overt oppositions abounding in his work make clear that he has no wish to underestimate the obstacles standing in the way of an optimistic outlook. He describes *A Happy Land* as a painting with 'a rather ironic title because it refers to something which doesn't exist, not in the world as it is today.' All the same, this awareness does not prevent him from striving for a sense of resolution in the work he pro-duces. The panel of deep red and blue stripes inserted in the centre of *A Happy Land* maintains an equable existence, even though the colossal black and orange staves around it introduce a more ominous order of reality. The expatriate Scully, well-placed to be conscious of the tragic divisions beleaguering the world, persists in attempting to overcome bar-

riers and bring even the most disparate elements into a convincing pictorial whole. While remaining alive to all the inevitable tensions that continually frustrate such an endeavour in the late twentieth century, he uses his art to offer a consoling prospect of survival, reconciliation and hope.

KEITH ARNATT
22 June 1989

The area around the Wye Valley has become hallowed by generations of poets, painters and photographers, all dedicated to defining and celebrating its undoubted allure. Acutely conscious of the way they have shaped our understanding, Keith Arnatt has nevertheless spent the last fifteen years presenting an alternative view of the locality. Rather than confirming the tourist-brochure familiarity of Tintern, he preferred to photograph the abbey's visitors in smiling pairs. Posing for his camera in their smart weekend outfits, they could hardly be further removed from the Wordsworthian notion of a traveller who experiences a lonely, contemplative encounter with a medieval ruin.

Arnatt's subsequent forays into the region yielded equally unpredictable results. Having lived there himself for many years, he was well-placed to seek out the less predictable aspects even of a district designated as an Area of Outstanding Natural Beauty. He adopted those consecrating initials, AONB, as the title of a series where lyrical panoramas are punctured by apparently unpalatable invasions. A mist-filled river is juxtaposed with a mess of litter spilling out of a soiled carpet to stain the foreground bank. Three dustbins lean tipsily by the side of a country path, and when Arnatt turned his attention to the Forest of Dean he continued to disconcert. A gaunt landscape is presented, scarred with tractors' tyre-marks and sawn-off trunks ready for sale to the timber trade. The few trees left standing are unavoidably reminiscent of the stumps projecting from the battlefields of the First World War. Rain-filled holes in the ground likewise stir recollections of the Passchendaele mud craters, and yet the prevailing mood of Arnatt's work is very different from the despairing moral outrage conveyed by Paul Nash in 1918. Ever-quizzical and alive to the ironies inherent in his subject-matter, Arnatt never seeks to polemicise about the state of the terrain he investigates. Far from condemning the pollution and other man-made intrusions found in the Wye region, he is

impelled above all by a desire to offer what he once described as 'an accurate portrait of the area'.

Such an ambition has links with the otherwise very different work Arnatt produced in the late 1960s, when he first became known as a 'conceptual' artist. Intrigued by reading a report of the hole Oldenburg dug in Central Park, as a contribution to a sculpture exhibition, he carried out projects where photographs offered evidence of the activities undertaken. Unlike Oldenburg, who had filled in his hole without providing any documentary proof of the digging itself, Arnatt ensured that his earthworks were recorded and revealed by the camera. Although he directed these photographs rather than taking them himself, they possess the same clarity as his Wye Valley pictures today.

Not long after making an oddly prophetic work called *Self Burial*, where Arnatt is shown descending with erect, sober fatalism into the ground, he began to withdraw from the conceptual art scene. His subsequent development has earned him an attentive audience in photography circles, and his current mini-retrospective does not look at all out of place at the Photographers' Gallery. But it would be wrong to suppose that Arnatt has simply retired from his role as 'artist' and become a 'photographer' instead. He resists facile classification, operating at just as much of a remove from the photographic tradition as he once did when questioning the 'fine art' context twenty years ago. Having studied at art colleges and then taught in them, Arnatt remains profoundly involved with painting and sculpture. He is fascinated in particular by their interrelationship with the much briefer history of photography, and claims the right to inhabit an analytical domain where his multiple interests can all be brought into play.

Until the mid-1980s he confined himself to monochrome photography, allying his work with a topographic tradition even as he introduced references to Nash's desolate war paintings. Since then, however, colour has taken over. In a small-scale yet outstanding series entitled *Miss Grace's Lane*, he used his new technical resources to bring about a more complex and refined encounter between rubbish and the pastoral surroundings it inhabits here. The lane itself has elements of enchantment, and Arnatt photographs its overgrown mystery with a devotion comparable with Samuel Palmer's hymn to Shoreham. At the same time, though, the discarded litter spewing out of polythene bags is more evident here than ever before. Paradise has been comprehensively despoiled, and the conflict between nature and refuse gives this series much of its pictorial tension.

But Arnatt is reluctant, ultimately, to deplore the pollution he surveys. His photographs are fascinated by the encounter between a green plastic

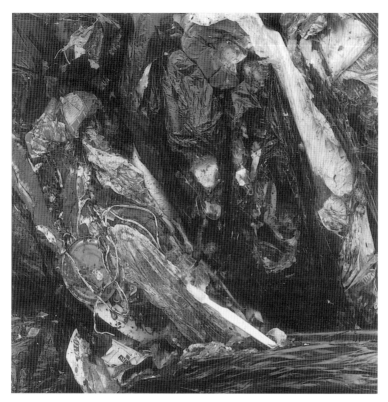

81. Keith Arnatt, *Howlers Hill*, 1988

bottle and the wild flowers springing up nearby. He is just as unwilling to dismiss the possibilities inherent in detritus as sculptors like Woodrow or Cragg, who have shown a similar readiness to incorporate so-called rubbish in the work they produce. Arnatt's involvement with these discarded fragments prompted him, in 1987, to move his camera closer to them. By focusing on a rotten mattress, at the expense of the locale around it, he was able to discover an unlikely metamorphosis. As the sodden and fraying sheet splits to reveal the soiled red mattress inside, the entire object takes on a comic resemblance to an open-mouthed whale. Humour, albeit of a peculiarly wry kind, has always played a distinctive part in Arnatt's work. He relishes the surrealist transformations found in festering dumps which most photographers would prefer to avoid.

The more engrossed Arnatt became by those rancid deposits, the more determined he grew to press his lens still further into their compressed, smelly crevices. At the aptly named Howlers Hill, a 'landfill site' in the Forest of Dean, he found an especially rich seam of images. They look, for a second, like a sequence of turbulent landscapes, where immense rock-faces still declare the seismic forces which brought them into being. Then our eyes detect an empty Coke can, a Hitachi tool-set box and other recognizable objects. A wholly different reading is demanded, wrenching us away from thoughts of the Turneresque sublime towards the reality of a late twentieth-century garbage dump.

But our response to these mesmeric and sumptuously printed pictures does not end there. Although the rock-face is now revealed as a stretch of creased plastic, bulging with the weight of the accumulated cast-offs it contains, the landscape resemblances persist. So, in a more recent sequence, do connections with still-life painting from the past. One sensuous image, from a group bluntly entitled *Pictures from a Rubbish Tip*, is dominated by a peach nestling among discarded flowers and fragments of silver foil. Arnatt savours their unexpected kinship with a Chardin, just as he remains aware of their links with a more elegiac tradition of *vanitas* still-life painting where the prospect of putrefaction is paramount. All these diverse considerations come into play in photographs as densely layered as the refuse they depict with such wit, cunning and obstinate sympathy.

GERHARD RICHTER

7 September 1989

On 18 October 1977 the bodies of Andreas Baader, Gudrun Ensslin and Jan-Carl Raspe were found in their prison cells. No one has conclusively established whether these three members of the notorious Red Army Faction really did commit suicide. Like the terrorism they inflicted before their capture, the deaths themselves became a taboo subject. Most West Germans preferred to forget the entire episode, or at least regard it as an enigma best left unexamined.

A decade later, though, Gerhard Richter found that he was impelled to look again at their mysterious extinction in Stammheim prison. Haunted by press pictures of the supposed suicide pact ever since their initial release

by the police, he was unable to repress a growing obsession with the events they recorded. Photographs have provided Richter with the starting-point for paintings throughout his career, and he now began collecting a mass of pictorial information from private archives as well as police files. Arriving at a conclusive verdict on how the terrorists died was never his intention. He believes that 'probably they did commit suicide' anyway, and the settling of such questions is best left to detectives. Rather did Richter aim at opening up his own response to an event he describes as 'monstrous'. Sifting through the immense number of photographs was a way of confronting this unfinished business. Eventually he produced a sequence of fifteen sombre paintings from his researches, concentrating not only on the terrorists' bodies but their arrest, imprisonment and funeral as well.

The entire series has now been brought to the ICA, where it raises fascinating questions about the problems involved in making a viable contribution to the tradition of painting contemporary history. Unlike David or Goya, Richter was obliged to acknowledge that his understanding of the Stammheim deaths had been shaped by the camera's lens. At first glance, his exhibition resembles an array of enlarged monochrome photographs, and he makes no attempt to escape from their often grainy sobriety. The temptation to invest these subdued images with a more heightened and bloody drama has been avoided. Sensationalism plays no part in Richter's restrained project, which likewise keeps well away from polemical point-scoring. These are not the images of a man who declares his solidarity with the Utopian politics embraced by the Red Army Faction's devoted adherents.

His paintings are, for the most part, modest in dimension. They refuse to blow the terrorists up to heroic proportions. The largest canvas is of their funeral, where no individuals can be discerned in the overcast and undifferentiated crowd. Even when Richter bases one of his pictures on a pre-terrorist photograph of Ulrike Meinhof, he simply calls it *Portrait of a Young Woman*. Her features are undeniably appealing, blanched and wistful beneath the long dark hair. But we are invited to reflect on the difference between this harmless teenager and the hard, single-minded perpetrator of violence she became. Our conclusions are bound to centre on the pathos of her transformation, along with the impossibility of ever wholly comprehending the forces which drove a bourgeois girl to turn against the society she grew up in.

This impenetrable mystery hangs over the entire suite of paintings, and Richter's readiness to declare it lies at the centre of his ability to revitalise history painting for our own doubt-beset era. The frank admission of inexplicability makes his dependence on the camera paradoxical in

the extreme. Richter has the technical command to bring his work very close to the look of the photographs he selected. Each painting commenced as 'an exact rendition' of his material, and the attempt to produce a facsimile lingers like a ghost in the final work. But the longer these pictures are scrutinised, the more ambiguous they become. Fidelity to their starting-point gives way to a far more complex ambition, which involves distancing the image a long way from its documentary source. Richter knows, more precisely than his viewers, that most of the photographs originated in police commissions. They present a version of the truth already shaped by the requirements of the state, and no independent insight would be gained merely by copying them on canvas. That is why he moves towards a more oblique approach, retaining the semblance of photographic 'authenticity' only as a springboard for more profound concerns. Richter's brushmarks, while deceptively smooth and purged of all expressionistic gestures, end up offering a surprisingly personal interpretation of that autumn day in 1977.

Since the photographs are not reproduced in the substantial catalogue, it is impossible to tell how far he departs from them. But he seems to have followed the elusive procedure informing all his previous photo-based paintings, progressively blurring the images and robbing them of their original substance. The outcome is strangely vestigial, so that even the pictures of Gudrun Ensslin while alive appear to presage her impending death. A trio of canvases entitled *Confrontation*, presumably culled from standard police identity shots, present half-length views of this elfin young woman. In the full-face picture she smiles at the camera, as if greeting a friend rather than brandishing any aggressive defiance. But the vivacity she displays is countered by the melting effect of Richter's paint. At the same time as he affirms his reliance on photographic sources, his brushwork undermines them by allowing Ensslin to slip away from close examination. In the profile shot she bows her head, as if in mute acknowledgement of the fate awaiting her at Stammheim. The dissolution of focus and form engendered by Richter accentuates the melancholy, and the paintings work best when they are at the furthest remove from the camera's gaze.

Two versions of an image called *Shot Down* exemplify this gain. They both seem to be based on the same photograph of a male terrorist lying on his back, with left arm outflung. But the second canvas cuts off his hand and wrist, as well as dispensing with the indecipherable objects lying next to his head in the first version. A greater intensity results, bringing us nearer to the slender corpse without any of the previous distractions. But this proximity is accompanied by a radical withdrawal of

definition. The figure fades into fuzziness, yielding its former solidity just as the terrorist had himself been divested of life.

The only forms to keep a significant amount of substance are located in the prisoners' surroundings. In a large painting entitled *Cell*, vertical brushstrokes break up the room like drizzling yet insistent rain. But the high and heavily loaded bookcase still registers its dark bulk, and so does the LP resting on its deck in a smaller canvas called *Record Player*. Both these paintings testify to the fact that all three inmates were granted unusual privileges, provoking the indignation of some commentators at the time. In the context of Richter's work, though, they only confirm the prevailing sadness. If the consolations of music and literature could not prevent the terrorists from killing themselves, their desire for extinction must have been formidable indeed.

Richter deplores the waste of their short lives, expended on a cause so fanatical that it drove them to assail their country with inhuman ferocity. In the end, they appear to have turned this fearful capacity for ruthlessness

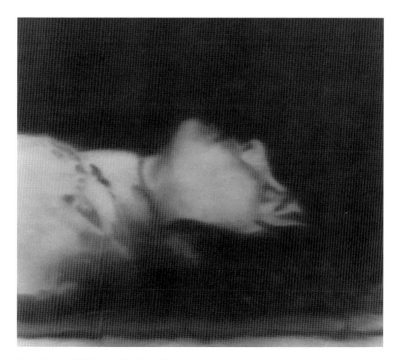

82. Gerhard Richter, *Dead*, 1988

on themselves, and the most affecting pictures close in on Ensslin's slaughtered head as it rests on the prison floor. The three versions of this image, all given the Goyaesque title *Dead*, distil the artist's fundamental sense of loss. Although he recognises that their cause was futile, Richter mourns the woman's destruction as he gradually lets her dissolve in his soft grey pigment. In the final canvas she is little more than a whisper of light, fading into a shadowy region where oblivion is waiting to envelop her for ever.

MICHAEL CRAIG-MARTIN

23 November 1989

The first object to confront visitors entering Michael Craig-Martin's Whitechapel retrospective is an unadorned glass of water. Resting on a glass shelf, which would normally be found in a bathroom cabinet, it is placed high on a wide, white wall – presumably to foil anyone tempted by the thought of reaching up, taking it off and enjoying a surreptitious sip. But the glass hasn't been placed there in order to quench anyone's thirst. A nearby text, cast in the form of an auto-interview with the artist, clarifies a very different intention. Asked to describe the work, Craig-Martin claims that 'what I've done is change a glass of water into a full-grown oak tree without altering the accidents of the glass of water'. As the interview proceeds, the questions Craig-Martin puts to himself prove that he realises how outrageous this bald assertion may appear. The artist seems to be arguing with himself, voicing two contrasted sides of his character. But he remains firm throughout, and when the questioner accuses him of perpetuating 'the emperor's new clothes', his rebuttal is disarming. 'With the emperor's new clothes,' he says, 'people claimed to see something which wasn't there because they felt they should. I would be very surprised if anyone told me they saw an oak tree.'

The reply sums up the matter-of-fact way in which Craig-Martin has always presented his adroit and subversive work. Over the past twenty years he has favoured resolutely mundane objects, and made sure that we understand precisely how they have been represented. But alongside this desire to demystify, and concentrate on everyday reality, he likes to confound all normal expectations. In the *Oak Tree* piece, the old argument about art requiring a willing suspension of disbelief is reframed with the

maximum amount of philosophical provocation. Like Duchamp before him, Craig-Martin wanted to shift the focus away from the object itself towards the artist's intentions, and at the same time extend the boundaries of art beyond painting or sculpture. Fascinated by the idea of escaping easy definitions, he fills the downstairs area of the Whitechapel with deftly manipulated propositions which rely on a wide array of materials. Nylon rope, milk bottles, buckets, paint tins, clipboards and mirrors are all incorporated in different works, by an artist who claims the right to be as inclusive as he likes. Whenever the exhibits begin to resemble sculpture, they turn out to have an equally strong connection with furniture as well. Many are hinged, inviting the visitor to change their identity by folding them in or opening them out. But their links with tables, seats or containers are not, finally, strong enough to make them qualify as functional objects. They defy easy classification, like all Craig-Martin's work, and inhabit a borderline region where our customary perceptions are tested all the time.

The relish with which he performs this feat is clear at every turn. One neon work is called *Sleight-of-Hand*, and a strong element of the conjuring trick runs through everything Craig-Martin has produced. He delights in deft, elegant and refined feats of showmanship, allied with a desire to draw visitors into a participatory relationship with the work. *Society* looks, at first, quite spare and retiring: eleven vertical strips of mirror are ranged along the wall, each enclosed by thin black lines and accompanied by spidery handwritten captions. But the reticence proves deceptive. Once we begin reading the captions, and moving along the row of mirrors, Craig-Martin involves us in an increasingly complex meditation on how we see ourselves and how others regard us. The confidence of the first caption, 'I have an idea of what I am like', undergoes so many modifications that it culminates in the more perplexed realization that the final strip of mirror merely reflects 'part of what I recognise others see'.

As the 1970s came to an end, all this monochrome sobriety was replaced by a more expansive mood. He began making colossal wall-drawings with tape, letting the contours of a hammer, a sardine tin and a sandal flow into each other. Monumental yet oddly weightless, the blown-up objects hang in space with surprising serenity. They could easily appear tortuous, but Craig-Martin's linear control allows them to achieve clarity and grandeur. Red is added to the prevailing black in *Modern Dance*, the largest of the wall drawings, and it gives the free-floating forms a festive air. Objects as mundane as a can-opener, safety-pin and tape-cassette take on a new suavity as they hover on the wall, like

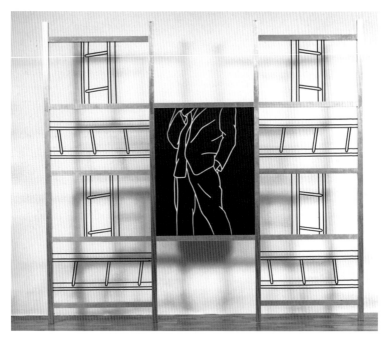

83. Michael Craig-Martin, *Still Life with Interior*, 1987

the contents of a space-rocket freed from their moorings to tumble and glide. They suggest that Craig-Martin shares some of Léger's optimistic enthusiasm for the fabric of the modern world. But they are also akin to the use of 'found' objects in the work of sculptors like Cragg, Woodrow and Wentworth, who share a fascination with the expressive possibilities of ordinary, disposable materials.

Colour comes to play a potent role in recent years, giving the upstairs section of the show a more flamboyant aplomb. Sometimes a monochrome diagram is juxtaposed with a brighter alternative rendering – panels of blue and scarlet are attached, in *Metronome*, to the black rods outlining the box itself. The encounter between two ways of representing an object takes a more disruptive form in *Side-Step*, where a framed segment of aluminium ladder is inserted in a linear 'drawing' of the same appliance. The manœuvre has a typically teasing Craig-Martin flavour, but when he inserts a blue cube into a work called *Globe* the result seems simply mischievous and lightweight.

Although most of these objects imply human use, he prefers to avoid direct reference to the figure. The appearance of a jacketed man in a perspex light box, at the centre of *Still Life with Interior*, is therefore unexpected. Even here, though, the man retains his anonymity. Craig-Martin refuses to include the face, and the most recent work returns to his old preoccupation with the inanimate world. Venetian blinds are assembled into structures reminiscent of minimalist paintings, and in the latest series he uses household paint to cover immense canvases with flat, single-colour areas of black, orange, yellow or green. Just in case anyone imagines that Craig-Martin has become an abstract painter, the canvases also include images of a light bulb, a portable television or a mirror. Each one is drawn in the familiar diagrammatic manner, deliberately devoid of personal style. But they are all changed by the new context he has devised for them – just as the glass of water became an oak tree when Craig-Martin issued that calm yet provocative statement of intent back in 1973.

THE OTHER STORY
7 December 1989

In an ideal world, the Hayward Gallery's exhibition *The Other Story* should not be necessary. But most of the twenty-four artists displayed here deserve more recognition than they have received since arriving in this country from Asia, Africa and the Caribbean. The show's organiser, Rasheed Araeen, therefore decided that he would try to put matters right by bringing them together – in a survey that questions what he calls the 'master narrative' of art in post-war Britain. The plan did not altogether succeed. Several of the younger artists he invited, among them Shirazeh Houshiary, Anish Kapoor and Dhruva Mistry, felt unable to participate. Having enjoyed considerable success within the mainstream art world, they were unwilling to align themselves with a context which stressed their separateness. Their attitude is understandable. No British artist wants to be herded into a ghetto, and Araeen himself hopes that a survey like *The Other Story* will never have to be organised again. But for the moment, at least, the exhibition serves a distinct purpose. By giving its contributors prominence in a major gallery, the show will introduce their work to a far wider public than before. If this exposure leads to a

fairer assessment of their significance, then the venture will be justified.

Not all the artists have suffered from neglect. Two of them, Avinash Chandra and F. N. Souza, even attained celebrity status for a while. But interest in their work began to fade over a quarter of a century ago, and they will seem unfamiliar to many visitors today. Souza's paintings are among the most dramatic in the show. His *Girl with a Goat* is boldly drawn, and the animal has a sharp-edged vivacity reminiscent of Picasso. But the woman herself – half hieratic and half sex-goddess – could only have been created by an artist with an Indian heritage. The result is a synthesis of two cultures, the Asian and the European.

Similar fusions occur throughout the survey, which testifies to the artistic consequences of what V. S. Naipaul once called the 'great movement of peoples that was to take place in the second half of the twentieth century'. It is fascinating to discover the enormous range of ways in which the synthesis has been achieved, and in this sense the exhibition has an air of celebration. But the pain lurking behind many of the journeys undertaken by these artists should never be underestimated. Balraj Khanna, who grew up in post-Raj India with a 'voluptuous' vision of England in his mind, was cruelly disillusioned when he arrived in London towards the end of 1962. He was greeted by 'No Blacks, No Indians' notices for rented rooms in shop windows, and racism has undoubtedly dogged the careers of many participants in *The Other Story*. Khanna himself, who has since developed into a mature and seductively lyrical painter, never received consistent support from the dealer system. His last London one-man show was held at the Horizon Gallery, a considerable distance from the well-trodden Cork Street circuit, but he is just as satisfying as many British-born artists with far greater reputations.

The same judgement applies to Aubrey Williams, who travelled to England from Guyana a decade before Khanna. Impressed by the Abstract Expressionists in general, and Arshile Gorky in particular, he detected stimulating links between their work and the pre-Christian Indian iconography of his native country. Over the last decade, Williams has incorporated overt references to the Maya civilization in his work, while maintaining a nourishing relationship with Western modernism. But he is still regarded as an outsider, by a culture which too readily saddles artists with the label 'exotic' and marginalises their true importance. Multi-racial Britain ought by now to have learned how to accept their validity, but the struggle continues. Araeen himself, born in Karachi and a resident of London for over twenty-five years, has long been preoccupied with the problem of *Making Myself Visible* (the title of his autobiography). In the late 1960s his work was severe and modular, related to

Minimalism but with a strong conceptual bias. During the next decade, though, he began to introduce polemical references to his own social identity, as a Pakistani-born *émigré* living in an often intolerant country.

The next generation of artists has been courageous enough to place racial division and brutality at the very centre of their work. Classified by his native South Africa as 'Cape Coloured', Gavin Jantjes won a scholarship to Hamburg and produced a series of hard-hitting screenprints about the evils of apartheid. Then, in the 1980s, he began painting, using history and mythology to explore the full ambiguity of the black dilemma. Jantjes himself has exhibited widely, and now wields considerable cultural influence as a member of the Arts Council. His latest work is more poetic, meditating on the relationship between African carving and the 'primitive' Cubism of Picasso against a star-spattered sky.

His earlier protesting anger reappears as a major force in some of the youngest artists at the Hayward. Both Eddie Chambers and Keith Piper, who met and befriended each other while studying at Coventry, share Jantjes's preoccupation with the history of the slave trade. Chambers was born in Wolverhampton, where Enoch Powell delivered his notorious 'rivers of blood' speech about black repatriation. Not surprisingly, the National Front became a special target in Chambers' angry, posterlike work. As for Piper, who says he was 'raised and mis-educated in one of Birmingham's many inner-city, third-world colonies', he arraigns 400 years of white tyranny over the blacks with excoriating indignation. *Go West Young Man* is the bitterly ironic title of a work which takes slavery as the launching-pad for an onslaught on the denigration and degradation of blacks in contemporary society.

Lubaina Himid, who came to England shortly after her birth in Zanzibar, channels her anger through the work of immediately recognizable Western artists. Picasso's celebrated running women on the beach, and Hogarth's *Marriage à la Mode*, are deconstructed in order to make satirical observations on racial prejudice in contemporary society. But Himid's work is fortified by hope, and she organised an outspoken show at the Africa Centre in 1983 which included the youngest artist in the Hayward survey – Sonia Boyce. Far from echoing the polemics of other contributors, London-born Boyce is prepared very honestly to expose her doubts about the complexity of modern life. While cherishing her parents, who come from Barbados and Guyana respectively, she defines the claustrophobia of family as well as its warmth. In a pastel and crayon work called '*She ain't Holding them Up, She's Holding On (Some English Rose)*', Boyce portrays herself simultaneously supporting and clinging to the family ranged above her head. Although it is an anxious

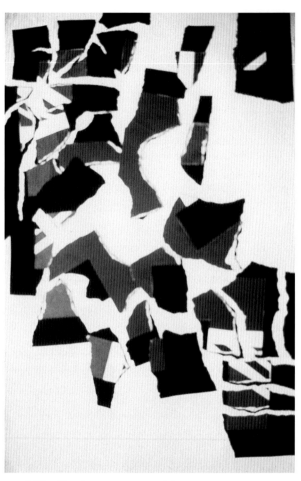

84. Eddie Chambers, *Destruction of the NF*, 1979–80

image, and filled with uncertainty, she assumes a defiant stance on the densely patterned surface of the picture. Acutely aware of the hazards, but determined to survive as an independent force, this stubborn little figure could well summarise the spirit of resilience unifying all the immensely varied facets of a challenging and salutary exhibition.

SENIORS

ROBERT RAUSCHENBERG
7 May 1981

It would be easy to overlook the old sepia photograph of a baby which Rauschenberg almost buried in a huge, hectic combine painting called *Canyon*. This faded little snapshot has to compete not only with a furious mêlée of smeared brushstrokes, feverish pencil-scratchings, buttons, newspaper cuttings, a mirror and a cardboard box, but also a stuffed eagle projecting from the picture and a pillow dangling down from a tatty length of linen. Once I had noticed the baby, though, it seemed an oddly appropriate pointer to the attitude behind Rauschenberg's best work. Seated on a bed of leaves in one of those absurdly artificial settings studio photographers loved to concoct for their sitters, the infant glances eagerly upwards and raises a chubby arm. Half reaching and half waving, he appears to be relishing the cacophony of colours, marks and bizarre trophies which shriek and swear all over *Canyon*'s unruly surface.

It is as if Rauschenberg wanted to admit, by including this photograph, that he aimed at making art with the uninhibited excitement of a child. Babies have no qualms about grabbing everything within reach and tearing, defacing or reshaping it to satisfy their own imperious desires. Rauschenberg revelled in a similar licence when, as a brash young Texan from Port Arthur, he settled in New York after the Second World War and responded to big-city life with scant regard for pictorial etiquette. Intrigued by the rich deposits of street junk waiting to be scavenged during short forages round the block, he filled his studio with the kind of detritus most artists would consign to the trash-can rather than the canvas.

There were, of course, artistic precedents for this love affair with the humblest of found objects. But the fastidious Duchamp, who obviously influenced his decision to regard ready-mades as fodder fit for art, never indulged in the delirious zeal with which Rauschenberg threw every conceivable kind of bric-à-brac into his work. Nor would Schwitters, who used urban waste-matter only in order to create an art of immense delicacy, restraint and refinement. As for Joseph Cornell, a fellow-American addicted to scouring the same New York streets for raw material, he would have been incapable of handling his discoveries in such an anarchic way. Rauschenberg's enormous, sprawling early works often look as though he has taken the tidy boxes Cornell filled with remnants and spilled their contents, pell-mell, on to whatever surface happened to be available.

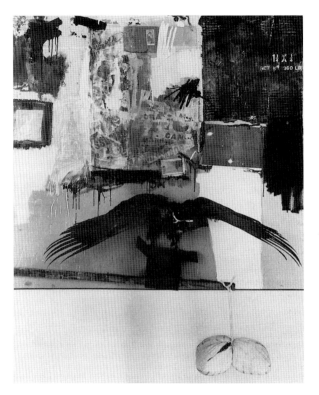

85. Robert Rauschenberg, *Canyon*, 1959

Just as Rauschenberg set no limit on the range of garbage he was prepared to employ, so he disregarded the notion that walls were the only legitimate destination for art. Since his work constantly made nonsense of traditional distinctions between painting and sculpture, it felt able to spread out on to the floor and invade the viewer's space. In 1954 Rauschenberg made *Minutiae*, a large free-standing work which could almost be composed of screens from his studio, where he tested out his brushes, pasted cuttings and even hung a circular shaving mirror that revolves as you pass. *Minutiae* is now exhibited as a gallery object, but it was initially made for a Merce Cunningham ballet performed to music by John Cage. Rauschenberg saw no reason why an artist should be confined within the conventional spaces where artists are expected to display their work. He devoted much of his time to collaborating with

dance companies, exhilarated by the discovery that his constructions could be placed on stage among the dancers. Much of his early work would look happier in such a context than it does in a museum: Rauschenberg's high spirits often conflict with the prim, white-walled solemnity of rooms where 'art' is supposed to be enshrined. Taking its place on equal terms with a dance troupe, and benefiting from the additional animation of the bodies leaping past, his work became far more difficult to classify.

It therefore satisfied his desire 'to act in that gap between' art on the one hand and life on the other. During the 1950s he was as cocky as a street-urchin besmirching walls with graffiti. Many of his surfaces seem to have been directly inspired by New York buildings covered in random stickers, eruptions of paint straight from the can, and fragmented messages ripped out of newspapers. Only Rauschenberg's vigour and inventiveness prevented these deceptively haphazard works from appearing as forlorn as the slumland of the city itself. In his bitter-sweet way, he was equally aware of the melancholy and the vitality in the world around him. The two strains are brought together most memorably in *Bed*, where the pillow, sheet and quilt Rauschenberg slept in are smothered with a delirium of paint, then up-ended and shoved against the wall. There the bed hangs, as crumpled and soiled with dribbling pigment as a dosshouse mattress, or the site of some hideously demented murder. But its gaudy colours make it at the same time a barbaric feast for the eyes, suggesting that Rauschenberg also wanted it to celebrate the flood of intense dreams and sexual pleasure which his own bed had probably witnessed.

To look at such a work, with its headlong blurring of the normal boundaries between an ordinary household object and a work of art, is to appreciate all over again how influential Rauschenberg's attitude during the 1950s proved to be. A lot of the artists who attempted, during the subsequent decade, to reflect modern life with as much rawness as possible owe a debt to his gargantuan appetite for rummaging around in the refuse-tip where Americans continually bury the remains of their disposable lives. Lichtenstein took the scraps of comic-strip which Rauschenberg's work often included, as one pictorial incident among many, and made it the centre of his art. Warhol benefited from Rauschenberg's determination to silkscreen on to his canvases newspaper and magazine images of anything from Kennedy to the fire brigade, from a free-floating astronaut to a boy gymnast. And an entire generation of younger artists found itself fired by his liberating insistence that art can take any form the artist wishes, blithely refusing to be restricted to a single material or place of exhibition.

No *enfant* was more *terrible* than Rauschenberg in his heyday, but the trouble is that even the most precocious child has to grow up. Now well into his fifties, he has long since outlived the effervescence which once gave his work such an infectious sense of involvement with urban life. The images he used to summon up as zestfully as a child punching his way through all the American television channels have lapsed into monotonous overkill. Staring at a 1980 work which mixes the Acropolis with McDonald's chips, the Statue of Liberty with a pylon, and some moored boats with playing cards, I soon grew immune to the spendthrift abundance. None of the images seemed to *matter* very much. Rauschenberg has fallen prey to the glazed indifference of a middle-aged man gazing at his television and failing to register the full meaning of the pictures flickering endlessly before his eyes.

Worse still, Rauschenberg is now polite where once he was bad-mannered. The rebellious scruffiness of the 1950s work has given way to a stifling concern with neatness, and the tatty old found objects are replaced by exquisitely displayed specimens – washed, ironed and tailored – which have never been near a real rubbish dump. The passionate engagement with modern society has grown bland: he seems more than ever like a poised and polished celebrity going through the motions of an activity which has lost its cutting edge. I cannot imagine him being impelled by the anger which at one time prompted his polemical attack on pollution in a picture called *Earth Day*, where his favourite eagle is surrounded by contaminated landscapes and smoke-filled factories. Nowadays, in his determination to avoid the despoiled side of life, he pretends that it does not exist.

When Rauschenberg was young, his works constantly seemed to stretch out towards spectators, inviting them to participate and react with vehemence. Today this welcome has been withdrawn, and exchanged for a defensive, closed-off stance. The loss is summed up very poignantly by the change in a 1961 work called *Black Market*, which originally encouraged visitors to swap their own possessions for the objects in a box attached to the main picture. Now, although the word OPEN remains printed on its lid, the box is closed and securely locked. The party is over, and the sense of wonder which once prompted the child in Rauschenberg to greet the world with an eagerly raised arm has vanished. I hope it does not prove irretrievable.

TINGUELY

9 September 1982

Most public fountains are refined and dignified affairs, shaping water into a variety of well-behaved patterns without drawing unseemly attention to themselves. But Tinguely's *Carnival Fountain* in the centre of Basle gleefully flouts this gracious tradition. The half-dozen machines which sprawl, squat and teeter in its basin are not overawed by the prominent civic location they occupy. Like children suddenly let loose in a swimming-pool devoid of attendants, they splash and squirt water everywhere with anarchic delight. The comedy in all this erratic spraying and spurting is made even more irresistible by the clanking eccentricity of the machines themselves. Although wheels turn and pistons thrust with a will, every movement they make is absurd. Assembled from rusting scraps long since discarded by their owners, these manic contraptions mock the whole rational basis on which machinery is supposed to rest. Their only function is to be useless, and they celebrate the pleasure-principle with as much boisterous vitality as Tinguely can devise. In a world increasingly dominated by the streamlined efficiency of computer technology, they look defiantly blustering and old-fashioned. More human than mechanical, their unapologetic noise and mess also offer a welcome corrective to the hygienic Swiss neatness of the city they enliven.

I came across the *Carnival Fountain* by accident a few years ago without knowing who had made it, and Tinguely is most effective working well away from the gallery circuit where his unclassifiable activities become saddled with the respectable certificate of 'art'. Since 1970 he has been intermittently constructing, with the help of friends like Kienholz, Soto and Rauschenberg, a gigantic environment called *The Head* or *The Monster* in a French forest. Divorced from the art market and the museum system which tames even the most subversive work it contains, this extraordinary sequence of rooms, stairways and passages may well never be finished. But its constantly changing structure is probably the most complete expression of Tinguely's fundamental belief in the inevitability of flux and movement, and it doubtless fulfils his urge to involve spectators in a rich variety of sensory experiences.

How can the outsize ambitions of this man, who wears blue mechanic's overalls while working and keeps in his bedroom the Lotus which won Jim Clark the 1965 World Championiship, possibly be conveyed by an exhibition at the Tate? I was afraid that Tinguely's protean restlessness would be confined too narrowly in such an institutional context, and at

first my forebodings appeared to be confirmed. Apart from an initial encounter with a huge assemblage called *Plateau Agriculture*, where nine forlorn yet hilarious fragments of farm and factory machinery jerk, gyrate and flop on a metal platform, most of the exhibits lay still and silent. They were waiting to be activated by foot-switches, and in repose a lot of them looked alarmingly similar to the abstract rusted-steel sculpture which has become such an orthodoxy in post-war Western art. *Vive la Liberté* cried the label on a 1960 exhibit, but I could find little evidence of the rebellious attitude towards museum culture which drove Tinguely, in that same year, to stage a notorious auto-destructive event in the garden of New York's Museum of Modern Art. Before the city fire brigade was called in to extinguish the flames, the invited audience watched an enormous white-painted monument of wheels, weather-balloons and other found objects obliterate itself in a blaze so spectacular that it threatened to engulf the building nearby.

This apocalyptic happening has since acquired a legendary reputation, and will perhaps always remain Tinguely's most infamous venture. But it would be a mistake to imagine that he is primarily concerned with such explosive tactics. The work which brought this Swiss-born artist into prominence during the 1950s was relatively small in scale, and the movements it performed were for the most part slow and gentle. Tinguely, who had not yet begun to scavenge industrial waste, made delicate compositions from metal, wire and painted cardboard which look almost vulnerable as they respond to their clockwork or electric motors. They seem closer to the lyrical floating of Calder's mobiles than to the ungainly exertions of the machine-world Tinguely would later explore.

Since many of them were made for the Paris galleries, they look entirely at home when set in motion at the Tate. Indeed, my response to the exhibition was transformed immediately I began to switch Tinguely's work on and realise how crucial a part movement plays in objects never meant to be encountered at rest. The most commanding moment in this early section of the show occurs when a long 1955 relief, of painted and metal elements ranged along a black wooden panel, starts emitting a simple but appealing series of sounds. The open structure of the work enables us to see how each of these percussive noises is made by tiny hammers hitting against bottles, bells and tin cans. This makeshift music, half-way between John Cage and a skiffle group, supplies an appropriate accompaniment to the rudimentary forms of the sculpture itself. If the machine age is evoked at all here, Tinguely ensures that we think of an earlier period when pioneering aeroplanes were held together with string and primitive automobiles cranked by hand.

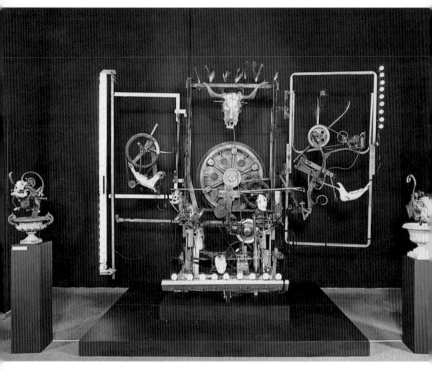

86. Tinguely, *Cenodoxus Isenheimer Flügelaltar*, 1981

Even the most grandiose of his later works are oddly rickety. Assemblages which appear forbidding at first sight become exuberant, astonishing or beguilingly ludicrous when our feet press the switches and galvanise them into unpredictable action. They mime their futile movements with such zeal that we cannot help smiling at their antics. Compared with the terrifyingly smooth and impersonal technology of today, these crackpot inventions reassure us with their squeaks, groans and pathetic moments of collapse. They are surely the work of someone who laments the passing of a more humanist era, an age of mechanical innocence.

Over the years, Tinguely's art might easily have degenerated into monotonous whimsicality, and some of the exhibits do seem dangerously superficial. But Tinguely shows no sign of becoming bored with his subversive sense of humour. The titles of his recent drawings proceed with

mounting relish from *Pandemonium* to *Pseudo-Pandemonium* and finally *Total-Pseudo-Méta-Pandemonium*. His appetite for motorised mayhem continues unabated, and within the overall emphasis on incessant motion a surprising variety of sensations are conveyed. A 1962 work called *Baluba*, which looks tattered and forlorn in repose, erupts into convulsions so violent that it might at any moment disintegrate. With plumes and rags inserted among the more familiar cans and rubber tubing, it evokes the frenetic whirling of tribal dancers, and Tinguely actually named it after the native warriors led by Lumumba in the 1960 Congo War.

A striking contrast is provided by *Totem No.3*, executed a couple of years earlier. Nothing happens immediately after the switch is pressed, but then a trigger is released somewhere within the tall, thin vertical of scrap metal and a startlingly loud bang explodes near the top. *Totem No.3* is restricted to a stern repetition of this single militant noise, whereas the colossal *Méta-Harmonie* indulges in a whole orchestral range of drumbeats and cymbal clashes. Wheels run up and down electric organs, cowbells ring and hammers clang down on metal discs to make a noise as violent as falling dustbin-lids. During this cacophony, an aural extension of the fitful movements made by the wheels within their scaffolding, we wait in suspense for a wooden puppet rising slowly above a battered piano to descend on its keyboard with a crash.

However much we may want to join in the fun, participation is impossible with *Méta-Harmonie*. Elsewhere, though, visitors are invited to enter a large arena encircled by netting and feed the monstrous *Rotozaza I* with plastic balls. After gulping them down and pushing them along a sequence of tracks and pipes, the machine punches them out again like an angry assembly-line disgorging its products. The whole endless process of swallowing and ejecting begins again, and it could easily become a nightmarish dramatization of consumerism run riot. But Tinguely is optimistic enough to let us enjoy the game, deciding whether we want to throw the balls back into the chute and thereby allow this mechanical ritual to grind relentlessly onwards. The choice, he implies, still lies with humans rather than machines.

But for how much longer? In 1981, Tinguely made a complex work inspired by Grünewald's Isenheim altarpiece, and on one level it is an entertaining satirical variation on some of the themes explored in the Colmar painting. Rows of flashing coloured light bulbs, normally to be found at fun-fairs or strip-joint entrances, run round the edges of the triptych structure. Within this gaudy frame feathers rotate, skulls open and close their jaws with macabre regularity, and a statue of Saint Bernadette at prayer trundles incessantly from side to side beneath an

awesome blue wheel. The whole extravagant tableau could simply be enjoyed as a burlesque, but it also possesses a grotesque ferocity quite new in Tinguely's work. His good humour is threatened by morbidity, and the large metal wheel seems to be presiding over these images of death with oppressive authority. The strain of barely suppressed hysteria in this work surely indicates that the man who made it has increasing difficulty sustaining his former buoyancy. Tinguely's splashing fountain at Basle has here been replaced by dry bones, and the carnival might soon degenerate into a wake.

LATE GUSTON
18 November 1982

Bulbous, unshaven and flushed with booze, a gargantuan head lolls on the table-top like a carnival mask discarded by its owner. At first glance the white gash daubed across its surface resembles a mouth, widening in a drunken grin which reveals two rows of stubby, uneven teeth. But then we notice that the mouth is really an eye, staring down at the green bottle lying in a stain of red wine nearby. This ludicrous head, with its bristly Desperate Dan chin and bedraggled hair, seems to be peering in the pathetic hope that the bottle may not be entirely empty.

Philip Guston was over sixty when he painted *Head and Bottle* in 1975, presenting himself as a Skid Row tramp too sozzled to realise that all the booze has gone. By creating such an absurd Portrait of the Artist as an Old Soak, he was in one sense confirming the prejudices of the critics who had dismissed his work five years before. At a notorious New York exhibition filled with equally provocative images, which seemed so shocking after the discretion of his earlier abstract paintings, Guston was dismissed by the *New York Times* as a 'mandarin pretending to be a stumblebum'. According to his detractors, he had exchanged the sensitive lyricism of his abstract canvases for a crude comic-book style, slap-happy and infuriatingly vulgar. Guston was unrepentant, and in paintings like *Head and Bottle* he continued to indulge his new-found enjoyment of bad pictorial manners until his death in 1980.

But the renegade element in these extraordinary pictures should not be exaggerated. If the sense of release he experienced was genuine enough, so also was his desire to regain contact with a part of his imag-

ination which had lain dormant since he was young. The grossly carica-tured *Head and Bottle* is the work of a man whose rage is as great as his debunking humour. While he laughs at the drunken old buffoon rolling around on the table, Guston is cursing his own decrepitude. At the age of seventeen, his radical social conscience had prompted him to make a sequence of sinister Ku-Klux-Klan paintings, and members of the Klan slashed them in revenge. Now, almost fifty years later, the anger returned. And so, incredibly, did the vigour of an impetuous young artist. But this time Guston includes himself in his wild meditations on the malaise of the modern world.

The hooded Klansman appears as the artist in his studio, puffing a cig-arette and painting another hood on the canvas. The picture implies, in its sly, tragicomic way, that Guston was burdened with a disturbing amount of self-disgust. And when he pulled off the hood to disclose the face beneath, the result was even more lacerating. In *Head and Bottle* a naked light bulb dangles down, its hard white glare ensuring that every wrinkle and bulge in this bloated lump of flesh is mercilessly exposed to view. Guston always worked at night under the dazzle of just such a light, and after each session was over he looked back on it as a state of delirium. 'I come into the studio very fearfully,' he once said, 'I creep in to see what happened the night before. And the feeling is one of, "My God, did I do *that*?" '

The pictures he produced during this furiously uninhibited burst of energy enable us to understand his amazement, and share it too. Although he started off by studying the ordinary objects around him – a shoe, a book, an ashtray and a nail – they soon began to undergo alarm-ing metamorphoses. A spray of water turns into hair, which then becomes the strands of a whip. The light bulb changes into a clock and a sun, with only slight modifications in colour and outline to define the differences between them. But the most astounding of all these transfor-mations centres on a beaten-up old shoe. Turning its hobnailed sole towards us, it multiplies and then sprouts spindly legs which become ever more entangled with each other in an awkward, sprawling heap.

Sometimes this ugly mound squats alone, like a dour monument to the weariness and drudgery of a thousand worn-out lives. In other pictures the mood grows darker still. The boots find themselves up-ended in a roughly hollowed grave, or thrown callously down the side of a bleak ravine. References to the atrocities of the Nazi holocaust seem inescapable, and Guston's quirky sense of irony prevents them from becoming at all pretentious. In a painting called *Entrance*, a heavy woo-den door is pushed open to reveal a horribly compressed pile of limbs and

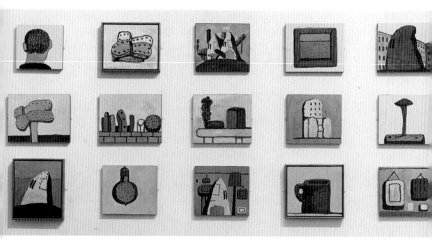

87. Installation view of Philip Guston's exhibition at Whitechapel Art Gallery, London, 1982

shoes rotting inside. But the tragic gloom is partially alleviated by four insects creeping past in a furtive procession. Their ability to make us smile is increased when we notice that, in order to create them, Guston simply attached little feelers to four shoes at the bottom of the funereal heap.

So although these late paintings appear forthright and gutsy, they are in a constant state of flux. In this respect, they link up with his abstract pictures of the previous two decades, which derived so much nervous vitality from the alterations, hesitations and shifting intentions of Guston's supple brushmarks. The late canvases are far more outspoken, but they remain in their very different way committed to the inevitability of change. Guston never lets us rest easily in front of them. As soon as we begin to accustom ourselves to the gaunt piles of shoes and scrawny limbs, relating them to Picasso's *Charnel House* on the one hand and cartoon strips on the other, they suddenly become threatened by a rising wall of water.

In some of these deluge pictures there is a feeling of panic: the water, painted in a lurid red which suggests a tide of blood, seems to be inexorably filling an enclosed space and drowning everything within sight. Elsewhere, however, the flood's fury subsides and is suspended in the lower half of the canvas. The water in a painting called *Wharf* is blackened with pollution, and a number of shoes bob on its oily surface like flotsam discharged from a passing ship. Towards the right side of the composition one of the shoes turns into a half-submerged woman's

head, and next to her the monstrous, bug-eyed image of Guston himself appears on a canvas attached rather perilously to a tilting easel.

Are they floating or sinking? It is impossible to tell, although they all look ominously inert. But in the same year Guston showed how swiftly he could move from despair to optimism without leaving this marine theme behind. In *Source*, the water sinks to a lower level and changes from black to a Mediterranean blue, providing the horizon line for an enormous pink woman whose head dominates the sky above. Even if we did not know she was the artist's wife Musa, the aura surrounding this goddess is clearly benevolent. She represents for Guston the centre of heat and light, and her upturned eyes imply that she is rising in the dawn to comfort the suffering world he painted with such sorrow, humour, disgust and understanding.

Even so, it is typical of Guston's late work that half her face still remains hidden. Poised between water and sky, she has not yet succeeded in establishing herself securely above the waves. Doubt and ambiguity always haunt these canvases, and some writers have explained that *Source* reflects Guston's concern about his wife's ill-health as well as celebrating the power of her love. I am sure this is true, but it would be wrong to confine such an image to their relationship alone. All these late paintings proceed without any apparent strain from the personal to the universal, and *Source* must also express his complex attitude towards the whole notion of a beneficent force in the world.

Only a year later, in a picture bearing the baleful title *Black Sea*, the radiant goddess begins to assume the form of a shoe again. Her halo has vanished, and in its place a hobnailed arch frames the featureless space where her face had once serenely reigned. The sky looks brooding and volatile, troubled by fluently applied yet agitated brushstrokes which range from cerulean, salmon and milk-white to a strangely turbulent grey-brown. Even in his most threatening pictures Guston's handling of paint is often superbly seductive, proving his ability to retain the subtle command over mark-making which had distinguished his abstract canvases.

But even if the late works are far more intimately connected with his abstractions than most writers seem prepared to admit, I still think the final decade of Guston's career was his most satisfying. For all their considerable beauty, the paintings of the 1950s and early 1960s withheld too much of his essential character. When the rude, unbuttoned, awesome, ludicrous and melancholy images did eventually burst through the tremulous veils of paint in his abstract pictures, he must have realised just how much of himself had previously been suppressed. *Black Sea*'s oddly unclassifiable amalgam of head and shoe may look battered and beleaguered as it moves through the murky waters, but Guston is endearingly aware of

its absurdity as well. Above all, it seems determined to withstand the foulest of misfortunes and survive, just as Guston endured long enough to confound all his critics with a resplendent last decade of work.

Since such an achievement must have required a considerable act of faith, I finally recognise that even the intemperate distortions in *Head and Bottle* are underpinned by a sustaining hope. For empty bottles can still be used to send messages from lonely survivors washed up on an alien shore. The dishevelled head stranded in this painting looks like the victim of a comparable isolation, but the hypnotic eye staring down at the green vessel could well be urging it to set off in search of a sympathetic response from a distant recipient. If Guston launched his late paintings in a similar spirit, he would be gratified to know how many proved durable enough to reach their destination and transmit their meanings intact.

FRANK AUERBACH

3 February 1983

With admirably stubborn, single-minded persistence, Frank Auerbach has never let his work stray very far from the people and surroundings he knows best. Many of his paintings are located inside the Camden Town studio he has occupied since 1954, where old friends faithfully give him the innumerable sittings he requires. Other pictures scrutinise the streets beyond this dark and absorbing interior, but they are usually confined to a narrow range of familiar roads and buildings: the approach to his studio, or gently decaying nearby landmarks like Camden Theatre and Mornington Crescent. He returns to these favourite places again and again, discovering how they are transformed by the seasons, the weather and times of day or night. Even when he exchanges this cityscape for an encounter with foliage, grass and spiky branches silhouetted against the sky, Auerbach does not forsake his chosen terrain. He simply takes a short walk across to Primrose Hill, where the presence of lamp-posts, passers-by and a network of straggling pathways distinguish it from the wild countryside he has never tried to paint. His commitment to a small area of north London remains remarkably steadfast, and he may well have developed a deep-rooted unwillingness to transgress its boundaries.

Even so, there is nothing lazy or timid about the images he produces within the self-imposed limits of this urban world. A lesser artist might

rest content with a complacent approach, lulled by the security of knowing exactly how to paint agreeable variations on well-worn themes. But Auerbach seems to start each new canvas unaided by any formulae which could help him arrive at a swift, facile conclusion. Instead of leaning on his familiarity with the gaunt features of his cousin Gerda Boehm, or the tall building with the gothic arch standing next to his studio gate, he seems obsessed by the fundamental strangeness of the subjects in his paintings. The better he knows them, the more astounded he becomes.

Only after a prolonged and arduous period of scrutiny can Auerbach fully appreciate the extraordinary character of the reality in front of him. Each new encounter with an old motif makes him realise, as if for the very first time, that people and things refuse to settle into a predictable identity. They remain obstinately raw and difficult to define, a formidable but fascinating challenge for any artist resilient enough to confront the full complexity of visual experience. That is why Auerbach finds so much to occupy him within a small round of perpetually revisited themes. Every painting he commences soon becomes a battleground. Yesterday's perception of a face, a building or a hillside is assailed by his courageous willingness to admit that today has brought an entirely fresh response. Rather than conveniently avoiding this conflict, by pretending that the differences do not really exist, he acts upon them at once.

Photographs have been taken of Auerbach's work in progress, and they reveal how radically he changes the image whenever he returns to it. Sometimes his alterations permit fragments of the earlier pictures to show through, so that the tension between his different reactions to the subject is kept disconcertingly alive. On other occasions he obliterates most of his previous work on the composition, scraping away until only the barest residue survives. But most of the time he employs an array of agitated approaches which cannot easily be disentangled from each other. Erasing, covering, simplifying, adding, cancelling and reinforcing all coexist on the same tumultuous canvas.

To look at the surface of a completed Auerbach painting is to become vividly aware of the struggle its creation provoked. The turbulent pigment has been gouged, smeared, dripped, dragged and piled into heaps as he wrestled with his conflicting attitudes to the motif. Using his fingers as much as a brush, he manipulates the substance of the paint with a frankness which boldly discloses the strenuous efforts involved in his search for an eloquent image. Auerbach's manual tussle with the thick yet endlessly pliable material of his art is as absorbing as his perceptual confrontation with the subject he observes. When the work falters, he allows his obsession with pigment to become detached from its representational purpose,

and we are left with a mass of flailing paint which apparently refers to nothing outside its own torment. But when Auerbach succeeds, his gestural activities become indistinguishable from the urge to see more clearly: they are both part of the same passionate determination to cross-examine reality with the fervour of an advocate pursuing the truth through a labyrinth of false trails, misunderstandings and partial evidence.

The outcome is, as he would wish it to be, the very opposite of slick and comfortable. Auerbach's work looks profoundly disquieting. It catches us off-balance, alarms us with its rasping urgency and rarely lets us pass by unmoved. People who have never seen his pictures before often find them repellent at first. They recoil from the paint's outspoken turmoil, and wonder why he views everything in terms of a restless combat. But Auerbach's work does not yield up its meanings immediately. Each image deserves and repays the kind of questing, alert and energetic scrutiny which he bestows on his subjects as he works.

Viewers prepared to grant him more than a superficial glance will discover that a surprising variety of moods and intentions lies beneath the troubled handling of pigment. In some of the pictures he slashes and pummels the paint so fiercely that his sitters do appear agonised and grotesque. They have a distressing intensity which reminds us that Auerbach, born in Berlin and sent to Britain as a boy to escape the horrors of Nazi persecution, has affinities with German art. Some of his faces, haggard and vulnerable in the gloom, seem burdened by a tragic view of life. They doubtless reflect Auerbach's inability to forget his own traumatic experience of the heartless, sadistic crimes perpetrated by the forces of evil during his childhood. Even if he does not consciously intend it, a very personal sense of anguish can be felt in his most convulsive paintings. They cause a shiver.

But he is not, in the end, an expressionist painter. His distortions arise from a close and rigorous observation of life rather than violent outpourings of emotion, and many of his works have nothing to do with teutonic *angst* at all. Auerbach has been living in London long enough to become identified with a particular English tradition. He is often associated with David Bomberg, whose classes at the Borough Polytechnic exerted a formative influence on the young Auerbach. Bomberg's habitual insistence on a close study of the subject, and at the same time on interpreting the landscape or figure with an immense amount of licence, led him to talk of locating the 'spirit in the mass'. Auerbach has remained faithful to both these priorities even as he asserted his independence from Bomberg's example. Empirical observation still lies at the centre of Auerbach's art, however far he may appear to depart from his starting-

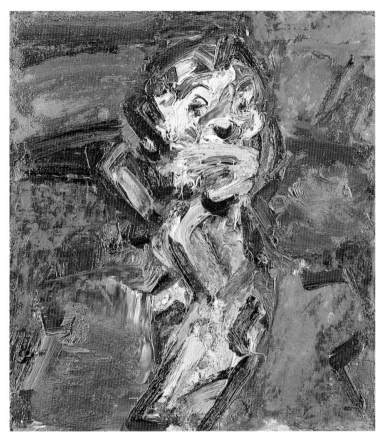

88. Frank Auerbach, *Head of JYM II*, 1981

point. His devotion to Camden Town also reminds us of a similar debt to Sickert, whose incessant exploration of Mornington Crescent and its shabby interiors often led him to take the most surprising liberties with the thing seen. Auerbach knows all about the exhilaration of discovering, in a tenacious examination of the motif, the freedom of manœuvre he seeks. A lyrical sequence of gouaches arose from his fascination with the way different qualities of light transformed the buildings around his studio, but the changes in the sky from milky white to peach and the palest of blues cause the façades below to erupt in astonishing blazes of scarlet, burnt orange and mauve. No literal account of the scene could

match the magnificence of Auerbach's highly charged interpretation.

Ultimately, though, he is at his most assured and intense with the human face. The portraits of a woman called J. Y. M. explore a whole variety of her feelings. At one moment she registers sudden astonishment by jerking her head upwards, and then she stares with steady, clear-eyed concentration at the man painting her. In a series of consummate chalk and charcoal drawings, another sitter, Julia, proceeds from a bout of open weeping, which contorts her face with angry, whiplash lines, to a state of tenderness and serenity. Auerbach's range is far wider than some writers have allowed, and even at their most wilful and audacious his images still persuade us that they represent a truthful account of reality as he sees it. By staying faithful to a few ordinary but deeply cherished subjects, his best work demonstrates how mysterious and inexhaustible the everyday world can be to those who know how to look.

FRANCIS BACON
6 June 1985

Stretching his leg towards the door, a naked figure struggles to place a key in the lock with his toes. The rest of his body is coiled and straining as he pushes this distended limb up to the hole. Every muscle is tense with the effort, and a strange red spotlight around the foot dramatises the urgency of the attempt. But the absurdity involved in such a tortuous manœuvre implies that it is a risky enterprise. The whole notion of unlocking a door with your toes is like a gambler's last throw. It smacks of desperation, as if every other possibility has been tested and found wanting.

The rest of Francis Bacon's paintings, now assembled for an overwhelming Tate retrospective, explain why this agitated figure is so anxious to get the door open. For everybody in Bacon's relentless world is enclosed by a claustrophobic structure from which there seems to be no escape. The surroundings his people endure may not be as overtly prison-like as the cages hemming in the baboon and chimpanzee, who in two glowering canvases of the 1950s roar with helpless rage at the confinement they suffer. But there is still something lacerating about the rooms inhabited by Bacon's human protagonists. In his early canvases the interiors are murky, illuminated only by a blurred face or a pale body passing indistinctly through curtains. Sometimes a sinister safety-pin

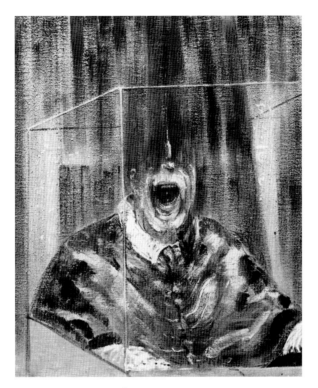

89. Francis Bacon, *Head VI*, 1949

shines with unexpected precision in the gloom. On the whole, though, Bacon does not specify the cause of the disquiet he creates with such macabre conviction. Shuttered like bedrooms where the inmates are too distressed to expose themselves to the light beyond, these penumbral spaces are permeated with unseen menace.

The men whose blanched and smeared features can be discerned here are dressed as correctly as business executives. But their formality can easily be undermined. In one tripartite work, which resembles three stills from a strip of film, the grinning face on the left is transformed into a yelling grotesque and then disintegrates completely, as if incapable of withstanding his hellish environment any longer. Even the Pope, who should be better able than most to defend himself against the terrors of the void, suffers from their onslaught. Shorn of all the spiritual sustenance

and power his position should provide, he clings to his throne and screams like a condemned murderer shuddering from lethal voltage in the electric chair.

Occasionally, Bacon's paintings do appear to break out of these unnerving regions and enter more spacious locations, supposedly in the open air. But they turn out to be just as disconcerting as the oppressive rooms. One figure seems so intimidated by the parched grassland stretching around him that he squats in the middle of it, unable to move. In another canvas a dog freezes on a pavement, staring down at the gutter and refusing to follow the legs of his owner walking past. Perhaps the animal realises that there is no point in exploring a street bounded by the same blackness which restricts the people in Bacon's interiors. The copulating lovers in a canvas called *Two Figures in the Grass* seem unaware that the edges of their field are hung with curtains. If they pause and look around them, however, the intolerable sense of restriction will once more press in on them. Bacon's so-called landscapes all turn out in the end to be variations on the theme established by the prison-like indoor settings, and even when he takes his cue from Van Gogh's *The Painter on the Road to Tarascon* the confinement does not really ease. For the artist's bowed silhouette looks burdened by the knowledge that he is restricted to the narrow route ahead. Agitated trees writhing by the roadside seem to prevent him from wandering into the fields beyond, and in *Study for Portrait of Van Gogh II* Bacon erects the familiar cage structure around the haunted traveller.

Soon afterwards, most of these deceptive references to an 'outside' world drop away. By 1960 the clinical room has become the prime stage-set for Bacon's theatrical tableaux, and he makes it more oppressive still by ousting the former darkness. The bare light bulbs dangling from the ceiling in so many of these interiors possess a merciless glare. It makes their surfaces blaze with strident oranges, crimsons and cyclamen pinks which ensure that everything is exposed with terrible clarity. In the formidable *Crucifixion* triptych of 1962, surely the most harrowing set of images Bacon has ever produced, two figures stand transfixed. One of them extends his arms towards the wall, as if anxious to leave. But his legs seem glued together in a single bulbous mass, and his companion's head appears to have been wrenched away from the shadowy profile suspended in space behind him. Both men are unable to prevent themselves looking back towards the source of their unease: the crucified feet thrusting down to the base of the cross, skin stripped away so that exposed bones and organs glisten bloodily in the light.

Far from discovering in the crucifixion a symbol of salvation, Bacon sees it as the ultimate degradation. The corpse sliding head-first down

the right panel of this triptych is little more than a carcass, its white spine and rib-cage picked out with surgical precision from the surrounding skeins of red meat. Bacon is more obsessed by mortality than any other modern artist, and a haunted apprehension of the human body's frailty underlies all his work. So does an acute awareness of isolation. In most of his paintings single figures are presented, confronting their loneliness. On the rare occasions when another person appears, there is little contact between occupant and newcomer. The one observes the other from the sidelines, like a voyeur concerned above all to keep his identity hidden. And the presence of cameras, perched on tripods resembling the legs of some monstrous predator, only adds to the suspicion that surveillance is the first priority.

Nor do the naked couples who sometimes appear in the centre of Bacon's triptychs offer much consolation. One painting shows them lying side by side in identical poses, without acknowledging each other's existence. And when they are seen making love, their urge to overcome loneliness gives them a furious quality. The figures close on one another with extraordinary forcefulness, as if attempting to ameliorate their solitude by merging flesh with flesh in a single pulsating organism. The sense of union is only momentary, too. Most of the time Bacon reasserts stern solitude, and when he assembles three figures in a triptych they are separated by the gaps between each canvas. Ensnared in an alien environment, where they are obliged to endure isolation without any respite, these beleaguered people could be excused for giving way to despair.

But the paradox is that Bacon's vision never seems limp and defeatist. A marvellously defiant belief in the essential exuberance of human life characterises all his work. The flatness and severity of his floors, walls and ceilings, which show how intelligently he has learned from abstract painting at its most refined, provide an ideal foil for the twisting, wriggling energy of the robust bodies they contain. Bacon's superbly resourceful manipulation of his materials gives these figures an astonishing eloquence, as he pummels, caresses, obliterates and coaxes the paint into forms which transcend arbitrary distortion. However much Bacon may rely on chance as a means of bypassing cliché and arriving at the metamorphosis he desires, the outcome is far from accidental. Even the splashes and flicks which sometimes desecrate the most immaculately handled areas of the picture have a nicety about them, indicating that Bacon pondered long about exactly where to fling the disruptive slivers of pigment.

This wonderful finesse, coupled with an instinctive monumentality which gives his work its grandeur, counteracts the depressing aspects of Bacon's world. Indeed, his exhilaration seems all the more persuasive

precisely because it is pitched against such absolute pessimism about the bleakness, confinement and vulnerability of the human condition. Bacon's assertion of an ecstatic vitality could not be more hard-won. No one can doubt the extremity of the violence and suffering from which his bruised figures emerge with such undaunted *élan*. That is why the leg striving to put the key in the lock is such a magnificent image, insisting against all odds that the door might one day be opened and offer a way out of the cruel and desolate cell.

KENNETH MARTIN

25 July 1985

Continual exposure to an artist's work can easily breed indifference. But in my experience Kenneth Martin does not stale. While studying art history at Cambridge, I passed his gleaming *Construction in Aluminium* every day outside the Faculty building in Scroope Terrace. Familiarity never dulled me to its fascinating ambiguity. From one angle it presented a solid, unruffled, almost monolithic façade. And then, from another vantage-point, it broke up into a spectacular sequence of spiralling, thrusting, shifting components. In this respect it was an ideal public sculpture, and throughout his career Martin succeeded in making similarly intriguing objects for a variety of indoor and outdoor locations.

But the final decades of his life were dominated by painting, and so it is appropriate that the Arts Council has now mounted an exhibition of works on canvas and paper at the Serpentine Gallery. The show was originally planned to celebrate his eightieth birthday, but his death last November has turned it into a more retrospective affair. Mercifully, though, the temptation to cram the gallery with a comprehensive survey of his late paintings has been avoided. Instead, each room is hung with a few carefully selected images, and the Serpentine has scarcely ever looked more beautiful.

Martin's images need a lot of space to breathe in. Although consistently modest in scale, the limpid brilliance of their colour and the energy of their linear structure fill our eyes with intense visual activity. Displayed close together, they could become too busy for comfort. But at the Serpentine all the pictures are able to extend their influence into the empty white space surrounding them. They seem to activate it with their

dynamism, thriving on the interplay between flux and order which Martin never tired of exploring.

Several small working studies are included here, and they show how each composition is underpinned by a numbered grid. Martin would take his line on a journey from one numbered point to another, but he never allowed the grid to bully him into producing excessively rigid paintings. The numbers for each line would be written on bits of paper and chosen at random. Martin was as attracted to chance as he was reliant on a rigorous overall system, and he thrived on the constant tension between them. He also realised that the painter should retain the final responsibility for the development of a work, and in 1982 he summed up his views on the matter by declaring that 'one must be master, not slave, of method, but to be master one does not treat it with neglect. Anyway it is one's own method that is being invented.'

The paintings themselves reveal just how inexhaustible his 'method' proved. The earliest canvases on display are quite spare in character, relying on a few clusters of diagonal and upright lines to carry the image. Suspended on the plain white ground which Martin usually favoured, they lance through space with a vivacity unshackled by the systematic procedures behind them. But as the Seventies developed, the quantity of lines and the directions they took both increased enormously. Scattered across the surface of *Chance, Order, Change 2*, they are strongly reminiscent of the criss-cross patterns created by a sheaf of pick-a-sticks lying on a table-top. Compared with subsequent paintings, though, they are thin, elegant and confined to a single colour. As he grew older, Martin thickened his lines, introduced a variety of colours and thereby allowed the paintings to sing with greater force. Sometimes the lines proliferate to an almost indigestible extent, and the picture-surface becomes clotted with their presence. On other occasions, however, Martin strikes a very satisfying balance between areas of meshed elaboration and intervals of pure whiteness. The spaces between his linear clusters are eloquent rather than merely vacant and inert.

Martin was always alive to such things in paintings by the artists he admired. He particularly cherished the memory of visiting the Rijksmuseum and coming across Vermeer's *Street in Delft*, where 'there is a small patch of cloudy sky and it is wonderful, like a perfect piece of jigsaw puzzle'. He wanted the various segments of his compositions to provide similar pleasures. At times, the white spaces even provide an experience akin to finding the sky in the middle of a tangled wood, but Martin did not want his paintings to be tied down to any specific reference of that kind. When he first began to develop his abstract idiom after the Second

World War, he asserted that 'the object which is created is real and not illusional in that it sets out to represent no object outside the canvas'. Far from creating an enclosed language, of interest only to initiates, Martin regarded abstraction of this uncompromising kind as a means of achieving 'a universal language'. It is certainly true that the paintings arouse a whole host of associations, and refuse to be confined within any of them.

At the Serpentine, their relationship with the natural forms of the park outside is evident. The principle of growth was very important to Martin, who took particular pleasure from observing the progress of a creeper outside his kitchen door. Some of his paintings resemble the interwoven branches of trees in winter, and Martin undoubtedly learnt a great deal from scrutinizing the gradual unfolding of plants, bushes and flowers. But it would be a mistake to conclude from his great respect for nature that he remained immune to urban inspiration. Martin was, after all, a city-dweller. Having grown up in Sheffield, he spent much of his adult life in north London. The kinetic vigour of the metropolis, its clangorous impact and incessant crowding, are surely reflected in his most outspoken paintings.

Several of the *Chance, Order, Change* canvases of 1981 evoke the stern geometry of steel bridges, cranes and hawsers. Others look like intricate sections of scaffolding, and I can well imagine that Martin would have taken special delight in the mechanical forms to be found on building sites. The very last paintings, like the acrobatic *Duo* (*Immobile-Mobile, Mobile-Immobile*), even suggest the patterns which converging motorways assume when seen from above. As an heir to the Constructivist tradition, Martin would hardly have been averse to the idea of responding to the machine-age city in his work. His paintings often remind me, in their

90. Kenneth Martin, *Duo (Immobile-Mobile. Mobile-Immobile)*, 1984

lucidity and compressed energy, of the industrial images created by Wadsworth during the Vorticist period.

Ultimately, though, Martin was always his own man. His best paintings, marrying structural rigour to a musical sense of poise and grace, place him among the most satisfying abstract artists England has yet produced. He deserves to be cherished.

PATRICK HERON
29 August 1985

Not even a spell in the school sick-bay could dampen Patrick Heron's innate high spirits. Confined to his bed, the fourteen-year-old patient managed to complete an exuberant design where melons are set free to float with branches and leaves in a whirling celebration of fruitfulness. It looks like an unbelievably sophisticated achievement for a schoolboy. But Heron was lucky enough to have been brought up by a father who knew many of the liveliest English artists of his day. A blouse manufacturer who founded Cresta Silks in the 1930s, Heron Senior was delighted when his son began to draw and paint. The *Melon* design made in the sick-bay was posted home and turned into a printed silk *crêpe de chine* scarf for Cresta. So part of its exhilaration surely derives from the young Heron's awareness that he might be entrusted with such a commission.

After all, Cresta's designers included Paul Nash and Cedric Morris, while McKnight Kauffer was responsible for the firm's streamlined stationery and packaging. No wonder *Melon* displays an alert and assured interest in avant-garde painting of the period: Heron grew up in an atmosphere where innovation was welcomed rather than mistrusted. He subsequently carried out many designs for Cresta, and the examples on show in his Barbican Art Gallery retrospective all possess an instinctive fluency and verve. At the same time, however, he was attempting to develop as a painter of still life and landscape. The earliest canvases on view here have the impulsiveness of the scarf designs. But they lack the seemingly effortless buoyancy Heron commanded from the outset in his Cresta commissions. He is, in the best sense of the word, a decorative painter, and only after the war would Heron learn how to invest his canvases with the spontaneity he had already deployed in his fabric work.

French art showed him the way. Although Heron can be related to

English painters of the time, and in particular to the equally rapturous Ivon Hitchens, he reserved his greatest admiration for Matisse, Bonnard and Braque. Picasso impressed him very deeply as well, but in the end Heron's art lacks the emphatic and agonised strain so evident in Picasso. No volcanic emotion disrupts the consistent pursuit of hedonism in Heron's paintings. They appear incapable of admitting the darker and more anguished side of human experience. The anxiety of the war years, when he worked on the land in Cambridgeshire as a conscientious objector, does not seem to have affected his art at all. Heron has a pacific temperament which shuns violence completely. The paintings of the 1940s concentrate on a serene and sometimes exalted vision. They savour the sensuous attractions of fruit, flowers and pottery, nestling on bright table-cloths in warmly lit interiors. Heron sees this enticing world as a haven. However much he experiments with semi-abstraction, rendering an apple as a single ball of scarlet and often defining objects with a loose outline alone, his starting-point is rooted in everyday observation.

After the war, Heron began a short-lived but memorable career as an art critic, first for the *New English Weekly* and then for the *New Statesman*. He became a lucid champion above all of contemporary French painters, defending them with eloquence and conviction against the absurd antagonism of so many other English critics. Heron's precision with words, which makes his criticism a pleasure to read, might lead us to suppose that his art would possess literary leanings as well. Nothing could be further from the mark. In his criticism and painting alike, Heron is preoccupied with the visual reality of the forms and colours assembled on the picture-surface. What they represent always plays second fiddle to their independent existence in Heron's eyes, and his writing attends very closely to their precise structure.

His paintings of the immediate post-war years are likewise ready to allow pigment a life of its own, departing wherever possible from a slavish adherence to the things its represents. Braque's great paintings of studio interiors are now the paramount influence, and in pictures like *Still-Life with Red Fish* everything begins to overlap with the mysterious ambiguity so evident in the Frenchman's later work. It is typical of Heron's outlook that he chose domestic tranquillity as the subject of a large painting commissioned for the Festival of Britain in 1951. His mother, wife and young children, absorbed in piano-playing or staring at the candles on a cake, are integrated with the mosaic-like pattern of floorboards, rugs and window-panes. It is one of Heron's most confident and sustained early performances, but the overt inspiration of Braque still had to be shaken off.

Stimulated by the abstract painters he encountered in exhibitions and

91. Patrick Heron, *Big Purple Garden Painting: July 1983 – June 1984*

wrote about so well, Heron defined his individuality by liberating himself more fully from the urge to represent. In practice, that meant letting the outside world penetrate the enclosed space he had so far favoured. Gradually the windows of his interiors assume more and more importance, until the views offered through the glass become merged with the scenes inside. Often the prospect was based on St Ives, where the Herons stayed every year in a studio cottage. But in 1956 they were able to acquire a house called Eagles Nest in wild country near Zennor. Whether he realised it then or not, the impact of this new home was immediate and profound. The superbly cultivated garden at Eagles Nest, where exotic plants and shrubs blend with huge stones and overlook a primitive landscape leading straight to the sea, prompted him to make some expansive and joyful new paintings. In my view they relate directly to the mist, shimmer and explosive colour of his surroundings. But because they are ostensibly more abstract than his previous work, Heron regarded them as a momentous departure.

Today they take their place quite naturally in the development of his painting, and inaugurated a particularly vital period. The scattered brushstrokes of his 'garden' canvases gave way to sweeping horizontal stripes, and then an imposing sequence of paintings where large rectangles of colour hover on glowing grounds. Works like *Yellow Painting: October 1958–June 1959* are among his finest achievements, retaining the

sensual delight of earlier periods and yet strengthening it with a magisterial sense of finality. I respond far more to these paintings, where Heron's natural lyricism and delectable brushwork are given full rein, than to the colossal paintings he executed a decade afterwards. Here the mark-making grows smaller and more rigid as the scale expands. His habitual panache and zest give way to a more constricted, even obsessive method. Perhaps Heron himself came to resent the drawbacks of this tight and arduous approach, for the most recent work has regained his lost freedom. The handling is openly gestural once again, the colour more sumptuous, and the gusto a pleasure to behold. Some of the very latest paintings are as impetuous and seductive as anything Heron has done, and they suggest that he is moving in his sixty-fifth year towards the most satisfying phase of a long and affirmative career.

EDUARDO PAOLOZZI: LOST MAGIC KINGDOMS
12 December 1985

Ever since Eduardo Paolozzi discovered the Pitt-Rivers collection in Oxford during the Second World War, his imagination has been richly stimulated by so-called primitive art. Many of his contemporaries, both at the Ruskin School and the Slade, would 'pooh-pooh' the work he found so powerful. But Paolozzi has always cast an exceptionally capacious net into the visual culture at his disposal, and in 1945 he devoted as much care to drawing African carvings as he did to copying Rembrandt at the Ashmolean. Like Epstein, Gaudier-Brzeska and Moore before him, he was enthralled by the densely clustered showcases of the old Ethnography Department at the British Museum, too. Culled from the Pacific, the Americas and Africa, as well as areas of Asia and Europe, the 300,000 specimens now preserved in the Museum of Mankind seemed to Paolozzi like the relics of 'lost magic kingdoms'. The stimulus of primitivism exerts a hold over his art as powerful as the inspiration he derives from the ephemera and artefacts of our technological society. So the Museum of Mankind should be congratulated for allowing him to repay this debt in the form of a hugely enjoyable exhibition.

After exploring the reserve collections over a three-year period, he has selected an unpredictable range of objects and intermingled them with some of his own work. As in a conventional show, the several hundred

92. Installation view of Eduardo Paolozzi's *Lost Magic Kingdoms* exhibition at Museum of Mankind, London, 1985

items are carefully displayed in showcases and identified by numbered captions. But in every other respect, the exhibition departs radically from the normal method of presenting an ethnographic collection.

The first showcase establishes Paolozzi's subversive approach by mixing together, with apparent recklessness, a plethora of objects from wildly divergent sources. Most shows at the Museum of Mankind follow a well-trodden curatorial path and group their contents according to period, origin and function. But Paolozzi, whose eye for the unorthodox has led him to fill much of his exhibition with items never before placed on display, ignores such classifications. Within the simple wooden shelving devised for the first showcase, a wooden figure from Easter Island lies cheek by jowl with a skull used for divination in Papua New Guinea. The playfulness of the one contrasts with the gruesomeness of the other, its teeth exposed in a macabre leer. Just as Paolozzi's own art thrives on juxtapositions of the most incongruous kind, so he delights here in bringing together a group of skeletons from Mexico and a Ghanaian oil lamp made from a blue light bulb. The latter is one of the most surprising pieces in the show, and would probably be considered too lowly for exhibition elsewhere in the Museum.

Paolozzi, however, is fascinated by such objects. He has never kept his enthusiasms confined within the limits of 'fine art', and in another showcase he includes a string of light bulbs used as house decoration in Gujerat, India. They are reproduced, with great audacity, on the back cover of the splendidly illustrated catalogue as well, for they exemplify Paolozzi's preoccupation with the inventive way old materials can be salvaged, reshaped or combined with the other objects. New meanings thereby arise, and in his catalogue preface he approvingly points out that the 'Pandora's Box of possibilities' presented by a large city like London has inspired 'a new generation of young sculptors who are alert to this and create a permanent beauty from these discarded motives'.

Paolozzi realises that new British sculptors like Bill Woodrow are alive to many of the possibilities he finds so intriguing. But *Lost Magic Kingdoms* examines comparable activities throughout the Third World. The house-decoration light bulbs take their place in a showcase which also contains an altar made from discarded European metal, and some wooden figures deliberately treated to look antique and authentic. Paolozzi points out that they all prove the cultures' stubborn 'power to overcome and transform their Colonial past and then combine together startling disparities'.

Throughout this refreshing and provocative exhibition, in fact, Paolozzi places ethnographic material in the same context as the colonial power-struggle which brought so many of these objects to Britain

in the first place. Rather than trying to present African culture as it was before the advent of the white men, he stresses the fact that museum collections often originated in trading posts or around mission stations. In one showcase he displays a large screen from Ijo in Southern Nigeria, made by an African trading group which controlled European access to the country's interior. It is surrounded by an extraordinary array of material – a toy aeroplane and helicopter made from painted wood in Madagascar, Paolozzi's own grinning head of a man wearing a colonial cap and tie, and a bowl of plastic fruit juxtaposed with a bowl full of objects like a pistol, a saw, a plastic hand-grenade and a rubber skeleton. All this scattered material evokes the sinister, desolating world of Conrad's *Heart of Darkness*. The abandoned weapons of the colonial period are brought into contact with the Africans' attempts to transform destructive material and make something new.

Much of the show revolves around this dual obsession with decay and reclamation. In one showcase Paolozzi produces a mesmerizing, Grand Guignol spectacle from ghoulish images originally used in the Mexican Day of the Dead festival. Two figures are laid out side by side, like corpses prepared for a ceremonial burial. One is a grinning man with slits in his eyebrows, bizarrely attired in top hat, evening dress and white silk scarf. He clutches a crucifix in his hand, and a black umbrella is hooked over an arm. But no amount of religious fervour or fine apparel can save him from the inevitability of his fate. For the figure lying beside him is a garish skeleton made from papier mâché, slashed with paint and encrusted with clouds of tawdry glitter. The aroma of death in this grisly yet compulsive showcase is intensified by the little objects Paolozzi has added to the recumbent ensemble: a pair of copulating plastic grasshoppers, a gun and a multi-coloured umbrella which makes its counterpart on the arm of the nearby body appear even more funereal. As an artist, Paolozzi has always been much possessed by the destructiveness of the modern world. And this exhibition reveals that his forays into the Museum of Mankind's reserve collections made him acutely aware of the mortality theme running through so much 'primitive' art.

In the last analysis, though, *Lost Magic Kingdoms* is affirmative rather than elegiac. Its robust enjoyment of so many diverse objects, ranging from the exclamatory painted shadow puppets of Turkey to a Sudanese stringed instrument festooned with a cornucopia of beads and shells, links up with Paolozzi's ebullience as an artist. It all ends up celebrating the art of making, and allows a contemporary British artist to pay a generous yet fully-deserved tribute to the anonymous people who gave their work 'an individuality and distinctiveness missing in the products of our own society'.

LEE FRIEDLANDER
7 August 1986

Now that the Reagan administration bombards us with so much propaganda about America as a glamorous and heroic country fit above all for 'winners', Lee Friedlander's photographs have become more telling than ever. For his downbeat work, assembled at the ICA in a quiet yet powerful retrospective, offers a steady corrective to a cosmetic vision of his native country.

He scrutinises America with the dour honesty of his own 1965 self-portrait, where the photographer sits in an armchair gazing directly at the lens. Dressed only in a pair of shorts, he looks bleary, tousled and overweight – like a million other American men approaching middle age. But his resolute refusal to romanticise either himself or his surroundings, where a lampstand casts merciless light over the chintz curtains and obtrusive radiator, compels respect. The firmness with which he places each of his arms on a side of the chair, and confronts his own camera with unflinching seriousness, reflects the integrity of his outlook. Friedlander has never been content to settle for images which obscure the reality of American life. He adopts an uncompromisingly prosaic stance, because only by avoiding rhetoric can his photographs arrive at the truth.

The picture he presents is not a reassuring one. People in Friedlander's work rarely look at the camera with the steadfastness of his own self-portrait. They seem guarded, treating the photographer with suspicion or blank incomprehension rather than warmth. Friedlander keeps his distance, too, as if determined not to cultivate any false intimacy with his subjects. He photographs them as he finds them, and they are invariably seen through glass shop-fronts where a complex play of reflections and advertisements interferes with their images. One boy, looking out of a Baltimore store window, seems hemmed in by stickers for 'icicle' lollies, sandwiches, Pepsi and 'Sleeping Rooms' at a local lodging-house. Their cumulative effect intensifies his air of defensiveness, implying that strangers are unwelcome in this area of Maryland.

But *New York City 1962* indicates that Friedlander feels even more alienated in Manhattan. None of the pedestrians moving through this street acknowledges his presence. Although they are clustered together in one part of an otherwise deserted space, there is no contact between any of them. Cocooned in their own isolation, they walk past a looming wall where an enormous question-mark has been applied to the brickwork.

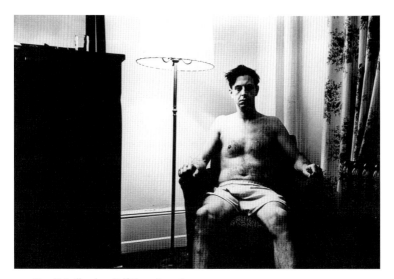

93. Lee Friedlander, *Self-Portrait*, 1965

It sums up the spirit of consistent scepticism which permeates Friedlander's work, impelling him to interrogate the accepted myths and clichés which too often impede a clear understanding of American life.

He discovers, above all, a country riddled with dislocations. The present conflicts with the past so jarringly that a bronze statue of a runner at Gateway Mall, St Louis seems to be escaping from a hostile environment of blank, standardised office-blocks. Friedlander is alive to the poignant irony of civic statuary wherever he goes. *The Spirit of the American Doughboy* in St Albans, Vermont, ought to be a triumphant figure with his upraised arm and martial stance. But snow has fallen over the statue and its accompanying cannons alike, muffling their forms to the point where belligerence lapses into impotence.

Many of the people Friedlander photographs are scarcely less passive. One extraordinary shot of a New York office window, opaque apart from a small rectangle in the glass, provides a view of a man slumped over his desk within. It is a tantalizing cameo. Is he asleep or dead? We do not know; for Friedlander, with Hitchcockian relish, prefers to leave the question open. Elsewhere in his work other figures may be awake, but they are no more capable of exerting positive control over their lives. The women hunched over factory machines in Canton, Ohio, feel oppressed by the

numbing tedium of the tasks they are obliged to carry out. Even the brisk cheerleader who struts smartly down a street will find herself encountering trouble further on, where a row of helmeted soldiers gather expectantly near a group of black youths.

Friedlander can create similar tension simply by focusing on a juxtaposition of disparate forms. At a race meeting in Salinas, California a large and hairy hand is placed next to a woman's back. Although she appears oblivious of its presence, the sense of impending menace remains. Nor does Friedlander exempt himself from the possibility of becoming an agent of male violence. One superb study, simply carrying the terse title *New York City*, shows the photographer's own shadow stamped aggressively across the back of a woman's fur coat as he walks down the street behind her. The picture puts the spectator in Friedlander's position, making us feel in uncomfortably close proximity to the unseeing woman. There is no physical contact between her and the man generating the shadow, but its blackness blots out so much of her coat that a threat either of direct assault or voyeurism is signified clearly enough.

Friedlander, in fact, is adept at conveying potent atmospheres with minimal means. Several photographs show television sets in seemingly empty bedrooms at Baltimore, Portland and Galax, Virginia. The hectic showbiz faces filling the screens accentuate the bareness and silence of the interiors they disrupt. Anyone beyond the viewfinder, inhabiting these rooms, is bound to be anaesthetised by such an ambience, and Friedlander discovered a related aridity when he travelled to Montreal in 1975. One shot simply reveals the interior of a phone box, with a mountainous directory lying open after use. The sight of all those names on the two visible pages, in a volume packed with so many other names, is at once overwhelming and intolerable. Friedlander seems burdened by the conviction that his own times are hopelessly besmirched. Another Montreal photograph shows a torn poster of a woman partially obscuring the view of a Gothic cathedral beyond. Although the poster looks even more tawdry in such a context, the photograph also implies that the growth of hoardings in the city could eventually block the cathedral from sight altogether.

For all his coolness and refusal to indulge in any devices which might seize our attention more dramatically, Friedlander is possessed by a brooding and apprehensive vision. He sees an America where cars are parked behind layers of thick chain fencing, where freeways intersect in a brutal cityscape long since devoid of passers-by, and where reality is often glimpsed as a sequence of frustrating fragments in a wing-mirror

which also incorporates a sliced-off portion of the driver's face. The emphasis is on dispersal, not wholeness. In one of Friedlander's studies of the immensity encircling lonely roads, his camera finds an isolated lorry making its way down an uninhabited stretch of land in the Western United States. A wooden house is being transported on this vehicle, and the sight serves to confirm the feeling of uprootedness implicit in so much of Friedlander's work.

Only in Japan does he find unalloyed tranquillity. A series of studies in Tokyo and Kyoto gardens generate an unsuspected lyricism, most notably in a photograph which fuses fish, water, sky and trees in a single exalted reflection. But this beatific rapport with nature does not bring out the best in Friedlander. He is at his most powerful when least ecstatic, and I returned to the urban images for a final confirmation of his strength as a photographer. The wilderness of unrelated signs, machines, buildings and people amounts to a disconsolate diagnosis of America today. Nothing connects, everything causes disquiet. And yet, from this grating and broken array of elements. Friedlander manages to create a pictorial order of stern compositional authority. His reserve contains a wealth of understated insights, and even his disenchantment takes on an austere compassion of its own.

REASSESSING BRITISH ART AT THE RA
15 January 1987

Choosing the exhibits for the first-ever survey of *British Art in the Twentieth Century* was bound to be an exceptionally challenging exercise. The selectors were determined to reveal the modern movement in all its exhilarating vitality, and we did not want to cram the galleries with a confusing and wearisome excess of names. Whittling the list down to just over seventy participants meant leaving out many artists whose work we respect, but their inclusion would have resulted in a congested and therefore self-defeating event. Better by far to give a relatively modest number of men and women enough space for their works to have a substantial impact. Artists as powerful as Henry Moore, Walter Sickert, David Bomberg, Edward Burra, Paul Nash, Stanley Spencer, Barbara Hepworth and Francis Bacon deserve to be seen in all their richness, and at Burlington House they are given room to breathe.

Nobody would dispute the important places Moore and Bacon already occupy in the history of modern art. But while honouring their achievements, the selectors also wanted to highlight works which have not, so far, acquired the reputation they deserve. We felt that the monumental carvings Jacob Epstein produced in his later years have been unfairly neglected. He expended an enormous amount of thought and energy on these titanic images, stubbornly making them with little hope of adequate remuneration or sympathetic understanding. Conceived in response to a deep private need, and subsidised by his work as a portraitist, the carvings emerge from the most personal and obsessive side of Epstein's imagination. The largest of them, *Behold The Man*, occupied him over an extended period and never found a purchaser during his lifetime. Several others were sold to a showman who treated them as sensational and even pornographic oddities in a Blackpool sideshow. The massive *Adam*, into which Epstein thought he had 'merged' himself more than any other sculpture, was installed for a while in a peep-show by a New York promoter. The humiliating fate of these carvings poignantly contrasts with the acclaim enjoyed by his portraits, and Epstein must have concluded that he was doomed never to be respected for the work which embodied his greatest aspirations as a sculptor.

The Royal Academy exhibition wants to redress the balance in Epstein's favour. His once-notorious *Genesis*, once denounced in a *Daily Express* headline as a 'MONGOLIAN MORON THAT IS OBSCENE', is included in the show. So is the colossal *Jacob and the Angel*, even though the weighty block of alabaster cost nearly £6,000 to transport from Liverpool to London. It is worth every penny, for *Jacob and the Angel* is the most turbulent, complex and impassioned carving of Epstein's later years. He began work on this masterpiece in 1940, and seems to have identified himself with Jacob's strivings. The two men shared the same first name, after all, and throughout his life Epstein had regarded carving as a protracted struggle with the massive blocks of stone he favoured. The alabaster employed for *Jacob and the Angel* was one of the most enormous he had ever tackled. Indeed, the effort he devoted to it was as prodigious, in its way, as the long nocturnal wrestling match which Jacob undertook with the winged figure he mistook for God.

Jacob and the Angel has been placed in a symbolic position at the exhibition entrance, exuding a spirit of boldness and vitality which we wanted the entire show to honour. British art has too often been belittled for its reticence, and this survey argues instead that an array of unrepentant individualists has given our twentieth-century painting and sculpture an infectious exuberance. Although a few of these artists are known beyond this

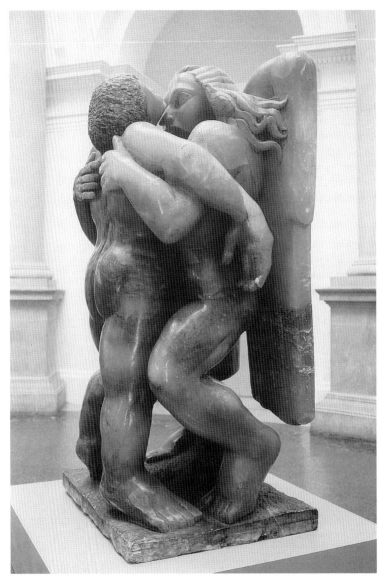

94. Jacob Epstein, *Jacob and the Angel*, 1940–1 (detail)

country, too many of them remain underestimated or completely ignored. We hope that the Academy exhibition will help to open more eyes to the strength of modern British art, not only in London but at its subsequent showing in Stuttgart. There, at long last, visitors from Germany and other European countries will have the chance to sample a full-scale examination of many key works never before shown outside these shores.

However defiant British artists have been in their pursuit of an intensely personal vision of the world, they never cut themselves off from international developments. The subtitle of the exhibition, 'The Modern Movement', announces our decision to concentrate on the men and women who shared the restless desire felt elsewhere in Europe and America to push art in a variety of innovative directions. This emphasis means that several of our most popular painters, including Augustus John, Alfred Munnings and L. S. Lowry, have been excluded from the survey. They displayed little or no interest in the most adventurous thrust of twentieth-century art, but the present exhibition may well help to pave the way for an alternative show of more traditional British artists active in the same period.

At the Academy, we have opted instead for work charged with the ardent desire to explore new ways of seeing and escape from provincial timidity. Sickert, who dominates the first room, knew a great deal about French Impressionism and was the first to propose that Gauguin's work be acquired by our national collections. His younger Camden Town colleagues were equally quick to respond to Post-Impressionism, displayed in London with such controversial results by Roger Fry in 1910 and 1912. Soon afterwards, the Vorticists, led by the rebellious Wyndham Lewis, grasped the importance of Cubism and Futurism. They forged a movement of their own, and launched an explosive assault on the cosiness of the cultural establishment through their eruptive magazine *BLAST*. The two sculptors associated with this movement, Henri Gaudier-Brzeska and Epstein, were likewise closely involved with continental developments, and so was the formidably gifted young David Bomberg.

But none of these artists made the mistake of producing pallid imitations of the foreign work they admired. Despite her first-hand knowledge of French painting, Gwen John's painting remains highly independent. Stanley Spencer managed to bring about a unique fusion of his interest in Gauguin on the one hand and Giotto on the other, while Burra never allowed his respect for Surrealism to dominate his own quirky and bizarre vision of the world. The two great sculptors who emerged between the wars, Barbara Hepworth and Henry Moore, remained at a crucial remove from the avant-garde groups with which

they were publicly associated during the 1930s. And Bomberg, who recoiled from the near-abstraction of his early work, followed an increasingly lonely and courageous path in later life.

Since 1945, British art has again been marked by outbursts of irrepressible audacity. No one could be more single-minded than Bacon, whose gruelling achievement has acted as an inspiration for younger painters as tenacious as Lucian Freud, R. B. Kitaj, Frank Auerbach and Leon Kossoff. Pop Art's brash involvement with commercial imagery, in a movement which spread across Europe and America in the sixties, owes a great deal to the pioneering work of Eduardo Paolozzi and Richard Hamilton. Figurative painting remains eloquent in the hands of painters as distinctive as David Hockney and Howard Hodgkin, while Anthony Caro and Barry Flanagan have proved that succeeding generations of British sculptors continue to win wide acclaim despite the brooding dominance of Moore.

The Academy show terminates with artists who had already established their identities by the early seventies, augmenting painting and sculpture with alternative media. Richard Long, Gilbert & George and Bruce McLean have inventively explored the possibilities of photography, performance and other new resources, but their work at the same time possesses links with many of the older artists in the exhibition. For all their determination to experiment, and participate in the modern movement's quest for an art directly expressive of its own period, all the participants remain profoundly conscious of history as well. From Moore's admiration for ancient Mexican sculpture to Bacon's anxious obsession with Velázquez, even the most original of our artists feed off an acute and discerning awareness of the past. It nourishes their work continually, and the tension between tradition and innovation gives the Academy's exhibits much of their enduring fascination.

CY TWOMBLY
22 October 1987

At a time when his seniors and contemporaries succeeded in making New York the unchallenged centre of western art, Cy Twombly took the surprising decision in 1957 to settle in Rome. Such a move contradicted the prevailing notion that America had finally wrested the cultural initiative from the old European world. Rome was widely regarded as lit-

tle more than a repository of the past, a museum devoted to the achievements of a tradition which had long since spent its finest energies. Many American artists adopted an aggressive stance towards Europe, proclaiming their freedom from any inhibiting reliance on the past. They saw themselves as creators of the future, and New York replaced Paris as the city every aspiring young painter now felt obliged to visit as often as possible.

In such a context, Twombly's move to Italy must have seemed perverse. After all, he had already formed relationships with many of the artists responsible for American art's formidable post-war vitality. In 1951, when he was only twenty-four, Twombly was invited by Rauschenberg to spend the summer at Black Mountain College, the celebrated avant-garde rallying-point in North Carolina. The chance it provided to meet painters like Kline and Motherwell must have been invaluable, but Twombly was more affected by the European trip he undertook with Rauschenberg the following year. Travelling through France, Spain, Morocco and Italy, he seems to have recognised a landscape and a cultural legacy that could feed his own work. Far from sharing the prevalent belief among the American avant-garde that the old order had nothing more to offer, he discovered a rich and fruitful continuity between the European past and his own concerns.

The realization did not tempt Twombly to assume a style in any way reliant on historical precedents. His starting-point lay firmly in the eloquent mark-making of Abstract Expressionism. However much he tried to counter its emphasis on the heroic sublime, and replace it with a less bombastic and more allusive way of working, his debt remains clear. It enabled him, fundamentally, to have faith in his peculiar handling of line. He soon learned that the vigorous, heavily loaded brushwork of Abstract Expressionism was inimical to the development of his own sensibility, which depended far more on deploying crayon and pencil after the ground had been prepared with paint. But the assertion of this graphic style, which makes Twombly's work immediately recognizable, was still underpinned by a faith in the abstract expressionist idea that the picture-space was above all an 'arena in which to act'.

The unfolding of his confidence and individuality is vividly conveyed in the Whitechapel Art Gallery's retrospective exhibition and a smaller show at Anthony d'Offay. Most of the earliest canvases seem embroiled in a congested world, where forms race across the compositions and threaten at every turn to collide with each other. The large *Panorama* of 1955 is especially tumultuous: on a dark distemper ground, white crayon contours are scrawled in such profusion that they threaten to choke the

space with their incessant, proliferating agitation. An aggressive metropolitan ambience is evoked here, and Twombly's feverish lines seem bent on conveying the turbulence of a place alive with the press of bodies, traffic and all the cacophony of modern city life. The smeared and partially defaced surfaces of these paintings suggest, too, that he has been impressed by the obliterations and graffiti on city walls. Such references are never explicit, for Twombly is too much of an abstractionist to let his work yield images that can be pinned down too literally. But in his elusive, oblique way, he manages forcefully enough to transmit the clangour, energy and besmirched environment of a New York far removed from the pristine lucidity Mondrian had asserted when he painted *Broadway Boogie-Woogie* just over a decade before.

After Twombly's move to Rome, the mood and formal organization of his work underwent a marked change. The sense of constriction and overcast atmosphere disappear, to be replaced by a radiant alternative. *Arcadia* summarises the transformation, letting joyful flicks and scribbles of crayon and pencil play across a canvas filled with pale yellow light. With the letters 'ARCA' decipherable among the welter of other marks, his calligraphic handling seems to revel in a feeling of release. Twombly clearly savoured the hedonistic serenity engendered by his new surroundings. He felt at home in a city where the classical and Renaissance heritage manifested its continuing fascination. His liberated lines dart and waver in a painting called *Sunset* like fish weaving their way through fronds on a river's bed. Rather than concluding that the contemporary American artist must feel detached from European tradition, he realised that Roman culture could provide him with a congenial means of refining and extending his own singularity.

After a while, Twombly's infatuation with his adopted habitat led to the flowering of an expansive and lyrical art. *Triumph of Galatea* is a dionysiac painting on the grand scale, animated by loops, flourishes and swirls of pigment far more outspoken than anything he had attempted previously. It shouts where his work had earlier whispered, and traces of figurative references enrich the vocabulary of gestures he uses. Although they still appear to issue from a region deep in Twombly's subconscious mind, and evade precise identification, the forms which erupt in a painting like *Leda and the Swan* are replete with suggestions of thrashing limbs, organisms swollen with desire and vegetation beaten aside by the urgency of violent motion.

Having attained this climactic explosion, Twombly subsequently retreated from the declaration of exclamatory emotion. Determined not to fall into the trap of complacently reiterating previous solutions, he

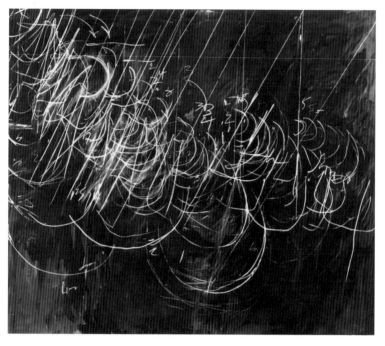

95. Cy Twombly, *Untitled 1968/71 (Rome)*

worked his way towards a far more spare and understated language. *Night Watch* reduces a meditation on Rembrandt's masterpiece to a cluster of rectangles, thinly delineated in irregular contours of white crayon on a ground as dull as a blackboard. Several large untitled canvases of the late 1960s turn away from this geometric quiescence towards a more hectic vision, where Twombly's chalk slashes diagonal shafts into arcs inescapably reminiscent of rain-puddles. But the insistence on monochrome prevails, even when the white squiggles take on a furious energy and fill an enormous canvas with a maelstrom of high-voltage marks.

Over the last decade, Twombly has continued to enlarge his range, introducing overt words into paintings riddled with references to Mars, Apollo and Adonais. As if in reaction against these verbal invasions, he also produced images where passages of heavily worked green pigment occupy the picture-surface as solidly as a hedge in high summer. Then he achieved a reconciliation between these two contrasted ways of working, and executed a *Hero and Leander* triptych where lusciously han-

dled evocations of a sublime realm are fused with the delicate inscription of Leander's name hanging in space. Twombly reveals the full extent of his romanticism in these seductive and unfettered paintings. He has recently become as impulsive as the red words sprawling across the sky in a windswept panel that declares his involvement with the *Wilder Shores of Love*. But his unwillingness to settle into predictability warns us against concluding that he has arrived, in his sixtieth year, at some kind of definitive conclusion about his vision of the world. An awareness of flux runs through all his work, and it is bound to lead this supple artist towards further stages in his complex and audacious odyssey.

LUCIAN FREUD
11 February 1988

Just as his grandfather Sigmund might have expected, most of Lucian Freud's work focuses unremitting attention on a single person seated or reclining in a quiet room. Occasionally the figure is joined by a companion: a sombre girl who leans towards her father's scarred face, or a naked woman who lies next to her pregnant friend and places a tentative hand near the swollen belly. Sometimes, too, a greyhound is discovered sprawling beside the figure, who allows her arm and hand to become intertwined with its attenuated limbs. But in the main, Freud's sitters are presented alone, patient and contemplative as they submit to the searching analysis of a painter who investigates them with absolute zeal.

Although the style has changed over the forty-year period surveyed at his marvellous Hayward Gallery retrospective, Freud's essential preoccupation remains undeviating throughout. The early paintings, concentrating largely on a young woman whose wide eyes often seem unbearably tense and expectant, are as smooth and glassy as Bronzino's portraits. Every undulating tendril of her flowing hair appears to have been picked out by Freud's vigilant brush, and her enormous pupils contain tiny reflections of the windows towards which she is staring so apprehensively. This obsession with piercingly scrutinised minutiae, recorded with a passion for exactitude worthy of Van Eyck, gives way to a broader handling as the post-war period proceeds. The overall aim stays constant, however. Sharing the same uncompromising mood of anxious isolation

as his friend Francis Bacon, and yet defining for himself an emotional temperature bordering on the glacial, he continued to centre on images of humanity marooned in anonymous interiors.

During the early years, this favoured locale was sometimes permitted to include a view of the world outside. The mesmerizing *Interior in Paddington* reproduced in Robert Hughes's new book on Freud's paintings reveals a prospect of dingy terraced houses beyond the balcony. It is a cheerless sight, uninhabited except for a small boy who leans against a wall and broods on the damp pavements around him. Although in no sense a self-portrait, he seems about the same age as the eleven-year-old Freud who escaped from his native Berlin in 1933 and settled in London. Nazi persecution of Jewish families made the move imperative, but it must have been a profoundly unsettling event. One of Freud's earliest surviving paintings, *The Refugees*, shows a weary and disorientated family staring nervously at the unfamiliar world that awaits them. The picture is clearly informed by personal experience, and even though Freud became a naturalised British subject in 1939 his work suggests that he has been unable to lose the sense of being an outsider, a restless loner who cannot feel wholly at home.

The people in his paintings never occupy surroundings they can call their own. Freud insists on uprooting them from a domestic context and transplanting them to a bare studio in north London containing dilapidated furniture, unruly plants, discoloured walls and a rudimentary sink where the taps obstinately drip. One sitter perches uncomfortably on a wooden chair, as if to emphasise the fact that it is only a temporary resting-place. The heap of white rags scattered across the bare floorboards behind accentuates the air of dereliction, and when Freud admits his own presence he still seems oddly elusive. One small painting catches his reflection in a cheap hand-mirror, jammed seemingly by accident between the frames of an open window. The likeness it reveals is untypically blurred; and even if other pictures contain more sharply defined self-portraits, they persist in showing him as a man who refuses to settle down. In one strange painting he must have depicted himself in a mirror laid on the floor: he towers above us, lit by the hard nocturnal glare of the naked bulb hanging near his shoulder. Elsewhere he peers out from the leaves of a luxuriant plant, little more than a shadowy observer who places one hand behind his ear to catch stray sounds breaking the silence.

He is unlikely to hear anything of consequence, for the figures inhabiting his work are in no mood to talk. In a rare admission of his own proximity to a sitter, Freud once depicted his feet behind the sofa where

a nude woman lies. But her head is turned away, and she gazes trance-like towards the split fabric of the couch rather than acknowledging him in any way. Even in the largest painting Freud has so far produced, where five people are gathered to echo the characters assembled in Watteau's *Pierrot Content*, there is no sign of conversation. Watteau's mood is playful and his dramatis personae revel in the theatrical woodland around them. Each of Freud's sitters, by contrast, is lost in a private meditation unalleviated by high spirits or friendly interchange. Bunched together the four figures on the bed may be, but the sound of the lute plucked by the girl in the striped dress serves only to deepen their reverie.

It seems inevitable, then, that Freud's people remain for the most part as lonely as they are naked. With a few memorable exceptions, like the ginger-haired man who holds a rat alarmingly near his own bared genitals, they are women who harbour no inhibitions about exposing their bodies to the artist's strenuous inspection. But that does not mean they display themselves before him conscious of sexual allure. Unlike so many of the female nudes who parade their flesh in images painted by men, overt eroticism is hard to find in Freud's work over the past twenty years. Sprawling on beds and sofas in often ungainly positions, these women make little attempt to entice. They present a physical type invariably removed from the sexual clichés promoted by the tabloid press and pin-up magazines. Sagging, red-faced, sometimes overweight and invariably past their peak, they are presented as vulnerable human beings no more able to withstand bodily disintegration than the rest of us.

Freud's skilful brushwork reinforces his refusal to deal with crude images which reduce women to titillating stereotypes. Far from caressing the bodies, his handling is crisp and stabbing as it registers every protuberance and declivity with awesome assurance. The granular texture of the paint aids him in this stern resolve to deal with mortal fact. He has no time for fantasies which avoid the more remorseless aspects of our condition, and the torn, battered furniture which spills its stuffing beneath the bodies' weight acts as a metaphor for human decay as well.

It is a harsh vision, the work of an unsentimental realist driven by the gnawing need to hunt down and disclose the truth with all the disconcerting clarity he can muster. But Freud is not a merciless artist. The superb sequence of portraits of his mother reveals quiet sympathy and a compassion which overrides the more acerbic side of his temperament. At first, in 1972, the recently bereaved woman is studied in small, close-up paintings of her head alone. She looks frail yet stoical, and a large painting then proceeds to juxtapose her with a young woman stretched out on a bed. The contrast is poignant enough, and both women seem painfully conscious of

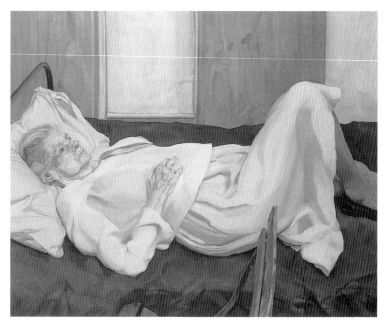

96. Lucian Freud, *The Painter's Mother*, 1982–4

the devouring agency of time. When he completed his magisterial *The Painter's Mother* a few years ago, though, a state of reconciliation had been arrived at. Dressed in white, she lies on an iron bedstead with a serenity quite unprecedented in Freud's work. The surroundings are as gaunt as ever, and the brushmarks retain all their penetrating lucidity, but the sense of tender acceptance is new and immensely moving.

DAVID BOMBERG IN RETROSPECT
18 February 1988

Just over thirty years have passed since David Bomberg died, penniless and virtually forgotten, in a London hospital. Having just undertaken a harrowing sea journey from Spain, where he eked out an isolated life in

Ronda, his sixty-six-year-old body finally failed him. Looking back on his career from the hospital bed, Bomberg could easily have felt indignant about the neglect he suffered. After almost half a century of distinguished achievement as painter and draughtsman, his work remained unrecognised outside a small circle of loyal relatives and friends. No dealer had given him a one-man show for fourteen years, and most of his work was unsold. Lying unseen in storage, this extraordinary legacy ought to have established him long since as one of the finest British artists of his generation. But recognition had been denied him by critics and museums alike, and the ignominy continued after his will was published. Although it stipulated that his paintings should be offered to public collections throughout the country for no more than £100 each, nobody was interested. Bomberg, it seemed, might as well never have existed.

Now his reputation has reached the point where a retrospective exhibition, the largest ever held of his work, has just opened at the Tate Gallery. As the organiser of the show, I cannot review its contents. But it does seem an appropriate moment to trace the dramatic sequence of events which led to the final recognition of Bomberg's stature. The great irony is that the process began very soon after his death in August 1957. He had long wanted a large exhibition which would reveal exactly what his work had amounted to since he left the Slade School of Art in 1913. And only a year after he died, Bomberg's indefatigable widow Lilian saw her efforts rewarded when the Arts Council staged a survey which at last opened many visitors' eyes to Bomberg's work. Although far from complete in its representation of his complex development, the show was particularly admired for the later paintings. After the Second World War he had taught for a few years at the Borough Polytechnic in London, where his legendary class nurtured students as formidable as Frank Auerbach and Leon Kossoff. By the late 1950s their powerfully expressive paintings had begun to make an impact, and so the work Bomberg produced during his final years duly gained admirers as well.

The full extent of his youthful achievement was, however, only discovered during the 1960s. Great early canvases like *In the Hold* and *The Mud Bath*, which can be ranked among the masterpieces of early twentieth-century art in Britain, finally made their appearance – first at Coventry in 1960, and then at Marlborough Fine Art where David Sylvester contributed an eloquent essay to the catalogue. Acquired by the Tate around this time, these two prodigious pictures altered everyone's understanding of painting in the 1914 period. They proved that the young Bomberg had been at the forefront of the innovative energies which transformed British art during those heady years. Both canvases

97. David Bomberg, *The Mud Bath*, 1914

took as their starting-point the East End world Bomberg had known since childhood. He grew up in Whitechapel, the fifth child of a Jewish leatherworker who had fled from the pogroms of Poland in the late nineteenth century. Bomberg was enormously stimulated by the dynamism of the machine-age metropolis, and he reflected that energy in the harsh, clean-cut organization of his early paintings.

Since the 1960s were the heyday of post-war abstraction, attention now focused on Bomberg's youthful work more than his subsequent career. When the Tate staged its first retrospective survey in 1967, the cover of the catalogue was filled with the thrusting, pared-down forms of an impressive 1914 drawing. One of the essays, by Andrew Forge, was wholly devoted to a cogent analysis of *The Mud Bath* alone, and by the early 1970s Bomberg's relationship with the Vorticist group was the subject of intense interest. He had always shied away from the movement which Wyndham Lewis and Ezra Pound hatched early in 1914. Although Lewis invited Bomberg to contribute to *BLAST*, the Vorticists' belligerent magazine, he preferred to retain his independence. And the outstanding one-man show Bomberg held at the Chenil Gallery that summer proved that he had no need of a movement to bolster his precocious reputation.

Each new generation assesses the art of the past in a distinct way, though. Towards the end of the 1970s, the dominance of abstraction gave way to a quickening of interest in figurative art. With commendable prescience, Nick Serota mounted a timely survey in 1979 of Bomberg's later years at the Whitechapel Art Gallery – where the artist had himself organised the 'Jewish Section' of a major modern art exhibition back in 1914. Serota's show made many people realise that it was a mistake to underestimate the work Bomberg produced after 1929, when he broke through to his mature style during a momentous stay in Toledo. The increasing freedom of his brushwork in subsequent years, when he discovered how to give full vent to his impassioned involvement with nature at its most primordial, now seemed close to the concerns of young painters once again.

In 1981 the Royal Academy's major exhibition, *A New Spirit in Painting*, reinforced the emphasis on highly expressive mark-making, and before long the Tate decided that Bomberg deserved a far more comprehensive retrospective to reveal the full extent of his achievement. Lilian Bomberg died soon afterwards, but not before hearing with enormous pleasure about the Tate's willingness to stage a survey almost twice the size of the 1967 retrospective. It contains many paintings never before displayed in London, including an exuberant 1931 portrait of Lilian called *The Red Hat* which shouts out its flamboyance on posters for the exhibition all over town. Bomberg may have been wounded by indifference and penury during his lifetime, but the work survived to ensure that it eventually gained him the recognition he deserves.

LATE PICASSO
14 July 1988

Although Picasso finally stopped making art in 1972, only a few months before his death, the discovery of his late work has become a dynamic force in the development of painting today. He continued exhibiting until the end, and everyone acknowledged that his prolific output testified to reserves of energy formidable in a nonagenarian. But few were prepared to admit, during Picasso's lifetime, that the final years had produced anything other than a decline. The work of his old age was widely regarded as crude, hasty and repetitive, the outpouring of a man

who had long since ceased to play a vital role in the momentum of contemporary art. At a time when abstraction was at its zenith, his obstinate adherence to the figurative tradition was seen as a marginal, even retrograde activity.

Since the accusation of elderly deterioration has now been repeated, in Arianna Stassinopolous Huffington's unbalanced and disapproving biography, why does the Tate's *Late Picasso* survey now seem so triumphant? Partly, of course, because the selection concentrates on the finest work, leaving aside the images which, even today, look indifferent or downright sloppy. But mainly because the progress of painting in the 1980s has transformed the way we look at Picasso's once-derided last years. Now that figurative work has regained so much vitality, his final period is revealed in all its uncanny prescience. The ageing painter still possessed much of his earlier ability to anticipate, and profoundly affect, the course of twentieth-century painting.

He even foreshadowed, during the 1950s, the current obsession with re-examining and paraphrasing the art of the past. Indeed, much of the history-quoting conducted today seems feeble compared with the gusto and sustained concentration Picasso brought to bear on his love of Delacroix, Velázquez and Manet. Rather than contenting himself with polite acts of homage, he worried away at three landmarks in Western painting until all the possibilities they offered him were exhausted. Picasso the restless innovator was also a man with a profound, albeit competitive, respect for the tradition he had earlier done so much to violate. His richly inventive variations on the themes provided, in successive order, by the *Women of Algiers*, *Las Meninas* and *Le Déjeuner sur l'herbe* became wholly personal achievements. Picasso tested his language against the pictorial resources deployed in these masterpieces, and it generated a fantastic range of styles as the variations proceeded. Ultimately, though, this extended dialogue with the venerated dead was a liberating experience. By the early 1960s, when the whole obsessive series came to an end, he had arrived at a clear understanding of how his own voice should assert itself. We are left, during Picasso's final decade, with a sense of unimpeded concentration on the predicament of old age.

Aware that he was now isolated as an artist, and conscious all the time of death's imminence, the obstinate old renegade refused to accept that degeneration was inevitable. Defying senility, he offered instead the spectacle of an artist who despised the whole notion of quietly reiterating or refining his previous achievements. Instead, the knowledge that time was running out provoked him into a fury of renewal. While continuing to meditate on exemplars like Ingres, Degas and Rembrandt, he devoted

himself above all to an angry, candid, self-mocking and sometimes uproarious examination of his own mortal dilemma. The waning of sexual powers led, paradoxically, to one of his most potent phases as an artist. Confined though he was to a studio-based existence, the increasingly reclusive painter produced stubborn affirmations of his voracious involvement with life.

His large, uninhibited canvases grow more and more boisterous in their handling. He reduces human bodies to their most primal elements, summarizing and asserting with the imperious directness of a child. But alongside this abbreviation of form, Picasso develops a wilder and more resourceful handling of paint than before. Even at their most resplendent, his earlier works had never been conspicuous for a sensuous or supple attitude to pigment. The magisterial command of line, which provides the foundation of his art at every turn, often led him to deny paint its most seductive properties. Now, however, advancing age released Picasso from that constriction. The brush applying runny Ripolin to his picture-surfaces is no longer afraid to juxtapose tough structural definition with areas of flowing, swirling colour. The pictures seem to breathe more freely, activated by an artist adept at changing, within a single image, from ebullient impasto to the thinnest of liquid stains. Often he is prepared to leave the white primer untouched, so that areas exposing the purity of bare canvas coexist with passages of vehement, even brutal complexity.

If Picasso rejoiced at his ability to extend the language of his art, he never pursued it as an end in itself. The autobiographical urge is stronger than ever in his late work, and he focuses above all on the immediate circumstances of his life. Again and again, women assert their irrepressible presence. Sometimes they pose in the studio for an artist who frowns with diabolic rage at the realization that his senescence compares so ridiculously with their unattainable poise. On other occasions they relax, play with cats and birds, or stretch out and display their luxuriant pubic regions in front of a garden window. Despising all the conventional limits which circumscribe depiction of the female nude, Picasso rejoices in the defiant high spirits of a *Woman Pissing*, full-length and wonderfully brazen as she hitches up her skirts on the deserted beach. Elsewhere she closes with her hungry lover in a full-blooded image of copulation, pressing herself against him in robust delight as his penis rams her hospitable flesh. This engorged coupling is counterbalanced, in other paintings, by a detumescent tenderness. *Woman with a Pillow*, one of Picasso's most consummate and idyllic late paintings, savours the intimacy of a lolling nude whose limbs are replete, languorous and gratifyingly close to the painter surveying them with such rapt appreciation.

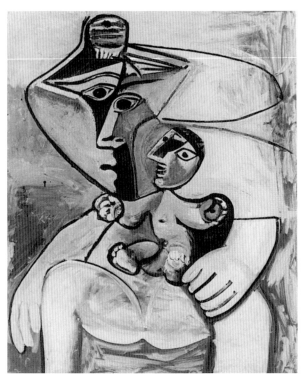

98. Pablo Picasso, *Mother and Child*, 1971

There is no trace, in these vital and generous paintings, of a self-pity-ing artist who wretchedly deplores his inability to participate in the delights he hymns. The inevitability of impotence led, not to bitterness, but a tragi-comic awareness of his marginal position when erotic encounters are depicted. While a bearded face merges greedily with his willing partner in *The Kiss*, Picasso allows a detached eye to spy on them through a cartoon-like curtain. Humour, and an unquenchable playful-ness, become the means of keeping despair at bay – especially in the etchings, where voyeurism and rampant, proliferating desire are dealt with in terms of a *commedia dell'arte*.

But this undaunted satyr could not keep death at bay for ever. In a dole-ful painting of 1971, produced during his ninetieth year, an elderly man in a sunhat sags with terminal fatigue as his legs trail across the ground.

Unable to frolic any more, and separated this time from the young woman who appraises his helplessness from a distance, he looks haunted by the knowledge of imminent collapse. Vitality reasserts itself some months later, most persuasively in a singing *Musician* whose gusto galvanises the entire picture. All the same, the skeleton of a stripped fish is brandished here as well, and the player's sombre costume takes on a funereal hue.

The last paintings are the most disquieting by far. Unable now to combat death's proximity with his former zest, Picasso paints a yellow and cadaverous *Reclining Nude* assailed by a vicious sun. Phantom-like silhouetted figures dance attendance, as mournful in their way as the harbinger crows hovering over Van Gogh's last cornfield painting. Vincent's art meant an increasing amount to Picasso when his own strength ebbed away. Sympathizing as never before with the Dutchman's awareness of an inevitable end, he produced one last image of figures locked in an embrace. By now, however, the tangled forms testify to confusion and defeat, their hands and feet lifted in Canute-like protest against an engulfing wave they are powerless to push back. Universal inundation must take its course, and in a painting called *Reclining Nude and Head* the lingering vestiges of human form have been divested of their former substance. The bodies which once filled Picasso's work with obstinate energy are here on the verge of melting away altogether, yielding their solidity to a white, bone-bleaching negation. Even now, though, as ultimate dissolution prevails at last, the weakening artist still manages to fire his dour testament with a spiky, obstinate grandeur.

LEON KOSSOFF
6 October 1988

Driving past Kilburn Underground Station on my way home, I often wonder at Leon Kossoff's audacity in choosing to paint such a forbidding subject. With two brutal bridges bearing down from above, spreading train noise and shadows across the whole area, the station inhabits an oppressive locale. Traffic never stops clogging up the High Road, and the booking hall is one of the most despondent sights in London. Garish lighting ensures that its grimness is clinically exposed. Most of the passengers obliged to pass through it do so as quickly as possible, acknowledging that nothing can be gained from lingering there.

Kossoff, though, thinks otherwise. He has never been afraid of confronting the most unlovely stretches of the metropolis. Initially an East Londoner, he used to stare down on Dalston Junction, where the railway tracks gouge through the congestion of Ridley Road street market and Salmon Curer's Yard. Although the legendary thickness of Kossoff's pigment paralleled the piled-up density of the city itself, the outcome was far from inert. For the artist, impelled no doubt by what he once described as 'the shuddering feel' of London, manipulates his densely loaded paint with fierce, almost brazen energy. There is nothing picturesque or dainty about the uncompromising vision of modern life which Kossoff presents, and he carried its raw authority with him when Kilburn and nearby Willesden began to dominate his art around twenty years ago.

The cascading rubble of a demolition site on Caledonian Road gave way, at first, to the light-filled interior of a vast children's swimming-pool. But the clamour of the figures who fill the baths with their lunging activity is forcefully conveyed, in a series containing some of his very finest pictures. The abrupt movements made by the swimmers as they dive, float and jostle in the water are defined by the prodding, swirling marks which Kossoff so openly declares. His pool is a raucous place, alive with din and unpredictable gesticulation. While spurning any literal attempt to offer a documentary record of the view from the spectator's window, his pool paintings end up providing a remarkably convincing and honest account of the scene he scrutinised.

Kilburn Underground Station is a far less propitious setting, and Kossoff's large picture of the booking hall does not evade its bleakness. The figures who walk through it are blanched, weary creatures, resigned to their surroundings and enclosed in isolation. The floor of the hall rises steeply behind them, so furrowed with heaped-on and worked-over pigment that it resembles a ploughed field. Kossoff seems to imply that such a terrain must be struggled across, and the heavy masses of the ceiling accentuate the claustrophobic mood.

Ultimately, though, this pummelled painting does not amount simply to a depressing interpretation of its subject. Without minimizing its melancholy in any way, Kossoff manages to discover an authentic and unforced grandeur in the unprepossessing territory he explores. The stoical Tube travellers take on a dignity that testifies above all to their powers of endurance. Despite fatigue, and downcast eyes which seek to avoid dwelling on their surroundings, they retain a sense of beleaguered resolve. Pushing themselves on, either out into the street or towards the platforms within, they are driven by a stubborn determination to endure.

99. Leon Kossoff, *Booking Hall, Kilburn Underground,* 1987

Everyday existence always seems difficult for Kossoff's people, even when they sit or recline for their portraits. The balding and bespectacled Chaim leans back in his armchair with an air of weariness, but he twists his head violently to one side as if attempting to stave off exhaustion as defiantly as he knows how. The frenzied skeins of white paint splashed over his body reinforce this feeling of resistance, and throughout the picture Kossoff's vigorous manipulation of materials confirms the desire to remain resilient. Elsewhere, even though Peggy is seen resting in a sequence of small yet especially powerful portraits, she never lapses into slackness. Her monumental head is stiffened by an underlying fortitude,

and Kossoff's brush contains Peggy's features in a sequence of strong, dark contours that invest her with an aura of invincibility. However worn and battered her face may be, it retains a formidable ability to weather any affliction which life may impose on her.

Perhaps that is why three of the exhibits in Kossoff's moving show at the Anthony d'Offay Gallery return to Spitalfields for their inspiration. Concentrating on the façade of Christchurch with the intentness that Monet brought to Rouen Cathedral, he finds in Hawksmoor's robust masterpiece a similarly indomitable quality. Rather than stressing its strong vertical thrust, his paintings show how solidly Christchurch's massive portico rests in the earth. But he does not neglect the subsequent rearing of the tower towards the choked grey-white clouds, an aspiring movement which reminds me in its vehemence of an early Philip Larkin poem about a bomb-damaged church:

> Planted deeper than roots,
> This chiselled, flung-up faith
> Runs and leaps against the sky,
> A prayer killed into stone
> Among the always-dying trees

Kossoff entertains no more illusions about the human condition than Larkin, and both of them share a haunted preoccupation with vulnerability and loss. From their awareness of life's fragile limits, however, arises an equally firm readiness to find a hard-won epiphany. Kossoff is not the man to force such a manifestation on the spectator, and his decision to paint a building as exalted as Christchurch is untypical. He is far more likely to concentrate his sights on a mundane street in Willesden, where no afflatus can be detected. All the same, his work is still able to wrest from this often relentless context an unexpected quickening of the spirit.

Suddenly, between Kilburn and Willesden Green at night, the scrubland and terraced dwellings bordering on the track are brought to life by the advent of a train. Windows radiant with light, and burnished with the colours of the passengers' clothes, it clatters across the composition with an oddly consoling gusto. Kossoff's handling becomes particularly excitable when he paints this fleeting intrusion, emblazoned against the darkness beyond. The tangle of foreground weeds quivers as the carriage rumbles by, and the houses give out a terracotta glow as if warmed by its passing.

Some of Kossoff's figures are capable of emitting the same richness. In the majestic *Fidelma, No. 1*, he arrays the seated nude in a russet splendour, big-boned and sensuous as she burns like a fire from the encircling

shadows. This effulgence, which can be located even in the most unlikely regions of Kossoff's world, springs directly from his involvement with oil paint. He engages passionately with his chosen medium, and always makes us conscious of the combat needed to attain the final image. The pictures resemble battlegrounds, and sometimes the sheer accumulation of pigment weighs his work down too heavily. It remains obstinately matter-bound, refusing to proceed from there towards the eloquence Kossoff would like to achieve. But on a gratifying number of occasions he wins through. The maelstrom of paint coheres into pictures which transcend their quotidian origins and arrive, quite unaccountably, at a state of grace.

ANTHONY CARO
12 October 1989

After Henry Moore's death in 1986, Anthony Caro could easily have settled back and assumed the title of British sculpture's Grand Old Man. The revolution he did so much to initiate thirty years ago is, after all, no longer a matter for apoplectic debate. Caro, who had spent some time as Moore's assistant, reacted against him around 1960 by introducing a radical new aesthetic. The monumental solidity of Moore's bronze figures, reclining with such overwhelming organic assurance on their plinths, was replaced by a frankly industrial vision. Welded steel became the primary medium for Caro and all the sculptors who followed in his wake. Instead of stressing mass and a kinship with the natural world, he took sculpture off its hallowed plinth and let it expand playfully across the floor. During the 1960s viewers were encouraged to enter into more direct and less predictable encounters with the work he so flamboyantly produced. The old boundaries between a sculpture and its onlookers were eroded, encouraging everyone to step into the space inhabited by Caro's angular yet zestful forms. Festive colours, deployed with swaggering insouciance, suggested that he drew just as much inspiration from painters like Matisse or Miró as he did from his sculptural mentor, David Smith.

Like many audacious initiatives, Caro's bracing language became an orthodoxy in the hands of his less imaginative followers. Steel, along with the abstract vocabulary of plates and sections it engendered, turned into a predictable part of post-war sculpture. A new academicism threatened

to grow up around it, and for a while Caro seemed just as entrenched in his standpoint as Moore had been before him. But the artist responsible for instigating an aesthetic revolution should never be confused with the school he spawns. Caro was too supple and inventive an artist to rest complacently on his achievements for long. Always attracted to the challenge of breaking the rules, he has succeeded in developing and enriching his work rather than reiterating a proven formula *ad nauseam*.

This much is clear from the exhibitions of Caro's recent sculpture now at Knoedler Gallery and Annely Juda Fine Art. Both of them contain surprises, and the larger show at Juda's bristles with objects that flout any lazy preconceptions about his limits as an artist. The most unexpected work is displayed halfway through Juda's barn-like spaces, where Caro presents a major piece made entirely out of earthenware and stoneware. Its terracotta and honey-coloured warmth is utterly removed from the characteristic stainless-steel geometry of *Box Tent* on the floor below. The world of urban technology has been left behind, and in its place Caro evokes a pre-industrial culture where pottery implements still play a central role in everyday life. The sculpture is called *The Moroccans*, presumably as an act of homage to Matisse's great painting completed in 1916. Many of Caro's rounded forms here recall the composition on which they are based, but it is in no sense a faithful recreation. Matisse is used simply as a starting-point for Caro's evocation of a primordial Mediterranean mood.

In earlier years, his admiration for Matisse often prompted Caro to indulge in an unfettered love of colour. Now, although he has followed Matisse into exploring the possibilities of paper, his colours are far more restrained. The wall sculptures he made from handmade paper at Ken Tyler's New York studio are mostly bleached in hue, limiting the use of pencil, chalk, spray paint and acrylic to a reticent degree. Most of the emphasis is placed on lightness, so that the nimbly manipulated sheets take on a dancing delicacy. Caro can be a marvellously deft sculptor, and some of the most delightful steel pieces in the Juda exhibition reject solidity in favour of airborne thinness. *Breeze* lives up to its title by allowing a slender expanse of rusted orange steel to unfurl like an elongated strip of banner in the sky. It is exquisitely poised, and must have benefited from Caro's extended preoccupation with the paper works.

He relishes his command of formal virtuosity, playing in *Catalan Cowl* with an upright pair of clippers until they are transformed by the undulating, almost intoxicated elements which curl, swoop and plunge around them. This is Caro at his most zestful, giving vent to an irrepressible love of improvising with Rococo high spirits which erupt again in the aptly

100. Anthony Caro, *Elephant Palace*, 1989

named *Fee-Fo-Fum*. But he is equally capable, in another mood, of making a sculpture as sturdy and imposing as the enormous brass *Elephant Palace*. The animal's trunk is given an important part in the work, as it curves away from the heart-shaped 'entrance' only to re-emerge, brandishing its phallic length, above the 'roof'. The sculpture's gleaming bulk is also redolent of the machine age, though. It seems bent on asserting an implacable authority, and the elephant may well be trapped within this sinister structure.

Elephant Palace indicates that Caro has become more willing to introduce overt representational references into his sculpture. Although bodily and landscape rhythms have always been implicit in his work, he used to shy away from declaring them for fear of limiting the freedom which abstraction granted him. Now, however, he has embarked on a Picasso-

like enterprise, making ambitious homages to Manet, Rubens and Rembrandt. All three of these painters were obsessed with the human figure, and Caro is not afraid to tackle complex figurative groupings even as he affirms his independence from the paintings which inspire him. The two versions of *Le Déjeuner sur l'herbe* at Knoedler's take place, not in a verdant glade, but on Y-shaped white table-tops. Caro takes full advantage of them, slinging his steel components between one table-arm and the other like Brunel bridging the gorge at Clifton with a suspension structure. Unlike Brunel, however, he takes a mischievous delight in allowing the central parts of both works to dip down into empty space. The welding prevents the threatened fall from occurring, but both sculptures gain from the vertiginous tension it creates. Like Boccioni's celebrated Futurist bronze, *Development of a Bottle in Space*, these complex works are alive with a sense of the dynamism inherent even in a picnic still-life.

But the second version makes Caro's new desire to deal with the figure more apparent than even before. It reaches a memorable climax in the large *Descent from the Cross (after Rembrandt)*, where a whole cluster of agitated bodies assist the lowering of Christ or stand mournfully in attendance. Caro here pushes his formerly mechanistic language a long way towards organic form, achieving in the process an unforced emotional deepening as he comes to terms – for the very first time in his work – with the pathos of death.

MERET OPPENHEIM

2 November 1989

Sometimes, a work of art can acquire enormous fame without furnishing its maker with a reputation to match. The Swiss artist Meret Oppenheim suffered just such a galling fate in 1936, when André Breton asked her to participate in a Paris exhibition of surrealist objects. She promptly paid a visit to her nearest branch of Uniprix. Having purchased a large cup and saucer with spoon, she proceeded to line them with the fur of a Chinese gazelle. The result, like all the most haunting surrealist images, hovered between the sublime and the repellent. On one level, the Uniprix crockery took on a sumptuous allure – transformed from department-store mundanity to the status of a luxury. But it also looked

101. Meret Oppenheim, *Déjeuner en fourrure*, 1936

sinister, as though cup, saucer and spoon had sprouted a disgusting, all-enveloping fungus.

After Breton had christened it *Déjeuner en fourrure*, perhaps to suggest that the overgrown objects were left over from Manet's naked picnic in the woods, Oppenheim's offering rapidly became a surrealist icon. It was acquired by the newly established Museum of Modern Art in New York, appeared in countless reproductions and was endlessly analysed as a classic example of bizarre, dream-generated imagery. The 'fur tea-cup' became a celebrity almost independent of the artist who had produced it. On the rare occasions when visitors to the museum noted Oppenheim's name, they imagined that she was a man who had, quite probably, only ever made one work.

The truth, as revealed by a retrospective survey at the ICA, is very different. For Oppenheim, a commandingly beautiful and individual woman, produced a substantial amount in a variety of media during her long career. Although the *Déjeuner en fourrure* is a definitive statement of surrealist ideas, it originates in the childhood of an artist who became fascinated by the unconscious at a precocious age. Her father, a doctor, was fascinated by Jung's weekly seminars in Zurich, and inspired

Oppenheim to record her dreams with unusual thoroughness. A small yet alarming study of a *Child-Devouring Devil* survives from 1923, when she was only ten years old. While its violence may owe a fairly conventional debt to Grimms Fairy Tales, the drawing has a savagery which prophesies her later obsessions as well. The child weeps copiously as its legs are crammed into the mouth of a predator who, with flamboyant sadism, brandishes a saw in his right hand.

Almost a decade later, when Oppenheim decided to abandon her academic studies and become an artist, her preoccupations were equally macabre. In 1931, the year before making a decisive move to Paris, she drew a 'votive picture' of a *Strangling Angel* – a murderous little protest against childbearing. Oppenheim was at this stage determined to avoid all wifely and maternal responsibilities. After her arrival in Paris, she went straight to the Café du Dôme with her friend the dancer Irène Zurkinden. There the artists congregated, and Oppenheim lost little time in establishing herself as a prominent member of the Surrealist movement. Friendships ensued with Arp, Giacometti and, most passionately, Ernst. But she retained her own identity among all these potentially overwhelming personalities, and refused to relinquish her obsession with grim themes.

One of the most disturbing is a stark Indian-ink drawing called *One Person Watching Another Dying*. The observer, his arms hanging down limply as if to admit his helplessness, stares glumly towards the silhouette of a figure who appears to be collapsing. In this instance Oppenheim seems convinced of human isolation, and maybe she felt fundamentally alone despite her wide circle of friends among the Parisian avant-garde. She was, after all, very young and cut off from her family in Switzerland. Another 1933 drawing surely reflects an awareness of her need for reassurance. It shows three hands rising from a single sleeve in order to wave and stretch in the hope of making contact with someone. Oppenheim saw the image as a 'life-saving device for drowning people', and the dream on which it was based surely reflected an underlying anxiety about a loneliness bordering on despair.

For the moment, she remained absorbed in Surrealist activities and proved a memorable model for Man Ray. Some of the photographs he took in Louis Marcoussis's studio mock the male artist's desire to turn Oppenheim into a focus for desire alone. Half-disguised in an overtly fake beard, the faun-like Marcoussis stares greedily up at her statuesque profile. But she remains proud and aloof, impervious to his overtures. And in a sequence of close-up photographs showing Oppenheim on her own, this strain of cool Swiss *hauteur* is intensified. Whether posing naked and

smeared with ink by a printer's wheel, or leaning on a table in a rubber swimming cap, she remains imperturbably poised. Behind the untroubled mask, however, Oppenheim nurtured images that arose from a profound disquiet. In 1936, the year of the fur crockery, she produced another object called *My Nurse*. This time, she relied on a pair of high-heeled shoes, inverted and trussed so that they resemble a fowl ready for roasting. Its considerable wit is allied with a strong undertow of anger, centring on the notion of a woman tied down and prepared for consumption.

Oppenheim's ability to discover an unexpected resonance in 'ready-made' objects now looks like the most impressive aspect of her otherwise uneven work. But *My Nurse* aroused hostility when it was exhibited in her first one-person show at a Basle gallery, and she soon found herself obliged to endure a long period of depression in her native country. After her Jewish father was forced to abandon his practice in 1936, Oppenheim could no longer rely on him for financial support. She returned to Switzerland, exchanging the perpetual stimulation of Paris for a far less lively context. Plagued by melancholy and the repression she felt as a woman artist, Oppenheim suffered from a sense of failure during the war years.

By 1954 she had recovered sufficiently to move into a new studio in Bern. The old obsession with violence remains important in her post-war work: in 1967 she produced a *Gingerbread Fiend* which shows the same ferocity as the *Child-Devouring Devil* over forty years before. But alongside this continuing fascination with the darker side of existence, which led her in 1964 to produced a *memento mori* in the form of a chilling X-ray self-portrait, Oppenheim acquired a new serenity. Much of her later work aspires to the condition of weightlessness. Far from being trussed and frustrated, objects often float far above the ground. The dream diaries which once testified to a disturbed psyche are now printed in shapes reminiscent of clouds, and placed on music-stands in a space bordered by white gauze draperies to suggest the formality of a salon. Such calmness often has an adverse effect, depriving her work of its former anguished tension. All the same, the spirit of the macabre stayed with her to the end: in 1985, Oppenheim uncannily fulfilled the prediction made on her thirty-sixth birthday that she would die at the age of seventy-two.

CAGE, CUNNINGHAM AND JOHNS

16 November 1989

Ever since Diaghilev came to commission a succession of outstanding painters to design sets and costumes for the Russian Ballet, modern art and dance have enjoyed a stimulating relationship. Nowhere more than in New York, where Merce Cunningham has collaborated with Robert Rauschenberg, Andy Warhol, Frank Stella, Bruce Nauman and other prominent members of the American avant-garde. Many of them were invited at the suggestion of Jasper Johns, who became artistic adviser to Cunningham's Dance Company in 1967. Johns shares Cunningham's admiration for John Cage, and helped organise the composer's retrospective celebration at New York Town Hall in 1958, where the *Concert for Piano and Orchestra* received its première with Cunningham conducting. All three men have now been reunited, over thirty years later, in an interdisciplinary tribute at the Anthony d'Offay Gallery.

One space is filled with the pages of Cage's original piano score for the *Concert* piece, displayed according to a chance-determined method devised by the composer himself. He divided the room into thirty-nine-inch spaces and placed the pages in a variety of positions on its walls. The sequence of sheets moves up and down the flat, white surfaces like dancers on a stage, and in another gallery video monitors offer a chance to watch Cunningham's company in incisive action. Like Cage, Cunningham relies on chance strategies, determining not only the sequence of movements but the number of positions and the dancers as well. No wonder Cunningham and Cage have been able to work so fruitfully together since the early forties, within a framework loose enough to let each of them retain autonomy.

Since this is a gallery show, however, Johns becomes its true focus. Drawing on loans from the Tate, the Chicago Art Institute and above all the artist, d'Offay's principal space brings together a remarkable group of paintings called *Dancers on a Plane*. Although Johns has designed sets and costumes for Cunningham, they are not included here – probably a wise decision. Without the dances to give them their proper context, Johns' contributions might well have looked diminished. Unlike the artists who worked for Diaghilev, he has always wanted his designs to remain discreet: the dancers were allowed to assert their own authority, unhindered by any attempt on Johns' part to stamp his identity on the proceedings. It is significant that, on the only occasion when he produced a set for a Cunn-ingham dance, Johns based the design on images derived from Duchamp's *The Large Glass*.

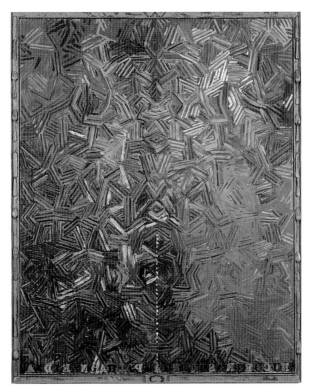

102. Jasper Johns, *Dancers on a Plane*, 1980–1

While the sequence of *Dancers on a Plane* paintings are linked with his work for Cunningham, they remain quite independent of any set or costume designs. Johns took as his starting-point an almost hallucinatory painting from Nepal, which he found in a book on Tantra. Produced during the seventeenth century, it shows the mystical figure of Samvara – a Buddhist deity who reflects forms of the god Siva – in the act of copulation. Since he brandishes seventy-four arms in the air, and his partner, Sakti, another dozen, their ecstatic love-making is accompanied by an extraordinary flourish of waving limbs. And Samvara's frowning head is repeated many times, in diminishing sizes. The entire image conveys a sense of formidable energy, enhanced by a pulsating combination of scarlet, purple, green and blue.

By choosing such a generative image, Johns implied that he saw 'dance' in its widest sense, as a means of expressing the universal themes of creation and destruction. He presumably aimed at a similar union in the earliest of the *Dancers on a Plane* pictures. The canvas is animated by the interplay of cross-hatched lines in red, blue and yellow. Their darting motion might easily have created a feeling of restlessness, but Johns stabilises the painting by making one half mirror the other. Combined with the lightness of the colours, this emphasis on formal harmony sets up a buoyant, even festive mood. As the clusters of lines weave their way across the picture-surface, they seem to bear out Blake's joyful declaration that 'Energy is Eternal Delight'. They also appear to exemplify Cunningham's belief that all dancing rests on the fundamental principle of changing weight from one foot to the other. And Johns' refusal to provide his painting with a focal centre echoes Cunningham's view that one point in space is no more important than any other.

But the next *Dancers on a Plane* exchanges litheness for a sombre alternative. Grey now becomes the predominant colour, and the cross-hatching is disturbed by eruptions of more violent and jarring activity. Within the overall sobriety, sudden flashes of orange, scarlet and yellow flash like lightning. In the right half of the picture, these outbursts are subjugated by a large area of grey brushmarks, but even here order is not restored. For these strokes contain a hint of figures struggling to emerge from the criss-cross system Johns initially devised.

The exhibition could easily have culminated in mournfulness, for Johns went on to base a large-scale painting on Munch's haunted self-portrait in old age, *Between the Clock and the Bed*. But he transforms Munch's anguished meditation into a more ambiguous image. The cross-hatch motif is still deployed, in an expanded form that relies on the activity of far fewer line-clusters. Within this network, though, an orange figure is able to dominate the centre of the picture. It is contained by the cross-hatching, and in that sense suggests there is no escape from the stern limits imposed by this powerful linear interplay. All the same, the figure has a luminosity and leaping vigour that allies it more with life than death. While accepting the inevitability of extinction, Johns here insists on savouring the ability to dance for as long as it lasts.

GALLERIES RENEWED,
TRANSFORMED, CREATED

THE SAATCHI GALLERY OPENS
23 March 1985

The art-collecting activities of Charles and Doris Saatchi suffered, until recently, from a venomous press. They first gained notoriety when word got around that Saatchi, flush with the profits of his advertising agency, was purchasing contemporary art by the wagonload. Accusations of vulgar bulk-buying gave way to more sinister suspicions when the Tate Gallery staged an exhibition by the controversial young American artist Julian Schnabel. It was execrated – in my view rather unfairly – and fingers were pointed at the Saatchis for lending so many works from their vast Schnabel collection. The feeling grew that the Saatchis, both prominent members of the Tate's Patrons of the New Art, were manipulative figures interested only in boosting the value and status of their own colossal investments.

Much of this sniping was based on hearsay rather than an accurate knowledge of the collection itself. But when a four-volume catalogue of its contents was published a few months ago, all this waspish scorn had to be hastily reconsidered. Far from amounting to a gross stockpile of work by a few over-esteemed new painters, the Saatchi holdings encompass a surprisingly wide range of images acquired over the last fifteen years. Minimal art is as prominent as the more expressionist canvases by younger painters, and the presence of several recent works by Richard Deacon proves that the Saatchis also appreciate the best of new British sculpture. The whole accumulation amounts to a survey of recent art probably on a grander scale than any other private collection in the world. It takes on an even more extraordinary significance in the context of twentieth-century Britain, where collectors have habitually operated on a more modest basis and prefer to distance themselves from present-day work. Even Samuel Courtauld, whose spending was munificent in the 1920s, concentrated on artists for the most part respectably deceased. As for Edward James, friend and generous patron of the Surrealists in their heyday, his enthusiasms seem narrow compared with the Saatchis' encyclopaedic interests.

Nor did James ever get around to placing his Magrittes and Dalís on public view in a specially converted gallery. Like most other collectors, he preferred to savour acquisitions in private, with only a privileged circle of friends and experts permitted to share his pleasure. The Saatchis, by contrast, have just opened a spectacular space where anyone interested in contemporary art can view their collection. Situated at 98A Boundary

103. Don Judd sculpture in the newly-opened Saatchi Gallery, London, 1985

Road, it is open free to the public on Fridays and Saturdays. The discreet grey entrance, inserted in an area of St Johns Wood where galleries are otherwise hard to find, gives little indication of the building it guards. Only the surveillance camera, strategically positioned near the entry-phone, hints at the high-security system which protects the multimillion-dollar contents within.

The gallery reveals itself slowly. Once inside the gate, we find that the sloping courtyard leading down to the building itself is low-key to the point of anonymity: the gallery used to be a warehouse, and no attempt has been made to embellish its functional austerity today. Inside the starkness continues, for nothing is permitted to distract attention from the work on display. Max Gordon, the architect responsible for converting the premises, has done his job unobtrusively well. Rather than trying to impose his personality on the surroundings or hide their origins, he concentrated on giving the collection as much space and light as possible.

And what a space it turns out to be! Ten times larger than the Serpentine Gallery, and lined throughout with pristine white plaster walls, the Saatchi building exudes an air of unadorned vastness. Each

exhibit is placed at a palpable distance from its neighbours, and the resultant clarity of viewing is enhanced by a uniform brightness. Although Gordon has retained the old serrated warehouse roof and left the steelwork exposed, the daylight from its glass windows is boosted by artificial light reflected off white panels installed in the ceiling. The outcome is almost dazzling, and compares very favourably with the altogether more fussy technological apparatus lodged in the roof of the Tate Gallery extension.

Don Judd, whose work thrives in settings of clinical bareness, looks imperious here. The largest of his sculptures, a massive plywood structure arranged in three magisterial storeys, confronts us as we enter the gallery's principal arena. Fused with the space it occupies, this brooding presence seems more like an integral part of the building than a temporary exhibit. It looks both inevitable and immovable, and its uncompromising modular organization prepares us for the equally severe formats employed by Warhol in the other large space.

The sad deterioration of Warhol's work over the past decade makes it easy to forget how commanding he could be in the early 1960s. Most of the Saatchi images were produced during that period, and their rigour ensures that they retain some, at least, of the impact they once possessed. Marilyn's face, repeated 100 times so that her smile takes on the rigidity of a mechanical mask, dominates the end wall. No artist has caught the mesmerizing and dehumanised power of mass reproduction more relentlessly than early Warhol. The grainy, smudged quality of the photographs he culled from tabloid newspapers, fanzines, film stills and police records conveys an authentic sense of the battering an image receives when it is multiplied, screened, bleached and transformed into a media icon.

Warhol's outsize, blatant and frankly machine-age art contrasts absolutely with the subdued abstraction pursued by Brice Marden in the gallery running alongside. He looks reticent to a fault in this context. Hampered by a steeply pitched roof which clashes with the rectangular steadiness of his paintings, Marden appears far less impressive here than in his Whitechapel retrospective a few years ago. Cy Twombly, the other artist given a substantial exposure in the Saatchi building, also seems diminished. His graffiti-like marks look oddly inconsequential, and incapable of holding their own in a building where bold, simplified and forthright images stand out with the greatest conviction. It will be fascinating to discover how the Saatchis' figurative paintings fare in a gallery which has effortlessly become one of the most compelling exhibition spaces in Britain.

THE FUTURE OF THE NATIONAL GALLERY
14 August 1986

Amid all the hullabaloo about Edmund Pillsbury's rejection of the National Gallery directorship, and the unexpected appointment of dark horse Neil MacGregor, surprisingly little has been said about the future needs of the gallery itself. But I think it is significant that MacGregor will approach his new job with a mind unclouded by years of museum experience. For the truth is that, over the next few years, the task of the director will be transformed by a dramatic increase in responsibilities and new opportunities.

The munificence of John Paul Getty II's promised £50 million means that MacGregor will be able to bid for major acquisitions with a purchasing power unknown to his predecessors. Instead of continually relying on help from bodies like the National Art Collections Fund, special government grants and tax concessions to British owners, the director now has an independent chequebook to wield in the market-place. It means that he could, armed with the right combination of knowledge, tactical shrewdness and sheer luck, secure a succession of paintings which the gallery has long since needed.

They come, for the most part, from the nineteenth century. Before Sir Michael Levey brought off the coup of buying a superb David portrait, the representation of French painting from the Revolution era was wholly inadequate. A figure composition by David is still a priority, but no more so than a masterpiece or two by the great painters who succeeded him. Until the National Gallery acquires canvases which show Géricault and Delacroix at their most ambitious, it cannot hope to inform us properly about the Romantic period in France. As for the same movement in Germany, a first-class landscape by Caspar David Friedrich is also a top priority.

The gaps are just as noticeable further on in the century. Realism is seriously under-represented at Trafalgar Square, where neither Courbet nor Millet are shown at full strength. And serious deficiencies still mar the gallery's holdings in the Post-Impressionist area. Any collection which lacks a Van Gogh portrait, a Cézanne still life and a figure painting or landscape by Gauguin still has a long way to go before it does complete justice to a crucial period in art.

Post-Impressionism is, of course, central to our understanding of twentieth-century developments. MacGregor will have to address himself very seriously to the question of how far the National Gallery ought

104. Neil MacGregor when appointed Director of the National Gallery, London

to approach the art of our own era. I believe he should conduct an adventurous policy, making every effort to acquire outstanding work by painters like Munch and Ensor whose work still exerts a formidable influence on young artists today. Sir Michael Levey has already burst through the barriers of the present century in a decisive way, purchasing an early Matisse portrait and a cubist Picasso. But they are not, in my view, good enough examples of either painter's work. MacGregor needs to find better pictures by both men, so that the story of Fauvism, Cubism and other early twentieth-century movements can be told with acquisitions of true National Gallery quality.

There may be protests that such works properly belong to the Tate Gallery, and that Trafalgar Square has no business trespassing on territory which ought to remain the preserve of Millbank alone. But the Tate,

with its much smaller purchase grant and ever-increasing responsibilities towards contemporary art, cannot now hope to make many prime acquisitions in the pre-First World War period. The recent buying of a top-flight de Chirico exerted a severe strain on its resources, and only the National Gallery has the funding to meet the cost of a prime Picasso or Braque from their heroic years. Some of the Getty money would be well spent building up a representation of key paintings from the time when Vienna, Berlin, Munich, Milan, Paris and Moscow were all at the forefront of fertile experimentation in art.

Why should the National Gallery bother itself with paintings executed only three-quarters of a century ago? The answer is clear. Even the most innovative work turns out, with hindsight, to possess profound connections with the past. As the National Gallery's own 'Artist's Eye' series has so rewardingly made clear, modern painters are often more deeply indebted to tradition than we might be tempted to suppose. Frank Auerbach, whom I regard as one of the finest painters in Britain today, is a long-term devotee of the National Gallery and has based one of his paintings on Titian's *Bacchus and Ariadne*. The collection's continuing impact on modern painting is potent indeed, and so is contemporary art's capacity to make us see painting of the past in new ways. In order to reflect this dynamic, the National Gallery should push its own holdings into the present century rather than arbitrarily terminating them around 1900.

Such a forward-looking policy might have seemed unrealistic a few years ago, when hanging space for the existing pictures was at a premium. But now that the Sainsbury family has come up with the funding for a new gallery on the site next door, MacGregor can afford to be unashamedly expansionist. Much depends on the building which Robert Venturi, the selected architect, designs. It will not, however, be a compromise as grotesque as the previous extension plan, which envisaged a gallery for quattrocento paintings marooned uncomfortably on top of an office block. With the merciful demise of that philistine project, Venturi is free to concentrate on the requirements of the National Gallery alone. So it should be possible to establish a new room for early twentieth-century art somewhere in the complex of old and new spaces.

As well as attending to the design of the extension, MacGregor must be conscious of the existing building's severe shortcomings. To put it bluntly, the interior of the National Gallery desperately requires a facelift. Far too many of the rooms look dingy and depressing, and the heat was stifling the other day when I went in to the gallery which houses the Post-Impressionists. Some of the rooms, most notably in the early Italian schools, are now air-conditioned and well-decorated. But even here a

tendency to appear over-clinical detracts from my enjoyment of the work in display. A great deal remains to be done before Wilkins's Victorian interiors can claim to enhance the paintings they contain.

Sir Michael Levey and his Keeper of Educations and Exhibitions, Alistair Smith, have done much to enliven the temporary shows and other activities offered by the gallery. The advent of the extension means, however, that the National Gallery will at last be able to stage major loan exhibitions. At the moment, only the Hayward Gallery and the Royal Academy mount large-scale exhibitions devoted to painting of the past, but I hope MacGregor ensures that the National Gallery organises an equally ambitious programme of surveys aimed at enlarging our enjoyment of the permanent collection. They would complement the existing shows, which focus in the main on recent acquisitions and small personal selections from the gallery's existing holdings. These surveys have been consistently stimulating and ought to form an integral part of a vigorous education policy. There is, however, plenty of scope for blockbuster exhibitions which generate a sense of excitement and make the building a centre of attention. Attracting wider audiences, and increasing their awareness of the richness of meaning which great art affords, must lie at the heart of our hopes for the National Gallery of the future.

THE TURNER GALLERY
9 April 1987

Several years ago, before the Turner Gallery was more than a tantalizing twinkle in James Stirling's eye, a press conference was held at the Tate to launch his design. A lengthy and seemingly comprehensive affair, it discussed in detail the brief he had been given, the thinking behind his design and the display techniques it would incorporate. I learned a good deal about Stirling's post-modernist willingness to honour the identity of existing architecture on the site – not only the Tate itself but also the former hospital building which would be retained to frame his structure. Heartened by the sincerity of his desire to respect the Millbank context rather than disrupt it with yet another Brutalist intrusion, the press conference's audience felt relieved and then benign. Only when the main speeches had finished did I realise, with a sense of foreboding, that nobody had actually talked about what kind of building would best suit Turner's paintings.

105. Entrance to James Stirling's new Turner Gallery at the Tate, London

Now that the new gallery is complete, Stirling's wish to create a structure overtly mindful of its surroundings is everywhere apparent. The façade nearest to the Tate echoes the stone courses and parapet heights of the old museum. Stirling has restricted himself here to a sober and disappointingly dutiful grid filled with ochre panels, punctuated at the centre by a triangular green window jutting out from the wall like the prow of a ship advancing on the Thames. Apart from so contained a moment of drama,

this section of the frontage is a dogged attempt to acknowledge that the Turner Gallery is not an independent entity. It flows without a break from the earlier block, and can be entered from the rooms in the existing Tate.

But Stirling was given the commission on the understanding that he enjoys a reputation as a sturdily independent architect. And when the new gallery turns the corner, he allows himself at first to assert a striking invention of his own. While the wall above temporarily abandons the panelled grid and presents a plain stone face instead, the grand entrance below is shaped in the form of a tent-like window. And the grid reappears to stamp its green geometry all over the glass. This is the most memorable individual feature of the façade, which then proceeds to reinstate the panelled patterning of the first wall as the building moves towards the river. It also begins to mirror, in colour and proportion alike, the character of the hospital lodge preserved beyond. The abrupt, jarring transitions in the frontage as a whole can only be understood if the presences both of the lodge and the old Tate are taken into account. They played a significant part in determining the eclecticism of a structure which combines overall discretion with sudden, surprising and often quirky bursts of inventiveness.

Immediately the Turner Gallery is entered from the garden, the outcome of this oddly nervous approach becomes clear. The side expanse of staircase rising ahead presents an uninterrupted expanse of sober cream – especially now that Sutherland's mediocre portrait of the donor, Sir Charles Clore, has been removed from the over-prominent position it occupied when the frontispiece photograph was taken for the Tate's new booklet on the building. As we ascend the stairs, though, a startling arch with a frame painted in vivid turquoise and ultramarine announces itself above our heads. The colours employed here recall the most 'dayglo' kind of hard-edge abstract paintings from the 1960s. Stirling exploits the *frisson* involved in playing off features like the puce staircase rail – warm to the touch because of the strip lighting it encases – against the more honeyeyed range of colours employed on the larger surfaces.

These abrupt eruptions of purple and pink are not simply selfindulgent devices, however. They signal the route in a building which goes out of its way to explore the limited space at Stirling's disposal. The staircase leads up in one direction only to inform us that we now have to turn round and walk toward the galleries in the opposite direction. By taking visitors on this roundabout route, Stirling invites us to explore the building from every angle. We notice, for example, how the grand entrance glass offers a handsome view of the Tate's original corner pavilion outside. The staircases enables us to savour this prospect and con-

template the relationship between the new gallery and the old structure to which it is attached.

But the most severe test lies within the rooms which house Turner's paintings. How does a building so absorbed in a highly self-conscious dialogue with the architecture of the past treat the pictures it is supposed to enhance? The answer is that Stirling has eschewed all his mannered and idiosyncratic devices when faced with the task of displaying the works themselves. He has opted for a downbeat and rather ordinary approach, providing a comfortable, self-effacing and unexpectedly intimate series of rooms for Turner's art. There are no tricks visible here, to distract attention from the canvases on view. The soft oatmeal carpet, more evocative of a private house than a clinical institution, marries with the beige walls and lighter ceilings to provide a modest backdrop.

All this restraint induces a feeling of anti-climax in anyone anticipating a suite of rooms dramatic enough to match Turner's dynamic vision. Stirling seems to scale the paintings down, refusing to be carried away by the apocalyptic urgency they convey. Perhaps he thought that Turner's art is so spectacular in itself, so overwhelming in the vision of nature it presents, that it needs a quiet environment. Anything more outspoken might clash with the tumultuousness of the most uninhibited paintings. There is, after all, enough drama in the gradually unfolding progression of Turner's work, away from the prevailing darkness of his early canvases towards the light-filled incandescence of his later years.

At one end of the longest gallery Andrew Wilton's thoughtful hanging has placed the nocturnal gloom of the little-known *Field of Waterloo*, where women search for their husbands by candlelight among the heap of corpses. And at the other end of this vista, tragedy gives way to hope in a blazing panorama celebrating *The Opening of the Wallhalla*. By providing this spinal link between the two ends of the gallery, the full extent of Turner's prodigious development is exposed with satisfying clarity.

A similar sense of lucidity informs the hanging in the rooms leading off this long space. Each one is devoted to a distinct theme like Turner's pursuit of the classical ideal, or the relationship he enjoyed with country-house life and landscape when staying with patrons who were his friends. Turner *en masse* can lead to indigestion, as I often discovered wandering through the rooms devoted to his work in the old building. Here, by contrast, he is divided up into a sequence of concise helpings which avoid the dangers of surfeit. The final room, enriched by loans from the National Gallery of masterpieces like *The Fighting 'Temeraire'* and *Rain, Steam, and Speed*, confirm that Turner reached his apogee in old age. It is marvellous to have these sublime canvases reunited, albeit for six months only, with

the Tate's choicest distillations – most movingly the lovely *Norham Castle*, where the emergent sun seems to dissolve everything in a pale and shimmering film of morning light.

Upstairs, for those not already punch-drunk by the canvases on the main floor, a reserve collection clusters the rest of the oils together so that everything Turner bequeathed to the nation is at last accessible. Stirling provides views from this floor over both the principal galleries and the entrance hall, thereby continuing to exploit every spatial possibility within his building. He reserves these ventures for the area outside the main room, implying a determination to let Turner stand alone, unaided by architectural diversions. In this sense, Stirling proves himself a follower of Sir John Soane, whose gallery at Dulwich demonstrates a related willingness to let paintings convey their own power in austere surroundings. But compared with the gaunt nobility of Soane's masterpiece, this new gallery is hampered in the end by Stirling's readiness to be over-respectful – not only to its environment but to Turner himself. For all its occasional eccentricities, the building as a whole appears constrained by a strange reluctance to provide an architecture of outright celebration, fully honouring the magnificence of Turner's long-abused bequest to the nation.

THE NEW LISSON AND THE SAINSBURY WING DESIGNS
23 April 1987

Disappointingly few of the dealers' galleries in London are anything more than perfunctory, box-like spaces. So it is especially gratifying to welcome the Lisson Gallery's new building, a handsome and resourceful interior which offers a dramatic arena for the works housed there.

The old Lisson, which celebrates its twentieth anniversary this year, has always been one of the most serious and adventurous galleries in London. Constantly introducing us to the most exploratory of younger artists from Britain and abroad, it achieved this remarkable feat from modest premises in Bell Street. Although operating well outside the West End circuit, the Lisson's director Nicholas Logsdail managed to conduct a more international policy than the majority of dealers in the Bond Street area. His track-record is exemplary, and yet the limits of the Lisson's original exhibition space have become increasingly confining.

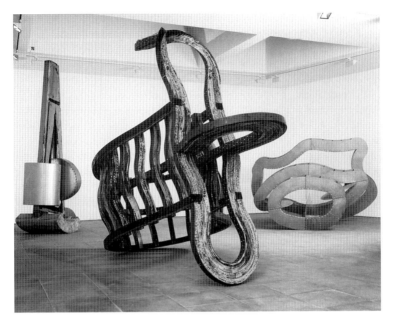

106. Richard Deacon sculpture at the new Lisson Gallery, London, 1987, with (left to right) *Troubled Water*, 1987; *Fish out of Water*, 1986/7; and *Feast for the Eye*, 1986/7

Over the past few years, the gallery has nurtured an outstanding new generation of British sculptors whose work grows ever more expansive. With an ebullience which is the mark of confident maturity, men like Tony Cragg, Richard Deacon and Bill Woodrow now command a scale that has far outgrown the rooms available at Bell Street.

The new gallery, now open in adjoining Lisson Street, is therefore a necessary development. Deacon, whose latest work comprises the inaugural show, finds himself in a room ample enough to give even the grandest of his sculptures the room it requires and deserves. But the architect responsible for the conversion of the site, Tony Fretton, has ensured that the new gallery provides something more than a sense of spaciousness. For the reticence of the glass-framed street frontage gives no hint of the spectacular experience within. At the end of a pleasant yet modest front room, appropriate for the display of smaller works, a flight of steps leads down into a second chamber. Here, in a gallery which accommodates three of Deacon's most swashbuckling sculptures with

ease, Fretton has created a marvellously compelling room. Illuminated at the back by a large rooflight that lets the full force of the sun invade the space, its spirit of airy largesse enhances everything on view. The theatrical presence of Deacon's work flourishes in the generous yet discreet proportions of a white arena paved with simple, polished slabs.

I cannot think of a better foil for the objects on show there. The space is so pleasurable to walk through that it encourages a thorough exploration of each exhibit. Deacon's two biggest sculptures undergo arresting transformations as we move around them. They unfold their complex identities with an *élan* confident enough to confirm my feeling that he has become one of our very best sculptors. *Fish Out of Water* is the most flamboyant image, a great baroque structure which sets laminated hardboard into an undulating motion redolent of oceanic rhythms. It also evokes the form of an ancient timber-framed vessel brought up from the sea-bed and beached, at a slightly tipsy angle, on the ground.

Feast for the Eye, another sprawling tour de force made this time of galvanised steel, lives up to its title with equal aplomb. It burgeons from a relatively quiet 'core', progressively loosening and rippling into ever more outspoken configurations. Deacon has the ability to marry an austere and almost skeletal grasp of structure with a fondness for exclamatory gestures, and the outcome is an eloquent imagery which animates the language of late twentieth-century sculpture with enormous metaphorical richness.

Until the National Gallery's extension is finally completed in 1991, we will not know whether the display spaces it contains are as successful, in their own terms, as Fretton's new building. But at least the long, bitter and at times farcical saga at Trafalgar Square seems to have reached a peaceful conclusion. Robert Venturi's designs for the Sainsbury Wing are now unveiled, and after all the adverse speculation they turn out to promise a responsible, sensitive and supremely thoughtful approach to a difficult site. Far from erecting a 'monstrous carbuncle' which would fulfil Prince Charles's most apocalyptic nightmares, the professorial American architect has proved eminently respectful of Wilkins's original National Gallery. It is not a building that has ever commanded wholehearted admiration, particularly from those who would have preferred Trafalgar Square to be crowned by a more magisterial edifice. But Venturi describes the Wilkins frontage as a 'much-loved friend', and he has frankly incorporated its distinctive columns and pilasters in his own design.

They only appear on the side nearest the façade of Wilkins's building, however. Venturi's extension is not simply a slavish post-modern homage. The windows echoing Wilkins become nothing more than vestigial

quotations as the Sainsbury Wing moves away from the existing National Gallery, and enormous entrance openings in an uncompromisingly modern manner are carved out of the stonework. Reminiscent in their amplitude of Stirling's grand entrance for the Turner Gallery, but more restrained in effect, these apertures will lead visitors towards an entrance hall imposing enough to escape entirely from the undistinguished foyers so beloved of contemporary architects.

It also leads, by means of a beckoning burst of daylight, towards the extension's *coup de théâtre*: the great stairs. This magnificent flight of wide stone steps proceeds up the side of the building towards a Latin inscription carved in the wall at the top. All the way up, visitors will be able to gaze out of a vast glass screen towards Wilkins's gallery and Trafalgar Square beyond. The enormous 'window' is unequivocally of its time. But it acknowledges the presence of history through the glass, and the staircase ceiling is spanned at intervals by ironwork 'vaults' which evoke Venturi's admiration for Paxton's Crystal Palace.

The main floor of galleries, which will house the collection of early Italian and Netherlandish paintings, commences at the top of the steps. Without comprehensive visual information about the exact character of these all-important rooms, a confident verdict will have to be postponed until the opening. But I do wonder whether the clerestory windows, rising so far above the gallery walls, might be somewhat oppressive. Despite the welcome amount of daylight they will provide, the gallery ceilings appear rather daunting and threaten to weigh rather heavily on the awareness of anyone enjoying the pictures beneath.

I warm to Venturi's desire to avoid the neutral flexibility of the archetypal modern museum, with its vast white anonymity. He has provided a sequence of relatively intimate rooms which promise to honour the modest size of most of the pictures. They could so easily be dwarfed by architectural gigantism, and Venturi is far too conscious of their needs to crush them with monumentality for its own sake. All the same, he will have to cater for paintings as substantial as Uccello's *Battle of San Romano*, and much will depend on the skill with which the rooms' differing sizes and heights are orchestrated.

The extension also contains temporary exhibition galleries in the basement, a well-equipped lecture theatre and, on the mezzanine floor, a restaurant overlooking Trafalgar Square. But the acid test will centre on Venturi's ability to provide Masaccio, Piero and Van Eyck with surroundings which enhance their work. His evident scrupulousness, coupled with the boldness manifested in the theatrical staircase, augurs well. Models and plans can be deceptive, though, and five years will

elapse before we can finally decide if his heartening respect for the past is allied with the capacity to shape a truly modern building worthy of the images it contains.

TWO NEW CONTEMPORARY GALLERIES
7 May 1987

At a time when philistine cuts are savagely affecting so many aspects of the visual arts, it is heartening to welcome two notable new galleries. They serve very different functions: one depends heavily on public funding, while the other marks the arrival of a young dealer aiming to promote the artists he admires. But both have established themselves in areas of London where exhibitions devoted to contemporary art are relatively hard to find. And for all their obvious differences, the two galleries are united by a clear commitment to supporting work which has not, hitherto, been granted the exposure it merits.

This may seem a surprising claim to make about Alison Wilding, who has been deservedly ranked among the most promising of younger British sculptors for some time. But the truth is that, apart from a rewarding show at the Serpentine Gallery some years ago, she has never enjoyed regular exposure in a British dealer's gallery. This unsatisfactory state of affairs is now rectified at Karsten Schubert Ltd., a splendid space which has just opened at 85 Charlotte Street. Half-a-dozen recent works by Wilding, some on an imposing scale, constitute the inaugural exhibition. They need congenial surroundings, and the two floors of this handsome white gallery provide them in good measure. Nothing is allowed to distract attention from the sculpture itself – not even the captions normally to be found on nearby walls. A handlist of the works is available for anyone who wants to find out their titles and materials. But the emphasis is placed firmly on art's ability to establish its own relationship with the viewer, unaided by explanatory props of any kind.

It has no difficulty in achieving this aim. Wilding is among the most directly sensuous sculptors of the new generation. Although her work appears at first to be abstract, it is filled with references to the visible world and to bodily experience. It also engages with the viewer in a very frank way, so that the first gallery is dominated by a dramatic form in galvanised steel which thrusts across the floor like an armoured vessel. Its

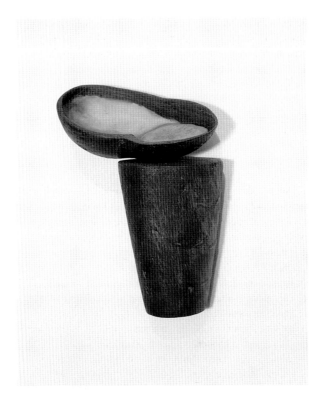

107. Alison Wilding, *Hemlock 3,* 1986, at the new Karsten Schubert gallery, London

sharp rectilinear harshness is, however, countered by the curving rhythms of a thin metal strip running beneath, and within the 'vessel' a large rounded lump of Cornish granite nestles comfortably. The opposition between this stone, speckled like an egg, and the severity of its container amounts to a classic Wilding confrontation. An organic image, culled from a natural site, is contrasted with the mechanistic starkness of the industrial world. Like everything she makes, the duality is explored with conciseness and precision. No redundant rhetoric mars the clarity which Wilding deploys, and in a smaller piece called *Her Furnace* an erotic intensity informs the shaping of the funnel with its inviting aperture.

This sculpture brings together copper and brass, but elsewhere in the show an unpredictable variety of other materials are employed. Lime and

hemlock are combined with lead, beeswax and pigment in a small yet memorable wall-sculpture, pregnant with sinister implications. And upstairs, a commanding work called *Slow Core* juxtaposes a thin sheet of rubber spreading stealthily over the floor with erect, tensile forms in leaded steel and phosphor bronze. On the evidence of this show, Wilding is developing into a sculptor of poise and maturity. No more propitious event for the opening of Karsten Schubert's beautiful gallery could be imagined.

A little further east, in an area of the city even less populated by modern galleries, the cause of Indian art is now being vigorously espoused. With the help of funds provided by the London Boroughs Grant Scheme, the enterprising Horizon Gallery has converted premises at 70 Marchmont Street into an inviting and ample showplace for contemporary work. An increasing amount of lip-service is being paid to the importance of supporting the art produced by 'ethnic minorities' nowadays, but it has not led to a notable growth in the representation of their work in London exhibitions. The Horizon Gallery is dedicated to rectifying this imbalance, and the shows organised there since its opening in January have proved that a plentiful supply of substantial Indian-born artists are based in Britain.

Some, like Sohail, are far better-known abroad than they are here. His show, which preceded the current exhibition, consisted largely of small drawings reminiscent in their size of Indian miniatures. Their tendency to crowd the composition with a plethora of incidents also recalled the miniature tradition, but Sohail was clearly aware of a whole host of Western artists as well. Many of his most powerful images concentrated on war-like themes, handled with a sense of horror and disgust that suggested a kinship with Goya and Dix. But such influences were subsumed in a way of working which still adhered to an eastern aesthetic, and the fascination of his work lay in an ability to arrive at a synthesis of these diverse sources.

A similar fusion can be found in the work of Avinash Chandra, a more familiar artist who once enjoyed considerable success in London. During the early 1960s, this Simla-born painter exhibited very extensively throughout Britain, and examples of his work can be found in many of our public collections. Over the past twenty years, by contrast, Chandra has shown his art less frequently. But he is still hard at work, and the walls of the Horizon testify to the fertility of his inventiveness over the past year. As Amal Ghosh points out in a catalogue foreword, Chandra's vision has altered since those heady days of early success. The sensual exuberance so evident in his 1960s period no longer lends the work an over-

whelming air of dynamism, and the headlong quality which gave his youthful pictures their vitality has been replaced by a more mellow mood.

An awareness of transience is now more noticeable, especially in the oil paintings where Chandra often invests his images with a new sense of harshness and strain. The idyllic paintings he once rejoiced in producing seem threatened, invaded by a feeling of foreboding and even imminent destruction. The world has become more vulnerable in recent decades, and Chandra's advancing age also makes him increasingly conscious of the possibility that the formerly impregnable paradise may one day be lost.

For the moment, however, he still remains as close as possible to the source of his earlier ecstasy. The most satisfying works are on the whole executed in watercolour, where Chandra feels less obliged to battle with his medium. He handles wash with instinctive ease, and achieves serenity in many of the smaller pictures where naked figures enjoy a mystical union with the forms of trees, birds and flowers. Although it is an uneven exhibition, revealing evidence of uncertainty and awkwardness, I warmed to Chandra's determination to develop a new means of expression which prevents him from resting content with a reiteration of former achievements. He is on the move, struggling to encompass his altered perceptions, and the Horizon Gallery has enabled him to show the full extent of his continuing activity.

THE NEED FOR CHANGE AT THE TATE
17 December 1987

While I applaud the Tate Trustees' discernment in appointing Nick Serota to their gallery's directorship, my pleasure is marred by the belief that they have also lost a great opportunity. For the impending retirement of Alan Bowness presented them with a marvellous chance to end, once and for all, the ridiculous schizophrenia of the institution in their charge. The Tate should no longer be expected to perform two irreconcilable roles in a single building. Every major Western city which cares about its cultural vitality now has a fully fledged museum devoted to modern art. They would never dream, in Paris or New York, of squeezing a twentieth-century collection into a building properly intended to house a historical survey of

108. Nicholas Serota when appointed Director of the Tate
Gallery, London

the nation's paintings. But the beleaguered Tate is expected to do just that,
displaying the entire gamut of British art from Tudor times to Tony Cragg
and, at the same time, telling the international story of modern art. It is a
nonsense that reflects very damagingly on our national attitude towards
contemporary work. If we cared as much about the vitality of the present
as we do about the sanctity of the past, an independent modern art muse-
um would have been created in London decades ago. Instead, the Millbank
Muddle has been allowed to blunder on indefinitely.

Occasional efforts are made to build an extension to the old building,
as if the addition of a few more rooms might somehow extricate everyone

from the folly. But it merely makes the confusion greater and more indigestible than ever. The Tate's fatuous dual role penalises both sides of the collection, too. On the one hand, it does not have the space to put on view the full excellence of its holdings in twentieth-century British art. On the other, its need to devote half the building to Hogarth, Blake, Constable and the rest militates against its ability to be wholehearted in its support of modern work. At the moment, for instance, the Tate's principal exhibition space is given over to a scholarly and rewarding survey of painting in the age of Hogarth. By fulfilling its responsibilities towards the historic British collection in this grand and comprehensive way, it is prevented from staging in the same period a major show devoted to a more contemporary subject.

Both sides of the collection suffer from this absurd state of affairs, but the modern half is penalised more severely in the end. Whatever the deficiencies of the building which James Stirling designed for the Turner bequest, it does at least allow this great array of work to be fully displayed at last. When the Turner Gallery was opened in the spring, our scandalous national failure to honour the terms of his will was finally rectified. But it did little to ease the difficulties afflicting the more contemporary aspect of the Tate's function. Many years will elapse before the buildings Stirling has designed for the land behind the Turner wing are erected. The colossal funds they require have not yet been raised, and in the meantime an unacceptably high proportion of the Tate's modern holdings are consigned to permanent storage. Worse still, it cannot afford to purchase twentieth-century work on a scale which would enable the collection to represent the history of modern art more fully.

Alan Bowness deserves to be warmly congratulated for his achievement in securing important canvases by de Chirico, Ernst, Picabia, Beckmann, Léger and Picasso during his directorship. But each one of these vital acquisitions involved the Tate in a desperate struggle to raise the necessary funds, and its responsibility towards the historic British collection made the problem far worse. Not long ago, Bowness succeeded in purchasing a major Constable, of a kind not previously represented at Millbank. It must, nevertheless, have prevented him from acquiring modern works he would dearly have liked to purchase. The decisions he had to make during his directorship were doubtless agonizing, and his tally of impressive acquisitions does him great credit. But now that the cost of top-class twentieth-century work is increasing so dramatically, the Tate's hopes of rounding out its uneven representation of the early decades is dwindling all the time.

There is only one honourable solution to this dilemma, and the Trustees could have taken steps to attain it this year. Instead of simply

advertising for a successor to Bowness, they ought to have declared that the Tate should henceforth be split in two. The historic British collection could thereby be given its own director, purchase grant and exhibition programme. As for the other half, it would be able to become a full-blown Museum of Modern Art at last, devoting all its energy and resources to the work produced during the present century alone. Such a task is big enough for any single gallery to cope with, after all; and without the historic British collection, the new museum would be better able to fulfil that aim.

The muddle has been allowed to remain, however. Nick Serota naturally wants to continue the intelligent and imaginative exploration of twentieth-century work he has pursued with such flair at the Whitechapel. But he will find himself hampered by the need to look after Gainsborough as well as George Grosz. Is it fair to shackle him with so unwieldy a task? Are we really prepared to go on cramming modern art into a chronically congested building which should, by rights, have been given over entirely to the history of British painting a long time ago? Having been given the directorship of both collections, Serota can hardly be expected voluntarily to divest himself of half his new job — even if the Trustees would allow such a move. But they should, at the very least, recognise the problem more clearly than they appear to do at present.

Their next director is admirably equipped to give this country a national museum with a vigorous, quick-witted commitment to the momentum of art now. It would be a tragedy if Serota were prevented from fulfilling that role as completely as he could. Since the Trustees will want to give him all the support he needs in his new task, they must address themselves to the whole question of the Tate's overloaded function with the utmost urgency. Sooner or later, a radical rationalization will have to be initiated at Millbank. It has been postponed far too long already, and the advent of a new director means that the whole complex process should now be given maximum priority. If 1987 was the year of the lost opportunity, 1988 might still inaugurate a new beginning for everyone who cares about the future of contemporary art in this country.

THE TATE OF THE NORTH

2 June 1988

It was, above all, a brave initiative. At a time of severe financial hardship at Millbank, where a philistine government is starving it of money, the Tate had every reason to back out of expansion in the north. Future funding of the new Liverpool building still looks uncertain, but the astonishing fact remains that the venture has succeeded. Jesse Hartley's magnificent Victorian warehouses in Albert Dock now boast galleries that double the space available for the Tate's modern collection. Chronic space problems at Millbank, where 85 per cent of the holdings are in storage, have been eased. And Liverpool has gained the first English gallery to be devoted entirely to modern art. A mighty blow has been struck in the cause of decentralization, neatly reversing the geographical bias established by Sir Henry Tate himself. Although his wealth came from the Liverpool sugar trade, he insisted that London should be the site of the gallery bearing his name. So it now seems doubly appropriate that the Tate's Liverpool base should be located in the very dockland area where Sir Henry's imported sugar was once unloaded – to be stored in the building which houses Picasso and Magritte today.

Not that Liverpool was devoid of modern art before. The Moores family has sponsored a celebrated series of contemporary exhibitions there for many years, and the city's handsome Walker Art Gallery possesses a small yet choice collection of twentieth-century art. Until now, though, the emphasis has been British rather than international. Richard Francis, the curator of the Liverpool Tate, is rightly determined to take a world view. Hence the decision to inaugurate the building, not with Moore or Bacon, but Surrealism and Mark Rothko. Millbank has a strong collection of surrealist art, and many of the choicest paintings are now on view at Albert Dock. Protected by a fireproof warehouse so solid that it survived savage Luftwaffe blitzing intact, the Dalís and Mirós now exert their dreamlike authority in the main ground-floor gallery. Showcases of surrealist literature complement the pictures, which include several of the Tate's most important twentieth-century canvases: de Chirico's erotic yet melancholy *The Uncertainty of the Poet*, Ernst's obsessive Freudian *Pietà* and, supremely, Picasso's frenzied masterpiece *The Three Dancers*.

They alone would make a visit to the gallery worthwhile, but the Tate of the North has also mounted a fascinating reconstruction of the murals Rothko painted for the Seagram Building in New York. Among Mies van der Rohe's most successful works, the Seagram contains the Four Seasons

Restaurant where Rothko's vast paintings were originally meant to hang. But he turned against the project, partly because of reservations about the space and partly, it seems, because the moneyed, exclusive ambience ultimately felt wrong for his work. So a group of the Seagram pictures ended up as a gift from the artist to the Tate, and they have now been supplemented by loans which provide a comprehensive notion of the original restaurant scheme. Although the columns in this room punctuate the view too insistently, the space is of the same proportions as the Four Seasons setting. How strange they would have appeared there, with their sonorous, deep colours, stern architectural forms and refusal to ingratiate themselves in any way! Grand and smouldering, the individual paintings can be seen more clearly here than at Millbank, where the light is always very subdued in the Rothko room. This clarity also prevails throughout the surrealist gallery at Liverpool, revealing the pitted and reworked surface of Miró's jaunty *Maternity* as if for the very first time.

Upstairs, where the ceiling level is much lower, I became uncomfortably aware of the large air-conditioning and electricity ducts running the length of each room. The architect responsible for the conversion, James Stirling, has made no attempt to hide these gleaming structures. They are a distracting presence, and might become overbearing if the work on display beneath them failed to sustain interest. Fortunately, though, the survey of British sculpture over the past twenty years turns out to be both lively and engaging. Its title, *Starlit Waters*, is taken from an exhibit by Ian Hamilton Finlay, who was a questioning and innovative force in the 1960s. Along with John Latham and Barry Flanagan, he provides a starting-point for a period of great energy and inventiveness in our sculpture. The sustained involvement with landscape, exemplified at its most powerful by Richard Long, gave way during the 1980s to a renewed exploration of urban themes by Tony Cragg and Bill Woodrow. But the human figure plays an important, often very poetic role as well in the work of artists as various as Richard Deacon, Alison Wilding, Antony Gormley and Anish Kapoor. The range of individual vision and choice of materials is as impressive as the consistent quality, and it seems right for the Tate to kick off its northern adventure with a celebration of this vitality.

About Stirling's conversion I have considerable reservations. As in his disappointing Turner Gallery at Millbank, he displays a weakness for brash and irritating colour-schemes. The orange and blue combination on the Liverpool façade is merely garish, and the swollen forms of the mezzanine floor have a disruptive effect on the foyer within. Luckily, however, he respects the building enough to be discreet in his alterations

109. Exterior of Tate Liverpool

elsewhere. Having provided the gallery with an ample service core, which rises between the two principal sections of the old warehouse, Stirling has tried to retain as much of Hartley's design as possible. Brought up in Liverpool himself, and educated at the local School of Architecture, Stirling retains warm memories of Albert Dock when it was still at the centre of a crowded working port. So he has allowed the sturdy old building to stand essentially as it must have done in 1846, when the complete majestic sequence of five-storey blocks was unveiled.

Walking round them, and admiring the epic scale of a development

which encloses a stretch of water as large as Trafalgar Square, I marvelled at the survival of this prodigious spectacle. While so much of Victorian Liverpool was laid waste by crass 'urban renewal' schemes in the 1960s, Hartley's *tour de force* remained derelict yet defiant. However glamorous its water frontage may now become, with shops, pubs and restaurants touting for the tourist trade, the architecture itself is robust enough to withstand gentrification with its dignity intact. The weekend crowds who already frequent it, and give the neighbouring Maritime Museum such healthy attendance figures, have encouraged the Tate staff to aim at attracting half a million visitors a year. They may exceed their target, for a trip to Albert Dock is an exhilarating experience. I only hope that the government, as well as paying lip-service to the importance of inner-city replenishment, remembers to provide this courageous venture with the funding it deserves.

THE RENOVATED NATIONAL GALLERIES OF SCOTLAND
1 September 1988

Surprisingly enough, the Edinburgh Festival exhibitions are overshadowed this year by dramatic display changes in the city's major galleries. Timothy Clifford, the flamboyant Director of the National Galleries of Scotland, has now unveiled his transformation of William Henry Playfair's great Victorian interior on the Mound. Although Clifford aimed at restoring the building to its original magnificence, the outcome is bound to provoke controversy among the National Gallery's many admirers.

The most positive aspect of the new look lies in its unabashed splendour. After years of dowdiness, all too familiar to anyone who frequents Britain's municipal museums, Clifford has displayed his faith in the collection by presenting it with bullish conviction. All the walls in the main sequence of rooms are now swathed in maroon, and an abundance of furniture has been added to banish the former austerity. Even more significantly, the large Corinthian columns introduced in the late 1930s have been swept away, so that Playfair's far more open series of archways now prevail once more. Clifford's structural alterations deserve unqualified praise, for they give the gallery an enormous increase in spaciousness. Each grand avenue of rooms is bound together, with a unity that allows

110. One of the redecorated rooms at the National Gallery of Scotland, Edinburgh

uninterrupted vistas of distant canvases. The deep red wall-covering is clearly intended to have the same harmonizing effect.

But the sheer richness of its colour is overpowering, and after a while the eye needs relief from this all-enveloping maroon environment. I have doubts about some aspects of the rehanging, too. In the very first ground-floor room, Titian's exquisite early masterpiece *The Three Ages of Man* now hangs opposite the entrance. But instead of giving it the entire wall, Clifford has added a garish and undistinguished painting of the early Netherlandish school directly above. It conflicts abominably with Titian's sensuous colour-harmonies, and I cannot imagine why such a clash has been allowed to occur.

Not all the rooms suffer from such baffling tactics. Titian's great later canvases, still mercifully on loan from the Duke of Sutherland along with much else in the collection, are given plenty of space to themselves. And Van Dyck's enormous *Lomellini Family* has at last been given the prominence it deserves. The finest complete space is found in Room 5, leading off the

principal galleries, where Poussin's *Seven Sacraments* preside in a setting which looks as if it were created specifically for them. With a new marble floor and banquette seat echoing similar elements in the canvases, the room offers an ideal means of contemplating Poussin's awesome and highly demanding images.

Elsewhere, though, Clifford has let his instinctive ebullience run away with him. The worst room, devoted to eighteenth- and early nineteenth-century paintings, is congested to a fault. Tiepolo's beguiling *Moses saved from the Waters* now finds itself hemmed in by other, far less admirable canvases. As for Lawrence's *Lady Robert Manners*, one of his most incisive and brilliantly painted portraits, it has been consigned to a place so high on the wall that his vivacious handling of pigment can be savoured no longer. It seems inexplicable that Clifford can inflict such a fate on this bravura picture while lavishing a key position on Benjamin West's colossal, ridiculously overblown painting of Alexander III saved from a stag. Reigning over the final room, it is given a prominence out of all proportion to its aesthetic merit.

The other major Edinburgh galleries seem restrained in comparison with Clifford's fireworks on the Mound. But Richard Calvocoressi, the new Keeper of the Scottish National Gallery of Modern Art, has now completed a rehang of his collection, too. He favours giving each picture the maximum amount of space to breathe in, and the outcome is very welcome. Epstein's formidable carving *Consummatum Est* has been liberated from its confining crypt, so that its full volumetric power is at last given free rein.

A similar hanging policy prevails in the first room of Calvocoressi's Picabia exhibition, now inhabiting part of the Royal Scottish Academy's splendid premises. Two vast early paintings dominate the space, both on loan from the Museum of Modern Art in New York. They show how the youthful Picabia established himself, before the First World War, as a formidably skilful and intelligent member of the Parisian avant-garde. He shared Duchamp's interest in combining organic and machine images, often to highly satirical effect. His deeply subversive outlook inevitably led to an involvement with Dada, and during the 1920s he continued to flout pictorial conventions with wit, resourcefulness and flair. One of his most engaging post-war pictures uses a delirious combination of feathers, noodles, canes and corn plasters to evoke a playful mediterranean landscape.

So Picabia continued for the rest of his life – superimposing one deliberately crude style on another idiom, borrowing the banalities of movie posters at their most garish, and finally arriving at a spare language where dots of colour float on heavily worked dark grounds.

The connections between many of the strategies he dared to deploy in his later years, and the work of young painters today, are striking enough. Calvocoressi is right to argue that Picabia has been underestimated, and this retrospective is well timed. But I feel that Picabia's insistence on continually breaking all the rules suffered, in the end, from the law of diminishing returns. The early work retains its superiority, and I missed the herculean ambition of the pre-First World War Picabia in his increasingly hectic, brash attempt to stave off the boredom of conventionality.

While our understanding of twentieth-century art is continually being revised, so too is the history of nineteenth-century photography. At the Scottish National Portrait Gallery, a fascinating show reveals the hitherto unknown work of John Muir Wood. By profession a pianist, teacher and musicologist, this modest Victorian regarded photography as an amateur activity. But his work with the camera, which was recently discovered and presented to the gallery by his descendants, establishes him as an accomplished, intelligent and often lyrical pioneer in the field. The finest photographs include a limpid 1847 view of Namur; an awed self-portrait of Muir Wood crouched in a top hat beside the rock columns at Staffa; and a mysterious woodland study which explores the delicate tracery of tangled branches rather than a conventional picturesque view.

By a happy coincidence, his woodland scenes resemble the recent photographic work of Thomas Joshua Cooper, now on show at the Graeme Murray Gallery. These dark, brooding panoramas of 'northern lands and islands' share Muir Wood's rapt response to the shadowy recesses of a landscape. Obsessed with an elemental interplay between rocks, waterfalls and foliage, Cooper's deeply romantic work has a dream-like sense of wonder which lingers in the imagination long after the exhibition has been left behind.

CANADA'S NEW NATIONAL GALLERY
22 September 1988

Wherever I went in Canada's capital city, an epidemic of museum-building seemed to be breaking out. Just a few steps away from the sedate turn-of-the-century architecture of Parliament Hill, a prominent notice proudly announces the site of a new gallery devoted to contemporary photography. It will open soon, like the vast double structure so clearly

visible from the bluff where the parliament buildings preside. Far below, down by the edge of the River Ottawa, the streamlined curves of the new Museum of Man promise an endlessly undulating experience for the first visitors next year. It looks even more lavish than the immense Museum of Science and Technology a few miles away, where crowds regularly gather round exhibits as dramatic as the rocket which launched John Glenn on his historic orbital mission. Ottawa, echoing the largesse of the American governments that funded the space programme during the 1960s, clearly is not afraid of blowing its dollars on showpiece, pub-licity-generating projects.

The latest museum to open in this big-thinking metropolis is the new National Gallery of Canada. Occupying an epic location across the water from the Museum of Man, Moshe Safdie's low-lying L-shaped building rises to a climax on the river frontage. There, on a corner offering panoramic views of Parliament Hill above, an octagonal Great Hall rises up in a great crown of glass vaulting. It deliberately mirrors the finest part of the parliament complex – the nineteenth-century Library, mirac-ulously saved from the fire that gutted everything around it in 1916. For Safdie respects his historic surroundings, while deploying the forms and materials of the late twentieth century. His entrance pavilion on Sussex Drive honours the presence of the limestone Roman Catholic Basilica, built over the road in 1841. He even salutes the bay windows of the less architecturally distinguished War Museum, whose crenellated bulk sits next door to his building.

An excessive awareness of the past might have resulted in a timid and eclectic National Gallery, all post-modernist quotation and no robust iden-tity of its own. But Safdie has given his £81 million building a definable character as well. Aided by a budget that encouraged him to think in terms of imposing public spaces, he introduces light, airy grandeur from the out-set. Since the entrance pavilion contains nothing except an information desk at its centre, its vaulted immensity is dedicated to the well-being of visitors alone. There is ample room to breathe in this high, sound-proofed chamber. It invites us to pause, and take stock of the city laid out for our inspection through the glass walls. No art works are permitted to disturb the architectural equilibrium, and the same austerity is carried into the long ramped colonnade which leads us towards the museum's collections. This tall, narrow walkway, devoid of distracting signs and images, exists solely to promote the pleasures of perambulation. It acts as a pace-slower, insisting that we adopt a more contemplative attitude to our surroundings.

Museum-visiting needs this kind of induction, and Safdie rewards us before the galleries are reached in the swelling polyphony of his Great

111. The new National Gallery of Canada, Ottawa, designed by Moshe Safdie

Hall. Spectacular from the outside, especially at night when it blazes in the dark sky, the 140-feet-high structure opens out to the world beyond. But it also serves as a gathering-point, allowing people to congregate for a drink or an informal concert. Although the Great Hall leads off into the Special Exhibitions Galleries, where the travelling Degas retrospective was held this summer, works of art are once again banished from view. Nothing, likewise, is displayed on the towering walls of the avenue leading to the Octagon, where the collections effectively commence. Safdie's expanses of rose granite remain bare, unaffected by any curatorial desire to festoon them with extra-large canvases that cannot be accommodated elsewhere.

Like most big public art collections, the National Gallery is unable to exhibit everything it owns. I saw some monumental First World War paintings in an Ottawa store which would, without doubt, look very impressive if space were found for them on the gallery's walls. But the display policy, especially in the rooms devoted to contemporary work,

favours spacious hanging. One especially vast interior contains only three or four works, including a jumbo-size Don Judd 'box' sculpture and an unusual free-standing Pollock executed on glass.

In the section given over to Renaissance paintings, though, this policy looked as if it were dictated by shortcomings in the gallery's holdings. The quattrocento is particularly weak, hampered no doubt by the fact that no significant Italian acquisitions were made during the nineteenth century. After the National Gallery was founded in 1880, its collecting activities remained low-key until Eric Brown was appointed the first full-time curator thirty years later. Shortage of purchase funds and other vicissitudes meant that the gallery waited until the 1950s before making a truly outstanding acquisitions *coup* – major paintings from the Prince of Liechtenstein's collection. They included a sinuous Simone Martini, a resplendent early Rembrandt and two consummate interiors by Chardin, all of which remain among the highlights of the museum today.

The Chardins are hung in one of the smaller, narrower rooms located off the main galleries. While these surroundings suit paintings of modest dimensions, they are easily missed by anyone traversing the principal sequence. The courtyards they give on to are among the building's delights, containing water, flowers and trees in sensitive designs. But the confusion between major and minor spaces remains an irritant. It is all too easy to walk straight past the pictures from the important Massey gift: early twentieth-century British works, which encompass one of Sickert's finest music-hall interiors, an incisive Spencer self-portrait and a glowing late Nash vision of the summer solstice.

On the whole, though, Safdie's galleries are high, wide and luminous enough to enhance the works they contain. The historical development of Canadian art is surveyed with appropriate richness – most notably the achievements of the Group of Seven, who did so much to define an indigenous sense of landscape. By far the most dramatic installation is reserved for the careful reconstruction of an entire nineteenth-century interior: the Rideau Street Convent Chapel, designed in 1887 by diocesan architect Canon Georges Bouillon. Saved from destruction after a vigorous campaign in 1972, the chapel's cast-iron columns, altars and stained-glass windows were all dismantled, kept in storage and then triumphantly resurrected in the new National Gallery. The mushrooming polychromatic fan-vaults give the chapel an extraordinary impact, even if the absence of pews makes the reconstruction seem faintly unreal. The saving of the chapel amounts to a remarkable act of faith, just as the five-year planning and erection of Safdie's building testifies to a spirit of cultural enterprise which Britain would do well to emulate.

BEYOND THE GALLERY

ART INTO LANDSCAPE

2 April 1980

It would be all too easy to compile a shameful catalogue of the bungled opportunities, unnecessary blight, cynical exploitation and bureaucratic stupidity which have disfigured the cityscape around us. But the scale of this abuse has now reached such uncontrollable proportions that it is altogether more difficult to decide how the wasteland laughably described as our 'environment' can be humanised once again. The worst atrocities are often committed for the best conceivable reasons – a paradox that proves, in itself, the extent of the malaise. Sterile civic precincts are usually the bastard offspring of well-intentioned planners, sincere in their desire to change our surroundings for the better but ignorant about how it might be done. We have long since lost sight of the particular attitudes and skills needed to create places genuinely fit for human habitation. So anyone attempting to redress the balance must accept that it will be many years before convincing ways are found of revitalizing our neighbourhoods.

The size of the problems involved is posed in a very acute form throughout *Art Into Landscape 3* at the Serpentine Gallery. Six years ago the Arts Council launched the first of these enterprising competitions and exhibitions, which encourage land-owning bodies to designate a site and then invite improvement proposals from members of the public, irrespective of their age or professional status. It has been a hard struggle establishing the scheme, but Sue Grayson courageously declares in the catalogue of this third instalment that the original aim is still being pursued: 'to offer people from all walks of life the possibility of improving their surroundings, of suggesting ways in which under-used public spaces could be enlivened to benefit the community'.

The ambition can only be applauded, and Ms Grayson reports with some pride on various projects from the earlier *Art into Landscape* shows which are now being implemented. Genevieve Glatt's glowering prehistoric monster has been installed in her dinosaur playground at Middlesbrough, where its horns bristle among the cranes and cooling towers of Teesside. At this very moment the GLC is moving on to a Rotherhithe location to commence Thomas Medding's overall 1977 prizewinner, an intricate and fanciful 'Brobdingnagian Knot Garden'. And over at Ware, one of those desolate roundabouts which continue to spread like ringworm across the British road system is being transformed by a 'grass weir' of trees and plants devised by Margaret Hogg and Tom Turner.

Although these emergent signs of activity are undeniably heartening, their significance remains minuscule in a national context. The poster announcing the current competition may have boldly offered '*your chance to enliven public spaces nationwide!*' But the fact remains that only eight sites from the whole of England, Scotland and Wales are put forward in the latest exhibition, and there is no guarantee that any of the proposals submitted will ever be realised. A venture like this needs to multiply the number of locations many times over before it can achieve any real impact on the way we live today. Substantial change will hardly be effected even if work is carried out on all the sites displayed at the Serpentine, and the Arts Council has no plans to enlarge the scheme in the foreseeable future.

It is an enormous pity, because the variety of projects encompassed by *Art Into Landscape 3* indicates how many kinds of setting could be tackled by a more comprehensive initiative. The requirements of a car park at Craigforth are sharply at odds with the challenge presented by a disused stretch of South Kensington tube station. Radically different approaches are called for to bring about the imaginative transformation of a harbour front at Irvine and an Ebbw Vale tip. Does anyone yet possess the ability to do justice either to these sites or to the other four, which range from a bankside on the Tyne estuary and a pier at Widnes to some land overlooking Regent's Canal and an earthwork ridge in Milton Keynes? All these locations should, in theory, stimulate solutions as ambitious as they are inventive, helping to inaugurate a widespread resurgence of interest in art's effectiveness throughout the public domain. But judging by the poor level of entries to the Serpentine competition, we still urgently need to foster a climate of thought which would encourage a better response.

One sensible move might be to rephrase the invariably daunting design briefs. Believe it or not, Halton Borough Council suggested as its theme for the Widnes scheme 'an expression of the significant role the area played in the industrial revolution by introducing innovatory chemical manufacturing techniques, and the heritage of dereliction and despoilation left to later generations'. How on earth would any artist or designer respond to such an indigestible notion? The answer, not surprisingly, is that most of the Widnes entries have retreated into frivolity or nostalgia. The prizewinner proposes to erect a giant rugby ball on the derelict pier, daring passers-by to kick it across the Mersey. And the runner-up wants to immortalise in a large-scale group sculpture the Ramsbottoms – that tiresome northern family whose rash son Albert was swallowed by a lion at the zoo.

The entire exhibition is filled with similar examples of our national weakness for whimsy, proving that more subtle or profound attitudes have little place in our notions of the form public art might take. In the so-called Open Category, where competitors are free to choose any setting they wish, one deranged wit suggests that the green at Shepherds Bush should be filled with an exact replica of Stonehenge. And another comedian would like to daub the whole façade of the National Theatre in a lurid combination of red, yellow and blue. Predictable monsters proliferate everywhere, from an earth serpent wriggling its way across Milton Keynes to some muppet-like fibreglass creatures (each one sporting a single Cyclopean eye and a row of jagged fangs) which would pulsate with light on South Kensington station and doubtless make unsuspecting travellers die of fright.

Whether consciously or not, a shallow desire to shock, titillate and amaze becomes the norm in much of the show. It is no substitute for the deeper and more lasting satisfactions which *Art Into Landscape* ought to afford. First prize at Milton Keynes was awarded to the proposal that a helium-filled cumulus nicknamed Cloud 9 be suspended in the sky to show approaching drivers where the city centre is situated. And as if the sight of such an object would not be enough to cause a pile-up, the entry also stipulates that Cloud 9 'would herald its heavenly position' at 9 a.m. and 9 p.m. with a roll of thunder and a green flash.

Elsewhere in the exhibition beleaguered motorists run into more trouble with an appalling project to resurface motorways so that tyre noise can be translated into Top Ten tunes, country sounds like mooing cows, and advertising jingles. Should you persist against all these odds in keeping the car on the road and reaching your destination, another contestant proposes blocking off access to a pedestrianised shopping area with a huge rockpile. 'In order to increase awareness of consumer manipulation, a hindrance has been constructed', explains the designer, seemingly unaware that most people would regard a mountain placed between them and their local shops as the most unacceptable manipulation of all.

Far too many of the entries adopt comparably facile attitudes. They seek to impose exotic and inappropriate ideas rather than taking their cue from a sensitive attention to the potential of a given context. One contender for the Ebbw Vale brief maintained that 'every artist must at some time dream of driving a bulldozer', and the desire to bludgeon all eight sites with heavy-handed follies was detectable wherever I looked. It came as a great relief to find that the first prize at Ebbw Vale went to an exceptionally sympathetic plan by David Hamilton, whose 'Welsh Fable' would change an industrial eyesore into 'a valued romantic landscape'. Hamilton's idea

112. David Hamilton, *'Welsh Fable', Victoria Tip, Ebbw Vale*, 1980

centres on asking the local population to invent a history for their site, and then construct the kind of artefacts which might be found on an earthwork rich in ancient associations. The artefacts would then be placed all over the tip, quietly transforming it into what Hamilton claims will be a place 'surrounded by myth, mystery, custom and property'.

'Welsh Fable' is one of the few proposals to entertain both the possibility and the desirability of collaborating with the people who would actually have to live with it. And in that respect Hamilton's thoughtfulness exposes the superficiality and presumption marring most of the entries. Their failings are symptomatic of a society unaccustomed to thinking in a positive way about changing its environment. That is why

the Arts Council's brave but inadequate scheme must be expanded forth-with, especially in co-operation with schools and art colleges, so that artists of the future learn how best to take their work out of the studio and into the world beyond.

CHARLES SIMONDS AND PIER + OCEAN
28 May 1980

Just off Camden High Street, in one of those alleys where London suddenly becomes ramshackle and overgrown, Charles Simonds has just built a clay dwelling. Nestling into the corner of a broken-down wall, and perched on a mound only inches high, it looks like the remnant of an older civilization still – astonishingly – surviving in a modern metropolis. But only just. Some tiny bricks scattered near this rudimentary building suggest that other structures have already fallen down. And the dwelling which remains is itself rickety enough to collapse under the slightest blow.

When it is destroyed, though, Simonds will ensure that the so-called Little People whom he imagines inhabiting his houses reappear in another city. For the past ten years this American artist has been erecting similar fragments of alternative societies, often in the streets of New York. Fragile and yet persistent, they crumble into ruins only to emerge elsewhere in a slightly different form. They are nomads wandering through an alien environment, obstinate reminders of a time when humans had a more direct relationship with the earth.

I do not know whether Simonds intends them as a direct criticism of urban life in the West today, where technology removes us from a first-hand understanding of nature while the need to acquire property confines our movements within rigid, separate boxes. He has himself admitted that the Little People can be related to the American Indians, so in one sense Simonds obviously wants them to remind us of races whose ways of life differ from our own. But the meaning of his work should not be pinned down too literally. At Camden Town the miniature dwelling resists straightforward interpretation, relying first and foremost on an element of surprise.

A decayed wall, bordering on a stretch of weed-infested wasteland owned by a car-park company, would scarcely be expected to harbour

anything other than rubbish and insects. It seems ripe for demolition, and yet this house of clay has been built up, brick by painstaking brick, among all the detritus. In order to be seen clearly the miniature habitation demands a close viewing, which makes us forget the scale of the city around us and enter a different world. Simonds is sufficiently precise to provide a convincing illusion of a settlement, and it triggers the realization that an equally primitive building might well be revealed by an archeological dig on the same spot.

After a few moments the illusion passes, and we revert to the present-day reality of the city. But by making his minute addition to its fabric, Simonds stresses that modern London is merely the latest, and by no means the most desirable, stage in a long history of different Londons – the earliest of which may have harboured attitudes worth regaining now. The vulnerability of his dwelling also implies that we might be forced to regain them sooner than we think, at a time when survivors of a world war could swiftly find themselves reduced to the conditions endured by his Little People.

Simonds' ability to provoke such thoughts depends a great deal on the contrast he establishes between his work and the location it occupies. He has been creating another street habitation this month in the East End as well, but his principal reason for visiting London was to participate in a major exhibition at the Hayward Gallery. The clay houses he is showing

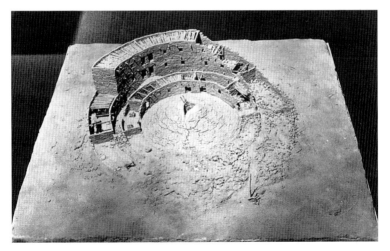

113. Charles Simonds, *People Who Live In a Circle*, 1976, at the Hayward Gallery, London

there are far more elaborate than the outdoor works, and the immense skill with which they have been crafted is admirably clear. Even so, they look sadly marooned at the Hayward without the street context to bring out their widest range of meanings. And their status as sculpture, on display in a gallery filled with exhibits by other artists, prevents them from enjoying the informal relationship found at Camden, where passers-by do not have to ask themselves whether his building is a work of art. It remains free to strike up contact with people on its own terms, whereas visitors entering the Hayward know that they are passing into a temple of High Culture and adjust their expectations accordingly.

The irony here is that the Hayward exhibition actually takes, as its starting-point, the desire to achieve a more 'open space' for artists. In his catalogue introduction, Gerhard von Graevenitz describes how art in the 1960s 'operated largely in the triangle bounded by studio, gallery and museum'. He goes on to declare that 'it was only at the end of the '60s that there were deliberate attempts to break through the frame, open up the space beyond, and push back the frontiers'. Hence the title of his exhibition, *Pier + Ocean*, which borrows the name of a famous Mondrian to show how 'the space of '70s art is an open space, to which the individual artwork relates as the pier does to the ocean'.

But *how* open? Over fifty artists are included here, and their use of everything from video to crates of stones, printed statements to beds of metal spikes, and stamped envelopes to fallen leaves, proves that artists can now employ anything they wish in their work. They treat space with great freedom, too, splashing lead along the bottom of a wall, placing drawings in chests of drawers, suspending a 'floating room' from the ceiling, and piling sacks in a corner. The fact remains, though, that all this liberated activity still takes place within 'the triangle bounded by studio, gallery and museum'. The supposed openness celebrated here ends up looking curiously enclosed, as if artists had claimed every freedom for themselves except the ability to act in social spaces outside the gallery.

There was hardly a visitor in sight when I went to the Hayward, and many of the exhibitors seemed trapped rather than released, condemned to repeat work they first made over a decade ago when 'pushing back the frontiers' was proposed as a real hope. Now it has receded. Simonds is the one participating artist to extend his activities further than the Hayward, but the smallness and vulnerability of his Camden street-work only emphasises the difficulties confronting any artist who still wants to 'open up the space beyond'.

ART UNDERGROUND
7 August 1980

Dilapidated, murky and often miserably depressing, most of London's tube interiors are a visual disgrace. Regular Underground travellers have long since resigned themselves to suffering their gruesome surroundings without protest. But visitors from cities as diverse as Paris and Moscow, where the tube stations are superbly decorated, must be appalled by the makeshift appearance of our escalators, corridors and platforms. The general air of decay seems perversely close to a deliberate policy, reminding people that they are penetrating a region of the earth notable only for its dank, claustrophobic gloom. If you have ever wondered what Hades looked like, descend into the lower depths of a typical London tube and find out. It is an abode fit only for spirits of the dead, and to condemn the living to such surroundings shows a callous disregard for human needs.

It also betrays the spirit of enlightened patronage pursued by Frank Pick, London Transport's Vice-Chairman half a century ago. Committed to good design as a guiding principle, he ensured that the exteriors of the stations built by Charles Holden remain striking examples of their period. But inside, the clean, simple and vigorous architectural standards set by Pick and Holden have long since been abused. So I was delighted last year when the Arts Council, pursuing a laudable new determination to support works of art in public spaces, joined forces with London Transport and announced an ambitious competition. Proposals were invited for one of the biggest art works in the world, to be installed on the vaulted ceilings of Holborn Station's two staircases and the concourse between them.

The site, larger by far than anything dreamed of by an easel painter, is the size of five tennis courts. And the audience wildly outstrips most artists' expectations as well: thirty-four million passengers a year, more than ten times the number who visit the National Gallery, would see the completed work at close quarters. The challenge posed to artists with no experience of such a project was therefore formidable. Quite apart from the scale of the site, competitors were asked to remember that the medium they used would have to withstand a considerable range of temperature, humidity and wind pressure, since the escalator shafts ventilate the platforms beneath. But to artists who care about their social effectiveness, all these difficulties are well worth confronting. Chances to work in such accessible forums occur so rarely in our society that they should be seized with alacrity.

Besides, one look at Holborn Station is enough to persuade anyone of

the urgent need to counter its unrelieved shabbiness. I travelled up and down its escalators the other day, and the desolation was distressing. The ceiling of the upper shaft, lit by tatty neon tubes which could easily have been installed as a stop-gap measure during the last war, is disfigured by sizeable holes. Nobody bothered to replace the missing chunks of plaster after they fell out, and the lower shaft's ceiling is almost as abject. Tacked together from a series of dog-eared panels, whose divisions are painfully visible, it arches over a rickety trio of escalators, one of which had broken. As I watched, an empty beer can came bouncing down the steps, its echoing clatter reinforcing the pervasive sense of neglect.

Grateful to escape, I made my way to the Whitechapel Art Gallery for an exhibition of the competition's nineteen prize-winners. How had they reacted to the complex problems involved in revitalizing a space so mal-treated and yet so full of potential? The answers varied enormously. Some artists were seduced by the possibilities of the computer, and James Utting wants to set up a programmed design unit which could be used by art schools, advertising agencies, political parties, news services and anyone else with a message to communicate. He would like this plug-in idea to abolish the distinction between art and advertising – a destructive ambition, since the artists most worth cherishing have always been at the furthest remove from commercial propaganda. Anyway, the tubes are filled with advertising already, so it would be an abuse of the competition to end up providing yet another tool for the agencies to manipulate.

Elsewhere, technological know-how is dedicated to less sinister ends in a proposal by three men: a composer, a designer and a computer systems engineer. They suggest 'an audio-visual mobile always in flux' which 'soothes and relaxes'. Discreet music would seep from speakers concealed in the ceilings while programmed patterns 'flutter in the wind' – a bland mixture of light and sound which seems dangerously comparable with the experience supplied by supermarket muzak. I warmed instead to artists who provided a more enlivening experience. Roger Barnard has the Magritte-like notion of simulating the sky in smooth plastic panels which would make the escalators appear to be out in the open air. David Tucker likewise turns the underground inside out by filling the ceilings with brightly coloured skydivers floating in space. And Deanna Petherbridge brings passengers back to subterranean reality with a harshly detailed line drawing which evokes the tubes and tracks of the underground system itself. Looking up at her design would be like travelling through a jungle of mechanised entrails, whereas Dante Leonelli puts forward a more reassuring tubular light sculpture wriggling its way down the shafts in response to 'the flow and movement of the escalators'.

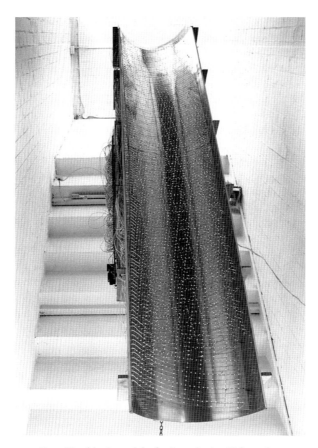

114. Ron Haselden's model of prize-winning Tube staircase ceiling at Whitechapel Art Gallery, London, 1980

For headlong exhilaration, I would single out Graham Crowley's fresh and inventive cornucopia of forms – some abstract, others resembling hoops, hands or hats – tumbling down the shafts. Matisse and Léger both seem to have spurred him into the creation of imagery filled with the circus spirit, and it indicates that Crowley's true *métier* may well lie in grand mural decorations. But he was only given the runner-up prize. The Holborn commission went to Ron Haselden, who also plunders the resources of technology to produce a sophisticated electronic model studded with tiny light bulbs. These winking points of colour are attached to

two grids that penetrate each other and respond directly to the presence of tube passengers. A photo-electric cell would detect every traveller arriving at the escalator and activate a band of the bulbs which follow the person up or down. The more crowded the staircase, the busier Haselden's ceiling will be with kinetic light, and he attaches great importance to the role played by the people who find themselves operating the work.

Like all the proposals it is hard to imagine *in situ*, but the working model Haselden has produced promises an attractive spectacle which combines ingenuity with simplicity, showmanship with gentle discretion. It might well have proved hugely popular, and I have no doubt that Holborn Station would be enhanced by its presence. London Transport's current financial crisis has, however, led to the 'deferment' of the entire project, along with the station modernization programme as a whole. It is a tragedy both for the travelling public and for artists seeking to apply their work in social spaces beyond the gallery. The vast hallways in the tube could be a marvellous new arena for art, and Haselden told me that he still hopes to implement his scheme with the aid of unemployed school-leavers who would benefit from the electronic training it provided. For his sake, and for all those who have to suffer the degradation of tube travel today, I implore London Transport to change its mind. It would be a small price to pay for starting to discover how art and the Underground might best be brought together.

SPORT AND ART
20 September 1980

For the past three years a gigantic martial-arts banner has helped to galvanise the leaping, kicking and thrusting figures who practise their dynamic skills in the Flaxman Sports Centre at Brixton. Hanging down in a series of interlinked canvas strips, the banner fills more than 800 square feet with the restless movement of crosses, triangles, arrows, rectangles and stars. They dart and weave across the design, treating the dark background as a foil for high-keyed colours like the curve of light blue which describes a path over to an impact-point in fierce yellow. Even on a purely abstract level, their quicksilver interplay evokes the sprung tension of the limbs exercising in front of the banner. But to the people who use this Sports Centre for the traditional art of Chinese

fighting, each arc and twist in the composition has a very specific meaning. Since the entire banner depicts the fifty-two positions of a Wu Shu Kwan fighting sequence, any participant can read its notations and translate them into bodily action.

In other words this handsome piece of decoration, cut with shears into hundreds of industrially dyed segments before the final sewing, is a diagram as well. John Dugger, the artist who made it, relishes the thought that his banner serves an aesthetic and a practical purpose at one and the same time. Just as Vladimir Tatlin applied his art to the social world beyond the gallery during the early years of the Russian Revolution, so Dugger's Banner Arts Workshop harbours a comparable ambition today. His works have appeared in a variety of militant and festive contexts, draped around Nelson's Column for a Chilean resistance rally in 1974 or carried above dancing, swaying crowds at the Notting Hill Carnival. But recently, after the Wu Shu Kwan banner showed how vital a part it could play in the enjoyment of physical culture at Brixton, Dugger has been concentrating on commissions from sports centres.

He is now working on some large hangings for the Michael Sobell Centre in Islington, a well-equipped building which could prove an ideal location for the coming-together of art and sport. Indeed, the prospect of finding monumental banners in such a public setting prompts me to wonder why on earth similar commissions have not been carried out before. Although Greece demonstrated centuries ago that sporting activities could inspire works of art filled with poise and energy in equal measure, we have brutally severed the connection between them. Artists today are reduced to envying the explosion of popular enthusiasm for sporting obsessions of all kinds, and those responsible for erecting sports centres throughout the country have so far failed to explore the possibilities for artists within these arenas. If the two were united, in buildings which offer marvellous opportunities for the creation of art-work on the grandest scale imaginable, sport and art could once again be seen as related ways of realizing our imaginative and physical potential, and enjoying it to the full.

At the moment, from schooldays onwards, art is often seen as incompatible with sport, and an interest in the one automatically precludes a wholehearted involvement with the other. But the future development of what sociologists so lamely call 'leisure activities' must embrace them both. And there is no reason why artists should continue to be excluded from the designing or embellishment of the centres which must be created if our society is ever to provide adequate facilities for the people whom technology will make redundant in ever-increasing numbers. Art

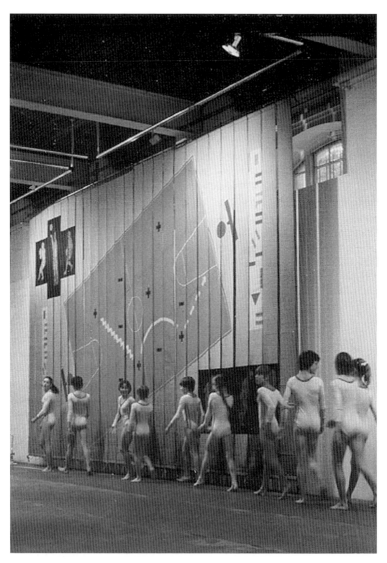

115. John Dugger's *The Basketball Banner*, Hillingdon Girls Gymnastic Club at the ICA, London, 1980

and sport both have vital roles to perform in redefining what we expect from life once the concept of full-time employment finally becomes obsolescent for a large section of the population.

So the ICA deserves congratulation for staging an exhibition which not only displays Dugger's banners but also widens the argument out, to encompass the whole question of sport's relationship with art. Taking an object like the Wu Shu Kwan work out of its usual setting is risky: it could easily be seen as a sumptuous piece of gallery décor, rather than a banner whose scale, form and content are all dedicated to enlivening a communal activity outside the boundaries of the art exhibition world. But the danger has been overcome by turning the ICA's Main Gallery into a multi-purpose gymnasium. The floor is marked out with white lines; a pair of basketball nets installed at opposite corners; a horse, bar, ping-pong table and cycling machine stand ready for use; and a trampoline leans folded against the far wall. Far from looking like a spurious attempt to concoct a keep-fit ambience, the room offers a remarkably convincing reconstruction of the surroundings where Dugger intends his banners to hang. On three evenings a week several sports and physical skills, including gymnastics, kendo and other martial arts, will actually be performed in the gallery. And a subsidiary section of the show documents three different types of sports centre in Britain, ranging from the professionals' Olympia at Crystal Palace to the resplendent Swindon Leisure Centre, where sport turns away from the competitive ethos and is placed in a more relaxed setting with theatres, crèches and pubs.

Few ICA visitors will be able to ignore the distinct social purposes which these banners are supposed to fulfil, but in the latest examples Dugger has made their sporting themes more explicit than the earlier Wu Shu Kwan work. The Golden Square Banner includes an elaborate sequence based on photographs of the positions adopted in judo, and at two corners of the vast Basketball Banner similar figures spell out the meaning of the diagrammatic patterns even more unambiguously. Both works thereby declare their subjects with great emphasis, and pictures of Dugger at work show that these banners were made with better resources than the Wu Shu Kwan, an appliquéd canvas sewn together with agonizing care on a small portable Singer.

All the same, I prefer the more uninhibited high spirits of the Wu Shu Kwan, which possesses a richer intensity of both colour and composition than its rigidly marshalled successors. The series of Judo moves in the Golden Square Banner are so subdued that they cannot be identified properly at the viewing distance such work requires. And although Dugger attaches understandable importance to rendering the diagram of

each sport as faithfully as possible, so that practitioners can translate it, I suspect he ends up confining his powers of design within too literal limits. The oblongs, crosses and circles inhabiting the central area of his Basketball Banner are arranged with clean precision, and Dugger's approach does indeed recall the Productivist art Tatlin pioneered in Russia sixty years ago. But he could still afford to regain the more headlong extravagance which makes the Wu Shu Kwan banner so memorable.

After all, sport itself is nothing if not exhilarating and full of surprises, so why should sports banners not arouse comparable excitement? In 1952 the ageing, crippled Matisse created a mural-scale work called *The Swimming Pool*, painting gouache on paper cut into figures who dive through space with astonishing freedom and grace. Intended as a design for a wall ceramic, it never did achieve transferral to the sides of a real pool. But it stands as a supreme modern example of the unbounded vitality Dugger should emulate, and I hope he receives enough commissions to achieve the union between art and sport which his banners have so bravely set in motion.

ART AT SCHOOL
6 October 1980

Having watched my own children discover the delights of painting, drawing and other kinds of image-making, I know how instinctive these activities really are. The human urge to assert a sense of identity in visual terms becomes powerfully apparent at an early age. It is a fundamental need, and many infant schools now encourage pupils to place it at the centre of their lives. The results festoon classroom walls, joyfully affirming the ease with which young children express their response to the world around them. Unforced and full of vitality, these images more than justify the belief that infant education should revolve around a commitment to the prime importance of a pupil's visual imagination.

But once the junior stage is reached, this wonderfully spontaneous state of affairs begins to deteriorate. Activities which used to be so integral a part of each day's teaching that they did not need a special name are now labelled 'art'. They are only permitted at particular times in the school curriculum. And too many children, made aware of their inability to

depict appearances in a so-called realistic way, reluctantly decide that they are no good at painting or drawing.

This gradual loss of enthusiasm for art goes hand in hand with its transformation into a school 'subject', one among an increasing number of rivals. It becomes an option as opposed to an invigorating habit. By the time pupils start preparing in earnest for their exams, they realise that success in art at O or A level carries very little value unless they aim to study it further at college or university. In other words, a lot of older children end up regarding art as a remote and often incomprehensible pursuit, practised only by eccentric misfits. Apart from a few token reproductions, and periodic displays in the art room, the school walls no longer carry the abundance of images which surrounded the pupils at infant level. Forgetting that they used to paint with such compulsive excitement, the majority of school-leavers enter adult life unwilling to recognise that art has any significance left for them. The educational system, which could do so much to promote a greater degree of understanding between artist and public, is instrumental in alienating them from each other.

Some educational authorities do, fortunately, give art a more prominent place throughout school life. Over the past thirty years, the Leicestershire Education Committee has made an outstanding attempt to ensure that pupils retain a lively awareness of art work at every age. But Andrew Fairbairn, Leicestershire's Director of Education, is under no illusion about the way British schools generally treat art. He has even warned that, 'because of the contorted values we seem to be placing on the supremacy of academic courses in our schools at the present time of crisis, there is a real danger that many schools will eliminate art . . . from the curriculum'.

It is a distressing prospect, and gives an extra urgency to an examination of Leicestershire's own post-war achievement. Principally through the efforts of Stewart Mason, its Director of Education from 1947 until 1971, the county has built up a handsome collection of original art works for distribution among its 476 schools and colleges. The purchasing budget was never large, so Mason made a virtue of necessity by offering welcome patronage to young artists who needed support at that stage in their careers. Sometimes, with the help of the Arts Council or the Contemporary Art Society, objects by established practitioners have been acquired. But the bulk of the collection, which ranges in generation from Henry Moore to Stephen Buckley, was obtained with means so slender that even the most hard-pressed education committees could be inspired by its example. Plenty of artists let Mason have works at advantageous

prices, and Knighton Hosking recently gave a large painting on the understanding that it went to a school. 'Although I don't see myself as a one-man charity,' he explained, 'I would sooner the painting was seen than turned to the wall in my studio.'

I hope as many educationalists as possible acquaint themselves with the Leicestershire venture. As Hosking's gesture recognises, the whole scheme is fired by a spirit of generosity which believes in establishing active relationships between art and its audience.

Photographs of the collection wisely concentrate on revealing where the works are placed within the schools and how the pupils react to them. Children are shown staring expectantly at Derek Boshier's mysterious perspex and glass globe, as if it might suddenly explode or fly off into space. They stroke Willi Soukop's *Donkey*, peer through Anthony Holloway's iron sculpture, run their hands down John Jackson's construction, and dash excitedly past Anthony Morgan's *Between Three Reds* curling off the wall above them.

Many schools would only think of hanging an art work in the most formal and dignified area of the building, but in Leicestershire they set no such arbitrary limits on the positioning of their collection. Classes swing and leap in the gymnasium while Peter Kalkhof's *Dawn Horizon* glows quietly on a wall nearby; kids in a school library play tunes while they read by running their fingernails over David Partridge's spiky metal *Observer*; and pupils bored with their teacher can stare through the window and speculate about the identity of Nicholas Pope's enigmatic *Thin Stone* floating in the pool outside. The works can be sat on, sheltered under, sketched, tapped and even lifted up, but they are difficult to ignore. Judging by the tape-recorded comments from the children, they insult the objects, heatedly debate their merits, and sometimes become passionately attached to them. It is hard to remain immune to art works when they occupy places frequented by the entire school. Even if the pupils may not feel they entirely grasp the meaning of an abstract composition, it does at least provoke them into thinking about why someone should want to make it, and what the artist was trying to express. The whole notion of creating art thereby becomes an accepted part of life, not an esoteric activity carried out in galleries alone.

One work in the Leicestershire collection fits into its setting so well that it stands for a unity between art and education itself. Curving, folding and dancing their way round a circular space in the middle of Countesthorpe College, the brightly painted metal components which make up Phillip King's *Dunstable Reel* could not hope for a more harmonious location. Like a group of graceful, poised performers in the

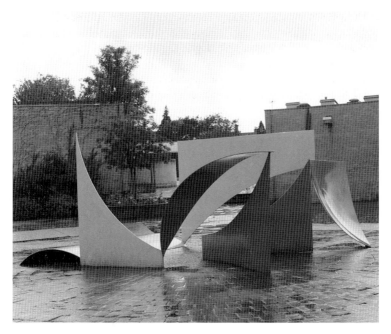

116. Phillip King, *Dunstable Reel*, 1970, *in situ* at Countesthorpe College, Leicestershire

centre of an amphitheatre, they seem effortlessly to hold the attention of the entire building surrounding them. King has enlivened the architecture, given it a soul; and the college's principal, John Watts, thinks that *Dunstable Reel* actually exemplifies the spirit of his institution. 'There you have, in hard-edged sheet metal, the symbolizing of the dance,' he explained, 'and *that* seems to me to be what education is essentially about. People joining together in doing something which is tough but enjoyable.'

Needless to say, Leicestershire does not regard its collection as a superior substitute for images made by the children themselves. Schools in the county display the two kinds of work, amateur and professional alike. They complement each other, encouraging the crucial idea that there is a link binding the familiar pictures painted in class with the often bewildering objects made by people called artists. It is a lesson well worth teaching, and suggests what might be achieved if schools elsewhere in the country followed Leicestershire's admirable initiative.

NEW SCULPTURE OUTDOORS

11 November 1980

For anyone who shares my hope that art might occupy a more central place in our lives, the recent installation of three remarkable sculptures on public sites across London is an encouraging event. Unlike the banal and shoddy objects which have given so much 'civic art' a bad name, these new works were made by men who would never compromise themselves by supplying safe, hackneyed images for fear of upsetting people's prejudices. All three sculptures did, in fact, attract controversy when they were erected. But since they are the products of three distinct generations in British art, and inhabit widely different locations, it is fascinating to discover how much they vary in their approach to the challenge of adventurous public sculpture.

Rearing up nineteen feet in the air, the enormous *Arch* which Henry Moore has given to Kensington Gardens is the most orthodox of the works. It keeps a safe distance, marooned on a secluded stretch of grass bounded on one side by the banks of the Long Water, and on the other by railings. So the entire expanse of Roman travertine marble, serenely white apart from areas of surprisingly bold chisel-marks, cannot be touched or walked through. It remains enigmatic and aloof from its surroundings, like a gigantic skeleton left behind by a prehistoric creature who once roamed across this territory and loftily dominated everything it surveyed. Someone with no knowledge of the sculpture's origins could be forgiven for seeing it as a weather-worn fragment which has survived – against all the odds – from our forgotten primeval past. Seemingly eroded by the action of wind and rain, its hollowed limbs nevertheless retain considerable bony strength. And at the top of the arch its side thrusts forward in a pelvic projection, indicating the immense muscular power it might once have possessed.

Moore himself would probably not be averse to such an interpretation: he has always stressed his work's links with remote history by evoking the forms of ancient hillsides, cliffs, caves and rocky outcrops. But he is also deeply involved with the human body, and the contours of his arch are too rounded and gentle to straightforwardly suggest the remains of a monstrous predator. Nor does this unaggressive sculpture interfere too much with its pastoral setting, despite its size and fifty-ton weight. After all, *The Arch* is not a solid, unrelieved mass. It opens in the middle to frame a view of the grass and trees beyond, as if Moore wanted to acknowledge his location's beauty. Indeed, the view through the arch from behind

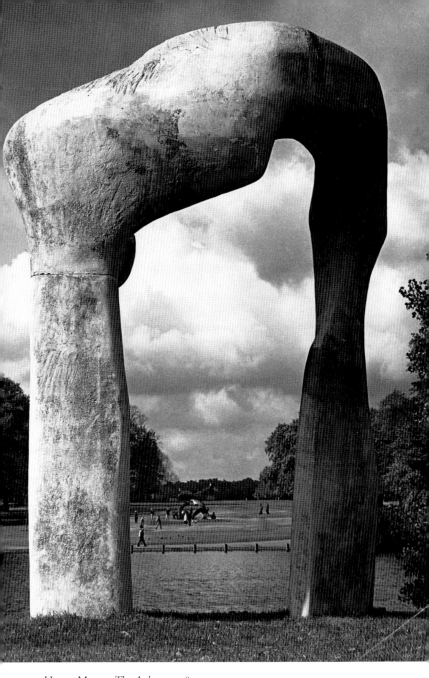

117. Henry Moore, *The Arch*, 1979–80

seems to centre very deliberately on the distant silhouette of Watts's *Physical Energy*, a heroic bronze statue which belongs to the Victorian academic tradition Moore rejected in his youth. Now, in his old age, he doubtless savours the disparity between the two sculptures, and is happy to let his *Arch* eye Watts's warhorse from afar, with wary affection.

No rival works of art or even a hint of the countryside contend with Anthony Caro's *London West*, commissioned for their new building by the governors of Hammersmith and West London College. Alone in a courtyard apart from students' bicycles, some of which have been cheekily propped against the sculpture, it occupies a site as urban as Kensington Gardens is rural. And although Caro was once an assistant of Moore's, he certainly does not share the older man's use either of time-honoured sculptural material or overt references to human anatomy. Carried out entirely in stainless steel, *London West* is an unashamedly abstract work. Its stripped-down linear geometry is as stark as a machine, and in some respects the bicycles leaning against it seem organised according to similar structural principles. But they, of course, have been constructed with a functional end in view, whereas Caro's sculpture is essentially a spirited and inventive attempt to draw in space with welded metal.

Like many of his works, it changes radically from different viewpoints. At first, having entered the college from Gliddon Road, I thought its severe cluster of semicircles, diagonals, uprights and rectangles seemed constricted, and oddly lacking in sculptural presence. But as I walked around it, the whole elaborate sequence of tubes and plates gradually loosened and relaxed. It was easy to imagine Caro improvising the work on site in an open-ended way, no more certain of exactly how it would fit together than a man assembling the frame of a large and complex tent for the very first time. In fact, *London West*'s vitality depends to a great extent on his refusal to resolve everything into a predictable harmony. It is an unruly, almost eccentric sculpture. Caro's willingness to take risks, indulge in extravagant flourishes, and bend his tubes into curves as taut as an archer's bow, gives the work a sprung tension. A fine autumn drizzle was falling when I saw it, and Caro's tilting, bending and intercutting lines shone bright against the dull stolidity of the red-brick architecture. The sculpture's irrational zest provided a much-needed contrast to the neat rationality of a building where tidy little pairs of black boxes marked LITTER are visible at every turn. The students who pass *London West* on their way to work, or view it through the many onlooking windows, may well come to value it as a reminder that the increasingly functional values of modern education are not enough.

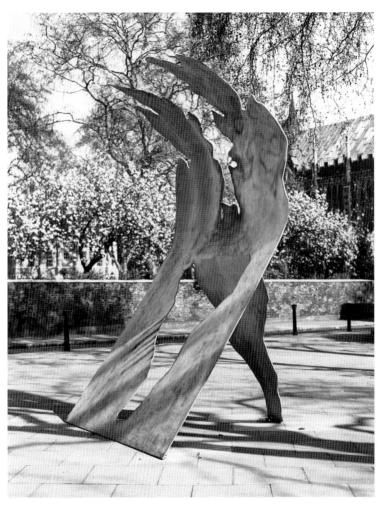

118. Barry Flanagan, *Camdonian*, 1980

Although parkland and college courtyards are both traditional locations for works of art, the corner pavement occupied by Barry Flanagan's new sculpture is a far less conventional setting. With the trees of Lincoln's Inn Fields behind, and the Association of Certified Accountants headquarters over the road, this tall sheet of steel seems

astonished at finding itself there at all. It bends in the middle, as if breathlessly recoiling from a sudden blow. And from the side it looks far too thin to withstand the inquisitive prods which passers-by constantly administer.

This fragility is an illusion, but Flanagan clearly wanted his sculpture to appear vulnerable. Belonging to a generation who reacted strongly against the massiveness Moore favours, he would never have imposed anything grandiose on the site. Even though the sculpture is more of a compact monument than Caro's sprawling ensemble, Flanagan stresses its lack of substance by slicing it up like a cardboard cut-out. The curved top sprouts two fantastic forms which echo the foliage behind, and at the same time suggest the exaggerated Punch-and-Judy profiles of puppets, leering wildly at each other. The space between them resembles a tree, while down below a shape strongly reminiscent of South America has been carved out of the sheet and bent backwards, providing a support for the sculpture as a whole.

As theatrical as a piece of stage scenery, and not in the least pompous, it rejoices in the ability to prompt a wide variety of possible meanings. While I was there a lot of pedestrians paused to examine it, and even the people who disapproved could not help smiling at Flanagan's offbeat wit. The antithesis of a routine public sculpture, it stimulates, puzzles and beguiles in equal measure. But it is above all *alive*, demanding and deserving a correspondingly alert response. If Camden should be congratulated for having the enterprise to commission it, praise must also go to the Arts Council for contributing to the cost of both the Flanagan and the Caro. They prove, together with Moore's *Arch*, that art works of quality are able to enliven the everyday space we inhabit, and that it is a nonsense to confine them within galleries alone.

HOCKNEY AT THE OPERA
4 June 1981

Hockney's brilliant series of opera designs have proved how enormously stimulating it can be for artists to take their work out of the gallery and on to the stage. His latest excursion, commissioned for a triple bill at the Metropolitan Opera in New York, unleashed a remarkable torrent of energy which then flowed back into his subsequent paintings. The venture

therefore turned out to have two-way rewards. It raised the often banal standard of opera design to a new level of visual literacy, and provided Hockney's other work with an imaginative release he badly needed.

His two previous opera projects – Stravinsky's *The Rake's Progress* in 1975 and Mozart's *The Magic Flute* in 1978 – likewise enabled him to move outside the problems he was encountering in his own painting. Designing for the stage reminded him that there were alternatives to the careful, almost photographic naturalism he had pursued in the early 1970s. Hockney felt stifled by the painstaking style he adopted for large double portraits like *Mr and Mrs Clark and Percy* in the Tate Gallery. However appealing and sensitively judged such pictures may have been, they repressed too much of the exuberance which had formerly prompted him to juggle with different idioms, keeping his options open and alive.

Glyndebourne's invitation to design *The Rake's Progress* must have reminded him immediately of the major print sequence with the same title he made in the early 1960s. The opera project unlocked an imaginative door leading back to the freedom and vitality of those years, and it must also have appealed to Hockney's love of theatrical devices. *Play within a Play*, a 1963 portrait of his dealer Kasmin trapped like a demented actor between a drop-curtain and a pane of glass, was only the most obvious of many youthful pictures which drew their inspiration from the stage. Elsewhere in his early work a *Grand Procession of Dignitaries* marches down a ramp with a theatrical flourish; the jaded couple in *The Second Marriage* are hemmed inside a room as flimsy and artificial as a stage set; and a van carrying the young Hockney on his *Flight into Italy* rushes past a striped Swiss mountain which flaunts itself as a frankly anti-realistic painted backdrop. Even in the later portraits, for all their diligent attempts to fabricate a lifelike illusion, Hockney displays his sitters as actors and actresses on exquisitely lit stages: Patrick Procktor, standing in gawky profile against the light seeping through his studio blinds, is almost as much of a motionless prop as the waste-paper basket, swivel chair and angle-poise lamp placed elsewhere on the carefully arranged set.

It was just a step from composing these paintings to designing opera scenery, a challenge which confirmed Hockney in his initial belief that artists should never become too ensnared by their ability to provide a faithful account of observed appearances. Many of his best early paintings look as if they have been devised by a marvellously skilful stage designer, and at Glyndebourne he was able, without any sense of strain, to translate this instinctive theatricality into three-dimensional terms. The success of Hockney's experiment owed a great deal to his particu-

119. One of David Hockney's stage designs for Stravinsky's *The Rake's Progress*, 1975

lar enthusiasm for opera: as Marco Livingstone points out in his thoughtful and very informative new study of Hockney, his father took him to see *La Bohème* in Bradford at the age of twelve, and he has been a confirmed, discerning opera-goer ever since. But he also turned out to be adept at using his equally sophisticated awareness of art history at Glyndebourne. Realizing that Stravinsky was inspired by Hogarth to choose *The Rake's Progress* as his subject, Hockney allowed the crosshatch technique of Hogarth's engravings to dictate the style of his designs. As a result, both sets and costumes look like eighteenth-century prints. And although they often contain an impressive amount of period detail, this consistently applied linear network lets them escape from naturalism into a more personal world. In the final Bedlam scene, the full force of Hockney's newly liberated imagination erupts as row upon row of inmates' masks grimace from their box-like cells, while the surrounding walls are festooned with a riot of crazed graffiti.

This uninhibited air of devilment provides a vivid demonstration of the release Hockney found in opera designing, and explains why he has been prepared to spend so much time on these commissions in recent years. They clearly give him just as much satisfaction as his other work, and the wealth of references to different artists in his sets for *The Magic*

Flute implies that he considers stage designing should be regarded with the same dignity and seriousness as easel painting. Quotations from his own earlier interest in Egyptian art are interwoven with allusions to Uccello, Leonardo and even Frank Stella. The inventiveness with which they are all fused together suggests that Hockney's operatic ventures may eventually be counted among his most satisfying achievements. To my eye, they take their place among his painted and graphic work without any sense of inferiority.

As if to acknowledge their status, the Riverside Studio is displaying the designs for the New York triple bill as a major Hockney exhibition. Hung alongside large paintings inspired by the same themes, they are filled with backward glances at his previous, non-operatic work: a gouache of a *Princess with Book* is instantly reminiscent of his Grimm's fairy-tale etchings, and a design for a drop curtain recalls the fringed and patterned drapes he hung on rings across so many of his pre-1965 canvases. But the overwhelming influence this time is early twentieth-century French painting in general, and Matisse and Picasso in particular. For Hockney was acutely conscious that all three of the New York operas refer to the heroic period of modernist art in France.

Satie's celebrated *Parade* was first produced in 1917, Poulenc's *Les Mamelles de Tirésias* is based on a play by Apollinaire staged in the same year, and Ravel's *L'Enfant et les Sortilèges* is inspired by a poem Colette wrote during the First World War. Moreover, Hockney's great artist-hero, Picasso, actually designed *Parade*, and the way he collaborated with the combined talents of Cocteau, Massine and Diaghilev on that hugely influential production shows how even the greatest modern artists have been prepared to devote their energies to work on the stage.

Not surprisingly, Hockney pays overt homage to Picasso in many of his *Parade* sketches, and even considered painting a pastiche of the famous backdrop used in the 1917 production. Finally, though, he decided to use the stage for *Parade* – the first offering in the triple bill – as a space that also contains props and scenery for the other two productions. The three operas were thereby given a unity which the director, John Dexter, strengthened by emphasizing the Great War theme binding them together. The coils of barbed wire running round the *Parade* set reappear during the Poulenc, and Dexter wanted to end the evening with a stage emptied of everything except this sinister symbol of trench warfare.

Practical obstacles prevented him from doing so, but it is clear that the spirit of wit and joyfulness Hockney found in all the operas has been set against the brooding threat of destruction. This dramatic contrast fulfils a dual role, making the optimism in the operas more vulnerable and at the

same time more miraculous. The circus atmosphere of *Parade* and the frivolity in Poulenc's music – heightened by Hockney in a South-of-France set as bubbly as Dufy – might have seemed merely lightweight without this chilling reminder of war's horror. But the barbed wire makes us realise that humour, even of the most flimsy and farcical kind, deserves to be cherished in the face of world-wide conflict.

This theme becomes clearer still in Ravel's opera, which shows how a child's violence can ultimately be redeemed by compassion. At the Riverside a clever change in the coloured lights trained on a painting of Ravel's garden scene shows how, on the New York stage, Hockney made the trees turn from blue and green to a brilliant, Matisse-like purple and pink. For those lucky enough to see the production, it marked the climax of the evening and affirmed a faith in humanity's fundamental goodness. A glimmer of this revelation can be sensed in the reconstruction offered to the exhibition's visitors here. But it can never be a substitute for the large-scale impact of Hockney's colour which, in concert with the music, moved the Metropolitan's audiences. There, on the stage of a vast opera house, he managed to resolve the divided loyalties that had afflicted so many of his paintings. I am sure other artists would be equally fired by the experience of working in similar arenas, if only music and theatre directors would give them the opportunities they need.

ART ALONG THE TRACK
1 October 1981

Most commuters who travel to work by train would agree that the railway tracks approaching London's stations invariably pass by the most desolate cityscape imaginable. Passengers can avoid the offensive views through their windows by arming themselves with books or newspapers, but it is difficult for even the most addicted reader to remain completely oblivious to the barren and brutal urban wasteland outside the carriage. Trains have a sadistic habit of stopping for long, unexpected periods just before they enter main-line stations. The cessation of movement is distracting and people find themselves automatically staring out beyond the glass. They could be forgiven for wondering why the prospect confronting them should be so relentlessly dismal.

One answer is that planners and architects have never bothered very much about the backs of buildings they cannot see. If one side of an office or a factory runs along a railway line, there is no incentive to worry over its appearance. A lot of developers are only too delighted to save money by erecting the most reprehensible structures, and then adding façades handsome enough to distract attention from the shoddy design-work behind.

As luck would have it, an impressive demonstration of how to effect an improvement has just been carried out on the grandest scale. Commuters who use the King's Cross line recently witnessed the dramatic transformation of the back of Pitt and Scott's new warehouse in Eden Grove with a buoyant mural extending 138 feet along the track. This gigantic shed was built to provide storage space for the works of art Pitt and Scott specialise in transporting, and when erected it could hardly have looked more oppressive. In order to enliven it, the owners at first contemplated spending around £6,000 on an enormous sign illuminating their firm. Then, mercifully, they realised that a mural could be commissioned for the same amount, and the Arts Council agreed to provide an additional £5,000 on the understanding that an open competition was held.

Some businesses would be tempted to plump for the painting which promoted their image most effectively. But Pitt and Scott have enough professional regard for the work they handle to know that good artists would never entertain the idea of supplying commercial propaganda. No triumphant fleet of speedy removal vans, each bearing the P&S motto *In Safe Hands* can therefore be found on Graham Crowley's winning submission. He was fired by the challenge of producing a mural which would respect both building and surroundings even as it attempted to enhance them.

Far too many wall paintings are well-meaning but hasty daubs, executed without due regard either for the architectural character of the surface they decorate or for the neighbourhood they inhabit. Crowley's mural is, however, remarkably alive to both these factors. The corrugated lines in the side of the warehouse have been turned into a majestic series of vertical white stripes, which parade across the entire mural and lend it a taut vitality. Moreover, the unusual opportunity presented by the building's long, low shape, so similar to the form of the carriages rattling past it, has been seized with aplomb. As the images travel over from one end of the painting to the other, they evoke the sequence of a journey. Crowley was aware that the mural will be seen from the windows of trains moving in two different directions. So he ensured that passengers

approaching King's Cross see this painted journey as a progress from country to city, while trains leaving the station give travellers an equally appropriate view of this journey in reverse. And because the mural unfolds to such a great length, like a Chinese scroll revealing itself stage by stage, people will look at it in a successive way which reinforces the whole notion of a passage through time and space.

Much will depend, admittedly, on the kind of train passengers catch. It has been calculated that an Intercity 125 would allow only 2.5-second glimpses of the mural, whereas a wayward local train might well permit a leisurely appraisal. But Crowley has resisted the temptation to produce a design easily digestible at one viewing. It will yield more and more at each repeated encounter, thereby giving commuters a constantly renewable source of pleasure.

Having been issued with a fluorescent orange jacket, I was able to walk over to the side of the railway line for an examination of the mural from ground level. I realised how well attuned the painting was to its extraordinary setting. The purple and yellow wild flowers rioting all over the nearby scrubland blend well with the mural's softer colours; the linear network formed by the tracks and overhead cables are echoed in the

120. Graham Crowley, *Pit & Scott Mural*, 1981

strong black contours Crowley uses to define prominent objects; and the quirky assortment of cogs, wheels and rods hanging from the cables seem to have inspired the weightless ease with which the spanner, nut and other pieces of machinery dance across the painting itself.

In all these subtle ways Crowley has made his decoration quietly at one with its location, unlike all those hamfisted outdoor muralists whose work only succeeds merely in disguising its uncongenial surroundings. Instead of acting as a visual cosmetic which prettifies a blighted area, Crowley's painting performs the remarkable feat of giving this ramshackle district a lively yet unforced sense of harmony. His mural is above all else a celebration. With stubbornly unfashionable optimism, it depicts the act of journeying as an occasion for delight. The branches, cloud and leaves floating against an off-white background in the rural half of the painting may give way, in the urban half, to a deeper grey dominated by machinery. But the same sprightly ribbons of yellow, orange, red and blue unfurl through both sections, unifying them and easing the transition from organic to mechanical forms. The calmness of the colours gives the whole decoration a reflective quality, removing it from the harshness of the present to a more dreamlike region, where train tickets curl and glide with the ease of birds in flight.

Crowley allows himself to indulge in a little jaunty humour, too: the ticket held by the giant stubby hand on the right could well be mistaken for a half-eaten British Rail sandwich. This comic-strip wit links the mural with a vivacious decoration in brilliantly coloured plastics which Crowley made for the ICA's staircase earlier this year; but compared with the frantic cornucopia of forms he invented in the project, this new wall painting seems altogether steadier and more assured. Without sacrificing any lightness, it does possess the kind of grandeur such a monumental surface demands.

Crowley has refused to overload his design with the anxious surfeit of incident which can so easily burden large murals. And his bold decision to emphasise the main objects with outlines running uninterrupted over the vertical stripes gives the whole painting a lean muscularity it would otherwise lack. Léger might well have approved of the way Crowley draws both landscape and city images in the same chunky, irregular style, implying that nature and the machine age have been reconciled at last. Indeed, the mural owes a clear debt to Léger's own large-scale late decorations. Perhaps too overt a debt: Crowley's individuality is in danger of being submerged by his mentor's massive influence. But it is still heartening to see a young English painter so zestfully pursuing the marriage between art and architecture, which Léger tried hard to foster.

While I was looking at the mural a surprisingly bright sun came out, and its impact on the corrugated warehouse surface radiantly confirmed the artist's ability to benefit from the dramatic light changes that paintings in the open air enjoy. Train passengers will benefit even more from the advent of this distinguished decoration. Nobody glumly commuting on the King's Cross line could have any qualms about accepting Crowley's invitation to accompany him on an alternative journey, into a world filled with robust imaginative gratification.

ART AND ARCHITECTURE

25 January 1982

Until recently, most modern artists and architects viewed the whole idea of collaboration with a scepticism bordering on alarm. Painters and sculptors who valued their independence were tired of trying to fit their work into unsympathetic foyers, stairwells and corridors, many of which were never intended to house art at all. And architects still clung to the purist belief that buildings were minimal sculptures in their own right. Any attempt to adorn the bare, simplified surface of a tower block or a slab of offices was regarded with disdain. One scornful architect, Norman Foster, spoke for the majority of his profession when he described decorative embellishment as smearing 'lipstick on the gorilla'. He clearly wanted the shimmering expanses of glass on his streamlined technological monuments to exert their own power, uninterrupted by any footling ornamental excursions.

A lot of artists preferred to keep their distance from buildings, too. Even Henry Moore, who has shown a consistent readiness to accept commissions for public sculpture, was reluctant when the architect of the London Underground's headquarters asked him to provide a large relief carving in 1928. Although he eventually agreed to make it, he insisted that 'relief sculpture symbolised for me the humiliating subservience of the sculptor to the architect', and in later years he usually liked his sculpture to retain a fully rounded, separate identity away from the building itself.

Why, therefore, is the ICA now able to assemble a distinguished array of speakers this weekend for a major conference intended, as its optimistic announcement declares, 'to be the start of a new period of collaboration amongst architects and artists'? The main answer is that the

crisis of confidence in modern architecture has provoked a reaction against the old, dogmatic disapproval of ornament. We have become terminally bored with the blank, brutal façades of the monoliths that continue to be erected in our cities. And this widespread revulsion has led to a reconsideration of alternative strategies, many of which would embrace a revival of decorative richness in buildings. Rather than continuing to suffer the appalling monotony and impersonal coldness of the developments that have deadened our environment for so many years, we are at last beginning to demand an architecture of distinctive variety.

In this bracing new climate, which welcomes individuality as much as it opposes the imposition of a ruthless norm on building style, the possibilities have suddenly become enormous. Architects are no longer regarded as criminals if they start considering how best to reinterpret traditional idioms, and James Stirling's proposal for the new Turner Gallery at the Tate is quite unashamed in its determination to juggle with a surprising range of references to the past. Unlike so many of his predecessors, who overlooked the character of the cities they disrupted, Stirling wants to honour the old Tate frontage and the nearby hospital in his eclectic design. So there is some reason to suppose that like-minded architects will soon be prepared to encourage the involvement of artists, and debate how their buildings could benefit from the incorporation of painting, sculpture and the other media of modern art.

Nor are they alone in their new-found readiness to collaborate. Artists are also growing tired of the isolated position they occupy in society, and they realise that architectural work is one of the most important areas waiting to be explored. Judging by the number of young artists prepared to carry out public commissions, there would be no shortage of applicants for experimental work on building projects. This enthusiasm is spreading to the older generation as well. Anthony Caro appears to have grown restless with the uniformity of the pristine white spaces his sculpture has always occupied in galleries and museums. 'Instead of just making things in limbo,' he said recently, 'maybe we have got to decide that we've got to fill a space . . . an alley, a roof, a square, something that is going to make sense in people's lives'.

I wholeheartedly agree. It is time to stop limiting our artists to a ghetto of exhibition areas, where work is usually displayed in rooms as anonymous as they are architecturally undistinguished. We ought to be deciding how all the other spaces in our society could become animated by art, and architects should play as prominent a role as artists in locating the most fruitful ways to achieve this. They certainly did in a great Renaissance city like Florence, where art and architecture were integrated with each other

to an extent unimaginable today. Walking round Florence is like visiting a series of special places, where painting, sculpture and the applied arts are continually allied to surfaces as individual as the walls of a monastery cell, the doors in a baptistery and the nave of a church. The space which houses Masaccio's frescoes for the Carmine is totally at variance with the chapel where Michelangelo's carvings for the Medici tombs are installed. In both cases, the works of art are a crucial part of the architecture they enhance, and the experience provided by the painting or sculpture cannot be dissociated from the building which surrounds it.

We would, of course, be foolish to fantasise about recreating the Italian Renaissance today. But we do have everything to gain from considering how to recapture, in a new and specifically twentieth-century spirit, the marvellous sense of place which art enjoys in Florence. Artists and architects need to work towards this goal, for their own sakes as well as ours, and although it is too early to say what paths they will follow, a modest indication can be found in the small exhibition accompanying the ICA's conference.

Its title, *A New Partnership*, is more resounding than the work on display, which represents the results of tentative collaborations between five pairs of British artist/architects. One team, Ed Jones and Ray Smith, even decided to erect a monument to the impossibility of working together, and Smith has laid a cut-out reclining skeleton across Jones's wall-size drawing of a tomb. It looks pessimistic enough, but the quotation from Adolf Loos inscribed on the tomb indicates a dissatisfaction with the state of architecture rather than the collaborative principle itself: 'Only the tomb and the monument are architecture – all the rest are building.' Moreover, Smith's cut-out figure, which looks so despairing, is based on a skeletal tomb effigy in Winchester Cathedral, where it presumably exemplifies the marriage between art and architecture advocated in this exhibition.

The altar-like table in brown York stone produced by John Miller and Paul Neagu also has funereal air, and Sir John Soane's tomb was in their minds while they worked. But the plumb-line hanging over its centre implies a more positive interest in the constructive aspects of building – an interest clearly demonstrated by the dignified way in which the table-top rests on its six robust supports. The sombre sturdiness of this table contrasts with the throwaway wit of Tony Cragg and Piers Gough's exhibit, which consists of eight shelves shaped according to the outsize contours of wine bottles, a traditional still-life subject in art. But the overall effect is oddly austere, and the exuberance of colour can be found only inside the 'magic box' made by Sarah Greengrass and Richard

MacCormac, who invite the viewer to look through an eye-hole at the miniature maze of painted glass and mirrors installed within.

Anthony Caro returns the exhibition to monochrome again with his 'bridge' sculpture, made as a proposed link between the old Los Angeles Central Library and Barton Myers's new extension. Although this 'bridge' would serve a functional purpose, enabling people to walk across from one area to the other, Caro makes little attempt to adapt his swashbuckling style to the character of the location. It looks like a huge, aggressive Caro sculpture placed in the middle of quiet surroundings, and it would be bound to have a startling, disruptive effect. I hope the final version adopts a less defiant attitude towards its location: at the moment, Caro seems bent on reasserting the artist's separation rather than seeking a greater unity with the environment.

But several of the other collaborators opt for a far closer working relationship, and they escape from the notion that artists always have to add something to an environment designed by an architect. Nobody can tell precisely how Miller and Neagu each contributed to the appearance of their massive and mysterious table structure, a complete amalgam of art and architecture. Its unclassifiable strangeness suggests that if the barriers separating these two divided activities are broken down, the outcome will be impossible to predict.

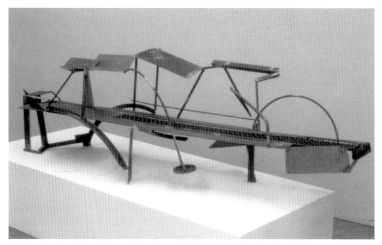

121. Anthony Caro's bridge designed with Barton Myers, shown at ICA, London, 1982

SCULPTURE FOR A GARDEN

23 December 1982

Although placing modern sculpture in parkland is a long-established practice, the outcome can prove disastrous. Objects made in the studio without any awareness of their precise destination often suffer if they are transplanted to pastoral settings. Monumental carvings may look drastically diminished on the spacious expanse of a lawn. Small-scale works run the danger of going unnoticed. Complicated sculpture easily appears fussy in comparison with the forms which nature assumes. Brightly coloured objects might seem garish when set against the green discretion of grass or foliage, and experiments deemed audacious in a gallery context invariably look self-conscious after they have been isolated in a landscape.

Sculptors who imagine that nature automatically welcomes their work should be disabused of the illusion at once. Man-made objects installed in places of natural beauty often look like monstrous intrusions, spoiling the sanctity of the original site. I remember discovering this awkward truth at the final exhibition of contemporary sculpture at Battersea Park, the annual summer event instrumental in promoting the whole post-war notion of displaying British sculpture against a verdant backdrop of trees and bushes. Welded steel structures, either deliberately rusted or painted in brilliant colours, were still the dominant mode. Their angular, sprawling forms appeared to conduct a physical assault on the landscape, and they seemed as out of place as a heap of scrap metal in a nature reserve. Rather than enhancing the park, they desecrated it. Sculpture which originates in its maker's response to an urban environment, where girders and machinery are an everyday spectacle, has no business invading a rural scene. But because conventional wisdom decreed that Battersea Park provided the ideal surroundings for modern sculpture, even the most uncongenial objects were dumped on to its helpless sward. It was an arrogant exercise, and nature revenged herself by making many of the exhibits look inept.

Today, however, a growing number of young sculptors have become interested in making work which refuses to enter into foolish rivalry with parkland. For the first time in a London exhibition, all the sculptures now assembled at Gunnersbury Park have been made specifically for a garden setting. They acknowledge their environment and harmonise themselves with it, realizing that nature is far too valuable to be flouted any longer. The sculptors do not adopt a slavish attitude towards

the landscape: letting a nearby slope or group of trees dictate the work would confine the artist's freedom too narrowly. The change in awareness is more subtle than that, and it certainly has no wish to ape natural settings in a literal manner. But it is still apparent immediately we escape from the incessant traffic in Pope's Lane and walk down towards the Large Mansion.

Among the fir trees, several spherical sculptures nestle in the grass, like eggs dropped by an outsize bird. A close inspection reveals that they are all split by fissures, as if the eggs were about to hatch. Instead of fledgelings, though, the fissures disclose clusters of fir and heather which may well have been gathered from the ground nearby. Paul Cooper, who made these cement and granite sculptures, also shows his sensitivity to the location by arranging his five spheres in the form of a spiral walk. They lead us gently around the side of the Small Mansion towards the magnificent downward sweep of the lawns beyond.

As we follow their path, a tall sculpture of flying birds seems to urge us on our way. The topmost bird raises its wings in full flight and a pair of elongated forms, bent like a tautened archer's bow, curve in plunging lines to link it with its companion below whose wings thrust downwards. The effect is elegant and airborne, and its buoyancy is reinforced by the columnar plinth which raises the sculpture high above our heads. Patrick Kirby calls the whole ensemble *Bird Table*, a title which would have been rejected with scorn by modernist sculptors in the past. But there is no reason why anyone should feel ashamed of making a work which can be enjoyed by birds as well as humans. One of the materials Kirby uses is lead, and he likes the idea of making a graceful sculpture from such a heavy substance. He also savours lead's 'long history as a material for garden statuary', and is happy to honour that tradition rather than rejecting it as an anachronism.

In the lower part of the garden, where Cooper's spheres terminate, not every exhibit responds to the environment with understanding. Julian Opie presumably wanted to convey his exhilarated response to the huge arena of grass his sculpture dominates. But the work itself is a classic demonstration of how to ruin natural surroundings. Called *Homage to Spring*, it shows a painted steel boat filled with highly unspringlike roses which tumble on to the lawn along with the gigantic words I FEEL GREAT. It is a naïve and garish insult to its location, and Opie's strident reds and blues only prove how blind modern sculptors can be to the special character of the place their work affronts.

Mercifully, though, the show recovers its true purpose soon enough with Antony Gormley's two versions of a carving entitled *Man:Rock*.

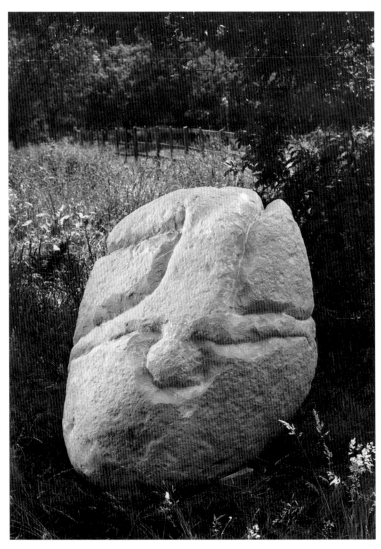

122. Antony Gormley, *Man: Rock 2*, 1982

One of them looks at first like a simple, rough-hewn boulder of Portland stone, but then we notice that the outlines of a man's arms and legs are incised on its undersides. The figure they belong to is hidden beneath, as if crushed by the boulder. But the sculpture gains in conviction from its grassland site, for we can easily imagine that the man has been driven deep into the turf by the weight of the stone. In Gormley's other version the figure is fully displayed, but there is no sense of triumph. This time his body is curved over the boulder, legs askew and arms stretched out as if holding the lump of stone in an embrace. Is he trapped by the boulder, or trying to unite himself with it? The carving is ambiguous, reflecting perhaps Gormley's own double-edged feelings towards the material he uses. At once deeply attached to the stone and afraid of being overcome by the challenge it poses, he has found a memorable way of expressing the sculptor's love–hate relationship with a boulder which tyrannises and sustains him in equal measure.

Nothing else in the park quite matches the direct yet complex power of Gormley's work. But plenty of other sculptors show a lively awareness of the possibilities their surroundings suggested. Mark Long's *Giant*, which my four young children all loved, seems from a distance to be three abstract stone carvings placed inexplicably far away from each other. Then they reveal themselves as a huge nose, a finger and a knee – the only visible parts of an immense figure lying beneath the lawn. If this sculpture had been carried out in an urban space, with a hard concrete or tarmac ground, it would not be so persuasive. It might also seem unduly funereal, whereas here we could almost believe that the giant was enjoying a slumber below the spongy turf.

Elsewhere in the park sculptors respond to nature above the ground. Christine Fox's *The Place* leads us, as its title implies, down a long line of standing slate sentinels towards a centrepiece which holds a blade-like aluminium form in its curved arms. Both sinister and mysterious, this enigmatic monument seems sharp enough to threaten anyone approaching it. But a rope links it with a stockade of stakes curving protectively round the stately cedar beyond, implying that Fox cherishes the great tree and wants to incorporate its dignity and strength in the space her sculpture occupies.

Gerard de Thame goes one step further. After approaching the sign which announces his exhibit, and wondering where on earth it might be, I read the answer: 'this sculpture is in the tree'. Sure enough, his *African Still Life* turns out to be a scrawny vulture perched on a high branch, with the remains of a safari helmet dangling down from his claws as a baleful warning. A light-hearted extravagance, the joke works well

enough. But I preferred the sober, lucid geometry of John Maine's large *Vertical Stones* carving, with its calm white interplay between cylindrical volume and deeply cut recesses. It is a very formal sculpture, almost professorial in its correctness and gravity, but Maine's choice of position ensured that it fused superbly well with its setting. Installed on a terrace in front of the Large Mansion, where it is accompanied by white *jardinières* and a classical arch, *Vertical Stones* seemed inevitable. Despite Maine's use of extreme abstraction, the carving might have been standing there for centuries.

This timeless quality remains my most abiding memory of the whole remarkable event. As I walked back towards the park entrance, my eye was caught by a small stone lying on a flower bed. Having wondered whether it was a renegade sculpture, I discovered from a notice that it was a glacial boulder found in the vicinity. Although thousands of years old, it immediately recalled Gormley's carvings and made me appreciate how attuned his sculptures were to the bedrock substance of the area where they had been positioned. Like Gormley's man impressing his body on the stone, modern sculpture seems on the verge of recovering a long-lost sense of kinship with the places where it rests.

ARTISTS IN SCHOOL RESIDENCIES
7 April 1983

When Picasso met Herbert Read at an exhibition of children's drawings, and confessed that 'I have spent all these years learning to draw like them', he acknowledged a debt many other modern artists have shared. In their desire to arrive at more direct and immediate ways of working, painters as diverse as Klee, Matisse and Miró all envied young children's ability to set down images without any of the inhibitions which so often plague adults. Some artists struggle throughout their careers to recapture the marvellously imperious confidence they possessed as infants. Five-year-olds are unafraid to take wilful liberties with appearances, producing pictures that vividly convey the nub of their intense reactions to reality. Even the most single-minded twentieth-century artists, who may appear to experience little trouble in defining highly individual ways of seeing, have enormous respect for children's spontaneous familiarity with their imaginative visions.

At a time when increasing efforts are being made to find places for artists to work throughout society, school residence schemes therefore offer a great deal of promise. Children hardly ever have the opportunity to meet practising artists, let alone discover how they make their work, and the experience might well prove stimulating for pupils of many different ages. Nor are the benefits one-sided. Plenty of artists would be delighted to spend a term in surroundings which triggered off fruitful memories of their early involvement with image-making. Encountering a child's fresh and unpredictable response may also be a welcome corrective to the opinions of the 'art world', and oblige artists to think again about the fundamental premises on which their work rests. Children, after all, have a habit of voicing the kind of hard, honest questions adults are invariably too embarrassed or polite to ask each other.

The notion of placing artists in schools, even if only for a term, might provoke initial resistance. Some art teachers, jealously protecting their domains, could feel threatened by the sudden appearance of an outsider whose ideas about painting, sculpture and alternative media differ radically from their own. Artists with no previous experience of working in public may likewise be disconcerted by their new setting, where the privacy of the studio no longer exists. Schools can be clamorous environments at the best of times, and retiring temperaments might find themselves incapable of dealing with the exuberant youngsters who invade their work-space.

But a lot of artists are robust enough to withstand these pressures, and all the parties involved in such a scheme ought to prove capable of adopting a flexible approach at the outset. Even the most apprehensive participant could soon discover that the venture yields unexpected pleasures once it is put into practice. Each school is a unique amalgam of staff, building, pupils and locality, and nobody can tell how all these elements might react to the presence of an artist. The only way to find out is to implement the plan, refusing to view it with a closed mind and paying as much attention as possible to the particular character and needs of the institution concerned.

Acting on this belief, a sustained attempt is now being made to place artists in a number of schools within the same area. Armed with funds from an Urban Aid grant sponsored by the Inner London Education Authority, the Whitechapel Art Gallery has organised eight schemes in various East End locations. Previous ventures elsewhere in Britain have always proved sporadic and piecemeal, and no confident conclusions could be drawn from them. But if the current programme is sustained and developed over an adequate period, it ought to provide enough evidence

to establish the principal strengths and weaknesses of the concept. Already, on the evidence supplied by the current projects, the variety of possibilities is becoming clear. Even though all the artists are chosen by the schools, and are expected to make their work accessible to children on an everyday basis, the resemblance between the ventures stops there.

Elizabeth White, selected by Malmesbury Junior School in Bow because of her interest in working directly from observation, spent a whole term drawing the architecture of the building and the views through its windows. The pupils, who had previously received scant encouragement to become interested in art, soon grew curious and started making their own pictures of life throughout the school. Both they and the staff found that White's activities helped them see their surroundings in a new light, and the enthusiastic headmaster raised funds for her to spend a further term in the Infants' School.

Most of the artists found that their efforts were given a similar focus by making works which arose directly from their experiences at the schools. Even so, several of them approached the task in less conventional ways than White. Kevin Atherton gave talks to all 850 pupils in Langdon Park School, Poplar, during the first week of his project, and then took his cue from the discussions that ensued. He also became very aware of the contrast between the playground when it was animated by children's activities, and the bleakness of the same area at other times of day. His work therefore took the form of a sculpture which would enliven this dull space on a permanent basis, and he spent some while drawing or photographing a number of pupils. The staff supported the idea, allowing him to take plaster casts of children's legs, faces and hands as well as fragments of sports bags. Ten casts, representing kids from all parts of the school and one teacher, were then taken along to a bronze foundry and the results positioned on walls throughout the playground. They evoke the movement of pupils in and out of the buildings, but the children immediately began to see them as quirky landmarks which gave a valuable sense of identity to the area.

Although the success of Atherton's venture depended to a large extent on the kids' ability to recognise their friends and classmates in the strange bronze objects protruding from the brickwork, representational work is not the only idiom permissible. At Woolmore Primary in Bullivant Street, Robert Russell completed a large sculpture which, although related to bodily movements, remained markedly abstract in style. But the teachers and children gained a genuine insight into his ideas and intentions from their daily contact with him. No longer automatically hostile towards the degree of abstraction he employed, they bought the

sculpture and installed it in the playground as a reminder of the enjoyment he had given them.

Like Russell, all the other artists were given rooms within the school and allowed to get on with their own work – on the understanding that they would welcome visits at any time and encourage children to collaborate with them. Jean-Luc Vilmouth, at Templars School in Tollet Street, proved so popular with the boys that they spent an unusual amount of time working in his studio. One of the results was a large *Construction of a River* made by a couple of twelve-year-olds with Vilmouth's help. It echoes his habit of improvising with the most unlikely discarded objects. Three old chests, turned upside-down on the floor and joined together with their lids open, have been painted blue and green. Fishes dart up and down their sloping surfaces, while a strange swan-like structure swims towards a boy's head bobbing among circular ripples. It is an inventive, light-hearted work which suggests that Vilmouth let the boys enjoy themselves hugely. As a tribute to the pleasure he provided at the school, Templars have commissioned him to make a sculpture for permanent display in the hall.

Rose Garrard took the spirit of open access one stage further at the Central Foundation Girls' School in Bow Road. Rather than working with particular pupils in a special space reserved for art, she used the

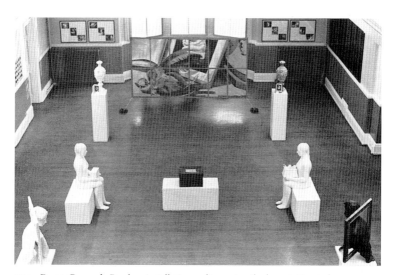

123. Rose Garrard, *Pandora installation: rediscovering the box*, at Central Foundation School for Girls, 1982

school hall as her studio. Everyone was therefore in regular contact with her as teachers and children moved between classrooms. Garrard found a theme which fully matched her central position in the building, too. She immersed herself in the history of the school, and the discovery of an old trunk filled with early Victorian accounts prompted her to use the myth of Pandora's Box as a key symbol. In a series of chaste reliefs and free-standing figures, the school's documents and official photographs are shown floating up from the open box. The pale, melancholy figure of Pandora expresses no triumph, but the sense of release from tyrannical constraints is unmistakable. Garrard places her feminist convictions at the heart of her work, and she left the girls in no doubt that they were just as capable as boys of becoming artists if they so wished.

Not all the schemes have proved such a notable success. Although Kate Blacker spent a rewarding term in Amherst Junior School, where her sculpture helped to suggest new avenues of thought for the teachers and inspired pupils to respond in prose and poetry, Claire Smith found the attitude of staff at Lauriston Primary sadly negative. But she was reassured by the children's interest in her work, and each project has so far justified the considerable amount of money, faith and effort expended. If it is too early to evaluate the enterprise as a whole, all the artists appear to share Kevin Atherton's belief that they gained widespread respect for their work. By discussing their ideas so openly with everyone around them, they managed to discredit the popular prejudice against incommunicative and obscure modern art. It is a signal achievement, laying the foundations for a new and more positive relationship between artists and the wider audience they urgently need to contact.

ARTANGEL IN THE EAST END
20 June 1985

Dark, grimy and regularly filled with the roar of trains overhead, the Beck Road railway arch is not a place to linger in for long. But throughout last week Julia Wood animated its shadowy recesses with a large plasticine outline of a yelling head. Executed on the arch's brick wall with the swiftness of a graffito, this defiant image seemed determined to combat the surrounding noise and gloom. It implied that humanity refused to be cowed, and a smiling profile detached from the head confirmed this feeling of resilience. Projecting from the wall like an inn-sign, it appeared to be dramatizing the point where the arch's darkness gave way to light. And a terracotta figure on the wall, leaping from the face towards the opening of the arch, looked even more positive – until I noticed that his toe had been impaled on some barbed wire in the street beyond.

Wood's blend of violence and optimism also characterised the other works installed in Beck Road. Near the arch a black taxi lay upside-down, half on the pavement and half in the road. It seemed at first to be the victim of a terrible accident, but close inspection disclosed a more playful meaning. David Mach, who was responsible for the work, cleverly ensured that the taxi appeared to be supported by an army of toy figures underneath. Soldiers, divers and assorted Action Men, all with arms raised above their heads, looked as if they were bearing the enormous vehicle in triumph. The macho pretensions of the tiny army were mocked by the absurdity of the enterprise: why would anyone *want* to carry an inverted and clapped-out taxi, after all?

A similar strain of fantasy was explored by Boyd Webb, who placed a large cibachrome photograph called *Trophy* on a roof-top across the road. Like the other outdoor works in this adventurous exhibition, it seemed tailor-made for the site. I viewed *Trophy* while brilliant white clouds floated behind it in a vigorous breeze, accentuating the strangeness and dislocation Webb created. For his photograph shows a naked man suspended in outer space. Clutching three miniature globes against his chest, he hurls another one up towards a coconut perched on a stand. Since two more globes are partially embedded in the planet where the stand is situated, the man's aim is far from infallible. We do not know whether he will succeed next time, and Webb likewise leaves us tantalizingly uncertain about the man's identity. Is he meant to personify God, or humanity exploring space? The question is left open. But this deceptively graceful composition still succeeded in leaving me with a trou-

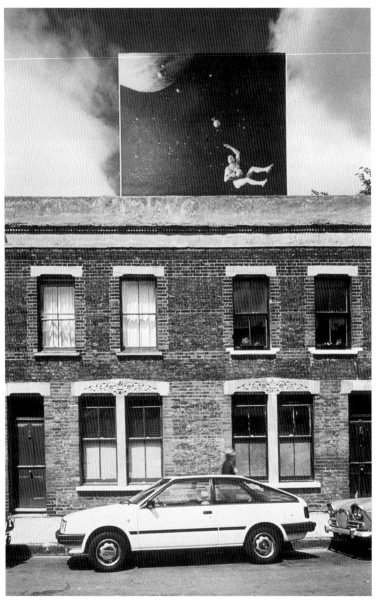

124. Boyd Webb's contribution, *Trophy*, to the Artangel project in Beck Road, London, 1985

bling image of capricious manœuvres, acted out in a cosmos where the planets themselves may soon be treated like targets at a fun-fair.

The apparent precariousness of *Trophy's* position on the roof reinforced the sense of imminent vulnerability which Webb conveyed. In the same way, Hannah Collins contrived to make full use of the façade of 21 Beck Road, where her enormous monochrome photo-print hung from the cornice to the pavement. The blackness of Collins's image, combined with the jagged white lines running down either side of the print, suggested that a hole had somehow been torn in the terrace behind. It was an appropriate illusion, for the upper half of *Things Lived and Dreamt* reproduced a faded photograph of some houses soon after they had been shattered in the Blitz. Unlike Beck Road, which survived the war more or less intact, the rest of the area suffered badly from German bombing. Collins became fascinated by the archive photographs of that destruction, and she used one here as a ghostly reminder of the terrible damage inflicted on the East End. But it is not simply a memorial to the past. The couple sleeping beside a television in the lower part of the print belong to the present, and they appear to be dreaming about the battered building hovering above them. Without making an openly aggressive or disturbing image, Collins created an awareness of the devastation which still threatens to obliterate us today.

All these intriguing street-works were installed with the support of the Artangel Trust, a welcome new 'arts caucus' established to present art in public locations. But on this occasion the outdoor projects were planned in collaboration with Interim Art, who hold exhibitions inside 21 Beck Road and staged last week the *Window, Wall, Ceiling, Floorshow*. Most of the work on view paid as much attention to the specific character of the location as the art outside had done. Tina Keane lodged a video screen in the floor to provide an apt setting for her exploration of hopscotch, while Jessica Shamash used the bath as the site for a heap of ceramic fragments shipwrecked in a shallow stretch of water. But the most effective space turned out to be an awkward, cramped area halfway through the house, where few artists would ever wish to work. Turning its claustrophobic confinement to intelligent account, Stuart Brisley invited visitors to take a seat in the alcove and confront a smudged mirror placed on the cupboard under the stairs. The narrowness of this boxlike place, lit only by a dim red bulb, echoed the feeling of restriction in the tape-loop of Brisley's voice heard on headphones. In a recording which moved from a description of the mirrored alcove to recollections of a Red Army barracks, he repeatedly used a phrase about being 'locked in the ice'. It eventually conjured memories of Brisley

himself, for many of his own performances dealt with caged-in feelings of alienation and helpless solitude.

Nothing else in the house matched the ominous power of his *Conversation Piece*. Upstairs, Jozefa Rogocki had removed the panes from a back window and then bricked it up, allowing glimpses of the garden only through chinks in the brickwork and a distorted circle of glass set in an antique clock. Twigs thrust their way through, as if nature were penetrating the room, and the whole ensemble was made even odder by a neat pair of net curtains. On the whole, it proved a difficult room to transform, however. Waj and Michaela Melian, who were also invited to work in this space, cluttered it with a superfluity of flowers, ascending fish and fairy lights. They became arbitrary and merely fanciful, lacking the conciseness of work elsewhere which allied itself more sparingly to particular architectural features. Walking back down the stairs, for instance, I found myself ducking to pass Julia Wood's plasticine man dangling head-first from the ceiling. Like all the best works on view, this vertiginous effigy made full use of the area at its disposal.

But the most memorable image belonged, in the end, to the street. Stepping out of the house and looking up, I found myself staring once again at Boyd Webb's free-floating figure, forever hurling his globe at a coconut through the star-spattered emptiness of outer space.

LES LEVINE ON THE STREET
19 September 1985

In this country, at least, making art for display beyond the gallery can be an unpredictable and even explosive activity. Works which seem quite acceptable in the context of an exhibition sometimes take on a far more inflammatory meaning in other locations. The distinction was spelled out as long ago as 1908, when Epstein's Strand statues aroused so much controversy. 'Nude statuary figures in an art gallery are seen, for the most part, by those who know how to appreciate the art they represent' declared one disapproving newspaper, before insisting that 'to have art of the kind indicated, laid bare to the gaze of all classes, young and old, in perhaps the busiest thoroughfare of the Metropolis of the world, is another matter'. The fuss generated by Epstein's austere, dignified figures now seems both misplaced and risible. But we have no reason to feel

complacent. If Les Levine had confined his current exhibition to the boundaries of the ICA, the work would not have been attacked at all. He decided, however, to place most of his large posters on eighteen hoardings around Chalk Farm and Elephant and Castle. The plans went well, promising an excellent inauguration for the ICA's welcome new Public Works policy, until the installation began. Then, without any warning, the scheme was frustrated by the bill-posting companies contracted to display his work. Claiming that complaints had been received from the public about the posters, they stopped pasting them up on site and even obliterated some of them with old Christian Aid posters. The ICA is angrily threatening legal action over the affair, and when I asked Levine about it he commented that London seemed a peculiarly censorious city.

Epstein would doubtless have agreed with him, but the adverse response to Levine's work did not centre on prudish condemnation of nudity. The Strand statues were vilified for their anatomical frankness, whereas naked figures are nowhere to be found on the posters. All Levine's exhibits are based on photographs he took in Northern Ireland. The posters do not, however, look like documentary images at all. Using the photographs only as a springboard for his own purposes, he executed a series of oil-crayon drawings. Squared up for transferral to the 10 × 21 ft scale of the final works, they already contain the words which form such a crucial part of the posters themselves. Levine is a conceptual artist of long standing, and over the past decade he has been particularly concerned with exploring the relationship between image and text. He ensures that the figures and townscapes in the ICA sequence are simplified to an almost cartoon-like extent, so that the words are not overpowered by the image they accompany. They retain a measure of independence which is an important element in the posters' impact. For although the massive capital letters are integrated with the design in a pictorial sense, they stop well short of directly illustrating it. Each poster carries a two-word phrase, and they all end in 'God'. The other words are vehement − 'Hate', 'Starve', 'Kill' − and arise understandably enough from Levine's observation of life in Northern Ireland.

Perhaps the people who complained about the posters took offence because they imagined that a blasphemous onslaught was being launched on the Almighty. But they should not have rushed to judgement so swiftly. If they had given themselves more time to look at the posters, and thereby enabled other members of the public to do the same, they would have realised that Levine was aiming at a very different meaning. By superimposing phrases like 'Attack God' on scenes he encountered in

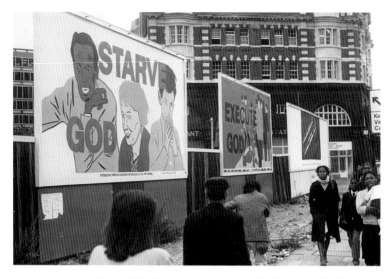

125. Les Levine, *Blame God*, billboard project in the Elephant and Castle, London, 1985

Northern Ireland, he wanted to reveal the ungodliness of the violence perpetrated in that troubled country. Although each heinous act is carried out by men who use God as their justification, the appalling damage they inflict has nothing to do with Christian belief.

This is the essential meaning of a poster such as 'Execute God', which shows soldiers and pedestrians grouped around a shrouded corpse on the pavement. Levine's fascination with the ambiguity of language leads us to discover alternative interpretations, of course: 'Execute God' could mean that the murder was carried out by someone who believed God's will was being executed. But the desolation of the image, and the melancholy expression of the haggard man walking away from the corpse, is in the end unequivocal. Levine sees Northern Ireland as a place where God is exterminated with relentless and brutal regularity. His posters focus on harsh stretches of brick wall, houses massed in bleak rows like prison huts, and children aiming toy guns at each other in front of a large Union Jack. The style he has developed is well suited to the depiction of a bare and cheerless no-man's-land. It is virtually a diagrammatic idiom, emphasizing rigidity to the point where total paralysis is conveyed. Everyone and everything appears to be trapped in a straitjacket of brusque, unyielding contours. It is a sterile world, unalleviated

by any hope of renewal, and Levine makes no attempt to mask its underlying despair.

This chilling mood certainly made itself felt at Castlehaven Road, the only Chalk Farm site where I could find a poster still on display. The words 'BLOCK GOD' were stamped in red across a funereal scene, where soldiers dressed in black uniforms stand behind the cruel grid of a fence draped with barbed wire. They are, presumably, guarding a prison, and one of the soldiers shouts through a megaphone. He may well be warning someone (Levine, perhaps?) that nobody is allowed to loiter near the fence. The raised megaphone obscures most of his face, giving it a sinister, robot-like aspect. But the more I looked at the poster, the more I realized that the soldiers looked oppressed rather than oppressive. One of them stares out of the compound as if longing to escape, and his companions also seem uneasy. They are 'blocked' just as much as God, even though their orders insist that they are themselves responsible for the 'blocking' of entry and exit to the prison. Levine has here produced an arresting image of stasis, and the range of interpretations opened up by his terse phrase ('block' could also refer to 'H' Block) only reinforces the sense of stagnant, forlorn helplessness.

The poster is placed on the corner of Castlehaven Road, where traffic pounds past in an almost ceaseless rush. But Levine has refined the design so well that even the fastest driver could be intrigued by the sight of this uncompromising image. It repays a quick glance far more efficiently, in fact, than the poster positioned at its side. For a long time I puzzled over this advertisement, wondering why on earth UniRoyal Tyres should be promoted by a picture of an explorer staring at a car factory across an icy waste. The answer came to me eventually, but it still seemed muffled and convoluted compared with the brazen impact of Levine's neighbouring exhibit. Instantaneous in effect, and yet capable of yielding rich layers of meaning, it possesses a commanding presence. It also gains from the billboard context, for anyone encountering this stern poster must conclude that it has nothing to sell. There is no instant solution to the tragedy of Northern Ireland, and Levine's work opposes the glib thinking which seeks to persuade people that there might be. All he can do, as an artist who wants to reach the broadest possible audience, is fill the street with images showing how violence takes the name of God in vain.

HANNAH COLLINS AT COLINDALE
20 February 1986

As if serious illness were not enough to cope with, many people enter-
ing hospital on a long-term basis feel acutely disorientated as well.
Deprived of their familiar homes, along with most of the possessions
they cherish, patients find themselves marooned in a clinical environ-
ment. Often alienating and always impersonal, the bareness of a hospital
ward hardly seems calculated to aid recovery. It accentuates distress rather
than alleviating it, and after a while promotes a loss of identity among
those unlucky enough to endure such surroundings on a permanent
basis. The problem is particularly evident in hospitals caring for a large
number of elderly patients, many of whom are unlikely ever to return to
their own homes. They need reassurance, and art could have a very pos-
itive role to play in helping them regain the selfhood they are in danger
of losing altogether.

This, I would imagine, is the belief underlying a thoughtful work
recently installed at Colindale Hospital in north London. Realizing that
an artist might contribute in a valuable way to the renewal of its accom-
modation for the elderly, Barnet Health Authority asked the Public Art
Development Trust to help them secure an appropriate work. After three
artists were shortlisted and invited to produce designs, Hannah Collins
was selected for the commission. She approached her task with
admirable sensitivity and commitment. Seeking to provide something
more than a decoration which took no account of the hospital's specific
requirements, she decided to root her work in the lives of staff and
patients alike.

The allotted site, in the entrance to the building, is positioned at the
beginning of an immensely long corridor. Its bleakness is disheartening,
and the presence of a few exhibition posters does little to counteract the
bare anonymity of its uniform walls and shining floor. Collins sensibly
decided that, after painting the space itself a quiet grey, she would create
a self-sufficient work within this unpromising area – something which
did not depend on its cheerless locale and encouraged viewers to forget
about the institutionalised drabness on every side.

The seven large boxes she has placed on the walls do not, initially,
appear to offset the austerity of their surroundings. Each possesses a sever-
ity reminiscent of a minimal sculptor like Don Judd, and their identical
size accentuates the sense of spareness. But this is no abstract exercise in
pure form alone. Collins places her emphasis on the box as a container,

not as a geometrical slab in its own right. The work on show here has more in common with Joseph Cornell than Carl Andre, and each of these rectilinear vessels is lit from behind to concentrate our attention on the objects arranged on its glass shelves. So although the boxes harmonise with the hospital which houses them, and appear to contain references to X-ray display units and medicine cabinets, their overall meaning is very different. For the shelves, placed in every box against a different background painted in soft colours, carry an array of possessions chosen by their owners to represent the most personal aspects of their lives.

Coming across this accumulation of souvenirs, utensils, trophies and photographs is a curiously poignant experience. Collins visited the homes of all the thirty-five people involved, and the selected objects must differ markedly from the identities they assume in their far less ordered domestic context. Quite apart from the fact that we are looking at coloured photographs of the objects in question, Collins has placed possessions belonging to five distinct individuals in each box. Every shelf is representative of a separate person, and so the ensemble is even further removed from the positions occupied by these objects in their owners' houses. But Collins has not anaesthetised the possessions by transplanting them to such an artificial place. On the contrary: the new arrangement encourages us to look at them in a surprisingly lucid way, undistracted by the clutter to be found in most people's homes.

We notice, for one thing, the sheer strangeness of the choices made by some participants. One person simply contributed two things – an egg-timer and a lump of rock. They sit on their shelf like a couple of surrealist found objects, and lower down the same case Collins has created some extraordinary juxtapositions. An antique sword hangs above one shelf, unsheathed and distinctly menacing. But on the shelf beneath an ornamental card bears The Ten Commandments in ecclesiastical script, while further down still a Lourdes statuette is placed next to a garishly illuminated model cathedral. These two symbols of faith look touching and innocent, suggesting that some people still find consolation in unquestioned traditional beliefs. Elsewhere, though, there are signs of a more disturbing reality which refuses to relinquish its hold over the men and women owning proof of its existence. A notable abundance of military images can be found in these boxes, ranging from a heroic photograph of the *Ark Royal* on the cover of a brochure issued at the time of her launch, to a faded sepia snapshot of a colonial officer astride a horse. In themselves, they reflect the triumphant side of war and exclude its more terrible aspects completely: one lump of wood is identified by a proud caption as a fragment 'from the teak of HMS *Terrible* whose guns

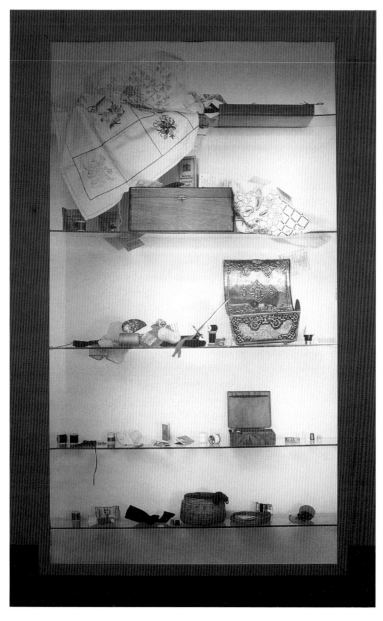

126. Hannah Collins, *Shelf-Situation-Shrine* at Colindale Hospital, London, 1985

relieved Ladysmith'. But taken together, these seemingly innocuous mementoes testify to the lingering memory of armed conflict in so many family histories.

Collins, in fact, appears to be fascinated by the persistence of memory in all the objects on display. She has herself placed a yellow duster in each of the boxes, to signify the role played by storage and conservation in any attempt to hoard the relics of the past. She likewise makes no endeavour to hide the pieces of wrapping paper and plastic bags which usually enfold these possessions at home. One shelf, in a box filled with dolls and Spanish ladies, holds a cardboard package sealed with peeling Sellotape. I wondered why it was there until my eye came to rest on the toy foot sticking out of its corner. By including such containers, as well as the items they are supposed to protect, Collins invites us to consider the urge to preserve. It is as if the destructive passage of time can be halted, for a while at least, by the determination to store surviving fragments in drawers and cupboards. They offer comfort to anyone who has suffered the loss of somebody irreplaceable, and in this respect the presence on one shelf of a gravestone photograph takes on a special pertinence. So do the family snapshots assembled in a well-worn album, the faded wedding group and the cheerful record of a works outing. These are the possessions which people value most highly, and I was struck by the absence from the shelves of anything flashy, expensive or self-consciously up to date.

The past was the focus everywhere, not the present. No one seemed to care about brandishing ostentatious items. They focused instead on possessions as modest as a seaside shell-box, a key-ring collection and even a proverbial little brown jug. By electing to assemble these ordinary but cherished objects, with a gentle precision which accords them genuine respect, Collins turns her unassuming boxes into secular shrines. On one shelf a National Registration Identity Card can be detected among the bric-à-brac, and the entire installation seems dedicated to retaining human individuality with the help of the things people value most. Until now, hospitals have failed to recognise the importance of these talismans in patients' lives. But here, in a spirit of quiet understanding, they are given a place of honour where their true significance is celebrated at last.

SCULPTURE IN THE OPEN

8 May 1986

With as many as one hundred sculptors displaying work on site, the National Garden Festival at Stoke-on-Trent is making a munificent attempt to give contemporary art the public prominence it needs. Vivien Lovell, the sculpture programme's enterprising co-ordinator, points out that the number of participating artists is greater than at any event in this country since the Festival of Britain. Local sculptors and little-known ex-students are given as much opportunity here as more established reputations. Many of them have made pieces specially for their chosen spaces, and valuable experience is being gained from the attempt to work on a grand scale. Since artists will only develop the capacity to animate the world beyond the gallery if they are given appropriate commissions, Stoke's bountiful initiative should be applauded.

But I have no intention of underestimating the difficulties confronting sculptors at such a jamboree. After all, a powerful strain of commercial razamatazz courses through an event promoted by its brazen organisers as 'Festive, Floral and Fun'. They aim at attracting more than four million visitors over the next six months, and to that end a cornucopia of brash attractions will be poured over the unsuspecting 180-acre site. How can sculpture hope to compete for the visitors' attention once the high jinks really begin, with eighteen 'gondola' cable-cars swinging incessantly over the terrain, and a busy railway track winding its way through the thicket of clamorous 'theme gardens' down below? What should the hapless artist do, confronted by the 'roller coaster of thousands of events' which the publicists promise in their breathless promotional hand-out?

I well remember the shock of revisiting the Stoke Festival's forerunner at Liverpool, and discovering how beleaguered some of the sculpture had become. On my previous visit, before the gardens were finished and the public arrived, works as impressive as Stephen Cox's *Palanzana* carving seemed serenely wedded to their quiet locations. But on my return, I found it almost engulfed by a deluge of shops, bric-à-brac and other 'attractions' which had swamped the area in the meantime. Landscape gardeners in the eighteenth century, who rightly believed that outdoor sculpture required placing with great care in contemplative surroundings, would be horrified to find art works fighting for their survival in the showbiz mêlée of a modern garden festival.

Somehow, curators and sculptors alike must combat these difficulties if calamity is to be avoided. Walking round the Stoke site before opening

day, I feared for some of the work placed uncomfortably close to souvenir shops, kitsch garden ornaments and even a funerary carvings centre exhorting potential customers to 'Say It In Stone'. But Lovell and her artists are clearly aware of the problems, and many do their best to counteract them. Alf Loehr, who has been working with the local branch of Michelin for some months, ensures that his forest of black rubber cones asserts its identity above the cars parked nearby. Even so, he has avoided the mistake of detaching his sculpture too much from its setting. The robust yet precise rubber forms relate both to the neighbouring black tarmac, and to the steeples and factory chimneys punctuating the horizon.

A similar awareness of the area's industrial character can be found in other sculptures, too. Vincent Woropay contributes an ingenious brick head of Josiah Wedgewood, Stoke's local hero. Viewed from one side, it is a straightforward portrait, simplified and unostentatiously grand. But from the other side, this clever carving undergoes an extraordinary metamorphosis. The man's features are replaced by a jutting stack of bricks, which look nearly as raw and blatant as Carl Andre's infamous *Equivalent VIII* in the Tate Gallery. Quite apart from engineering an enjoyable stylistic conceit, Woropay appears to be stressing the component parts of his sculpture as a salute to the historic role played by brick kilns in the locality.

Potteries, however, are not the only industry Stoke houses. The festival gardens have been created on the site of a former steelworks, and even now the dramatic roar of rolling mills resounds from some vast sheds still in action. The influence of the steelworks takes its most literal form in Sarah Tombs's *Man at the Fire*, a heroic figure wielding a hammer in a pose reminiscent of the resolute worker in Biró's celebrated Hungarian War Loan poster of 1918. Tombs, who had a placement at the steelworks recently, used the material available there and welded it into a dynamic painted presence. But the triumphant muscularity of her figure looks like a romantic anachronism in the context of Britain's desperately ailing steel production today. A more realistic response to the industrial state of the nation is provided by Stephen Marsden's ironically entitled *Age of Plenty*, which displays on one side a relief carving of a cooling tower. Austere and elegant in style, the image resembles a design on a gravestone. And Marsden told me that his starting-point for the carving was the announced destruction of some cooling towers he particularly admires.

Obsolescence and redundancy are so inescapable throughout the West Midlands that they were bound to be reflected in the sculpture created here. Although the Festival has spawned its share of light-hearted work, like Sokari Douglas Camp's spirited metal *Cock* perched on a pole, the

127. Ana Maria Pacheco, *Requiem*, 1986

most memorable exhibits carry a distinctly melancholy charge. Richard Wilson meditates on decay by assembling rusty car headlamps and spiky wing-mirrors in the shape of a tower. The junkiness of these discarded components makes an eerie contrast with the stern formality of the monument as a whole, rising up from a precisely organised landscape

setting. At night, the tower takes on the guise of a lighthouse: one after another, the headlamps send solitary beams out into the surrounding gloom. They will resemble dying flickers more than affirmative blazes of energy, thereby reinforcing the pathos Wilson has already proclaimed in this memorial to the detritus of a once-great manufacturing region.

The sombre mood persists even when waste-lot materials give way to figurative carvings on a grand scale. Further along The Ridge, an area left mercifully wilder than the rest of the site below, Ana Maria Pacheco is hewing an upright man out of a massive limestone slab. Although she was still working on the figure when I went to see it, the stillness and solemnity of the sculpture had already become strikingly clear. On one level Pacheco intends the carving to act as a requiem, and she has made it in memory of her father. But it is in no sense a portrait. Rather does the figure embody the idea of a man beached on a bed of broken stones, set apart from the world and tethered to a mysterious pile of slates behind him. Far from looking down at the panorama below, his gaze is directed across the landscape towards the horizon. He possesses the compact, bullish dignity of a late Epstein carving, and I hope the relatively untamed character of The Ridge will ensure that his meditative gravity is not unduly disrupted by the arrival of hectic festival side-shows.

A desire to repudiate any hint of frivolity also governs Antony Gormley's *A View, A Place*. As the title suggests, this outstanding sculpture gains much of its power from the locale it inhabits. Although the standing man of lead can easily be seen from far away, where he gleams dully in the overcast English light, the subsequent walk towards Gormley's sculpture becomes an integral part of the experience it offers. For he is positioned at the very edge of The Ridge, and only approachable along a straggling, narrow path which accentuates his solitary stance. The walk completely removes us from the hubbub elsewhere, as well as acting as a preparation for the isolation he personifies. Alone beside a trig point, this expressionless figure resists all thought of using the instrument to survey the site. His eye-sockets are voids anyway, and the entire figure is as empty as the protagonists in Eliot's 'The Hollow Men'. In the company of this stoical presence, all feverish activity drops away and we are left with a sobering, elegiac alternative:

> There are no eyes here
> In this valley of dying stars
> In this hollow valley
> This broken jaw of our lost kingdoms.

MODERN SCULPTURE IN A GEORGIAN CITY

5 June 1986

Bath has become a resoundingly beautiful city without the aid of prominent public sculpture. Apart from Queen Victoria's effigy on the façade of the Lending Library, and discreet reliefs inserted in the sweep of crescents and terraces, the Georgian streets are devoid of statuary. Perhaps the architects who created this seductive ambience thought its epic curves and block-like masses constituted a powerful sculptural experience in their own right. Bath seems such a complete and harmonious environment that it might easily be violated by an ill-considered attempt to install large-scale sculpture in the city's central spaces. So the festival's decision to display an unprecedentedly large exhibition of outdoor sculpture throughout this sensitive locale was daring indeed.

Despite the vandals who damaged one of the finest installations before it had even been completed, I think the decision was justified. Every effort was made by the organisers, Sean Kelly and Michael Pennie, to ensure that the sculptors respected the identity of their chosen sites. Many of the exhibits were made specifically for the places they inhabit, and their makers had special reason to approach the city with the care it deserves. For the sculptors have all been associated with the nearby art college, Corsham Court. Its move to Bath is marked by this exhibition, and so the participants could be expected to show particular understanding in their attitude to the settings their work occupies.

At Parade Gardens they certainly handled the location well. None of the four sculptures placed there disrupts the existing character of the well-tended lawns and flowerbeds. Unlike so many open-air exhibitions I have seen in the past, which cluttered their parkland to the point of outright congestion, these pieces approach their allotted places with tact. Peter Randall-Page's *Fish out of Water*, a stone carving which nestles in the grass, is so modest in size that it might well be overlooked by the hasty visitor. Positioned only a few feet from the banks of the Avon, so that the fish looks as if it has just slipped out of the water, the carving blends easily with its site. It also relates happily to an old sundial nearby, decorated with fish whose undulating bodies echo the serpentine curve of Randall-Page's delicately chipped stone.

A similar chiming can be discovered in Richard Deacon's exhibit, which looks even better from above than it does from the ground. Clearly designed to take both vantage-points into account, the work is framed by old trees when seen from the terrace of North Parade. Its

wood arms wave in the air, as if acknowledging the rhythms of the gnarled branches close at hand. But Deacon's sculpture is not content to establish a dialogue with the forms of nature alone. The arms are attached to a glinting galvanised steel structure with openly exposed rivets. It exists in tension with the wood, serving as an apt reminder that Parade Gardens are situated in the middle of a busy city where heavy traffic continually rasps past. Bath owes much of its attraction to a constant interplay between stern urban grandeur and the softer organic presence of parks and richly foliated countryside. Even in the centre of a city which becomes more bustling each year, the eye can move away from the press of bodies and machines to find glimpses of the surrounding green hills. Deacon seems to be aware of this delightful paradox, whereas Nicholas Pope's contribution to Parade Gardens evokes the prehistoric origins of the city. Four poles of painted wood rise up from a mound and provide support for a weird biomorphic form which appears to float above them. It is a bizarre spectacle, and yet even here Pope contrives to find unexpected correspondences between his poles, the columns of the bandstand and the iron bars propping up frail trees in the vicinity.

Not all the sculptures are as respectful of their surroundings. Over in Kingston Parade, a paved courtyard next to the Abbey, a far less felicitous encounter has been created. Charles Hewlings' large *The Ladder* brandishes its ragged steel components in open defiance of the Gothic buttresses nearby. The proximity both of the Abbey and Roman Baths is daunting competition for any sculpture, and Hewlings' hectic diagonals lunge, rear and dart to little effect. In such a context, where angels can be seen mounting far more impressive ladders on the Abbey's great west end, *The Ladder* looks merely disjointed. It reminded me of the bad old days when large chunks of abstract sculpture were dumped, with an arrogant disregard for their setting, in civic piazzas and precincts all over the Western world.

So I was relieved to find that the other sculptures in the festival exhibition did not suffer from the same failing. A compelling marriage between site and exhibit was arranged by Antony Gormley, who placed a lead and fibreglass figure in the disused Cross Baths. Visible only through a barred window, the man stands knee-deep in water with his hands cupped in front of him. He stares down at them, but a hole in his body ensures that they are unable to hold curative liquid. Forlorn and yet quietly resigned, the bather could well represent a phantom from the era when the Cross Baths were filled with patients in search of remedial treatment. But now the water is scummy, the cubicles deserted and the building itself a crumbling relic of the past. The figure's strange persistence in

occupying this derelict space is matched by his haunting inability to find sustenance there.

Not far from the Cross Baths, I discovered Andrew Sabin's *Modern Industry* in the middle of the city's busiest pedestrian thoroughfare. As befits the location, it offered a walk-through passage which children found irresistible. Half industrial component and half truncated body, this ambiguous object straddled its site with a confidence enhanced by the white ceramic forms wriggling all over a grey ground. It might become as popular a landmark as Denise de Cordova's *East Wind* in Burton Street, a battered marble head contorted with the effort involved in blowing an explosion of stone wind from his mouth. As squat and bullish as a late Epstein carving, the sculpture is already being used by shoppers who find the flattened forehead an ideal resting-place.

Plenty of other sculptures resist such a utilitarian role. David Mach's provocative nuclear submarine of used tyres, a Soviet variant of his noto-rious *Polaris* on the South Bank, rebuffs the onlooker with its boorish assault on a narrow space outside the Assembly Rooms. At the opposite extreme, Michael Pennie's refined, Brancusi-like trio of white limewood women is removed from passers-by on the grass of Victoria Park. But the most outstanding sculpture in Bath positively welcomes us to enter it, wander round its scattered elements and ruminate on its ruins. Anne and Patrick Poirier, whose exhibition can be found at the enterprising Artsite Gallery, have installed an elaborate work called *The Soul of the Sleeping Wanderer* in The Circus. Loosely arranged in a formation which honours the curves of the surrounding architecture, it combines golden classical statuary with broken columns, piles of antique rubble and a golden boat pierced by an arrow. Sharing its Greco-Roman inspiration with the Georgian buildings enclosing it, this dreamlike ensemble meditates on the loss of a remote civilization. At the same time, though, the Poiriers show how an elegy can itself generate new meanings, not only in the sculpture but also in the place where it is housed. Both mourning and revivifying, they have succeeded in transforming The Circus into an arena for their poignant meditation on time, memory and transience.

128. Anne and Patrick Poirier, *The Soul of the Sleeping Wanderer*, in The Circus, Bath, 1986 (detail)

STATE OF THE ART

13 February 1987

Since television does so little to explore the work artists are producing today, *State of the Art* deserves a welcome. Its six hour-long programmes offer an opportunity to scrutinise a broad array of activities, and the seriousness with which its makers address the condition of art in the late 1980s is salutary. After all, the last large-scale attempt to bring modern art to our screens fell conspicuously short of tackling current developments. Although Robert Hughes called his series *The Shock of the New*, he expended most of his energies on the past rather than the present. Indeed, he was quite open about his belief that recent art seemed threatened by terminal constriction, especially in comparison with the inventive exuberance of the modern movement's most heroic years.

So there was every reason why the triumvirate responsible for *State of the Art* – Geoff Dunlop, Sandy Nairne and John Wyver – should concentrate wholly on the present day. Whether or not they feel vastly more hopeful than Hughes about the scene their programmes survey remains uncertain: 'the artists and works selected for *State of the Art*', they explain, 'do not illustrate any single thesis or unifying view of art today'. But it seems fair to assume that they are firmly committed to the importance of maintaining contemporary art's vitality, even if the series constantly warns the viewer against taking an over-optimistic view of the artist's position in society today.

The first programme established this guarded note very clearly, by accompanying images of the modern world's impersonal and disorientating immensity with quotations like the passage from Saul Bellow's *Herzog*, who worries about the 'negligible' status of self in 'a society that was no community and devalued the person'. Over twenty years have passed since Bellow wrote those prescient words, and the difficulties confronting the individual are now still more acute. The artists who make brief, tantalizing appearances in this introductory section tend to share Leon Golub's trenchantly articulate view that everything is 'falling apart'. Positive goals are desperately hard to achieve, and Mary Kelly emphasised the need to be very precise about 'what we're going to attempt to change'. Her remarks were reinforced in the most heartening of the programmes – the fourth, devoted largely to women artists' exploration of 'Sexuality, Image and Identity'. Even so, the rest of the initial programme dwelt on modern art's haunted relationship with history, described by the Roman painter Carlo Maria Mariani as 'a great nostal-

gia for the past and melancholy'. Fortunately, Mariani's listless meanderings were succeeded by the far more impressive paintings of Anselm Kiefer, whose turbulent meditations on the Nazi era were backed up by some powerful camerawork surveying the ploughed fields and epic forests which inspire his art. But despite the sympathetic inventiveness of Jonathan Borofsky, who concluded the first programme with his expansive Californian willingness to meet visitors at his exhibitions and involve himself elsewhere with the plight of prisoners, the sense of formidable obstacles remained.

The second programme did little to dispel this mood. Investigating 'Value, Commodity and Criticism', it stressed the ever-increasing power of the market. Mary Boone, who runs one of the most influential galleries in New York, exemplified a media-saturated world where 'art dealers are more famous than their artists'. So are collectors as extrovert as Douglas S. Cramer, producer of soap operas like *Dynasty* and *The Colbys*. He has amassed an up-to-date houseful of contemporary work, whereas the fictional treasures assembled by the wicked Sable in *The Colbys* seem to consist of instantly recognizable Matisses and Picassos stolen from the great museums of the world.

There is nothing laughable about the effect of voracious millionaire collecting in the 1980s, though. Inflated values abound, fashionable galleries have become playgrounds for the art investment game, and Hans Haacke drily pointed out that crowded American museums tend to 'manage appeasement' rather than promote 'intelligent awareness.' The only definable hope, in a programme awash with misgivings about burgeoning commercialism in art, came at the end of this depressing analysis. American critic Thomas McEvilley was seen tapping away on his word processor in a quiet book-lined room, a lonely figure but one prepared to uphold the importance of remaining proudly independent of gallery pressure.

It was a refreshing moment after the relentless market hype, and the third programme turned out to be the most optimistic of the entire series. Joseph Beuys dominated its investigation of 'Imagination, Creativity and Work', arguing that 'every human being is an artist' with a messianic conviction undiluted by the scepticism of the 1980s. But while I enjoyed seeing Antony Gormley submit to the casting of his own body, or Miriam Cahn immersing herself in the pushing and rubbing of chalk onto paper, the programme suffered from an air of diffuseness.

The presence of an authorial voice might have helped here, explaining more precisely why artists as disparate as Howard Hodgkin and Susan Hiller had been enlisted to elaborate this theme. The makers of the series

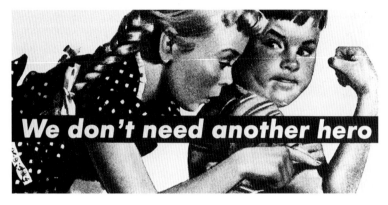

129. Barbara Kruger, *We Don't Need Another Hero*, 1987

deliberately avoided such a voice, in the laudable hope that a more open-ended approach would encourage viewers to make up their own minds. I sympathise with their desire to escape from the convention of The Presenter Who Tells You What To Think, and they managed to reflect the fragmentation of art today in the very structure of their programmes. All the same, reading Sandy Nairne's book of the series made me realise how much of his ability to argue a case had been excluded from the television version. I would have preferred him to play a stronger and more visible role in the programmes, rather than reserving so much of his verbal analysis for the book alone.

There are plenty of other voices worth listening to in the series, most notably during the fourth programme where artists as substantial as Cindy Sherman, Mary Kelly and Barbara Kruger discuss their distinctive attempts to subvert cultural stereotypes. The flowering of women's art has been one of the happiest developments of the 1980s, and this programme gave them enough time to present their views and work alike.

But the subsequent programmes re-establish the earlier pessimism. Terry Atkinson's honest doubts about the ability of 'a socialist art practice' to effect change is followed, in the final programme on 'Identity, Culture and Power', by the alarming sight of Aborigines enacting a desert ritual in a smart urban gallery filled with a white Australian audience. Aboriginal art has become dangerously close to an exotic spectator sport for the very people whose ancestors were responsible for its virtual destruction. And the whole series ends with an equally troubling image of Warhol's collaboration with Jean-Michel Basquiat, once a wild

black graffiti artist on the Lower East Side streets and now the darling of the white Manhattan gallery circuit. It is a depressing conclusion to watch, and yet in Nairne's book his final words arrive at a far more constructive verdict, declaring that today's artists can 'create the fragments of a resistance, working to discover not simply who they are, but how we all might be'. Amen to that.

COMMON GROUND IN DORSET
April 1988

In the most memorable recent attempt by British artists to fuse their work with a landscape setting, Ian Hamilton Finlay and his wife Sue set about making a garden of their own at Stonypath. In this extensive marriage of sculpture and horticulture, which has grown steadily since 1967, the Finlays attain a notably sensitive balance between art and nature. Carved inscriptions to admired painters of the past occupy carefully judged positions within areas of the landscape planted in homage to the work they produced. At every step, object lessons are offered in how to integrate sculpture with the earth it inhabits. Fronting the Finlay's house an English garden contains a profusion of flowers, a walk paved by slabs bearing the names of types of sailing vessels, and a sunken garden harbouring a one-word poem on a weather-worn stone. But as we walk round the house towards the out-buildings, the scale changes from intimacy to grandeur. Against an epic backdrop of the Pentland Hills a small loch appears, created by the Finlays when they dammed a tiny stream, and on the water are glass fishing-floats inscribed with poems. Literature is as important as sculpture in Finlay's work, especially within the Garden Temple where the heart of Stonypath's meaning is located. Inside the building a spirit of stern dedication soon becomes apparent, with carvings on plinths extolling the neo-classical spirit of Saint-Just and the French Revolution.

To move from such a carefully orchestrated site into the countryside itself could easily become a presumptuous enterprise. Many rural locations are cherished precisely because they appear unaffected by human intervention of any kind. The threat of sculptural intrusion becomes even greater when the area is as superlative as Dorset, where the gaunt yet lovely landscape is honoured for its sense of an unbroken link with

primordial origins. Reminders of Dorset's prehistoric identity abound; and since the country already boasts a remarkable array of stone crosses, obelisks and standing stones, the New Milestones Project centred on reviving this tradition in contemporary terms. A proper awareness of the past does not, mercifully, allow degeneration into pseudo-archaic excursions. All the sculptors participating in the venture have resisted the temptation to ape spectacular precedents like the White Horse at Weymouth. The new works belong firmly within their own time, and Peter Randall-Page felt that it would be quite inappropriate for him to produce an image large enough to vie with epic chalk drawings in the hillside. Rather than attempting to compete with the grandeur of the clifftop walk from Lulworth Cove to Ringstead Bay, where the bare land continually gives way to the immensity of the water beyond, he opted for a wholly different course. Deciding that anything on a massive scale would be defeated by the sheer vastness of the area, he produced carvings of relatively modest dimensions instead. It was a well-judged conclusion to reach. Walking up the clifftop, we find our eyes falling with pleasure on the fossil-like forms, each one nestling within a dry stone niche set into the grassy bank. These enclosures reinforce the feeling of intimate encounter which the sculptor wanted to engender. But the carvings still relate very closely to the surrounding country. Their shapes pay implicit tribute to the richness of fossils in this part of the Dorset coast, as well as echoing the ample yet tightly curved rhythms of the hills around the niches.

In total contrast to the wayside-shrine aspect of Randall-Page's work, Simon Thomas elected to place his sculpture out on exposed grass nearby. No enfolding walls protect his four wood carvings from the elements. Inspired by Thomas's discovery that part of the land was devoted to grain cropping in the Bronze Age, their forms evoke the germinating power of the grain itself. Just as Randall-Page had used a hard local limestone for his contribution, so Thomas hewed the quartet of carvings from an ancient oak tree which had fallen on the Weld estate a quarter of a century before. The choice of such a weather-worn material helps to integrate these images of fertility with the earth they inhabit. Lying like four swollen mouths between the centuries-old grain land and the present-day wheat and barley fields, they seem determined to broadcast the delights of ripeness to the four corners of this austere yet beguiling landscape.

In common with Randall-Page and Thomas, Andy Goldsworthy concluded that the Working Woodland site at Hooke Park demanded 'something smaller' than the tree-filled area around his sculpture. But he finally produced two sizable rings on either side of the road at the woodland entrance. Part of the time they act as a barrier to cars, and the sculpture

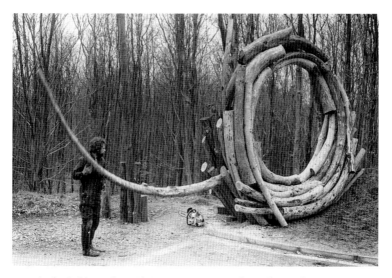

130. Andy Goldsworthy with *Entrance*, 1986, Hooke Park Wood, Dorset

is then at its least resolved. While the two projecting 'arms' fulfil their role efficiently enough, they dissipate the coiled energy contained in Goldsworthy's circular clusters of bent pine. When the 'arms' are raised, and restored to the clusters, they ensure that the work as a whole is charged with tension. It calls to mind Ezra Pound's remark about his celebrated marble portrait by Henri Gaudier-Brzeska. Recalling that the hieratic *Head* 'was most striking, perhaps, two weeks before it was finished', Pound declared that 'there was in the marble a titanic energy, it was like a great stubby catapult, the two masses bent for a blow'. Goldsworthy's bound pine exudes a similar vitality, but the two clusters also seem to proffer an invitation. Aimed at the scale of a walker or rider, they draw onlookers forward, enticing them to penetrate the mysterious darkness of the wood beyond the road.

Goldsworthy's sculpture has already established itself as a local landmark, and Christine Angus's carving will probably perform a related function when she completes it later this summer. Positioned at the meeting place of five paths, it stands on a hilltop which demands that the work acts as a beacon-like monument identifying the eminence it occupies. Angus is eager to make the work fulfil those expectations, and she sees the large vertical stone in the foreground of her triangular site as a marker. But its interlocking structure is also redolent of interdependence

– a theme she considers central to the philosophy behind the Manor Farm whose owners commissioned the sculpture. Since they recently adopted a more organic approach to their work, Angus responded by making all her carvings embody the interaction between delicately balanced natural forces. The planting of twenty-three beech and wild cherry trees will eventually transform the sculpture, and Angus is taking their future appearance into account as she continues working there.

The most epic of all the New Milestones works so far is, without doubt, John Maine's ambitious project at Chiswell. Intended to commemorate the completion of the sea defence system at the village, it will rise in undulating terraces from the coast path. Maine wants each stone wall to evoke the motion of the waves, whose action has exerted such a powerful eroding force at the Portland end of Chesil beach. But between the terraces earth platforms will be created and planted with local grasses, thereby symbolising the regeneration of Chiswell. The scale of the surroundings poses a particular challenge to Maine. He will need to acknowledge its grandeur without imposing on the site a sculpture that violates its allotted space and provokes understandable resentment among people required to accept it as a permanent part of their surroundings. Any evaluation will have to await its completion, but Maine's drawings indicate that he made every attempt to arrive at a thoughtful marriage between image and setting. In this respect, it is fully attuned to the spirit behind the entire New Milestones Project – an initiative dedicated to proving that good sculpture, alive to the demands of the places it enlivens, can become an indispensable part of life in the country.

DAVID MACH
28 April 1988

Among the youngest of the men and women who have revitalised British sculpture during the 1980s, David Mach has never fought shy of working on a spectacular scale. Nor is he afraid of choosing the most unlikely and 'debased' materials for his outsize objects. Before graduating from the Royal College of Art in 1982, Mach built a life-size Rolls Royce from around 15,000 secondhand books for Richard Booth's legendary Hay-on-Wye bookshop. The outcome was at once beguiling and inert. Even as he displayed a flair for simulating the mighty machine with dog-

eared paperbacks and unwanted encyclopaedias, Mach seemed to be mocking the vehicle's inability to function. The great icon of Britain's former prowess as a car manufacturer had been robbed of all its power, and reduced to a symbol of industrial decline bordering on outright absurdity.

Mach always claims that polemical intentions play no conscious part in the shaping of his work. The most notorious sculpture he has so far produced, a scaled-down yet still massive image of a Polaris submarine, was built on a walkway near the Hayward Gallery without any political statement in mind. The idea of making it from used tyres came from someone else, and the work occupied its riverside site with grey solemnity. All the same, the submarine's sober bulk gave it a sinister presence that matched the surrealist ridicule involved in the whole enterprise. Beached among the concrete culture-bunkers of the South Bank, Mach's Polaris acted as an eerie reminder that titanically destructive forces could be lurking even in waterways as innocuous as the Thames itself. The redundancy of the worn tyres also implied that nuclear weaponry, however expensive, has an awkward and wasteful habit of lapsing into obsolescence. But the bizarre humour of the work was underpinned by an awareness of its apocalyptic potential – an element dramatised with gruesome effectiveness when a would-be vandal burned himself to death while trying to destroy Mach's rubber mastodon.

The much-publicised tragedy must have made him acutely conscious of the dangers involved in exposing vast and provocative ensembles beyond the protective embrace of museums. But it did not lessen his commitment to the course of action he had been pursuing. Mach continued to install his sculpture in spaces where the public would encounter it with a sense of surprise, unprepared by the mediation of a gallery ambience. He investigated the possibilities inherent in a wide range of ready-made objects, too, discovering how to recycle back numbers of magazines, empty wine bottles or defunct telephone directories for his own deft and exclamatory purposes.

Sometimes, the aim has been primarily to entertain, for Mach takes a conjuror's delight in his capacity to fashion persuasive likenesses of familiar objects from the most far-fetched materials. At his weakest, he can appear superficial and disappointingly eager to sacrifice subtlety for the sake of theatrical panache. His appetite for grand-slam tactics, while yielding a high level of instantaneous impact, can seem insubstantial once the initial *frisson* has subsided. In his best work, though, this callow ebullience is stiffened by a nagging sense of calamity. The mundane and often vulgar objects he culls from the late-twentieth-century urban world are often caught in the undertow of rhythms impelled by a seismic convulsiveness.

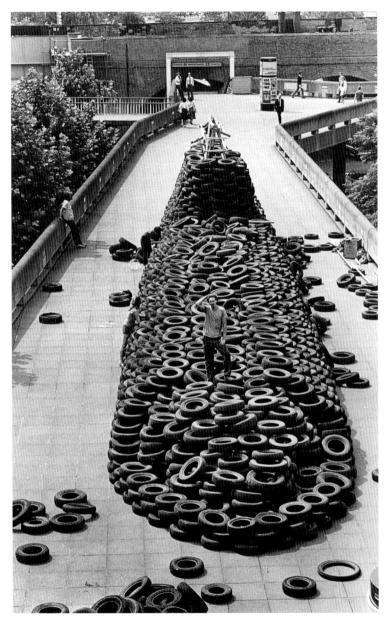

131. David Mach, *Polaris*, 1983, under construction on the South Bank, London

Mach's sculpture is haunted by imminent collapse, threatening the precarious balance he achieves by stacking, slicing and fanning his chosen elements with the flair of an instinctive showman.

All these conflicting forces are brandished in his mammoth installation called *101 Dalmatians* at the Tate Gallery. Another artist might have been cowed by the size of the room placed at his disposal, and reacted by filling it with an embarrassment of over-elaborate exhibits. But Mach revels in the opportunity to operate once again on an epic scale. Visitors entering his space are confronted straightaway by a scene of utter upheaval. Pandemonium has broken out in a domestic interior, tipping up tables, assailing furniture and pitching gas cookers into a state of terminal turbulence. The instigators of this chaos turn out to be the Dalmatians themselves, transformed from lovable household pets into snarling avengers. They bite into the cheap table-legs, tear their way through defenceless upholstery and even gnaw at the enamel surfaces of kitchen hardware.

Nothing will prevent them from completing this wholesale onslaught. The owners of the ravaged home are nowhere to be seen, and Mach does not hint at how the dogs might have invaded the premises in the first place. He simply dramatised the moment of attack, and handles the onslaught with considerable deftness and aplomb. Far from appearing ungainly and bereft of order, the Dalmatians carry out their devastation like performers trained to flaunt their agility. The acts of gnashing, ripping and toppling are choreographed like a macabre ballet, and a perverse feeling of pleasure is generated by the poise with which everything finds itself broken up by the canine maniacs. One of the dogs balances a washing-machine on his upturned nose, like a circus seal doing a trick with a ball. The Dalmatian appears to be courting applause, as if aware of the viewers wondering at his antics. And Mach himself adopts a similar attitude, savouring the nimbleness he has relied on to set the whole deranged tableau into action.

What does it all add up to, beyond the turmoil of animals going berserk? In a far less clamorous installation he produced last year, Mach made china dogs purchased from a gift shop preside expectantly, and somewhat balefully, over a sculpture heavy with savage implications. They have now been fulfilled at the Tate, and the main aim must be to subvert the coyness promoted by these kitsch effigies of doggy devotion. Man's Best Friend has been metamorphosed into Man's Worst Enemy, even if Mach was obliged this time to model his own animals rather than rely on the mass-produced variety. By casting Dalmatians in the role of crazed marauders, he is cocking a snook at the widespread British tendency to

cocoon their pets in an aura of soggy sentiment. For the dogs have now rounded on their masters, ripping apart the accumulation of furniture and appliances which clutter the average Western interior. The time has come for the tables to be turned in the most literal manner imaginable, and Mach manipulates the resulting havoc with a relish he makes no attempt to disguise.

TSWA 3D
14 May 1987

The desire to take art outside the gallery's confines has quickened considerably in recent years. But the outcome of this admirable urge is too often marred by hidebound and over-cautious thinking. After orthodox exhibition limits have been left behind, the true freedom of manoeuvre which presents itself frequently remains unexplored. Instead of responding to the new possibilities with audacity, patrons and artists alike revert to well-tried formulae. More challenging possibilities are avoided, in favour of sculpture parks and other 'safe' arenas where art works can once again be quietly sealed off from more challenging encounters with the world beyond.

There are signs, however, that such stifling timidity is now giving way to a spirit of genuine experiment. With an ambition and initiative which deserves to be encouraged in these timid, cost-trimming times, Television South West has collaborated with its regional arts association on a scheme of almost visionary magnitude. Last week they unveiled TSWA 3D, a nationwide event which enables fourteen artists to tackle sites of enormous and stimulating variety. Flatly resisting the temptation to settle for the predictability of a civic precinct or an office-block foyer, they have secured instead an array of genuinely challenging locations. Some are to be found at the heart of great urban centres, like the portico of St Martin-in-the-Fields or the south tower of Tyne Bridge in Newcastle. Others, by contrast, have been situated in an area as remote as Bellever Forest on Dartmoor. Within these two extremes, other locales offer an intriguing fusion of the civic and the rural. Calton Hill, a prominent and ample mound in the centre of Edinburgh, sets Athenian monuments in a pastoral context which brings city and country into a classical union. As for the Finnieston Crane, still standing on the bank of the

Clyde as a proud yet melancholy symbol of former industrial might, this towering machine occupies a space poised between Glasgow and the water which once provided a livelihood for so many of its inhabitants.

A careful blend has been retained, in TSWA 3D, of outdoor and indoor sites. While the city walls at Derry provide a place commanding extensive views over the communities within and without, the Oratory near Liverpool's Anglican Cathedral constitutes an enclosed chamber permeated with neo-classical memorial imagery. Two galleries have been incorporated in the scheme as well, at Birmingham and Bristol, but only on the understanding that the artists put conventional exhibition display aside to make installations which respond imaginatively to the spaces at their disposal. Such an emphasis implies that gallery buildings, like the sites selected for art work outside them, can be treated as something more than the supposedly neutral, white-walled containers they are expected to represent.

The Ikon Gallery, for instance, is lodged in the middle of Birmingham – an oasis of contemplative calm in a city otherwise jarringly filled with the aggressive forms of post-war redevelopment at its most indiscriminate. Aware of this context, Hannah Collins has devised a photographic installation which uses an invented space within the gallery to propose unexpected correspondences between the Egyptian desert and Birmingham during the Industrial Revolution. Her decision to approach an understanding of Birmingham through the use of archive photographs, which reveal a network of canals more extensive than Venice, points towards the unifying thread running through the entire TSWA 3D venture. For all their diversity, the works show a consistent regard for the full historical implications of the settings they inhabit. Without this understanding, and the determination to make it an integral part of the contributions they make, the artists would have betrayed the richness of potential meaning offered by their sites.

Antony Gormley could never have made sense of his location – Derry's city walls – if the sculpture he placed there ignored the site's political dimensions. Erected in the seventeenth century to protect the interests of the London companies who had invested in Ulster plantations, the walls stand today as an inescapable symbol of the country's enduring divisions. Gormley's cast-iron double figures stretch their arms out in a cruciform pose, thereby acknowledging the plight of a people who continue to suffer from the gulf between Catholic and Protestant. The figures are conceived in a redemptive spirit, too, looking both ways and implying a hope that the separate communities might one day be reconciled with each other.

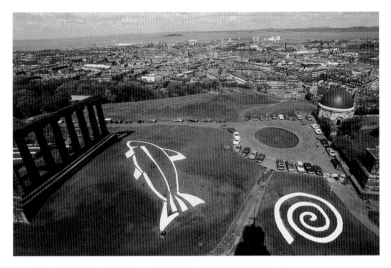

132. Kate Whiteford, *Sculpture for Calton Hill, Edinburgh*, 1987

Other artists uncover aspects of history not so evident in the place itself. Rather than dealing directly with the Hellenic inspiration of the National Monument, which gives Calton Hill much of its Athenian character, Kate Whiteford decided to avoid setting herself in competition with the Parthenon-like architecture. Instead, she has carved into the hillside, depicting spirals, leaping fish, cups and ring markings redolent of the Pictish tradition. Whiteford evokes the prehistoric images cut out of the land's surface elsewhere in the country, and the forms she deploys here refer to a layer of Scottish history far older than the classicism of the National Monument.

Just as her painterly excavations will be wholly visible only from the top of Nelson's Tower, so Ron Haselden's work in Bellever Forest necessitates a climb up the spiralling structure he has installed among the trees. Mounting this belvedere edifice, reminiscent of Bruegel's *Tower of Babel* and yet veiled in green netting to make it as unobtrusive as possible, gives the climber access to a world normally occupied by animals and birds alone. They are the principal inhabitants of Dartmoor, but Sharon Kivland's contribution to Bellever Forest collaborates with the people who live in the area. Inspired by French shrines and grottoes, she has suspended from the trees small wooden dwellings that house souvenirs and other possessions borrowed from local people. They are accompanied by

lights, which glow and twinkle in the forest gloom with an affirmative yet vulnerable brightness.

The hint of frailty in Kivland's work grows to the proportions of outright destruction at Newcastle. Far from cherishing the sanctity of the natural world, Richard Wilson has devised for the Tyne Bridge tower a work which depends on mounting disintegration. As if to offset the incessant speed and noise of the traffic barging past on the London to Edinburgh road, he hangs over 1,000 vehicle components from the tower roof. During the six-week exhibition period, all these hubcaps, bumpers, fuel tanks and ball-bearings will be severed from their catgut lines by a programmed mechanism. One by one, the shining chrome and silver fragments plummet down to join a monstrously redundant heap at the bottom of the tower. Accompanied by a layered sound tape of the sinister crashing ritual, the whole work dramatises industrial obsolescence and, by extension, refers to the remorseless process of unemployment in cities like Newcastle, where human beings as well as machines are severed from their function in life.

A similar dilemma afflicts Glasgow, and George Wyllie's work for the Finnieston Crane acknowledges it with both humour and pathos. He has made a train of straw and, after parading it through the streets with the same ceremony which once celebrated the advent of real trains, slung the replica from the crane's arm. The absurdity of this bizarre spectacle is matched by Wyllie's awareness of Clydeside's proud past. Even as the straw machine dangles so uselessly in the air, its mournfulness embodies the hope that Glasgow will one day enjoy a regeneration worthy of the great crane itself.

It should be clear by now that TSWA 3D has no intention of playing safe. The artists are independent enough to provoke us as well as honour the identities of their sites, and Edward Allington's work is bound to create widespread astonishment in Trafalgar Square. With considerable boldness, he has inserted a colossal baroque scroll in the Corinthian pillars fronting St Martin-in-the-Fields. Hanging over passers-by in the portico, and protruding into the square as well, this hallucinatory object seems to flout its surroundings altogether. But Allington has taken his cue from the baroque spire which caps Gibbs's church, thereby jolting us into reconsidering the true meaning of a site we might otherwise take for granted. Fighting the visual complacency with which we treat our environment lies at the very centre of TSWA 3D's enterprising endeavour.

TESS JARAY AT VICTORIA STATION
9 June 1988

When British Rail invited Tess Jaray to design a vast terrazzo floor for Victoria Station a few years ago, she had no previous experience of making art for a permanent public location. Apart from producing a mural for the British pavilion at Montreal's *Expo '67*, this very private painter had spent her career refining her own, quietly consistent vision of the world. With only rare excursions into the commercial gallery system, Jaray could hardly have expected to find herself involved, all of a sudden, in extending her work on the grandest scale imaginable. But she carried out the commission with total assurance, devoting all her energies to the project until a fully realised solution had been achieved.

The problems involved in making a coherent design for such a space should not be underestimated. Victoria Station's south-east concourse is often crowded and noisy, its frenetic atmosphere chiming with the busy lattices of Sir John Fowler's glass roof overhead. Jaray decided that her design ought, above all, to bring an alleviating calm to the floor at her disposal. So the plum-coloured sequence of lozenges she devised here move across the arena with serene deliberation, asserting an order that derives from a precisely calculated organization of lucid form. All the same, it does not lapse into easy predictability. For one thing, the design's coolly gliding progress diminishes towards the far end, where it concertinas as if to acknowledge the diagonal wall ahead. This gentle slowing strategy impresses its rhythm on us as our feet walk over the floor, signifying the termination of the concourse well before we arrive there. But when Jaray's lozenges give out, their soothing influence is missed at once. For the softly coloured, fine-ground marble chips exert a subdued yet enticing appeal. Their sensuous lucidity offers a corrective to the makeshift profusion of shops, burger counters and information kiosks which increasingly litter modern stations.

British Rail deserve to be congratulated for their foresight in appreciating that Jaray would be capable of enhancing Victoria with such a distinguished floor. But the design elsewhere in the south-east concourse fails to measure up to the high standard she has set, and it is in danger of undermining the integrity of her terrazzo. If BR really do want to improve the appearance of their long-abused stations, they should attend to the totality of the surroundings in their care. They ought also to have let Jaray carry out the second part of her projected commission, which aimed to provide the west concourse with a spectacular sunburst image.

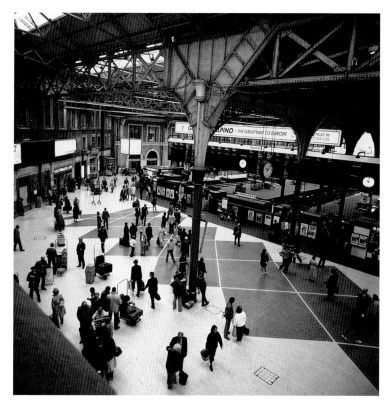

133. Tess Jaray's south-east concourse floor at Victoria Station, London, 1985

Explosive where its counterpart is reticent, it would have offered an ideal complement to the lozenges and animated the west arena with radial axes redolent of a flower fully extended in the sun. But the design was never taken beyond the stage of the intricate studies Jaray made for it, and a far less impressive alternative by another designer has now been installed there instead.

The loss is ours, for Jaray is ideally equipped to provide public spaces with the nourishing grace and exuberance they need. Although the first twenty years of her career were focused on easel paintings created in the studio, the work displayed at the Serpentine Gallery shows just how readily her language lends itself to architectural application. The exhibition surveys her paintings and drawings of the eighties, concentrating on a

body of work which she continues to regard as her central preoccupation. But the forms it deploys, and the references it evokes, continually point towards the intensity of her response to the built environment. As the Victoria concourse makes clear, she is fascinated by the poised geometry of Islamic tilework and marquetry. But a visit to her studio discloses an appetite for a rich array of Gothic and Renaissance sources as well. Photographs of buildings, piazzas and architectural ornamentation are on hand whenever she paints. Whether taken herself on foreign expeditions, or culled from books and magazines, they testify to a receptivity which dominates the images she produces.

Not that they feed her pictures in a literal way. Titles like *Recollection*, *Cadence* and *Diversion* indicate her preference for working at a tangent to the material she uses. Jaray remains, before anything else, an abstract artist. She would never want to provide a straightforward representation of the mosques, naves and pyramids which kindle her imaginative resources. Rather does she aim at equivalents for the awesome structures and decorated surfaces that have given her such profound satisfaction in Italy, Egypt and Syria. Rigorously organised, the units of form which enliven her canvases with their delicate coloured progressions never contain overt references to human inhabitants. Even so, the scale of Jaray's work is intimately allied to the relationship between a monument and the figure who encounters it. 'What other model of measurement do we have than ourselves and ourselves as part of nature?' she enquires, connecting her love of architecture to the fundamental principle of growth found in the organic world. She cherishes the ornament articulating a minaret at Kushnar, or the striped columns in Siena cathedral nave, for the way they 'reveal and unite the structure.' Beyond that, however, she regards them as universal in their implications – springing from archetypes reflecting 'some fundamental and continuous human need, irrespective of time or culture.'

Sparing and yet quietly optimistic, Jaray's work is founded in a defiant belief that contemporary art can deal with constants capable of engaging the sympathies of a wide audience. That is why she is so committed to the importance of testing her art on the most public scale, where it will be encountered by the widest possible audience. The floor commissions which followed her work at Victoria have all been notable for their precision, limpidity and understated warmth. At Stoke-on-Trent, she designed a circular floor for the main entrance in multicoloured brick, welcoming visitors to the National Garden Festival with a festive tondo of floating forms. Its central avenue, no less than the clusters of interlocked rectangles hovering round it, gave people an inviting spatial experience. The design carried out in three-dimensional terms the intentions

underlying her recent paintings, which are likewise inspired by the memory of moving through the places Jaray has found most stimulating.

But even the Stoke commission begins to appear modest when compared with Jaray's current project at Birmingham. A brick floor she designed in 1987 for the city's Midlands Arts Centre, where it fills a space outside the premises with a harmonious circular composition punctuated by saplings, has now led to the biggest area she has tackled so far. Her designs for the vast Centenary Square in the centre of Birmingham are still at a preliminary stage, and nothing has been finalised. Already, however, they promise to transform the heart of this grievously disfigured city with a disciplined yet poetic grasp of art's regenerative potential.

SCULPTURE IN THE CLOSE
21 July 1988

Cambridge colleges have never been renowned for their involvement with contemporary art. Twenty years ago, when I was an undergraduate, the advent of a fierce yellow Anthony Caro was greeted with superior disdain in many common rooms. A few years later, this hostility towards the modern reached a vicious climax when Barry Flanagan's sculpture was completely destroyed by vandals, soon after its installation in Laundress Green.

Sculpture in the Close, an exhibition which has now transformed the grounds of Jesus College, is therefore something of a miracle. Colin Renfrew, the Master of Jesus, whose informed enthusiasm for contemporary sculpture is conveyed in his catalogue essay, has allowed his lawns and cloisters to be occupied by work from half-a-dozen sharply differentiated artists. He pays tribute to the role played by Veronica Ryan, Artist in Residence at the college over the past year. Her organic forms, instinct with a feeling for the materials she employs, express themselves most mysteriously in the lead sheet *Cavities* sunk into the grass of Cloister Court. Far from violating their surroundings, they take their place gently enough in an area which contains the oldest of Cambridge college buildings.

She is not the only sculptor to have made work specially for a particular location at Jesus. True to his long-standing ecological concern for nature, David Nash has taken his cue from the eight topiary bushes

which give Pump Court its quirky character. Their bulging, tilting shapes, which reel almost tipsily across the lawn, have now been augmented by Nash's response. It takes the form of a *Beech Bottle Bush*, an equally idiosyncratic stack of sliced wood standing beside the topiary. Nash's addition looks like an affectionate salute, made by a sculptor whose instinctive respect for the existing landscape leads him to honour his surroundings with humour and sensitivity.

Keir Smith's contribution is, at first, difficult to discern. Made of Jarrah railway sleepers, his sculpture lies very serenely on grass near the most recent of the Jesus buildings. As in *The Iron Road*, which he laid down as a 'track' of objects along a pathway in the Forest of Dean two years ago, he relies here on a cumulative effect. Each sleeper in *Portrait of a River* contains references to a journey along the Medway, and maritime images blend with the railway origins of each block. The sense of a flowing current at times reaches sinister proportions, threatening to lead a rudderless boat into dangerous waters. But the predominant mood is meditative, in tune with the nestling quality assumed by the sleepers on the lawn.

Denise de Cordova adopts a more eruptive approach. A carver who adheres to Epstein's belief in respecting the character of the sculptor's raw materials, she is not afraid to stress the most brutish aspect of the stone. A large *Portrait of a Remorseless Man* rears up from its resting-place, staring at the surroundings with a baleful expression which the college grounds have done nothing to appease. Manic of eye, with a sneer curving his full lips, this big-eared giant barges his way into existence at the end of a curving row of breeze-blocks. He looks raw and clumsy in this context, the product presumably of de Cordova's determination to produce an image untamed by civilities. He also resembles a warning, from a woman anxious never to underestimate man's capacity for implacable aggression.

The two most impressive participants in the show are not, however, at war with their environment. Barry Flanagan's *Bronze Horse* occupies its prime position in the First Court as if it had always been positioned there. It seems absolutely right and inevitable, embodying the sculptor's tribute to the horses of San Marco with poise and dignity. The grace Flanagan displays in this five-year-old work reaches a new pitch of elegance in the more recent *Kouros Horse*, with its slimmer and surprisingly attenuated proportions. Compared with the confidence of the *Bronze Horse*, it appears more vulnerable, too, with a prop supporting its raised front leg. This unease becomes overt in Flanagan's third exhibit, the bronze *Elephant*. Modelled with a far rougher and more broken touch than the horses, perhaps to signify disquiet, he perches unsteadily on a

base too small to hold his weight with comfort. The elephant is stranded, as if forced to occupy his awkward mound by a ringmaster who imposes his alien will on the long-suffering animal.

Equilibrium is restored in the Fellows' Garden, where Richard Long has made a large work specially for his allotted place. In a wide stretch of lawn near one of the most majestic trees in Cambridge, he incised a series of concentric circles in the turf. They show up grey against the prevailing green, and expand quietly outwards like the ripples caused by a pebble thrown into a pond. The rhythms of the work echo the grand circular arena encompassed by the tree, and yet Long's installation does not appear dwarfed by its surroundings. Assured, plain-spoken and at the same time suggestive of primordial secrets, it fuses with the setting in a deceptively effortless harmony.

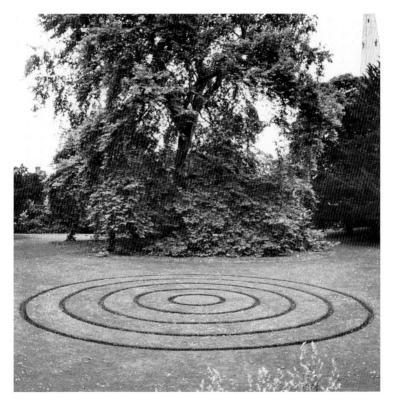

134. Richard Long, *Turf Circles*, 1988, at Jesus College, Cambridge

OLDENBURG AND VAN BRUGGEN:
THE LARGE-SCALE SCULPTURE
4 August 1988

In 1966, when even the most outrageous conceit seemed feasible in London, Claes Oldenburg produced a rash of cheeky proposals for city monuments. One, a cluster of outsize lipsticks extending their pink tips into the air above Piccadilly Circus, has become an icon of that heady period. The discreet sexuality of Eros was hidden within a forest of gleaming phallic cylinders, suggesting perhaps that the metropolis had finally been taken over by the cosmetic industry at its most rampant.

The project never got further than Oldenburg's collaged postcard, subsequently acquired with all due solemnity by the Tate Gallery. Now that Victorian Values have been reasserted with such vehemence, and Eros restored to a pristine state, it seems impossible to imagine that the lipsticks plan ever stood a chance of implementation. But Oldenburg certainly acted as if the whole of central London was his playground. Not content with a single scheme for Piccadilly, he also proposed installing a gigantic drill bit on the Eros plinth, echoing the incessant swirl of traffic around the former island. Another project centred on slicing Swan & Edgar's store with a vast knife, and the delirious artist further suggested that the new Post Office Tower be replaced by a building in the form of a massive office typing machine. Refusing to confine his satirical vision of late-twentieth-century society in any way, he also put forward a colossal monument of fag-ends for Hyde Park. And if litter could be memorialised in this hallowed location, Nelson's Column was not allowed to escape from the subversive onslaught. Oldenburg's swift, decisive use of felt pen, crayon and watercolour set to work on a postcard of Trafalgar Square, obscuring the hapless admiral in favour of a black gearstick. It would, the artist maintained, move in and out of positions like the innumerable small versions manipulated by drivers on the roads far below.

With hindsight, it seems regrettable that nothing permanent arose from this intoxicated yet weirdly analytical obsession with London. After all, Oldenburg went on to realise similar monuments in a remarkable range of civic areas throughout Europe and America. As his Serpentine Gallery survey testifies, he has installed a prodigious array of large-scale sculpture in collaboration with his wife Coosje van Bruggen. Even the notorious lipstick idea was put into practice several years after its Piccadilly genesis, in the unlikely setting of Yale University campus. This time, a single cylinder was assembled on caterpillar tracks. Oldenburg

wanted it to lumber into position and serve as a platform for student speeches, so that orators would be able to climb on the deck and gain attention by inflating the pink stick. Mechanical failure later obliged the artist to settle for a permanently erect plastic lipstick instead, but the monument stands to this day on its site beside Samuel Morse College.

Like all his most memorable sculpture, the Yale piece transcends its origins and takes on a character of its own. If Oldenburg's work merely succeeded in creating blown-up versions of banal objects, the outcome would defile the prominent locations they have been granted. But his instinctive understanding of the potential lurking in the raw material often means that a genuine metamorphosis occurs when the enormous image is installed. Rather than resembling a monstrous lipstick, the Yale column ascends from its caterpillar base with unexpected elegance and dignity. Its cosmetic origins have not been concealed, for Oldenburg wisely savours the tension between his initial inspiration in the everyday scene and the new identity his sculpture acquires. Even so, the 'found' starting-point of the Yale piece is subservient in the end to the alternative presence it assumes on campus, serving there as an unorthodox beacon to the right of free speech and independent opinion in a public arena.

Not all the images erected by Oldenburg and van Bruggen achieve such a transformation. Some of them, like the huge pickaxe lodged in the bank of the Fudda River at Kassel, still seem stubbornly wedded to their original function. But they are the price which the artists have to pay for their consistent adventurousness, a policy which often means that proposals remain stranded on the drawing-board. Potential patrons find themselves shying away from the boldness of an artist who still adheres to his claim, in the early 1960s, that 'I am for an art that is political-erotical-mystical, that does something other than sit on its ass in a museum . . . I am for an art that embroils itself with the everyday crap and still comes out on top.' By no means everyone would be prepared to let such a man put up a painted steel *Batcolumn*, over thirty-three metres high, in front of Chicago's Social Security Administration Building. The objects produced by Oldenburg and van Bruggen have a boisterous presence, unashamed to make a flamboyant appearance in the loftiest of urban precincts. As that early credo indicates, they are likely to administer a polemical sting, too. Although Oldenburg's youthful geniality persists, it is increasingly allied with a readiness to incorporate a strain of protest in the familiar defiance.

Incensed by the repression suffered by both staff and students at the University of El Salvador, the two artists decided in 1983 to produce a

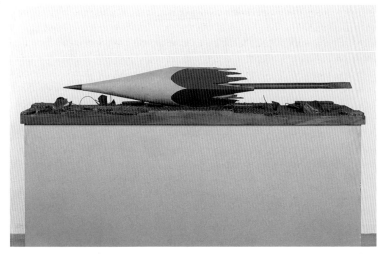

135. Claes Oldenburg and Coosje van Bruggen, *Proposal for a Monument to the Survival of the University of El Salvador: Blasted Pencil (Which Still Writes) Model,* 1983

monument to its survival. They donated to the university a model and engineering plans for a full-scale *Blasted Pencil,* its wooden casing savagely splintered to reveal the graphite rod within. Preliminary drawings demonstrate that they initially thought of sticking the shattered utensil in the ground like an arrow, so that its head would still appear to be capable of writing. But the model opts for a horizontal position, leaving the graphite point suspended above a terrain strewn with fragments of broken pencil. The implications of the wreckage are clear enough, and a writer would find such a shattered implement difficult to handle. But the head is intact, still capable of making marks and thereby symbolizing the steadfast bravery of the university's inhabitants as they continue in the face of demoralizing adversity.

Their fragility is summed up in a study for a print of the *Blasted Pencil* project, where the monument is seen as a tiny image surrounded by brusquely applied strokes of felt pen. For all the vigour, wit and panache displayed in Oldenburg and van Bruggen's work, they remain aware of vulnerability as well. In 1987 they produced an *Extinguished Match* which stretches its scorched, curling length twenty-two feet across the Serpentine's floor. As in the El Salvador model, part of the match remains unaffected by the flame's action. But the other end, burned and twisted,

still rises from the ground like a sinister reminder of the match's destructive potential. The prototype of *Extinguished Match* was included in an exhibition against nuclear armament a few years ago, and more recently in a benefit show for the American Foundation for AIDS research. Lending itself equally well to either context, this sombre sculpture reveals how Oldenburg's consciousness of tragedy has intensified since the days when he so blithely punctuated London with light-hearted exclamations.

Nowadays, he and van Bruggen see their work in more embattled terms, summed up most poignantly of all by their proposal for a sculpture in Middlesbrough. Intrigued by the area's association with Captain Cook, they came up with the notion of a large tilting *Bottle of Notes*, carrying two interlinked quotations. On the outside, an extract from Cook's journals describes how 'we had every advantage we could desire in Observing the whole of the passage of the Planet Venus over the Sun's disk'. Inside, the message by van Bruggen declares that 'I like to remember sea-gulls in full flight gliding over the ring of canals'. So however frail they may sometimes feel as they launch poetic messages in these uncertain times, the two artists are sustained by the delight they obstinately derive from their escapades in the world beyond the gallery.

KEITH HARING
19 October 1991

When he died of AIDS at the age of thirty-one, Keith Haring was mourned by his many admirers as a grievous loss to new American art. They may be right in supposing that his best work was yet to come. But nobody can really tell how he might have developed, and the truth is that Haring had already packed into his brief, hectic career a prodigious amount of hard work, commercial success, international celebrity and the ability to make graffiti-like images which became instantly recognizable on subways, T-shirts, street walls, watches, posters, Grace Jones's body and – when he found the time – galleries and museums as well. Looking back with hindsight on all these frenetic strategies, I am tempted to wonder if Haring ever had a premonition that he might not live very long. He was always in a hurry, forever astounding eyewitnesses with his maniacal capacity to paint a colossal night-club wall in a matter of hours. Even filling a whole exhibition did not occupy too much of a working

week. Roy Lichtenstein shared the general amazement when he went to the Salvatore Ala Gallery in Milan and found Haring 'creating his show right there, on the spot! I mean, the gallery had stretched all these canvases for him, and he was painting a show that would open in two days! It was extraordinary!'

Why was Haring galvanised by such an incessant need for hyper-productivity, not to mention the souped-up media coverage which usually accompanied it? Part of the answer, as a new biography indicates, can be traced back to an adolescent impatience with the parochial sleepiness of his childhood home. It bore the unlikely but oddly appropriate name of Kutztown, PA, and he grew up there as the only son of an electronic engineer who became a manufacturing supervisor at AT&T. Life was conventional, disciplined and extremely frugal. He never forgot the 'total horror' of shopping in the bargain basements with a dominant mother who was fiercely devoted to saving money. Relations with his father were remote, and the young Haring found release only in the zaniness of cartoons. Disney and, more especially, the frantic absurdity of Dr Seuss obsessed him. So did the pop colours and unflagging antics of Daffy Duck or Bugs Bunny on television. They became his alternative reality, and his burgeoning talents as a draughtsman allowed him to make up his own cartoon world at Kutztown Junior High.

Precocious drug-taking may also have quickened his leanings towards frenzied, outsize exploits. Only fifteen when he started smoking pot, Haring soon moved on to the immensely dangerous Angel Dust. A minuscule amount distorted his perceptions so radically that he felt capable of superhuman feats, and his parents were devastated by their son's unrepentant recklessness. Suffocated by Kutztown, where he had already become notorious, Haring lost little time in moving to the Arts and Crafts Center at Pittsburgh. Here he discovered a kinship with an array of innovative artists from the recent past, Pollock, Klee and Dubuffet prominent among them. Then Christo came to give a lecture about his enormously ambitious project in California, covering acres of farmland with his celebrated *Running Fence*. Listening to him, Haring became fired by the idea of making highly public work capable of exciting everyone who happened to come across it – regardless of whether they knew anything about art.

But how could he fulfil such a seemingly impossible aim? The only answer lay in New York, where he secured a place at the lively School of Visual Arts. In the pre-AIDS innocence of 1978, the homosexual Haring soon located back-room gay bars like The Stud where anonymous sex could be enjoyed at will. Just as quickly, he learned how to promote him-

self within the school. 'If he was in a student show,' recalled a contemporary, 'he'd make hundreds of Xeroxes announcing it and hand it out to everybody and put it up everywhere. Some people thought, "What is this guy? He's just promoting himself." A lot of people were really appalled by Keith Haring.' His teachers, however, were impressed. Even though he flaunted his sexuality by concentrating on phallic imagery, Haring scored a hit when he brought 300 drawings of penises into his class. Then he flirted with performance art, sitting quite still in a small, cell-like white room dressed completely in red and wearing a blindfold for three hours at a stretch. But graffiti proved the decisive influence. Haring's arrival in New York coincided with the flowering of inventive sprayed-on calligraphy in the streets, subways and the trains themselves, inside the carriages as well as outside. Realizing that 'graffiti were the most beautiful things I ever saw', he was astonished that 'these kids, who were obviously very young and from the streets, had this incredible mastery of drawing, which totally blew me away'.

Haring was particularly impressed by the scrawled literary graffiti of a practitioner who signed himself SAMO (reputedly short for 'same old shit'). He turned out to be the equally legendary Jean-Michel Basquiat, a black high-school student who would die two years before Haring of a heroin overdose. Convinced that Basquiat was a great artist, Haring began drawing graffiti on the street himself in the winter of 1980.

Inspired by semiotics and the theories about chance advocated by William Burroughs, whom he saw at a convention around this time, Haring set about developing his own imagery. He favoured the form of an animal which came to resemble a dog, its jaws forever open in a bark. He also grew preoccupied with a small figure crawling on all fours called The Baby. Cutting up these images à la Burroughs, and juxtaposing them in a variety of ways to convey different meanings, he drew them on a Johnny Walker scotch advertisement in the subways. It contained a peaceful landscape under snow, providing Haring with a tailor-made white space for rows of his ubiquitous babies. Up in the corners, he drew flying saucers which zapped down into the snow to hit the babies. 'I put rays all round the babies', Haring recalled, 'because they had been endowed with all this power'.

Although he never explained this obsession with magically energised babies, they might well symbolise his belief that the young were poised to take the art world by storm. Graffiti work was proliferating in New York at the time, infuriating Mayor Koch but turning its exponents into underground heroes. Haring got to know them, discovering that they were evenly mixed between blacks, whites, Hispanics and Chinese. He

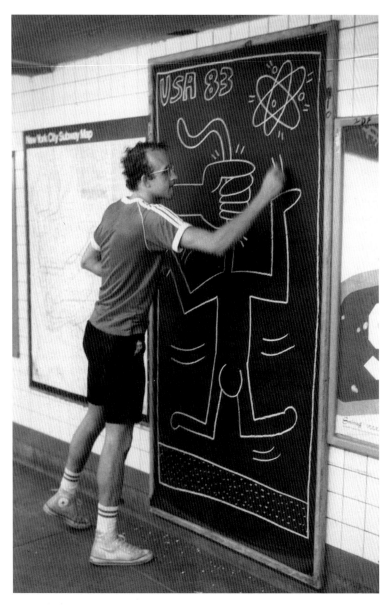

136. *Untitled* (Photograph of Keith Haring drawing in the New York subway), 1983

especially admired the work of Lee Quinones and Fab Five Freddie, the kings of the graffiti world, and they all held an exhibition called *The Times Square Show* in a former massage parlour. The event proved a turning-point, persuading the art community to acknowledge the underground's existence and admire the untutored vitality of its draughtsmanship.

For a while, the entire subway became a giant canvas for Haring's restless activities. Drawing in white chalk on the empty black panels used to cover up old advertisements on the platforms, he moved from station to station executing up to forty drawings a day. They became hugely popular, and prominent collectors like Donald and Mera Rubell began visiting Haring's studio to buy his work. The shows he held at night-spots like The Mudd Club and Club 57 began to sell out. Then Henry Geldzahler, New York's flamboyant Commissioner of Culture, declared that Haring was a genius, and the bandwaggon started to roll in earnest. Even when a cop caught him drawing in the subway, and took the unrepentant artist in handcuffs to the Fifty-ninth Street police station, the arrest ended in triumph. As soon as the other cops realised he was 'the kid who does the subway drawings', they all wanted to meet Haring and shake his hand. So did the gallery-goers who mobbed the opening of his first one-man dealer's show. It was held in a newly fashionable SoHo gallery run by Tony Shafrazi, who in 1974 had himself caused a scandal by spray-painting Picasso's *Guernica* in the Museum of Modern Art as an anti-war protest. People from the club scene and the graffiti world mixed at the private view with art-world luminaries like Lichtenstein, Rauschenberg, Serra and Clemente. CBS-TV gave the exhibition prime-time coverage on Dan Rather's evening news programme, and Haring's national notoriety was assured. He became the graffiti artist who had managed the 'cross-over', bringing his streetwise drawings into the gallery and winning instant acclaim.

Andy Warhol, Madonna and Princess Gloria Von Thurn und Taxis became his friends, and Haring's glitzy new social life-style incurred the disapproval of former allies who accused him of selling out. *Rolling Stone* listed him as 'a person who rips off third-world artists'. Even a close collaborator nicknamed him The Iceman, because 'he's not extremely warm'. And the more Haring diversified his art, by applying his talents to vodka ads, Swatches, a BMW convertible, Madonna's jacket and Grace Jones's naked flesh, the more alienated his old friends became. He opened a Manhattan retail store in 1986 called the Pop Shop, selling inflatable babies, toy radios and an abundance of cartoon-like T-shirts. While the museums refused to buy his work, and critics blanched at the blatant commercialism of his marketing ploys, Haring remained irrepressible. His

facility as a lightning painter of king-size surfaces, whether on the Berlin Wall or a Tokyo roadway, continued to beguile. Moreover, his willingness to produce murals for hospitals and work with children, often free of charge, won him many new friends.

His luck did not last. Haring's former lover Juan Dubose died of AIDS, and then he was diagnosed HIV positive. His phenomenal energy continued for a while, and the whole Keith Haring Inc. enterprise was boosted after news of the illness made his prices soar. Finally, when physical deterioration came, it was swift and savage, robbing him of the ability to draw altogether. But at least he had made the most of a talent which, while lacking in subtlety and depth, injected a boyish irreverence into an art scene which often takes itself far too seriously.

SOUNDING THE ALARM

ANGER AND HOPE IN 1985
19 December 1985

I haven't visited the Victoria & Albert Museum since the Trustees were gracious enough to slap a whopping £2 'voluntary' entrance charge on the place. The protest badges issued by angry members of its staff have, however, occupied pride of place on my jacket for some time. They go some way towards reflecting my deep sense of anger about the whole shameful affair.

The quality of the V & A's collections, and the exhibitions it displays, will oblige me to go back there before long, of course. But I won't relish the experience. Indeed, I abhor the reprehensible notion of a great London museum making visitors feel guilty if they fail to pay at the door. It is an absolute affront to a long and noble British tradition, which has always insisted that public museums funded by the taxpayer should make themselves available, free of charge, to the people who subsidised them in the first place. Why on earth should they be expected to stump up, all over again, each time they want to look at some of the objects they already own? It is a shabby strategy, and particularly hits visitors who like to pay brief but frequent calls on the art they cherish.

The V & A Trustees may try to argue that nobody is forced to hand over £2. But they reckon without the humiliation this scheme automatically inflicts on all the people – schoolchildren, the unemployed, the elderly and parents eager to take their families on a weekend visit – least capable of forking out such a sizeable sum. Do the Trustees really want those people to feel ashamed or guilty as they wander through the galleries? I hope not, but the risk is a very real one. Nobody deserves to be embarrassed about the limitations of their income when they look at the art in our museums. Moreover, the whole point of the great national collections lies in their capacity to encourage the *museum-going habit*, and the V & A's scheme is calculated to make anyone think twice about dropping in to see the Raphael cartoons, the Pisano carving or the Constable oil studies.

At the moment, I am glad to report that the other major central London museums are in no mood to follow the V & A's example. But an alarming precedent has undoubtedly been established in South Kensington, and it is up to everybody who deplores the admission fee idea to make their opposition known as vigorously as possible. Otherwise, the 'voluntary' may soon become 'compulsory' wherever we look, and only the wealthy will be able to afford regular visits to collec-

tions intended by their creators to be for the enjoyment of us all. The Victorians, whose 'values' are constantly being lauded by the government, would have been appalled to discover that their crucial principle of free admission was now being betrayed by the very museum which bears their monarch's name.

The other great cause for concern in 1985 centres on the future of the South Bank. As the co-author of an independent report on the future of visual art on the South Bank, commissioned earlier this year by the GLC, I am especially conscious of its vulnerability. The South Bank Board, which looks as if it will be in overall charge of the site from 1 April 1986, plans to take over the direct administration of the Hayward Gallery from the Arts Council the following year. But as Vincent Dowd pointed out in this magazine recently, the Board does not yet know if the government is prepared to fund it satisfactorily, and I fear for the future of art on the South Bank if cuts have to be made.

The British have an unpleasant habit either of forgetting about visual art's existence, or of questioning its right to exist where contemporary work of a controversial kind is concerned. So I am worried that the South Bank Board, not overpopulated with dignitaries known to count visual art among their most pressing interests, might regard exhibitions as an activity less important than plays, films and concerts. When our report is ready for publication in the new year, I hope to write about its principal recommendations in *The Listener*. But for the moment, it is worth stressing and deploring the fact that the survival of art exhibitions, at the Hayward, the Royal Festival Hall and the newly opened Crafts Centre under Hungerford Bridge, now appears so precarious. The South Bank is one of Britain's most important centres for visual art, and the galleries it contains should never be treated as a dispensable option by politicians bent on dismantling the democratically elected authority of the GLC. Anyone who cares about art in this country ought to monitor the future of the South Bank Board with particular vigilance.

There have, mercifully, been positive developments to celebrate in 1985 as well. Our great regional cities, too many of which have lacked adequate galleries devoted to twentieth-century art, began to make amends at last. In Liverpool, the ambitious suggestion to transform a dockland warehouse into the Tate of the North became a practicable plan. I question the advisability of imposing the name 'Tate' on Liverpool, whose inhabitants may suspect that the metropolis regards their city as an outpost to be colonised. But it is a handsome building in a superb location, and modern art in Merseyside will benefit hugely from the advent of such a grand centre for exhibitions.

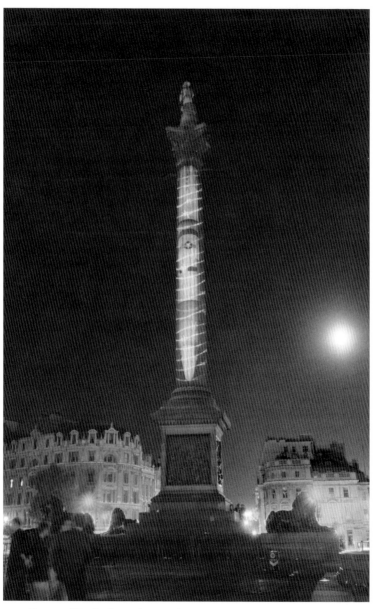

137. Krzysztof Wodiczko, *Nelson's Column*, Artangel projection, London, 1985

The importance of adequate buildings has been demonstrated this year in two crucial places. At Manchester, a dismal lack of commitment to contemporary art has finally been rectified by the opening of the Cornerhouse. Positioned in a prime site, where few will be able to ignore its presence, this gallery-cum-cinema seems welcoming enough to establish itself as an important part of the city's cultural life. The Whitechapel Art Gallery has, of course, played a distinguished role in London for many decades. But now, with its old exhibition spaces restored, an additional gallery for new art, and facilities that include a lecture theatre and an audio-visual room, it is splendidly equipped. More and more galleries are realizing, like the Whitechapel, that the staging of exhibitions should be accompanied by an extensive education programme, which backs up the art on display and reaches towards those members of the public who are not, as yet, well acquainted with art. The Whitechapel area is lucky to have a gallery that recognises its responsibilities in this respect, and devotes so much of its energy to involving the local community.

Contemporary art should not, however, depend solely on galleries to fulfil its potential. Enormous opportunities exist beyond their boundaries, and our society does far too little to encourage the development of art in a broader variety of public spaces. That is why I welcome the arrival this year of the Artangel Trust, which has been set up specifically to fund artists working 'in unorthodox public locations, urban and rural'. It has already collaborated memorably with two galleries, Interim Art and the ICA, on ventures in the street. Krzystof Wodiczko's arresting projections on Nelson's Column and the Duke of York Memorial dealt with the myths and ideology of civic architecture, while Boyd Webb and David Mach were among the artists who enlivened Beck Road in East London with specially conceived works for a pavement and rooftop. The Artangel has also helped to finance Stephen Willats's exploration of the residents' lives at a Brentford tower-block, and Mark Ingham's work in several sites along a Peckham canal.

At the moment it is supporting Andy Goldsworthy's activities on Hampstead Heath, timed to coincide with a retrospective of his photoworks at the Ecology Centre. Concentrating on outdoor projects, Goldsworthy uses the natural elements around him to make works which range from the permanence of rock to the evanescence of snow. He should be well worth encountering in the gallery and on the Heath, and I can safely guarantee that no 'voluntary' admission charge will be requested before you see his work.

ART ON THE SOUTH BANK
20 March 1986

Looking round the barren, wind-buffeted starkness of the South Bank today, it seems almost impossible to believe that the whole dreary site once played host to the Festival of Britain. For this exhilarating event, staged in 1951 as a 'tonic to the nation' after the long years of war, offered a welcome corrective to the prevailing mood of austerity and fatigue. No hint of humourless, monolithic planning could be found in the cheerful cluster of pavilions and restaurants erected for the festival. The buildings included structures as remarkable as Wells Coates's inventive Telekinema and Ralph Tubbs's Dan Dare-like Dome of Discovery. Everything was conceived in a celebratory mood, and the public duly responded. More than 100,000 visitors came every day, excited by the prospect of a brighter and more affirmative future. Artists played a vital role in the proceedings, too. There were specially commissioned sculptures by Epstein, Moore, Hepworth and Paolozzi, murals by Nicholson, Pasmore and Piper. Towering over them all was the dramatic Skylon by Powell and Moya. Soaring up from its angular launching-pad like the space-rocket Britain could fantasise about but never afford to build, it became for a while one of those rare monuments which help to supply a city with its popular identity.

What a contrast this friendly festival offers in relation to the South Bank of today! After nearly all the commissioned buildings and art-works were swept away by the incoming Conservative government, a terrible *rigor mortis* gripped the entire site. Over the next thirty years it came to resemble an accidental dumping-ground for isolated cultural monuments, each pursuing its own interests regardless of the area's overall context. As a result, it is today a bleak and strangely inert locale. Although the South Bank can still spring into spectacular life at weekends, especially when the GLC held its Thamesday festivities, the public areas look desolate most of the time. The outdoor walkways are so exposed that they appear uninviting, while the dark, dirty and extremely smelly regions underneath are even more successful at deterring anyone from entering them. Large stretches of the Jubilee Gardens remain undernourished, while the children's playground is too near a busy road and invariably deserted. A number of the arches beneath Hungerford Bridge are closed to the public, used merely as storage areas. They look shabby and generate a gloomy, stagnant atmosphere. As for the car parks which occupy so much space throughout the area, they should never have been allowed such prominence. Their

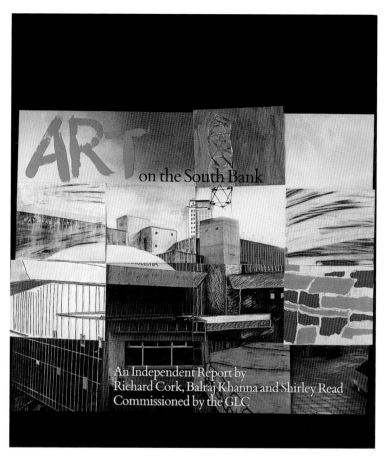

138. Cover of *Art on the South Bank* report, Greater London Council, 1986

presence gives the South Bank an alienated air, suggesting that it is meant for machines rather than people.

It is ironic indeed that an area containing so many buildings dedicated to the nation's cultural vitality should be, in some respects, such a waste-land. And it is even more ironic that the Hayward Gallery, which has housed so many splendid exhibitions devoted to the finest achievements in both art and architecture, should be the most bunker-like of all the South Bank's arts buildings. Squat, boorish and offensive to the eye, its

grim hulk makes no attempt to entice the visitor inside. Nor is the Hayward's harshness alleviated by the bare, exposed walkways around it. People might reasonably expect a gallery's faith in visual art to be reinforced by a sculpture or mosaic outside. But the Hayward is marooned in a depressing expanse of unembellished concrete, which implies that art has no role to play in the public spaces of today.

This week, just before the GLC is finally abolished, it publishes an independent report called 'Art on the South Bank' written by Balraj Khanna, Shirley Read and myself. The document examines the future of visual art on the largest arts complex in the world, a site about to be taken over by the newly created South Bank Board.

All through the researching and writing of our report, we were guided by the conviction that the South Bank urgently needs an injection of the vivacity, resourcefulness and imaginative flair which once made the Festival of Britain such a delight. For this 270-acre site, which already attracts two and a half million visitors each year, has enormous potential. An exciting new Museum of the Moving Image will soon be added to centres that include the Royal Festival Hall, the National Theatre, the National Film Theatre, the Queen Elizabeth Hall and the newly opened Craft Centre. With the Hayward Gallery right in the middle of this extraordinary group of major venues, the South Bank is well placed to provide the widest range of visual art for the broadest conceivable audience, irrespective of race, class, age and gender.

But how can this marvellous potential best be fulfilled? The answer, in our view, takes a multitude of forms. Any visual art policy for the South Bank must consider the area in its entirety, and emphasise first of all the need for greater co-ordination between the various centres. None of them makes enough of an effort to publicise information about the exhibitions on display at other buildings, and there has never been an attempt to collaborate on an exhibition which uses the resources of them all. So a regular liaison should be established between the staff in charge of exhibitions at all the centres. And every so often they ought to join forces on a major event, so that different aspects of the same subject can be explored simultaneously in several venues. Collaboration should also be extended to embrace other art-forms as well. If, for example, a survey of African art were mounted at the Hayward Gallery, African drama, music, dance and film could be examined at the theatre, concert halls and the Museum of the Moving Image. But on a day-to-day basis, the exhibition directors in the South Bank buildings ought to establish common ground in policy-making and issue joint publicity sheets listing current and forthcoming exhibitions at all the centres. It would certainly

encourage people to use the South Bank more fully, rather than visiting a show at, say, the Hayward and then hurrying away without even thinking of other activities in the vicinity.

All the buildings would stand to gain from this greater sense of integration, and they would likewise profit from jointly drawing up a coherent strategy about how to deal with the exterior spaces around them. Since the Hayward is the 'headquarters' for visual art on the South Bank, its staff are well-positioned to spearhead a programme of commissioning sculpture, mosaics, projected light-works, banners and performance events for these areas. The advent of the Museum of the Moving Image opens up possibilities for artists using television as a medium, through the installation of heavy-duty screens on outdoor sites.

Co-ordinated decisions should also be made about the best way to develop other exterior facilities, like the stalls and bookshops which have already begun to appear on the South Bank. They deserve to be encouraged as warmly as possible, for the success of Covent Garden as a pleasurable urban centre depends to a great extent on the markets, shops and cafés it contains. The South Bank should aim to foster a similar range of attractions, and the street entertainers who make the Covent Garden piazza such a delight could also be invited to animate the South Bank with their exuberance.

If the dismal walkways were dismantled and the car parks taken underground, the whole site would be transformed. But there is one particular area where galleries, shops and pubs ought to spring up: in the arches beneath Hungerford Bridge. The Hayward has much to gain from the introduction of galleries here, for they would help to establish the South Bank in the public's mind as a place where contemporary art can be bought as well as displayed. Similarly, other arches could be taken over by a cinema or an experimental theatre group. Their advent would turn the site into a centre for arts activities of an innovatory kind, as opposed to an area where monolithic buildings are unaccompanied by alternatives to the programmes they present. Anyone who doubts whether the dingy, damp and derelict arches are suitable for such developments should visit the welcome new Craft Centre. The success of the elegant and convivial Archduke Restaurant likewise proves that the pleasure-principle can flourish underneath the bridge, and that the arches could be converted into highly attractive spaces which people will enjoy visiting.

Ultimately, though, any visual art policy for the South Bank must focus on the galleries it contains. Because the Royal Festival Hall is not recognised as a 'proper' art gallery, the shows it stages are rarely reviewed as extensively as they might be. But the GLC's admirable 'open foyers'

strategy has meant that the exhibitions held there can command up to 30,000 visitors each week – a built-in audience which many other art galleries would surely envy. The broad range of subjects explored in these shows also promotes the notion that they are not intended solely for the initiate, and we would like this success to be built on. Without in any way pretending that the Royal Festival Hall is an exhibition venue equal in importance to the Hayward Gallery, or tampering too much with spaces never intended to serve as galleries, the RFH ought to be better equipped for the exhibitions it mounts. An Exhibition Organiser and two Assistants should be appointed there, to develop an adequately funded and planned policy and improve standards of display in the existing gallery areas. Armed with these improvements, the RFH could pursue an exhibition programme ranging beyond the 'fine art' boundaries of most Hayward shows. It has already staged acclaimed exhibitions of both Scarfe and Steadman, and other aspects of the cartoon, caricature and poster traditions could well be surveyed in future. So might architectural, environmental and historical exhibitions about London, as well as shows devoted to art for the blind and for children, who need to be encouraged to visit the South Bank more frequently.

But the most complex and challenging task is reserved for anyone prepared to tackle the shortcomings of the Hayward. At the moment it is, quite bluntly, under-used. The gallery is only open for nine months of the year; the distinguished exhibitions it stages are not backed up by a full-scale educational programme; the staff run it at a distance from the Arts Council's Piccadilly headquarters; and the Hayward fails to offer visitors a proper welcome with its cramped foyer, minuscule bookshop and bleak, undernourished cafeteria. So the first step must be to appoint a full-time Director of the Hayward, with overall responsibility for the creation of a clear direction for the gallery. The administrative staff should also be increased, so that they can take on a much-expanded educational role. The gallery itself ought to become their permanent working base, and here they could create a sense of involvement with the local population. The South London area is, on the whole, very poorly served by art galleries compared with north of the river, so the Hayward should try to establish genuine links with its neighbourhood. One way of achieving this aim would be to launch an ambitious programme of placing artists in a variety of settings throughout the locality: in schools, hospitals, factories and so on. The gallery could thereby establish relations with people who, at the moment, are unaware of its existence.

Alongside this development of local roots, the Hayward must also expand its international horizons. The attraction of the gallery lies in its

ability to mount an extraordinary diversity of major exhibitions, from Indian sculpture and Celtic art on the one hand to Picasso, Matisse and the ubiquitous Hockney on the other. But this advantage can become a weakness, and the Hayward's programme sometimes seems arbitrary and capricious. Instead of moving round the map of world culture without a fully coherent purpose, it should announce its determination to counter the British habit of concentrating on Euro-American art. The Hayward ought to replace this narrow view with a genuinely international outlook, embracing the Third World countries which so rarely succeed in displaying their work in any of our galleries.

None of these ideas can be fully implemented without a substantial increase in the Hayward's space. An extension should therefore be built, not only to allow a significant expansion in activities but also to make the grimness of its façade more inviting. It entails making the entrance more ample and welcoming, as well as providing space for an enlarged foyer where a greatly expanded bookshop can be situated. Upstairs, a proper café, a lecture theatre and an education workshop could be built, and a glass dome or pyramid erected on one of the sculpture courts to create a conservatory. Light, airy and colourful enough to counter the surrounding grey concrete, the extension should also include a glazed extra gallery at first-floor level to house exhibitions of new art. Contemporary artists are not shown very often at the Hayward. We would like the new gallery to change all that by presenting exciting developments in art as they occur, without being afraid of provocative innovation. New art of this lively, questioning kind would invariably encourage us to see historic exhibitions elsewhere at the Hayward in a stimulating new perspective.

All these recommendations, and the many others made in our report, will need financing. The South Bank Board, whose membership requires broadening to incorporate a far wider spectrum of cultural interests, faces a formidable challenge in its efforts to raise funds for the task ahead. But the potential rewards are inestimable. We believe that this unique site could be turned into a powerhouse for art in Britain, and that not a moment must now be lost in restoring the festival spirit to the South Bank of the future.

HEATHROW BLUES

25 September 1986

'Welcome To Terminal 4' proclaims a bright yellow banner outside the façade of a building described by the Chairman of the British Airports Authority, Sir Norman Payne, as 'Europe's most modern international gateway'. I certainly needed a welcome, after driving down an arid dual carriageway past rows of identical Monopoly-style houses to arrive at the long-term car park ('for spectators'). Fenced in by barriers eerily reminiscent of a concentration camp, I left my car in Lane 3 of Zone A and caught a bus to the terminal itself.

What kind of experience is on offer there, in a £200 million show-piece intended by architect Ken Gilham 'to instil confidence in the air-line passenger'? Its festive banner notwithstanding, the building's initial impact fails to reassure. In front of the façade stands a multi-storey car park, depressingly similar to the kind of uninviting structures found in redeveloped city centres all over the country. The terminal entrance itself strives to redress the balance by brandishing a cat's cradle of tubes in the projecting canopy. But this attempt to emulate the high-tech boisterous-ness of the Pompidou Centre in Paris ends up oddly muted. For the tubes are rust-coloured ('terracotta' according to the promotional litera-ture), and they are attached to a silver exterior box which extends a greeting no warmer than an aggressive factory frontage.

Inside the terminal, this distinct coolness continues to prevail. Dominated by a ceiling packed with stainless steel service ducting, fash-ionably exposed, the concourse stretches away to an infinity as enervat-ing as a mega-supermarket. The analogy is reinforced by the trolleys parked at frequent intervals, the long row of check-in counters and the Skyshops where travellers can burden themselves with even more bag-gage than they had before. But instead of supermarket muzak, the only sound to be heard on the public address system is flight information and, with unsettling regularity, security warnings about unattended suitcases and the need for incessant vigilance.

In order to cheer myself up, I wandered into a bookshop lined with shiny paperbacks. Even here, though, the message was ominous. Under the heading 'Holiday Reading', my eyes kept alighting on titles like Alistair MacLean's *Night Without End*, its cover sporting an apocalyptic picture of a burning jet smashing into an ice-cap. Nor did I draw any comfort from Betty Toottell's *All Four Engines Have Failed*, even though it professed to tell 'the true and triumphant story of Flight BA009 and

the Jakarta Incident'. Titles like that gave an alarming new meaning to the supposed jolliness of a nearby sign saying 'Buy Here, Buy Now, Bye Bye!' It didn't sound as if they expected you to return, and no amount of Harry Heathrow Bears or Concorde Child's T-Shirts elsewhere in the shop could banish my scepticism.

There is, of course, a certain excitement to be derived from a building flickering with the names of so many tempting destinations, from Khartoum to Hong Kong. They give the heady impression that the entire globe is within reach, and no amount of familiarity with airports can altogether blunt the *frisson* created by all those flashing words. But the design of Terminal 4 fails to capitalise on this sense of quickening anticipation. Instead, it provides an experience seemingly calculated to dull the brain. Presumably in an effort to clear the building of anything that might impede passenger flow, the designers have omitted to provide any images which divert and enliven. Utilitarian sign-boards, triangular in form with a mesh motif reminiscent of the grim fencing in the long-term car park, carry advertisements for the delights of the Petits Fours Restaurant, the Forecourt Self-Selection Cafeteria and T4 Two (get it?).

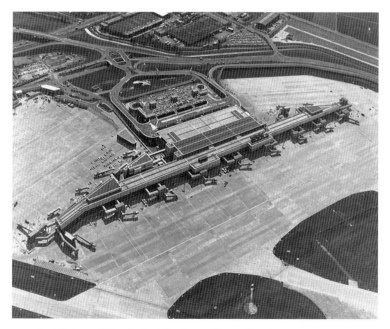

139. Aerial view of Terminal 4, Heathrow Airport, London

Nevertheless, the busy graphics employed here, bending tennis-players, pianists and waiters into the all-pervasive shape of a '4', were not backed up by lively imagery elsewhere in the terminal.

A glossy brochure on its 'Technical Profile' boasts about 'BAA's policy of providing an on-going and high level art programme in its airport buildings'. But their level is so 'high' that they have become well-nigh invisible. Apart from an unpleasantly synthetic wall-hanging, displayed between two long boxes filled with equally plastic-looking plants, I could find no evidence of art playing a prominent part in the main halls. Although passengers do encounter murals and a sculpture while reclaiming baggage and leaving customs, spectators like myself are given nothing to alleviate the anodyne functionalism of the concourse. Only in the lavatory did I find myself staring at two screenprints called *Aeneas I and II*, but these bland evocations of mountains and sky are the epitome of vapid 'airport art'. The artist has been sensible enough to hide behind an indecipherable signature, so no blame can be attached to anyone except the official who purchased such supremely forgettable work. Walking round the terminal, with its endless succession of steel panels divided by discreet vertical 'terracotta' slits, I grew angry with the realization that a great opportunity had been lost. For this building could so easily have prompted the imaginative commissioning of large-scale work by adventurous artists throughout its public spaces.

Timidity triumphs, however, not least in the restaurant area where decoration of some kind is urgently required. The softly lit Petits Fours room displays predictable framed photographs of Tourist Britain on the walls, and in Four To The Bar a statue of a dinner-jacketed pianist extends silver-painted hands towards the keyboard. But nothing relieves the visual mediocrity of the Forecourt Restaurant, where an awkward blend of geometric modernity and 'old quarter' ironwork can be found. My reaction to this particular venue is, admittedly, soured by the prices charged there. I took children with me, and discovered that five jam doughnuts cost an incredible amount. Still indignant about such an extortionate mark-up, in a terminal which knows all too well that no alternatives are available to the hungry traveller for miles around, I sat down on a grey rubber chair. Its seat turned out to be divided into two impeccably neat halves, with an avant-garde gap between them. The 'design concept' behind that little innovation left me baffled, and my disgruntled mood was shared by a man at the next table. 'You'd think in this day and age, when people can get to the moon,' he said in a loud voice, 'that they'd be able to make a teapot which poured.' The streamlined efficiency of supersonic travel does not, it seems, extend to British Airways' catering facilities.

The visit might have been redeemed if Terminal 4 provided a spectacular viewing area for anyone who enjoys watching planes taking off. But here again disappointment set in. Although side windows offered a chance to watch preliminary manoeuvres, the runway itself proved invisible. A jovial PR officer admitted that the roof of Terminal 4 could have afforded a marvellous viewing platform: 'it's like Brighton beach up there', he said, 'with pebbles and a railway track'. But the building is simply not strong enough to support quantities of visitors on the roof, and anyway – the Airport Controller 'doesn't like spectators'.

The feeling is mutual. I don't like the people responsible for perpetrating Terminal 4, which seems so preoccupied with its high-tech prowess that human needs have been overlooked. Impersonal, sterile and fundamentally inhospitable, it refuses to implement the welcome promised by the banner slung so deceptively across its gleaming façade.

CRISIS IN THE ART SCHOOLS
18 December 1986

At the Service of Thanksgiving for Henry Moore, held in Westminster Abbey on 18 November, Mrs Thatcher was a prominent member of the congregation. She presumably attended in order to honour the achievement of an outstanding sculptor, whose career proved that it was possible for a modern British artist to gain a high degree of international acclaim. But Moore himself, an ex-student of the Royal College of Art and a stalwart defender of British art schools, did not approve of what Mrs Thatcher was doing to the nation's art education. For the blunt truth is that she presides over a government whose policy towards art schools has been described by Patrick Heron, the distinguished painter and Tate Gallery trustee, as 'a total disaster'.

Heron's impassioned condemnation is borne out by the cries of alarm from art colleges all over the south of England. Within London itself, schools as sturdily independent as Chelsea, St Martin's, Camberwell and the Central now find themselves enclosed within the voracious body of a new mega-authority called The London Institute. But they are not the only colleges who feel that their very identity is threatened by this insatiable bureaucratic appetite. Angry protests can now be heard from Wimbledon, Maidstone, Canterbury, Stourbridge, Falmouth, Winchester,

140. Wimbledon School of Art, London

Great Yarmouth and Southampton, all of whom fear that they will be swallowed up by similar predators before long. The recent move to merge Wimbledon School of Art into the vastness of Kingston Polytechnic prompted a letter to *The Times* from signatories like Sir Roy Strong, Roger de Grey, Peter Blake, David Puttnam and Sir Peter Hall, united in their belief that 'such a merger will do irreparable harm to a school of international renown'.

Why are so many of Britain's major art colleges battling against strategies which, they feel, could lead to extinction? The short answer lies with three initials that have taken on a sinister significance over the past year: NAB. This suitably nasty little abbreviation stands for The National Advisory Body for Public Sector Higher Education, a quango created by the unlamented Sir Keith Joseph when he was still hard at work decimating the entire education system. NAB's main brief is to demand savage monetarist cuts throughout higher education, and the art schools soon felt the full slashing force of its blade. In the summer of 1985 Falmouth School of Art was dismayed to find, on the strength of a one-day visit by a single NAB member, that it was faced with virtual closure. Falmouth's bewilder-

ment and distress were accentuated by the astonishing fact that the NAB official who came to inspect them had nothing to do with art education. He confessed, during his flying visit, that he was an ex-army officer – a qualification which presumably made him ideally fitted, in NAB's view, to be a Thatcherite hatchet-man.

This military onslaught did not intimidate Falmouth for a moment. Although only a small school, it succeeded in marshalling the fierce indignation not only of artistic luminaries like Henry Moore, but the entire Cornish establishment as well. The county became understandably incensed by this threat to its only art college, and the campaign for the defence was conducted with such martial vigour that NAB's forces withdrew in embarrassment. Their disarray was, however, only temporary. Determined to secure a victory eventually, they returned to the fray with a demand that Falmouth form a 'consortium' with the former Camborne Technical College nearby. Patrick Heron, a governor of Falmouth and long-term Cornish resident, is convinced that nothing but harm could result from such a plan. Falmouth's excellence as a school of art is inextricably linked with its unique character, and this individuality would easily be lost in the standardised anonymity of a 'consortium'. Besides, as Heron points out, administrative and unit costs 'rocket with the move to Polytechnics'; so the government would not even fulfil its desire to save money.

The uneasy truce which prevailed in Cornwall was disrupted last week by dramatic news that a coup had been engineered by the county's Higher Education Committee and the Camborne College. Falmouth has now been told that only two of its seven co-opted artistic governors will sit on the new board. The rest of its twenty-strong membership will be dominated by the Camborne design and technical drawing faculty, and an incensed Patrick Heron is convinced that Falmouth will be submerged by this manoeuvre.

Elsewhere in the country, turmoil thrives. Only the other day, Maidstone College of Art issued an urgent plea for help, revealing that NAB 'is recommending a reduction in student numbers on Degree Courses in Art and Design in Kent of 52 per cent, from 462 to less than 220.' The colleges offering these courses at Canterbury and Maidstone are threatened with closure, and the Maidstone students have just completed a week's occupation of the college as a protest. They point out that NAB has given 'no educational reasons for such a devastating cut in higher education in Kent'. Moreover, Maidstone claims that 'NAB's policy of discrimination against the small colleges in favour of the large polytechnics, regardless of academic excellence or quality of education

offered, is arbitrary, and reduces opportunities, diversity, and freedom of choice for students'.

These arguments are echoed at Wimbledon School of Art, but in this case the staff claim that NAB's sole reason for proposing a merger cannot be substantiated. Back in April, they received a letter from NAB maintaining that the merger with Kingston Polytechnic was intended 'to secure the continuation of the range of work currently offered by Wimbledon School of Art . . . located in an environment capable of withstanding the possible effects of the demographic decline in the 1990s'. But Wimbledon argue that the NAB plan is based on mere conjecture, and in late November the government's own Department of Education published new and very different forecasts of student numbers over the next decade. They now indicate that, by the end of the century, 18.5 per cent of young people could be taking full-time or sandwich courses in higher education, compared with less than 14 per cent at the moment.

NAB's initial reason for the Wimbledon move is therefore out of date, but the battle continues. Staff at the school are exasperated by NAB's refusal to answer their carefully prepared evidence. They also harbour serious doubts about NAB's ability to assess them with any real discernment. When members of the body visited Wimbledon, they told the Head of Painting, Bernard Cohen, that they had never been to an art school before. Cohen's incredulity can be imagined. His darkest fears were confirmed, and the Wimbledon staff are all convinced that the government simply does not realise what it is in danger of sacrificing.

Like so many art schools at risk in the country, Wimbledon thrives on singular strengths which could well be blurred or destroyed by the merger. Last year a £1 million building programme was completed at the school, an event which reflects the high standing enjoyed by its theatre and film courses. David Puttnam maintains that 'Wimbledon has contributed enormously to the development of an important craft and design area of the film and television industries', while Sir Peter Hall considers that NAB's proposal 'strikes at the uniqueness of the Wimbledon course, which combines design, wardrobe and practical studio work to a high level, and gives just those conditions of challenge, expertise and collaborative skill which prepare students for work outside in the theatre'.

Over and above these particular strengths, though, the Wimbledon affair raises fundamental issues which apply to art education in general. Roger de Grey, arguing from his vantage as President of the Royal Academy, thinks this current dispute is symptomatic of a nationwide tragedy. 'We have inherited from the 19th century a magnificent system

of art education which we are now destroying' he says, and the crisis at Wimbledon highlights what he means. Its staff believe that the character of the School could not survive in Kingston Polytechnic, because increased expenditure on central overheads would mean less money for teaching and materials. Wimbledon's Acting Vice-Principal Bill Furlong spells it out, explaining that there would be a 57 per cent cut in materials and a 32 per cent reduction in academic staffing. The latter, he says, is 'bound to be passed on to the part-time staff – permanent staff are the last to go. It'll mean that Wimbledon loses a lot of its valuable contact with practising artists, because so many of them rely on part-time teaching to subsidise their own work as painters and sculptors.'

If the part-time teachers are sacrificed at all the other art schools currently under threat, the effect on British artists would therefore be grave indeed. Most of them find it impossible to make a living out of their own creative work. There is an enormous gulf, in the market for contemporary art, between the small number of celebrated names who command vast sums and the others who struggle to sell even at modest prices. Teaching provides them with an invaluable source of income, and the art colleges gain hugely from the presence of men and women who can give students the benefit of their experience as practising artists.

Fine Art finds itself in an especially isolated and unprotected position, for NAB does not understand how artists contribute to the national economy. Assessed in crude monetarist terms, Fine Art rapidly finds itself cast in the role of higher education's soft underbelly. That is why it is bearing the brunt of the cuts – 20 per cent from Fine Art courses as opposed to 5 per cent from Design. In a system increasingly controlled by administrators rather than artists, there is a growing lack of understanding about the position of painters, sculptors and those working with alternative media. Representatives of NAB visiting art colleges are disconcerted to find studios smeared with paint, besmirched by plaster or clay, and cluttered with scrap metal and found objects scavenged from the street. To eyes unfamiliar with the ways of modern art, it can easily look anarchic, scruffy and somehow disreputable. One NAB official touring Wimbledon enquired how many 'commodities' a student was expected to make each term, as if Fine Art should be reduced to the production of 'articles of trade'.

Government officials have little difficulty appreciating the value of design, which can be directly applied to industry and thereby contribute to economic regeneration. But a painting seems disconcertingly 'useless', and the British have always regarded the whole idea of art with instinctive suspicion. Our national readiness to underestimate and scorn

the artist compares very poorly with France, Germany and Italy, where art is seen as an important activity and a source of national pride. In Britain, by contrast, art is deprecated at every turn. After introducing all our children to the pleasures it affords on a daily basis at infant school, the curriculum gradually relegates it to the status of a specialised and even arcane pursuit, of interest only to initiates. The study of art is not taken seriously enough as an academic discipline, either at O and A level or beyond. The history of art is offered as a degree course at disgracefully few universities, and so the abundance of well-run, energetic art schools in this country is something of a miracle.

They certainly played a vital part in the development of an adventurous culture during the 1960s, when so many rock singers emerged from art colleges alongside painters of the period as precocious as David Hockney. It is easy to convince politicians that groups like The Beatles make an invaluable contribution to our export earnings and tourist industry, not to mention the substantial sums which they pay each year to the coffers of the Inland Revenue. But it is hard to persuade the government that the human imagination, as embodied in the visual arts, should also occupy a crucial place in our sense of national priorities. A country without culture would be a wasteland of crass materialism, where a man like Henry Moore could never have the opportunity to flourish. His work deserves to be cherished, not for its ability to command high prices but because it conveys a vision of the relationship between humanity and the natural world that is of enduring value.

Moore's international reputation rests on images which fuse bodies and the landscape they inhabit with such resounding organic conviction that we cannot tell where one ends and the other begins. It is an affirmative and consoling achievement, like so much of the greatest art, and it cannot be reduced to the kind of myopic, philistine arguments which NAB representatives employ. They would do well to pause in their deliberations, pay a visit to the Tate Gallery's Moore collection and ask themselves if they are running the risk of preventing the Moores of the future from fulfilling their true potential. Only then will they arrive at a sensible assessment of the role which art colleges should be allowed to play in nurturing the artists Britain deserves.

MUSEUM ENTRY CHARGES: AN ABOMINATION
16 April 1987

Earlier this year, spurred by the realization that time was running out, we spent a couple of Sundays exploring the Natural History Museum. The expeditions were a huge success. From the dinosaur skeletons looming over Waterhouse's *tour de force* of an entrance hall, to the imaginative ecology section filled with clever reconstructions of the countryside, my children found plenty to absorb them. Far from tiring of the exhibits after a brief inspection, we left each time promising ourselves a return visit very soon. Even the crowds of other families surging through the Victorian rooms failed to detract from our enjoyment. The sight of so many people fascinated by the inventive human biology display only added to the prevailing sense of pleasure. For many years the Natural History Museum has provided the most enlightening free family entertainment in London, and I am incensed that such an experience has now effectively been withdrawn from the people it benefits most.

If only the April Fool's dateline fixed for the imposition of entry charges were simply a seasonal joke! It is not, and the turnstiles installed at the Natural History Museum at the beginning of this month are bound to have a calamitous impact on the service it provides. The Museum itself predicts that it will lose as much as 40 per cent of its audience, and the calculation is probably correct. How many of the families who used to frequent the building, and stand amazed in front of its immense Blue Whale, can afford the punitive £2 admission fee? Even though children are half-price, the cost for my family amounts to a hefty £8 – more than enough to give us pause before going off there again. After paying for transport, refreshments and anything the children might need from the museum shop, a sizeable expenditure is now involved. Many of the visitors we saw there in February and March are bound to conclude that they cannot afford it any more, and plenty of others will be forced to regard it henceforth as a rare event.

In other words, the whole museum-going habit is at risk. Once discarded, it will not easily be revived. Only those who need not worry about the cost will continue to savour the Natural History Museum on a regular basis, and frequent visits are always the best way to enjoy such places to the full. After a couple of hours even the most committed spectators find their attention flagging. Better by far to drop in for a relatively concise period, get the maximum amount of pleasure unalloyed by fatigue, and then make another trip soon afterwards. Museums are so vast

141. The Natural History Museum, London

that they can become associated, all too easily, with cultural overkill. Free admission encourages a selective and refreshing approach, but entry charges force most of us to restrict ourselves to the occasional, lengthy visit which could succeed in crushing the pleasure principle outright.

Attendance figures are certainly decimated whenever turnstiles have been introduced. At the Victoria & Albert Museum, where outsize cash registers were hauled in over a year ago, the number of visitors has dropped by almost a third. And that is only a so-called *voluntary* charge, negotiated by hapless members of staff who spend the entire day asking startled visitors whether they would 'like to make a contribution'. The ideal response to such importuning would be to flash the admirable badge produced by angry museum unions when the 'voluntary' scheme was initiated. Its succinct retort proudly declares that 'I Didn't Pay At The V & A'. But many people feel too embarrassed to refuse a contribution, and the experience is unwelcome enough to ensure that the museum's public dwindles to a wretched level.

At a time when attendance figures at our free museums continue to climb, such a decline is obscene. Public interest in art is now palpable enough to be encouraged as vigorously as possible, and there can be no excuse for promoting a return to the rotten old days when nobody really cared if the museum-going audience enlarged or contracted. But the government, through its miserly and philistine treatment of the funds at its disposal, is forcing more and more boards of trustees to penalise anyone wanting to discover the extraordinary richness of our national collections. The advent of turnstiles at the Maritime Museum in Greenwich two years ago now threatens to spread throughout central London, and Mrs Thatcher presumably views the prospect with approval.

What would happen to the booming numbers who frequent the National Gallery if such a policy were implemented there? A chilling answer is provided by recent history. Although Conservative politicians may prefer to forget it, entry charges were indeed introduced at Trafalgar Square in the dying stages of the Heath administration. During the brief period of their existence, before the incoming Wilson Government threw them out, the turnstiles had a disastrous effect on the National Gallery's popularity. In March 1974 attendance figures plummeted to an abysmal 31,476, compared with the 115,700 visitors it had received in March 1973 – thereby temporarily thwarting the efforts of a museum which wanted to open itself up to a far wider cross-section of the population.

At the time, I hoped that the mercifully short-lived episode would never be repeated. Attributing it to the feverish misjudgement which

afflicted the Heath cabinet in those beleaguered days, I concluded that we would never again witness such a deplorable imposition. For the principle of free museum entry is a great national tradition. It symbolises our belief that the finest achievements in world culture should be made available to us all, regardless of our financial standing. As someone who grew up in the regions and spent much of my adolescence saving up for trips to the London galleries, I know precisely how important the lack of turnstiles can be. It meant I could glut my growing appetite for art as often as I liked, and far, far more regularly than would have been the case with admission fees.

High unemployment, combined with the formidable cost of maintaining even a very modest standard of living, now ensure that people of limited means are deterred from entering the museums they should be able to frequent at will. After all, the upkeep and acquisition funds of these institutions are already financed by tax revenue. So why on earth should we be ordered to pay, at the door, for an experience made possible through contributions from our own pockets in the first place? It amounts, in effect, to an outrageous double tax. And it flouts the wishes of the generous collectors who have, in the past, donated works on the tacit understanding that free access would always be granted to their gifts. In this context, admission charges are nothing short of a squalid betrayal of the trust these donors placed in the museums they respected.

It is ironic that the affront should be committed by an administration which claims to set such faith in the revival of 'Victorian values'. For the Victorians were responsible for founding most of these institutions, and the Natural History Museum's charter solemnly promises that it is intended 'for the use and benefit of the public who may have free access to view and peruse the same'. The officials responsible for drawing up this noble document would be astonished and dismayed to learn that we are now prepared to let the same museum become the preserve of those who wield the mightiest monetary muscle.

Do not imagine I am exaggerating the threat that hangs over even the collections most resolutely opposed to charging. The pressures exerted by shrinking grants are growing apace, and by the end of the 1980s turnstiles might easily have been erected in all the major museums. The loss to the quality of our cultural life would be incalculable. We need to protest about this gathering abomination, as loudly and fiercely as possible, before it is too late.

PARIS THRIVES WHILE LONDON FOUNDERS
5 May 1988

Returning from an unexpectedly sweltering spring visit to the Paris exhibitions, I cannot help making jaundiced comparisons with the London art scene. In the great French museums everything seems galvanised by a spirit of expansion and renewal. Far from feeling complacent about the immense popularity of the Pompidou Centre, the government has recently agreed to spend millions of pounds improving its celebrated culture palace. Pontus Hulten, the Pompidou's former director who recently returned there in a consultative role, told me that the staff will be moved out of the building into alternative premises nearby. The extra space will provide much-needed accommodation for the permanent modern art collection, much of which has to be displayed on rotation at the moment. Funds are now also available for improving the display of the twentieth-century holdings, thereby preventing the Pompidou from deteriorating into a dated and inappropriate monument to high-tech fashion.

Contrast this buoyant state of affairs with our own dear metropolis, where all the major museums are beleaguered by cutbacks, the prospect of entry charges and threats about the need to sell off substantial parts of their collections. Without gifts from the Clore family and the Sainsburys, neither the Tate nor the National Gallery would have been able to build extensions on neighbouring sites. In France, on the other hand, the government was eager to pay for the creation of a Picasso Museum in a superb Marais mansion, and a vast survey of nineteenth-century art at the old Gare d'Orsay. The April crowds thronging both these spectacular additions to the Paris museumscape prove how enduring their attraction has become.

A lively programme of temporary exhibitions helps to keep both institutions at the forefront of public attention. At the Musée Picasso, I enormously enjoyed a small yet revelatory show devoted to the genesis of *Les Demoiselles d'Avignon*. New York collections had been persuaded to lend not only the masterpiece itself but also El Greco's wild and flame-like *The Opening of the Fifth Seal*, a canvas Picasso may well have seen in the early years of the century. The links between these two great Spanish paintings are persuasive and fascinating. But the extended series of Picasso's drawings for *Les Demoiselles* reveal how the young artist struggled to resolve all his conflicting ideas. For some time he wanted to include a male figure in the composition: either a sailor or a medical student whose bookish air would have made the Avignon prostitutes still

142. I. M. Pei's Pyramid at the Louvre, Paris

more brazen. Even today, when so much has been written about the cardinal significance of *Les Demoiselles*, it retains the capacity to challenge and astound.

Over at the Musée d'Orsay, Van Gogh's short but momentous stay in Paris is being examined with great thoughtfulness. It was, for him, a transitional period. First-hand contact with the Impressionists stimulated him into moving away from the dark, dour preoccupations of his Dutch peasant pictures. But the impact of new ideas made him very uncertain for a while. The presence in this exhibition of similar Paris subjects by Renoir, Monet, Lautrec and others often reveals how tentative he could be. As the show proceeds, though, it gains in confidence and expressive power. The Paris years laid the foundations for Van Gogh's explosive maturity in Arles, and the last room bristles with signs of incipient eloquence. A commanding study of the avuncular Père Tanguy, surrounded by the Japanese prints Vincent admired most, introduces a new sense of authority. The same room also contains a painting of sunflowers, their severed stalks harshly exposed. It announces the dual obsession with vitality and death he would spend the rest of his brief life exploring further south.

Paris shows no sign of growing complacent about its burgeoning museums. As if determined to prove that even the most venerable asset can be improved, a hugely expensive glass pyramid designed by I. M. Pei

is nearing completion at the Louvre. Intended as a new entrance for the collection, it will also house a long underground shopping mall, restaurant and other facilities to cosset the visitor of the future. The whole extravaganza has been fiercely debated, not least by those who claim that Pei's minimal geometry sits unhappily with the Louvre's existing architecture. As I inspected the scale models of the project, on view in a temporary display beside the vast construction site, I wondered more about the need for such a venture. Crowded the Louvre's existing entrance may often be, but is it really chronic enough to justify this intrusive concoction? Although an appraisal of Pei's ability to chime with the old Louvre must await the building's completion, the money absorbed by the pyramid could surely have been better spent on other aspects of art in Paris.

The French have a weakness for grand, theatrical gestures when ordering their cultural affairs. At its worst, the outcome leaves a gallery like the old Jeu de Paume stripped of all the Impressionists which used to make it the most delightful museum in Paris. The Manets and Cézannes have been transferred wholesale to the uppermost section of the Musée d'Orsay, where they look oddly forlorn in their new, clinical rooms. Too many of the paintings at the d'Orsay seem ill-at-ease, dwarfed by the sheer immensity of a railway station which Orson Welles once used as a location for a Kafka film. The appetite for spectacle at its most overwhelming runs riot in this converted train terminus, where the architecture often diminishes the art it is meant to enhance.

In the end, though, the Gallic desire for lavish excess is easy to forgive. For this weakness is countered by an admirable belief in the central importance of art. The French, to their eternal credit, are convinced that it deserves a place at the very heart of national life. They know how to celebrate their own painters, too. At present, Degas's entire career is scrutinised with magisterial aplomb at the Grand Palais. It is enthralling to see him develop, stage by stage, from his early veneration for Ingres and the classical tradition. Of all the artists connected with the Impressionist revolution, he was the most steeped in a love of the past. His copies of Renaissance and antique images are exquisite. The young Degas must at times have felt torn between his profound respect for history and an equally powerful urge to experiment. It certainly fills his large early historical canvases with tension, and the struggle is only resolved when he abandons Sparta or Babylon in favour of the modern urban scene.

Once the horse-races and ballet dancers begin to dominate his work, a new sense of assurance emerges. Offsetting passages of high finish with surprisingly loose areas of freely applied paint, he defines the athletic grace of human and animal movements alike. No wonder he was

obsessed by the sight of dancers in rehearsal, or jockeys preparing themselves for the contest to begin. Behind each of Degas's deceptively confident canvases lay a host of studies in which he tested, again and again, his ability to seize and convey the essence of action. The National Gallery has lent two fine paintings to the Grand Palais: the best of the early history pictures, and a late version of his favourite hair-combing theme which reduces everything to a soft, glowing statement of essentials alone. But the Degas show itself will not be coming to London on its international tour. It goes straight to Canada, leaving English museums to struggle against a philistine climate which seems increasingly hostile to the whole notion of developing our cultural resources at all.

TREASURES AT RISK

22 December 1988

Whatever the outcome of the bitter *Mappa Mundi* controversy, Hereford Cathedral's original decision to sell such a treasure raises alarming questions about the future of our national collections. In a country that really cared about safeguarding its culture, the Dean of Hereford would never have felt obliged to auction the *Mappa* in the first place. It is, after all, the grandest map to have survived from the thirteenth century, revealing on a monumental sheet of vellum the medieval world-picture in absorbing detail. Richard de Bello, Canon of Lincoln and the probable maker of the *Mappa*, went about his task with the zeal of a crusader. He provided what must have seemed like comprehensive information about Europe, Asia and Africa – where monstrous races are drawn with a distinct sense of fear. But the *Mappa*'s centre is reserved, unequivocally, for Jerusalem, and at the top of the design Paradise is depicted with true religious exaltation. The whole elaborate image, fusing cartography with devout ideas about the creation, fall and redemption of humanity, gives a marvellously vivid insight into the Middle Ages' view of mortal life on earth. It has probably been at Hereford Cathedral since the 1280s, and the thought of allowing it to be sold should never, ever have been contemplated.

I do not blame the Dean, the Very Reverend Peter Haynes, for this appalling state of affairs. Faced with a financial crisis, and unwilling to impose a compulsory entrance charge on 'a place of worship', he felt there was no alternative. His decision is all too understandable, for he

143. The *Mappa Mundi* at Hereford Cathedral

cannot have held out any hope about assistance from the state. The blunt reality is that the government shows little sign of honouring its full responsibilities towards national collections elsewhere in the country. At a time when West Germany was delighted to pay a record price for a Kafka manuscript, and considered it a bargain, we live in a nation which seems increasingly ready to dispose of its most important possessions.

How else to account for the Charity Commissioners' recent announcement that Royal Holloway and Bedford New College should be permitted to sell off its celebrated Victorian collection of paintings? The pictures have been faithfully preserved at Egham in Surrey for nearly a century. They include masterpieces by Constable, Turner, Frith and many other important British artists of the period, all purchased by the man who gave them to Royal Holloway College – Thomas Holloway. This outstanding philanthropist, whose wealth came from patent pills and ointments, would have been dismayed to realise that his benefaction now faces imminent dispersal by the college he founded. Today's collectors, who might have considered following his example and donating their treasures to similar institutions, are likewise bound to be alienated by the Charity Commissioners' disgraceful decision. But the Royal Holloway is now part of London University, an institution so gravely beleaguered by cuts that it must contemplate desperate measures.

The government's fundamental responsibility for the crisis confronting the Holloway pictures is, therefore, clear. But neither Mrs Thatcher nor her Minister for the Arts, Richard Luce, is likely to be concerned about the paintings' fate. After all, Conservative administrations have cut the purchase grants of all the national museums by an astounding 33 per cent during the 1980s. While the prices of art objects have spiralled to previously unimaginable heights, the directors of these great collections have become resigned to the near-impossibility of competing in the salerooms against foreign competition. They cannot even afford to run their existing institutions. The overall revenue of the national museums has been cut by 3.2 per cent in real terms since 1979–80, despite the rapidly rising cost of their running expenses. As a result, storage and conservation problems worsen all the time, and the fabric of the buildings themselves suffers from progressive deterioration.

With a collective shrug of its shoulders, the government is fond of declaring that the trustees of each museum are responsible for coping with these problems. That is why the entrance-charges policy, first implemented at the National Maritime Museum and the Natural History

Museum, has recently been extended to the Science Museum, where it would now cost me a punitive £8 to take my family for a single visit. Attendances have dropped by 40 per cent since the turnstiles were installed at the Natural History Museum, but the government does not seem remotely worried. It would like to see the directors of the British Museum, the National Gallery and the Tate charging entrance fees as well, so that the gallery-going habit is confined only to those with enough money to pay for the privilege.

So far, this particular pressure has been stoutly resisted. But for how much longer? As the Dean of Hereford has demonstrated, it is time to think the unthinkable. The government would even approve if our national museums started disposing of their assets as well. Why, it asks, should there be such a fuss about maintenance of works in store when they could so easily be auctioned off? It is an argument which must be resisted with wholehearted determination. By all means devise ways of displaying more of the collections, so that the public can enjoy them. The Tate took an adventurous step in that direction earlier this year, when it opened a new gallery in handsomely refurbished dockland premises at Liverpool. Soon, the Victoria & Albert Museum plans to follow suit by displaying some of its great but long-hidden Indian collection in new Bradford premises, where it will be especially valued by the large Asian population. That is the right way to deal with art in storage. But starting to sell it can only lead to mistakes.

The Lady Lever Art Gallery in Port Sunlight now regrets its rash decision, around thirty years ago, to sell a Fantin-Latour painting. Recent efforts to buy the picture back foundered when the gallery realised how expensive its once-spurned canvas had since become. Yesterday's unfashionable reputations have a habit of undergoing radical revaluation. The assessment of art never stands still, and it is folly of the most myopic kind to imagine that our contemporary pantheon will stand unchanged a century from now. Any museum worthy of the name does not amass collections for today's visitors alone. Its director and trustees also have to consider their responsibilities towards the future. Who can say what our descendants may wish to rescue from the basement and reinstate in the main galleries? We should not be too hasty in presuming to know, just as we must refrain from supposing that our museum buildings will always be as restricted as they are today.

In a hundred years' time, our society may well have become enlightened enough to provide national museums with the space to show far more than they can at the moment. We would never be forgiven for auctioning collections merely because of our present government's niggardly, short-

sighted attitude. There was a time when museums in this country adopted strategies based on expansion, not diminishment. Pride was taken in steadily increasing attendance figures, which nurtured the hope that a greater proportion of the population was coming to appreciate the collections we all possess. The current narrow obsession with turnstiles and selling-off must be replaced by a more positive, generous alternative. If it is not, I fear we will witness the steady destruction of an asset which, once dismantled, may never prove possible to replace.

THE FALKLANDS FACTOR

12 January 1989

Any exhibition scrutinizing the images spawned by the Falklands war should be, above all, free from the inhibiting influence of the government and armed forces. It boded well, therefore, when Manchester City Art Gallery's *The Falklands Factor* received a verbal exocet before opening day from the noisy Tory MP Geoffrey Dickens. He branded it as a 'slur' on the soldiers who fought there, and *The Star* published an indignant leader headlined 'Don't Mock Our Heroes'.

Quite apart from their predictability, these missiles were wide of the mark. The show devised by Howard Smith, Keeper of Exhibitions at Manchester, offers far more than a facile debunking of military myths. Take its analysis of a key Falklands photograph – the celebrated shot by Martin Cleaver of HMS *Antelope* exploding. This fiery disruption of the winter night sky was only taken because Cleaver was prepared, in freezing conditions, to sit for around five hours without gloves and wait for the magazine to blow up. When it did, his fingers had frozen so severely that he barely managed to close the shutter on his shot. But the ordeal paid off. His picture became an icon of the conflict, and newspapers used it in different ways according to their political dispositions. The *Daily Mail* reproduced it with the headline '*Antelope* Dies In A Blaze Of Glory', whereas the *Morning Star* used the selfsame image to illustrate the caption 'Senseless Sacrifice'.

Both these opposed views are given equal room in the exhibition, which also devotes generous showcase space to the *Sun*'s shameless sex-and-violence treatment of the saga. Under the headline 'The Sun Says Knickers to Argentina!', a topless model poutingly sports the aforemen-

tioned underwear with the name *Invincible* embroidered on it. Sailors' wives, apparently, enjoyed wearing such patriotic lingerie, and one of them even took off her bra at the dockside to give Our Departing Lads a frontal view of what they would be missing. But all this elbow-nudging sauciness and jingoism did not go down well with the troops themselves. After the infamous 'Gotcha' front page lauded the sinking of the *Belgrano*, the *Sunday Times* reported that 'people were throwing the paper over the side of the ship because they felt that the guys who had gone down on the Belgrano could have been them'. In fact, the *Sun*'s circulation dipped during the war, suggesting that quite a few civvies agreed with the troops' verdict. *Private Eye* supplied the definitive comment on the *Sun*'s disgraceful antics with a single pithy sentence: 'Kill An Argie And Win A Metro (details p. 11)'.

The most fascinating part of the exhibition derives from media coverage of the period. Only twenty-nine journalists accompanied the task force, among them just two photographers. They were all berthed on navy ships, and no satellites could be found to relay television images from the battle zone. No more than three batches of film arrived in London before the conflict finished, and so it ended up, in the words of the catalogue, as 'one of the most under-reported and mis-reported wars of modern times'. No British corpses can be found in the photographs that were taken. Adrian Brown, of 40 Commando, took a picture of a marine standing triumphantly over a dead Argentinian. But there is scarcely a hint of the suffering undergone by our forces. Instead, Tim Smith of the *Daily Express* provided morale-boosting pictures of Falklanders giving a soldier a 'welcoming cup of tea', and the first Argentinian prisoner wearing a British marine jersey.

A rare poignant note is sounded by Paul Haley of *Soldier* magazine, whose photograph of captured rifles reveals the devotional image of a Madonna and Child stuck to a weapon's butt. On the whole, though, breezy optimism prevails, and the sole official war artist sent out to cover the events fails to provide an alternative view. Unlike the most distinguished of her predecessors in the two world wars, Linda Kitson shows little sign of questioning the events she portrays with swift, perfunctory strokes of conté crayon or ink. Paul Nash's determination to confront the British public with 'a bitter truth' in 1918 plays no part in these offhand images. Soldiers are shown, for the most part, standing around with an air of lethargy waiting for something to happen. Even when she sketches the ward in a Field Hospital, Kitson conveys scant understanding of the pain and despair experienced by so many of the war's victims. She lacks scepticism, not to mention an informed anger. Only her drawing of the

144. Peter Brookes' cover design for *The Listener*, 20 May 1982

cruelly gashed *Sir Galahad* hints at the horrifying destructive forces unleashed during the conflict.

As an antidote to all this anodyne imagery, several cartoonists did succeed in viewing the events with bile. Ralph Steadman drew a typically repellent design for the *New Statesman*'s cover, where outsize flies descend on two lamb chops shaped like the Falklands islands on a blood-spattered globe. Gerald Scarfe mocked the ostentatious belligerence on both sides, showing Galtieri and Thatcher waving bunched fists at each other while shouting 'We shall fight until the bitter compromise'. One of the most hard-hitting attacks on the war's immense political significance comes from John Kent, whose *Private Eye* cartoon presents a Falklands memorial topped by Mrs Thatcher's carved head and inscribed: 'They Died To Save Her Face'.

Any organ of the media that dared to criticise the war underwent heavy bombardment from the Tory press. Peter Brookes drew an elegant cover for *The Listener*, depicting Broadcasting House as a flagship in turbulent seas. Explosions abound in water and sky alike, but the nastiest threat is posed by a missile bearing the words 'Up Yours, BBC'. Not all the conservative papers dished up unqualified support for the government, though. Nicholas Garland, working with much of Vicky's acerbic wit for the *Daily Telegraph*, portrayed Mrs T as a naval rating on the prow of a destroyer. Above the caption 'Clear The Decks', she sweeps a UN peace plan and other mediating proposals straight into the ocean. As for the indefatigable Steve Bell, he produced a robust indictment for *City Limits* two years later. When the PM declared in September 1984 that 'some things can never, never be revealed', he transferred her remarks to the centre of a Union Jack. With nails in her mouth, she attempts to pin the flag over a monstrous heap of skeletons. But they spill out through a rent in the cloth, tumbling down towards an accusatory caption asking: 'Why Cover Up If There's Nothing To Hide?'

Compared with these forthright cartoons, painters have so far failed to produce anything with a similar amount of punch. Jock McFadyen's ugly, anti-jingoist picture of dockside hysteria is refreshing after Terence Cuneo's *Boy's Own Paper* painting of *A Lull in the Battle, Port San Carlos*. But I searched in vain for an artist with even a fraction of Goya's savage, protesting imagination. In the end, more insight was displayed in the section of collages made during 'Post-Traumatic Stress Syndrome Therapy Sessions'. A steward on HMS *Invincible* produced a collage riddled with images of graveyard crosses, burials at sea and burning destroyers. Dominating the whole design are three enormous capitals spelling 'WHY', and within each letter are the names of men who never returned to a hero's welcome.

TREES IN EXTREMIS

13 August 1989

Ever since the terrible storm of October 1987 decimated so many English trees, their vulnerability has become increasingly hard to ignore. The sight of severed and uprooted trunks in our streets and parks also made us more aware of how easily entire rainforests can be destroyed elsewhere. It gives a sense of urgency to the tree images produced for two timely exhibitions, both inspired by the environmental arts organization Common Ground.

Not that the larger of the shows, at the Royal Festival Hall, is conceived as a polemical warning. Rightly emphasizing the primacy of the artist's imagination, it prompts several participants to interpret the theme without any apparent ecological alarm. Stephen Cox's *Salamander*, a relief carved in volcanic stone, is dominated by an oak triumphantly irradiating the planet with shafts of beneficent light. Balraj Khanna's painting *In Love with Life* is even more ecstatic, festooning the tree's foliage with an abundance of phosphorescent birds, crosses and orbs all trailing streamers down to its roots.

In other sections of the show, though, signs of disquiet soon surface. John Virtue's multi-panel work amalgamates a number of different views, all probably culled from a walk through woodland where trees heave and sway in response to an accelerating wind. The dense ink hatching scored into the paper by Virtue's surgical nib suggests a firmness capable of withstanding the storm. But Ron Haselden's *Electric Tree* is more unstable. Flashes of scarlet leap and crackle all over his ingenious version of a bonsai tree, inspired by a disused length of computer ribbon cable. Rising from an exposed heap of wires on the floor, this crazily tangled apparition pulsates with electronic energy. It looks frenetic enough to erupt, at any instant, into flame.

Burning is already well advanced in Andrzej Jackowski's canvas *Walking to the River*. Against a penumbral background, where mountains are dimly perceptible, a silhouetted figure moves through an archway formed by two trees. Although the heat and smoke from their fiery branches threaten to overwhelm him, he manages to remain standing. Jackowski's broken brushstrokes promote ambiguity, but the figure seems to be heading for the other trees flaring like torches by the water's edge. An ordeal is surely in progress, and the painting's elegiac mood suggests that nature will soon be devastated by a holocaust.

At least a chance of survival remains here, however – especially when compared with the terminal bleakness explored by Tim Head's colour

photograph of *Winter*. For he presents an inverted tree, dangling in the darkness and frozen by a cold blue light. Ripped from the earth and strung up to die in a nocturnal void, the skeletal tracery of branches resembles the X-rayed interior of a body as well. The tree is equated here with the life-structure of humanity, and extinction threatens them both.

Because Head distances himself from this annihilating theme with the help of the camera's clinical precision, he avoids melodrama. Eileen Cooper is less successful when she transforms her *Sad Tree* into a woman. Her doleful eyes, together with branch-arms outstretched in a crucifixion pose, fail to escape sentimentality. I preferred Amikam Toren's *Actuality*, where an ordinary chair is whittled down to a framework of emaciated wooden strips. The metamorphosis produces a far more attractive piece of furniture, with a tensile strength of its own. But one leg has been bent in genuflection over the discarded seat, indicating that its resilience cannot last.

Although the exhibition has been given the reassuring title *The Tree of Life*, in honour of ancient symbolism, most of its contributors view their subject in a pessimistic light. Garry Fabian Miller assembles ninety-six torn sycamore leaves from a wood in the Trent Valley and reaches the conclusion, no doubt with reluctance, that fragility remains their fundamental characteristic. The precarious state of nature's balancing act is neatly summarised by Bill Woodrow's *See-saw*. Taking a pair of kitchen scales, enamelled in an appropriate green, he places a truncated saw on one end. It turns out to be far heavier than the other end, where Woodrow has shaped a sapling from strips of metal. For the moment, leaves sprout from the shoot and it stays more or less upright. But its isolation is inescapable, while the saw's ominous weight conveys the prospect of catastrophe to come.

Over at the Crafts Council Gallery, the most spectacular exhibit reinforces this notion of an inevitable tipping towards destruction. Andrew Darke's *Standing and Falling* arranges nine slender slices of oak in a fan formation. They resemble a Futurist image charting the successive stages of a tree's collapse, and only the wood's sensuous warmth alleviates the melancholy of their fall. On the whole, though, this is a more lightweight show than *The Tree of Life*. Jan Zalud promises *The Wrath of the Green Man* in his contribution, but it turns out to possess no more avenging power than a funfair toy. At the push of a button, the lime head rolls his eyes and opens his mouth to reveal an oak leaf instead of a tongue. Whimsy has crept into this survey, encouraging some of the artists to indulge in excruciating wordplay. Darke displays two *Log Books* in cedar and laburnum, while Adelle Lutz cannot resist offering a *Fir Coat*. A fashion-conscious

145. Bill Woodrow, *See-saw*, 1988

Green visitor could assemble a whole ecological outfit here, with oak-leaf earrings, brooch and cufflinks to accompany a jacket decked out with (you guessed it) oak leaves painted in gold.

Two of the artists escape from the show's prevailing frivolity. Andy Goldsworthy stitches leaves together with thorns, leaving a strip of single leaves running down the centre in a near-transparent spine where sunlight can shine through. Strength and delicacy are handled with equal subtlety by David Nash, whose beechwood *Crack and Warp Column* has been sliced with lateral cuts. It looks thin and brittle, scarcely able to remain upright. A closer look discloses, however, that Nash has left the column's inner core intact. Travelling defiantly from base to apex, it reaffirms nature's capacity to withstand even the most grievous assault after all.

But neither Nash nor Goldsworthy can compensate for the rest of the exhibition's deficiencies. The nearer these exhibits come to the condition of craft, the less willing they seem to address the life/death duality explored so provocatively at the Royal Festival Hall.

FINALE

OUT OF THE DARKNESS
13 July 1989

Enter the immense arena of Studio Two at Riverside Studios and you are confronted, at once, by the ominous bulk of Anselm Kiefer's *The High Priestess*. A couple of steel bookcases, divided in the middle by a sheet of thick glass, stretch twenty-six feet from end to end. The volumes they contain are equally awesome. As battered as the books in some ancient library newly uncovered by archaeologists, they lean at weary angles or lie in piles as if awaiting examination. But their lead pages prohibit visitors from attempting to lift these weighty objects from their resting-places. They retain their mystery intact, inviting assessment as sculptural presences rather than a series of texts to be read.

In order to fortify the connections with a remote past, Kiefer has written the names Euphrates and Tigris on plaques attached to the shelves. By evoking the two rivers which bounded Mesopotamia, he encourages us to see the outsize volumes as remnants of the very beginning of civilization. In this respect, they look like an affirmation of culture's eternal importance, long outlasting the people responsible for producing them. In another sense, though, they prompt melancholy reflections. If so little now remains from the extraordinary flowering generated by Mesopotamia's inhabitants, what chance does our civilization have of surviving any disasters to come?

As *The High Priestess*'s title indicates, with its reference to the knowledge hidden in the Tarot card-pack, no straightforward answer to that question presents itself. But the fact that these books are made of lead, a material capable of protection against radiation after a nuclear catastrophe, raises other fears. Have these books recently been selected for special treatment, by authorities aware of the possibility that annihilation could soon overwhelm us all? Viewed in this light, *The High Priestess* suddenly seems to bear on the future with as much disquieting pertinence as on the past. In Germany, Kiefer called his colossal library *Land of Two Rivers*, and his decision to give it an alternative name in English indicates a desire to stress the work's contemporary relevance. Both titles should ideally be borne in mind, for Kiefer has always thrived on his ability to mould time with immense suppleness and place the present in the context of history's widest ramifications.

As if to remind us that Kiefer is fundamentally a painter, the rest of the enormous Riverside space is occupied by three monumental images hung on the white-curtained walls. They are as full of foreboding as the

146. Anselm Kiefer, *The High Priestess* installation in progress at Riverside Studios, London, 1989

bookcase, continuing its meditation on transience in an even more apoc–alyptic mood. Just before the First World War, Kiefer's compatriot Ludwig Meidner became haunted by images of devastation, anticipating the conflict to come in paintings where cities are assailed by explosions of terrifying force. Kiefer's approach is far less explicit, and it would be a

mistake to see him simply as a neo-expressionist who confirms Meidner's gloomiest presentiments. All the same, the paintings displayed here offer a desolate view of the contemporary world.

One, *Barren Landscape*, belies the second word in its title by offering a vertiginous view of an archetypal modern city. Based on São Paolo but applicable to any urban centre where skyscrapers cluster in abundance, it looks down from an incalculable height on the proliferating tower-blocks. Without specifying the possibility of collapse, Kiefer gives the entire picture a feeling of profound unease. Ash, chalk and hair have been mixed with the acrylic to give the city a dusty and neglected air. Instead of exemplifying streamlined modernity, the buildings seem tarnished and almost uninhabitable. No figures can be glimpsed in this listless locale, where dizzying perspectives are unable to hide the underlying malaise. Whether the city will eventually be demolished, or succumb to an inferno already hinted at by the heating element inserted in the painting, remains unclear. But the entire image is overshadowed by the implication that life in such a megalopolis has become unfit for humanity, and deserves to disintegrate before long.

Across town at the d'Offay Gallery, where Kiefer's mammoth show continues in three substantial spaces, these premonitions are confirmed. Nowhere more alarmingly than in a panoramic canvas called *Princess of Siberia*, where the foreground is occupied by railway tracks shabby with disuse. A pair of real ballet slippers hangs from the side of the picture, but they look almost as abandoned as the lines converging on an equally derelict town in the distance. The contours of two tower-blocks, corroded with dull orange rust, lean from either side of the tracks and threaten to fall. Their demise will probably go unmourned, for the whole area seems to have been evacuated already. It is a gruesome prospect, made still more oppressive by the expanses of lead filling the sky with an inexorable grey weight.

Other aspects of the d'Offay show counter this relentless pessimism. Even though Kiefer's forebodings convey a formidable amount of conviction, he is prepared to entertain the Nietzschian possibility that a rebirth might emerge from the destruction. In the large upstairs gallery at 23 Dering Street the emphasis on materials like salt, chalk and ash is replaced, from time to time, by manifestations of organic growth. In *Multatuli* the lower half of the picture is dominated by tulips, pressed on to the lead background and long since dead. But extinction is balanced in this case by the possibility of future growth. Nature's recuperative powers should never be underestimated, and the fragmented stems, leaves and petals blowing around the upper reaches of the picture alleviate the sadness generated by the tulips' *memento mori* symbolism.

Kiefer is too wary of humanity's self-destructive impulses ever to indulge in an immoderate amount of hope. He first made his reputation, a decade ago, as a painter born in the post-war period and yet obsessed by the tragedy of German history during the twentieth century. The warnings he issued in his previous work have not been forgotten, and they continue to inform the most powerful of these new exhibits. Their grandeur, however, is equally undeniable. Out of the darkness Kiefer succeeds in forging an affirmation of art's ability to warn, and he deserves to be heeded.

INDEX

Page references in *italics* indicate illustrations. Works are listed under artist and subject.

state-sponsored art, 157
Steadman, Ralph, 472
Steinbach, Haim, 17, 115
Stella, Frank, 32
Stevens, May, 4, 28
still life, 273
Stirling, James, 197–200, 322–6, 335–40, 379
Stokes, Anthony, 109
Stonehenge, 145
Stubbs, George, 13
Surrealism, 308, 309, 310
Switzerland, *see* Oppenheim, Meret

Taaffe, Philip, 115
Tate Gallery
 Liverpool/'Tate of the North', 18, 284–340, 339, 441
 London, 136, 333
 directors, 333–6
 exhibitions, 42–5, 50–2, 201–4, 254, 266, 419
 Moore collection, 458
 see also Turner Prize
Tchalenko, Janice, 112
television
 art on, 410–13
textiles
 weaving, 221–4, *223*
Thatcher, Margaret, 11, 453, 461, 468, 473
theatre, *see also* dance; opera
Thomas, Simon, 414
Tingueley, 56, 254–8, *256*
Tombs, Sarah, 403
Toren, Amikam, 475
town planning
 Bath, 406–9
 see also architecture; Arts Council, *Art into Landscape*; context; environ-ment; Land Art; landscape; nature
Trakas, George, 108
trees, 474–6
Trinidad, *see* Caribbean art
TSWA 3D, 23, 420–3
Tucker, David, 356
Turner Gallery, 322–6, *323*, 379; *see also* Stirling
Turner, Prize, 16–17, 119–122, 133, 136
Turner, Tom, 348
Twombly, Cy, 130, 287–91, *290*, 318

Uddin, Shafique, 81
Uglow, Euan, 142
Ukeles, Mierle Laderman, 4, 29
USA
 American Indians, 352
 artists, *see* Andre; Basquiat; Bickerton; Bleckner; Craig-Martin; Gober; Halley; Haring; Johns; Judd; Koons; Longo; Marden; Morris; Rauschen-berg; Rollins; Schnabel; Steinbach; Stella; Taaffe; Warhol
 see also New York
USSR, *see* Russia; socialist art
Utting, James, 356

Vaisman, Meyer, 115
Venice Biennale
 1980, 155–8
 1988, 129–31, 133, 135
 1990, 146
 see also Italy
Venturi, Robert, 321, 328–30
Viallat, Claude, 129
Victoria & Albert museum, 440, 461, 469
 exhibition, 137–9
video, 27, 137, 312
Vilmouth, Jean-Luc, 389
Virtue, John, 122–5, *124*, 474
Vorticism, 55, 273, 286, 296

Walker, John, 168–72, *171*, 191
war, 104–5
 Africa, 37
 Congo, 258
 Falklands, 470–3
 Images against War exhibition, 177
 see also First World War; Second World War
Warhol, Andy, 17, 32, 147, 149, 219, 252, 318, 412, 437
Webb, Boyd, 98–102, *101*, 104, 391, *392*, 394, 443
Weber, Bruce, 138
Wegman, William, 139
Wentworth, Richard, 110, *111*
White, Elizabeth, 388
Whitechapel Art Gallery, 45, 80, 84, 133, 140, 180, 194, 221, 232, 242, 260, 288, 297, 356, 387, 443
Whiteford, Kate, *422*
Wilding, Alison, 4, 53–5, *54*, 110, 330, *331*, 338

CREDITS

The publisher has made every effort to contact the relevant copyright holder for the images reproduced. If, for any reason, the correct permission has been inadvertently missed, please contact the publisher who will correct the error in any reprint.

Scotland, 110; Courtesy Malak, Ottawa, 111; David Hamilton, 112; Courtesy the artist, 114; John Dugger, 115; Rowan Gallery, London/Courtesy the artist, 116 (photo: Roger Bradley); The work illustrated on p. 367 has been reproduced by permission of the Henry Moore Foundation, 117; Barry Flanagan, 118; Courtesy the artist, 120; Courtesy Whitecube, London, 122; Courtesy the artist, 123; Courtesy Artangel, London, 124, 137; PADT, London, 126 (photo: Edward Woodman); Pratt Contemporary Art, 127; Courtesy the artist, 130, 132; Tess Jaray, 133; Claes Oldenburg/Coosje van Bruggen, 135 (Malmberg International Malmö, Sweden/photo: Dorothy Zeidman); British Airports Authority, 139; Wimbledon School of Art, 140; © The Natural History Museum, London, 141; I. M. Pei/© Serge Hambourg, 142; Hereford Cathedral, 143

COPYRIGHT LINES